Music For Vagabonds
The TUXEDOMOON Chronicles

Printed in the UK and US by Lightning Source
Print On Demand Services provided by OpenMute

Copyright (©) 2008 by Isabelle CORBISIER

FIRST EDITION: 2008

All rights reserved.
No part of this book may be reproduced or transmitted in any form, by any means,
electronic or mechanical, including photocopying, recording, or by any information
storage and retrieval system, without written permission from the author,
except for inclusion of brief quotations in a review.

UK ISBN 978-1-906496-08-1

Isabelle Corbisier

Music For Vagabonds
The Tuxedomoon Chronicles

To Françoise De Paepe

CONTENTS

FOREWORD .*XIII*

PROLEGOMENON
The Tribe .*1*

INTRODUCTION
On the road to San Francisco . *5*
Peter Principle... trains for a drum set . *7*
Blaine L. Reininger... the prairie starts there... . *9*
Steven Brown... how to scare the hell out of your neighbors... *12*

PART I - SAN FRANCISCO (1977-1981)

CHAPTER I
The Angels Of Light . **19**
Thomas (Tommy) Tadlock . *20*
The Angels Of Light . *21*
The Angels Of Light and situationism . *28*
From hippies to punks - first take . *29*

CHAPTER II
Tuxedomoon New Music Ensemble in the Houses of San Francisco **33**
Tuxedomoon New Music Ensemble . *34*
From hippies to punks - second take . *41*
3645 Market Street . *43*

CHAPTER III
From "Just Desserts" to Milk and Moscone's Assassinations . **57**
Airplane Show; Gregory Cruikshank quits the band . *57*
Tuxedomoon starts playing at the Mabuhay Gardens . *59*
Opening for Devo . *61*
From hippies to punks - last take . *62*
Tuxedomoon and drug use . *67*
"Joeboy The Electronic Ghost" . *72*
A (mis)adventure out of town . *72*
Miners' benefit . *74*
Victoria Lowe quits the band . *74*
Paul Zahl and Michael Belfer join the band . *76*
Another (mis)adventure out of town . *79*
"No Tears" . *80*
Fall-out with Tommy Tadlock; Peter Principle joins the band; Bruce Geduldig
starts collaborating with Tuxedomoon as well . *81*

Page VII

The turning point: Milk and Moscone's assassinations*84*

CHAPTER IV

Outgrowing San Francisco..**87**
Recording of the "Stranger"/"Love/No Hope" 7"..*87*
Tuxedomoon plays at the Deaf Club in San Francisco....................................*87*
Tuxedomoon plays LA and the East Coast...*89*
*The Residents' connection: Subterranean Modern compilation and Scream
With A View EP*...*91*
New No Wave Festival in Minneapolis...*94*
Michael Belfer drifts away; recording of the Half-Mute LP.............................*95*
In December 1979, Tuxedomoon played at the Boarding House *100*
Soma Show at Temple Beautiful ... *101*
Short East Coast tour.. *102*
Urban Leisure Suite.. *103*
Ian Curtis' suicide and what follows... *104*
Recording of the "Dark Companion" single... *104*
The European connection... *105*
Tuxedomoon's first European tour and recording of the Desire LP *106*
Start of Tuxedomoon's love story with Italy... *114*
Searching for a home in Europe and recording of the Joeboy In Rotterdam LP.......... *119*
*Tuxedomoon briefly returns to the US via NYC where they are filmed for the
Downtown 81 movie and perform a few dates* .. *122*
Shooting of the "Jinx" promo video clip by Graeme Whifler............................ *123*
*Tuxedomoon plays a series of farewell shows in San Francisco and leaves for
Europe for good via NYC* .. *127*

PART II - EUROPE (1981-1988)

CHAPTER V

From the Ghosts of Nancy to the Ghost Sonata .. **133**
The Ghosts of Nancy... *133*
*Tuxedomoon as artists-in-residence for the Midland Group at the Clarendon College
in Nottingham, a prefiguration of The Gost Santana*.................................... *136*
The Celluloid fiasco ... *138*
Four years of Tuxedomoon: Blaine Reininger's car accident *142*
*Eviction from Utopia; Tuxedomoon moves to Brussels, works with choreographer
Maurice Béjart, Les Disques Du Crépuscule and releases the Une Nuit Au Fond De La
Frayère single for Sordide Sentimental (the situationists return)*........................ *146*
US tour.. *154*
The Crépuscule package tour .. *156*
Blaine Reininger records his first solo album, Broken Fingers *157*
Tuxedomoon records the Time To Lose 12" .. *159*
Another triumphant tour in Italy... *160*
Tuxedomoon record the double 12" Suite En Sous-sol for Italian Records................ *162*
Patrick Roques' arrival in Europe.. *164*
The Ghost Sonata.. *168*
*Ending up at the school of the deaf, dumb and blind. Hear no evil, speak no evil and
see no evil*... *185*

Page VIII

CHAPTER VI

From "This Beast" to THE Beast in Dreux - Blaine Reininger leaves Tuxedomoon................. **189**

In August 1982, Reininger and Brown start to work on "The Cage" and "This Beast" in the absence of Peter Principle ... 189

Each member of the group embarks on a myriad of solo projects, collaborations or productions .. 189

A German tour in the Winter ... 194

Tuxedomoon records a soundtrack for Dutch alternative film-maker Bob Visser's film Het Veld Van Eer (Field Of Honor) ... 201

Michael Belfer arrives in Brussels ... 201

Tuxedomoon turns down an offer made by Les Disques Du Crépuscule to record an album with them .. 205

French tour including the fateful date in Dreux, after which Blaine Reininger states his intention to leave Tuxedomoon ... 205

Martine Jawerbaum becomes Tuxedomoon's manager and Luc van Lieshout becomes a member of the band ... 214

Blaine Reininger records his second solo album, Night Air 218

CHAPTER VII

Tuxedomoon's Holy Wars – Winston Tong leaves Tuxedomoon **225**

In May 1983, a new live show entitled Music In Four Suites Based On The Times Of Day, performed in Spain .. 225

Steven Brown in the Zoo Story play and Peter Principle provides music for the Pandemonium short film ... 226

Blaine Reininger has thoughts about leaving Europe 227

Winston Tong collaborates with Niki Mono (Theoretical China single and Theoretically Chinese album) ... 230

Tuxedomoon tours in Italy .. 234

Various Tuxedomoon events in Lille ... 235

Steven Brown creates soundtrack music for Jean-Pol Ferbus's Jean-Gina B movie 236

Recording of the Soma single; some tours and scattered gigs; Fifth Column; recording of the Holy Wars album; more gigs; Scandinavian tour 237

Work starts on Operation Revisionaries ... 242

Tuxedomoon signs with Crammed Discs ... 246

Peter Principle records his first solo album, Sedimental Journey 247

Steven Brown releases his second collaboration with Benjamin Lew: A Propos D'Un Paysage .. 248

The Revisionaries performance in Lille on March, 15th, 1985, and release of the Holy Wars album ... 248

In Spain on Paloma Chamorro's TV show .. 255

Reininger's ventures alone or with Steven Brown; Bruce Geduldig starts The Weathermen .. 258

Steven Brown meets Antoine Pickels; Winston Tong fades away 260

CHAPTER VIII

The end of Tuxedomoon's second era ... **269**

1985 (from August): Ivan Georgiev joins in time for Tuxedomoon's German tour in September ... 269

Recording of the Ship Of Fools mini LP ... 274

Page IX

Tuxedomoon at Oslo's Opera House. . *276*
1986: various Tuxedomoon members act in and/or work on the soundtrack of Patrick de Geetere's video film entitled Fuck Your Dreams This Is Heaven, a tribute to Syd Barrett . *278*
Blaine Reininger records his Live In Brussels album and Steven Brown his Me, You And The Licorice Stick EP. . *280*
The Ship Of Fools show at Ancienne Belgique, Brussels, 04/03/86 . *281*
Dutch journalist Jan Landuydt's attempt to describe Tuxedomoon . *283*
American tour . *285*
More dates in Spain and Scandinavia. . *287*
Reininger records his Byzantium solo album . *287*
Tuxedomoon participates in Bob Visser's Plan Delta film project . *288*
Recording of the You album and last concert of Tuxedomoon second era at Elysée Montmartre on November 27th, 1986; No Tears '88 project . *289*
1987 through 1988: release of the Pinheads On The Move compilation album. *293*
May 1st, 1987 Andy Warhol's Workers Party Day at Brussels's Résidence palace *294*
Steven Brown's next solo recordings: Searching For Contact and Brown plays Tenco. . . . *295*
Tuxedomoon's 10th Anniversary meal; the Reunion Tour. . *299*

PART III - THE WORLD (1988 *till present*)

CHAPTER IX
From the eighties into the nineties (1988-1997) or Tuxedomoon's Dark Age **315**
1988: in July, Peter Principle records his Tone Poems solo album. . *315*
Blaine Reininger records his Book Of Hours solo album . *316*
Steven Brown records his Steven Brown Reads John Keats solo album and works on his Greenhouse Effect show . *318*
1989: Tuxedomoon's misfired attempts to come to life again. . *321*
Steven Brown's various solo undertakings. . *325*
Blaine Reininger & Steven Brown work together and release two albums: De Doute Et De Grâce (with Delphine Seyrig) and 1890-1990: One Hundred Years Of Music *330*
1990: Steven Brown works with Italian choreographer Julie Ann Anzilotti, Belgian choreographer Thierry Smits and releases his Besides All That compilation CD. *332*
Blaine Reininger releases his Songs From The Rain Palace CD . *335*
Peter Principle releases his Conjunction album and returns to the USA *336*
1991: Brown releases his Half Out album, co-founds Act Up Brussels, gets filmed for Julien Bosseler's documentary entitled Steven Brown – L'Autre Chez Moi and tours with his band . *341*
Blaine Reininger works with the Virulent Violins . *347*
1992: Reininger and Brown release their Croatian Variations CD . *348*
Some Tuxedomoon related events in Brussels and Athens. . *349*
1993: dissolution of the Tuxedomoon ASBL . *351*
Steven Brown leaves Brussels for Mexico City. . *351*
Release of Tuxedomoon's Solve Et Coagula compilation album . *353*
From 1994 to 1997: Brown and Reininger's works in Europe and Mexico respectively. . . . *354*
Page X

CHAPTER X

From the nineties till Tuxedomoon's 30th Anniversary in 2007 : the never ending story continues... **361**

1997 (continuing) - 1999: release of Joeboy in Mexico.................................... 361

Tuxedomoon plays as a trio in Tel Aviv, Athens and Polverigi; release of Nicholas
Triandafyllidis's Tuxedomoon - No Tears documentary 362

Blaine Reininger leaves Brussels for Athens with his wife JJ La Rue terminally ill;
Reininger releases his The More I Learn The Less I know solo album..................... 363

2000-2003, the long road in the making of Tuxedomoon's next official album: Edo
Bertoglio's feature film Downtown 81 is presented at the Cannes Film Festival......... 368

The Sandro Pascucci and DJ Hell connections; Nine Rain releases a second album,
Rain Of Fire, and tours in Europe .. 369

Tuxedomoon touring in 2000 (St Petersburg and Belgrade) 372

Tuxedomoon's second residency, in 2001 in Cagli, Italy................................. 377

2002: a transition period ... 388

2003: Tuxedomoon plays prestigious venues including the Beaubourg (Pompidou)
cultural center and records their Cabin In The Sky album 389

Cabin In The Sky and related events in 2004... 397

2005: Tuxedomoon is back in San Francisco ... 402

Tuxedomoon tours in Spain... 409

Tuxedomoon participates in the New Atlantis Festival in Amsterdam.................. 410

2006: Tuxedomoon releases the Bardo Hotel travelogue album and tours in Europe
while working on the Vapour Trails album, released in 2007 414

2007: Tuxedomoon is 30 years old and the never-ending story continues 420

ENDNOTES

ENDNOTES...**425**

SELECTED BIBLIOGRAPHY

SELECTED BIBLIOGRAPHY..**441**

ACKNOWLEDGEMENTS

ACKNOWLEDGEMENTS ..**447**

INDEX

INDEX..**449**

FOREWORD
TUXEDO...

I still see myself as a teenager, my hair bleached and then dyed blue, watching the orange sky* from my attic room, listening to the new record I had purchased that day. I loved the smell of new records, the thrilling, soothing odor of vinyl and the sweet fragrance of the brand new cover, plastic unwrapped – Ralph Records! 'HALF MUTE'. Mesmerizing music from Tuxedomoon. It's difficult to describe what went through me… It was serious, man. It was cool! It was great music, I felt proud to own it. Then I got 'DESIRE'. And that was where my future began. I felt relieved. I knew there was a whole new exciting world waiting for me, out there… I owe a lot to Tuxedomoon and all kinds of "new wave" bands. They helped me develop an attitude, they would shape the person I am today. Bands, and authors like William Burroughs, film directors like John Waters…

*I was not living on Mars at that time, but in a Brussels suburb. At night the sky often taints with orange in Brussels. It all has to do with the huge, powerful lighting of the highways. Highways to love, highways to hell. Since Belgium is one vast highway with some villages alongside it, it is this country that lights up at night in the northern hemisphere, as can be seen from space… As can be seen from the **MOON**. (As a kid, I loved to think that the King of Belgium had a big switchboard in his palace, with all the motorways lined up before him. From there, he would command the lights.) Still a favorite landing spot for UFO's, if you believe in them. Little did I know back then, in my attic room listening to my vinyl dreams, that Tuxedomoon would actually move to Brussels – "Mortville," as they would call it – and that we would become lifetime friends… It's a jinx, it's a jinxxxx…

Recently (Oct. 2007) I saw the band perform again with a gig spread over two nights at the Beursschouwburg, one of their old spots in Brussels, as part of their 30th anniversary tour. The first night they played "the classics," a catalogue of their earlier years. Sure enough, these amazing songs still stand up today and the band has developed a solid virtuosity. What I witnessed was fellow travelers that have been crossing many roads all over this planet, performing with contagious

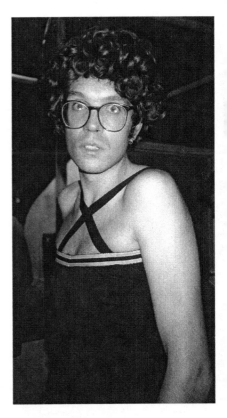

Rudi Bekaert at Steven Brown's Birthday Boat Party, Brussels canal, 1989. "Nautical drag was required, so I dressed up like a harbor whore."

delight. But I was even more overcome with joy – hallelujah! – the following night, when I heard them perform their new stuff from "Cabin In The Sky" and "Vapour Trails." The new Tuxedomoon is cooler than ever. Nostalgia is a noble feeling but you should only take it in small doses. Life is now.

In the eighties, Brussels looked dreary on the outside, a grey spot on the map. You could watch beautiful houses rot away, abandoned to the winds and the rains and the pigeons. Sick pigeons. Or get thrown off the Grand Place because you were "scaring the tourists away." But if you looked under the surface, it was quite an exciting place, especially for music and art in general. We had good alternative labels, good venues, good record stores. The public had a great time, I can assure you. Brussels seemed to inspire many "alternative" bands. Also, if you wanted to take off or get totally zonked out, you could always find a dealer around the corner. It's a miracle I'm still alive, and that goes for the most of us, when you consider…

As for those that have gone, I still have great memories of Martine Jawerbaum, Yvon Vromman, and sweet, crazy J.J. La Rue. Like how she used to call me at 4 a.m., "Hi, did I wake you up?!" "Yeah, J. J., you did…" "Good!" And then she would hang up… Another time, she would be standing by my bed when I opened my eyes in hospital. I was lying there because I had been run over by a speeding undertaker. Thank you for that visit, by the way, J.J. and Blaininger.

A whole crowd of friends and fans had developed and gathered around Tuxedomoon. Never a dull moment. The climax must have been the Andy Warhol's Workers Party at the Residence Palace, sponsored by Campbell's soup. I remember shooting up a speed ball at that party (the Residence Palace has now been converted into the Media Centre for the European Union). I have no good memory for dates, unlike the author of this wonderful book. I remember myself in jail at one point and the immense happiness of getting mail from Steven. I drew a lot of courage from that. Or more recently, sitting with Steven and Chavela – that's Isabelle in Mexico – on Monte Alban, Oaxaca, watching the stars. Thank you Peter for sharing your New York with us. I'm glad Luc and Bruce still live in Brussels. Tuxedomoon takes a large part in the soundtrack of my life. Grateful and proud am I. Love to the people!

Rudi Bekaert, Brussels, December 31st, 2007.

PROLEGOMENON
The Tribe

(Listed in alphabetical order of last name, with indication of date and place of birth when available)

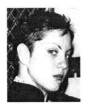

ALLEN, Victoria (*née* Lowe): visual artist, member of the Angels of Light, performer with Tuxedomoon (1977-1978). Now lives in New York City, New York, with book design as her present occupation

BELFER, Michael (1959, Nigel Falls, Canada): musician and producer, member of The Sleepers, Tuxedomoon (on an intermittent basis from 1978 till the early eighties), Black Lab. Worked with Blaine Reininger solo. Now lives in Los Angeles

BROWN, Steven Allan (08/23/52, Berwyn, Illinois): musician, member of the Angels of Light, Tuxedomoon, (founding member) Nine Rain. Presently lives in Oaxaca, Mexico

CRUIKSHANK, Gregory (11/11/52, Los Angeles, California): DJ/VJ, member of the Angels of Light, performer with Tuxedomoon (1977-1978). Now lives in San Francisco, California

GEDULDIG, Bruce (03/07/53, Santa Rosa, California): cinematographer and visual artist, member of Tuxedomoon (from 1978 till present), The Weathermen, Microdot. Now lives in Brussels, Belgium

GEORGIEV, Ivan (08/21/66, Brussels, Belgium): musician, member of Tuxedomoon (from 1985 until 1988). Now lives in Brussels, Belgium, where he composes film soundtracks

JAWERBAUM, Martine (12/08/55, Brussels, Belgium): Tuxedomoon's manager from 1983 until late 1985. Died in 01/1996

LA RUE, JJ (née Janet Beth Shulnes, 09/19/54, Peters Township, Pennsylvania): Blaine Reininger's wife, occasionally actress and lighting designer for Tuxedomoon and Reininger solo. Died on 07/15/98

LUPINI, Saskia (née Klute, 09/11/58, Rotterdam, The Netherlands): Peter Principle's partner for most of his life in Europe, visual artist who designed some Tuxedomoon record covers, took many photos and acted with them on stage and film; she also worked with Peter Principle solo

MARTIN, Gilles (06/20/56, Rouen, France): sound engineer, producer, worked on many of the Tuxedomoon and solo members' recordings through the eighties and early nineties. Now lives in Paris, France

PRINCIPLE, Peter (né Dachert, 12/05/54, New York City, Queens): musician and producer, member of Tuxedomoon (from 1978 till present). Now lives in New York City, New York

REININGER, Blaine Leslie (07/10/53, Pueblo, Colorado): musician, member of Tuxedomoon (founding member, 1977-1983, 1988, 1997 till present). Now lives in Athens, Greece

ROQUES, Patrick John (11/19/53, Tacoma, Washington): graphic designer, designed record covers for Tuxedomoon and solo members, acted as Tuxedomoon's manager from Spring '82 until Spring '83. Now lives in Los Angeles, California

SHAW, Nina (03/15/57, Santa Monica, California): lighting designer for Tuxedomoon, Bel Canto. Now lives in the United States

TADLOCK, Thomas (Tommy) (05/20/41): genius, visual artist, mentor, producer of Tuxedomoon in the early days. Died on 06/04/95

TONG, Winston (03/12/51, San Francisco, California): theater performer and member of Tuxedomoon (from August 1977 till 1985). Now lives in San Francisco, California

VAN LIESHOUT, Luc (01/06/60, 's Gravenhage, The Netherlands): musician, member of Tuxedomoon (from 1983 till present), The Flat Earth Society, Microdot. Now lives in Brussels, Belgium

ZAHL, Paul (*né* Southard, 06/02/54, San Francisco, California): musician, drummer for Tuxedomoon (from 1978 till 1979 and in 1988), The Readymades, SVT, The Flamin' Groovies, The Yanks, The Cowboys, The Weathermen, Flesh & Fell… Now lives in Oostende, Belgium

Abbreviations used throughout this book
AM for Anne Militello, a lighting designer who worked with Tuxedomoon in 1982 (*The Ghost Sonata*)
BG for Bruce Geduldig
BL for Benjamin Lew, a Belgian artist who worked with Steven Brown solo
BLR for Blaine L. Reininger
FL for Frank(ie) Lievaart, a Dutch sound engineer who worked with Tuxedomoon
GC for Gregory Cruikshank
GL for Greg Langston, a San Francisco drummer who worked for a few months with Tuxedomoon in the late seventies
GM for Gilles Martin
GS for *The Ghost Sonata*, an opera without words: a theater piece and an album written and performed by Tuxedomoon
JJ for JJ La Rue
IG for Ivan Georgiev
KK for Katalin Kolosy, who acted as Tuxedomoon's manager for a short while upon Tuxedomoon's arrival in Brussels in the early eighties
LTM for LTM (Les Temps Modernes) Recordings, a British record label owned by James Nice
LvL for Luc van Lieshout
MB for Michael Belfer
Mab for Mabuhay Gardens, a famous punk venue in San Francisco in the seventies-early eighties
MR for Maria Rankov, a theater agent from Paris who worked with Tuxedomoon in the eighties

MH for Marc Hollander, the head of Crammed Discs
MJ for Martine Jawerbaum, who was Tuxedomoon's manager in the eighties
MTM for *Made To Measure*, a collection issued by Crammed Discs, a Belgian record label
NA for Neo Acustica, a Russian record label founded by Oleg Kuptsov and friends
NS for Nina Shaw
NT for Nicholas Triandafyllidis, a Greek film-maker and concert promoter who worked with Tuxedomoon and BLR
PDG for Patrick De Geetere, a French film-maker who worked with Tuxedomoon and various of its members
PJR for Patrick (John) Roques
PP for Peter Principle
PZ for Paul Zahl
RN for Roberto Nanni, an Italian film-maker who worked with Tuxedomoon and some Tuxedomoon members solo
SB for Steven Brown
SF for San Francisco
SL for Saskia Lupini
TM for Tuxedomoon
TT for Tom (Tommy) Tadlock
u.m. for unknown material (played at gigs)
VL for Victoria Allen (Lowe)
VP for Velia Papa, director of the *In Teatro* theater festival in Polverigi, Italy
WT for Winston Tong

Typographical convention followed throughout this book: single quotation marks (') are used when quoting from written/printed material (magazines, books, articles, letters or e-mails) whereas double speech marks (") are used when quoting from interviews or speech transcripts.

Unless otherwise referenced, all the interviews featured in this book were conducted, either orally or in writing, by the author.

Warning: the timelines provided in this book bear absolutely no pretension to exhaustivity. The facts listed were gathered from the author's sources (tour lists, flyers, posters, written sources of all sorts, interviews) but it is nonetheless certain that some of the gigs that Tuxedomoon or solo members performed are not listed here, as either lost in the night of times or played aside from an official tour list. Tuxedomoon is often described as an "open" collective in the history of underground music and culture, so is their history.

INTRODUCTION
On The Road to San Francisco

This book tells the story of an open collective of artists named Tuxedomoon. This group is best known for their music but they also occasionally trodded the avenues of theater, cinema and other disciplines, in an attempt to merge all these artistic forms into one coherent whole, a variation on the so-called *Gesamtkunstwerk* theme.

Tuxedomoon always proved hard if not impossible to be classified into a single *genre* or movement in the history of popular music. They started out in San Francisco in 1977, just around the time when the local version of punk rock broke loose. Their heritage was clearly in the hippie era, as their music tended to be more on the psychedelic/experimental side, but they borrowed from the punks a distinctive energy and a dark edge which led some to categorize them as early figures of the gothic scene. Moreover, the band was an offshoot of a theatrical group – The Angels Of Light, daughter of The Cockettes [1] – which inspired some of the most famous heralds of glitter/glam rock.

Some view them as pioneers of electronic music or, more recently, as early explorers of a genre later named "techno" music. It is true that Tuxedomoon arose from the encounter of two individuals, namely Blaine Reininger and Steven Brown, who were both enrolled in an electronic music class, and it is undeniable that the band always was keen to use the technology at hand. But using machines was never an aim in itself. Rather, it was a means to continue creating and performing music even when the band was restricted to a small number of members. In fact, for most purists of electronic music, Tuxedomoon is not an electronic band, as they always used classical instruments (violin, clarinet, saxophone, trumpet…) along with machines.

Others would say that Tuxedomoon forms an *avant-garde* or *art band* – a slightly derogatory classification as often their music would then be described as "difficult" or "not for everybody." On the contrary, Tuxedomoon's goal was always to make avant-garde concepts leave the confines of University and art galleries and to reach a wider audience.

Personally, I see Tuxedomoon as some sort of "missing link" between the hippies and the punks, a meeting of opposites that was facilitated by the specific context presented by San Francisco. This city is most well-known for its beat poets who gathered there in the fifties and for its hippie communal experiments in the sixties and early seventies. But it also developed its own version of punk rock/culture by

It is the story of a dream of Europe, shattered by the borders of a *fin de siècle* continent, where existential angst mutated in the malaise of exile. It is the story of an encounter between Americans dreaming of Europe and Europeans who, thanks to them, were confronted with their identity and their ideal of Europe, beyond borders and battle fields. Tuxedomoon wandered around the old continent, dragging along their nostalgia of some romantic Europe that might have never existed. If nostalgia could be given names, then one of them certainly would be Tuxedomoon. But, after all, where does reality start and where does the dream give way to reality? None of our most precious dreams is realistic but without them none of us would survive.

the end of the seventies and early eighties. As a consequence Tuxedomoon crossed over from their hippie roots to embrace the energy of punk rock. Today, the members of Tuxedomoon proudly introduce themselves as "old hippies" but are no less happy about their affiliation with the punks, who kept the doors of their venues wide open for them while they were rejected everywhere else.

Geography, taken in its literal sense but also on a more poetic/spiritual level, does also help in understanding Tuxedomoon and why their story so interesting.
In 1981, the band emigrated from San Francisco to Europe, a move that is still quite exceptional today but even more so back then. They established themselves in Brussels, the crossroads of Western Europe yet at the time considered by some a "nowhere land," where they discovered that their art appealed to a sensitivity that lead to yet another attempt to describe them as "the most European of American bands." Living in Europe entailed many adventures, as they found themselves in the situation of being exiles who discovered and sometimes lost themselves in the process of wandering. They became eternal musical vagabonds who gradually scattered themselves around the globe. Their story is a tale of our times. Nomadism is a way of life that has become almost banal for many Europeans nowadays, however it wasn't when Tuxedomoon moved to Europe. In the eighties, the old continent was still made of borders and walls of all sorts: physical, geographical, cultural, political, linguistic and more. Tuxedomoon, being a group of Americans who had been used to moving around freely and easily within their native United States and a band that always seemed to mock barriers and divisions between genres, often ended up in the situation of Don Quixotes fighting windmills. Furthermore the process of traveling was different in those days. People essentially boarded trains (flying was then generally way too expensive) and had a totally different notion of time and distance in traveling. It was like another era, and yet it was only 25 years ago.
Tuxedomoon's nomadism takes on yet another meaning when considering the already-mentioned difficulty to label them neatly within a well-defined genre or style. Recently, French journalist and musician Patrick Eudeline wrote an article/homage to the late Jean-François Bizot – a prominent figure of French underground culture and founder of the *Actuel* magazine – in which he stressed Bizot's taste for Tuxedomoon to illustrate the fact that, in his view, Bizot never really was into rock 'n roll but rather into jazz "in its most abstruse forms." [2] An abtruse form of jazz or rock mutated into a bizarre form of jazz: this is yet another example of a "non-label" for Tuxedomoon. However this other non-label is fairly recent [3]

and probably owes a lot to the increasing importance of Luc van Lieshout's "Milesian" trumpet playing. Jazz *aficionados* also like Tuxedomoon for another reason: their freedom in artistic creation. Jazzmen often improvise on stage; Tuxedomoon not so much, but the way they compose their music is based on improvisations largely determined by the surrounding context, *i.e.* the place where they compose, [4] who's playing in the band at the time, [5] the instruments they have available, [6] the projects they're involved with, [7] etc. Tuxedomoon never was a rich entity financially speaking, hence their constant navigation between their dreams and the travails of survival, the necessity to sublimate shortage into *another* work of art. In that sense the freedom that they always felt they had to "ransack the vaults of art" (dixit Winston Tong) to form new combinations of their choice was instructed as much by their strongly independent personalities as by the realities of everyday life.

Tuxedomoon are now celebrating the 30th Anniversary of a seemingly never-ending story. This is a band that some consider "underground" yet who left their mark on the history of music and exerted an influence on many younger musicians. They are also precious witnesses to a period in the history of culture and music on two continents before the band went global, getting dispersed all over the world in the nineties, as the world itself became "globalized." This is their wandering story.

Steven Allan Brown, Blaine Leslie Reininger and Peter (*né* Dachert) Principle, the three main characters of this story, were born in very different places. San Francisco will bring them together. Let us focus on how they all came to find themselves in that city around the second half of the seventies…

Peter Principle… trains for a drum set. Peter Dachert *aka* Principle was born on December 5th, 1954 in the very urban and cosmopolitan New York City (Queens).

"I was a borderline juvenile delinquent type of brat, troublesome person, until I discovered the drums. I went to public school in Queens, NYC. I was always smart and my father raised me smart. We didn't have a television when I was growing up. So I drew pictures, made things with my hands, all that kind of crap. I went in nature, my father sent me over to overnight camps about as soon as I got old enough so that he could get rid of me for the summer and that was a good thing. I discovered that I could play the drums at a summer camp. So when I got back I took drum lessons from a little drum school not too far from my house and bought a drum set. I had to sell my trains to do it because I did not want to

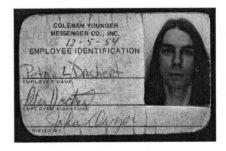

Peter Principle, 1970

King Solomon's carpet. Peter Principle: "When I was a kid, we used to go where they parked the subway trains, so we could get into the subway tunnels and we used to play all kinds of games. We

knew our way through tunnels actually because there was a water reservoir where I grew up and we had maps in our heads… So we used to bring kids down there and then leave them out, scare the shit out of them and then come back and get them again (laughs). Oh well, I'm such a nice guy, now. You have no idea what it was like when I was a kid! When I was a kid, I grew up in a place a little bit rough.
So I had to be a little bit rough in order to be able to survive in a comfortable away…"

Patrick Roques, riding freight trains as a youngster. *"...* And then my friends and I got involved with riding freight trains. We just wanted to go places all the time. We didn't want to live where we lived (Tacoma, Washington). We wanted to be out on the roads. I mean Jack Kerouac. We were inspired by the people that we loved. We were reading *On The Road, The Electric Kool-Aid Acid Test, Huckleberry Finn*. As kids we read tons of comics and science fiction. It filled our heads with dreams. Then you get to 14, 15 years old and, bang! You're out the door. We wanted to escape the oppression of our parents' home life. Run a-way. So we used to hitch-hike and ride freight trains, smoked weed, listen to music, anything that kept us in any kind of constant motion.
There were freight yards on the outskirts of Tacoma. We hung around there and learned how to pick trains. You learned how to read the numbers (written on the boxcars) and by that you figured out where they were heading out to… So you found a boxcar and hide-away, try and get comfortable and hope not to get caught. You had to be very careful not to get caught by railroad detectives. In some freight yards you could get a real beating… It could be dangerous but it was a great adventure and a very dirty way of traveling… We roaded out towards NYC that way. It took all summer. I mean there was no destination really. You would think that it'd be nice to end up in New Orleans but then you might fall asleep in the middle of the night and end up in Phoenix. We had very little money, so we used to "eat and run." We'd scope-out some nice roadside restaurant (like a Sizzler's Steak House). We'd go into a gas station restroom and spend an hour or so trying to clean all the railroad grease off. Then we'd head over to the place and order up some roast beef and when we were almost done eating we'd run like hell out a side door. Skip out on the bill! We got caught a few times and had to wash dishes or bum some cash off of some crazy people we'd met… Another trick we used was to go into a Denny's diner and put our sad faces on and start eating out of the garbage bins. The waitresses would usually feel so sorry for us that they'd give us some free food. We were young, broke and hungry. We used to panhandle for spare change too. That was a common "hippie/street people" pastime in the late 60s early 70s.
The only city we were really interested in getting to was DC simply because we had friends there who we thought would take us to New York City where the Underground Stars were. We thought we'd meet Andy Warhol and be discovered! Imagine these skinny little

take a job, so my father said: "Well, if you're not going to work, you'll have to give something up." So I sold that shit.
Then I played in bands with kids I knew and eventually I found myself hanging out with a bunch of kids who were all older than me. Eventually we got started on a circuit and ended up to be the house band in Cafe Bizarre at Greenwich Village (Winter of 1969-70). That was really a great gig. We played four hours Fridays and four hours Saturdays. You just hung out there and got totally involved in the scene. That was definitely an education for me. In the meantime I had seen lots of concerts.
The guy I replaced in the band as a drummer reviewed records for the *East Village Other*. So I got exposed to all underground musics in 68 and it changed my life for ever. Anyway, I played the drums for a while but then it got kind of boring. I wanted to expand musically. I grew up in an environment of classical music from the 20th century and my father was a record collector: he collected jazz music from his youth, like swing music and also 20th century large classical works. And rock music was expanding at that time and everybody was stretching out and everybody wanted to be a bar band. And I didn't want to be a bar band, I wanted to be an "artiste." So I figured that I had to learn other instruments. I started to play the guitar, which I had already known how to play moderately bad. I spent hours practicing, read a book about harmony, and tried to develop some sort of wacky experimental music.
In my youth I had discovered the tape recorder and with a tape recorder you can do all kinds of things, you can do music with that anyway. I had already been knowledgeable about that and, probably around 1970, I discovered on the radio, WKCR from Columbia University, all kinds of wacky experimental music and I figured: "Oh, these intellectuals doing this shit and I'm doing it at home!" And so I thought: "There must be a career as an 'artiste' in the music world." So, since I had gotten bored of bar bands playing always the same kind of blues riffs, I quit playing drums and decided rock 'n roll was dead etc.

The way I came to San Francisco is kind of a wandering story. I found myself in a jail in New York. I was not really in prison but I was taken off the street and held for the 1974 Halloween week-end because I had been arrested at a Youth International Party party, you know: the Yippies. [8] We were busted and parted off and then because of the week-end and in between - the first Tuesday of November is always Election Day in the States - they kept me in this holding cell until Wednesday. In the meantime I had met these people, the guy I was sharing a cell with, and I ended up going with him to his house in Washington Heights, which is basically like Harlem. He brought me around to his dealer on 137th street or so and he kept on telling me: "Yeah, my friends would kill you if you

were not with me" etc. I got bored with that story and I went to the George Washington Bridge and took a pee into the river, then I walked to the other side and hitch-hiked.

I decided I was going to go to Los Angeles because I knew some people who had just recently moved there and we had started a band together while we were living in New York. So I thought: "Oh I go out there and we'll continue with that adventure…" But everybody who picked me up told me: "You've got to go to San Francisco, go to San Francisco!" Then I did! That's how I came to be there: that was an escape from New York that involved a random meeting with some very hardcore individuals and also just an intuition to leave the situation while I was standing on the bridge. That was kind of a spontaneous thing…"

Blaine L. Reininger... the prairie starts there... Blaine Leslie Reininger first saw the light of day on July 10th, 1953 in Pueblo, Colorado, "a middle size industrial city: the prairie starts there, immense flat stretch of land that goes endless to the East Coast." His family, Hispanic on his mother's side ("this was something to be ashamed of at the time: people were trying to be white") and with remote German ancestors on his father's side, was not too wealthy but he went to public school where he got an excellent education.

His mother, who had once nurtured an ambition to become a singer, detected Blaine's musical predispositions quite early on and, consequently, made him take singing lessons at age six. His first ever public exhibition came almost immediately thereafter (end of 1959), his most striking memory of it being that the local newspaper, struggling with his first name, announced an "Elaine" Reininger, thus mistaking him for a girl. It was the evening that got Reininger hooked to performing before an audience: "I, for the first time, experienced the kind of fascination that a performance before an audience entails and this fascination, this feeling, would never leave me to this day." [9] However Blaine's first really "professional" appearance would take place a few years later, when he performed before an assembly of freemasons: "with this one I was introduced to the mystery of symbols and cult rituals. That had a deep influence upon me." [10]

As music lessons were offered in school, Reininger soon learned to play an instrument. First he wanted to play trumpet but he ended up learning violin because there was one lingering around in his grandmother's basement.

For quite a while he didn't particularly like playing violin, as he was a rather fat kid who found himself quite ridiculous in the posture of a violin player. However things changed when he met a professor, Burt McKinnis, who made him like the instrument; "There was a photo of him on the wall, wearing

country tramps coming to the Big Apple. We were in New York for barely one day, it was so crazy and expensive we left. As soon as we got off the train at Penn Station we thought: "No. We have to leave. We're not ready for this." Plus we had our backpacks, we were dirty. We were still so wet behind the ears, even though we'd had these "on the road" experiences, we had no idea how to deal with New York. We knew we were going to get ripped off in a second… When I left on that freight to go East that summer, I had thirty dollars and I was gone for three months. I ended up broke. My mom sent me ten dollars in the post to get back home, I had promised her that I'd start the 10th grade on time! I left from Washington DC with ten dollars and I had something like $7. 32 left when I got home after traveling 3,000 miles! You would live on fifty cent a day or something. All we ate was chocolate milk and Oreo cookies. I'm not saying we were the poorest people in the world but we didn't have any "recreational" money, no "disposable income." As kids If you made sixty dollars in the summer picking berries you were doing good, but we had to stretch on it. The sixties are perceived as a time of great American prosperity. From my perspective that was total bullshit. We were from working class families, our parents just didn't give out money, you had to work for it.

During the 1930's, the depression era, a lot of people were riding freight trains out of necessity. A lot of old time musicians also traveled this way. Woody Guthrie rode freight trains, so we would ride freight trains. There is a lot of romance tied to Hoboing, my friends and I were all bitten by the Hobo bug.

I tell you one of my favorite rides, it's up over the top of the Rocky Mountains, out of the Columbia river gorge. The trains have to go very slow through there because it's a very steep grade. They slow down to five-six miles an hour. It's really beautiful and hot as hell up there during the summer, you can see snow way up on mountain peeks, fresh cool rivers, the wild life... The train follows the river up over the peeks, over to the other side of the mountains. Since they are barely moving you just hop out of your boxcar and float down the river besides the tracks. See, the rivers flow east out of the Rockies so you can just float along. There is such a beautiful amount of country out there, I mean America is so vast and magical when you ride freights, especially going along the Columbia river. Woody Guthrie's "Mighty Columbia." At least that's how it was in the early 70's I have no idea what it's like out there now."

Blaine aged 3, dressed-up by his mum like a little girl

"If I was to grow up in the United States today, maybe I would have evolved in a totally different way. Lots of things have changed there in the educational system. I got a very good training in a public school, where my professors taught me some universal vision. But there have been so many cuts in the budget devoted to education that the quality drastically dropped and, as a matter of fact, the number of analphabets is increasing in the USA." (L. VANDER TAELEN, "Blaine Reininger: uit Tuxedo Moon stappen was als een echtscheiding", *Topics magazine*, 01/84)

a tuxedo in an all-girl orchestra in the twenties." McKinnis was sort of a grandfather to Blaine and introduced him to a great variety of subjects, like Paganini, Debussy, Schönberg, Stockhausen, Varèse, the use of a magnetic tape, the direction of an orchestra ("he gave me the stick and taught me the basic principles") and made him read a magazine named *Fate*, which got him interested in astrology, parapsychology and the like.

In the meantime, as the violin was not hip, Reininger had learned to play the guitar and played in a band named The Tycoons that made him a local popular figure. "Musically, I was doing two things: first I played in schools' symphonic orchestras and I studied the classical *répertoire*, played Bach etc. and, on the other hand, I slowly evolved towards a musician who earns a living with music. I played in bars, night clubs. All this happened in Colorado (…) And in Colorado, that is for that matter quite comparable to many central states of the United States, there's very little chance to go anywhere to play one's own compositions. As a consequence, the local musicians get to transform themselves into human juke-boxes.
I learned a lot during this time period when I got to play practically all styles of music. It gave me a *répertoire*, a palette of multiple colors (…) I played in country bands, in heavy metal bands, in psychedelic bands, all sorts of bands. I played guitar, bass guitar and of course violin." [11]

For a long time, violin and guitar belonged to very different worlds. But by the end of the sixties, playing the violin suddenly became hip, as Jean-Luc Ponty played for Frank Zappa in 1969, Papa John Creach for Jefferson Airplane in 1970 and Jerry Goodman for The Flock. As a matter of fact, it was in a band named The Flog that he was told one day to play the violin on a rock piece. "It made me very happy and it was then that the fusion between the rock musician and the musician playing in classical music orchestras operated and always remained in me since." [12]

Reininger's other passion was for writing. At his school he published an alternative underground newspaper. He also wrote lots of short stories, heavily influenced by science-fiction. One of those stories, that he wrote for his German class, contained this assertion: "I want to form an electronic band named Tuxedomoon, that will be a multimedia venture." Tuxedomoon also occasionally appeared as a character ("Tuxedomoon woke up, shaved, got to the cabinet to take a bunch of valium etc."record).
Beyond writing, he discovered his fascination for languages. All kinds of languages, from music to computer systems, passing by foreign languages of which Blaine can always faithfully reproduce the sounds. It was only later, then living

in Europe, that he discovered that this interest for languages stemmed from what he calls his "fluid identity or personality," that allows him to sort of fade into different environments. "I think I change all the time, within the same day lots of configurations take place. I think that personality is not a fixed thing. Although we don't change radically – as we are always variations on the same theme – we are never precisely the same."

As a teenager, one of Blaine's favorite activities was to go to the arroyos (desert) with his pals, "driving around in a car, hang around, drink, take drugs, and make a big fire. We were mostly boys, a few with their girlfriends. Sometimes I would play with a generator and a couple of light bulbs."

In 1970-71, while attending high school, Reininger became the concertmaster of the orchestra, playing in competitions all over the state, and was selected for two years running to participate in the Colorado All-State Orchestra, a symphony composed of the best players from the whole state. The recordings of the group's concerts were released as a LP, sold mostly to the parents of the performers, marking Reininger's first appearance on vinyl. In 1971, after graduating from high school, Blaine began to attend the University of Southern Colorado on a scholarship given by the Pueblo Symphony Orchestra. There, he studied violin, composition and theory, conducting, music history, poetry, philosophy and piano, the whole range of subjects required for a degree in music. He later attended the University of Colorado in Colorado Springs where he studied for a year.

Reininger left for San Francisco in 1976. At this point of his life he realized that he was standing at a crossroads. At this time he was still a student. "I had no work, no money but there was money for scholarships." Originally the plan was to move to Boulder, "a Buddhist University, where Ginsberg taught." Then the University of Colorado offered him a scholarship for Regensburg in Germany, which he finally turned down in favor of a move to San Francisco. "I thought: "San Francisco is this amazing, beautiful, vital place, full of wonder. This is the place for me."" San Francisco was the center of the hippie movement and a big city, compared to anything he could find in Colorado. One of Blaine's best friends had moved there and looked like someone coming from another planet whenever he came back to visit.
"I was also fascinated by this polymorphous sexuality. San Francisco is famous, as you know, as homo capital of the world. There was this kind of androgynous, ambiguous sexuality that fascinated me."
Furthermore, there was also a musical and theatrical scene in San Francisco that interested him. People like The Tubes,

who wore costumes on stage and did theatrical rock. At the time David Bowie was the star for him, as the music world by then was such a macho desert which he couldn't relate to. He also felt very attracted to the English psychedelic music (Pink Floyd) and to artists like Captain Beefheart. Hence Reininger wanted to be part of that scene and was thinking of media concepts that later came to be called "post-modern," in other words "a bit in the guise of a band that was called Ant Farm in San Francisco, that drove a Cadillac through a wall of televisions. American culture eating itself…"

Steven Brown… how to scare the hell out of your neighbors… Steven Brown was the first born (on August 23rd, 1952) of a family of four siblings living in a middle class suburb of Chicago: Berwyn, Illinois.

"I always felt "different," somehow. I guess part of that was fear of others or maybe fear of acceptance. When you're a kid in school, all that is pretty traumatic. It was for me. I didn't feel like I was being set apart, I thought like I had set myself apart! And then I just sort of cultivated that. I wanted to be set apart. I wanted to be different. Maybe because I knew I was but also, at some point, I just wanted to develop that, flaunt it in some way, just set myself apart somehow. Eventually that's what happened…

I listened to my parents' records. They were very few. My mother had a Barbra Streisand record, which I listened to for years and maybe Harry Belafonte, and my dad had this record called *How To Scare The Hell Out Of Your Neighbors*. It was Bach, *Toccata And Fugue*, the organ music that they use in horror movies. I liked that one! I would put that one on and turn it way up to scare the hell out of my neighbors.

That's all I knew really about music for a while until the Beatles came along. The first album I bought was *Sgt. Pepper's*. I thought that was music! I didn't like all the crap on the radio. I liked the Motown music, black music from the sixties: Diana Ross, The Supremes, Marvin Gaye... The rest didn't really grab me until *Sgt. Pepper's*. About this one I thought: "Wow, this is something…" You know, a little bit more experimental and yet still very nice to listen to.

I didn't have any plans or desire to make music. I wanted to make movies and I started making movies when I was 13 years old. My father was the cameraman and I was the star and I would write these scripts with my friends and we'd put these movies together, usually inspired by real movies. The first one was *Frankenstein*, which actually won an award in New York City (the Kodak super 8 prize, in 1970). I'd get the actors together, we'd rehearse, I'd write the script and I'd get the costumes, so I did everything myself with my friends helping out. I did that for years, all through high school and

Steven Brown in 1959 with his sister Jennifer

even into college and I still do to this day. So I wanted to do films …

Then one day in the sixties I saw *The Seventh Voyage of Sinbad*, [13] the movie directed by Nathan Juran, and was particularly impressed by a scene where the hero can be seen fighting against an army of skeletons. I realized that the music, composed by Bernard Herrmann, was an important part of the film and I thought: "That's it, when I hear music, I can see images." Also I heard the music that Bernard Herrmann did for *Jason And The Argonauts*. Fabulous film! I was like 14 and really that did it, for me!

So at that point I wanted to be involved in cinema and my plan was to go to school and study cinema. In the end I didn't. Couldn't find a school, which I could afford. So I went to University (Western Illinois University - Macomb, Illinois - and Sangamon State University, Springfield, Illinois) [14] and studied just whatever. I was editor of the University newspaper for a while. Got involved in journalism, art classes, history classes, nothing really specific, because what I really wanted to do was film."

Reininger adds: "Steven was running this coffee shop in Springfield, Illinois, this University town. At Steven's coffee shop, they showed films. Steven was a local alternative culture kind of figure leader and I was the same in my town…"

Brown's life as a young student also brought to light the political activist he's never ceased to be since, taking part in innumerable demonstrations politically left-oriented, with a special interest for the rights of oppressed minorities. In 1971, he got a grant to work on a project on Mayday, shooting images of strikes and pacifist demonstrations against the Vietnam war in Washington DC from which he produced a Super 8 documentary. [15] Later on, in 1973, he worked in Washington on a video document filmed during the demonstrations against reinstating Richard Nixon as the President of the United States. [16]

Steven adds: "Then I went to San Francisco – for high school graduation my parents had given me a ticket to go to San Francisco with a friend of mine – and that's where I flipped out. California was another world, another planet that I wasn't aware of. Beautiful! Not so much San Francisco city but North: Marin County and the coast. I really fell in love with that whole area. I went back to Chicago and then back to San Francisco as soon as I could and I was literally seduced by this androgynous being that was San Francisco. I met a guy, slightly older. I stayed with him for a while. He was a performer in a group called The Angels Of Light."

In 2005, Brown posted this entry on his blog, [17] that

Fuga. 'We lived in an upper middle class neighborhood in a suburb of Chicago.

Steve and his siblings had many playmates in our immediate area. Steve always ran the show – carnivals, shows, movie and popcorn in our "theater basement." All the children made a point of attending and always looked forward to Steve's next adventure. Basically Steve was very quiet and preferred to just sit in the background and observe people (…)

Steve was a great swimmer with the Hinsdale High School team as well as a participant in the band. Steve had plenty of love and attention. His grandmother, whom he named Mangi, was his champion. When he was born, we lived with her and Grampa Brown for several months. Grampa Brown loved carrying Steve around everywhere and also playing the violin for him. Both grandparents played in the Salvation Army Band in Chicago. So you see, he comes to music naturally. That same family had several artists as well.

We had a very active church life, camped as a family, did a lot of boating and water skiing. Since Steve's father traveled in business, we often went along during the summer months and had some wonderful trips to hotels and resorts. As a family we had vacations from Illinois to Florida, Wisconsin, Michigan, Canada, Arizona and Mexico. (…)

REGRETS? – Yes, a few.

I guess I didn't listen well or we did not communicate. I never knew Steve wanted a film school. He had never expressed what he wanted to study (…)

When he was very young, I feel his Dad and I were too hard on him. We expected too much of him as number one son. I did not realize how sensitive he was and demanded more than necessary. In Middle School (then called Junior High), he was put in accelerated classes. I changed him back because of his quiet demeanor. Maybe that wasn't the wisest thing to do. Perhaps the challenge was what he needed.' (Tina Brown-Fuga,

Steven Brown's mother)

Big Brother. 'Steve and his high school friend Rick that lived a few blocks from our house put the Rick and Steve Fun Fair together. They would put out advertisements to the neighborhood kids when the Fun Fair was taking place at our house. There would be games for the kids to play for a penny or nickel a piece. I can't really recall the games but they were probably like throwing balls into buckets and the like. As I recall, the prizes for winning a game were actually used toys of mine and my brother Dan and Sister Jennifer that Steve would ask us to donate to the fair!! As I recall, we were Ok with giving up these little toys for the good and fun of the fair. The neighborhood kids loved winning these little toys and it was quite a fun day for everyone. Especially Steve and Rick since they probably made a few dollars!! I don't remember how many times Steve put this fair on but as with most of his adventures, he repeated them at least for a few times, usually on a yearly basis.' (Mark Brown, Steven Brown's brother)

You did it his ways – or you left. 'Steven was often the center of attention among peers. A leader, an idol. He had the neighborhood entranced with fun houses, movie nights, activities where all would come. His peer group would do anything to be in a movie or help entertain at his events. He was demanding and precise with what he wanted - you did it his way or you left. His early movie interest led him to awards from Kodak and praise from my father. As a younger sister, I loved him and his friends. Always trying to get praise by baking cakes for them or being a messenger. Anything to be included. I think this was a general attitude among those around him. He was not an easy child for my parents because of his individual approach and outspokenness. He protested heavily Vietnam and government action. Traveled to Washington D.C. for Mayday protests and got arrested with hundreds of other protestors. In

could serve as a summary of his early days in Illinois, as linked to what would become his later life in San Francisco.

'Just saw *The Weather Underground*, a documentary film by Sam Green and Bill Siegel (…)

The immediate parallel I found myself referring to was the Cockettes documentary. [18] Stylistically they resemble one another – newsreel or amateur footage from the time, newspaper clippings, contemporary interviews with the survivors. In addition the time period covered was the same: late sixties to mid late seventies. I was thrilled and inspired by both groups. I worked in one of them (The Angels Of Light, daughter of The Cockettes). I think somehow in our own ways we believed that what we were doing was just as profound in a political social and cultural way as what the Weather Underground was about. For one thing the Angels were an anarchist vegetarian tri-sexual gender-fuck commune or cadre. Visitors passing through regularly. At one point there were many communes in San Francisco buying food from a food co-op. There was a commune that ran a community off-set printing press, another that baked bread, music communes. We did free theater. We were simply groups of free spirits living together whose day to day lives were works of living art and hence political. Had the Weather Underground had the same appeal as the Angels Of Light, I don't think I would have hesitated. In the documentary, the murder of Black Panther Fred Hampton is covered. The film points out that Hampton was a powerful and dynamic speaker and rapidly galvanizing the black community. It was decided to take him out. He was 21 when he apparently died in his sleep in his home at four am riddled with police bullets. I saw Hampton speak at rallies in Chicago. This was the time of the Chicago Seven Conspiracy [19] trials and there were rallies for that and against the war all the time in Chicago. I saw the young Jesse Jackson speak on various occasions. He was hypnotic and charismatic and sexy. A fotog friend of mine gave me 8x10 b&w prints of him once. I was 16 years old and living in the very white suburbs. Still I could feel the force resonating in the inner city. I wanted to learn more. I really wanted to be a part of this energy, this struggle for liberation for lack of better words. I took super 8 films of the rallies. I first saw the controversial new Picasso in Chicago at a rally in front of the Federal Building. In 1971 I drove with carload of student friends from Macomb Illinois to Washington DC to get arrested in the Mayday anti war – *Shut Down D.C.* – demonstration organized by SDS president(?) Rene Davis. I made a film that I would show back at W.I.U. on 3 screens with stereo sound... A few years later I was doing sci-fi drag musicals with a free theater group in San Francisco.

Now looking back it seems a logical step.'

The Angels Of Light certainly played an important role in the genesis of Tuxedomoon. They form the subject of the first Chapter of this book.

school he was very bright but a non-conformist.' (Jennifer Bayer-Brown, Steven Brown's sister)

PART I: SAN FRANCISCO (1977-1981)

CHAPTER I
The Angels Of Light

San Francisco seems to have always been some sort of haven, literally and symbolically: a place for open-mindedness. Everyone remembers the 1950s beat poets and writers gathering around City Lights bookstore and about the Haight-Ashbury hippie happenings in the 1960s. San Francisco was, in the sixties and seventies, the place where would converge all those who were too crazy or eccentric to fit in a consumer society losing its landmarks. But, as Simon Reynolds points out in his recent book focusing on the postpunk era: 'San Francisco also enjoyed a third golden age with punk rock and industrial culture in the late seventies and early eighties – bands like Chrome, Tuxedomoon, The Residents, Factrix and Flipper, to name just a handful.'[1]

Like Peter Principle, thousands of young people hitch-hiked to San Francisco in the sixties/seventies and many were, like Blaine Reininger, attracted by the unique atmosphere of sexual experimentation that seems to have reigned over San Francisco since the Gold Rush. As Gregory Cruikshank – erstwhile member of The Angels Of Light and of early Tuxedomoon – stresses: "San Francisco always had a sort of leniency towards outsiders and even in the Gold Rush days, when San Francisco was established, because the miners were coming back with all this money and they wanted to party. That was a very exciting time for them and there were hookers. And so the whole kind of environment that developed from that was a whole lot more liberal towards… not so much gays at that time but towards prostitution. Also being a sea port, the ships would dock, the sailors would want to party. So it grew into a very convivial city that was very open to the idea that you can create something of a quality of life, of entertainment that is not so rigid, not so connected to the parochial idea. So San Francisco always had that.
Some time in the sixties and earlier I'm sure, it was very dangerous and practically impossible to live outwardly as homosexual in the rest of the country and I think that a lot of people felt that it was a little bit easier in San Francisco. It was more a "live and let live" kind of scenario.

"'San Francisco's the kook capital of the world," The Residents' spokesman Jay Clem once observed. It has long rivalled New York as a bohemian capital, a centre for artistic experiment and non-conformist living. "What this city means to me is the last stand on American ground," Damon Edge of Chrome declared in 1979.' (SIMON REYNOLDS, *Rip It Up And Start Again: Postpunk 1978-1984*, London, Faber and Faber, 2005, p. 245). According to the same Damon Edge: "People who don't fit anywhere else will come here. That's why the bridge is so popular to jump off. There's no place to go in America. If you can't relate artistically in San Francisco… you jump off the bridge" (M. GOLDBERG, "I left my heart in San Francisco. The residents, MX-80 and Tuxedomoon", *N.M.E.*, 11/17/79)

Steven Brown – Self-portrait, circa 1975

Excerpt from Wendy Mukluk's diary
'Friday June 4, 1971
home made light show

That night Grasshopper came over & said they had a light show, so we went across the street to his house & there was a light machine Tom Tadlock made, about two ft by three ft on a stand, a board with four rows of various kinds of light bulbs, & four lightbulbs on top, different colors, & flame ones, & they all hooked up to the stereo & go on & off at different frequencies & volumes. It was very hypnotic & pretty to watch. I thought of the mirror room [*at the Exploratorium*] & how a light machine in it would be incredible. [*So, a bunch of us got stoned and sat and watched the light show. We tried different records. Rock worked pretty well. Bagpipe music didn't, because of the drone -- the yellow lights on the bottom stayed on the whole time.*]' (http://www.astro.wisc.edu/~mukluk/Osnaps/1970s-book/1971-p5.html)

Interview of Tommy Tadlock ("T") by Patrick Roques for Vacation Magazine ("V"), Oct. 1st, 1979, with Steven Brown ("B") occasionally joining in the conversation:

'Tommy Tadlock, record producer and sound engineer (Tuxedomoon, Pink Section, Winston Tong, Noh Mercy, SST and Minimal Man), electronic wizard, innovator, madman and ace intruder. A Dr Jekyl/Mr. Hyde who can pull a micro moog out of his hat or cut the power off in the middle of your set (…)
B: Forget the tape, we can get that another day. Did you feel it today? It was strange.
T: The electromagnetic radiation shit, yeah, everyone did! (…) Long-wave electromagnetic radiation waves. Television waves, all kinds of radio waves. You know, they're above light but below atomic radiation in wavelength. We're experiencing them in our environment from radio and T.V. stations. We have been since the turn of the century. An in big doses for 20 to 30 years! (…) The Soviets are beaming (…)
B: So you think it's the Soviets that are doing this? Or the American government? (…)
V: (…) You're 39 years old. When did you first start dabbling in electronics?
T: When I was about 10, I started playing around with electronics. I didn't know anything except how radios worked and I used to be able to fix them just by hitting them the right way (…) like one who is very intimate with an old machine. I started getting into radios and, living where I did in the remote hills of Maryland, I'd get a lot of radio that came in late at night like WWVA and other AM radio that came in late at night that had this mysterious machine calling electronic sound… It'd be like a lure, there's not much like that now in the world. I kind of miss that feeling. The same kind of yearning for far-away things that would come from hearing a steam locomotive racing through the night (…) TV hadn't hit then and my best friend at the time, …, used to work in his attic on electronic stuff. He got me into radar tubes. We spent days trying to get a picture on the cathode ray tube (…) That was at the start of television. Then I was 16 in the 50's and I got more into hot rods (…) Then my mother sent me off to the Rhode Island school of design (…) and ended up being a bored college student, then finally a bored rodder. Then the first waves of psychedelia came on the scene. So me and some friends sent away for some peyote. And started getting more into music. We were the first five pot heads at the Rhode Island school of design in '59 or '60. This was before hippies. Then I started getting into a heavier underground scene (…) This was the beat generation! The philosophy was very much no future (…) Getting back to psychedelia, one day when we were tripping

Also at a parallel time the beat generation and the beatniks also felt that they could live here and establish communities in North beach. San Francisco has a lot of very old money and they were very quiet about those things, it was Ok. There was an elegance just around *cafés*, dining… Also prohibition didn't have much of a take here, so there was alcohol around at all times, again because of the port and, basically, that creates a party…"

Thomas (Tommy) Tadlock (born on May 20th, 1941), who would become Tuxedomoon's mentor and genius producer, certainly qualified as one of those queer birds for whom San Francisco appeared as a "last stand." Bob Burnside, a friend of Tadlock in college, reminisces: "In 1960, a computer chose us to be roommates in college at Rhode Island School Of Design. We didn't get along with each other that well and we ended in a fist fight (…) He was a bad boy. He had a Ford convertible, he had redone it all. I remember being on the lookout while he and this other guy stole the radio out of another car. We would entertain ourselves stealing books about hypnosis and then spend our time trying to hypnotize each other (…) So we made friends, we became lovers for one brief time, we took drugs together (…) He would get obsessed by things and spend all of his energy on it.

He dropped out of school because he was obsessed by cars and motorcycles. Then, when he was living in New York, he made a light machine which was a very primitive array of flashing lights and one of those things was in the Howard Wise gallery in New York. [2] Then he became obsessed with music and he bought this organ that had these discs in it – I believe it was called the Optigon. So he would play that obsessively and collected the discs for it. Then he became obsessed with drugs. He would be obsessed with this or that boy, younger guys appealed to him, effeminate younger smart guys that had obsessions of their own…"

Thanks to Howard Wise's patronage, Tadlock was appointed as a professor at New York University where he had a studio course called "perception 1006." [3]

The reason why Tadlock moved to San Francisco remains nebulous. According to Gregory Cruikshank: "He was very active on the East Coast for a while and he made an installation – I think in the museum of modern art – and he was fascinated with the idea of sound and the response that sound would get to light, so he created this room that responded to sound with light. He did it with color TV tubes. I think that's what drove him to the West Coast and the thing that he had a great regret about is that he heard that color TV tubes at that point in time were causing people to have cancer. So he thought he had created this huge art room that was damaging people,

that this art thing that he created was a monster. So he came here and made a smaller version of it."

At some point, Tadlock got involved with The Angels Of Light. Greg Cruikshank: "He had an outrageous personality. He wasn't really in the shows but he was really good for detecting exactly what we needed and building sets and props. He would go on the street at four in the morning and find things in this amazing car which he had stripped the back out. It was a pink 57 Chrysler and he had a rocking horse on the top of it that would sort of gallop while he drove and he made a covered wagon out of tubing at the back of it. It looked like a kind of hippie batmobile. I was very young so my first impression of him was of someone who was sort of always having it together but at this amazing level. He was very conscious about construction."

The Angels Of Light. Both Steven Brown (after he fell for a bearded member of The Angels Of Light and went to live with him in the Angels' commune) and Tommy Tadlock (Tuxedomoon's future mentor and producer) got involved with The Angels Of Light. Who were they?

In the beginning, there were The Angels Of Light that originated in San Francisco circa 1968 from the Kaliflower commune. Their leader was young erstwhile New York actor, George Harris, who had changed his name to Hibiscus, a character that "looked like Jesus Christ with lipstick." [4] Allegedly Hibiscus had undertook a spiritual journey into the mountains outside of San Francisco and had met someone who told him that he was an angel or at least one in training and so he called his group "The Angels Of Light." [5]
Steven Brown casts an interesting light on the Angels' "angel-ism": "Hibiscus meant it as a play on words, as Lucifer is literally the angel who brings the light." The Angels' life was in itself a performance (or maybe was it the other way around?): just by showing up outrageously made up, wearing transformed thrift store costumes and glitter and beads, dancing in the streets.

One day Hibiscus decided that it was time to move from the streets onto the stage. After a memorable first public appearance at the San Francisco Palace theater end of 1969 – the show ending up with basically everyone naked on stage with the audience joining in – the group mutated into The Cockettes, a gender fuck theatrical group that is said to have inspired the glitter rock era of David Bowie, Elton John, and The New York Dolls, to name just a few. The Cockettes (composed of gay men, a few women and infant Ocean Moon, a baby who was born within the group) were, according to film-maker John Waters, "hippie acid-freak drag

we went over to some guy's house, whose brother had built this little thing. It had random flashing lights (…) The psychedelic drugs, coupled with the fact that we were listening to a lot of music got me into making these light machines that were triggered by sound waves to accentuate the high that would transport us to alternative states of consciousness (…)
V: These were the forerunners of stereo component light boxes, right?
T: These were vague and crude caricatures of this phenomenon (…)'
Talking about his class "Perception 1006" at NYU:
'T: These kids were hip. I had long hair, slicked back, and was very severe (…) We'd have conferences in the back of the class where students would turn me on acid and hash.
V: What was this class really about anyway?
T: Well I asked the President of the school of the arts, a brilliant man, what I was supposed to be doing here besides laundering this money. He said: "Turn them on, you know, just turn them on" (…)
My class made a film to go with the Beatles song Baby's in Black. I kind of explained to them what the song was about, that the girl had become a nun. So they made the film and every time the song said "Oh dear! What can I do? Baby's in black and I'm feeling blue," there was a girl in a nun habit going into a church seen by a guy looking real sad, a black leather guy by his bike. Then it says "She thinks of him, Bong! So she dresses in black," and she'd be kneeling by the altar looking introspectively with a beatific look on her face. It was like the antique catholic occult digs by the Beatles. Also, subliminally through the whole thing was the Christ figure dressed in a white robe with a crown of bloody thorns on his head. Then, in one part following this incredible guitar lick, it showed the christ figure and the nun stop (*sic*) fucking in bed in all these different positions, very fast and radioactive…'

The Cockettes dressed in women's clothes but wore beards, didn't they? Gregory Cruikshank: "Yes, it doesn't make sense now but at the time to have the two gender identities being combined was a very powerful statement. It was a confrontational and very political thing as well. The country was in the middle of the Vietnam war and my peers were ready to be drafted and one of the main taboos about being in the army was homosexuality and if you admitted it you were insane. So the extreme of that, nobody was really willing to fight that war anyway, just being gay was going to cause you to be insane, so "Go ahead and be insane!" and it made it for this incredible power of change."

About The Angels Of Light.
'We were very serious about our work. "Perfect Your Art" was our motto. The Angels were multicultural long before it was fashionable, incorporating Indian

Hindu dancing, Japanese kabuki, Chinese opera, belly dancing, Balinese dance, Christmas fairy tales, Bible stories, Greek myths, Scheherazade, Nijinski, Cocteau, Tennessee Williams, Von Sternberg films, Dietrich, Edith Piaf, Isadora Duncan and Broadway musicals, often all in the same show. We were influenced a lot by Josephine Baker and Yma Sumac, and we all wanted to live in Europe.' (Bambi Lake & Alvin Orloff, *The Unsinkable Bambi Lake – A Fairy Tale Containing The Dish on Cockettes, Punks and Angels*, San Francisco, Manic D Press, 1996, p. 32).

Sylvester. 'Sylvester was just getting started on his rapid ascent to stardom (…) In an interview with Wade Carey in the *Berkeley Barb*, he said, "I miss the Palace Theater a whole lot because it was fabulous. It was the best thing that ever happened to me, and I think it was one of the best things to ever happen to San Francisco. I think The Cockettes were the biggest contribution to glitter in the history of the world, and all that's followed has been on a different plane!"' (Pam Tent, *Midnight at the Palace: My Life As a Fabulous Cockette*, Los Angeles, Alyson Books, 2004, pp. 123-124).

Bernard Weiner, "'Sci-Clones' A phantasmagorical New Show", San Francisco Chronicle, March 31st, 1978.
"'Sci-clones' a new show by the Angels Of Light, is an often outrageously entertaining mix of (if you can imagine it): a "Winterman"-type ballet, a Balinese mask drama, a Chinese folk opera, a science-fiction extravaganza, "The Yellow Submarine" and "Hair."
It sounds like a phantasmagorical mish-mash, you're right (…)
The plot involves the fun-loving Uma people being taken over by a science-oriented race from another planet. The Uma are then turned into a conforming, easily manipulated mass, who are constantly being convicted for the "crimes" of dancing and dreaming.
In other words, the plot is fairly conventional beware-of-technocrats stuff. But what the Angels Of Light do with it is often extraordinary: in the grandiose opera-style sets; in the elaborate, colorful costumes and masks; and in the powerful staging of many of the dance and musical numbers, especially the religious-style ballet where red-and-black costumed initiates are to be accepted into the machine world.
(…)
The result demonstrates the best and worst aspects of collectivism. On the one hand, they've been able to draw in a large number of enormously talented artists to perform and design; on the other hand, without a single creator's vision and with no director in charge,

queens." [6] They put up shows on acid every month, bearing titles such as *Madame Butterfly, Fairytale Extravaganza, Journey To The Center of Uranus, Hollywood Babylon*, all being quite chaotic performances featuring singing, dancing and in-your-face sexuality. They launched Divine's career and introduced future disco star Sylvester to San Francisco.

Unfortunately, The Cockettes were somehow the victims of their rapidly growing success as the band, that was composed mostly of people who couldn't stand the idea of being directed (and were too stoned to get any direction anyway), started to evolve towards somewhat more professional shows and welcomed the idea of being paid for them. This led Hibiscus to depart from the group with a few other rebels in 1971: "Everything comes out right when you do it for free," Hibiscus told Rolling Stone Magazine that year [7] – and re-formed The Angels Of Light in an attempt to recapture the essence of free theater. In 1973, Hibiscus moved back to New York City where he eventually started The Angels Of Light on the East Coast. He died of AIDS in 1982 and was one of the first people to die of this disease.

Meanwhile, The Angels Of Light survived Hibiscus's defection whilst The Cockettes disappeared in 1974, their decline being precipitated by a disastrous *première* of their show in New York City in November 1971. The Angels continued to put up shows in the free theater spirit until well into the eighties. It is with this group of people that Steven Brown started to live and work around 1974/75, and with which an early Tuxedomoon would collaborate after the group was born in June 1977.
Brown recalls the first Angels' show he attended in Marin County: "It was just this anarchistic explosion, right in front of us. No theatrical pretenses. Just a bunch of blasted people prancing around in costumes and glitter and… Couldn't tell who was a boy, who a girl or what. It was just like a spaceship had landed and these people had gotten out… They started to sing a song and dancing around with funny painted backdrops. It was like a dream… I was in heaven. I thought: "Wow… It's what I want to do too."" [8] At the time Brown joined, the Angels needed a musician. "They needed somebody that knew something about music and I knew something about music because I had taken piano classes and I played clarinet in high school. So I ended up joining as THE musician, wrote some original music for shows and eventually met Tommy Tadlock, who was also working with the Angels…"

Gregory Cruikshank argues the specificity of The Cockettes/Angels Of Light as a pure San Francisco product which as such couldn't be exported to New York city. "I started to work on the periphery of The Cockettes. I was very close to

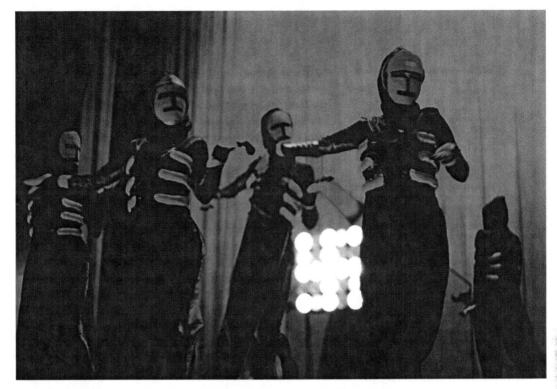

The Angels of Light performing in the « Sci-clones » show (1978), with Tommy Tadlock's light machine. Photo Dan Nicoletta

a main member of The Cockettes who absolutely refused to participate in the commercialization of the group. A famous columnist from New York came here and had one of these experiences when he got stoned and took all these drugs and then they took him to a Cockettes show and he flipped out. So he went back to NYC and arranged for them to do their show on Broadway. That was a disaster because that was more of a community thing where everybody was so stoned. But when you take that out of context and put them on a stage in NYC and invite everyone from the theater and tell them it's going to be fabulous, it's a miserable failure. It was much more of an idea of expressing what's going on in the community and there were very little differences between the audience and the performers.

Everybody wanted to dress up, everybody wanted to make a statement about who they were, their identity. People were living Fellinian lives 24 hours a day. We used to dress up every day and go out. Even men who weren't into drag would dress into dandy style stuff. It was very challenging and provocative, as a male to dress like that. So The Angels Of Light developed around that ideal and also because The Cockettes failed in New York.

There was a strong feeling by some founding members and me and other people that we could harness this energy, that we wanted it because we were all interested in the theater but we also wanted to be political and never to commercialize this energy. So we decided to perform for free and create the show sways this way back and that giving evidence of a lack of artistic control. (…) Their shows, generally less elaborate than this one, are mounted with donated money (amazingly enough "Sci-Clones" cost only $3,000 to stage; the sets are made of cardboard, most of the costumes and masks are self-made etc.) since the Angels are dedicated to free theater and charge no admission. They also teach free classes in song, dance, clay work and mask making.'

RANDALL KRIVONIC, "Sci-Clone", San Francisco Sentinel, Vol. 5, # 7.
'(…) I'd like to define "Free Theater" as exactly – companies that ask nothing more for admission than your presence. Most of these groups, like the S.F. Mime Troupe, have political reasons for that generosity. Art should be available to anyone who wants it, says their philosophy, or else it is elitist (…)

While the last Angels show I saw was a real dog (performers unable to stand up, incoherent dialogue, etc.), they nevertheless developed a reputation for glittery pump rivaling that of Busby Berkeley.

And in "Sci-Clones" we see a new era for the Angels on the horizon. Dazzling choreography; more (and talented) women; sets and costumes somewhere between Fellini, Star Trek, and Las Vegas; a well-crafted musical score; and a book that mated flower-power, soap-operatics and science-fiction. (…)

While "Sci-Clones" was pure entertainment, the real triumph of its success is that it was a jewel, given freely and with much apparent love and joy by its performers. You won't find this kind of sparkle at A.C.T., San Francisco Ballet, or Civil Light Opera (…)'

An excerpt from Wendy Mukluk's journals, about the "Sci-Clones" show:

'Sunday March 19, 1978 was the opening night of the Angels show. It was great, it was like the Palace, tons of people we knew were there, dressed to the tits, just like a big cocktail party, everyone milling about, chit chatting before the show & during intermission. At the show's opening this guy comes up to me & says he owns the Peacock Garden (a store) & says my skirt is like an Escher print (I was wearing the kitty skirt - old woven kimono cloth with a black and white design of cats that I had made into a small tied top and short wrap skirt - & zebra spike heels). Later Anthony said the same thing about the skirt, I'd never thought of that before. In the bathroom there were dykes giving me attitude for being dressed so skimpily. Out in the theater, Dennis I kept seeing from a distance & we got close enough to say hi & then were spirited away. Reaction & Beau were staggering about. Beau was looking at my hair like he couldn't figure out what it was (he was dusted) & he'd run his hand through it & have a puzzled look on his face. Teddy & Erik were all in satin & sequins, Chinese costumes. Erik had a long top & pants like pajamas & those shoes like white boats & he was running around like a little kid with a big smile saying hello to everyone.

The show was really good except for a couple of things – dumb plot (little paradise taken over by machines), long pauses between scenes & bad acoustics. Otherwise it was really good, I was amazed all these people could do acrobatics & tap dancing & ballet that a year ago couldn't. The costumes & sets were really nice & my favorite part was the Machine Worship, where about 15 of them come out, all in black leotards & satin hoods & red masks with faces like a big capital I & red gloves, & there's this big flashing light machine of Tom Tadlock's & they do this robot dance to electronic music & red lighting (…)'

Scrumbly Koldewyn:

'TUXEDOMOON elevated the artistic level of the Angels Of Light up several notches, and began to bring the troupe to its peak. Naturally, I saw all the shows they were involved in, the best of which was *Sci Clones*, which featured TUXEDOMOON on stage, and had the best music up to that point ("Dancing Is Illegal" was the song that sticks in my memory) of any Angels' production. I really liked their taste in music.'

French film-maker Stéphane Lambert reminisces on The Angels Of Light:

"In 1974, I was twenty years old and in France we were hardly getting out of Gaullism, so we were a few centuries behind and a bit naïve. I went to San Francisco on an exploratory journey to choose a film school and landed at an acquaintance's place – he had an antique shop on Market Street near a place called *Twin Peaks* that was a haunt of drag queens and studs – unaware that he was a member of The Angels Of Light. So the Angels would pop up all the time: Wally, Teddy, Scrumbly and all the others. I was intrigued because I liked glitter rock a lot and at the time Mick Jagger would put make-up and dress up like a woman in Nicolas Roeg's *Performance*. It was

these shows that would also bring the community together. At the shows, there was free food and there was reference of where you could go to free clinic if you needed it. There was a huge underground community in San Francisco that was really based around succession from the unions. At the time the political environment was so extreme that it was very clear: it was us against them. It was: "Don't trust anyone over thirty." It was all the hippie *clichés* but very much put into action."

As to the kind of shows performed by The Cockettes/Angels Of Light, Cruikshank continues: "The Cockettes shows were centered around the imagery of creating a provocative drag. What they were basically doing were old thirties musicals because at that time it was very difficult to find old movies. When you saw these movies thirty years later in the sixties, they were camp and they were amazing. And there was something very trippy about them with their geometric choreography. People would be watching these movies in Berkeley and get stoned while watching them. Hence The Cockettes thought: "Why don't we make the movie instead of watching it?" So they did these amazing thirties inspired costumes and sing songs from the thirties.

The Angels, on the other hand, were kind of more concerned with community and immersion and different cultures that had ceremonial rituals. One of the early shows the Angels did was the Chinese show which kind of brought together all these reasons to sort of dress Chinese but also make dragons, have Tibetan art involved etc. The sets were always amazing in the Angels' shows because a few of the key members were very visually oriented, had studied it in college and then had dropped out but still brought that kind of artistic ability to the sets. Because the shows were free, the more spectacular the better because you didn't pay for it. So you had these amazing sets and glitter and all made of cardboard and at that time it was very easy to find things because we were very much into recycling and so you would find amazing things in the thrift stores: clothes, bargains… The whole theater group existed around that kind of idea of recycling, divorcing themselves from the mainstream, creating a community that supported itself without exploiting other people."

Scrumbly Koldewyn, [9] who was active as a performer and musician in The Cockettes and occasionally in The Angels Of Light discusses the relative importance of women's involvement in The Cockettes/Angels Of Light: "Both groups were very similar in that Hibiscus inspired and formed the groups and was the driving energy behind them. His legacy can never be forgotten. All that was different was that there were more women in the Angels (…)

The feminist movement began at the end of The Cockettes'

tenure and the beginning of the Angels', so the confluence of ideals differed a bit, but generally, while a few Cockettes may have snubbed the women, on the part of most of us, there was no discrimination. But unlike The Cockettes, the Angels' company was more dominated artistically and numerically by women. [10] As for costumes, The Cockettes and The Angels Of Light were about even, until Beaver [*Bauer*] [11]'s genius really emerged, producing stunning group costumes for dances, and integrating them with the sets into an over-all look for each show."

The politics within The Angels Of Light are worth to be explored a bit more at length. Being an Angel and living in The Angels Of Light's commune was quite a statement as not only did you have to devote yourself to the cause of free theater but moreover you were not allowed to get a job "because, recalls Cruikshank, basically the idea was that you divorced yourself from society." Therefore everybody in the commune was on welfare and had to perform their first theatrical act in convincing the authorities that they were mentally disturbed and hence needed assistance. The program was first called ATD (Aid to the Totally Dependent) and later SSI (which stands for Supplemental Security Income) when it was transferred from city to federal control. The Angels would accurately re-baptize ATD "Aid to The Divine." Bambi Lake, a transsexual who lived for a while at The Angels Of Light's commune recalls: 'They said I could live there only if I went on welfare, so I went down to the Department of Social Services to apply for General Assistance. I needed a gimmick, so I stuck my thumb in my mouth and offered them a piece of paper which read *I must not speak/I must only seek/the truth of the fairy kingdom*. They asked me if I had seen a psychiatrist. I just moved my lips without making a sound. Those were the days of real Academy Award performances for getting on welfare. People painted themselves gold, peed on the floor, covered themselves in mud and molasses. I'll never forget the great line "I am the Brian. You are the moon. And everything is Ok." There was a lot of LSD damage going around. I wouldn't fake my way on to welfare now but back then it seemed like the only way to survive.' [12] As Cruikshank observes: "It really was a test to do that because basically you fucked up your whole social security and we were still young and had to be able to say: "Well, we will never be able to hold a job again since we'll be held totally incapable of doing it!" So it was like either: "Do that or be part of the other world!""

Tadlock was one of the first to go get declared mentally insane, later followed by Steven Brown: "I most certainly did go to the government offices and do my act... An act I also had to do repeatedly with shrinks prior to applying for aid. I was declared unable to work and did get on the dole. This if I remember

a trend in rock 'n roll that appealed a lot to me as quite related to a drug culture with many dreamlike and psychedelic openings to it, a poetry, a style of drawing, anti-conformism and counterculture.

So I was attracted but it was still an enormous cultural shock for me as there was quite a gap between my fantasies as a young Parisian and the reality in San Francisco. It was the end of the hippie movement initiated with Altamont and there was this whole opening to homosexuality that was entirely new to me. So I found myself in the middle of this group of guys dressed like chicks and, naturally, I became sort of their mascot, their little page (…)

There was this big cultural crossbreeding in the seventies, and a great attraction towards Europe, any kind of drag represented the spirit of the Berlin *cabaret* that got them closer to their Saxon roots – as many Americans have German and Austrian ancestors – and Anglo-Saxon roots, all countries where people love to travesty. And there was also Venice, Italy, the masks, the make-believes.

That was the atmosphere amidst the Angels: raging queers scheming all the time, assassinating each other with gossips and rumors about who got laid with whom and who did what. We were like in a court of aristocrats, something that Fassbinder described well in some of his films, oligarchies with the most beautiful or the master(s) and all this little court around. The Angels were even more bitchy than the worst jealous and assassin chicks.

I remember of an evening spent with them. They were very excited as they were doing a lot of coke: this was new to me as it hadn't reached France yet. They also had extremely strong hash sticks and every time I tasted what they smoked, it was Hiroshima, an atomic bomb in my head and it blew up my paranoia that I could be cornered by one of those gay guys – but they were nice to me most of the time and charming people who just wanted to be loved. So one evening we went to see a play at some theater on North Beach. For once I had dressed up for the occasion and the Angels had put tons of make-up on my face. I sat through the play, half-stoned and by the end of it, the Angels – still extremely excited with all this coke – stood up and vanished before I even could brace myself to stand up. So there I was, very young and very lost, dressed like a transvestite, having forgotten where my hotel was. Working my way back was quite an ordeal…"

correctly was required or at least strongly recommended to live in The Angels Of Light commune." Cruikshank: "They would find you unable to maintain a livelihood and so you would be getting some amount of money monthly to support yourself. The severe cases were institutionalized. But you can't minimize the political climate at that time. The governor of California was then Ronald Reagan and he was about to take all the money away from federally funded institutions. That was one of his aims to cut the money for people who needed help. All of a sudden people who had been in institutions for years were thrown out on the street and that was a big deal. And he took those kind of ideas and moved into the White House.

There was this incredible schism between the haves and the have nots. We thought that we put the federal money to better use by doing what we did, rather than supporting the war. Supporting the war was leading to cuts in art programs. Eventually we ended up getting some sort of subsidies that were connected with arts. We had some kind of residence in the University of California extension which was on Haight Street. So for me, it was really like sort of going to college but taking all the courses that I wanted to take and being involved with people that I wanted to be involved with.

I had a very strong conviction about it and found like-minded people. Steven was really concerned about being an artist and so were most of the people in The Angels Of Light, as well as Tommy and others. There was nothing except creativity 24 hours a day: we were working on the show, working on music, working on movies, playing around with photography. We went out to see movies a lot because at that time you didn't have a chance to go get a video. So when *Satyricon* from Fellini would come in the theater, everybody would go and dress up accordingly (…)

The Angels Of Light were for me immersion of all things theater, designing, acting, performing and also on the political and very active community wise level. Earlier in my life, when I was still living in Los Angeles, I was a political activist, an anti-war activist. Within The Angels Of Light there was someone who was in The Weather Underground and someone who was very active in the East Coast tradition of extreme theater, the "La MaMa" group. [13] So I was very interested in being as extreme as possible. I immerged myself in that experience. We basically ended up living in a huge house together and we did a number of shows. The Angels Of Light on the East Coast weren't as political and they did end up doing shows where they would charge some money.

I went to Europe with them. They arranged for a tour of Europe. Four people of the New York group and four people of the San Francisco group met in London, did a show in

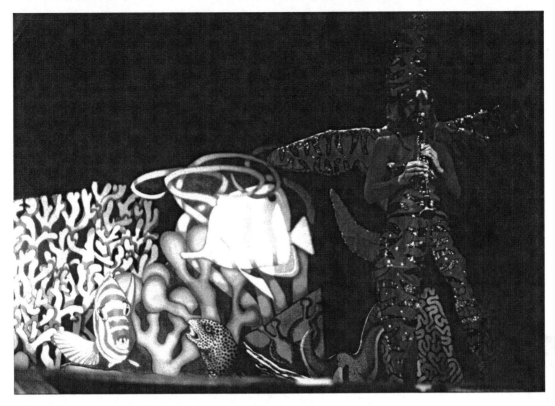

Steven Brown performing in Angels of Light show "Paris Sights under the Bourgeoisie". Photo Dan Nicoletta

London and did a show in Amsterdam. I ended up staying in London for about two years. I came back on the East Coast, did a show with The Angels Of Light on the East Coast and then came back on the West Coast and arrived just for the Halloween show.

At that point, Steven had already joined the group, he was doing the music for the Halloween show and I was immediately: "Let's do a number together." It was in 74-75. When I got back, we started working on a show called *Paris Sights under the Bourgeoisie* (Steven Brown: "That was a play on words, you get it? Parasites under the bourgeois sea…") and I know that Steven and I worked together on that one and specifically on my number, I wrote a song and he wrote the music to it. He wasn't in the shows as much as being involved in creating music for the shows. I have a picture of both of us in a scene underwater and Steven was a starfish and he's in this amazing red star costume playing the clarinet and I was a mermaid. And the set was all this entangle coral. It was otherworldly. And it was really prrrecious (laughs).

It was my little poetic moment. It sort of established a relationship between me and Steven as far as being involved in music. I had a frustration about the Angels at that time because there was a big move to do all these tap dancing numbers and all these big choreographed things that were not very progressive and I always wanted to be more contemporary than that."

Guy Debord on the Society of the Spectacle:

'The first stage of the economy's domination of social life brought about an evident degradation of *being* into *having* — human fulfillment was no longer equated with what one was, but with what one possessed. The present stage, in which social life has become completely dominated by the accumulated productions of the economy, is bringing about a general shift from *having* to *appearing* — all "having" must now derive its immediate prestige and its ultimate purpose from appearances. At the same time all individual reality has become social, in the sense that it is shaped by social forces and is directly dependent on them. Individual reality is allowed to appear only if it is *not actually real*. (…)

Philosophy — the power of separate thought and the thought of separate power — was never by itself able to supersede theology. The spectacle is the material reconstruction of the religious illusion. Spectacular technology has not dispersed the religious mists into which human beings had projected their own alienated powers; it has merely brought those mists down to earth, to the point that even the most mundane aspects of life have become impenetrable and unbreathable. The illusory paradise that represented a total denial of earthly life is no longer projected into the heavens, it is embedded in earthly life itself. The spectacle is the technological version of the exiling of human powers into a "world beyond;" the culmination of humanity's *internal* separation.

As long as necessity is socially dreamed, dreaming will remain a social necessity. The spectacle is the bad dream of a modern society in chains and ultimately expresses nothing more than its wish for sleep. The spectacle is the guardian of that sleep. (…)

The reigning economic system is a *vicious circle of isolation*. Its technologies are based on isolation, and they contribute to that same isolation. From cars to television, the goods that the spectacular system *chooses to produce* also serve it as weapons for constantly reinforcing the conditions that engender "lonely crowds." With ever-increasing concreteness the spectacle recreates its own presuppositions.

The spectacle was born from the world's loss of the unity, and the immense expansion of the modern spectacle reveals the enormity of this loss. The abstractifying of all individual labor and the general abstractness of what is produced are perfectly reflected in the spectacle, whose *manner of being concrete* is precisely *abstraction*. In the spectacle, a part of the world *presents itself* to the world and is superior to it. The spectacle is simply the common language of this separation. Spectators are linked solely by their one-way relationship to the very center that keeps them isolated from each other. The spectacle thus reunites the separated, but it reunites them only *in their separateness*.

The alienation of the spectator, which reinforces the contemplated objects that result from his own unconscious activity, works like this: The more he contemplates, the less he lives; the more he identifies with the dominant images of need, the less he understands his own life and his own desires. The spectacle's estrangement from the acting subject is expressed by the fact that the individual's gestures are no longer his own; they are the gestures of someone else who represents them to him. The spectator does not feel at home anywhere, because the spectacle is everywhere' (Guy Debord, *The Society Of The Spectacle*, translation by Ken Knabb, op. cit.,

The Angels Of Light and situationism. At this point, it's interesting to note that quite a few elements characterizing The Angels Of Light are quite evocative of the surrealists, dadaists [14] and more specifically of the situationist movement, the latter being the product of the two formers. These elements were: that part of their inspiration was derived from their aversion for warfare; their performance art that, at least at the beginning, was not reserved to specialized professionals and furthermore was practiced in close communion with the audience; their refusal to get a job within a society that they rejected and their claim to be considered as lunatics within such society (even if, in a world of Absurdia, such claim entitled them to get welfare assistance from that very society). Later on Tuxedomoon will repeatedly state a Dada reference when attempting to describe themselves. As to The Angels Of Light, they could surely be analyzed as a situationist statement in action.

Just a brief introduction to the situationists. They originally stemmed from the Lettrist movement – a challenge to the world order established after the second world war – that was founded in Paris in 1946 by Romanian refugee Isidore Isou and French Saint-Germain-des-Prés figure Gabriel Pommerand, to evolve into the *Internationale Situationniste*, born in Italy in 1957. It counted about 70 members, of which never more than a dozen were active at the same time, scattered mainly between France, Belgium, Italy, the Netherlands, Germany and Algeria. It was dissolved in 1972 but gave rise to a vast international movement that is still active today even though its *âge d'or* was probably during the seventies. [15]

The situationists were way more than just this group of lost young people, some of whom were exiles, drifting from one *café* to the other, getting drunk and overtly smoking hashish, [16] ironically naming themselves "situationists" where their "situation" was: "Never to work!" [17] One of their theorists, French Guy Debord (author of *The Society Of The Spectacle*, 1967 [18]) recognized the importance of the Dadaist movement (formed around the Cabaret Voltaire, created in Zurich, 1916, by Tristan Tzara, Hugo Ball and Richard Huelsenbeck [19]) in that it undermined the traditional vision of culture in a first attempt to go *beyond* art. To quote Tzara: "We didn't want to distinguish between life and poetry; our poetry was our way of being". [20] In a few words, situationism can be sketched into the opposition of the Spectacle – being the alienation of non intervention in a capitalist society or, stated differently, an external/specialized representation of reality, the Spectacle for which the so-called "reality shows" nowadays stand as a topic illustration, that becomes more "real" than the reality itself leading to isolation and solitude – and the construction of Situations that consists in the (collective) creation of

ambiences that determines the quality of a moment. Stated differently: situationism represents a possibility to live poetry and incarnate a total work of art, beyond art, being achieved in (creative) life itself. [21]

Belgian Raoul Vaneigem (in his *Revolution of Everyday Life*, 1967 [22] – one of the authentic sources of inspiration in the May 68 movement in France [23]), focuses on the everyday life as the space within which to develop situational creativity and, as a matter of fact, the situationists maintained close ties with Belgian surrealists, as the latter always preferred Everyday Life to the Marvellous – divorced from reality - set forward by many (French) surrealists [24] (Breton, for instance).

As recounted above, The Cockettes/Angels Of Light *were* mainly the characters that they later brought on stage and, like the situationists, they refused to work in a society that they rejected, relying on a "do it yourself" (DIY) philosophy and on recycling to present free shows with spectacular backdrops at costs that seemed ridiculous compared to the same show on the traditional circuit. As such they can be viewed as situationists *in action*. Also the fact that their survival in the society was dependant upon being perceived as lunatics would probably have amused Gilles Deleuze and Félix Guattari, a philosopher and a psychoanalyst entertaining a vision of humanity as schizophrenic producing/desiring machines and whose main ideas were quite close to the situationists' paradigm. [25]

From hippies to punks – first take. It has been pointed out that the situationist and hippie adventures were indissolubly linked. [26] Interestingly enough, the influence of British situationists on the explosion of the punk movement has been extensively elaborated upon: Malcolm McLaren, Jamie Reid and Vivienne Westwood will divert the situationist mottos and aesthetics and put them at work for their own glory. [27] It is worth mentioning here that McLaren, when he went to America in 1974 to manage the New York Dolls (for whom The Cockettes were an influence), would come into close contact with William Burroughs, Patti Smith, Richard Hell and The Ramones, and participate in the inception of a back then still underground punk movement. Hence, amazingly we have a common ancestor for two movements that are often perceived as antagonists, the punk movement building itself against a backdrop of hippies' demise and their failure in carrying out their ideals.

Some members of The Angels Of Light, which undoubtedly could be considered a hippie venture, let themselves, to use a word quite dear to the situationists, *drift* towards this new source of energy called "the punk

thesises # 17, 20, 21, 28, 29, 30).

Raoul Vaneigem on the Revolution of Everyday Life: 'People who talk about revolution and class struggle without referring explicitly to everyday life, without understanding what is subversive about love and what is positive in the refusal of constraints – such people have a corpse in their mouth. (…) The real demand of all insurrectionary movements is the transformation of the world and the reinvention of life. This is not a demand formulated by theorists: rather, it is the basis of poetic creation. Revolution is made everyday despite, and in opposition to, the specialists of revolution. This revolution is nameless, like everything springing from lived experience. Its explosive coherence is being forged constantly in the everyday clandestinity of acts and dreams.(…)
In the struggles to come, the desire to live intensely will replace the old motive of pillage. Tactics will become a science of pleasure, reflecting the fact that the search for pleasure is itself pleasurable. Such tactics, moreover, can be learned every day. The form of play known as armed combat differs in no essential way from that free play sought by everyone, more or less consciously, at every instant of their daily lives. Anyone who is prepared to learn, from his simple everyday experience, what tends to kill him and what tends to strengthen him as a free individual, is already well on the way to becoming a true tactician' (Raoul Vaneigem, *The Revolution of Everyday Life*, London, Rebel Press, 2003, p. 26, 111, 262).

Tribal spirituality. 'For Hibiscus, the Angels presented an opportunity to practice tribal spirituality. Whereas The Cockettes had glamorized the trappings of the '30s and '40s, he envisioned the Angels transforming cultural consciousness through song and dance. As the Kaliflower ethos advised, "Instead of dropping out of the culture, you should make your own culture." That was the theory behind the Angels' shows. (….) The Angels Of Light free shows drew large crowds, and they passed out food at those events, which featured exquisitely designed sets and costumes courtesy of Beaver, Rodney, and Angel Tony, formerly of the Living Theater (…) Beyond that, nudity and sex were encouraged in the shows and often included audience participation. Drinking and drugs were a given (…) Scrumbly (…) felt that the early stuff with Hibiscus and the Angels was so chaotic that it was hard to watch. Beaver recalled (…) "We picked people off the street and dusted them off"' (Pam Tent, *Midnight at the Palace: My Life As a Fabulous Cockette*, Los Angeles, Alyson Books, 2004, pp. 123-124).

Gilles Deleuze and Félix Guattari on desiring machines: 'It is everywhere, functioning

smoothly at times, at other times in fits and starts. It breathes, it heats, it eats. It shits and fucks. What a mistake to have ever said the *id*. Everywhere *it* is machines – real one, not figurative ones: machines driving other machines, machines being driven by other machines, with all the necessary couplings and connections. An organ-machine is plugged into an energy-source-machine: the one produces a flow that the other interrupts (…) A schizophrenic out for a walk is a better model than a neurotic lying on the analyst's couch (…) Producing-machines, desiring-machines everywhere, schizophrenic machines, all of species life (…) Oedipus presupposes a fantastic repression of desiring-machines (…) Revolutionaries, artists and seers are content to be objective, merely objective; they know that desire clasps life in its powerfully productive embrace, and reproduces it in a way that is all the more intense because it has few needs (…) Desiring-machines (…) continually break down as they run, and in fact run only when they are not functioning properly: the product is always an offshoot of production, implanting itself upon it like a graft, and at the same time the parts of the machine are the fuel that makes it run (…) The artist is the master of objects; he puts before us shattered, burned, broken-down objects, converting them to the régime of desiring-machines, and celibate machines as so many technical machines, so as to cause desiring-machines to undermine technical machines. Even more important, the work of art is itself a desiring-machine. The artist stores up his treasures so as to create an immediate explosion, and that is why, to his way of thinking, destructions can never take place as rapidly as they ought to.' (*Anti-Oedipus: Capitalism and Schizophrenia*, Minneapolis, University of Minnesota Press, 1983, pp. 1-32 s)

Two techniques dear to the situationists: drifting and psychogeography. The first could be described as a sort of free association in terms of city space. The idea was simply to follow the streets, go down the alleys, through the doors, over the walls, up the trees and into the sunlight, etc, that one found most *attractive*; to wander, alone or with one's friends, following no plan but the solicitation of the architecture one encountered. Drifting was an attempt to orient oneself in the absence of any practical considerations: to find the types of architecture one desired unconsciously (…) *Psychogeography* was the study and correlation from the material obtained from drifting. It was used on the one hand to try and work out *new emotional maps* of existing areas and, on the other, to draw up plans for bodies of *situations* to be interlocked in the new utopian cities themselves.' (*Leaving the 20th century. The incomplete work of the situationist international*, translated and edited by Christopher Gray, first published by Free Fall Publications, 1974, new edition by Rebel Press (London), 1998, p. 4)

Vale: "It's not like life is better now because it's not. Now everyone I know has to work for a living. In the Sixties and during the Punk Rock, nobody had to work 40 hours a week to pay the rent. During 1977-78 when I published Search & Destroy, my rent was 37,50 a month, I worked two six-hour-a-night shifts at City Lights bookstore and was able to survive. More than survive: life was great. We stayed up all night. We had a lot of fun. We didn't have much money, but you didn't need much money. Your quality of life didn't depend on a lot of extra money. All your clothes came from thrift stores, and everybody seemed to get in free, I don't know how the Mabuhay even survived. Punk rock started as kind of a rebellion against

movement." Amongst these Angels were Gregory Cruikshank, Esmeralda Kent (future member of Noh Mercy!), Victoria Lowe (future member of Tuxedomoon) and Steven Brown. As a matter of fact, San Francisco, as one of the hippie Meccas, was a focus of the drift, with "conversions" taking place overnight. Esmeralda Kent: "I was certainly a hippie, all of us were, but there was a cynicism that took over when the dream was really over, the dream of changing society into a healthy organic recycling social democracy. Air waves were taken over by The Eagles and Fleetwood Mac. It was so boring that everybody thought they were going to die in 1976. Also the politics… So many wonderful revolutions had been going on sexually and socially in the country and then everything had been set into packages and sent back. Then The Sex Pistols came, and it was like: "Yes…" There was something in all of us, the Angels, an edge that the hippies didn't have, that "Fuck you, brat," that edge that wasn't "Peace and Love." We were pissed off because it seemed that we had lost the revolution and here with The Sex Pistols, there's no future, everything is complete crap, it doesn't matter and it just appealed to a lot of us at that time. We were hippies, which means that we were very romantic people but the flip side of this is to be very cynical. When that romance turned, it turned into punk rock."

Quite revealing of the drift from hippies to punk is this excerpt from Wendy Mukluk's online journals (the Mukluk family settled in a house located on 3645 Market Street, before some members of Tuxedomoon moved in there with Tommy Tadlock [28]) about Greg Cruikshank's birthday party on November 12th, 1977 [29]:

> As soon as we walked in, there was punk rock playing, & one room was empty except for Gregory dancing, so I went in & danced with him. We were jumping up & down (your basic punk rock step) & bumping into each other & Gregory knocked me down & we were rolling around on the floor. Two or three other people started dancing, one was that girl Lectra, severe punk haircut who I saw at that creepy punk rock party but she's pretty nice.
> It was a great party. Also I had tons of drugs – gin, quaaludes (half to start & Dennis gave me another half, MDA, dust, wine). I felt like I wasn't stoned enough. I was slurring & falling down but mentally I felt straight. It was weird. I said, "More drugs more drugs," & Reggie was trying to get me to sit down. Some Jesus freak girl was hanging out in front of the house & said, "It's like Hell in there."

Patrick Roques (who was soon to become Tuxedomoon's friend, graphic designer and, for some time their tour manager) comments these lines:
"Interesting pages. Lost times and some lost people. Back

then, in the early 70s a lot of creative, costumed freaks hung out at this gender bender cafe called Hamburger Mary's. Drugs taking was a common thing. Quaalude and MDA were popular and LSD was a mainstay. PCP (Angel Dust) was around but made you crazy, very destructive. I never saw the allure there. The two paragraphs from the diary illustrate two important points.

First there was a very big rift between the emerging punk scene and the radical drag groups. As in 'As soon as we walked in, there was punk rock playing, & one room was empty except for Gregory dancing...' and 'Lectra, severe punk haircut who I saw at that creepy punk rock party...' It was a "war" of philosophies, style and attitude between the "hippies," which the Angels were seen as part of and the streamlined, confrontational punks then emerging. The second is the type of drugs the former group did. The Acid Head or Psychedelic generation were seen as indulgent, hedonist, out of touch. Alcohol and Speed were the chosen drugs for the Punks at that time. Punk seemed a "vertical" movement, the other "horizontal." Punk was anti-art and outwardly more political *i.e.* workers rights etc. But Tuxedomoon weren't anti-art or artifice. With them there was a link back to the Glam Gender Fuck days which separated them from the British style of Punk that was influencing West Coast Punk. Of course androgyny still played a strong role. We all had short hair and dressed alike, they (The Cockettes and Angels) all had long hair and dressed alike. Punk seemed more heterosexual. Bi-sexual is probably more accurate. So there was of course mingling and overlap. Steven and Gregory, Walter Black (a close friend of Tommy Tadlock) and others cut their hair, bought 60's thrift store suits and joined in with the Punker riff-raff. Punk of course was were the new party was after all. Tommy Tadlock loved the Punks. He told me he "hated those fucking hippies!" He hated the whole Haight Street peace and love movement. He was a "fucking Beat!!!" Not a Beatnik, but a pissed-off artist from New York who slept on the floors of cold water apartments in freezing NYC winters, living only on oranges and food ripped off from art openings and super markets... Not flaky hippie assholes. Tommy was a "punk" at heart. Subsequently I've encountered many people (artists, writers, leftists) over the years, mostly in their late 50's who had found that the so called "hippie movement" to be somewhat suspect and embraced Punk as a valid, relevant statement. Most of these people found Punk a return to a more anarchistic social and political stance: more meat on the bone."

rock, what rock music & pop music had turned into. This kind of rebellion had happened before; at the beginning of the century the Dadaists and Futurists had tried to completely overturn every musical value and oppose noise to it, as in Luigi Russolo's essay 'The Art of Noise' (....) In order to have any kind of youth rebellion, you have to have some free time and you have to have a meeting place" (quoted by J. Stark, *Punk '77: an inside look at the san francisco rock n' roll scene, 1977*, San Francisco, RE/Search Publications, 1999)

J.G. Ballard: 'We're desperate for excitement of some kind. That's the drawback to living in an entertainment culture – the entertainment begins to pall after a while. It's like spending too long at a theme park – you begin to long to get out of it. And when you realize that there's nowhere to get out to, that it's all like this, that the theme park now circles the planet and that's all there is – that makes for desperation (*Frieze*, 1996)' (excerpt from *J.G. Ballard Quotes*, quotations selected by V. Vale & Mike Ryan, San Francisco, RE/Search publications, 2004, p. 65)

Punk rock music is folk music turned up really loud. Patrick Roques: ""Kill the hippies!" was the scream of the Punks. The word "hippie," by the late 1970's had become a derogatory term exemplified by bands like Journey, Led Zeppelin, Pink Floyd... These big corporate rock bands became convenient symbols for what had become a stale society, a society on hold. Music as a popular art form wasn't progressing, it had been fully co-opted and any relevance to 60's revolution or hope for a free society were long gone.

So "Kill the hippies!" and "I hate Journey," became a kind of jingoistic rant for Punk rebellion directed against the "dinosaur bands," the dinosaur music industry. The so-called Hippies living the late 1970's were viewed as complacent burn-outs who smoked pot and drank beer on a boring stay-at-home and watch TV level. The idea of revolution, of enacting Sociopolitical change for the most part was over. There were even nazi hippies, guys with long hair who were Right Wing reactionaries made up of ex- Vietnam Vets and Bikers, who are in fact still around. So long hair as a sign of "Friendly Freaks" became meaningless as well. The death of the Counter Culture could be seen as the birth of Punk. People started to make independent music and records, magazines, films. So you had new musical forms, new art forms, film, photography, writers. The whole anti-capital system of DIY

– do it yourself – was exploding up. New noise-pop bands like DNA in New York and new art bands like Tuxedomoon in San Francisco. Punk was politically to the "Left" for the most part. A lot of Punks were Socialists. They supported workers' rights, Unions. Some were activists, anarchists, dada-ists... They were very aware of the controlling political system at hand (Reagan and Thatcher). Some of their ideas were based on Marx. Some wanna-be's mouthing a kind of "faux communism." Some were true believers. So I've always thought of Punk Rock as a kind of Folk Music turned up really loud and played really fast. A lot of Punk Rock seemed to be loud Woodie Guthrie with that great anthemic feeling to it. Like the political activists of the 60's the Punks wanted to change the old world and create a new world. The approach was more through art than direct action, as in the civil rights and anti war protests of the 50's and 60's. The "No Future" slogan borrowed from the Situationists by Malcolm McLaren who handed it over to the Sex Pistols, saying, "Do this" showed the kind of angst that was there. There was a lot of anger but there was also a lot of creative energy and change in the air. We had moved from the utopian ideals of the 1960's to the dystopian reality of the late 70's. Punk was such a small group of people back then. Eventually it was commercially exploited as a way to sell New Wave sunglasses and bondage gear to middle class teenagers. But Punk in 77-78 was very diversified. There was no real set "dress code" in place. It was mixed up, with older intellectuals from the 50's and 60's, like Slava Ranko over here for instance, gays, lesbians, frustrated art school brats and street punks. Over the years Punk became very dogmatic and split off in different directions but it's still around, that sort of amazes me in a good way."

Gregory Cruikshank resumes telling his story: "After the *Paris Sights* show with the West Coast Angels Of Light, I went back to Europe to collaborate on another show with the East Coast Angels Of Light. That didn't work out but I did end up staying in London again for another few months and while I was there I met Vivienne Westwood (…) who had an amazing impact on me, less hippy and much more provocative. She wanted to do music with Malcolm McLaren and create a band named The Sex Pistols (…) The Sex Pistols' first performance was like a cathartic experience. After that I went back to San Francisco, The Angels Of Light were still going and doing tap dancing and I didn't feel that I was still connecting on that level, so that's when I moved out of the commune and moved to the avenue where the party was. I wanted to inject some more contemporary ideas into the art world. That's when Steven Brown and I sort of clicked. I remember writing Steven from London while I was there, about music and probably about the Pistols in '76…"

Also worthy of note is the sociological configuration of the "new-born" punks that came to populate the streets of San Francisco. As publisher Vale (of *Search & Destroy*, THE fanzine that accompanied the SF punk movement at its apogee) points out: "(…) you had a scene which wasn't defined. Basically weirdos and outcasts and artist types, post-beatnik types, were the main audience at the Mabuhay [*San Francisco's most notorious punk rock venue*] (…) it wasn't as young as it was in England (…) people were at least in their twenties and thirties. It was definitely an older scene. In a way that was kind of good, because it seemed to be a richer scene."[30] For Bambi Lake, 'Far from being the teenage hooligans many people imagined them to be, the original punk scene in San Francisco was composed of trendy art school students, talented musicians, fashion designers, dissident intellectuals (lots of Dada and deconstruction points-of-view) and an amazing number of trust fund babies.'[31]

The latter description might be slightly tainted with exaggeration but the point remains that being arty and punk was not necessarily seen as a heresy in San Francisco and, in this sense, the soon to be born Tuxedomoon will have to be seen as a pure San Francisco product. As French journalist Elisabeth D put it: 'In 1977, the punks decided to raze these old ruins of utopias. But those of San Francisco are less nihilist and cynical than their English counterparts. The firsts applaud Tuxedomoon at the Mabuhay Gardens, the local punk temple. Tuxedomoon are surprised: they (…) discovered that they could get along.'[32]

CHAPTER II
Tuxedomoon New Music Ensemble in the Houses of San Francisco

Although Steven Brown maintained his collaboration with The Angels Of Light until well into 1978, with Tuxedomoon eventually acting as a musical backdrop for their shows (as was the case with the Sci-clones show), he left the Angels' commune around 1977 and moved to a house located on 3645 Market Street. In this house, formerly the home of the Mukluk commune, Tommy Tadlock gathered around him several young artists, among whom were Steven Brown, Blaine Reininger, Patrick Roques and Paul Zahl.

In those days, socializing mainly took place in private homes. Peter Principle: "San Francisco is kind of clannish as it all closes by two a.m. by law. Many things are over much earlier than that as it is a small town. So a lot of the living and social life goes on in private domains which through a fortunate fluke of luck were mostly large Victorian rambling structures. These had gone out of fashion in the fifties when people wanted suburbs or penthouses. Consequently these large flats were not expensive until the early eighties when the city changed civil policies rather dramatically, but that's another story..."

This situation explains why there was such a high concentration of artists in San Francisco at that time. The houses where Tuxedomoon members lived in their San Francisco days –particularly 3645 Market Street and 1344 McAllister Street for Peter Principle – can be considered as true "characters" that played a significant role in building Tuxedomoon's *anima*, somehow as the missing link between the hippie and punk movements, and as a multimedia experiment.

This Chapter primarily deals with the initial encounters that lead to the forming of Tuxedomoon. Then it describes the various members' ways of life in their San Francisco houses in a context that saw punk rock bursting out of the ashes of an agonizing hippie culture. The description of their life in those houses covers most of the period when Tuxedomoon was active in San Francisco, with occasional references to events that marked Tuxedomoon's career in that city. These events will be expanded upon in their chronological order in the next Chapter.

Tuxedomoon New Music Ensemble. We left Blaine Reininger when he had just arrived in San Francisco, some time in 1976. "I was miserable when I got there, I was scared, he recalls. It was overwhelming. It took a long time to adjust. I was mostly frightened. I had no place to live. I was in a situation of transition."

So the first six months proved difficult. Reininger decided to go back to school, community college more precisely: "I wasn't willing to get a diploma but to educate myself, open my mind up, keep myself alive."

The community college was offering a music program – even musical instruments if you couldn't afford them – and it was free, a dream come true for Blaine who, in addition to studying electronic music, also focused on creative writing, computer programming and film-making. For the electronic music class, candidates were systematically disheartened by being told that the class was full, forcing the applicants to go and beg for admission. Blaine: "Even though they were saying that it was full, it was like a zen kind of thing because when you'd get there it was not full at all. There were only three, four people there. It was a strategy to keep away idle curiosity."

As it turned out, Steven Brown, encouraged by Tommy Tadlock, had enrolled in the same class of electronic music but was six months ahead of Reininger. A friend of Blaine, Leslie Ward, who had known Steven Brown as well, while he was running a coffee shop in Springfield, Illinois, had told Reininger that they should meet. "The meeting of the two local heroes," laughs Reininger.

Their encounter was hardly love as first sight. "The first time I met Steven, he didn't want to have anything to do with me. I don't know why. Maybe because I was fat and I had this stupid hairdo, dressed really strangely. So he was: "Wow! Who is this?" That's what he said. And I thought he was arrogant. The guy wasn't saying anything to me. So I was: "Fuck you!" We ran into each other once in a while in class. He didn't come to class every day. He was with this guy named Tom Tadlock. He was a very strange, older, guy. We thought he was old. He was like 35. "Oh he's hanging out with this old man!" He was this bizarre wretched insane creature but they came in the first day of class. Steven was there with him and then I never saw Steven again in class…"

Brown: "I didn't like him at all. I just found him repulsive. He wasn't that fat at the time, he was BIG. He was just too big: his hair was big, his ego was big, everything about him was big. Not much has changed actually… He was just too overwhelming and very much in his own world. You couldn't really communicate with him. He was always in this haze, this cloud of (…) Valium I would say. He was in this blue haze all the time. I didn't know at the time but… Also it's his

personality. It's just the way he is. I was very aloof somehow and so I didn't want to have anything to do with this person. I didn't see really what we had in common."

Blaine resumes the story: "I was going to this electronic music class about twice a week. I was learning how to play the synthesizer, going about my business, making tapes. And at the same time I was living with the Sufis, a religious community. I stayed with them for about six months. I had a Sufi name, Bilal, and I was making music with them.
At the end of the school semester [*around May, 1977*], we had to give a performance and what I prepared was already a statement of synthesis of the disciplines that I was trying to pursue. I did a performance – called *Neo-Mayan Easter* – where I had included the music I had made on the synthesizer, poetry I had written and I involved the computer to a certain extent. They were really simple programs. Like a program saying: "Print this text one hundred times" and passed them out to people as they came in. And I showed films, my own films, on myself. I had transparencies that I had made. I was then fascinated by photomontage... So I was projecting these things on myself and I was wearing a black kimono and a Japanese robot mask and a hair dress made of different colored balloons. I had a propeller in one hand and I was doing a Mayan ritual. My idea was to do a modern electronic Mayan mass and I was the priest. And there was my music in the background and I was singing and ranting and raving, reading my poetry, and all this thanks to the equipment I got from the school. That was my performance."
Steven Brown: "I saw his performance at the school and I really liked it because what he did was so over the top and so unexpected in this situation of, you know, University electronic music class. Everybody was doing this horribly boring conceptual music and then Blaine gets up there with a dress and balloons in his hair and a movie running and singing these crazy songs and doing his gig. I said: "Yeah, cool!""
Steven Brown's piece was called *Amnesia*. Brown: "It was based on a design of Brian Eno at the back of one of his records [*i.e. Discreet music*]. There was a diagram that explained how he did this album. Me and Tommy [*Tadlock*] saw that: "Cool, let's try it!" And so that's what I did for the end of the year. It was two tape recorders and a keyboard, I played keyboard. It went in one tape recorder and then, like with a long tape loop, across the room into another tape recorder and then back to the first tape recorder. So what happened is you played a note and you kept playing but that note you had just played would come back ten seconds later and then when you heard it you played with it and so, because of the tape loop, within five minutes you had this whole wall of sound…"

Page 35

Reininger:"He worked together with this Tadlock, this wretched creature. He was an electronic genius. Steven had this enormous loop of tape, across the room, five meters long. He was sitting there playing synthesizer with two tape recorders. He'd play something and it'd keep coming back around and around and around and he kept building layers and layers and layers. He just sat there playing the polymoog synthesizer and it was very impressive, visually impressive. Just this big piece of tape going around on stage, musically impressive and technologically impressive. We didn't have a polyphonic synthesizer. So it was: "Wow, what is this?" I was impressed. Presumably, he thought the same of my performance.

Tadlock saw my performance and said to Steven: "This guy is great! You've got to work with this guy, Steven." And I thought two things: I was impressed by Steven's performance and also I was impressed by the amount of gear Steven had available. So I thought: "Well, I'd like to get to know this guy because he seems to be interesting musically and creatively and also it's a way to get to the equipment he's got there, to use this tape recorder, to use this synthesizer." The limitations of the school were becoming clear and I wanted to leave and go somewhere else to pursue my thing. So I thought: "Here's a situation." Steven was in a situation: (imitating an affected voice) "I work in a four-track studio and I have a polyphonic synthesizer and I work in a theater company." "You do? I want to work there too!""

After those memorable end of term performances, Reininger did not wait for long to act upon his plan. "Here's a *café*, the place is called Just Desserts, where lots of my friends worked at the time. I talked them into letting me do a performance in electronic music. I told them that it would be very ambient, background music. It would seem to be just an extension of what I was doing in school. It was not a job for money, just a manner to be, to perform. So I got this job, playing in this *café*. My idea was to get Steven involved in it. I started calling and calling, trying to find him: I didn't know where he lived, I didn't know his phone number. I knew people that did know. He was so hiding out. I was calling: "Is Steven Brown there?" and then (imitating a whispering voice) "I'm not here! I'm not here!" Another voice out loud :
"No.
- Where is he?
- I don't know where he lives."
I kept calling and calling and calling. The date that I had booked for this show came and went. He was not available. I couldn't find him. I decided: "Well I'll wait till he's available." Finally I succeeded in getting in touch with him some time later and he was:
"What do you want? Why are you following me around, calling

Gregory Cruikshank about the Just Desserts pastry shop: "This was the kind of key place as this was the sort of thing that the Angels Of Light people would have gotten into if they couldn't be making money out of being "crazy." *Just Desserts* was kind of cool: they were making bakery products with pure ingredients and they had little salon things going. I remember talking to Blaine and Steven about this and they wanted to be aural wallpaper: while people were into their eating, it would just be part of the ambience. Steven and I had often talked about that idea of ambient music and about Brian Eno and I was constantly looking for new music. I talked to Steven about a group in England called This Heat and what they did was that they would have a picnic on stage and at the same time they would be making music while dining. I remember Steven being really fascinated by that and I think it might have been an influence." To be noted: in May 81, Tuxedomoon did a short British tour with This Heat.

me all the time?

- I just want to see if we can play music together, you know…

- Well let's play, let's do something!"

So we started, from that point on, we worked out and: "It's kind of good. Let's get together again." I told him about this performance and we started working towards that. And by that time I have this name, waiting in the background, Tuxedomoon, and I said: "Well let's call it this." The first choice was *Tuxedomoon New Music Ensemble at Just Desserts, June 14th, 1977*. And that was the first gig we did together…

At that time I was reading this local newspaper, about what's going on and I had seen things happening in San Francisco. People were having private parties in garages, at schools or other places. They were not quite performances, they were not quite dance, they were not quite theater, they were not quite music. They were a little bit of all of these things and I saw a few of those that impressed me. I saw one at the conservatory of music that included electronic music with some of the guys using projections and wearing costumes. I saw another guy doing a show, that was called something like *My Holiday In Alaska*. He was doing nothing but wearing an enormous bird head and there was a photo cell inside the bird's head. Every time he opened the bird's mouth, it played the synthesizer and it changed the slides, these slides of this large Winter empty wasteland. Very impressive. And I saw a performance just in a garage somewhere. I went there only because there was free wine. There was some woman dancing, using a laser. I had never seen such a thing. She would hold her hand up and you would see the laser as if it were in her hand. There was electronic music also. I was impressed and I wanted to do something similar to those performances.

So we did this show. Steven and I had met regularly for a few weeks before the first show and we had put together ten or eleven pieces. "Litebulb Overkill" was one of them, probably the first thing we ever did. Steven was working with this free theater company called The Angels Of Light, drag queen show. People from the more sophisticated theatrical background started to get involved (…) Steven was working both with them theatrically but mostly with the musical side of things because they had managed to put together a recording studio to go with their show, from gifts or grants from rich patrons and whatnot. So I sort of slid my way into this situation, to work within this larger context."

In August 1977, the then still infant Tuxedomoon participated in the Castro Street fair [*a famous gay parade taking place on Castro Street in San Francisco*], during which a memorable gay version of Marvin Gaye's "I Heard It Through

Steven Brown: "That's how Tuxedomoon eventually started but, again, it was Tommy Tadlock's genius and equipment that made it possible. He had all the gear: tape recorders, synthesizers, we didn't have anything, a violin and a saxophone… We started working at Tommy's house, in his studio, our two first studio records were done with him in the bedroom. Before that, it all started with The Angels Of Light, gay, underground scene. That's what Tuxedomoon comes from. Late seventies, mid seventies… Out of these Angels Of Light because eventually Blaine and I both did music for this group. For one of their shows at least, we played live, like in the orchestra pit, in front of the performers, we did original music. I guess it was probably the first time we played together. It was in the context of an Angels Of Light show. That's really how things got going. San Francisco was still… Some of the magic of the sixties was still there, was still very much alive with this magical energy. So it really gave us an alchemical oven in which to work. I don't know if it could have happened anywhere else except San Francisco at that time…"

Scrumbly Koldewyn (ex Cockettes & Angels Of Light) about The Angels Of Light's growing professionalism: "At first, their shows were not nearly as good as The Cockettes, but as Beaver [*Bauer*] and Rodney [*Price*]¹'s artwork and dance took focus, they became better and better. Since they lasted much longer as a group than The Cockettes, the shows evolved into something approaching professional theater."

Castro street fair, with Gregory Cruikshank (sunglasses) and (in the back holding a violin) Blaine Reininger.
Photo Lig

Steven Brown about Gregory Cruikshank: "He's from The Angels Of Light, a local wiz kid, a genius, renaissance man, actor, singer, dancer, painter (…)" (Steven Brown interviewed by James Nice, July 5th, 1987, unpublished)

The Grapevine" was recorded with Gregory Cruikshank on the vocal part. Cruikshank: "The Angels Of Light had a small studio on Valencia Street and every three or four months there would be a show grabbing from what anybody was doing (…) One of the shows that we did was Jimi Hendrix coming back from the dead. Blaine and Steven played on it and I believe that Walter Black [*i.e. a musician who was another close friend of Tadlock*] was also in the group back then. We did the Castro Street fair at one point. Tommy was very interested into that because he was tired of the uniformity of the gay community and he wanted to make fun of it. I wanted to do "I Heard It Through The Grapevine" and we got this idea to do it over the telephone and we worked on the arrangements. My friend Brian played the bass (…) It wasn't Tuxedomoon specifically then. It was the group playing for The Angels Of Light's shows and the Castro Street fair. I had no idea that it had been recorded. That was something that Peter [*Principle, who will become a member of Tuxedomoon in 1978*] found a long long time later. It's on Tuxedomoon's *Pinheads On The Move* compilation album" [*released in 1987 by Crammed discs*].

Two other people were involved in this early phase of Tuxedomoon: Victoria Lowe, from The Angels Of Light, who brought along theater performer Winston Tong, the latter

participating on an on-and-off basis that will never cease to be his *modus operandi* with Tuxedomoon.

Victoria Allen (*née* Lowe): "I will never forget meeting Winston. I went to a party in the Castro district and I was told that there was going to be a performance by someone. Votive candles were put in the corner of this bay window area and so began the first performance by Winston Tong that I ever saw. I was utterly spellbound. I felt like I was seeing my own soul played out before me.

I will never forget it. He was so brilliant and I was so deeply moved by his performance. He walked out in a tattered dress with a tattered suitcase in the circle of votive lights and he opened the suitcase at the sound of Chopin's *Nocturnes*. I was already spellbound. Out of the suitcase immerged the most beautiful, mysterious, enigmatic dolls, puppets that I had ever seen in my life. And this poetic little story unfolded: Patti Smith as a mermaid, leopard with a human face, a self-portrait of Winston in a tuxedo, bow tie, holding a little cigarette that he'd sit on his lap and communicate with, whispering to himself.

When the performance was over, I couldn't talk, I couldn't move. Everyone kind of got up and moved away and I sat, spellbound, watching Winston beginning to pack up his little performance gear. Eventually he noticed that there was this girl sitting there, un-moving in front of this tiny stage. So he and I talked for the first time and I just felt it was such an honor to talk to him because I had never seen an artist do such beautiful work. So we became friends and soon began to collaborate."

Regarding her collaboration with Tuxedomoon and the arrival of Winston Tong: "I was then in The Angels Of Light theater group. I heard that Steven Brown had started this band and my friend Adrian had heard them perform and that they were really good and that I should check them out. So (…) I talked to Steven before some Angels party and I told him that I would love to hear his band and would be interested in joining perhaps.

First I heard the music. It was just like Winston. It was so beautiful that I immediately wanted to be a part of it. So I said this to Steven and he invited me to an audition for the band. Having barely ever sung before, I went to the Mission and I probably sang the only song I knew. Steven was there, Blaine was there, I don't remember who else.

The next day Steven told me I could be in the band. I had already developed a relationship with Winston and I, in fact, introduced Winston to Tuxedomoon. When I discovered their music and started getting involved and knowing Winston and his art, I felt that they had to meet. So I got Winston to meet everyone and being willing to also join the band and

Victoria Allen (*née* Lowe) was born in New York City, Greenwich village. Her father, Jacques Lowe (http://www.jacqueslowe.com/) was a famous photographer who moved to Europe when she was ten. She stayed on in NYC with her mother who opened one of the first art galleries in Soho: "So it definitely influenced me. I always wanted to be an artist, mostly a visual artist, from a very young age. I grew up around artists. Everything changed when I was 16. My mother went to California for the summer and fell in love with someone in California. She returned to NYC with a pick-up truck and she and I crossed the country together on our new adventure when I went from the heart of Greenwich village, NYC, to Marin County, Inverness. Suddenly I was living in a very beautiful yet very small town, the heart of a small quiet area. After about a year living in this small town, I moved to San Francisco and met Winston Tong shortly after that.

So it wasn't really my idea to move to San Francisco. My mother was just burnt out on NYC when I was 16 and just wanted to be somewhere different. So I went along. I was starting my junior year in High School when I moved to California. I finished a year in Marin County but after that I went to San Francisco. I finished high school living with three gay men on Polk Street in San Francisco. I graduated from high school and then I was free.

I first joined the underground theater group The Angels Of Light and Steven Brown was a member of The Angels Of Light…"

Winston Tong was born in 1951 in a family of Chinese Americans, as the oldest of a family of four siblings (three sisters): "I was a little daddy at age 11. I went to school here and then I went to Cal' Arts where Pee-Wee Herman and a couple of other people have passed. I studied theater there and I started design. I started in 6^{th} grade to go to art classes at the museum of modern art where mostly I saw teachers smoking marijuana, hiding behind the screens smoking pot. That was interesting (…)

At Cal' Arts, I studied with Beatrice Manley and later with Eric Morris, who mainly trained people focused on cinema in a way that was quite close to Stanislavsky or Lee Strasberg. He wrote a book called *No Acting Please* and it's with him that I discovered these internal resources that enable you to really become another person rather than playing a role: *being* rather than thinking of. It's been brought to such a level that we [*Tong and Bruce Geduldig*] abstain from rehearsing: I want to believe in this method even though it can lead to disasters on *premieres* (…) We ended up into doing more like a performance art thing where we found empathy to work from anything: music, feelings… anything.

So that's where I started to develop as a performance artist, using any stimulus as the beginning for a work. That encouraged us to do our own writing, directing ourselves, to be able to do that. I stopped going to school at 22 I guess and I did my grand tour, went to Europe (…) Then I came back to San Francisco from Europe and I was living in a warehouse here [*Ronald Chase's commune*]. I did some work for opera companies, made some props for them, masks, hairdresses for New York City opera.

Then I started to go to these little events. I think that the first time I met Steven was at an Angels Of Light show that Victoria Lowe invited me to, my girlfriend at the time: "You've got to come at this thing, it's really amazing and there's somebody I want you to meet there." And it turned out to be Steven Brown and I remember trying to leave the show at the end and Steven calling my name out, plaintively: "Winston, Winston, stay: I want to talk to you…" So he

Page 39

invited me to come and meet and that's how it started. (…)" (Winston Tong interviewed by author; D. DE BRUYCKER, "Plan K : métamorphoses de Winston Tong", *Le Soir*, 11/82, translated from French).

"(…) *as a kid*, I grew up in North Beach, right around the corner from the Old Spaghetti Factory. So, every night I'd drift off to sleep to the sound of bongo drums & castanets, flamenco dancers and wild men screaming in the streets. I think it must be where it all began – and my mother, she's sort of a *sidewalk actress* – does this stuff in her life that's pretty dramatic. And when she was a little girl in China she used to go crazy when the acting troupes came to town – she'd dress up and put *rouge* on her cheeks and sit in the front row and dream away – she wanted to run away with all these troupes. She never did, but I think she sorta passed this on to me somehow. Out of all the kids in the family (…), I was involved in this most directly. So I was always in plays at school, I would spend a lot of my time making up puppet shows, amusing myself and my friends. Gradually that led to acting classes at school, staying after school to work on the set (…)
This came to a point - around the time I got out of high school I really hated everything, I hated myself, I hated what I was doing, I hated theater and I hated life! (…) those drugs I took made me hate everything! I was a manic depressive – no flowers for me (…) But drugs are essential to life itself" (KAMERA ZIE, Interview, *Search & Destroy*, # 7-11, 1978)

As to Tong's *use of puppets as a theater performer:* "It was after Gordon Craig's idea, human marionettes like super people. He said he'd rather deal with marionettes rather than people because people have too much ego. The puppets were people in my little world. And I'd be godlike and I directed them to do whatever I wanted and I made myself as well: there's a portrait of myself. There were fantastic things I could do like rescue Patti Smith or turning myself into a mermaid and so on. And after a while, I cut the strings of myself, you know. I didn't like the idea of manipulations so much. So I just made them into dolls and I called my technique "playing with dolls," my hands were on them and I played with them like a child would. Of course I rehearsed with mirrors and so on but it was really very simple, very direct transmission. The thing with playing with dolls fascinates people so much (…) It's almost like a psychotherapy. At one point I made some puppets for a therapist to use with children. And for adults, it's a way to get back to childhood" (Winston Tong in conversation with author).

About theater: "I think the roots of theater go back to shamanism in which some specially appointed person who was in touch with higher forces would try to act something out to try to improve the situation of his tribe. He would try to make magic – healing magic usually – and healing is an important idea in performance." (KAMERA ZIE, Interview Winston Tong, *Search & Destroy*, # 7-11, 1978)

About Tong's theater: 'It is difficult to describe adequately the different theatrical elements used by Winston Tong in *Solos* – lights, puppets, recorded tapes, words, himself, dolls, projections, props – because his work is extremely organic and equals more than the sum of its parts. There's poetry brought to life, and, like the best poems, it is short, distilled, light' (Press sheet BOA, the agency of Tong's agent in France, Maria Rankov, reproducing – in

the rest is history (…)"

Steven Brown: "I went to this private party – *salon* – on Castro Street. Winston was there performing. It was like a little low-key party, not so many people: drinks, real quiet, refined. Then Winston comes out with his tuxedo on and he's got these two dolls. I don't remember exactly what happened but I do remember he just captured everyone's attention immediately and it was just magic. He did this little ten-minute thing with his dolls and everybody was like: "WHAT IS THIS?" He had just such control of the public in this party…
Then, later, we started working with Victoria Lowe singing, and she said: "Oh, my friend Winston Tong, you have to meet him!" I had already seen him at the show so I said: "Ok, great!" He came in with his dolls, his puppets and started doing his act that I had seen at the party, here with me and Blaine at the back playing. That was how he entered the group at the beginning. He didn't sing. He just did his show and we kind of provided a soundtrack for it. Victoria was singing with us at the time. We were me and Blaine and Victoria and Winston with his dolls. So it was this whole *ensemble*, kind of *cabaret* post-modern theater musical thing that was happening, pretty interesting, with a friend of Blaine painting our sets, a real multimedia undertaking. Little by little, Winston got more involved. He started writing songs, eventually started singing, got rid of the dolls and just became more of a singer-actor on stage with Bruce [*Geduldig*]. The two of them would be in charge with the visual-theatrical aspect and me and Blaine would take care of the music and that's how we worked for a couple of years."

Blaine Reininger: "At one point we organized an event that was very much in the line of the kind of free things that I had been seeing. It was called *Chez Dada Salons*. The primary event was me and Steven playing and then we invited along other people we knew, friends who were visual artists like painters or photographers. We invited them to come, do installations, paint things on the walls. I also saw myself as some sort of catalyst for my friends, providing them with an opportunity to show their things, providing a central spine for people's activities to form around… For instance in one of these shows, *Chez Dada Salons*, Winston Tong was invited along. I suppose that Steven knew him. "Oh this guy is great, you know, maybe he wants to work with us!" And he came along one day while we were rehearsing. He started to sing some things with the music we were doing and he liked the music and before we knew it he was involved in the thing. He was well-known in theatrical circles and he introduced us to people and made our way into places that we probably wouldn't have been allowed in before. We ended up doing performances on the

Shezwae Powell
(Scorpio)

Joey Richards
(Taurus)

Merria A. Ross
(Scorpio)

Annie Sampson
(Taurus)

Eron Tabor
(Aquarius)

Philip M. Thomas
(Gemini)

Winston Tong
(Pisces)

Bill Windsor
(Aries)

HAiR confederacy

Silver Indian	MICHAEL BUTLER,
Artistic Director	TED RADO
Operations Director	MAURICE SCHADED
Sales	CARL KILLEBREW
Administrative Director	RONNIE TONGG
Public Relations	GIFFORD/WALLACE
Group Sales Co-ordinator	MARGARET OPSATA
Production Managers	WILLIAM ORTON, ROBERT CURRIE
Foreign Operations	KEN MYERS
Theatrical Counsel	MORT LEAVY
Communications Co-ordinator	CAREY KING
Hospitality	JUDY BINNEY
Tribal Communications	SHIRLEY KENNEDY
Corporation Counsel	HOWARD PRATT
Doctor	JOHN M. BISHOP, M.D.
Astrologer	MARIA CRUMMERE
Merchandising	PAMELA HUBERMAN
Decor	THE FOOL
Security	TERU KAWAOKA
Tarot Reader	EARL SCOTT

staff for BAY HAiR

*Tribal Chief, Ohlone Tribe	CARL SAWYER
Secretary to Mr. Sawyer	NANCY CURREY
Tribal Bookkeeper	NEDRA CARTER
Group Sales Director	JOAN FEENEY
Press Representative	CLAIRE HARRISON ASSOCIATES/ CLAIRE HARRISON REED/ NAN HOHENSTEIN
Special Assistant to Tom O'Horgan	GALEN McKINLEY
Production Stage Manager	NEIL PHILLIPS
Assistant to the Production Stage Manager	FRED KOPP
Assistant Stage Manager	LARRY SPIEGEL
Casting	RANDY HOEY
Dance Captain	GAYLE HAYDEN
Musical Contractor	GERRY COURNOYER
Box Office Treasurer	WALTER MURPHY
1st Assistant	PHYLLIS GORMAN
Production Technicians	MIKE MONTELL, LOWELL SHERMAN
Property Coordinator	JOE FALCETTI
Production Coordinator	GLEN CHADWICK
Master Carpenter	STEVE TOBIN
Master Electrician	CHARLES GILMORE
Properties Master	RUSSEL ANNECSTON
Sound	DOUGLAS FINN
Production Wardrobe Supervisor	WARREN MORRILL
Wardrobe Mistress	MILDRED McNICHOLS
Tribal Hairstylist	SUSANNE GILLEN
Front of the House Supervisor/ Copyist	JAMES WELCH IRVING RAYMOND
Souvenir Book	GIFFORD/WALLACE
Tribal Photographers	HANK KRANZLER, WILLIAM GANSLEN
Advertising	CLAIRE HARRISON ASSOCIATES

Furs by Jay Furs, New York City
Lobby Display—K. Lee Manuel

An excerpt of the leaflet for the Bay Area *Hair* Musical, San Francisco, Orpheum Theatre, 1970, featuring Winston Tong as "Pisces" (right row, third from top)

strength of his reputation for more arty circles of people."

From hippies to punks – second take. Reininger believes that he was never really accepted by The Angels Of Light. "A lot of the people in the theater company kind of resented me because I was coming in there as an outsider. Also I represented some kind of bizarre culture and I had no problem whatsoever with working for money (…) [Also] they were not sure, nor was I actually, of what my sexuality was. At the outset I was bisexual anyway but primarily heterosexual. So that scared some of these people: "Who is this guy, hanging around with Steven? Because he's heterosexual, he's meat, he's interested in money, he smokes cigarettes, he drinks, he's evil!" This guy Tadlock, he thought I was Satan, evil influence coming into Steven. I was going to steal his boy away from him… (Tadlock was very gay). (…)

French – an excerpt from an article published in *The San Francisco Bay Guardian*, 08/31/78. 'Tong's pieces are reveries, and sometimes nightmares, about his life and about fragments of the lives of others who have become part of him (…) A contemporary marauder, Tong pillages all arts, all cultures and all times to create his polymorphous works (…) They are flowers with their roots.' (R. McDonald, "Winston Tong's cultural synthesis", *artweek*, 09/23/78) '(…) the final production craft and reference merge into a form that is more structurally varied than conventional theater and more illusionistic (and deliberately entertaining) than the usual performance art offerings. Ultimately Tong's attraction rests with the eccentric scenarios that place personal ritual on view. While his work cannot really be termed mystical, it reaches in that direction, and in its diverse reference points it gives a ritualizing significance to both past and present cultural forms (…) His impact suggests a yearning for a magical art – art in which factual information is transposed into the sensual and experiential. Art that in fact offers its viewers a brilliant mode of escape.' (H. Fischer, "Winston Tong", *Artforum*, 12/78)

Winston Tong – Some random facts.

1949 Tong's parents flee Canton. They settle in San Francisco

03/12/51 Tong was born in San Francisco. Later studies at Cal' Arts

1969 Tong lives at Ronald Chase's commune at 136, Embarcadero (see below)

1970 Designed the illustrations for a children's book named *The Dinosaur Coloring Book* (Troubador Press, re-published in 1998 as *Dinosaurs*)

1970 Plays in the San Francisco cast for the musical *Hair*

1971 Tong allegedly was part of a production of *Jesus Christ Superstar* (source: V. SABA, "Winston Tong: "multimedia" a comporre poesia", *Lei*, 12/81)

1972 Designed props for a Washington Opera production of *A Village Romeo and Juliet*

1973 Graduated in *design and theater* from California Institute;

Between 1975 and 1977 Recording – by Steven Brown in San Francisco – of the music for *The Wild Boys* that will later appear on Tuxedomoon's LP *Joeboy in Rotterdam* (1981)

1975 Tong plays in *Upon a Dying Lady* (with the *Certain Artists'* group) and then in a local production of Sam Shepard's *The Tooth of Crime*

1976 Tong creates his *A. Rimbaud* performance piece

1976-77 Tong creates *Bound feet*, which will win him an Obie award in New York City (1977-78 season)

08/77 Tong starts collaborating with Tuxedomoon.

'*A. Rimbaud* (…) is about a romantic passion. Dressed in loose black pajamas, with a make-up that highlights an unexpected sensuality on his face, Tong manipulates his dolls in gestures with a baroque feeling to them, that remind of Jean-Louis Barrault in *Les Enfants Du Paradis*. In the middle of a bare stage, within a circle of light formed by a spotlight and little lights (candles on shells), Tong lays a battered suitcase on the ground, and pulls out the complicated skeleton of a doll. The skeleton is covered with a scarf that reproduces a Cézanne landscape, on which a woman-doll lays down. A man-doll comes about with an air of passionate assiduity and finally lies down over her. Suddenly, a fabulous animal, sort of a leopard, leaps up from the dark, devours the man and attacks the woman in at once violent and erotic gestures. The wildcat disappears and Tong gently picks up the woman, caresses her with desire and grief, looks at her, then, after a glance to the back, leaves the circle of lights, blows off the candles and lies down in front of them.

Bound Feet tells a (…) short story, about suffering and beauty, in a few images, using several theatrical elements (voice, body, music, color, light, dissimulation) with the unrestrained efficiency of poetry. First Tong, dressed as a woman in the Chinese tradition, binds his feet whilst we hear a conversation recorded in Chinese between a mother and her daughter. Then, he makes his dolls play a love scene during which the man erotically removes the little red silk slippers, to kiss the woman's feet. In the end, Tong himself puts on the same kind of grotesquely small red slippers and walks out limping' (Press sheet BOA, reproducing – in French – an excerpt from an article published in *The Villager*, 05/11/78)

They were gay but also extremely self-righteous vegetarian male hippies, post hippies. They represented some kind of mutated form of hippy thinking and I was a sort of pre-punk. I had been there before. I had been a kind of hippy fascist. There is a tendency for vegetarian people like them to be very self-righteous and to condemn anyone else: "You eat meat, you're bad. Meat is murder. Animals are our friends! We are holier because we don't eat meat!" And I rejected that, this kind of self-righteous fascism. I hated that in myself and I wanted to change it. It didn't make me popular.

The same people that had kind of rejected me for what I stood for ended up wearing safety pins in their ears and embraced the whole punk rock kind of thing. But it was not until later. That was something I didn't like about what me and Steven were doing and we sort of gradually gravitated towards these punk people because they seemed to be more interesting and there was a new way of thinking.

I don't know if Steven and I ever were such good friends. Our relationship has always been like it is now but we had similar ideas and also we were moving in similar ways. Steven was probably not so ready to move away from this kind of vegetarian hippy gay people but he was ready enough to try something new. And also these punk rock things started to happen in San Francisco not long after that. That scene was so full of energy that it seemed like a logical place to go. I remember that one night Steven went out to this punk night at some bar. It was still a really new thing to all of us. He said: "Hey it's GREAT! It was so great! We spent all night just bumping against each other, destroying the place and getting drunk and it was chaos. It was wonderful! I loved this!" And I thought that was the night of Steven's conversion. After that he wanted this energy because it was anarchic and it was fresh.

San Francisco had already been into the hippy way of thinking for some years. The intelligentsia were basically hippies and they were quite authoritarian. Especially in Berkeley, this political correctness, this kind of puritan fascism from the left was born in Berkeley. These ideas that are now spread all over the world were born in Berkeley, like no smoking in restaurants, this forced purity. And so as a reaction against this very self-righteous lifestyle, people just wanted to: "Well fuck-out! I want to do drugs and I will cut all my hair off! I will outrage you, dying my hair green and pierce my nose and wear dirty torn clothes and LOVE PLASTIC because you hate it!" Also the hippies were much older than we were. We were somewhere in between but not old enough to be them. We were not quite young enough, we were some middle generation. I wanted to outrage these kind of people.

Still the kind of stuff that we were doing was not in keeping with the punk ideology. It was still kind of psychedelic. It still

partook of the hippy ethos. We had some kind of "niche"… There were people who were attracted by the newness and the vitality of the raw energy that was the punk ideal. They were people in the art institutes for instance. They generally tended to be artists, not so much musicians. They were people who were accustomed to think conceptually of some sort of all embracing conceptual architecture, conceptual hierarchy in their mind and in their action. That included how they dressed, how they thought, what they ate, what they did. They adopted a pose but at least this thing was a bit closer to this kind of ideal, state of weirdness that we were seeking. It was a bit closer than what these kind of guitar player hippies were doing. It was just too pure to live.

It was also something that bothered me about the Sufis. People from the Sufis tended generally to be hippies and "good." I told my teacher: "It seems to me that the truth has to partake of the dark energy as well because black has to be there for white to be visible and vice versa." Not that we should embrace demonism but it seemed that art had nothing to do with this kind of washed-out celestial landscape, so celestial that it was just limp. Some power had to partake of darkness as well.

It became evident that there were other people of like mind, who adopted maybe the outer stands of punk rock but who aren't real punks. We were not as anti-intellectual or nihilist. Well in San Francisco it was still an intellectual movement. It was *poseurs*, dandyism was also part of it. It was just fashion really, also in England… The initial fuel came from New York City and Malcolm McLaren was very shrewd and transformed it into some kind of political movement in order to sell clothes.

In America, it was more or less the same thing as surfing or skate-boarding. It's an entertaining activity that requires some kind of clothing and a certain language and a certain way of behavior. It was just an imitation culture, an ersatz. It's like a culture without the content, a culture "light." As far as our look went, we just looked bizarre. We didn't fit from a fashion standpoint. We didn't fit…"

3645 Market Street. In September 1977, Blaine Reininger moved into Tadlock's commune on 3645 Market Street. Patrick Roques moved there early in 1978 and Paul Zahl, who became Tuxedomoon's on-and-off drummer, moved in some time during the Spring or Summer of the same year. Both retain larger-than-life memories of living in THE HOUSE, witnessing Tuxedomoon's progression towards the "dark side." These memories extend over a period when Tuxedomoon was evolving, busy doing gigs, recording songs and recruiting new members like Michael Belfer and Peter Principle. All these events took place while many of

San Francisco visual artist Ronald Chase on Winston Tong: "Winston Tong came to my studio with an apprentice of mine Donald Eastman (who was sent by the National Opera Institute). Both were graduates of Cal' Arts. They lived at the warehouse at 136 [*Embarcadero: see http://www.ronaldchaseart. com/lifestyle/136/136.html, with a photo of Tong performing in 1969*] for at least two years, and Winston moved with us to the new location at 1477 before he broke away on his own. His first occupation was with puppets, haunting and human. He began working with Donald on conceptual theater pieces at the warehouse, and they would also give performances at some of our elaborate dinners.

This is during the period of the filming of *Lulu*, a feature I made simultaneously with the production at the Houston opera of Berg's opera. Winston appears with his symbolic puppets in the film. Winston also designed props for a Washington Opera production of *A Village Romeo and Juliet* in 1972. This is all pre Tuxedo Moon. Winston began performing his midnight theater pieces, went on to win a Obie for *Bound Feet* in New York, and worked a bit with me on a production of Dr. Faustus at Wolftrap in Washington, D.C.

I'm mentioning all this, because Winston did not come from a totally "hippie" atmosphere, but from a punitive, ambition-mad Chinese mother, and a family he tried to avoid as much as possible. His suppressed anger took on a sweetness flavored by tough defiance. The warehouse in its early days was certainly "hippie" inspired, much for its freedom and inclusive attitudes but since we were all working with film and opera, it was far more ambitious than most. Winston around 1976 became enamored of Bessie Smith, and some of the more self-destructive blues singers. He basically became obsessed of the "tragic" as a mode of behavior. He longed to be a star, and saw his quickest route as music. I never found him very talented in this vein (certainly not equal to his genius in theater) but his great helpings of attitude

Page 43

generally helped him along. It is ironic, that in 1978 I spent the year in Paris trying to raise money for a film entitled *Tuxedo Moon* (I had asked them permission). It used the band as a basis for a film about a German journalist who comes to write about the San Francisco scene, but the film (somewhat on the lines of *La Boheme*) was about the collapse of the ideals of the sixties into the more nihilistic attitudes which became punkdom. Tuxedo Moon seem to be the perfect metaphor for that change!"

them were living in the house. Tuxedomoon's chronology will return in the next Chapter. For the moment, let us focus on the atmosphere reigning in that house on 3645 Market Street.

Patrick Roques met Steven Brown in San Francisco at a bar called Tattoo Lagoon (on 9th and Howard). He recalls: ""God Save The Queen" was playing on the juke box, it had just come out. Steven came up to me, he was very mod looking, very British, like a Clem Burke look-a-like from Blondie. He just started to talk to me about music and I was: "This is cool." We exchanged numbers."

Roques had been impressed to learn that the house where Brown lived had its own recording studio – which was very unusual at the time – and that his band was very much into experimenting with tapes. Hence, Roques, who had lured Brown into believing that he was a drummer, went up to the house on 3645, Market Street. 'Brown gave me some drinks and tried to get me into some kind of orgy with Victoria Lowe. That was cool. I wasn't wet behind the ears, but that wasn't going to be my scene. So I told him: "Well, this is a waste of time when we should be trying to make some art, because we're going to change the world, you know. We can either be friends and do that (make art), attempt that in that idealistic way, or not." So we decided we would be friends. Then I tried to play the drums and Blaine came out and told me to shut up, that I would never be a drummer. We drank some beer. Blaine had a few beers and then went back to his room. You could always hear the typewriter in Blaine's room, sort of going like on that Brian Eno record ("Blank Frank")… Now typing on a laptop is not the same, you don't get that great sound… (…) I was looking for some kind of art community with a distinctive edge to it, some kind of empowerment within the larger Punk movement. I saw a connection to the Dada-ists, William Burroughs. We all identified with those artists. We felt that we were also subversive… So I ended up moving to Market Street with my stuff while Tuxedomoon and Tommy Tadlock were away, most probably for their week of

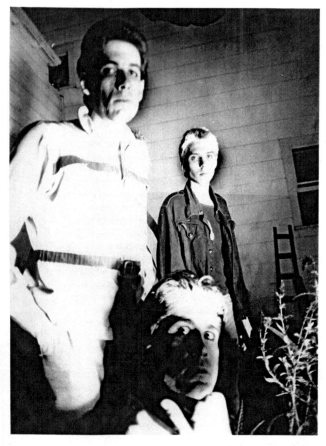

Blaine Reininger, Steven Brown and Michael Belfer at 3645 Market Street - R. R.

Peter Principle in the House at 1344 McAllister Street. Photo Annie Coulter

residence in Colorado Springs. When I got in there I changed the whole dynamic of the House, physically, aesthetically. That change caused a lot of problems between me and Tommy [*Tadlock*].

When I moved in, I just had tons of raw energy to burn. I was kind of an insane, frustrated interior decorator. I discovered all of Tadlock's hippie stuff which was filthy, falling apart and faded by the sun. These big upstairs rooms had large bay windows with no curtains... So I cleaned out the garage and I moved all of Tommy's stuff into the garage. Then I painted the kitchen glossy pink and moved in things I had been collecting over the years from Thrift Stores. So that was it, we had a completely different house, an austere minimal kind of aesthetic. Before it was a kind of a jumbled relic of Tommy's past. That was the energy of the Punk movement, time to accelerate things. But that change was a psychic rape for Tommy. Steven on the other hand loved it but for Tommy, who had erected this world, it was very traumatic... It was a battle of wills. It was the ship of fools and J.G. Ballard's *High-Rise* rolled into one.'

Paul Zahl: "Entrance room, to the right there's a garage and a kitchen, two big bedrooms [*Tadlock's room and the recording studio*] to the left. You go through, dining room and then on into the big living room with a large panoramic window with a view on a very steep hill where other houses were

From Balboa Park to 1344 McAllister Street. Peter Principle lived in two communal houses in San Francisco, one at Balboa park and the house located on McAllister Street. Principle: "After having hitchhiked to San Francisco [*in 1975*], I fell in with a group of people, called the *Agape lodge*.[2] They were a kind of commune post digger [3] hippie. This commune at Balboa Park was more or less founded by Peter Alcantara, was very idealistic and did many anonymous acts including helping support things like the Haight-Ashbury free clinic and switchboard (networking resource).

The building passed for a hostel of sorts and was listed in many international underground tour guides, and people (mostly hippies) from all over the world came to stay there on their treks to and from wherever. People like myself who were working in the support capacity – I often painted houses or did carpentry – were housed in what was affectionately called the hobbit hole, a complex of rooms under the first floor excavated out of the side of a hill (the building

itself had the back on stilts of sorts, this being San Francisco, everything is on a sharp incline...). We had built rooms in the area beneath and behind the retaining wall and went through a trap door to get there.

As the building was well-known to city services for exceeding occupancy capacity, inspectors who had heard rumors of these extra rooms came often and searched in vain as we had done this well. Peter Alcantara eventually faked his suicide from the Golden Gate bridge as the feds had finally staked out the house (there were stories involving a forged state seal used to print welfare checks, and a real connection to ex-members of The Weather Underground). Peter Alcantara turned out to have fled to Canada and did indeed visit us at McAllister Street a few years after this. The aftermath of how everyone left after he split (stabbed each other in the back and ran off with all the agape assets) is directly involved in how I came to McAllister Street in the first place. Even though idealistic gestures were the motive, the methods of this group were much more mundane, as we had a construction company, bred afghan hounds, printed t-shirts for tourists (not at all political but the opposite, unabashedly commercial), and stole and fenced etc. The money was then fed back into the underground in support, free food and housing for indigents. Anyone could stay for three days for free but only return if you were invited.

There was a big common room where they slept and a giant kitchen where everyone was fed, very hippie. I believe that Peter and a few others who started the Agape lodge were connected to the diggers. This was an interesting group who were very involved with the social (and political) implications of the events San Francisco is most famous for and they were very prescient in their dire predictions for the eventual results of the social experiment once less dedicated people got involved. They knew life was work and that massive efforts

built [*Tuxedomoon would frequently perform in this room at the many parties held there*]. Very impressive. You go downstairs and the first floor downstairs was like a vast open space that people had been subdividing. Like you could move in, find a corner, get some two by four and some cheap rag, nail it up, hang a curtain where the door was and that's your room (...). When I first got there, there were five or six rooms down there, plus the two rooms upstairs that makes eight... plus Patrick Roques's art studio at the front downstairs, so he also had the panoramic view of the city and his bedroom was right next to that [*Blaine's room was next to Roques' and Brown had his own on the other side of the same floor*].

Now there was another level below, kind of basementy, and like the real mole people lived down there [Roques: "Ralph — who had been in The Cockettes and Angels Of Light — lived somewhere down in the basement, hiding from the crazies. Like a silent Gnostic he just appeared one day. I never even knew he was down there and I'd been living there for a few weeks by that point! He instructed us in the making of gluten and vanished. We rattled the floorboards and people appeared to disappear"]. I think some of the rooms had dirt floors. So if you figure there were eight bedrooms and lots of the people who lived there were couples, that made a potential for 16-18 people plus the sleepovers because there was sort of a big family room in the middle of the first floor downstairs. There was a mix of couples: gay and straight. It was pre-AIDS, and right above the Castro district that was the hottest district in San Francisco and thus it was very much "anything goes."

No kids (everybody was very young). I was 24. It was very much like everybody was on welfare. Nobody had any money. Everyone was expected to pay a rent to Tommy but Tommy was renting the whole house, I believe, for 200 or 300 dollars a month. So the rent was divided among the people who were there. Tadlock would be in the kitchen, making huge pots of beans in a pressure cooker. Everybody would go and buy tortillas and you'd put beans and he'd grow bean sprouts and that was it.

It was full of artists, actors, actresses. They were all there and that was how the theatrical part of the group started to evolve. It was just because we'd be playing music and some performance artists would come in and say: "I've been listening to you guys rehearse this damned song for three hours now and I've got a great idea of what to do with it." And they'd go upstairs and they'd put a bunch of junk around in the garage and say: "Ok, we do this and we do that..." and we go: "Yeah, great, perfect..." It wasn't like a grand scheme or a plot. It wasn't like everybody was going: "Oh, you know, let's do theater and music." It was like there were people around with ideas. That's how it started to grow. There were so many

people in the house, that tons of ideas started to flow. Some were brilliant and some were less brilliant but still they became a wealth of sort of information burbling around.

In the house there also were like just weirdos that Tommy liked. At this time there were lots of people who were getting GA [*i.e. General Assistance*], which is like total bottom of the food chain (…) There's a track called "I Left My Heart In San Francisco" with Blaine calling, begging for GA. They'd give you like forty bucks a month and a block of cheese and a can of horsemeat or something (…) Blaine worked at a switchboard, an answering service, like from midnight until eight o'clock in the morning, sitting there. He was getting all messages for Tuxedomoon there, so got kicked off…

THE HOUSE was just a crazy place. I found something compelling about it. I loved it. I loved the vibe there, creative… So I wanted to move in. I was like: "Can I come to live here and play all the time?" They also had a studio over there, a small four-track studio. Tadlock was like a genius. He invented a thing called the color organ, which is a box of lights, very popular in discotheques. You hook it up to your amplifier and then different colored lights flash in time with the music, so like bass red light flash, vocals green light flash, treble blue light flash. He invented it and he sold the rights for a huge amount of money. So that's why he had a recording studio. You know, in 1975 nobody had a recording studio in their house. He had all the latest synthesizers, he had multi-track tape recorders, just tons of stuff. I was also very attracted to that because I felt that I could be very creative in and outside of the normal musical approach sort of way. I thought that I had ideas that I could contribute to avant-garde music that nobody ever thought of before, at least that's what I thought as a 23-24 year old. So this atmosphere of creativity – you know you just go upstairs to the studio when you have a good idea and blah blah blah – was very appealing to me… And they said: "Ok, you can move in!" So I did...

That's when I started learning about how the politics of that place really were evolving and what was the hierarchy, who were the bottom feeders and what was going on. Initially I fit right in. It was great. I enjoyed the communal living, that was really fun, like helping Tommy cook, doing the dishes… But then, again I don't remember how long I lived there… After a reasonable period of time, six months or eight months, cracks started to appear. People weren't coming up with their rent money and Tommy was like this… crazy guy. Tommy was the kind of guy: if you had to go from A to B, he would devise a way to do it by going to C D E F G H I J K L M N O P Q R S T U V W X Y and Z AND taking a side trip to Mars in order to get from here to there.

He would overcomplicate things to an unimaginable level.

were necessary. They did not live by words, but deeds, and this has always been an inspiration to me... So I was living with this Agape Lodge people for two years and they changed my life completely. In the meantime, I was not doing any music.

Then due to the already mentioned problems with Alcantara, the commune had to break up and I went with some friends, we moved into the house on McAllister and renovated it. One of the methods/ fronts for sustainance throughout these times was that we ran an independent painting and renovation contracting company (myself, Roland and a partner named Rick inherited this from the Agape where they/we had also done the same) and this was how we met the owner of the building in the first place... Many people came to the house as we were actually directly descended from the last of the Agape Lodge. I and some others found the McAllister house and sort of moved the remaining people and things there *en masse* although we had very different ideas about where we were going... It turned into a more anarchic collective which had really no political agenda at all, but was really about hedonism and some philosophy... This house at 1344 McAllister Street was the top two floors of a large late Victorian building. There was a sun roof of sorts where we had planted many bushes in garbage cans along the perimeter, some stolen from the park up the block including a Japanese flowering maple. We also grew some pot there. There were 14 rooms. Originally the second floor of our part of this four story building had been some sort of ballroom with two tortuga window seat vestibules which we used as a sort of public area but one night I got it in my head that that should be my bedroom. Prior to that I already had a nice room in the front on the first (third actual) floor with a bay window and two pillars and birdseye maple fireplace with a heater which I sacrificed for the much larger space upstairs. Also I moved upstairs for privacy as I was starting to shift my focus from the life inside the house to one

Page 47

outside. By this time I had been in Tuxedomoon for about a half year [*Peter Principle joined Tuxedomoon in September/October 1978*]. Prior to this The Doctors [*a band in which Principle played before joining Tuxedomoon*] had rehearsed in the big room upstairs and also another group which I was in that never had a name but was a power trio with a guy named Ernie (I think) on keyboards. A funny thing was that Ernie wrote and performed the music for a Roger Zelazny sci-fi play that evidently Tommy Tadlock and Blaine had turned down the gig to do although of course I didn't know them at the time. Anyway there was also Dave the drummer, who kind of lost it eventually and we had to pawn his drums and use the money to send him home to his parents in Connecticut with the pawn ticket as we were afraid he wouldn't make it. Suffice it to say that we all took lots of drugs, mostly acid. Poor Dave was not ready...

The house itself had very few rituals. We celebrated Thanksgiving by randomly inviting people through the radio. Mostly we celebrated randomly with random acts of celebration. In other words whatever we had in abundance we shared.

There were often *impromptu* adventures. It was noisy (kind of like bohemia groove all year long...) and having a normal job was very hard because the activities never stopped. Mostly that perpetual adolescent exploration of personal ideas about everything under the sun...

The other thing we did was actively decorating any of the 14 rooms. Most of us were involved in collage/painting/sculpture, and there were a bunch of talented artists that lived there on and off over the years. Even I did a lot of oil paintings and collages and constructions (all lost when I left my things in storage too long...). It was nice to have all that space. Blaine always remembers the fact that the hallway leading upstairs to the ballroom (eventually my room) was papered with punk rock flyers in a massive collage and that Roland had made a chain of camels

Because he didn't want to be the one always going after people for the rent money, he came up with a rotating system so that every month somebody else would be the one to collect the rent money. That introduced a whole bunch of weirdness because there would always be someone who didn't want to get it, there would always be someone who did not want to give it. Because there never was any one person who was the central authority figure, the collecting of the rent just went into complete shambles. So all of a sudden, the rent wasn't being paid and everybody was going: "That's your fault! That's your fault! That's your fault! I paid you for the food last month! You owe me for my food for the last month!" and it just got into this huge... squabbling thing. But I sort of think that that's what happens in communes. If nobody wants to become the boss, just sort of an anchor, you need somebody in the center to keep everything from flying apart (...)

Anyway, so Tadlock complicated it like that and there were starting to be also fractures among the population of this commune because different camps, so to say, were starting to form. There was like the Blaine and Patrick [*Roques*] camp who were like the benign artists, smoked cigarettes, took valium and had artistic visions. Patrick would be painting and Blaine would be typing lyrics... Then there started to be the speed part of the house (...) Things started to get really weird and fragmented between Tommy and Blaine and Steven when Steven brought along a guitar player, a young blond blue-eyed guitar player named Michael Belfer. Steven wanted Michael Belfer to be in the band. Blaine not so much. Tommy was dead against it and I was the new guy so nobody asked me, really.

I didn't really understand why Steven was so adamant that he had to play in the band, partly because of my naivety and partly because, even if I considered Belfer to be a brilliant guitar player, I thought he didn't fit in Tuxedomoon's sound. At that time Tuxedomoon's sound was sort of streamlined and linear and I found Michael Belfer's guitar playing to be jaggedy and noisy and it fucked up the continuity for me. We made these nice rhythms that sort of moved along like waves on the ocean and Michael Belfer put in these sort of I found aggravating noise things. But Steven was adamant: Michael had to be in the band. When I was there, I had the impression that Steven set himself up with things. He set himself up in such a way that something was unattainable to him. He had to suffer and I think that Steven was in love with Michael and Michael was hopelessly heterosexual and I believe that's the problem that Michael has with Steven to this date.

Steven took to brooding about it, torturing himself, suffering, all that dark stuff that he tended to indulge himself in. It also created a huge amount of friction between Tommy and

Steven and Blaine because they already had their little dynamic going and Steven was trying to bring an outsider into that sort of love triangle that they had going (...) Adding Michael into this kind of weird equation, you could feel a tension going on (...) As it started to fragment and turn into different camps, there started to be the speed camp. There were rumors like people would disappear into one of the rooms for like three days of time, not come out to eat and that these people were shooting speed. Then later on, this was when the music started to get really dark, it started to get really fragmented with Tadlock, around the time when we were recording "No Tears."

Something major went down between Steven and Tadlock and Tadlock said: "Fuck you guys, I don't want to work with you anymore." Tadlock had produced their first single and suddenly Tadlock was refusing to be in the same room with Steven for some reason that I didn't know. It was between them but it was after Belfer was on the scene. That was when we were working on recording "New Machine," "Litebulb Overkill," "No Tears" and "Nite & Day" [*during the summer of 1978*]. Tadlock wouldn't do it, so I started doing it, sort of operating all the recording stuff, just basically making the record with those guys. And Tadlock started getting really out there, like he'd come into the house and raging on PCP [*Phencyclidine (acid, Angel Dust, Crystal, Supergrass), a powerful hallucinogen known for inducing violent behavior*], running around naked, screaming about how Steven had put a curse on him and there were evil spirits coming into the house. One day, the day that Blaine and Steven went to Oakland to buy some equipment – a drum synthesizer that was some kind of milestone in Tuxedomoon's sound – while they were gone, Tadlock was running around raging, that Steven was sending demons to kill him. He was in his underpants, he was painting himself red to keep the demons out of him. He went to paint the door frame around the front door red to keep the evil spirits away from him that Steven was sending out. I was in the studio working and I was like this guy is really trying to get out there and the atmosphere in the house had changed. It had become loaded with this tension. It was like just right before a big thunderstorm, you get that smell of ozone in the air and then there's going to be a big discharge of electricity. Blaine and Steven came back and Tommy was like: "Wow!!! Get away from me! You're sending demons on me!" And Steven was: "We get out of here, Tommy, I don't

A view on the inside of Peter Principle's house on McAllister Street. Photo Annie Coulter

cut from cigarette packs that ran tail to mouth all the way around the room at the wainscotting. Probably 700 or so camels long... We had a 118 foot hallway that lead from the two room parlor at the top of the stairs to the back kitchen area with 11 doors leading off of it and we determined to paint the entire thing in various hues of the rainbow. Many people did murals (some were nice and abstract and some were quite hippie as one of the artists was a commercial book cover designer who painted very fast: unicorns and castles and the like but we lived with freedom...) and when we were bored or disgusted we painted over it all and started again...

Anyway we had a great house. Many interesting people slept there and I even slept with some of them. At one point Robert Altman looked the place over when he was trying to make a film similar to *Performance/Stardust* about a recluse rock star from the sixties. They were amazed at the decorations but actually thought the environment wasn't organic enough. Too acid. Also we refused

to give permission to cut down the tree that blocked they said the view of the pyramid building. On a number of occasions I can remember standing on the roof watching the surrounding buildings swaying in a minor earthquake. We always joked that we had a great view of the destruction if it happened as one could even see part of the Bay Bridge in those days from there... Of course now, since they repealed the height limitations for skyscrapers around 1980, you will not notice, but San Francisco was a city where every window had a view of something interesting as it was all so low.

More thoughts about the house... There were a number of children that lived there over times, mostly with single mothers. Once we had a whole family in the back: he was a jeweller. Eventually they had to move as it was not really practical for them but he really liked to live there. We had a painter named Philip who lived in the front room. I used to shave his head. He did endless self-portraits of his bald head and when he ran out of canvas, he painted over them and started again. He made incredible bread (the edible kind) and it was always a party in the kitchen when he was baking. He had such a green thumb that the pot plants in his window were so obvious that school kids used to yell up to him for joints in the morning on their way to the bus...

We had a large kitchen which came with the house which originally was built for two servants quarters and so the kitchen had swinging doors which opened on the paneled dinning room and there was an insanely large stove and oven with a chrome griddle 12 burners and a mirror system for looking in on the progress of things in the back of the oven.

These kinds of spaces were only available to people who were willing to share with roommates. Otherwise the landlords cut them up into smaller units. The way we lived was not as unusual at the time as it might sound. Also we did a lot of restoration and renovation on both the other floors and our

know what you're talking about…"

I continued making the "No Tears" record and we went to a little studio because the track on "No Tears" had real drums on it and we didn't have facilities to record real drums at the Market Street house. So we went to Peter Miller's studio and Belfer was there. He had his guitar parts and we recorded two versions of it, two takes and we took the second take and went back to the Market Street house where I brought the tapes together and set up the record to be pressed. I was really excited because I thought that it really was a ground-breaking record. I really thought that it was something that nobody had done before.

But at that time, the communal atmosphere in the house was starting to unravel and around the time of "No Tears" or shortly thereafter there started to be rumors that like in one corner of the downstairs house everybody had hepatitis (…) In that corner, they were getting more and more withdrawn, paranoid and the other parts of the house were sort of continuing. Blaine was starting taking lots of valium hiding in his room and Tadlock was just getting crazier and crazier and crazier and the rent wasn't getting paid anymore. So the landlord who lived next door was starting to make threatening noises about throwing everybody out. Steven kept on getting more and more depressed and withdrawn. I vaguely remember him starting to have shrieking battles with Michael Belfer, like real psychodrama, theatrical, breaking furniture and stuff, which just made Tommy crazier and made Blaine stay in his room even more.

Then the record came out and things got sort of stabilized. I'm not really sure whatever became of the hepatitis scare but in the house it got to where some people always stayed upstairs and some people who always stayed downstairs. Before it was like we'd make huge quantities of pop corn and all sit around passing around a huge paper bag full of pop corn. That kind of communal activity stopped happening around this time and it started becoming like little groups of people anchored down in their corner talking about what the other groups of people were in their own corner saying about "us." And it started to be becoming very "us and them" and the level of paranoia started going up and up and up.

We did a few more gigs around that time and the record came out to much acclaim in the underground press. Everybody was like: "Oh Tuxedomoon is really pushing back the boundaries now, doing amazing stuff." We started working on new material after that and there was stuff that would eventually come out later on *Scream With A View*.

It was right around that time that I got into another band. For me Tuxedomoon was always so scattered and fragmented that we would sort of work for a while and then stop. We'd have a

Page 50

fight and then for two, three, four weeks, nothing happened. I was full of energy and I wanted to progress and I was seeing other people playing still. I figured that Tuxedomoon was like whether we would work or not for a month would depend on Blaine and Steven speaking to each other. Then I felt that I had to do something to keep myself busy. So I started playing with another band and this other band started to get more and more popular and then I had the occurrence that I was thrown out of Tuxedomoon…

Steven had booked a gig after two or three months of doing nothing and it was on the same day as the other band I was in (SVT) was going to play at the Geary Street theater. It was a good place to play – it was a sold-out concert co-headlining SVT and The Jim Carroll Band – while Tuxedomoon was playing at some dive, in somebody's squat, a basement or something plus they still held their tape backups. So my judgment at that time was: "They still can do the show without me and it won't damage their show at all since they have most of my drums on tape." The only song where they had actual full blown live drums on was "No Tears" and there were 2,000 people at the Geary Theater. So I figured: "Well, I'm going to have to blow off the Tuxedomoon gig." So I called Steven and he was enraged and the next morning he called me and fired me and Blaine later called and said: "You know Steven's adamant that you're fired." I said: "This is ridiculous! We hardly ever worked and I've arranged things in such a way that I could never ever play with you again and you guys could continue with all my drums parts. So I don't understand that we can't work together again." It was because Steven said so.

So then they hired another drummer [*Greg Langston, end of 1978 - early 1979*]. This is typical classic Tuxedomoon. They replaced me with another guy and he couldn't play the drum parts the way I did. So somebody called me out and demanded that I'd come at Tuxedomoon rehearsals and teach this guy to play the drum parts like me, which I did. I went to a couple of rehearsals to do that. It was kind of strange. Then they had his first gig, his debut at a prestigious place called the California Hall [*on May 25th, 1979*], which was another place leaning more into the arty direction as they did music and theater rather than just rock 'n roll kind of thing. Somebody called me up and asked me to come and do their sound because Tommy, who was their sound guy, was refusing. Tommy was still refusing to have anything to do with them. So after I got kicked out of the band, they demanded that I'd teach their new drummer my drum parts, then they asked me to do their sound for them, which I found ironic. It was like: "If you ask me to do all of this stuff, why don't you ask me to just play with you guys?" But that was unacceptable to Steven.

own as well we painted the exterior. On the second floor between my area and the sunroof thing was a long attic (almost as long as that hallway below) which one had to travel through to reach the roof and that area was dark, very dark, and we used it for an astral projection room. Also Roland often slept there as no sunlight could penetrate and when he slept, he slept for many hours, not a daily routine...

Once there was an accident at the lab where they made LSD and a friend of ours came over with paper towels full of acid in unknown quantities and concentrations randomly distributed throughout. There were maybe four or five sheets of "bounties" or something... Anyway this was maybe ten thousand doses on some paper towels and for many weeks people came (the house was known to the initiated and also the local police who came more than once on other business. Eventually they took the pot plants from the roof although we weren't prosecuted) and we had many adventures… Anyway enough with the dope, we also did other things. Before I moved into the ballroom we had chariot races in three wheelchairs that were there and had a quadraphonic sound system which was eventually stolen. We had a giant piano harp from the inside of a grand piano and we often made music on it with hammers and the like until late at night. Another thing was we were so into the new music that we taped every specialty college radio show and that combined with my record collecting habit made us a center of interest for music lovers, and this is how we ended up to produce shows at 330 Grove Street [*i.e. San Francisco's gay community center*] including the Avengers and Dead Kennedys.

A patron of ours introduced us to one Dennis C. Lee who was the publisher of *Stains On Paper*, a sort of mystical alternative newspaper that was free but no one knew of it, and we started the masters of gnosis together (…) which was dedicated to making some cultural events, mostly we produced concerts (…) One of our projects

was to try and restore the painting on the exterior of the Family Dog House (this was an early commune that helped launch the ballroom music scene of the late sixties) which was right around the corner from us as the neighborhood was becoming gentrified and we were afraid that someone might paint over it all as it had fallen into disrepair. Although we did not get the job, in the end the owner did restore the original artwork and I think we were responsible for instigating this...

Anyway these were the kinds of things I was involved in at the time. Even though people like Tommy Savage hung out there, and I had long since cut my hair and was well aware that most of the culture I had been inspired by had been commodified and watered down, I really am still an old hippie. But I love energetic and dynamic and electric and so as things took off I realized that something I could do was to make music myself again and this was how I ended up doing so. I had gotten the bass guitar around the time we started to do shows at Grove Street which must have been in summer of 1977. Not all the shows we did were punk, but the most notorious were of course. However we didn't support punk for any reasons other than that it was there and needed a venue. I liked other types of music and performance as well.

As you can see my interests then and even to this date are directly related to a stream that surfaced in the sixties. Although I loved the fact that there were new musics and fashions etc., I was never a nihilist, and didn't take the "No Future" concept seriously as we all have to live in the future when we return... Since I think everything has meaning I didn't relate to meaninglessness, and as an experienced of communal living I didn't understand the no responsibility for my actions movement that was growingly popular. I did understand existentialism though but not moral bankruptcy and this still sets me apart from a lot of popular culture.

Many things were learned. By the

So I did their sound for them, for a couple of gigs. This is when I started meeting Bruce [*Geduldig*]. He started coming in around this time, and like doing lighting installations and showing films. There was a place, it was in the basement of a church, near Castro Street. They were doing a series of shows there, like four-five shows, like very not music gig like, like wine before the show. That was the first time that they were going into this sort of pretentious – "We're *artistes*, we're not musicians, we're *artistes*" – kind of show. Winston opened the show, with a big puppet show extravaganza, like 45 minutes Winston thing and then they did the Tuxedomoon thing. I remember that they had big blue tubes, not neon tubes but it had like electricity going inside, it was like electrical bolt going through them and they were laying over the floor. There were two problems with that. First it was interfering with the sound equipment and people kept stepping on them and they exploded releasing like toxic gas. So it was just a fiasco. Blaine would play the fiddle solo and then one of these things would explode, blowing the circuit breakers and everything would go off.

We're getting close to the end of phase one: I joined the band, I played with the band and I watched what happened in 3645 Market and I got fired. At the time that happened the landlord started making good on his: "Get out of the house, now, I MEAN it" and it was fragmenting very quickly and people were just vanishing. People started moving out. It was like: "Thank God, nobody died." We didn't find any dead bodies or anything that I remember of. Anyway, Patrick was still there and I believe that he was paying the guy next door and there was practically nobody left. Like the Tuxedomoon thing had gone away from the place but there were still sort of things going on. Then one night the landlord that lived next door sent over a cop because he was an old retired jerk, he sent over a cop with a shotgun, like bang on the door. It was around five o'clock in the morning and he said: "You people are out of here. By midnight tonight I'm coming back and I'm going to arrest everyone of you mother fuckers!"

And we just all went like: "Fuck!!!" That cop sort of intimated that he wasn't just going to arrest, he was going to crack our skulls and then arrest us. So we just started grabbing everything we could find, calling people, getting cars over there and we just got the fuck out of there, right then…

The amazing thing is that like ten years later the house was still seemingly empty, the door frame still painted red. I used to go and sit on the door step [*the house got torn down a few years ago and was replaced by a dull grey apartments condo*]. It's an unbelievably beautiful location and it was the epicenter of this weird thing that happened. It seems to me like it could have been five or six years but it was probably eighteen

months that I was involved, if that… But so much weird stuff happened. Sexual politics and it was like too many oversexed people, climbing around. It just got incredibly complicated and difficult and it fucked up a lot of people's relationships with each other. There were people that got along perfectly with each other until they went through the machine that was that house. (…)

At the time my girlfriend Heather, who had been like the love of my life, for eight or nine years – she started to call herself Heather Zahl, much to my chagrin, after we broke up – started going around and screwing all these guys, including my best friend to spite me. That for me was really rough. She had been my only, we'd been together for all those years, sucking into this promiscuous thing and she just started fucking all these guys, like looking at me: "What are you going to do about it? Nothing! Ha!" I found that really difficult and around that time she started hanging around with Jane D – another inhabitant of the house – and I know that that was the first time that she ever did drugs intravenously and she never stopped…

We parted company. We'd see each other once in a while, every two or three years and she'd always go: "We should get married. You're still the love of my life." Then around 1993-94, my mother called me and told me that she had died horribly and tragically in an OD related fire… God, this is morbid but this is also part of what that whole thing bred. She'd been struggling with heroin addiction since 1987 and she went to another mutual friend of ours' house, who was also hopelessly addicted to heroin, still living in California. This is leading on to part of the reasons why I'm not there anymore. She went to this friend of ours' house, said: "I want to go take a bath now." She put candles all over the place, millions of candles, she loved candles, got into the bath, took a bunch of heroin, OD-ed, fell face first in a bunch of candles, set her hair on fire and basically burned this part of her body off. She was always famous for her beautiful long red hair and she burned it all off… I have a lot of those stories in what has been going on in my life in the last 25 years since that fateful morning that Steven kicked me out of Tuxedomoon."

Patrick Roques: "THE HOUSE was a bit labyrinthine, architecturally and psychologically. Michael [Belfer] was a frequent visitor at THE HOUSE. At this point in time Tommy T. lived upstairs. Everyone else lived downstairs. This house had three basements. Most everyone lived in the first basement: Blaine, Steven, Paul and Heather, Jane D, Loren, myself and my recently reunited girlfriend Kim. Steve P and his then girlfriend Brenda lived in the second basement in a sort of cozy side room on the down side slope of the hill (which you entered through a trap door in the floor). For a while his mentally disturbed brother Coots lived there as well, until he started freaking the girls out. THE

end the house changed hands and the new landlord called the police on us and harassed us into moving. I had to return to San Francisco after the Tuxedomoon gig at the New No Wave Festival in Minnesota [in October '79] in time to appear in court to defend my claim on the property which by then I was squatting. My lawyer was the bishop of Haight-Ashbury who had ordained me a priest in the universal life church, but again I digress. Anyway you can see from this that I was still traveling with a different crowd than Steven and Blaine in those days..."

Patrick Roques: 'Peter's house was coming out of the lysergic acid diethyl amide renegade radical Haight lifestyle. Upper Market was methedrine, junk and punk futurism. Austere and empty. If Peter's house was "light" ours was "dark." Nihilism and narcissistic. The large upstairs front room was kind of a no-mans-land of high tech grey/black but done with a more art deco feeling. Like a furniture museum. It was cold.'

HOUSE had started to evolve into a party house. An arty party. After a Tuxedomoon show with the Screamers [*at the California Hall, on May 25th, 1979, already mentioned by Paul Zahl above; the Screamers were a prominent band of Los Angeles punk rock*], we invited a few people over and about 300 showed up as well as the cops. I ended up having to throw everyone out. It was really uptight. Blaine and Steven moved out at some point, I think because the new roommates were basically insane (the massive amount of Methedrine was getting to everybody). Tuxedomoon were serious about making music, and other people wanted to get very, very, very high. There was a brief yet intense period of madness and people moved out. The band was spending a lot of time writing, rehearsing and playing out, signing to Ralph in the US and Pre Records in the UK, outgrowing San Francisco.

Before this... at THE HOUSE.

(…) Heather, who was notorious as a great seamstress and costume designer and all around fox, made Paul and myself pairs of bushed cotton stovepipe pants. They looked like leather but were very light weight. Paul's I believe were red and mine were black. They were some damn fine sexy trousers. Heather was a true super star. We loved our pants, a lot.

I have to say I was an interloper in that I was always trying to get Steven to get rid of Winston and Victoria. I wanted the band to become more professional, less loose and Campy, darker. They got darker but musically that just happened naturally for them... So in other words, I welcomed Peter's arrival as a step in the right direction in terms of sound sonics and taking things more seriously.

The dynamic of the House always seemed to be in flux. During the calm in the storm I was designing sleeves, posters and was working on the idea of starting a magazine.

This was the height of the original S.F. Punk movement and there where maybe 200-300 hardcore people at the center of the Bay Area scene. So everyone was very busy, in the creative sense. All-in-all it was a fantastic time, and things got better when Tuxedomoon went to play New York. New York was the turning point.

After a while most of the original people moved out (of THE HOUSE), even Tommy finally moved out in the end, after trying desperately to hold on. I moved back to South of Market near where I'd lived when I first moved down to San Francisco in 1973 (around the corner from Hamburger Mary's). The "miracle mile" as it was called back then, because there were more gay bars per square mile there than anywhere else in the world, supposedly at that time. By then I had started doing my magazine and was hanging out more with Mark Pauline and the Survival Research Labs

crowd and working closer with Michael Belfer and The Sleepers than Tuxedomoon. I started hanging out with the NYC "no wave" bands and started living on and off in New York."

Paul Zahl: "You could feel like seismic shifts from day to day in this house. It would come down to someone's tiny pettiness to mess up the whole grand scheme of things."

CHAPTER III
From "Just Desserts" to Milk and Moscone's assassinations

We have seen that Tuxedomoon [1] was born as a result of the encounter between Blaine Reininger and Steven Brown, how it started to evolve as a musical backdrop for The Angels Of Light into giving multimedia salons, and also how the band started to recruit its first members, Gregory Cruikshank, Victoria Lowe and Winston Tong. The previous Chapter also contained a description of the houses where most Tuxedomoon members lived during their San Francisco period, each of the these houses illustrating one of the universes from which Tuxedomoon was born, namely the communal hippy environment of Principle's house and the dark angst ridden, definitely more punk, atmosphere of the house located on 3645 Market Street.

From June 1977 until March 1981, San Francisco will be Tuxedomoon's base. Many events took place, some of which will be decisive in their decision to emigrate to Europe and from then become the perpetual exiles that they remain to this date.

1977: Airplane Show; Gregory Cruikshank quits the band; Tuxedomoon starts playing at the Mabuhay Gardens

After their very first gig at *Just Desserts*, their *Chez Dada Salons* and memorable performance at the Castro Street Fair, Tuxedomoon's next big event was an *Airplane Show* that was initially presented at the Loft of The Mutants [2] in the Fall of '77 and later at the Mabuhay Gardens.

Steven Brown: "We did an airplane show. Actually this is all an offspring from The Angels Of light. We did borrow, more than we realized maybe, from them (…) We wouldn't really do like the average rock 'n roll band and bar band. We set these special shows. There was a loft downtown and that was a punk collective. A band lived there, The Mutants. They had a huge space, like two floors in a warehouse. They had a party and we did a show at the party. Somehow we did a mark-up of the inside of an airplane. We built an airplane set and Tommy Tadlock had a lot to do with this one. We got these old army surplus, air-force, microphones, these things you put over your head and make you sound like… (talks with a nasal voice). It was perfect for our purposes.

So I was sitting in this cardboard airplane, me and Blaine and (…) Victoria was there, dressed-up like in the air-force and

Tuxedomoon and solo members: some facts

Note: set lists are sometimes provided to give an idea of the actual content of sets, to make it clear that a lot of tracks were performed on stage eventually a long time before they were recorded or never recorded at all. Many of these lists were compiled from bootlegs and hence are not necessarily complete. Many more set lists can be perused at http://www.tuxedomoon.org/tuxedomoon_set_song_list.htm . Reminder: 'u.m.' stands for unknown material.

1977

06/14/77 First gig at Just Desserts, San Francisco: Blaine Reininger, Steven Brown and… a tape recorder, a frequent line-up in Tuxedomoon's early days

08/77 Tuxedomoon and the Angels Of Light (SB, BLR, GC, Walter Black, TT etc.) perform at the Castro Street fair during which a gay version of Marvin Gaye's "I Heard It Through The Grapevine" was recorded, later to appear on the *Pinheads On The Move* compilation album (Crammed, Cramboy, 1987)

From 08/77 on Tuxedomoon holds *Chez Dada Salons* and Winston Tong starts collaborating with Tuxedomoon

Fall 77 *Airplane Show* at The Mutants' Loft, SF (BLR, SB, GC, VL, TT and Walter Black) during which "Rhythm Loop" was recorded, later to appear on the double LP version of the *Pinheads On The Move* compilation album (Crammed, Cramboy, 1987). SB: 'produced 'airplane show' … 3 ½ hours inside mock B-52… band members sing thru flight masks… audience wander in and out of sweltering top floor of Terminal Concepts Loft on 1ˢᵗ Street in San Francisco… home of the Mutants' (excerpt from a CV used by Steven Brown in 1981). In 2007 Crammed Discs released TM's 30ᵗʰ Anniversary box set with the *Lost Cords* CD (part of the *Unearthed* double CD/DVD) featuring the track "Devastated" that was probably taken from that show

Gregory Cruikshank "mooning" on stage with Tuxedomoon. Photo Lig

these crazy microphones on and meanwhile our synthesizers and stuff were at work while Tommy was there doing the sound and back-up tapes. The show was up for like hours of us just playing this music written especially for the scene (…) Everything we did was just theme shows because this was before we got into the circuit, the "rock thing." We'd play at people's birthday parties or Halloween parties or new year's parties, at people's apartments and at community centers and things like that. And invariably we would wear some kind of crazy costumes and masks. That was assumed. Usually we would have some kind of visuals and/or painted backdrops, again from The Angels Of Light (…) So every show was different: different costumes, different music, different backdrops. Theme shows (…) Gregory Cruikshank was working a lot with us at the time (…)."[3]

Gregory Cruikshank entertains bittersweet memories of that show as it represented his *grande oeuvre* with Tuxedomoon but also resulted in him becoming distant from the band: "I was thinking of how we could incorporate our energy into the band, so I wrote a scenario for a show where we were pilots. It was a conceptual show: instead of picnicking, we were flying a cargo plane and I think I presented the sketch to Steven. We built a concentric thing that was great, very industrial looking when looking at it with a perspective that looked like the inside of a plane. And the way that the musical instruments were set up, it kind of seemed like there was a cockpit. Each song had a different scenario. We later scaled the event down because there was a gig at the Mabuhay.

I was the pilot and Victoria was sitting somewhere at a *café*. We had obviously landed and we danced and there was a point in the waltz when I turned and that's when I mooned. I don't think I had done it at the show at The Mutants' but I thought I could do that at the Mabuhay. It was a smaller venue and we were focused on just a few numbers on that night. So I did that

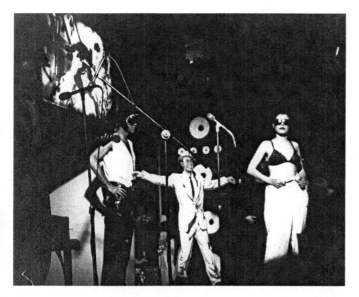

Gregory Cruikshank and Victoria Lowe, on stage with Tuxedomoon, *Lively As A Walk On The Moon* backdrop. Photo Lig

and I remember Steven seeing a picture a couple of weeks later going: "What?! What are you wearing?" I said : "That's the Tuxedomoon
- You did THAT?"
I felt then that I was being censored and that there was a bit too much of seriousness around that whole idea about who they were and what they were now. Most of what I could contribute to Tuxedomoon would be visual and that's what I was really concerned with. I was also singing and dancing and doing little acts like that. Victoria was a pretty stunning presence on stage, quite compelling. She did Lily Marlene with them. She was such a focus in the band because Steven and Blaine were mostly behind instruments all the time. When I felt that there was the tiniest question about what I should be able to do or not, I felt like I got other venues."
The climax of the Airplane Show came when Reininger got to drop The Bomb, Dr Strangelove style…[4]

Some time in 1977 Recording of "Next to Nothing" (BLR, SB, WT) by TT during some rehearsal, later to appear on the *Pinheads On The Move* compilation album (Crammed, Cramboy, 1987)

12/22/77 TM's first gig at Mabuhay Gardens (with The Readymades and The Liars), SF : *Lively as a walk on the moon*. GC, who was sort of taking shifts with WT as a performer with TM, drifts away from TM

Tuxedomoon starts playing at the Mabuhay Gardens. Soon enough Tuxedomoon will also become a regular at a legendary San Francisco punk venue: the Mabuhay Gardens (aka "The Fab Mab" or the "Mab"). Originally the Mab, owned by the shrewd Ness Aquino, was a restaurant holding Filipino

Scott Ryser (from The Units): "The room in the Mab reminded me of CBGB's in New York. Small and dark with a low ceiling and snotty waitresses. Like many famous places it was really nothing special to look

Tuxedomoon (WT, BLR, VL and SB) in front of the Mabuhay Gardens. Photo Lig

at. But boy would they pack 'em in. Five or six hundred people in a room the size of a two car garage! It, like the Deaf Club, was a Fire Marshall's worst nightmare. And like most music clubs it was a nightmare to try and project films in. Every surface in the room had the texture of an old movie house floor...extremely sticky. Chairs, walls, floor, everything! It was like walking into a roll of fly paper! It smelled like stale beer, cigarettes and barf. I think they even tried to serve meals before the shows, that's probably where the barf smell came from... some kind of Philippine concoction that gave food poisoning a good name. Dirk would try any angle to make a buck. It was a lot of fun though.

Dirk Dirksen, the black sheep nephew of Senator Everett Dirksen of Illinois, never tired of his cynical, wise ass remarks when introducing a band. He was a real card. He was half the show. He would basically get up on stage and insult the audience and their taste in music. He took great pleasure in getting them all riled up. The way he looked and dressed was never influenced by the scene he helped create. He had a mustache and wore a cheap polyester suit and looked like a door to door vacuum cleaner salesman. I kept waiting over the years for a bottle or something to come flying at him from out of the frenetic mosh pit but it never happened. Somehow over the years he had garnered as much respect as Wyatt Earp did in Dodge City. When he was in the saloon nobody touched him"(Interview (Fall 2000) available at http://www.synthpunk.org/units/ryser1.html).

supper club shows. In 1976, proto-punk Mary Monday convinced Aquino to let her have her show there [5] and, by the end of the year, two bands, The Nuns and Crime – that were searching for a place to play – convinced Aquino to have two nights a week devoted to rock 'n roll. It was immediately a success. In February 1977, Aquino decided to go exclusively rock 'n roll and, since punk rock had then become *en vogue*, had decided to showcase this music with Dirk Dirksen in charge of booking bands until 1981/82. [6]

Michael Belfer, who played there with Tuxedomoon (from 1978) and with The Sleepers, remembers how the booking was done at the Mab: "Once a month, like every last Sunday of the month, it would be the booking party. All the bands in the music scene would show up and there would be this big blackboard up on the stage with a calendar of the next month, and tentative shows that were booked and what was left over that people would get. It was all run by the man behind the San Francisco punk scene Dirk Dirksen and his small dog Dummy. In the background free fried chicken and all the beer you wanted was being served. This was good because everyone knew that at least one day a month we could count on food at the booking party. But for me the real reason for being there was all the musicians were meeting each other, asking questions about each other, talking art and politics and what you want to do to change music in the world!!! Because we all somehow could feel the buzz in the air, the electricity like a hum from a big transformer making the air bristle with all the possibilities of new art and musical combinations we could make. We knew it was fucking REAL and that whatever we did it would make some kind of impact. So we had better do a fucking good job of it!!!"

Blaine Reininger:"(…) first we ate dinner. They served us some kind of basic food and then we would go about making out the schedule for the month and it would go like:

"Ok Wednesday October 2nd. Who wants to be the opening group? Nobody… Who wants the headline?

- Oh, we do, we do!

- You're not ready! You can't headline yet! …

- Ok Wednesday will be Tuxedomoon, Crime and The Nuns!'"

Tuxedomoon first played at the Mab on December 22nd, 1977, a show named *Lively As A Walk On The Moon*. Blaine: "We had this backdrop on stage. We had this man floating in from an old fifties magazine, an ad for shoes saying: "It's like taking a walk on the moon!" It was this kind of graphic guy in the fifties with his suit wearing a hat with this kind of stupid grin on his face. In a sense it was our logo. We kept on reproducing that image until it took a life of its own and we had rear projections of slides. We used a projector that I had bought at a second-hand store. It was also in keeping with this artistic philosophy

Tuxedomoon playing a "Masonic" show at Mabuhay Gardens, Photo Lig

of using materials at hand, like an old television…"

> **1978: opening for Devo; from hippies to punks – last take; Tuxedomoon and drug use; "Joeboy The Electronic Ghost"; various (mis)adventures out of town; Miners' Benefit; Victoria Lowe quits; Paul Zahl and Michael Belfer join the band; "No Tears"; fall out with Tommy Tadlock; Peter Principle joins the band; Bruce Geduldig starts collaborating with Tuxedomoon; the turning point: Milk and Moscone's assassinations**

Tuxedomoon's first big event in 1978 was their opening for Devo at the Mab on January 6th and 7th. "'I remember it well, jokes Reininger, it was raining. I was carrying my Pierre Cardin umbrella. I walked into Dirk Dirksen's office and he said, "I like you guys. Have you ever heard of Devo?" I said, "Yes [gulp] I think I've heard of them."' [7]

For Reininger, this concert was a turning point: "A lot of people saw us and a lot of people liked what we were doing : "Oh these guys are just as interesting as Devo, maybe in a different way." So from that point on we were beginning to be treated with a new respect in this club and by people in general…" As UK LTM Recordings owner [8] and long time Tuxedomoon fan James Nice put it: 'As well as exposing

1978

Some time in 1978 WT appears as "Puppeteer" in Ronald Chase's film entitled *Lulu* (also as make-up artist with his sister Moucci Tong)

Some time in '78 Recording of "Day To Day" (demo); "Remember" (live) and "Oceanus" (live), all featured on the *Lost Cords* CD, part of the *Unearthed* double CD/DVD included in TM's 30th Anniversary *77o7* box set released by Crammed Discs in 2007

Early 1978 recording of "Rhumba" (BLR, SB) by TT on four track, SF, later to appear on the double LP version of the *Pinheads On The Move* compilation album (Crammed, Cramboy, 1987)

01/06 &07/78 TM opens for DEVO at the Mab, SF

01/20&21/78 Gigs at the Mab (with Blackout), SF

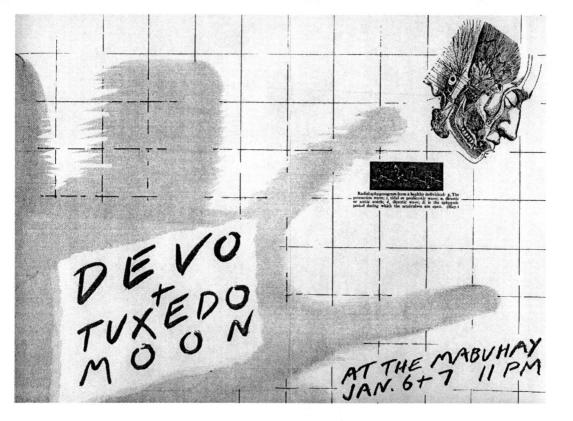

their art to a wider audience, the show was also a catalyst in the band's metamorphosis into a "rock group" rather than a willfully esoteric artists' collective.'[9]

From hippies to punks – last take. From that moment Tuxedomoon was linked to the San Francisco punk scene [10] while remaining largely ostracized by the so-called "hardcore" punks.

Peter Principle: "(…) although I liked the energy of punk music, I didn't really have a big affinity with their philosophy, being who I was (…) The first time I saw those guys [*Tuxedomoon*] they played in a orchestra pit in front of a theater show that was done by The Angels Of Light. It was roughly based on some kind of Roger Zelaszny's science fiction story [*it probably was the Sci-clones show that was performed in March 1978*]. Everybody was wearing these kind of aluminum foil costumes and I liked that! So for sure Tuxedomoon were not really that involved in the punk scene. It's only because they were friends with this group, The Mutants, and they were people who helped to instigate the whole art school punk movement of San Francisco. But Tuxedomoon was always ostracized and it was only after we left San Francisco that they really started to claim us as their "famous" band or anything that they ever supported."[11]

It is well established that prior to their gigs at the Mab, Tuxedomoon didn't really relate to the San Francisco punk scene. Steven Brown recalls: it "was like a totally alien world.

Blaine and I didn't have any connections in the scene, weren't interested in it, never went to the Mabuhay..." [12] However this scene undoubtedly exercised some influence on them as, still quoting Steven Brown, the music that they were doing at the time "was a lot more derivative than now. We were doing some sort of quasi-punk then. We'd listen to a record and say: "Let's make this sound now." We tried all kinds of different things. We were much more into rock 'n roll at that time." [13]

Illustrative of the point that Tuxedomoon was never really accepted by the San Francisco punk scene is P. Belsito & B. Davis' slightly condescending description – also tainted by factual and spelling mistakes – of Tuxedomoon and the fact that, even if they recognize that Tuxedomoon was for a while the most celebrated band of the Bay Area, they just devote these few lines to them practically not to mention them again in a 60-page treatment of the San Francisco punk movement. After having elaborated about The Mutants, pointing that the latter were more concerned with ruination of art rather than being an "art" band, they write: 'Tuxedo Moon, on the other hand, left no questions as to their pursuit of artiness. Their first performance at the Mab late in 1977 thrust them into a totally alien Punk world where their angst rock blended telepathically with the nihilist attitudes of Punk. The group was founded when members Steve Brown and Blaine Reininger met in a San Francisco City College class on electronic music. They enlisted guitarist Michael Belfer, who was later replaced by Peter Principle, and Chinese performance artist and vocalist Winston Tong, who would later win an Obie Award for his performance Bound Feet. At their height Tuxedo Moon was the most revered group in the Bay Area, to the point where even their alleged use of heroin was widely mimicked.' [14]

Brad Lapin (*aka* Brad L.)'s analysis for Damage magazine [15] in 1980 goes further:
'"*Tuxedomoon is a redundant, artsy-fartsy, bland fag band, but your record is nice dinner muzak.*" graffito, Geary Theater
Many people have, as the above indicates, dismissed Tuxedomoon as an art band, a group of self-styled aesthetes in the Oscar Wilde meets Oscar Levant meets John Cage

Tuxedomoon (SB, VL and WT) performing "Pinheads On The Move", probably at Palm's café. Photo Lig

'PRAXIS: You've been labeled as an "Art Band." Do you resent this?
STEVEN: Yeah it tends to rub me wrong because it is a label. Then again, do we really know what "Art" is? It's a very loaded term (...) In some circles, it might mean something glamorous, while others

Page 63

Tuxedomoon (Steven Brown) at Savoy in North Beach. Photo Lig

connect it with rapid, highbrow, upper class zeros. I mean what is it? One definition I came across was in a book that Eno suggested called *Man's Rage For Chaos* by Morse Peckham. It defined art as: "Any artifacts that we perceive in a culturally approved situation." In other words if Duchamp takes a urinal and puts it in a museum and writes whatever he wrote on it, it becomes art. If you see it on the street, it's not art; if you see it in a museum, it is. So it gets me thinking, any band, from your most ignorant, good time, bar band to Pataruvski – they're both playing on stage and they're playing with people there to watch them, and the whole thing is a ritual, an artistic situation. So if you look at it that way, every band is an "Art Band," because it all comes down to theater – every band is theater' (BILL EDMONDSON, "Interview Tuxedo Moon, week of July 15, 1980", *Praxis*, vol. I, n° 6, November 1980)

vein. Some feel their sole contribution to the scene has been to water it down, to turn it into safe, easily disposable new wave product fit for gutless art students and others to whom skinny ties are more than neck ornamentation. For most of the band's existence, in SF at least, their reputation as a band only more humorless than pretentious has denied them acceptance into the broader reaches of the scene. Attending a Tuxedomoon show even now, the audience is largely composed of fashionably-attired, socially-mobile new waverers who would not only look, but truly be out of place at, say, a Flipper or Circle Jerks *extravanganze*. There also seems to be a larger-than-normal number of gays at their concerts, many of whom seem to have crazy-colored their hair for the occasion. Looking back over the last three years' worth of audiences, Steven explains the indifference or hostility of the more hardcore elements of the scene in this way: "The West Coast punk scene was very ideologically pure, very frightened also. Many people were (are) scared of losing their punkhood."

Perhaps much of the difficulty people have had in getting beyond Tuxedomoon's art band image lies in the band's own ambivalent relations to the underground itself. As Steven noted, prior to their first gig at the Mabuhay in the late '78,

neither he nor Blaine felt any connections with the people and bands who were centered around the Mab or to the hard-driving, aggro-basic rock which it came to feature almost exclusively. Their world had been the semi-rarified confines of the avant-garde, like "salons" at the Angels Of Light studio, polite, if somewhat lethargic, audiences who came to see them at art galleries or the music of Stockhausen, Cage and Eno. As, more and more, they were absorbed into the punk scene, the basic differences between their intentions and approach and that of the other bands with whom they often played became necessary to emphasize. In one sense, Tuxedomoon's artsy-fartsy image was a self-imposed defense against the homogenization which rapidly was overtaking the punk scene (…)'

After observing that the message expressed by punk rock is quite simple, basic and accessible, Brad L. goes on:

'In contrast Tuxedomoon's complex, somewhat halting experiments into the meaning of their own experiences and of their music as a process by which those experiences can be understood lends itself to a state of almost perpetual uncertainty, to a gnawing anxiety (or, if you prefer, *angst*) about, well, everything. When Steven says "we've changed every six months," he's enunciating the evolutionary character of their music and, just as importantly, of themselves as people. Those changes and the anxiety they produce is what has made the band so stark a contrast to the other groups who compose the scene's long term members, and may account for the disdain many people especially on the hardcore fringes, feel for them. The one consistent characteristic that binds all of Tuxedomoon's music together, whether live or on disc, has been a palpable sense of dread, perhaps grounded in the artist's well documented fear of not being sufficient to his or her vision. That dread is as powerful a message as any punk has produced. Its effects on the audience are the same, but in Tuxedomoon's case, the effect is mental rather than purely physical. Not dance but trance music.'

Steven Brown: "We had absolutely no connection with that scene [*i.e. the punk scene*] at all. It was just by coincidence, or default, that we were linked to this New Wave thing. We made no attempt to reach these people at all. They came to us, but that wasn't until much later (…) When we first started we had this idealistic, missionary idea of taking electronic, Avant Garde music out of the usual high brow, egg head type of environment and playing it for quote "normal" people, making it more accessible, as opposed to other routes we could have taken, like the Stockhausen route, or the John Cage route – you know, playing Avant Garde music and not caring if anyone else likes it or not. On the other hand, we didn't want to be a rock band and fall into the syndrome of

playing in bars every night. We wanted to be very Guerilla, and play unknown venues, different kinds of venues that had never been played before – you know, pop up here, pop up there, doing it sporadically." [16]

Blaine Reininger: "They wouldn't let us into the secret cloisters of hipness for years, until everyone else disbanded." [17] "The punk movement claimed to be an anti-intellectuals one, when it counted within its ranks quite a few people who appreciated using their brains. I hate this Maoist side that leads you to disavow what you are. To think is not a crime. I'm fascinated by culture, history, and this does not prevent me to entertain for that matter a quite physical relationship with music." [18]

This relationship of attraction-repulsion that Tuxedomoon maintained with the punk scene will follow them throughout their career. In 1985, for instance, journalist Jack Barron, after attending a show in Lille [*France; the first of the so-called Revisionaries Shows*], underscored the contradiction he saw between the circumstance that the band allegedly started as a punk group while the show he witnessed reminded him of Pink Floyd. Bruce Geduldig and Steven Brown's rejoinders were sharp:

- (Bruce Geduldig) "I think we've always been that way. We were yelled at years ago when punk was big in San Francisco for being an art band. But what happened was, when New Wave hit San Francisco there was a door opened for new energy and we simply went into that room. We didn't have any notion of being a punk band.

- (Steven Brown) It wasn't a question of punk, you shouldn't fall into this trap. At that time there was no question of punk, there was a question of this new energy (…)." [19]

Tuxedomoon's exile starts here. They were never part of any "scene" and this fact explains why they are largely ignored by most rock 'n roll encyclopedias or any effort to synthesize a musical movement that marked the history of popular music. As some sort of missing link between the hippies (they culturally grew up with them as "tails of the sixties") and the punks (from whom they borrowed energy and freshness), they didn't really belong to any of those groups, or conversely could be seen as belonging to both of them. Peter Principle: "We all came together in this group because of all this punk or new wave movement where we didn't belong completely, but it was as if a door opened and we saw a new state of things that influenced us very much, all this "information" that influenced many others as well, but also pushed away a big part of the exponents of orthodox punk (…) then you perceive the distinguishing line between yourself and the rest. It is similar to the way energy is distributed in the universe by filling some boundaries." [20]

What Principle is telling us here relates to the very essence of Tuxedomoon: growing out of the punk movement without being really accepted there underlines what will become their long-lasting status of border strollers, musically as geographically, filling up interstitial spaces between genres and conventions of all kinds.

We will return to the various efforts that were made to characterize Tuxedomoon and their music, all of them sounding like a Dada statement, from the "a perfect mix between the Velvetian discord and the Debussian lightness (…) the missing link between Joy Division and Radiohead"[21] to "the Samuel Becketts of electro-punk."[22] The difficulty of such description begins here, as they "started out with the energy and insanity of the punks while being heavily influenced by Genet, Bartok and Morricone."[23] As Jan Landuydt points out, in what is probably the best article ever written about Tuxedomoon,[24] the band had a love-hate relationship with the punks in that, on one hand, it has always been minimalist in the means being used and carried an impression of a certain "amateurism" about them, while, on the other hand, it always displayed its attraction for "more elevated" ways of artistic expression, like literature and theater, to integrate them into their music. Steven Brown: "We have proved that there can be electronic garage (…)."[25] And, by the way, is Tuxedomoon really a "rock" band? Blaine Reininger: "We never were rock (…) Of course we do however have affinities with the rock media. Only the punks didn't want to have anything to do with us: they saw us like a bunch of psychedelic hippies"[26][27].

Tuxedomoon and drug use. As seen above, P. Belsito & B. Davis' book about the West Coast punk movement closely links Tuxedomoon with the use of heroin. Even though Tuxedomoon was far from being the only band to be notorious in the Bay Area for their use of psychotropic substances (The Sleepers[28] – of which Michael Belfer was a member – and Chrome[29] were probably as famous for it), their name nonetheless remained like some sort of a banner for the bands that did not limit their use of drugs to the occasional ingestion of aspirin. Scott Ryser (from The Units): "Let me put it this way… Tuxedo Moon, and some other bands in the scene, inspired fans to do more than take piano lessons. And there was indeed some terminal fun to be had upstairs at the "Fun Terminal" arcade where The Mutants had their big loft. There seemed to be two camps. The uppers and the downers. It seemed to me that it started with the uppers... speed and coke. Speed does weird things. In the beginning you were glad you had a mike onstage so your voice could be heard over the sound of the crowd's grinding teeth. The

Peter Belsito strikes back. In an e-mail conversation with author (2006), Peter Belsito expressed his vision of Tuxedomoon: 'Part of Tuxedo Moon's allure was their strong association (real or imagined) with heroin. TM's music typified the tortured-artist on drugs mystique. This image went hand-in-hand with TM's deification by their fans and the would-be cognoscenti of the time, who were all too happy to recommend a heroin lifestyle to anyone who would listen. IMHO: heroin chic is a dull and illusory aesthetic no matter how brilliant its progenitors may seem. In retrospect that is how I would sum up Tuxedo Moon as well: dull and illusory.' If San Francisco, the 'kook capital of the world,' had been ready for Tuxedomoon, puritanical America probably never was…

A trip along the railroad tracks.
Principle: 'One time we were playing in Bellingham, Washington. I seem to remember we did this Bellingham gig with DNA etc. I remember the promotor gave us a cabin to sleep in and that was about 12 to 15 people on the floor. I took one look at that and decided to dose myself with some L and went for a many-hour walk along a railway that passed through all of these refineries... I walked for hours and I found a mine that was venting gas and that stuff was really great. I loved walking along railroad tracks. This was an amazing journey on which I never once ran into a hostile dog. We were really in the boondocks, and it is my good fortune that I didn't get lost. Of course tracks are easy to follow out and back but I do remember being pretty stoned. When I got back to the cabin, it was only about 7:30 a.m. and the place stank and was full of loud snoring individuals. I knew I had made the right decision and walked off in search of a diner for breakfast...'

pogo developed in the punk clubs from all the twitching going on in the audience. I'm convinced the alcohol and tobacco companies shipped free speed and coke into S.F. as a way to increase sales, and it worked! How else can you get a roomful of people to chain smoke and guzzle booze for twenty four hours at a time... It was like an Olympic marathon! In the gay discos there was an amil nitrate fog hovering over the dance floors that was so thick you could get a heart attack just by walking across floor! I guess finally everyone got so burned out that they had to start taking heroin just to stop being paranoid and get a good nights sleep." [30]

The fact is that Tuxedomoon and the band Noh Mercy! had a drug dealer in their close entourage. Esmeralda Kent (from Noh Mercy!): "(...) so there'd be like mountains of this stuff on the table, just outrageous. When you have that much access to it, you can really go over the cliff. And it was free (...). But you know it was free and not because of all that time we were consuming into this and also everybody went really crazy and oppressed all the time. It really affected Winston, that's what led him to heroin. [31] He remained addicted for a very long time. I think that the fact that they left [*for Europe*] saved them."

Blaine Reininger explains how he got addicted not only to drugs but also to alcohol very early on in his life: "Where does

Blaine photographed by Vic Vinson circa 1980

Page 68

alcoholism come from. Is it genetic, is it taught, I don't know. Is it some kind of psychological trauma: in the end it doesn't matter. It's a syndrome, it's not a disease, it's a syndrome over which one has no control. So what one can do is check it. Alcohol was my liberation. I had a certain amount of pain in my life and also it liberated me from my shyness and self-loathing: that was put behind me, I didn't care, it suppressed inhibitions. I was 13 and I was already an alcoholic back then… I just wasn't one of those guys who would get just a little bit high. I was wasted as often as possibly could and that was my aim and that was alcoholism: if you're drinking or taking some drugs to a point of oblivion, it's beyond recreational use, you know…"

Peter Principle expands on his personal story of drug use and on the association of Tuxedomoon with such use: 'I grew up in a culture of casual drug use. I was born with a small sensitivity-like clairvoyance and my childhood memories are full of mystical and religious experiences despite my practical Unitarian upbringing. Growing up, I also had an appetite for challenging will, especially endurance and conquering fear (I loved stories of American Indian passage rights). This kind of attitude prepared me fairly well for what came my way in life. I don't mean that I was a tough guy, I actually wasn't. I was just recklessly optimistic and undismayed...

I had read about LSD in *Life magazine* that year and was immediately determined to seek out and experience this new technology. I was 12 at the time and it didn't take long in New York City to achieve this. The deed done (this was the first real drug I ever took, before smoking pot), I was totally convinced of the possibilities. I was already a sort of researcher into what I didn't at the time know were states of consciousness. I was curious about all things paranormal and an avid reader and a subscriber to things like *UFO magazine*. I had read about training techniques both from the point of view of mystics and that of the intelligence community. I took immediately to Ken Kesey and the sort of challenge offered by self-exploration in groups. John Lilly and the idea of reprogramming self images also reached me. Leary was obviously a pop-star wannabe, but also wrote and said all kinds of good things about inter-relationships and also the civil rights of body chemistry...

By the time I had moved to San Francisco I had taken quite a few "trips," but soon after arriving I met some people who were at the top of a distribution pyramid, and at that point I got to take quite a bit more. Much of this exploration took place at the infamous 1344 McAllister Street house (…)

I am a needle virgin as in my youth I saw enough people lose control or worse while "using" it in this way and so I early vowed to never cross that line and never did. That said there

At the French border (early eighties). Principle: "Once at the French border Winston was stopped and they looked at the tracks on his arms and they said: "Oh, we see you're a user!" And he said: "No I quit!" And the guy said: "When?" And he said: "Five minutes ago." I thought THAT was really good! It worked like a charm. Everybody hated us but they let us go. One time they took the fire extinguisher apart and they found white powder inside but of course there's white powder in many fire extinguishers, that's how they work! Oh well, we had to sit there while they chemically analyzed it, sitting on the side of a French road for four and a half hours and then the border guys having their fun with us. Then in the end they let us go, there was nothing going on. The FRENCH BORDER used to really hate us, we had a lot of trouble there. I think it's because we had a Belgian ATA carnet and we spoke poor French. Yeah… They knew we were a rock band, and so they didn't have a lot of sympathy for us…"

At the French border still, about ten years later. Steven Brown: "One day I was with Martine [*Jawerbaum*], we were driving from Belgium to France… It was like right after they repelled passport control at the borders within the EU. So one day we go to Switzerland to see a friend of ours singing an opera. We leave Belgium and we get into France. And we drive: "Ooohhh!" Right by the passport control. "Wow! Great! *Longue vie*, viva Europa! Happy new year! Great!" Well, ten minutes later, on the free way, fucking cop comes out in the middle of the road. All these cars gone by, he stops US. He stops US! It's like this! Right on the street, you know how they are… "What the hell is going on here?!" Right, we've just been like singing the praise of the New Europe. The guy pulls us over, immediately goes into my pocket, pulls out the hashish. Me and Martine, we're just like (bursts out laughing): "Ohhh no!!!!" I said: "WHY US? All these cars going by and how did you choose us, wow…" He didn't say. So we had to pay a fine. I had to wait there while Martine went off with

the police to a bank machine to get money out. So at that point I realized Europe is ALMOST without borders, it depends on who you are. To them in their eyes, we're two gypsies who obviously are doing something illegal… and they were right, you know! (…) It's just the change of emotions: going through the passport control and feeling so free and then ten minutes later, bam! Right between the eyes, it's just like a cold shower. Woke us up too: "well, reality still isn't that great, is it? No, sorry…""

is another element to this that reflects my personality and world view and is that I always took drugs not to escape or obfiscate reality, but to gain insights into it. I was a firm believer in the Kesey/dr.Tim/Lilly view of drugs as tools to extend the capabilities and capacities of the nervous system or even consciousness itself (whatever that is). I learned to play the bass guitar for instance in a matter of days while on LSD. The scene I first arrived upon in San Francisco was very much in this arena philosophically and I had some good experiences with other people who shared this notion.

There are many books written about this period and world view like *Storming Heaven* [*by Jay Stevens*] or *Acid Dreams* [*by Martin A. Lee and Bruce Shlain*] and I still to this day believe that some good has come from the introduction of these tools to the public. I am sure that there is a lot of irresponsible things said and done, but I am not convinced that all is bad here. I never really had an affection for trash culture, self-hate or immolation. No cult of the dead or of the blood here, just healthy self-serving hedonism and spiritual/intellectual curiosity, combined with the sometimes naïve conviction that one could "learn" valuable things about one's self and the universe while using drugs...

As well there is a bonding effect that goes down amongst users of common substances (Robert Fripp had a joke that the band should all be on the same drugs or no drugs at all as anything in between led to disaster...) and so I have socially imbed with the guys, especially in work related circumstances like studios, tour bus etc. But my overall intent was to seldom have any H on my own. Usually I was just smoking hash while the rest were drinking and drugging. This came to a head when during some interview with Red Ronnie in Italy [*in 1982*] it came out that there was an attached rider to our contract that asked for certain substances and the Polygram people heard about this and dumped us around the time we licensed *Divine* to them. As I remember we were trying to make a deal for more recordings... Also the various books that have been published, especially the Belsito/Davis one, [32] have associated the band heavily with heroin use and that's a drag since it wasn't me or really Blaine much either. Even Steven was a lightweight in the end.

Anyway, I often took acid before playing shows in the early days of the moon, even dosed some of the other members. A few memorable occasions come to mind, one being in Bordeaux, France [*in March 1981*] on the California wave tour where we were stranded for a few idyllic days by the local promoters' incompetence and somehow we all got stoned (Winston, Steven (…) and myself at least, probably Bruce as well) and by the time the gig happened we were quite toasted and then had a fit about the quality of the sound system and I

left the stage with him swing the mike stand around over his head. G… had somehow eaten something he was allergic to and was throwing up out of a second story window onto the street below which was full of carnival type crowd with no traffic. At this point Blaine was rather drunk and took a pee over G…'s head out the same window. We all felt better the next day.

Recording "Dark companion" [*in June 1980*] is another story... This is a story involving LSD and this was an accidental dosing. I had been given a vial by a friend. It was sort of empty but lined inside with white powder. I thought that perhaps it was speed or coke and in my enthusiasm to "get going" that morning (this was 1980 after all) I filled the vial with water and dumped the contents in my nose. Ten minutes later I discovered it as LSD crystal, very very powerful and more than enough. Luckily I am a trouper and after the initial shock I called Blaine and told him exactly what had happened and said I would be somewhat late and rather incapacitated. He called me a taxi as I obviously wasn't walking over to the studio and then they started to record. A funny thing happened next. As I didn't do the bass line tracks first, Blaine counted the rhythm in without realizing that the accent was not in the right place for the rhythm section to click into a groove with the bass. The parts were all laid down in tandem to the rhythm and when I finally was grounded enough to record my part, it was too late to change it (in 1993 or so I corrected this in a studio in NYC for release on the *Solve* [*i.e. the Solve et coagula compilation that was released end of 1993*] set where the drums play like they were intended, like we did it live for all those years, as we never tried to repeat the mistake that is on the original record).

There are a million stories from the period, most of which had a happy ending. By the mid-eighties I had pretty much decided for a myriad of reasons that taking hallucinogens for enhancing perceptions was not the way for a logic thinking westernized 21st century person like myself and I have more or less returned to those pragmatic Unitarian ideals from my roots like Ralph Waldo Emerson and Thoreau, tempered with a decidedly self-made postmodern outlook (I don't proselytize or evangelize) based on observation as unbiased as I can muster which admittedly is nowhere near 100 percent. Also I still know that the exercise of truly free will is the best way to get anywhere in life and holds the most responsibility for the results. If I was to "lecture" young people about drugs today, my words would simply be:

"Keep your mind open
Know your sources
Don't kill yourself" and I mean that on many levels.'

02/78 TM (BLR, SB and VL) records "Pinheads On The Move," "Joeboy The Electronic Ghost" & "Pinheads On The Move (Reprise)," prod. TT. The first two tracks will compose TM's first 7" published first by Tidal Wave Records then by Time Release Records in 1978, later to appear on the *Pinheads On The Move* compilation album (Crammed, Cramboy, 1987)

"Joeboy The Electronic Ghost." February 1978 saw Tuxedomoon record their first single featuring "Pinheads On The Move" and "Joeboy The Electronic Ghost," produced by Tommy Tadlock and allegedly recorded in the kitchen of 3645 Market Street with spoons, pans, bottles and chop sticks serving as percussion. [33]

Blaine Reininger: "We were always working with tapes anyway and we would play with back-up tapes. We didn't have a whole band, so Steven and I would do multi-track recordings and then we'd play with a tape recorder. Hence we were always recording. The simple thing to do was to move a step forward and make a record."

1,000 copies were pressed on the band's own Tidal Wave Records for a mere $300 borrowed from Donald L. Philippi (*aka* Slava Ranko [34]). Blaine: "We printed our own sleeve and hand-packed them in like plastic bags." The first 25 copies came with a bonus hand-crafted collage. [35]

Both tracks are 'crude yet effective stabs of electro punk (...) betraying the influence of *Mongoloid*-era Devo and also Ultravox – the latter always an influence on Reininger in particular.' [36]

This recording also saw the first appearance of "Joeboy," an electronic ghost that will become some sort of Tuxedomoon *alter ego*. It will follow them throughout their career, as a denomination for their production company (*Joeboy Productions*) or an alternate band name for some of their recordings (*Joeboy In Rotterdam, Joeboy In Mexico*). It will also be used later in combination with "Crammed" to form the name of their sub-label: CramBoy published by Crammed Discs. It originated from a graffito left by a local Chinese street gang: 'Joeboy Police R/R Police Joeboy/Joeboy R Police.' [37] It remains an inexhaustible source of inquiry for puzzled observers and an endless source of mischievous "non-answers" for the band as this 2003 Peter Principle quote indicates: "There is a Joeboy, the electronic ghost. He was earlier here today but they managed to get him out. Joeboy the electronic ghost is the fifty cycle in Europe – sixty cycle in America – hum which gets in your wires when you're trying to make recordings. Do you know anything about ground loops? And the physics of grounding? Ok, so Joeboy is in the ground. It's a voice of the electricity but we didn't really ask it to sing along, so..." [38]

02/78 TM (BLR, SB, VL, WT, TT) in Colorado Springs for a week as artists-in-residence, first gig outside of San Francisco that forms the material of a bootleg LP named *L'Age d'Or*. Some images from the performance can be seen in: *Tuxedomoon – No Tears*, Greek TV documentary directed by Nicholas Triandafyllidis, Astra Show Vision & Sound, 1998 and a 27:02 min. film entitled *Colorado Suite* was released on the *Found Films* DVD, part of the *Unearthed* double CD/DVD included in

A (mis)adventure out of town. Also in February 1978, while Patrick Roques was instigating the New Style of the times upon moving into THE HOUSE on 3645 Market Street, Tuxedomoon (then composed of Brown, Reininger, Tong and Lowe) and Tommy Tadlock drove a pick-up truck across the mountains to Colorado Springs for a week as artists-in-residence. It was at the University of Colorado that they

Page 72

TM's 30th Anniversary *77o7* box set released by Crammed Discs in 2007
Patrick Roques moves to the house on 3645 Market Street around that time

02/14/78 TM plays at the Mab (with Leggs & Whoremones), SF: *Valentine's Party*

02/16/78 TM plays at Keystone (with Crime & Novak), Berkeley

02/26/78 TM plays at Hula Palace Salon, SF: *Induced Vibrato* with Adrian Brooks and Winston Tong (performing *The Wild Boys*), benefit for the Eureka/Noe Artists Coalition and the Gay Community Center Building Fund

02/29/78 TM plays at Palm's café, SF

03/10/78 TM plays at the Mab (with Crime, The Sleepers)

03/12/78 WT performs in *Nijinsky, a birthday piece*, Top floor Gallery, SF

03/20&21/78 TM (BLR, SB, WT, VL) participates in a benefit concert organized for striking Kentucky coal miners at the Mab (with The Avengers, Dils, UXA, Negative Trend, The Sleepers, The Mutants etc.), SF. In 2003, White Noise Records put out *Miners' Benefit* with tracks recorded from the performances of UXA, The Sleepers, Negative Trend and TM ("Intro," "We Won't Go Back To Work," "Holiowex Flies Tonight," "Steven Brown announcement," "New Machine," "Litebulb Overkill")

03/29/78 TM plays at Palm's café, SF

03/19, 24, 25, 26&31/78 & **04/01&02/78**
The Angels Of Light in the *Sci-clones* show, with TM as musical backdrop (+TT). PP attends one of these shows, it is the first time he sees TM

04/20/78 WT performs *Solos*, namely *A. Rimbaud/Wild Boys/Bound Feet* at La MaMa theater, NYC. Music for *Wild Boys* composed by SB. See KAMERA ZIE, Interview, *Search & Destroy*, # 7-11, p. 76 : "(…) I feel some close connection with him [*i.e. with Steven Brown*] as far as music is concerned. He's done music for WILD BOYS (…) I wanted music that sounded like the Blue Desert of Silence, Desert of Blue Silence, the Silent Blue Desert – I don't know which. Anyway he did it and it was great…" First time that BG sees WT perform.
'All of the phrasing and quotes in the piece were adapted from Burroughs' book *The Wild Boys*, and the music from the soundtrack a la "Blue Desert of Silence" was recorded between 1975 and 1977 by Steven Brown.' (Moucci Tong, Winston's sister).
'*The Wild Boys*, after William Burroughs (…) Tong is himself the main puppet-actor. One sees him first living

Page 74

performed their first gig outside of San Francisco. However it didn't prove to be the triumphant homecoming that Reininger dreamed about, as 'they were rudely assailed by outraged locals who summarily invited them to "Go back to San Francisco, you godamn Bowie-imitatin' faggot-ass punks!"' [39] However the gig was preserved at the university video library and it is from this archive that a German fan later produced a bootleg LP named *L'Age d'Or*. The LP contains a few tracks never published elsewhere, among which a rendition of "Lili Marlene"; also two tracks entitled "Angel Of Love" and "Phantom Of The Opera" are respectively better known as "Pollo X" (or "Holiowex Flies Tonight") and as the final piece composing their later released *Urban Leisure Suite* (1980).

Miners' Benefit. Still in February, on the 20th more precisely, Tuxedomoon participated in a Benefit for striking coal miners in Appalachia. This event, the brainchild of Howie Klein – a punk pioneer in the Bay Area who had toured England with The Clash in 1977 – came as an offspring of the short-lived period of social activism that followed the Sex Pistols' ultimate concert in San Francisco (Winterland Ballroom) on January 14th, 1978. [40]
The so-called *Miners' Benefit* saw Tuxedomoon share a bill with The Avengers, The Dils, The Liars, The Mutants, Negative Trend, U.X.A, The Sleepers, The Nuns and more. A video, *Louder Faster Shorter*, was shot by Mindaugis Bagdon for the occasion but the film totally ignored Tuxedomoon (Steven Brown: "Of course we're not in the film. We were really the niggers of this scene: too arty, too this and too that, not at all hip…" [41]). And this even though the band was the only one that presented special material for the show (reworking of traditional miners' songs).

In March, Tuxedomoon will be involved with The Angels Of Light for the already mentioned *Sci-Clones* show, which is when Peter Principle saw them for the first time.

Victoria Lowe quits the band. Victoria Lowe left Tuxedomoon allegedly at the end of a concert at the Mab [42] in some theatrical gesture that was not understood by all. Paul Zahl [*then not yet a member of Tuxedomoon and in the audience*]: "She came out on stage the song before last and made a big announcement: "I'm sorry to inform you that I will no longer be performing with Tuxedomoon. I'm starting my solo career tonight. Thank you all for being so supportive of me and that's it for me in Tuxedomoon." There might have been nine people in the room, eating pop corn and drinking cheap beer…"
The whole story of Lowe quitting Tuxedomoon is worth elaborating upon a bit, as it is exemplary of the complex

personal dramas that will punctuate the band's nonetheless long life.

Victoria Lowe: "My part, since I didn't play instruments nor read music, was singing and I was very involved with the visuals. I sort of became our publicity photographer. I was involved with set design, costume design and the visual aesthetic of the band. I also would sing or back-up lead songs, "Lily Marlene," "Joeboy Police R"... But I was mostly involved in the visuals that I really thrived in, which was a spillover from my involvement with The Angels Of Light. I remember taking a series of close-up portraits of each of the band and made portrait masks that were used on stage. I also did a lot of photography for our slide projectors. I remember going to the library and going through beautiful books archive to find intriguing images, photograph them and make 35 mm slides and we would have these non-sense yet beautiful visual shows. And I tried to coordinate costumes. In the studio I always felt a little inept and we were all drunk anyway, so I always sort of hung around and time would pass, and I would sing when I could. It was great. Steven was so talented and would come up with such beautiful tunes and he was very serious about his work. I was on the inside and on the outside at the same time but it was a really inspiring place to be and I was thrilled to be part of it.

Why and how did I break up with them? It's kind of a loaded question and it's complicated. Looking back, I don't have a vivid specific reason so much but it was a combination of different factors. The first is that I was the only straight girl – mainly every Moon is gay – and there was a growing animosity as I was feeling more and more uncomfortable about the fact that I was the only female in the band. Also the truth is that I did feel inadequate as a musician and a little overwhelmed by my role. Looking back today I would not have done things the same way. I was quite talented as a performer and as a visual contributor but I couldn't see that at the time and I think that a combination of some tensions between the band members and me and my feelings of inadequacy and as the band got more notoriety, a little discomfort at the kind of local celebrity quality that was going on, made me feel very uncomfortable.

I remember it was Winston who kind of encouraged me to quit the band. I remember that we were all, particularly him and me, very obsessed with Patti Smith at the time. Winston and I were talking about Patti and Winston said: "You know, Victoria, Patti Smith lives her life out-front on stage. She has no secret and if you want to quit the band, you've got to do it out-front and on stage!" And he promised that if I quit the band, he was going to follow. So I regret this to this day and I'm sorry band members, particularly Steven and Blaine,

mechanically in a room filled up with manufactured rubble and later, as an *ombre chinoise*, as a shadow/puppet, reciting the credo of the so-called "blank generation." It's a delicate and distanced portrait of Burroughs's proto punk world, a world of wildly alienated homosexuals, with a tough skin and nothing inside.' (Press sheet BOA, the agency of Tong's agent in France, Maria Rankov, reproducing – in French – an excerpt from an article published in *The Villager*, 05/11/78)

05/28/78 TM plays at Palm's café, SF during which "How Strange" was recorded, later to appear on the double LP version of the *Pinheads On The Move* compilation album (Crammed, Cramboy, 1987). Set list: 1. "Instrumental" 2. "Nite and Day" 3. "Little Daughter" 4. "The Underground" 5. "Rhythm Loop" 6. "Cybernetic Cowboy" 7. "New Machine" 8. "Coal Miner Song" 9. "Lili Marlene" 10. "Rhumba" 11. "Death in Venice (loose)" 12. "Hing Diddy (loose)" 13. "Litebulb Overkill" 14. "Joeboy the Electronic Ghost" 15. "The Stranger" 16. "The Undergound" 17. u.m. 18. "Modern World" 19. "Remember" 20. "PolloX"

06/01/78 TM plays at 330 Grove Street (SF Gay Community Center, with Dils, Freeze, Negative Trend, The Sleepers), SF. 'The opening of 330 Grove Street (…) to Punk Music signified the end of the Mabuhay Gardens' reign as center of S.F.'s Punk scene': P. Belsito & B. Davis, *Hardcore California – A History Of Punk And New Wave*, Berkeley, The Last Gasp Of San Francisco, 1983, 6ᵗʰ printing of July 1996, p. 84

06/12/78 TM plays at the Mab, SF. VL leaves TM around that time

because I never talked to the band about quitting. I was in this Patti Smith rock 'n roll dream fantasy and once when we were performing somewhere, in the middle of the performance I announced: "This will be my last Tuxedomoon performance." I was quitting the band and it was all very dramatic to me and I remember that when the show was over Steven wasn't talking to me. And I was: "What's wrong with Steven?" But in fact he was extremely pissed off at me because I had announced I was leaving the band when I had not even told a word about that fact. And sure enough that Winston did not follow in my footsteps and I felt very betrayed by him and hence because of this kind of very traumatic and abrupt ending, I did not stay in touch with any of them. I did not really ever talk to any of them again (...)"

The fact that Winston Tong met and established a long-term personal as well as work relationship with Bruce Geduldig – a future member of Tuxedomoon yet to be encountered – around that time might not be unrelated to Tong encouraging Lowe to leave. Lowe: "You see I was very close with Winston. I would say I was in love with him, certainly as an artist most of all, and did in fact have a very limited sexual relationship with him in a very asexual sort of way. Things were odd on that level in those days. Well, my memory is that Bruce kind of shook things up between Winston and I. The short version is that: I was in love with Winston, who was basically gay, and Winston was in love with Bruce, who was basically straight... So with this lovely triangle of explosive potential, Winston was invited to do an 11-city tour through Holland, starting with a two-week run at the Mickery Theater in Amsterdam. Winston was very close with both Bruce and I at the time so he invited us along: me as the "lighting technician" and Bruce as "stage manager." It was quite a trip! But, it was the beginning of the end of my relationship with Winston. Bruce and Winston became closer and I felt increasingly estranged from both of them and upon our return we parted ways. I don't remember having any further contact with Bruce after that and barely any with Winston. It was a very painful time..."

Summer '78 Paul Zahl and Michael Belfer join TM

Paul Zahl and Michael Belfer join the band. Shortly after Victoria Lowe's departure, Paul Zahl came to live at THE HOUSE on 3645 Market Street, as documented in the preceding Chapter. In addition to being an accomplished drummer, Zahl proved to be a priceless studio technician who undoubtedly left his mark on the recordings he did with Tuxedomoon.

Around the same time, a young guitar player named Michael Belfer came into the picture. Born in Canada, Belfer had landed in Moutainview, California when he was nine years old, after one of his father's many journeys that brought him work in Palo Alto. The place was so bleak that Belfer was

Tuxedomoon at the Mab with (from right to left): Winston Tong, Paul Zahl, Blaine Reininger and Steven Brown. Photo Jeff Good

abused in school for expressing interest in reading books. "It's like the worst thing about the public education system in America. This is one of those school districts where all the kids (…) were kind of illiterate. They couldn't read or write. People would graduate from high school and not being able to read, it's incredible. So I started to be playing music, by myself at first and then I got a little electric guitar and I used an old reel to reel tape recorder as the amplifier etc. I only did that for about a year and then I went to look for people to play with…"

Michael was very inspired by Jimi Hendrix's guitar playing ("all these different kinds of filtering and distortions and echoes and feedback and playing backwards…") and spent most of his teenage years playing in garages with friends. That was how he met the drummer with whom he started the band The Sleepers, at age 16. After high school graduation he immediately moved to San Francisco to become a fulltime member of the punk scene.

He met Steven Brown at one of the Mab's already described booking parties. "Steven and I started talking. And he told me about his band and I told him about The Sleepers. The way we were describing our ideals, it sounded like we had the same band because we were very much interested into the same kinds of things. We wanted to achieve the same goals with our music. I wanted to do a lot of experimenting in the recording studio. I wanted to use the studio as an instrument.

Michael Belfer: "I was born in Niagra Falls, in Canada. My family moved around a lot. I don't think we stayed anywhere more than a year for the first ten years of my life. I think it's had a very strong impact on me as an adult. It's like I don't feel like being from anywhere. I don't know what my home is and I've lived myself in a lot of places (…) My father was always looking for something better and he thought: "Better over there." And so we just moved. He was raised in France during the war by nuns. He was sent to an orphanage when he was very small and they had to baptize him as a catholic because on that side of the family they're all Jewish. And my great grand-father, all of my great uncles, they were killed in Auschwitz. My father was kept apart from that (…) I never knew that growing up. He never told us that. It's my sister who actually discovered that because she had to take a genealogy course at the University and she did a family tree. She had the French government sending her our dad's birth certificate and they said that all these people were dead "pour la France" and would

Page 77

say Auschwitz with a list of the relatives of that person and it was all names like Goldstein, Rotstein, very much Jewish names (…) We never knew that when growing up, why we moved so much. We didn't understand our father. He never talked to us, he would never answer questions. Even when my sister came forward with these death certificates from France, he denied, he said: "That's not true" (…)

My grand-mother on his side came from Romania. I don't know where she met my grand-father who was David Belfer. But they were in the hotel business and they came from Poland originally (…) I would like to go there some day, that would be an interesting experience. That's one of the things I loved about being in Brussels, people looked like I could be related to them, they looked like my people and I had never been surrounded by that before."

And that was the inspiration I got from those Jimi Hendrix records, especially the two-three first ones, creating these incredible atmospheres in the recording studio. I love the idea of acid rock, having taken a lot of LSD as a kid and having all of those auditory hallucinations and thinking how great it would be to be composing music specifically for people that are going to be on acid listening to it. Of course, I don't take LSD anymore and I don't know anybody who does but the experience of having done it has left a mark with me. It's like I can always hear music in that way. That was one of the things that Steven and I had in common actually. We were talking about creating music that had sort of auditory allusions, trying to reconstruct what we were hearing under the influence of those psychedelics, trying to recreate these really intense atmospheres and energy, recreating the experience of an acid trip but doing it through the music and using the technology. And Steven was really into synthesizers and into processing sound, of taking the saxophone and running it through the synthesizer and processing it. Also I wanted to learn a lot more about synthesis in general. It was still a fairly new thing to me and he invited me to come over, to their studio at their house."

Brown was originally dead against the idea of recruiting a guitar player as he didn't want Tuxedomoon to be related to a rock genre that was totally alien to him. But then the encounter with Belfer made him change his mind. [43] "He was in a band called The Sleepers, remembers Brown. Dynamite guitar player! Somehow I lured him up to our den where Blaine and I have been living in this house overlooking the city (…) So I lured Michael up there, put a guitar in his hands and said [lowering his voice to a an imploring tone] : "Play!… Michael." (…) Michael… he does that fantastic guitar sound…"

Belfer: "So I went up to the house on Upper Market and got to the little room set up upstairs with the reel to reel. At that time we were just using a four track reel to reel. Blaine was very skeptical of me. He felt threatened. He felt like he had the guitar playing covered or, you know, am I Steven's new ally and then it'll become Steven and Michael against Blaine.

But Steven had some kind of intuition regarding me. And as we walked into their recording room Blaine seemed startled, like: "Who is this guy?" and "You know Brown (as Blaine would address Steven) we got a lot of work to do." Steven tells Blaine that I've got all kinds of new song ideas, and he wanted me to record something. The whole notion that I had all these song ideas was total bullshit, but I just rolled with the flow. I remember I had to lie to them and say: "Oh yeah, sure, I've got this new song idea!" Steven said: "Well Ok, I'll engineer it! We'll put you up on the first track. Go ahead: play!" And I just started improvising something. And he said: "Ok, do you

want to do overdub to that?" And I said: "Yeah, put me on the second channel" He put me on the second channel and played harmony to the first track and while I was doing it, I came up with some other ideas and I said: "Put me on the third track" and he did and I kind of finished off the piece.

It turned out that I was being auditioned and I didn't even know it. No one had asked me if I wanted to join the band. I didn't think I was going up there to become part of the band. They would listen to the piece for a few days and then they would ask me to come and record with them (…) Oddly enough, about a year later, Winston [*Tong*] got a request from his friend in NYC, Diego Cortez, a film-maker. Diego was making a film about the Baader-Meinhoff gang that he titled *Grützi Elvis* and he wanted some music from Tuxedomoon. Winston sent him a tape of all these forgotten recordings, which included that funny little audition composition, and that was the piece [*entitled "Eurasianstab"*] that Diego chose. By the way, that soundtrack for *Grützi Elvis* came out on Ze records and included a bunch of tracks produced by Eno of the downtown Manhattan "No Wave" scene. bands like DNA, Lydia Lunch, Mars, Teenage Jesus etc. etc. and I would kill to find a copy!?"[44] Unfortunately to this date, neither film (a feature with Anya Phillips, Vernon Presley; produced by Michael Zilkha, Michel Esteban) nor soundtrack (co-produced by Diego Cortez and Brian Eno) were ever released.

Another (mis)adventure out of town. In June '78, Tuxedomoon embarked on a strange venture – very Pink Floyd in a way – when the band (composed of Brown, Reininger, Tong and Belfer) drove to the desert of Nevada in Tadlock's pick-up truck for the dedication of a giant earth drawing (in fact a stone wall in the shape of an enormous triangle). Tuxedomoon were to play at sunset, providing dinner music for some 40 invited guests while the artist, Ann Labriola, was to descend on the area by helicopter. Belfer: 'Tadlock had all kinds of really far-out audio systems he was designing (…) for both live performance and for the recording studio that he put together at the house on upper Market Street. How about a self contained live set-up where there were no individual amps, everyone came out of these two big speaker cabinets in Stereo being mixed by Tommy from the side stage. They could also run on Diesel truck batteries. Which would be used when we played at this art opening out in the middle of the desert in Nevada.'[45] However this was not painlessly conducted as Tadlock's pick-up truck broke down in the mountains *en route* to the site with the performance being consequently delayed.

06/78 TM (BLR, SB, WT, MB, TT) plays 'at environmental sculpture opening in middle of desert outside reno nevada. provide dinner music for some 40 invited guests… artist ann labriola arrives at remote site by helicopter… band plays electronic music powered by ten truck batteries' (excerpt from a SB CV)

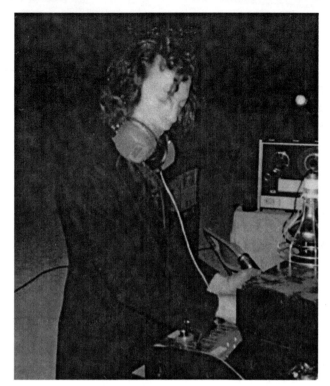

Tadlock working on The sound of Tuxedomoon in the desert of Nevada. Photo Bob Burnside

Summer '78: TM (BLR, SB, WT, MB and PZ) records "New Machine," "Litebulb overkill," "Nite & Day (Hommage à Cole Porter)," "No Tears," prod. TM and TT. These pieces will compose a 12" first published by Time Release Records (1978) then by Crammed (Cramboy, 1986). Later these tracks will be part of the *Desire/No tears* CD published by Crammed (Cramboy, 1987 and 2003)
Arrival of Adrian Craig as TM's manager

"I wrote "No Tears," says Reininger, when I split up with a girlfriend, but then discovered that I was incapable of feeling anything. I thought that I should be able to feel something, but in the end I didn't. So I wrote this piece. Some of my best songs have come out of similar situations. In the end when I separated, I was relieved deep down. I felt that I should be upset because that woman had left, but actually I was happy to get rid of her. The same thing happened with the piece "What Use?" - separation with a girlfriend and then again me feeling nothing. I thought that I ought to feel hurt (I was a little hurt, actually) but the same hidden relief showed up" (I. RALLIDI, "I'm a citizen in the demonic empire. Interview with Blaine Reininger", Sholiastis (Greece), 1988, translation by George Loukakis)

"No Tears." The early summer of 1978 had seen the arrival of Paul Zahl and Michael Belfer right in time for the recording of the *No Tears* EP, featuring "New Machine," "Litebulb Overkill," [46] "Nite & Day (Hommage à Cole Porter)" and the legendary "No Tears." It was recorded at Peter Miller's studio with Tommy Tadlock still officially producing alongside Tuxedomoon, but in the troubled atmosphere that Paul Zahl described in the preceding Chapter. Belfer: "Tommy Tadlock was supposedly producing it. He was there in the studio when we were recording. But what he was doing I'm not sure, the engineer was really producing it."

The piece "No Tears" was written by Blaine Reininger and was allegedly offered to Steven to sing as a reconciliation present after one of their quarrels. This song probably remains the most popular Tuxedomoon song to date. There isn't a single Tuxedomoon concert, even today, without people in the audience shouting out for this song, to no avail as the piece requires real drums that have been missing from most of Tuxedomoon's concerts and furthermore represents a very "rock" approach from which Tuxedomoon are very distanced. Reininger: "At that time we became to be more like a band and we had a drummer from time to time, Paul Zahl. The band was more rock, with the drums and bass and guitar. Eventually things moved back around again, we stopped working with the drummer.

There was always this tendency in the band, probably mostly from Steven and Winston I suppose, to pull the band away from being rock. I wanted to rock, I came out of rock music and I played guitar and I like rock. I like the beat, the rhythm and performing, I like the energy. So there was always this kind of cross current of me being something like the Paul McCartney. Although it's not really so. I always wanted to pull things in a more rock direction, a more psychedelic rock, bit avant-garde. So at some times my faction would win out and at some other times Steven's faction would win out.

"No Tears" is very rock but the next thing that followed we had already moved towards more of an electronic kind of thing."
The record was financed by Adrian Craig, originally a fan who would move on to become Tuxedomoon's manager for about a year. Craig set up Time Release Records for the occasion but the actual release was delayed until January 1979, [47] as Craig's

expected cash had to come from the proceeds of an auto crash settlement which took time to pay out.

Fall-out with Tommy Tadlock; Peter Principle joins the band; Bruce Geduldig starts collaborating with Tuxedomoon. The Fall of 1978 was a troubled period and decisive in Tuxedomoon's evolution as a band. First of all came the fall-out – already described in the previous chapter – with Tommy Tadlock.

Belfer: 'We had a falling out with Tadlock, and I remember coming to the studio one day only to find all the equipment gone, and our tapes just laying there, not even rewound, like across two reels!!!'

Reininger: "After having been cast out by Tom Tadlock – which forced us to leave the house on Market Street as well – we didn't know what the hell to do. All of a sudden we didn't have access to all of this wonderful equipment. So we were obliged to find another way to make music. I remember Steven came to my apartment and he had hepatitis. He decided my place was a good place to just come be sick, sleeping on my floor. So we were both there, lamenting on our fate.

We were rehearsing in my kitchen. We managed to borrow some equipment, made some attempts to do some music. But we were both depressed so we didn't do anything. Also we couldn't really play with just the two of us. It's just not enough noise because we didn't have enough equipment. What we did was to become a band. We couldn't make tapes anymore. We didn't have access to these recording facilities anymore, so we decided it was time to find other musicians, find a bass player, for instance (…)

We went on radio. We were doing an interview with this guy who had a punk rock program at night and we said: "We need a bass player" and Peter [*Principle*] happened to be listening. Adrian Craig made his house available to us just to rehearse. Peter came there one day. We wanted him in the band because he had an amplifier [48] but it was not the only reason. Mostly he could play! One problem with a lot of these people that we were seeing is that they didn't have any basic musicianship. They had the pose and they had the ideology but they couldn't play their instrument. We needed somebody that could play! Peter knew how to play a guitar. So, "Yeah that guy is the best that's come along. Let's work with him!" We had some shows coming along. Initially I thought that Peter could play these shows and who knows what we were going to do after that… But he stayed and we kept working together. So that's how Peter got involved…"

Peter Principle, who was then living at 1344 McAllister Street, reminisces about how he became a member of Tuxedomoon: "(...) I had got a bass guitar in an exchange and had taught

07/16/78 TM plays at Palm's café, SF

08/11&12/78 WT performs *Solos* at Eureka Theater, SF

08/12/78 TM plays at the Mab (with The Sleepers), SF

08/18&19, 25&26/78 WT performs *Solos* at Eureka Theater, SF

08/27/78 TM plays at the Mab (with Timmy Psychopathic electricians), SF

Fall '78 Fall out with Tommy Tadlock (when he painted the door frame red at 3645 Market Street). As a consequence TM does not have all of TT's gear at disposal anymore and are forced to become a "normal" band with a drummer (PZ) and this will lead to PP's arrival in the group in September

09/01&02, 08&09/78 WT performs *Solos* at Eureka Theater, SF

About the origin of Peter Principle (né Dachert)'s pseudonym. "The Peter Principle [developed in the book entitled The Peter Principle by Laurence J. Peter (published by William Morrow & Co., 1969)] is a theory of advancement in the corporate world and it was a Dada joke but I hope it doesn't become a self-fulfilling prophecy (…) Because in the Peter Principle, the idea is that you get accelerated up the ladder of success to your point of incapacity and there when you fail you stay. So it's not exactly a great icon for a self-image but I didn't think about that at the time, I only thought about the pun [the term is a pun on Sigmund Freud's theory of the pleasure principle]. And also because I'm the principled one. At least I have been in the past the extreme idealist. Then there was a joke in it but even I didn't understand the economic theory involved in it at the time, I just took the name. I knew that the book existed and I was looking for a better name than Carcinogenic and a better name than Dachert and so I thought: "Oh Peter Principle, that's great," out of a whim. But people used to leave me copies of the book on stage all over the world: they would have brought paperback copies of the Peter Principle and left it on my amp or something, like they thought I didn't know. So I got so many times a copy of that book that I've read it and I know what it is. That book is by a guy named Dr Peter and he is a social economic theorist. It's like Murphy's laws: every time you do well it'll advance you until you don't do well and then you'll be stuck there with no possibility of advancement anymore and your reputation will either get worse if you continue not do well and then you're gone, you're fired or ignored or otherwise you'll have to change job and start again, that's the theory. That's why in America, everybody avoids responsibility. They like to do everything by committee and it's always somebody else's fault if it didn't go well. This way you don't become a victim of the Peter Principle because you take no responsibility for anything. Even the President of the United States is like that now…"

myself that bass guitar and at the same time new music was starting to happen. That was around 1977 and I started to play with a group called The Doctors [with whom he named himself Peter "Carcinogenic"]. We played at the Mabuhay Gardens. Two of the guys worked as night nurses at hospitals, so we had these lab coats. It was a punk band, it wasn't something serious.

In the meantime I had seen Tuxedomoon with The Angels Of Light and I had heard that it was Tadlock and Brown and Reininger in the orchestra pit and so I saw The Angels Of Light doing their theatrical thing. That was really cool but I did not know who made the music or did they have a connection with that record that they started to air on the radio. I heard a demo cassette of "Litebulb Overkill" and "No Tears" (sent at *The Heretics* radio show, that played punk songs from demos of lots of local bands) and I thought: "Wow…" This kind of music has got to be very cool because it wasn't as wacky as The Residents but it was as experimental as what I used to think that rock music had gotten like when I was really fascinated by it in the late sixties. So here is this kind of punk music that is already mutated into something else, really interesting. I also at that time read an interview with Winston Tong for *Search & Destroy* in which he discusses himself as a member of Tuxedomoon. I thought: "Wow, maybe they're a bunch of Chinese Americans and that would be a really great fusion to do rock music with people coming from a totally non-western musical tradition." And since I've always been interested in oriental music...

Anyway, on the radio they said that they were looking for a bass player. So I took the phone number and went over there to audition. It was only Steven and Blaine in Adrian Craig's boyfriend's house. There's a funny story connected with that too. Before I had met them and during this Doctors period and even before that I had gotten involved in a production company and we booked punk rock concerts at a place called the Gay Community Center, 330 Grove Street. It was right up the block from The Residents' warehouse and Mel, Adrian Craig's boyfriend, was the director of this community center. At a certain concert, with The Dead Kennedys, some people had thrown the toilet out the window and it landed on a car parked on the street below. Of course we had no insurance to cover this and so I had gotten thrown out by Mel: "Out of the Gay Community Center for ever now!" And like a week later I showed up at his house to audition with the band that his boyfriend was managing and would let rehearse in that house! So I showed up there and I passed the audition, then we did some gigs together (…)"

In September, Tuxedomoon played some memorable gigs: one was at the Pit, a club in a South of Market residential

Page 82

warehouse called Project One and two shows entitled *Art Songs of the 20ᵗʰ Century* at the Eureka Theater. Around this time Bruce Geduldig, Winston Tong's partner in visuals, started to collaborate with Tuxedomoon as well, introducing films and slide projections that soon became an essential component of Tuxedomoon shows.

A native of Santa Rosa, California, Bruce Geduldig had graduated in interdisciplinary creative arts at California State University, a curriculum that provided him with a solid training in performance art as he studied film, television production, radio production, electronic music, advertising, psychology, creative writing and more. Geduldig remembers his time at the University as a crucial one in defining his approach to film-making and using films for performances. "There were a lot of Marxist teachers and a very rebellious counter-culture attitude in San Francisco especially. There was a lot of radical structuralist perspective on popular culture, television, popular films. Sort of a spirit: "Let's demystify this stuff and see how it works," looking for subliminal messages in advertising and things like that. So it was a radical approach to film-making and it probably gave me the format that I still use when I make film, kind of a non-narrative approach to telling a story rather than using the normal format or illustration. For Tuxedomoon, instead of illustrating a song, I would choose a film that could work alongside or even collide with the intention of the song, so it had a life of its own, so it wasn't dependant on the music and the music wasn't dependant on it. They existed side by side and hopefully created some kind of poetic collision."

After graduation, Geduldig had traveled through the United States. He was living in New York City when, following some friend's advice, he went to see Winston Tong performing at the La MaMa theater in April 1978. Geduldig: "I went to see the performance and just loved it. I went backstage afterwards and met Winston and we just kind of understood each other right away. It was obvious that we could eventually do something together. So when I finished my journey and went back to San Francisco, we met up again. He started collaborating more and more with Tuxedomoon. And at that time Tuxedomoon would be quite modular. At one concert Winston would be there and at another concert he wouldn't, some other concert Michael Belfer would be there, a lot of people… Paul Zahl sometimes would be there. And that's how I started actually working with them.

We talked to them about me projecting some films during the concert. Quite soon after that Winston and I started working together on more theatrical projects that use the same kind of elements as the one we were using with Tuxedomoon. Certainly concerts is a totally different situation, nothing is very

09/12/78 TM (with WT) plays at the Pit, SF. Some never published tracks are performed like the allegedly by hepatitis tainted "I'm seeing yellow where it should be blue," "Tonite are you living?" and superb Pasolini inspired "Teorema" sung by WT

Greg Langston at the Pit show. Greg Langston, who will later become Tuxedomoon's drummer, remembers of the Pit show: 'First, the Pit itself. A metal catwalk leads downstairs to the door. Inside the stark concrete room a single colored bulb lights the stage. People milling about were very "cool" compared to myself and suburban friends, some dressed head to toe in black leather, punks and new wavers. On the Rag played their joyous cacophony, then The Hitmakers mod fun. Tuxedomoon were swirling and hypnotic, with uncommon instrumentation. Peter was tall and somber in his striped jacket. Steven, calm behind his synth, then dynamic death-like vocals. Blaine was lurking around like a madman while torturing his violin. They all looked quite crazy. Winston shut his eyes and let the music take him away, as if in a trance. He'd sing softly then scream. Paul was simply amazing on the drums. I had seen him in Killerwatt and I knew he was quite capable. The band rocked hard, yet sounding like nobody else. The set was probably close to the one I would be learning in a few months. When the show was finished, I knew I'd see them again, and I did, at the Mabuhay. I remember later seeing photos of this show and seeing myself in front studying everything. I called Aquarious records every other day to get the new record as soon as it came in. With this and the first single, I knew six songs of the set. When I found out from the radio that they needed a drummer, I already knew some of the set. Soon, I was in! Although it lasted less than a year, I enjoyed every minute of it, and it was a solid beginning of a twenty year music career' (e-mail sent by Greg Langston to the author, 09/13/02)

09/21&22/78 Two concerts by TM (with PP) + WT&BG entitled *Art songs of the 20ᵗʰ century* at Eureka Theater. After these gigs WT will momentarily leave TM to concentrate on theater

The Portraits. Gregory Cruikshank: "At one point Winston and I were quite close and he asked me if I had ever met "that" boy. The really amazing thing is that he had seen a poster (it was a flyer with a black and white picture with the boy's eyes glaring) with a photograph of that boy and had kept it because the picture was something that he always had wanted to have with him put on the wall. And that was Bruce Geduldig… I think it was only a year later, or even more, that they actually met. I remember that story because I was so jealous! Once he came to my house and he said: "I met the boy, I met the boy in the flyer!" I think that there was a really strong connection between those two. At that point it wasn't Victoria's obsession with Winston, it was Winston's obsession with Bruce."

Bruce Geduldig: "The first time I saw Winston was in a film by Patrick Miller [*aka Minimal Man*]. It was at a punk/new wave event somewhere. There were some images of Winston in a park with sunglasses on and bleached blond hair. I just thought like: "Wow, this guy is exotic and great." And then for most of the people, seeing this Chinese guy on stage, doing the kind of delivery and heartfelt poetic outbursts that Winston did, kind of Patti Smith in a way, coming out of nowhere and brilliant… He was immediately captivating because he's Chinese.

Page 83

```
O GOD WHAT AM I TO DO WITHOUT YOU
O GOD HOLD ME TIGHT JUST HOLD ME

IT HAS TO DO WITH LOVE
NOTHING BUT ZEROS IN THE REGISTER
NO MR NO MRS NO MS
NO MESSAGES
IT HAS TO DO WITH LOVE
A WORLD OF LOVE
LEAVE YR LITTLE BOY ALONE
& SEE HOW YR GARDEN GROWS
IT HAS TO DO WITH LOVE
WHEN NOTHING'S UP YR NOSE OR IN YR CHEEK
NO BONDAGE NO BAILBONDS NO DOPE
IT HAS TO DO WITH LOVE WHEN THERE'S NO HOPE
IT HAS TO DO WITH LOVE WHEN THERE'S NO HOPE

LET'S PUT AN END TO THIS CONFUSION
SET SOME THINGS STRAIGHT
C'MON BABY
TWIST & SHOUT
IT HAS TO DO WITH LOVE WHEN THERE'S NO HOPE
IT HAS TO DO WITH LOVE WHEN THERE'S NO
```

WINSTON TONG
SF 12/26/78

It's the first thing that sort of hits you. It's like when I first saw him in New York, in this off-Broadway collection of pieces, part of the fascination is that this person is like Chinese doing this really punk stuff, wow. And all the sensibility, you sense immediately some of the Chinese family. You just see it right away. It's just operating at a different wave length. There's a whole different set of rules involved in this person's sense of reality and presentation. And so this person crossed over, Winston was one of the first crossovers. For me he was immediately exotic and interesting, and not just because he's Chinese, it's much more than that. He's a genius. When he's on he'll just roll over anything and everything just because he sees this right, it's clear. That's what a genius is: a clear channel to God."

10-11/78 WT + BG&VL on tour for 11 dates in the Netherlands including perf. at the Mickery Theater in Amsterdam. WT, whose agent in Europe is Maria Rankov, performs *Solos*, namely *A. Rimbaud/Bound Feet/Wild Boys* for the first time in Europe. From now on, all WT's mentioned perfomances will include BG

elaborate in terms of depth in a sort of story. So we did performance art that was more theatrical than most performance art that I saw as it was less conceptual and more kind of modern fairy tales in a way, modern mythology. And meanwhile at the same time collaborating more and more with Tuxedomoon, becoming regular units."

After these shows, Winston Tong deserted Tuxedomoon to concentrate on theater, only to return in January 1979 for the recording of the "The Stranger"/ "Love/No Hope" single and later participate in a few gigs. Around October '80, he reunited with Tuxedomoon for their first European tour.

The turning point: Milk and Moscone's assassinations.
On November 27th, 1978, San Francisco Mayor George Moscone and gay activist Supervisor Harvey Milk – both extremely popular – were assassinated by Dan White. White was a "family man," who represented conservative values against Harvey Milk's gay and pro-minorities activism. He had grown a hatred towards Milk and Moscone as they both got in his way of re-investing a position as Supervisor from which he had previously resigned. [49]

This double assassination raised such emotion in San Francisco that it was expected that Dan White was going to spend the rest of his life in prison. However on May 21st, 1979, an all-straight jury convicted Dan White of the lightest possible charge for the assassinations of Milk and Moscone. White's defense had argued that his over-consumption of junk food and sugars (the so-called "Twinkie defense") pointed to a state of deep depression. He was sent to prison for an eight-year sentence (of which he served five years; he committed suicide less than two years after his release).

To many it was clear that White wouldn't have got away with such a light sentence if only (the straight) Moscone had been killed and hence felt that the sentence was tainted by homophobia. That night, thousands of angry citizens, gays, punks and straight marched on the City Hall, where they rioted

Page 84

and destroyed police cars, provoking a police crackdown in retaliation a few hours later (this episode became known as the "White Night Riots").

These tragic events led to radical changes of policy in San Francisco, as 'under new Mayor Diane Feinstein, the city's boho-friendly downtown was torn up for redevelopment: speculators moved in and brand-new office buildings went up.'[50] "The city took a turn to the right after that. It was a coup," says Peter Principle. "It was disguised as some random act of a madman but they immediately sacked the police chief, who refused to take the stick to demonstrators. He was the first to go."[51]

It was the beginning of the end for San Francisco's "third golden age"[52] as the scene began contracting and by 1981 most of the original enthusiasm for punk had faded away.[53] Steven Brown remembers: 'We all participated in that march after the double assassination. I walked with Blaine. I believe I was staying at his place on Market Street at the time and march went by the apartment house. We always cited this tragedy as instrumental in our leaving San Francisco. Supervisor Diane Feinstein immediately became Mayor and we always had our suspicions about her and her real estate businesses. We even wrote a song: "Dear Diane your 'slip' is showing, we know what's going on..." (…) I used to take my film to get developed at Harvey [*Milk*]'s camera store on Castro Street.' Peter Principle observed in October 1980: "There used to be a couple of decent clubs in San Francisco but now there's only one I can think of, this place is called Savoy Tivoli. There's nowhere worth to play now, it's just like anywhere else. It used to be a little bit better when there was the Deaf Club and whatnot but the political scene there has changed since the assassination of the Mayor."[54] This episode, one of the reasons why Tuxedomoon later departed for Europe, inspired Tuxedomoon's song "(Special Treatment For The) Family Man" (recorded in August 1979 as part of the *Scream With A View* EP).

11/27/78 Double assassination of SF Mayor George Moscone & gay Supervisor Harvey Milk by Dan White

12/02/78 TM plays at Eureka Theater, SF

12/06/78 TM plays at the Mab, SF

12/09/78 TM plays at the Mab, SF

12/14/78 TM plays at the Mab, SF

12/24&25/78 *Free party xmas nite* with Tuxedomoon + it came upon mdnite; Queer, Mabuhay Gardens, SF

12/31/78 TM plays at the Mab, SF

01/01/79 New Year's eve private party (that was performed after the gig at the Mab during the same night)

End of 78 PZ leaves TM

CHAPTER IV
Outgrowing San Francisco

In 1979 Tuxedomoon was not solely consisting of the duo Reininger/Brown anymore. It had become a band, even if its personnel tended to shift.

From 1979 onwards, the band will enlarge its horizons, outgrowing San Francisco and ultimately reaching the European shores, staying there for a much longer time than they could have imagined back then.

> **1979: recording of the "Stranger"/ "Love/No Hope" single; Tuxedomoon plays at the Deaf Club in SF; Tuxedomoon plays LA and the East Coast; The Residents' connection: Subterranean Modern compilation and Scream With A View EP; New No Wave Festival in Minneapolis; Michael Belfer drifts away; recording of the Half-Mute LP; Tuxedomoon plays at the Boarding House**

The first notable event of 1979 was the recording of the "The Stranger"/"Love/No Hope" single by "Winston Tong w/ Tuxedomoon," to be released by Adrian Craig's Time Release Records. It saw Peter Principle's first appearance on record with Tuxedomoon, along with Greg Langston playing the drums on "The Stranger." It was also Paul Zahl's last recording collaboration with Tuxedomoon, co-producing (with Tuxedomoon) and playing drums on "Love/No Hope." Tommy Tadlock was back on board producing "The Stranger."

In January Tuxedomoon also entered into a two-year personal management contract with Adrian Craig, terminated a few months later when the band stroke a deal with Ralph Records.

Tuxedomoon plays at the Deaf Club in San Francisco. During San Francisco's punk era, there were quite a few entrepreneurs looking for new cheap places for bands to play. Going about his daily business Robert Hanrahan (the then manager of The Offs and Dead Kennedys) noticed a small building one day on Valencia Street with a sign that read *San Francisco Club Of The Deaf Inc.* It was in this second floor social club for the deaf 'that the most memorable series of punk shows to rattle San Francisco's ear drums took place,'[1] starting on December 2nd, 1978 until by the end of the summer of 1979, when the club became the victim of its own success and closed down due to its inability to comply with fire codes and maximum occupancy regulations. Although the

From environmental to dreadful. "'Recently, a couple of people told us that they were terrified by our shows," says Blaine Reininger (...) "And it is true," continues Reininger (...) "that a number of our songs are based on certain intervals in music that are traditionally known to create tension and fear. There is this one interval, the tritone, that was banned by the Church in the Middle Ages. It was considered the Devil's sound." "But we are not satanists or anything like that," Steve [sic] Brown (...) hastens to add (...) Reininger and Brown cite William Burroughs, David Bowie, Albert Camus, John Cage, Brian Eno and Giorgio Moroder as influences. Their music is a blend of rock and roll, esoteric electronic music and *musique concrète* (...) Reininger: "(...) To take those avant-garde ideas and wed them to the primal rock and roll beat, that's what we're doing." (...) "I guess our original concept was to provide environmental music that didn't make any demands on the listener," says Brown, "We wanted to provide an environment so people could drift in and become involved in it and then they could drift away and go on with their conversation. But our ideas have changed a lot since then. We no longer try to be unobtrusive." "We're after displacing the audience now," says Reininger. "Creating a tension that can take people out of their normal framework. Transporting the audience to a different space.'" (M. GOLDBERG, "The terror of Tuxedomoon", SF Chronicle, 01/14/79)

1979

Some time in '79 WT&BG perform at the Walker Art Center of Minneapolis

Some time in '79 BLR & SB (prod. TT) guest on James Himself's 7" entitled "The City Of Merchandise" (James Himself was in fact James Jacobs – deceased in 2000 – a friend and benefactor for TM as he financed the purchase of the micro moog that was TM's only synth for years in spite of the band's reputation to be a synth band)

Early '79 Greg Langston joins TM replacing PZ

01/01/79 TM plays at a *New Year's Eve private party*

01/79 Recording of the 7" including "The Stranger" and "Love/No Hope" by "Winstong Tong with Tuxedomoon" (BLR, SB, first appearance of PP on record, GL on drums on "The Stranger" and PZ on drums on "Love/No Hope" + voice Albert Camus, prod. TT for "The Stranger" and TM & PZ for "Love/No Hope", published as a 7" by Time Release Records in '79, later to appear on the *Pinheads On The Move* compilation album (Crammed, Cramboy, 1987). This release marks the reconciliation between TM and TT

Early '79 Recording of "Straight Line Forward" during a rehearsal by TM (BLR, SB, PP, MB) and voice Ricky Williams (The Sleepers), later to appear on the *Pinheads On The Move* compilation album (Crammed, Cramboy, 1987)

Early '79 Recording of "Fifth Column" during a rehearsal of TM (BLR, SB, PP) by Christian Hoffmann, vocal take of *Half-Mute* track, later

Page 87

to appear on the *Pinheads On The Move* compilation album (Crammed, Cramboy, 1987)

01/11/79 TM plays at the Mab (with Noh Mercy), SF

01/24/79 TM plays at old JC Penney building (with Rachel Webber): *Girls At Play*

01/25/79 Signature of a two-year "personal management agreement" between Adrian Craig/Leroy Mentley and TM (represented by BLR, SB and WT) that will however be terminated by the later deal with Ralph (see *Scream With A View* EP, 08/79)

01/27/79 TM plays at the Mab, SF

02/14/79 TM plays at the Deaf Club (with Noh Mercy and Pink Section), SF

02/16&17/79 WT&BG perform *Bound Feet* at Eureka Theater, SF

Interview of Tommy Tadlock ("T") by Patrick Roques for Vacation Magazine ("V"), Oct. 1rst, 1979, with Steven Brown ("B") occasionally participating in the conversation:

'T: (…) what about that suicide at the Deaf Club.

V: You saw that? I can't believe it.

T: Right as this band called Red Asphalt was playing, they were real percussive, an anti-music, anti-life, anti-everything kind of sound.

B: This guy jumped from the window while they were playing?

T: Yeah, this guy got up on the fire escape and screamed: "I can't stand it any longer!" Splat! Right there on the sidewalk.

V: I heard about it but didn't believe it (…)

T: B(…) from the group Blank was on acid at the Deaf Club and he went outside and just stared at this dead man who had jumped out of the window. When the police took the body away there was a chalk outline on the street with all this clotted blood all over. He looked at it and then squatted down like a shaman reading chicken's blood and moved it around with his fingers looking totally freaked out. The police were looking at us: this kid is out of his mind. And all the time there's this Da! Da!Da!Da!Da!Ta!Da!Ta!Da! blasting out of this building. I said: "B(…), let's get out of here. The cops are looking weird at you." He looks at me very seriously and says: "This is very important." He was making these ritualistic designs in the blood. Then he made a very introspective face and spit into the blood! I grabbed his arm and got him out of there.'

blossoming was brief, for a short-lived period the Deaf Club had become synonymous with punk and practically all the emerging bands in the city played there to capacity crowds. [2] 'The place was reminiscent of Beat novelist Jack Kerouac's description of the underground jazz clubs in Frisco nearly three decades earlier. The crowd face to face with the band in a tiny, smoky, steam box of a room, pogoing, screaming, drinking, drugging, necking, pressed together, throbbing like one big heart (…) It was so loud that speech was as useless for the punks as it was for the deaf people who always came to the gigs.' [3]

Tuxedomoon began to play there quite early on. "We were involved with the Deaf Club right from the beginning, remembers Reininger. We started to play there more often than we did this other place [*i.e. at the Mab*]. That was an interesting place. It was opened to new people (…)"

'The Deaf Club was a scene out of a horror movie, recalls Scott Ryser [*of The Units, i.e. one of the most popular San Francisco bands from the punk era*]. There was no sign or light or anything out front. You just knew where it was. I remember going up a long narrow staircase to get to the actual club. The staircase was full of smoke and must have been two feet wide, four stories up, and jammed with people. Getting up there was half the fun. I remember stepping over a dead person on the sidewalk who had fallen out the window. Right in front of the stairs. The ambulance was on the way, and we had a soundcheck, so we stepped over him and made our ascent up Mt. Everest. If and when you made it to the summit you squirmed into the room like a sardine into a can. Once inside, the smoke from the stairs turned into a fog so thick the light from our projectors could barely find its way to the screens. You couldn't hear a fucking thing. It didn't matter because half the people in there were deaf anyway. They were either born that way or had developed tinnitus like me from having put their heads next to blaring loudspeakers for too many years. I clearly remember our first show there. People were spitting on us. Well, not really on us, more like at the stage. From the ground level stage, trying to peer through the spit, lights and smoke, the audience looked like the *Night of the Living Dead*. Only with smiles.' [4]

Peter Principle: "The Deaf Club was the center of a sub-scene but it was THE center. That was the place where you could go with no idea of what was going on there and be sure to be entertained. It was always interesting plus the atmosphere of the Deaf Club itself was a hundred percent unique because of the deaf people. They would just be snoring of cocaine off the table in the back there, all those fucking deaf people. The bartender was deaf, so you had to order drinks and everything with sign language or writing. There was no way

Page 88

to talk your way in at the door either because the door person was deaf. This was fabulous! Plus they really liked it because they said they could feel the bass and everybody jumping made them feel good. So they were really depressed when it got closed but it was the fire laws that got it closed and rightfully so because the place was surely a fire trap. But that was a great club and they were for sure doing really bizarre stuff (...) We used to play there all the time actually." [5]

"59 To 1," one of Tuxedomoon's best songs was created at the Deaf Club: "Steven and I once worked out an entire set for a duo show at the Deaf Club from which Tuxedomoon culled "59 To 1,'" recalls Principle.

Tuxedomoon were regulars at the Deaf Club until the very end and featured on the farewell compilation LP *Can You Hear Me? Music From The Deaf Club* that was recorded in September '79.

The building that hosted the Deaf Club on Valencia Street in 2003. Photo Isabelle Corbisier

Tuxedomoon plays LA and the East Coast. In early March '79, Tuxedomoon played their first two dates in Los Angeles at Madam Wong's, where they were supposed to share a bill with Noh Mercy! (Esmeralda Kent's duo that had released a single, "Caucasian Guilt" on Tadlock's label and with which Tuxedomoon shared a manager). Unfortunately Madam Wong didn't appreciate the quite punk lyrics of "Caucasian Guilt" [6] and refused to let the pair play. Peter Principle: "She and her Chinese mafia henchmen were threatening to force us off the road on our way back to San Francisco and that they would be following us for years. The actual quote went: "Years from now, after you have forgotten this event, you will look over your shoulder and you will see THE TONG." To cut a long story short, Winston told them that HE was Tong and negotiated for hours with Madam Wong in Chinese to get her to reinstate the gig. She would still have nothing to do with Noh Mercy! though, so we had to do two sets per night." [7]

From March 27th until April 9th, Tuxedomoon embarked on their first East Coast tour. The "No Tears" EP had just been put out and it was on the strength of that record that they went to New York City.

Reininger: "That was a breakthrough but this was also the work

02/19/79 TM plays at Victoria Theater (with Minimal Man): *Sound Of Sex*

02/23&24/79 WT&BG perform *Bound Feet* at Eureka Theater, SF

02/25/79 TM plays at 330 Grove Street (with WT and Noh Mercy), SF

03/04/79 TM plays at the Mab, SF

03/05&06/79 TM (with WT) plays at Madam Wong's (with Noh Mercy), Los Angeles. On the 6th, recording live of "Touched" (BLR, SB, PP, GL), later to appear on the *Pinheads On The Move* compilation album (Crammed, Cramboy, 1987)

03/09&10/79 WT&BG perform *Bound Feet* at Eureka Theater, SF. Later they go to Chicago, Minneapolis and New York City

03/11/79 TM plays at the Deaf Club (with Mutants, MX-80 Sound, Pink Section), SF

03/14/79 TM plays at the Mab (with Cramps and Pink Section), SF

03/16/79 TM plays at Pauley Ballroom (with Readymades, Cramps), SF

03/21/79 TM plays at the Mab (with Pink Section and Units), SF

03/22/79 WT&BG perform Bound Feet/Nijinski at La MaMa Theater, NYC

From 03/27/79 until 04/09/79 TM (BLR, SB, PP, WT, MB, GL) plays on the East Coast, *Off The Deep End Tour '79*. This tour comprises the following dates:
03/27/79 TM plays at Hurrah's (with WKGB), NYC
03/28/79 TM plays at Hurrah's (with Theoretical Girls (Glenn Branca)), NYC
04/01/79 A concert scheduled at the Mudd Club, NYC, was cancelled
04/03/79 TM plays at Max's Kansas City (with Klaus Nomi), NYC
04/07/79 TM plays at the Hot Club (with Judy Nylon, King of Siam), Philadelphia (PA)
04/09/79 TM plays at Max's Kansas City

(with Ludacer), NYC

According to GL, the set list on that tour was the following: "Joeboy (The Electronic Ghost)," "Pinheads On The Move," "No Tears," "New Machine/Litebulb Overkill," "Nite & Day," "19th Nervous Breakdown," "In Heaven," "See Red," "Tritone," "Metro," "Clock On The Wall," "Accessory," "Love/No Hope," "Today," "Touched," "Stranger," "Waking," "Everything You Want," "No Way." Some of these songs were never released even though some of them will be repeatedly played at gigs until much later ("Today," for instance, was played in Oslo on 12/01/85 but never released to this day).

TM also played the Bonds Club on Times Square (*Tuxedomoon – No Tears*, Greek TV documentary directed by Nicholas Triandafyllidis, Astra Show Vision & Sound, 1998)

GL quit TM some time after the NY shows.

During their 04/79 stay in NYC, TM jammed with medieval instruments at a private party: 'It was a party at Milos Forman's producers house in which there was a collection of medieval instruments and we jammed on that for about an hour, remembers Principle. A not very good tape was made by Patrick Roques on my machine. Too bad as there was a version of "Pinheads" in the midst of all that noise... Very rough though...'

Greg Langston: 'I remember when we played in Philadelphia [*at the Hot Club on 04/07/79*]. I don't remember much about the set but I remember that Elvis Costello was there. We actually stayed at James Chance's place. When we went to New York, it was cool because we were thrust into the Contortions, all of those New York bands, they had heard of us. So as a 19-year old kid, there you are talking to the Talking Heads and John Cale and all of these people, I loved it. From the point I joined the band, I never felt intimidated about talking to the musicians because we were all musicians (...) The sound of the band was back then probably punkier. That's how I was back then. And before the first album came out, I could see their vision of what they wanted to be, I didn't fit in to be honest with you. They really wanted me to play more like a rhythm machine and you couldn't tell a 19-year old kid that. That's why I didn't work well with the group after all. I love what we did but had I been five years older and a little more experienced, I probably would have fit in a little bit better. After the NY gigs, they said: "We're making some changes and you're not part of it." Believe me I was pretty upset but I found another band right away and I

of our manager. They sort of heard that some of the principal members in this band were gay and our manager was also gay. There was then and probably now a network that was making contacts between gay people easier. The guy that booked that famous club in NYC [*Jim Fourratt*] was gay too... So our manager arranged some pretty good gigs for us in New York. We played some important places [*Hurrah's, Max's Kansas City...*]. Somehow we ended up being accepted in New York, kind of blending in with this *no wave* scene, guys like Arto Lindsay (...) And there our record had come out and it was popular and well received. There was a Dadaist movement in New York music, just after punk, sort of conceptual artists doing imitations of all kinds of bands, some kinds of cultural templates. There was this guy called James Chance, James White and the Blacks and the Contortions. He did some deconstructed imitation of James Brown and adopted some of the forms that James Brown was very interested in... The Lounge Lizards did some kind of deconstructivist version of a jazz band. So we fell in with a lot of these guys and they accepted us, which is unusual for a California band to get any kind of respect as there's this clash between coasts (...) That was gratifying to everyone that we were actually accepted in New York and that people liked us there. And from there, it was reasonably easy to move on to Europe. The contacts with the greater world were more in New York. San Francisco was provincial to a certain extent because it was such a nice place, people are just going to settle down in San Francisco: "We like it here..." New York is more of a struggle..."

However the acceptance described by Reininger developed only gradually and this first sojourn in NYC actually brought about bitter-sweet memories for the band. It was so not only because of the destitute state they found themselves in – all six living in one room at the Chelsea Hotel – but also because they were received only moderately well in the clubs, even though they attracted some attention in the press. "At that point, we still weren't very much in touch with ourselves, says Steven Brown. We were still experimenting with different styles; it wasn't quite jelled yet." [8] The band had to wait until February to meet with large appreciative crowds in New York [9].

Singer/musician and Tuxedomoon's friend Anna Domino remembers these times in New York: 'First heard Tuxedomoon in NYC, 1979 at Hurrah's (club). Out with two friends, we all leaned into each other and watched Winston's spot lit face and hands. The band played a dirge/groove but all you could see was Winston – heavy lidded, flawless and slightly reptilian. Then a small screen lit up with flickering black and white images – old silent era film of stylized dancing – theatrical witchcraft ritual frenzy that repeated over and over. It was

Page 90

wonderful spooky stuff. The band hardly moved: Steven sang in his monotone, Blaine's violin flew around, Peter held the main melody with his nearly distorted "hard-wood" bass and Winston's mutable enigmatic face at the heart of the thing. After the show we ran after Steven to tell him how utterly we loved it – he stopped, stared at and then through us and turned away. This was his cruel phase [10] I was to discover, it didn't last.

We walked home that night through dark, deserted, 1970's New York – shivering all the way and not from the weather. Days later I spotted one of my Hurrah's night friends in a coffee shop talking to Steven. We all walked down to the Mudd Club – me trying to talk to Steven all the way asking annoying questions about music, music, music and he ignoring me completely. We reached Mudd and as we went in I turned to Steven who glared and stomped off. I'd really blown his evening – three's a crowd. So I bought all their records and kept them to myself – like all the music that moves me the most. Never played it at parties – just by myself, over and over.'

The Residents' connection: Subterranean Modern compilation and Scream With A View EP. Upon their return from the East Coast, Tuxedomoon found themselves in a difficult financial situation, with Steven Brown still on welfare and Peter Principle forced to work in promoter Bill Graham's t-shirt sweatshop. [11] Worse, in April Reininger lost his answering service job that he had been able to maintain for three years. "It was kind of a Tuxedomoon office because it was an answering service. Because I worked there and I was a kind of senior employee, bookkeeper, I got free service on my own phone. So when somebody would call my number there would be a woman saying: "Tuxedomoon!" and in this way people had the impression that we had an office with a secretary but it was just where I worked. Anyway I was going about Tuxedomoon business as part of my work there. That was the reason why they fired me: "You're doing too much work for your band, you're not doing our business here anymore. You are using our office space as your office space." Indeed they delivered boxes and boxes of the "No Tears" EP to my job."

Fortunately, Tuxedomoon were soon contacted by the infamous Residents who, for the past year, 'had been watching Tuxedomoon with increasing interest, impressed not just with their music but also by their comparative longevity in an era when bands formed and split overnight.' [12] The Residents invited Tuxedomoon to participate in their one-shot San Francisco compilation album, *Subterranean Modern*, on which both bands featured along with MX-80

just kept going. I played on a lot of records.'

KIRB, "Tuxedomoon (…) Max's Kansas City, N.Y.", Variety, 05/09/79: 'Tuxedomoon is a first rate New Wave rock combo from San Francisco (…) Overall sound is high decibel, but it's the vocals that are ear shattering. Winston Tong, who's performing theatrically at La Mama, NY, and Steven Brown handle most of the lead vocals, often switching within a number (…) Although audience response and anticipation indicates Tuxedomoon has impressed in an earlier Gotham outing, there still are professional rough edges that have to be straightened out (…) Despite this, however, Tuxedomoon, appears on the way.'

Greg Langston's reaction to TM's alleged lack of professionalism: 'It's quite possible that there was some lack of professionalism, remember, 1979 punk rock in New York was a time of reaction to the old dinosaur rock. We felt that breaking some rules was Ok. There seemed to be quite a few mind altering substances around, these definitely had an effect on the NYC shows. It seemed quite normal at the time. In the short time in NYC we saw the Ramones, Police, Richard Hell, The Contortions and more. We saw a new music show at Carnegie Hall with Steve Reich and John Cale (D. Bowie on violin!). Winston did a *Bound Feet* performance. We went to a party also attended by David Byrne and Tina Weymouth, Klaus Nomi and John Cale. We were busy!'

05/79 TM is invited by the Residents to participate in Ralph's *Subterranean Modern* compilation (various artists) for which TM records "Waterfront Seat","I Left My Heart In San Francisco" & "Everything You Want" (BLR, SB, PP, MB + a blind busker and his dog on "I Left My Heart…"), prod. TM. Published by Ralph Records (1979). Later all these pieces appear on the *Pinheads On The Move* compilation album (Crammed, Cramboy, 1987).

Page 91

05/79 WT&BG participate in the *Theater Der Welt* festival in Hamburg and then tour in Germany

05/05/79 BLR + MB + PP at the Mab, SF, as "Peccadillos" ("Uptown" & "Right Mind" are part of their set). As to using these different names: 'As well as a means of letting off musical steam it proved a useful moneymaking ruse too, Tuxedomoon thus able to use these other formations as opening groups at the Mabuhay and net $700 – at that time A Big Deal' (JAMES NICE, *Tuxedomoon*, unpublished manuscript, 03/21/92, p. 12).

05/08/79 TM plays at the Mab, SF

05/25/79 TM plays at California Hall (with Screamers and Units), SF

06/01&02, 08&09/79 TM plays at Eureka Theater (*Midnight At The Eureka Theater*) (with Noh Mercy on the 8th and 9th), SF

06/22/79 TM plays at Temple Beautiful, SF

06/29/79 TM plays a Benefit concert at The Women's Building (with Camille O'Grady, Ruby Zebra, Tattooed Vegetables), SF

05-07/79 SB guests on Snakefinger's LP *Chewing Hides The Sound* (Ralph Records, 10/79) on the track "The Vultures Of Bombay," recorded at El Ralpho Studios, SF, prod. Snakefinger & The Residents

Summer '79 Recording of "Over his head" during a rehearsal by TM (BLR, SB, PP), SF, later to appear on the *Pinheads On The Move* compilation album (Crammed, Cramboy, 1987)

08/79 Recording of *Scream With A View* EP by TM (BLR, SB, PP, MB), prod. TM, "somewhere in San Francisco" namely in the Residents' recording studio. Free studio time was offered by Ralph to TM as an incentive to quit Adrian Craig's Time Release Records. Tracks: "Nervous Guy;" "Where Interests Lie;" "(Special Treatment For The) Family Man;" "Midnite Stroll." Published as a 12" by Tuxedomoon Records, later by Crammed (Cramboy), 1985, finally appears on the *Half-Mute/Scream With A View* CD released by Crammed (Cramboy) in 1987

08/07/79 TM files patents on the band's name

Mark Pauline's prank at Steven Brown's birthday party (08/23/1979). Mark Pauline: "It was a birthday party for Steve Brown (of *Tuxedo Moon*). There were many people present, including some *very* nicely dressed girls. The party featured an enormous, thick, grotesque, creamy chocolate cake. I planted this huge explosive in the bottom of it – much bigger than propriety would normally have allowed. There were these two *really* slickly dressed new wave *babes* that somehow got there because *Tuxedo Moon* attracted those flashy, stylish sorts. We had just placed a bunch of candles on the cake and lit them.

Page 92

Sound and Chrome.

Hardy Fox (of The Residents's management company, the Cryptic Corporation): 'I personally loved their music right from the start. We used *Sub Mod* as a way of seeing who we might work with before extending actual album deal offers. We selected three SF bands who were doing something, not only different, but different from each other as well. Tuxedomoon was an obvious choice. The band was completely free to record as they wished. Ralph was a totally artist driven label and Tuxedomoon turned in excellent recordings.'

Tuxedomoon contributed three tracks including a mandatory cover of the Tony Bennett standard "I Left My Heart In San Francisco." Their version reflected the DIY philosophy still at work within Tuxedomoon, as the piece consisted in the title track played on harmonica by a blind busker accompanied by his dog (paid fifty cents by Reininger for the occasion).

Tuxedomoon's contribution was well received: 'With one synthesizer, a rhythm box, brass and treated guitar, the group offers surreal soundscapes of machines gone mad,' commented Michael Goldberg. [13]

Andy Gill's review was also quite eulogistic: 'For Tuxedomoon, smoothness is an integral part of the overall design, a booster rather than a dampener. Both "Everything You Want" and "Waterfront Seat" have a slinky sinuosity which gives them all the appeal and accessibility of, say, Gary Numan, despite their massive superiority in terms of complexity and sheer inventive imagination.

Working on a ground of hazy guitar and/or synthesizer drone-cycles, Tuxedomoon build what can best be described as textural sculptures. "Waterfront Seat" is a soaring ski-slide haunted by interweaving mirages of soprano sax (something like a coarser version of Terri Riley's "Poppy Nogood And The Phantom Band"), whilst "Everything You Want" uses its hypnotic sway to hint at mounting paranoia and unrest. Both pieces are emotionally formidable – not for nothing is their publishing company called *Angst Music* – and as musically engrossing as anything produced this year (…).' [14]

This release also gave an opportunity for Peter Principle and Michael Belfer to emphasize the "proletarian" or even "garage" – *dixit* Belfer – features carried by Tuxedomoon. "The sound of a lot of our stuff is just the rhythm box and bass guitar. You don't need a lot of synthesizers to make electronic music. We're very stark Proletarian", said Principle. [15]

Subterranean Modern impressed The Residents enough to make them want to sign Tuxedomoon to their own Ralph Records. "They very specifically approached us. They said they had been watching Tuxedomoon already for a year and they said it was one of the most interesting bands and they

wanted to form a label around bizarre acts (…) They wanted to have Tuxedomoon also, recalls Peter Principle. I guess they had seen a version of the band play at the Palms café, and had an idea to do something like Stiff records as Jay Clem [*i.e. Ralph Records' business person*] put it and wanted to get a roster of local groups." [16]

As an incentive for Tuxedomoon to act upon the offer and split from Adrian Craig's Time Release, The Residents, upon Belfer's initiative, offered the band free studio time in August to record their next EP *Scream With A View*. 'The Residents were courting the band to get us to sign a contract with them, and it was in this atmosphere of them trying to build friendly relations with us, that I asked for the favor of getting them to let us use their studio to finish these recordings that we had been working on,' remembers Belfer. 'They were actually started in the old rehearsal studio on Valencia Street using Tommy Tadlock's recording equipment. So I asked The Residents if there was any time available… And Snakefinger [*Ralph Records recording artist and frequent Residents' collaborator*] had just finished making a record he owed them. And so there was this time open until The Residents themselves would start recording again. They only asked that we not credit them or their studio, which is why it says on the record "recorded somewhere in San Francisco." I also remember having quite a bit of production input on the making of that one. In fact I consider that record the first one in my career that I really was able to do some producing on, right down to the art-direction…'

The reason why this recording – that features "Midnite Stroll," "Nervous Guy," "Where Interest Lies" and the Milk/Moscone assassinations inspired "(Special Treatment For The) Family Man" – was named *Scream With A View* is interesting.
Michael Belfer: '*Scream With a View* is a title I came up with from a dream involving me and Patrick Roques. The dream went like this... Patrick and I were on the cable car just coming over the top of Russian Hill. The ride at that point takes on a slightly terrifying but very beautiful quality all at the same time. As the cable car comes over the crest at the top of Leavenworth Street, you're struck by this amazing, extremely panoramic view of the bay… Well the cable car was full of tourists too, and as we began to descend, the cable snapped, making this really loud noise. And it started to pick up speed like crazy!!! All the tourists began to SCREAM, and as I looked over at Patrick, I remarked to him, thinking we were all surely going to die, that: "At least they have a good view." Patrick said: "Yeah, Scream With A View!" And I said: "That's it! The name for our next record!" Then I woke up and jotted this all down, that's the story! The front cover photo is the back of

These two girls were standing in front of the cake, chattering about it. Steve Brown was on the other side of the room; in fact, everyone in the room knew what was going to happen except for these two girls, I guess. Steve went, "Let's do it now!" I flipped the switch and it exploded all over these girls. It didn't just get on them – it *slathered* them from head to toe and completely covered the wall behind them with all this gooey chocolate mush. They panicked. They started screaming, yelling, and complaining, but everyone in the room was laughing: "Oh, it's Steve Brown's birthday party and Mark Pauline blew up the cake!" Most people in the room got a bit of cake on them, but not like the two girls who remained quite hysterical. Steve said to them, "Don't be upset. That wasn't the real cake. We've got the *real* cake over here!" Then of course we brought out another cake and the girls just couldn't believe it. They went crazy and began screaming about getting someone to pay for their clothes, but no one seemed to be backing up their version of reality. People were coming by and saying, "Oh, here – just wipe it off with this napkin." Everyone kept ignoring them, and finally they just left. It was perfect because they didn't really know anyone at the party (…)" (*RE/Search # 11: Pranks!*, San Francisco, 1987, p. 14).

08/24/79 TM plays at the Deaf Club (with Minimal Man), SF

Fall '79 TM signs a record deal with Ralph Records

Page 93

Patrick's and my head, and it was an attempt to capture the vibe of the dream.'

Roques's involvement was not limited to being a partner-in-dream for Belfer and cover art designer. He came up with the $3,000 necessary to finance the initial pressing of the record in a quite unorthodox way.

'When this recording was up in the air, recollects Roques, someone had to pay for the manufacturing of the record. I had an old friend from school who's family owned butcher shops in the Pacific North West. They were well off. This family was something out of a Flannery O'Connor novel, Jim Thompson might be more accurate. I approached them for the loan of $3,000 and for some reason they sent me the money. We (…) paid them back, the record had sold well (…) A few years, later this family was busted by the FBI for racketeering and grand theft. They had been stealing truck loads of meat from a nearby army base for years and selling it through their stores (at 100% profit). They had an inside military man, a four star general who was forging the records and delivery forms. All these guys used to hang out at this strip club where they all gambled their ill-gotten gains away into the whiskey stained mornings. When the bust happened the general accidentally shot himself in the face with a 12 gauge shot gun while hunting ducks in a field next to his home. Two family members went to prison (…). So the *Scream With A View* EP was financed with tainted money laundered through the young art rock band. And it's still my favorite Tuxedomoon record.'

In view of the imminent deal with Ralph, Adrian Craig and his Time Release label brought a law suit that he eventually dropped a few months later. Reininger: "We were on this fools' label that we like naïve jerks signed with these demons from hell. These demons from Hell tricked us by means of their black horrible magic and their drugs and deciding with their vile illusory company. As a result of that, they sat on our records and didn't distribute them." [17]

A sad conclusion to the Tuxedomoon/Time Release story was the fire that devastated the Time Release office some time later and destroyed the master tapes of *Pinheads On The Move*, *No Tears* and *The Stranger*, along with over half the pressing of *The Stranger* as well. [18] In the Fall, Tuxedomoon signed to Ralph, the deal requiring them to deliver five albums in five years, and allowing Ralph to exploit all recordings for a maximum of ten. [19]

New No Wave Festival in Minneapolis. In October the band participated in a large *New No Wave* festival in Minneapolis: 14 hours a day of music for three days.

Peter Principle: "The featured bands were legion since it was

"The Cryptic Corporation did not just sign bands, it gave them advances in the region of $10,000-20,000. Jay Clem was concerned with being scrupulously fair. So much so that the contracts he drew up ran into fifty pages and covered such esoteric areas as the division of royalties from sales on American army bases. When Tuxedomoon could not afford to pay for a lawyer to read through their contract, Clem arranged for Ralph Records to lend the band the money to hire one. This lawyer then advised the band to seek more favorable terms from Ralph who were meeting his fees." (I. SHIRLEY, *Meet With The Residents*, Wembley, SAF, 1993, p. 87)

held in a large indoor football practice room totaling three fields – it snows a lot in Minneapolis. Devo played as Dove so as not to breach an exclusivity contract they had with a local venue. There were also the [James Chance and] Contortions, [Robin Crutchfield's] Dark Day, The Girls, Fleshtones, The Pop, Monochrome Set, DBs, DNA."[20]

It was a success: '(…) the group received a degree of appreciation that had, as yet, eluded them back home. The festival culminated in a mass jam session which Steven and Blaine closed. "All the guitarists just packed up and left, all the bass players quit, all the drummers split and it was just me and Steven battling for the final lick of the festival, recalls Reininger, and I got it. Steven quit and I turned up my echo box and let it feed back."'[21] This end-of-concert musical battle between Brown and Reininger, each trying to get the last note, will become a recurrent anecdote in their history of gigging together. Recently long lost video footage of the festival was put out and shown in theaters. [22]

Michael Belfer drifts away; recording of the Half-Mute LP. It was in December 1979 that Tuxedomoon – reduced to a trio, namely Steven Brown, Peter Principle and Blaine Reininger – went into the studio to record their seminal first album, Half-Mute. This recording was so named on account of half of being instrumental.

"In the early days of Tuxedomoon, remembers Peter Principle, one of the reasons we did instrumental music is that we thought that we were easy listening music for the dark depressed *nouveau* poor and so they would be sitting in a café, just listening to Half-Mute and drinking a Campari. That was really cool and we were really into that…"

Their debut LP proved so timeless that it brought Tuxedomoon back together some twenty years later for a European tour centered on Half-Mute.

However Michael Belfer was absent from this album. Belfer: 'From what I remember of those times, it was really the beginning of the end of me being involved with Tuxedomoon as a full time band member. We had finished Scream with a View, and rehearsals were focused on writing material for Half-Mute. I became restless – as I often did in those days as I was only 19 years old – out of a desire to play in a more visceral

TUXEDOMOON

Photo: Robert C. Johnson
© 1981, The Cryptic Corporation

A Ralph promo picture/flyer for Tuxedomoon

09/01/79 TM plays at Temple Beautiful, SF

09/08/79 TM plays 1839 Geary str. at Fillmore (Temple Beautiful) (with Levi & the Rockats and DOA), SF

09/15/79 Joeboy Productions present Tuxedomoon, Winston Tong, Specialguests, Peccadillos, *Never Before-Never Again*, at the Mab, SF, where Specialguests are MB and SB and Peccadillos are MB, BLR and PP

10/79 TM participates in the *New No Wave Festival* in Minneapolis, produced by the Walker Art Center

10/79 BLR meets his wife, JJ La Rue, in SF

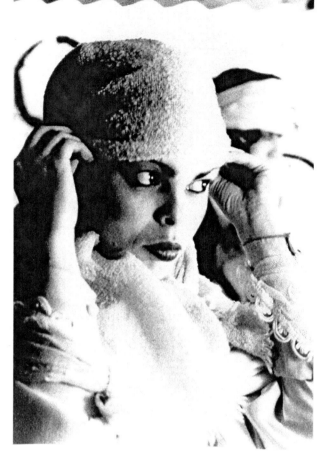

JJ Larue. Photo Saskia Lupini

10/09/79 TM (BLR, SB, PP, WT, GL) plays at the Deaf Club, SF. KSFX radio recording. Recording of "In Heaven," "19th Nervous Breakdown" and "Work Coda," the first two to appear on the compilation *Can You Hear Me? Music From The Deaf Club*, Optional/Walking Dead Records (1980) and the first piece to appear later on the *Pinheads On The Move* compilation album (Crammed, Cramboy, 1987) whereas "Work Coda" is featured on the *Lost Cords* CD forming part of the *Unearthed* double CD/DVD contained in TM's 30th Anniversary *7o7* box set released by Crammed Discs in 2007. During the same night at the Deaf Club, SB participates in the recording of Patrick Miller's 7" entitled *She Was A Visitor* by collaborating to "She Was A Visitor" and "He who falls." The Target Video (*Tuxedomoon: "Four Major Events"*) excerpts shot at the Deaf Club (recognizable as the stage was wrapped in cellophane) are probably from that night. About Target Video in San Francisco, see P. Belsito & B. Davis, *Hardcore California – A History Of Punk And New Wave*, Berkeley, The Last Gasp Of San Francisco, 1983, 6th printing of July 1996, p. 105

10/10/79 TM plays at the Deaf Club, SF

10/20/79 TM plays (with various bands) a benefit for the South of market neighborhood arts cultural center, 934 Brannan (8th & 9th), SF

From 10/29/79 till 11/01/79 WT&BG participate, with the performance entitled *Eliminations*, in the Festival International de

project (read: real drums, louder, with a little more slam to it). And so, I had started up The Sleepers again (…) and I came less and less to Tuxedomoon rehearsals …'[23]

It was however during the same recording sessions as *Half-Mute*'s that Belfer and Reininger will record a popular track named "Crash" after J.G. Ballard's novel. Belfer: 'Blaine approached me to do some writing trying to keep me involved. I immediately seized on the idea of using [Jeff] Raphael [*The Nuns' drummer*] on a track. As far as I was concerned, we were overdue for something that rocked. It was songs like "59 To 1" that I was losing interest in. So I had this guitar melody that I wanted to really put through the wringer, processing wise. Blaine had dug up this really cool sounding Clavinet that we would use for the bass line. I had been reading a lot of J.G. Ballard, and I really wanted to try to evoke the mood of the world that exists inside that book. Once we got into the studio, I started to run into a lot of resistance from the engineer [Jim Renney] every time I had an idea I wanted to try out. At that point in my life I'd done enough recording to be totally sick and tired of engineers trying to tell me what was acceptable practice in the studio. I got into it more and more with that guy (the engineer). I finally insisted that we flip the entire tape upside down. The more he said no, the more I became convinced that it was exactly what needed to be done. And so it was, we turned the entire tape upside down, and Blaine then re-tracked his Clavinet forwards against the rest of the track, which was now going backwards. We handed the tape in to The Residents, and they heartily approved of using it as the b-side for the forthcoming "What Use?" single. That's the story of how "Crash" came about as I remember it...'[24]

"Crash" was not included on the *Half-Mute* album and was relegated to obscure b-sides or compilations. The reasons for the fact remain unclear. Some would insist on personal dissensions leading to some sort of "banishment" of the young Belfer. Others would point out that "Crash" sounds musically very different from *Half-Mute*'s mainly minimalist accent. At any rate, from that moment on Belfer concentrated on The Sleepers although his story with Tuxedomoon was not complete.

Half-Mute was immediately considered a masterpiece:

'Tuxedomoon scares my daughter. They scare me too (…)
Their particular "rear-view mirror" to the present may be the work of such diverse composers as John Cage, Captain Beefheart, and Brian Eno, but the emphasis here is on the new, and untried. Past musical forms are stated, altered, or mutated, if you will, and then disregarded in an almost random manner. (…)
Half-Mute is clearly about designing a new game plan for the 1980's. And what makes "What Use?" such an outstanding song is the rocking authority with which these musicians state their case. Whether or not *you* buy the concept of "new noise," *Half-Mute* is not just another empty-headed gesture. For better or worse, this band is serious about the music they make.
(…) "Seeding the clouds"…
They're seeding the clouds today
Watch!
Nothing's gonna go your way
These cheerful lyrics follow about 60 seconds of spooky electronic doddling in the John Cage tradition and are delivered by someone who sounds like the ghost of Jim Morrison. If that isn't enough, the track ends with the synthesized beatings of helicopter blades against empty space. Scary, huh? I couldn't help being reminded of the nightmare sound of the Army choppers in *Apocalypse Now*.
(…) Tuxedomoon succeeds in creating moods and spaces that very few bands have created before (…) Make sure you don't listen to it alone, in the dark, on drugs. Really, I wish I could say I was just kidding.'[25]

'The first must piece is "Nazca," after the Pre-Columbian, Central American Earthworks – spaceport of the Gods or earth art of the Gods? Here, it's a drift through heavenly tones, pastel sonar clouds, celestial hums. Sax sings a love lament, giant lovebird calls and Andean Indian love calls, maybe an alien love call (…) "59 To 1" (…) The sax comes in and finds a duel with the clock, playing with time: speeding it up and slowing it down slyly, making time illusions that can't really lie 'cause the bass keeps it up (…) "Loneliness" (…) The vocal is sad but severe, like a benevolent zombie lecturer (…) "What Use?" (…) "(…) Why fly to Rome on your credit card?" This is the best *ennui* song to come down the cultural reward pathways in a while (…)'[26]

'If you're of a mind to hear what is indisputably some of the best music ever produced in San Francisco, the United States or anywhere, then beg, borrow, steal or buy *Half-Mute*, the band's debut album on Ralph Records.
(…) What they've succeeded in doing is to make a highly accessible extremely listenable record of the traumas and

Théâtre de Bruxelles, Halles de Schaerbeek, Brussels

11/10/79 TM plays at 1839 Geary (Temple Beautiful) (with Mutants and Punts), SF

12/79 TM (BLR, SB, PP + MB & Jeff Raphael, respectively guitar and drums on tracks 14 and 15) records – at Audio Amigos Studios, SF, prod. TM – the tracks that will compose *Half-Mute* + "Crash," namely: 1. "Nazca" 2. "59 To 1" 3. "Fifth Column" 4. "Tritone (Musica Diablo)" 5. "Loneliness" 6. "James Whale" 7. "What Use?" 8. "Volo Vivace" 9. "7 Years" 10. "KM" 11. "Seeding The Clouds" 12. "What Use Remix" 13. "59 To 1 Remix" 14. "Crash (1)" & 15. "Crash (2)"
Tracks 1 to 11 will compose *Half-Mute*, LP published by Ralph in 1980, later by Crammed (Cramboy) in 1985. Later *Half-Mute/Scream With A View* will be published as a CD by Crammed (Cramboy), 1987
Tracks 7 and 14 will compose the *What Use?* 7" published by Ralph in the Spring of 1980
Track 9 will go on a 7" Ralph Records Sampler, 1980
Track 12 will go on 12" *What Use Remix*, Ralph, 1982 and on (Various Artists) *Best Of Ralph*, double LP, 1982
Track 13 will form the B side of 7" *Dark Companion*, Ralph, 1980
Track 14 will appear on LP (Various Artists) *Frank Johnson's favorites*, Ralph, 1981 and TM's compilation LP entitled *A Thousand Lives By Pictures*, Ralph, 1983
Track 15 will go on 12" *What Use Remix*, Ralph, 1982
Tracks 14 and 15 will be presented as bonuses on the *Night Air plus* (re-issue of BLR's solo album *Night Air*) release by LTM (2002)
In 2007, Crammed Discs releases TM's 30th Anniversary box set with the *Lost Cords* CD (part of the *Unearthed* double CD/DVD) featuring a prototype version of "Crash" named "Ill (April In Afghanistan)"
Production of the *Half-Mute* album will cost $ 7,000 only (JAMES NICE, *Tuxedomoon*, Materiali Sonori, 1988, p. 12)

"In "What Use?" there's this sentence: "What's the use of living at all"
- (Steven Brown) Indeed, it's beautiful, isn't it?
Well when Blaine wrote these lyrics, he was feeling like what the song says. Had gone through a bad time. That song came out of his perception of his life at that particular moment. There's even a line in the song: "Flying to Rome on your credit card." That relates: I was going to go to Rome with Winston and Blaine apparently was affected by that, so it just added to his depression and he wrote that into it. But that's all little fragments of his life at that time, that's all…" (Steven Brown interviewed by J-M MIEVIS, January 11th, 1983 (unpublished)).

Page 97

trials of modern life; what they call the music of "urban angst."

This is music that is, to quote Hermann Hesse and the *Damage* masthead, "Not for everybody." It's too radical, too threatening, too full of the stresses and subtle pressures that drive perfectly nice people nuts. To be honest, it's the kind of music that keeps playing inside your head long after you wish it would stop. Almost painful, but compelling 'cause it's so familiar, so appropriate.

(…) if it were up to me, I'd make it obligatory background music in all subways, bus stations and department stores: guaranteed social collapse. This is Muzak to commit ritual suicide by. Music of our time, of our places, of our abandoned hopes and drug-induced fears. This is alienation. This is the modern world.' [27]

'Tuxedomoon or the *Chien Andalou* in vinyl (…) Tuxedomoon does psychiatric rock.' [28]

'(…) this is the "experimental" album I'd take to a desert island. Originally nurtured by fellow San Franciscans The Residents, Tuxmoon brought an exotic, rarefied mix of conservatory, jazz nightclub, tea dance and Hollywood camp to their musical adventures which, on this debut especially, made them cherishable. Pieces like "59 To 1" harked towards tough, bony electronic funk, "Nazca" and others mixed bittersweet jazz sax (the excellent Steven Brown) with moody electronic lyricism, the swelling gigolo romanticism of pieces like "Fifth Column" put first-album Roxy Music to shame and "James Whale" (a tribute to his famous "Frankenstein") is a brilliantly understated piece of aural picture-painting. It hasn't dated a minute and your record collection will look shabby without it. A maverick masterpiece.' [29]

About "What Use?", the single: '(…) How is it that they can make a song about boredom and despair sound that much more interesting and enjoyable (…) And do it with *synthesizers* yet? Could it have something to do with integrity perhaps – a refusal to comply with the showbiz tic-tac system which lays down little rules like "synthesizers lack feeling" and "dancing music must deal with happy things" (…) "What Use?" comes like the proverbial breath of fresh air (…) And the only truly honest record of the week.' [30]

The last review outlines an element of Tuxedomoon's music that will always come as a surprise to most commentators reviewing a band using synthesizers and electronic percussion: the emotional quality of their music. Bill Edmondson, who interviewed Tuxedomoon for *Praxis magazine*, once observed that many synth groups using electronic percussion tend to sound cold whereas

Tuxedomoon, on the contrary, sounds very warm.

'Blaine: Technology lends itself first and foremost to repetitive machine music. And that's what people do when they first buy a synthesizer – they just let it go automatically and build a song around it. But the time has come when the synthesizer is an instrument with a history, with many people playing it in different ways – thus it becomes humanized.

Peter: Violins and saxophones have a lot to do with it: we use acoustic instruments where a lot of electronic bands use strictly electronic instruments.

Blaine: I read a survey once where they asked people what they thought of the sexiest sounding instrument was and they said saxophone first and violin second. So there you are, we use both.' [31]

According to Glenn O'Brien [*editor of Andy Warhol's Interview magazine who also had a show entitled TV Party on NYC cable TV* [32]]: 'Tuxedomoon was not a prototype of today's synthesizer dance band. Some of their music anticipated such stuff, but they weren't a dance band. They played in various modes, all of them rich in ideas and feeling. Much of their work seemed to be soundtracks for non-existent *films noirs*. Their tonal palette was most expansive; sometimes they sounded distant and alien, sometimes they created melodies of great warmth and sophistication. But whatever they did was always intelligent, beautiful and provocative.' [33]

As Jan Landuydt [*a Dutch journalist who wrote in musical and art magazines*] put it: 'By Tuxedomoon, normality and strangeness meet (…) Hence the music is never esoteric (…) The music possesses an inherent openness, there's always an aspect to which the listener can relate (…) an attempt to "build what was never heard before while not losing contact with the emotion."' [34]

Peter Principle elaborated further in 1997: "We always tried to make acoustic instruments sound electronic and electronic instruments sound acoustic. So that was another aesthetic that we had. We didn't want to use the electronics just to sound cold, alienating and electronics by themselves. We had a firm belief that technology is an extension of the human condition and we wanted to make that apparent through our music." [35]

Another remarkable aspect of *Half-Mute* is its cover designed by Patrick Roques, a somewhat abstract/symbolic painting featuring three figures. Roques: 'There was a separate back cover painting that was never used as there was no budget for it. The art director at Ralph came up with the idea of flopping the films to give the red color for the back. Later they switched the red to the front as they felt is was "brighter" and therefore more commercial. The green front is the original. I painted it sitting on my bed, down at

the Natoma Street flat in about four hours. It was just a water color sketch to show to the band and The Residents. It was again the Ralph records art director who really loved the work and I sort of "finished" it off in 20 minutes and when it came out it got a lot raves. I was shocked. The three shapes on the cover are the band: Blaine, Steven and Peter. I got 750 bucks and bought a vintage 1940's hounds tooth suit. About a year or so later, I met the painter Dougie Fields (Syd Barrett's old flat mate) and he had on a very similar suit. I was impressed (…) *Half-Mute* was selected by Virgin books as one of the best LP covers of 1980.'

A combination of great music with brilliant cover art made *Half-Mute* an unexpected commercial success and, still to this date, the album is being cited by many artists as one of their influences.

12/03/79 TM plays at the Boarding House, SF, as part of a whole night Ralph Records special that also included gigs by MX-80 Sound and Snakefinger. The show was recorded by Terry Hammer for a SF radio show (see http://www.angelfire.com/oh/liveperformances/livetapes.html).

12/08/79 TM plays at Temple Beautiful (1839 Geary) (with Pink Section, Eye Protection et Impatient Youth), SF. Set list: 1. "East" 2. "What Use?" 3. "7 Years" 4. "Volo Vivace" 5. "Litebulb Overkill" 6. "59 To 1" 7. "Fifth Column" 8. "(Special Treatment For The) Family Man" 9. "Loneliness" 10. "Nervous Guy" 11. "Seeding The Clouds" 12. "Pinheads On The Move" 13 u.m.

1979 WT obtains the West Coast Critics Circle award 1979 for his work at the Eureka Theater

12/31/79 TM plays at *New Year's Eve Party* at Showbox (with Pink Section, The Debbies, Minimal Man), SF

In December 1979, Tuxedomoon played at the Boarding House, San Francisco, as part of an all night Ralph Records special that also included MX-80 Sound and Snakefinger. During the show "Nervous Guy" was dedicated to David Byrne (of The Talking Heads). At one point the audience shouted:
"Do something live!
- (Brown or Reininger) We never do a thing live…"
The concert was reviewed by P. Ramont for *The Daily Californian* in quite eloquent terms: 'There'll be no dancing either because Tuxedomoon was up next. This is music to sit down and die by. No, I mean that in a nice way. It's time we admitted it, there will be no golden harps in the afterlife. If it's to be orchestrated at all, it will likely be something like

Patrick Roques' (green) original paintings for the cover of *Half-Mute*: front cover painting (left) and back cover painting (that was never used). Photo Katy Kolosy

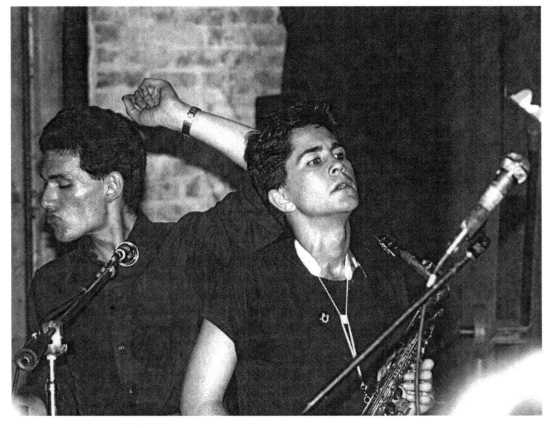

Blaine Reininger and Steven Brown playing in San Francisco, circa 1979. Photo Lig

Tuxedomoon – a nightmare vision of the darker elements in us that we spend lives trying to conceal. Tuxedomoon do not set out to entertain – they want to take you into a dark alley and push you around. Three extremely talented and versatile musicians, Tuxedomoon arrived easily at the type of instrumental mosaics that Brian Eno and David Bowie have spent albums striving for.'[36]

> *1980: Soma Show at Temple Beautiful; short East Coast tour; Urban Leisure Suite; Ian Curtis's suicide and aftermath; recording of the "Dark Companion" single; the European connection; Tuxedomoon's first European tour and recording of the Desire LP; start of Tuxedomoon's love story with Italy; searching for a home in Europe; recording of the Joeboy In Rotterdam LP*

On January 25th, 1980, Tuxedomoon performed *Soma*, a special show written by Winston Tong at the Temple Beautiful on Geary boulevard, another famous venue of the punk era that, like the Deaf Club, had a very short life (from February 1979 until March 1980). The Temple Beautiful, previously called The House of Good in the seventies when it hosted rock shows promoted by Janos Kovacs, was a pre-earthquake Jewish synagogue complete with stained glass windows,

1980

01/19/80 TM plays at Roosevelt, SF

01/25/80 TM (GL may have played "No Tears" on that show) plays at Temple Beautiful, SF, *The Soma Show*

02/80 Short East Coast tour negotiated with DNA culminating in several successful New York shows, a.o at the Mudd Club and at TR3 (NYC, 02/22/80), after which PP will stay on in NYC for a while with SB and BLR consequently working alone on the *Urban Leisure Suite*.

1980 SB guests on the "Trapped" piece on Robin Crutchfield's Dark Day's first album, *Exterminating Angel* (Infidelity, 1980), recorded in NYC, Sorcerer Sound, 1980, prod. Charles Ball. See http://nowave.pair.com/no_wave/dark_history.html

02/13/80 WT&BG perform at the UMBC, Baltimore
'Their performance was comprised of seven short pieces, totaling less than an hour, and consisted of variations on this basic technique of manipulating the audience by manipulating the space. In *Don't Explain*, Tong sang along with a Billie Holiday record while Geduldig, manipulating a handheld projector with a slide of a metal grid, created around Tong's presence several brief realities. Projected at Tong's feet, the grid was a sewer grate, and Tong a hooker on the street; projected on the wall, it put Tong behind bars. In *Against Nature*, Tong read from Huysman's novel a passage about a bored hedonist, while Geduldig projected a small, out of focus image of a man masturbating in eery, mechanical slow motion. Everything was executed with a kind of post-minimal cool (...) in the final piece, *Nazca*, Tong and Geduldig wrapped themselves in packaging paper an they promptly walked out the back door, leaving the audience alone with the tape recorder, projectors and lights. After a moment of silence, the tape suddenly complained about the light – and the light obligingly switched itself off' (J. STRAUSBAUGH, "Winston Tong's cool gestures", *City Paper* (Baltimore), 02/29/80)

Spring '80 TM (BLR, SB) records the *Urban Leisure Suite* in SF, prod. TM. Composed of four parts.
Part four will be included on a flexi disc published with *Praxis Magazine*, vol. I, n° 6, July 1980 with BLR and SB's interview
All four parts will appear on the LP *Joeboy In Rotterdam/Joeboy In San Francisco*, Backstreet Backlash Records, 1981, then will be included in the LTM Records compilation of TM tracks named *Soundtracks/Urban Leisure* (with leaflet including the *Praxis* interview) in 2002

Spring '80 Ralph signs a licensing deal with Pre for the British Market and with French label Celluloid for the rest of Europe

03/22/80 SB guests on The Sleepers's 7" entitled *Mirror/Theory* for track "Mirror", Adolescent Records, 1980, later to appear on The Sleepers's compilation album called *The Less An Object*, Tim/Kerr Records, 1996

04/11-12&18/80 Etudes/Steven Brown Bruce Geduldig Winston Tong/ Midnight April 11 12 18 1980/Eureka Theater San Francisco 1. Death+the bed/2. Suspending disbelief/3. Resurrection (source: sheet of paper belonging to SB)

04/27/80 TM plays at City Disco, SF. *Oakland Tribune*, wed April 23rd: 'To celebrate the record's release [*i.e. The Residents's LP entitled Diskomo*], Ralph records is throwing a *Diskomo Night* dance party Sunday at 9 p.m. at the City nightclub, Montgomery at Broadway, San Francisco. Other entertainment includes a performance by Tuxedomoon, a dance contest and the showing of two Residents films, *Hello Skinny* (world premiere) and *Third Reich 'n roll*'

05/18/80 Death of Ian Curtis and hence the project for an European tour in the Fall with Joy Division aborts. Consequently plans were made to bring Tuxedomoon to Europe at the end of the year and to record their second

a vaulted ceiling and a huge U-shape balcony that could accommodate hundreds of people. [37] It was peculiar also for its location: between Bill Graham's original Fillmore and... Jim Jones's People's Temple. [38]

It wasn't the first time that Tuxedomoon played there. Peter Principle: "(...) also at the Temple Beautiful we used to often play and this was a much bigger thing and only at Saturday nights while the Deaf Club was every night in the week." [39] "*Soma*, continues Principle, was a performance we did at the Geary Theater (...) We originally got the idea from Aldous Huxley's *Brave New World*, where soma was a drug that was used to keep society in line. A number of different people joined us for various aspects of the show, doing performance pieces and acting out little skits while we played. At the end we did "Soma" which is a very angelic and hypnotic piece, with all these women dressed in white and singing in very high voices. It had a very religious feel to it, and a good video came out of it."" The way we used [*Soma*], adds Steven Brown, had a kind of satirical bend to it: "Soma" being the control mechanism used by modern society to keep everyone ignorant and passive – like television." [40] Also to create a 'special ambience, Sue and Sally Mutant passed out xeroxed extracts from the New York Review of Cocksucking at the door.' [41]

The "Soma" song will be recorded about four years later. In fact this show and its title illustrate Tuxedomoon's creativity at the time and how crucial it was for their career as a lot of the material that they will use in the following years will be derived from these special shows. 'Principle recalls an unstoppable flow of creativity: "Every three or four weeks, we'd have a gig booked and say, 'Let's write a new show – a whole new show.' We wrote albums' worth of material that we later mined over our career. We all had other areas to draw on and feed us... Blaine had been trained as a classical musician and played in an orchestra; Steven was a kind of film-maker who was fascinated with soundtrack music; I had tried to do radio theater – avant-garde psycho-dramas. I've always been involved with foleys – the guy in the movies who collects the noise of, say, car horns on a bridge. So we all had experience with sound design and sounds used out of the context of pop music."' [42]

Short East Coast tour. In February, Tuxedomoon conducted another short East Coast tour negotiated with DNA. This time it was a success: 'Traveling to New York again (...) the band met with large, appreciative crowds. Glenn O'Brien, a long time supporter, raved about them in *Interview* and showcased them on his local cable TV show [*TV Party*]. At the Mudd Club, owner Steve Maas was so impressed that he offered them twice their guarantee just to do an encore. Clearly, Tuxedomoon had won over the Big Apple in a big

Page 102

way.' [43] Reininger however took this success with a pinch of salt: "I doubt that we would have met with the success we've met with if we'd started in New York because the competition is far more intense. If you have anything of quality in San Francisco, you have a far greater chance of making it in the world. San Francisco still has world's attention but the quality of the art there is so poor that if you do something good, then you stand a greater chance of getting world's attention whereas in New York, we'd probably be still playing Max's Kansas City." [44]

Urban Leisure Suite. Following this tour, Peter Principle remained in his native Big Apple for a little while. 'I assisted Phil Kline with the very first tape loop experiments back in early 80 (before boomboxes), recollects Principle. We had to use regular cassette recorders and had ideas to do an installation at a downtown bar/gallery (…) We used to call the technique "time vegematic" as it appeared to distort time as if it was ground up in a vegetable chopper. I also played with the transitional Robin Crutchfield's Darkday/Del-Byzanteens, painted the first Danceteria, was an extra in two porn films. This all while Steven and Blaine did *Urban Leisure*…'
Reininger and Brown, back in San Francisco, started to work on another performance piece entitled *Urban Leisure*. Some of the material was already in existence for at least a year as part of what became the *L'Age d'Or* bootleg.
Steven Brown: "It came out of some tapes I was making in Patrick Miller's house where I used to live on Oak Street [*Patrick Miller was a California (punk) graphic artist/musician aka "Minimal Man" who designed some flyers for and was a close friend of the band*]. In fact we all lived there at one point or another. It was a big old San Francisco apartment. We had set up our little studio there in the front room, four track, mixer, keyboards, we later wrote "Jinx" there, we wrote "Desire" [*both featured on their next album entitled Desire*]… We wrote a lot of shit there, kind of high on a certain amount of drugs. And this rhythm started to come out, kind of languid sound environments, mainly based upon slowed down rhythm boxes, alto sax, and then Blaine joined me, with violin over-dubbed to get a quartet sound. I came out with this phrase "UrbanLeisure" of just being in the middle of a city, stretched out on your lounge chair. It's your leisure time, and you're relaxing. This is the kind of music you would listen to. This is urban leisure music." [45]
'Blaine: Steven drew a picture of it, and we did a show around it, with the concept being us wearing white suits, sitting in lounge chairs, sipping long cool drinks in front of a projected slide of the Trans-America Pyramid.
Steven: I kept working on the rhythm tracks. Blaine

album in Britain

05/80 TM plays an *Urban Leisure* concert

Some reviews of the Urban Leisure Suite. 'San Franciscan forged but self-consciously European leaning, this collection of four suites by the premiere avant-chamber collective transcends their original visual stimuli. Impressionistic in ways both broodingly martial and woozily arch, layered onomatopoeic orchestrals and absurdist horns vie with minimalist piano strokes and primitive electronics' (N. COOPER, *Glasgow Herald*, 06/23/02)
'*Urban leisure* is the four part soundtrack of a multimedia project that was mainly conceived by Steven Brown, Blaine Reininger and one member of the excellent San Francisco Indoor life, Bob Hoffner. It's a kind of perverse easy-listening made out of aerial rhythmic and instrumental fragments, airplane take-offs and melodies played on the *saxophone*. Only the images shot at the time are missing to better understand the nuances of the music' (C. CONTE, *Les Inrockuptibles*, 09/0/02, translated from French).

05-07/80 BLR guests for the track "Don't Lie" on Snakefinger's LP *Greener Postures*, recorded at El Ralpho Studios, prod. Snakefinger + The Residents, published by Ralph (1980), later appears on Snakefinger CD *A Collection* (Torso, 1988)

made to melodic form and structure. Winston worked on narratives, and Bruce started on the visuals. Winston and Bruce actually had a narrative story line, where at one point they were at a party, in another part they were driving a car… just a story integrated with the music. There was a projection screen with films being shown.

Blaine: There was this real nice one that went with "Devil's Drums," a real percussive thing I did with two drum tracks out of sync with each other, with no beat, but obviously were throbbing drums. During this, Winston was miming driving a car, and wearing this horrible terrific mask. Behind him was a film of the Trans-America Pyramid projected on a realistic cardboard model of that same structure. The film had been filmed at such an angle that the film and the model were the exact same size, but one was moving while the other was stationary – one was moving forward through space, as if you were driving in a car.'[46]

The live performance of *Urban Leisure* took place in May, with Brown, Reininger and Bob Hoffner of the band *Indoor Life* constituting the orchestra, Tong/Geduldig doing the visuals. [47] Brian Eno, who was in town recording *My Life In The Bush of Ghosts* album with Talking Heads' David Byrne, was in attendance. Reininger managed to persuade film-maker Diego Cortez to introduce him to the *maestro* and to ask him about his opinion of Tuxedomoon's show. Eno replied: "Well, Doctor sax never did perfect his instrument, did he? Excuse me now but I have to pee…" Quite disappointed, Reininger went over to Cortez and said: "Well, there goes another hero down the drain," to which Cortez replied: "That will teach you to have heroes."

That was it for Tuxedomoon's personal variation on "ambient music" for the time being. It will serve them again many years later, in Greece in 1997.

Ian Curtis's suicide and aftermath. On May 18th,1980, Joy Division's frontman, Ian Curtis, committed suicide just before the start of a US tour. Contrary to what some rumors suggest, [48] Tuxedomoon was not to be part of that tour but, sharing the same agent as Joy Division [*i.e. Michael Nulty*], they were scheduled to do a European tour with Joy Division in the Fall. Of course the plan with Joy Division fell through but not the tour. In the Fall Tuxedomoon toured alone.

Recording of the "Dark Companion" single. In June, Tuxedomoon recorded a new single, "Dark Companion," which would be their last American recording. Peter Principle: "'Dark Companion" was our idea to do a single as we didn't like the one-album-with-single-from-it a year approach and wanted to follow the (then) English model of putting out new

06/80 TM (SB, BLR, PP) records "Dark Companion" at Mobius Studio, SF, prod. TM, to be put out as a 7" (with a remix of "59 To 1" as B-side) by Ralph Records (1980). Later this track will be included on (Various Artists) *Frank Johnson's favorites*'s LP, Ralph, 1981 and TM's compilation LP entitled *A Thousand Lives By Pictures*, Ralph, 1983

Page 104

material as often as possible in order to maintain visibility in the indie world.'

The European connection. Things were then starting to unfold for Tuxedomoon in Europe as enlightened musicians and journalists started to rave about them.

Patrick Roques: 'I was reading an interview with John Foxx of Ultravox in *New Musical Express* in 1979. When asked if there was any new bands he was interested in he mentioned an "obscure American band, Tuxedomoon." This was just at the same time Tuxedomoon was being courted by Ralph Records.'

Words were also spread about Tuxedomoon care of the then immensely influential French magazine *Actuel*: "There was a fairly large community of expatriate French people in San Francisco, remembers Reininger. There was that woman who worked for *Actuel* for instance [*probably Elisabeth D*]. We would meet with these little groups of French people who lived in San Francisco. At one point, some favorable reports were done in France and we didn't know, in all of our American arrogance and ignorance. We didn't know that *Actuel* was so important. We thought it was a fanzine. We began to be known in circles like that in Europe. There was something interesting and rare in the fact that we were from San Francisco because there is that image attached to it that is fascinating to Europeans…"

'In America there existed no parallel movement to Cabaret Voltaire, Throbbing Gristle and their industrial/Futurist ilk. This scene was certainly one they felt more affinity for, things back home having taken a downward spiral into the Dead Kennedys,' writes James Nice. [49] Peter Principle: "(…) we discovered that in America we couldn't find any engineer that knew anything about effects and it's still true in a big way, unless you're working in a disco, then you get into a different kind of aesthetics. You know on tour, almost every PA is still mono. Anyway we had a feeling that we had to go to Europe and record in England because there were all of those rhythm machines bands coming on and we felt some sort of affinity for that sound (…) Unless you're in country & western or in soul in America, you're not serious." [50]

That Spring, Ralph Records had signed a licensing deal with Pre for the British market and with French label Celluloid for the rest of Europe. As it turned out Tuxedomoon had already made a deal with Pre in 1979 for *Scream With A View*: "Richard Butchens, recalls Peter Principle, had a label called "Pre," which was a sub-label of Charisma – and on it he had Delta 5 and a few other bands – and he wanted to sign Tuxedomoon. We had *Scream With A View*, which we had just recorded at The Residents' studio in a deal in which

A review of the Dark Companion single. '"Dark Companion" fogs up the windows, evokes a dockside mystique like that old Bogart flicks and paints a fuzzed-out image in TM's unique drone. It's an intelligent, haunting, surreal image done with wicked electric brush (…) Shades of brilliance on both sides, but I still don't know what to conclude; I guess that's a good sign.' (A. Spiliotopoulos, *The GW Hatchet*, 02/09/81)

08/80 TM plays at Rock City, SF, on the 6th.

'August 6, 1980
Rock city
The look on Steven Brown's face: Transfixed, almost other-worldly, like one of those medieval paintings of saints in ecstasy… the frozen concentration that says more in a minute about intensity than all the convoluted stagey antics of all the cheap would-be-rock stars throwing themselves spazy around the stage ever could…' (Brad L., "Tuxedomoon", *Damage*, n° 9, 09-10/1980)

'In San Francisco, I met the five from Tuxedomoon who dilute their hallucinated music into their life and vice versa. That gives the sort of characters I like.
"We are the most neurotic group on this earth. This is how we survive. Ah! Ah!"
Blaine, the violinist of Tuxedomoon bursts out laughing while his friend Steve adds venom to our conversation. Suddenly Steve blows up: "I'm fed up waiting! I wanna go out! I wanna leave! I want! I want!" Now he holds his head in his hands and bangs it violently against the wall. Ouch! Must be painful! But that's all the better, for then Steve won't have wasted the day.
The boys from Tuxedomoon don't like to spend a single day without accomplishing something absurd. It's their only self-imposed disciplin: leaping on the hood of a passing car while growling at the driver, rushing to the next door supermarket and buy all the translucid plastic rulers to make gifts for friends. Spend the coldest night of the year outdoors, lying amongst the rubble on a building

site, with their heads sheltered within the jaws of a sleeping mechanical shovel. Each and every strong emotion or absurd situation feeds their poetic universe, which they build in place of a decisively too farcical world' (ELISABETH D, "Ils n'en font qu'à leur tête", *Actuel*, n° 15, January 1981 (translated from French)).

08/80 TM takes part to an *August Angst Tour* with DNA and Minimal, which comprises the following gigs:

> **08/08/80** TM plays at Urban Noise, Portland

> **08/09/80** TM plays at The Showbox, Seattle

> **08/10/80** TM plays at Roscoe Louie, Seattle

> **08/11/80** TM plays at Gary Taylor's, Vancouver

Blaine Reininger: 'We spent the whole tour in this woman's [*DNA's Ikue Mori*] company and not a peep. Not a syllable passed between us. That is, until one day when we were apparently staying under dormitory conditions. There

we had agreed to do *Subterranean Modern* and perhaps the option for their albums if they let us record this EP there. We'd licensed the EP to Pre, and they wanted to put Tuxedomoon onto Charisma. They tried to make a deal, but we'd already made a deal with Ralph, so we tried to make a sub-deal." [51] Apparently the separate deal struck by Ralph with Celluloid made sense as Pre wasn't interested in anything else on Ralph [52] and, also, 'Celluloid were much better connected in New York,' remembers Peter Principle.

In the meantime Steven Brown had written to John Foxx, asking if Tuxedomoon could get on his MetalBeat label but, says Principle, "MetalBeat never made us more than a general offer." [53] Renowned British designer Jonathan Barnbrook, who was turned on Tuxedomoon quite early on by the same John Foxx, recalls: 'Just remembering about John Foxx, I did interview him a long time ago for a magazine that never happened (yes one of those) and I asked him about Tuxedomoon releasing on his MetalBeat label. He said that it didn't happen because he realized what he could and couldn't do with the label. He said he just wanted to be a musician and not be involved "on the other side of the desk." He also said he liked Tuxedomoon's music because he wanted to release "beautiful strands" in their work but realized he wasn't the right person to do it.' At any rate by then the band had decided that they wanted to record their next album in England and so they composed a letter together in which they asked Foxx for help in finding an engineer/producer. He replied with the contact for a then young and promising sound engineer: Gareth Jones. [54] Peter Principle: "[*we*] convinced Ralph to do *Desire*, recorded on a Ralph recording budget but through the auspices of connections in England. So that's how we actually came to be in England, working with Gareth Jones." [55]

So with an agent in the UK (Michael Nulty and his Promo Promo agency) organizing a European tour for them in the Fall plus the recording connections in England, the band, after an August West coast *Angst Tour* (with DNA and Minimal Man) and a few more dates in San Francisco, set off for their next big adventure. They left for Europe re-united with Winston Tong/Bruce Geduldig, bringing along their soundman/road manager Gerry (Gerald) Hesse as well as Reininger's wife JJ La Rue, starting their still current wandering story around the world.

Tuxedomoon's first European tour and recording of the Desire LP. Tuxedomoon's first ever European date was, quite symbolically, on October 1st, 1980, in Brussels at the then legendary *Plan K*. This venue, a renovated sugar factory located on – believe or not – *Manchester* Street in the industrial district

Page 106

alongside Brussels's canal, had become the home of Frédéric Flamand's *Plan K* dance and multi-media group. [56] It hosted many of the most remarkable musical events that took place in Brussels during the eighties. More specifically, many of the Les Disques Du Crépuscule – the Belgian counterpart of Manchester's Factory records [57] – parties took place there under the auspices of this label's co-founders: Michel Duval and Annik Honoré.

The concert was very well received and this even though Tuxedomoon's American transformer broke down for a good ten minutes after only two songs.

The next day, the band gave an interview to Brussels's *Radio Capitale* revealing that they were already seriously disenchanted with San Francisco and the United States.

Peter Principle: "There used to be a couple of decent clubs in San Francisco but now there's only one I can think of. There's nowhere worth to play now, it's just like anywhere else. This place is called Savoy Tivoli. It used to be a little bit better when there was the Deaf Club and whatnot but the political scene there has changed since the assassination of the Mayor…"

Steven Brown: "Getting back to the vitality of the clubs' scene or of any kind of scene (…) six months ago we played in New York and the vitality was present and now it's gone. We've all heard the music. We've all gone to the clubs. We've all been trendy. It's over, *au revoir*. It's like the whole movement is dead, it's over: good bye to the New Wave. It's time for something new. The only question is what is going to be the next break. It's over in the United States."

Blaine Reininger: "I take this opportunity to paraphrase Marcel Duchamp. He said that the reason why he preferred chess to art is because chess is closer to a pure activity of the mind and no danger of commercialization. I think that we've been co-opted by big money and they've put out safe substitutes to new wave like Blondie, to keep everybody under control…"

However Reininger remained optimistic regarding the fate of Tuxedomoon's music: "It's not our intention to define ourselves in terms of any mainstream. We're addressing eternity. We're not addressing 1980, we're addressing history." [58]

After their concert in Brussels, the band played a series of successful dates in Eindhoven, Rotterdam, Amsterdam, Berlin, Düsseldorf, Bordeaux and Paris.

In Rotterdam Peter Principle met Dutch visual arts student Saskia Lupini, with whom he will form a couple for about ten years. Lupini will collaborate with Tuxedomoon on several occasions and will also participate in Principle's solo undertakings.

Bordeaux's adventure was documented by *Actuel*'s journalist Elisabeth D:

was something like a communal shower. On my way to use it, I spy her coming out and she says: "Pretty wet in there." That was it.'

08/16/80 TM plays at the Palace of Fine Arts (with DNA), SF

08/18/80 TM plays at the Palace of Fine Arts (with DNA), SF

08/21/80 TM plays at the Eureka Theater

08/22/80 TM plays at the Eureka Theater

08/23/80 TM plays at the Eureka Theater

09/01/80 TM plays at the Jet Wave Gallery, SF. Some images can be seen in *Tuxedomoon – No Tears*; Greek TV documentary directed by Nicholas Triandafyllidis, Astra Show Vision & Sound, 1998. In 2007, *Jet Wave (1980) A Multimedia Loft Jam* is featured on the *Found Films* DVD (part of the *Unearthed* double CD/DVD) that is part of the TM 30th Anniversary *77o7* box set released by Crammed Discs in 10/07

09/01/80 TM plays at Savoy Tivoli, SF

09/09/80 TM plays at the Polish Theater, Los Angeles

10/01/80 TM plays at the Plan K, Brussels (Belgium) as first ever and successful European date

10/02/80 at the Plank and 10/03/80 in the studio WT records "The Next Best Thing To Death" with TM for music generation,. This track appears on (Various Artists) *The Fruit Of Original Sin*, double LP put out by Crepuscule in September 81, later Interphon CD, April 87 and Crepuscule CD, Summer '89

Page 107

Tuxedomoon at the Plan K. Photo Benjamin Lew

'A one tour somewhere over the mid-atlantic

Delerium of lemons

The next best thing to death is resurrection
we should be like this all the time
we will be like this all the time, no doubt about it

Comme d'habitude
I am making it up as I go along
There are those who feel that this is not a valid way of working
but it has become apparent to me that there is no other way of working
this is it
moment by moment
putting it together as we go along

Form follows function and function is prescribed by necessity

Somebody is screaming now, singing I suppose, in the next room where
a conglomeration of artists is trying to relax for a night

Here we are, all us together, for some (is that proverbial) first night here, in Europe, the seat of adolescent fantasies, castles and traditional
happy endings, trolls and elves and

'Tuxedomoon gets late in Bordeaux.
"You should have been in time, says the landlady, the gig is cancelled. Here customers don't wait." Tuxedomoon spends a remorseful night in a little hotel in town. The next day they return to the club:
"We want to play tonight, for free," they tell the landlady.
The landlady frowns, she smells a swindling of some sort. One does not play for free. But yes! It took her two hours to understand that Tuxedomoon still possessed that kind of innocence. They spend the rest of the week-end in a Bordeaux castle that smells stone, cork and ghosts. They take acid (…) They're craving for a night of adventures.
They spend their last savings (…) and go back to Paris waving Bordeaux as a yardstick for living:
"Can you believe it? The peasants over there do read books! It's over there that we want to live!"' [59]
In Paris the band will have the difficult task of sharing a bill with the famous Master Musicians of Jajouka with of course writer Brion Gysin [*i.e. the British rediscoverer of Tristan Tzara cut-up technique, close friend of William Burroughs and author of The Last Museum that will later be an inspiration for Tuxedomoon' Bardo Hotel album*] in attendance [60] at a party organized by *Actuel* magazine. "They blew us offstage," recalls Reininger [61].

In November, after a showcase at the University of London, the band retired to the deep English countryside, at Jacob's Studio in Surrey, to start the recording of their *Desire* LP, a process that will take them through to December. Tong was back in the States to perform his *Frankie & Johnnie* theatrical

piece, showing up in Surrey just for three days in order to record his parts on the album.

"What are your memories of recording Desire and that period?
- Steven Brown: It was pretty grim to be brutally honest. *[Laughs]*
- Peter Principle: Right. The food was funny. He *[Steven]* is a vegetarian, so we would try and get some vegetables but they would all be boiled, so you'd have green water and white vegetables. And we had that story where you had to put the coins in the electric meter and we never had any money *[Steven laughs]*, so we were always trying keep the heat on. It was a bit of a struggle, and in the end we were leaving the country and were one day over our visa – 91 days – and they said: "Well, you've overstayed your visa" and we were like: "But we're leaving!" *[Steven and Peter laugh]*. They made us know that we weren't really welcome. It was a time – I don't know if it's changed at all – but back then for musicians from America to come to England and work was very hard. You had to find work for an English musician in America, it was very strict how the unions were running everything there. So it wasn't easy to come to England and be here, whereas in the end it was quite easy to go and be in Belgium.
- Steven Brown: (…) we were in a farmhouse, way out in the middle of nowhere…
- Peter Principle: Yeah, so when there was nothing to do but record that was nice. We had some high concentration and we had quite a bit of material that we'd luckily written in San Francisco and so we didn't need to write any music while we were [t]here."[62]

Gareth Jones, who recorded and mixed *Desire* remembers: 'My friend and mentor John Foxx introduced me to the band – in fact they had approached John about having him help record *Desire*. John felt that I would be a good person to record and mix the album for them. The session started with Peter, Steven and Blaine. Winston flew in later. Peter, Steven and Blaine all seemed like serious committed artists to me. We were all very passionate about what we were doing and we started work immediately. I was new to the band, and relatively inexperienced in the studio at that time. Time was short and I was focused on my job as recording and mixing engineer so I had little time to decipher the details of intra-band relationships. It was clear to me that there was a real energy here, and that something special was being made. So there was lots of mutual respect as far as I could tell. Winston was also much admired by the members who had already arrived at the studio – there was an excited tension about his impending arrival.

As a recording engineer my role was to help the band get their ideas onto tape as easily as possible – they had a clear

wicked, sisters in their proverbial huts in hell, which is really the weed, rat backyard of your mysterious neighbour.

It is all inbreathing they say control of thoughts, the wrath of each cell of your body and the very passage into and out of life itself.

And they are all screaming in the next room, and I am still here plunging along. Unsure of what the next moment will bring but trying with
all my mind not to try to embrace the moments as they come and go.

Scream, scream, scream maybe that is the solution solution to scream and scream and scream
I am hardly able to do that at the moment look as I feel so wonderful (It just doesn't seem to be any reason to scream or feel myself with "Angst")
who needs it ?

I've had about enough in this solitude, going to join the others in the
next room; slip back into the comfortable void of a movie.

Signing off yours in cold blood'

W. Tong - Brussels 12.35 a.m. 3d of October 1980 (this text appears on the leaflet of the *The Fruit Of Original Sin* double LP compilation, released by Interphon in '81)

10/03/80 TM plays in Eindhoven (Netherlands). Set list: 1. "East" 2. "Jinx" 3. "Music #1" 4. "Dark Companion" 5. "Nervous Guy" 6. "Volo Vivace-Litebulb Overkill" 7. "Desire" 8. "Incubus (Blue Suit)" 9. "Everything You Want" 10. "(Special Treatment For The) Family Man" 11. "What Use?" 12. "Waterfront Seat" 13. "In the Name of Talent" 14. "In Heaven" 15. "Again"

10/04/80 TM plays at Exit, Rotterdam (Netherlands). PP meets Saskia Lupini

vision and ideas for how to realize that vision. All the material was written, so it was just a question of getting the mics up and rolling tape, and being open to anything that the band wanted to try. I introduced the string players Vicki [*Aspinall*] and Ali [*Robinson*] to the band, and when we came to mix I simply did my best to make everything audible!

We were recording in a country residential studio, so everyone was together all the time. This made for an intense creative atmosphere. We were "living" the album. I was kept pretty busy, so for me time was probably all too short. Of course the sessions were intense, but I would not describe them as painful. I remember the sessions fondly – it was an exciting time for me, and a steep learning curve. I loved working with the band and did work with them again later (on tour and in the studio).'

Peter Principle: '[*I was*] very impressed with Gareth. We were right off the boat and England seemed to be living up to all of our fantasies what with the poverty and the musician lifestyle with the vibe of being on the verge of breaking... fun times. John Foxx came by the studio in Farnham once to listen to "Blue Suit" [*from Desire*] while we were mixing and of course he loved it and everyone was excited. It does sound very *Foxxy*. He especially loved the reverb snare rimeshot when the line is shot at the ceiling. This was no surprise as Gareth had done the same thing all over John's first album. It was new at the time...'

Desire, on first hearing, had the potential to take *Half-Mute*'s dedicated listeners by surprise as it sounded quite different, in a baroque sense, from its predecessor. It saw Tuxedomoon move further away from their quasi punk roots and *Half-Mute*'s minimalism towards a sound that has as much to do with European folk as it does with rock music. "Minimalism is not something that we're against, said Peter Principle in 2001. But we're not obsessed with it now. It was a statement to make on the *Half-Mute* record and it really did cut a profile for sure. In a way with *Desire* we went the opposite direction."

The European press immediately noticed this diversity in the music leading to a perception of Tuxedomoon as an open collective. 'In their suitcases, wrote Elisabeth D, they carried surprising records. From one piece to another, it was as if one was listening to a different band: electronic flows, cold and gloomy as snakes would be, hammered and grave rock tracks in the good tradition of the *Velvet Underground* revised by punks, pseudo-oriental incantations, a plaintive saxophone, helicopter noises, music for films. Things that you would not hear anywhere else.'[63]

Luca Majer, an Italian journalist also highlighted the "open collective" characteristic of Tuxedomoon in an early – for

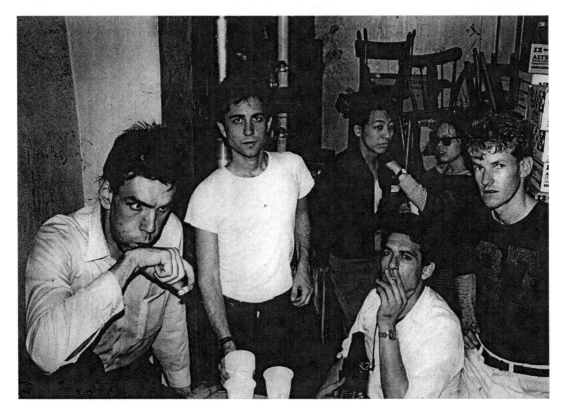

Tuxedomoon at Exit, Rotterdam, 10/04/80. Photo courtesy of Peter Principle

Europe – interview he conducted with the band: "'The music of the band changes all the time because the people who work with that band change all the time. The tracks on *Subterranean* were very much in the spirit of our guitar player, for instance. I [*Steven Brown*] and Blaine are the ones who stay in the band all the time and we see to give subconsciously a certain direction to the music, a direction that comes out modulated and transformed into something else, depending on who is working with us in that particular moment. Tuxedomoon is an amorphous thing, it's not a "typical" band: every recording has a different line-up and the music slides along unrestrained. Moreover, the fact that we have a rhythm box to give the tempo is just a coincidence. In *Scream With A View* we had a drummer and also on some of *Sub Mod*: when we have one, we use him. If we don't have one available, we are as happy to use electronics."

[*Blaine:*] "Our compositions are the product of improvisation in most cases. Steven and Peter first work on a rhythmic base, they build a bone structure and then we add one element after the other and when we find an idea that we like, we'll investigate it further or maybe use it in another context. Sometimes someone comes up with a precise idea in mind, then we try to work following his directions; sometimes we just turn the tape recorder on and just let go, we improvise and then listen to what we did and we choose the fragments that we find most interesting (…) Improvisation plays a much

Peter Principle and Saskia Lupini. Photo Saskia Lupini.

Saskia Lupini: "Peter used to lie on the bed and listen to the gurgling sounds in the pipes of the radiator and he would think that it was music and so he would be sitting there with his eyes closed and pretend that this was music, hearing all the sounds in the building. Peter is much more a sound instrumentalist. He's not so much a classical musician, he's more in the way sound works and make soundscapes."

Peter Principle: "She was studying photography when I first met her in Rotterdam in 1980, and we clicked right away because she was doing in images many of the same things I'm doing in sound. Her work is like abstractions that take on new structures and forms when lifted out of context or scale, so it's not exactly conventional – like my music is not so musical in a conventional way of organized melodies played on various instruments, but is more about textures that I bring in an abstract way. Well, she was doing this with light and color in the video medium really early on." (N. Martinson, "Peter Principle", *Proof*, nr 1, 1999)

Page 112

greater role at creation of a song rather than at its maturity." [*Steven:*] "As a group we work on the basis of a tacit premise: if we reject things that would be too anti-conventional and if we refuse things that would be too conventional, we try to operate a synthesis between these two extremes. This dynamic of acceptance-refusal is generated and restrained by the boundaries of the group: we don't have labeling problems, it's all between us three.'"[64]

Desire received generally enthusiast reviews although, as Andy Gill put it, sometimes colored with a *sense of unease*: 'Tuxedomoon's brief (…) Just as Throbbing Gristle operate in the area of unpleasantries, and any number of bands operate in the field of hearts and flowers, Tuxedomoon stick pretty firmly to their predominant atmospheres of despair and desolation, producing musical images of strangely stark, flowing beauty, occasionally hurtling right over the top into climes of bleak melodrama – as happens here in the overwrought vocals to "Victims Of The Dance."

Inner-city perils and pastimes feature in a darker fashion than the more conventional, emblematic use of such imagery in rock music. This is conveyed in menacingly comic fashion on the final track, "Holiday For Plywood." Based on one of those old standards you recognize but can't name ("Holiday For Strings," I think), it starts with a pizzicato violin figure – TM's Blaine Reininger joined by The Raincoats' Vicky Aspinall – before swinging smoothly into the main, bucolic body of the piece, which is used here as a blissful backdrop to a tongue-in-

cheek spoken vocal about domestic breakdown: "You daren't sit on the sofa/ The plastic makes you sweat/ The bathroom's done in mirror tiles/ The toaster wants your blood."
Both humorous and unsettling, this is exactly where Tuxedomoon are operating: the place where your materialism turns on you and devours your humanity. The true New American Music.' [65]

'This San Francisco group have produced one of the most stimulating and acutely contemporary works to be released this year. Dark, brooding but nevertheless irresistible, the music of Tuxedomoon compares with the best of Eno or Kraftwerk while relying more heavily on traditional instrumentation, strings and horns, than the latter's new electronics.
The subtle manner in which Blaine Reininger's violin weaves between the brass and keyboards has created a chilling landscape that slowly magnifies round the scary lyrics and oblique vocals.
Reminiscent of the sleazy soundtrack for Scorcese's *Taxi driver*, tracks like "In The Name Of Talent" and "Incubus" make up a collection of twisted West Coast chamber music: the perfect backdrop to Metropolis 1981 style.
Despite the undertones of surrealistic doom and encroaching chaos the melodies and rich tonal variations contained in the deviously complex songs are compellingly haunting and always memorable. Each play reveals new dimensions in the dense tapestry of sounds which is so cohesively put together that it draws every disparate element into one flowing whole; the ultimate psychotic muzak (…)' [66]

'For Californians, Tuxedomoon do not exude the sun. In San Francisco, they are seeking the shady, cold and humid spots, under the cliffs shredded by seisms (…) Great classical momentums, almost pinkfloydians (…) Winston, the Chinese guy in the group, sings like with a knife thrusted on his throat, a voice full of weary desires, of bitter violence. His lips salivate and Winston staggers, drunk with sadness. Chamber music gets distorted into dislexic sounds, like a man on the electric chair. Tuxedomoon carries us far away from rock 'n roll, where zombies are watching stars flickering on their disturbed television set.' [67]

'I do have mixed feeling about Desire. The pieces and their sonorities do not form a whole as was the case for Half-Mute.' [68]

'(…) music frankly opened, accessible, almost "commercial." With all the gimmicks of the times: muzak pointing its nose (…) Ambiance jazzy saxes solos mingling with corny violins straight from science-fiction movies from the fifties (…) There

10/05/80 TM plays at Flora's palace, Amsterdam (Netherlands)

10/06/80 TM plays at SO 36, Berlin (Germany)

10/07/80 TM plays at Rötinger Hof, Düsseldorf (Germany)
Principle: 'I think this is the gig where Blaine tried to steal the hotel lamp and I wrote: "hotel ausgang sucks" on the door... (famous story). We screamed so loud to try and get Blaine to wake up in the car in front of the hotel that the police came to see what was up... We showed up late for the gig and had to load in through the audience and after the gig Blaine fell asleep standing at the clavinet while we were winding wires. Memorable night...'

In October, TM will also play in Bordeaux (see *Actuel*, 01/81) and in Paris at a party organized by Actuel magazine with the Master Musicians of Jajouka. A short excerpt of the Target Video (*Tuxedomoon: "Four Major Events"*) shows TM and the Masters playing.

From 11/05 till 12/14/80 WT&BG
in *Frankie & Johnnie: A True Story* at the Magic Theater, SF (see http://www.magictheatre.org/pages/history.shtml), for six weeks. It's the start of their collaboration with Nina Shaw. This show will also be presented in Italy, Bologna, in the Spring of 1981
'(…) a piece that can be seen at once as bi-dimensional theater and as tri-dimensional film. The live performance takes another dimension by the projection of images: Winston Tong converses with his own person appearing on film. The tension is further deepened through the use of two dolls, who in turn materialize a scission of the character on the screen and on the stage.
The musical backdrop is composed of sensitive moments in the work of Billie Holiday, emphasized by Winston Tong's penetrating voice. Passionate fragments in the life of the jazz singer constitute the piece's backdrop. Thus *Frankie and Johnnie* consists in an expressionist approach of a schizophrenic personality, through the filter of a transvestite, with emphasis put on the rivalry between man and woman in a torn individual'
About the title of the piece: (Winston Tong) "These are the names of a boy and a girl, after a traditional nigger ballad, that everyone knows in America, it's about jealousy leading to murder (…) Frankie and Johnnie are two aspects of the same individual. Hence the ambiguity in the names (…) takes on a wholly different meaning here. The piece is about a buried passion, that never manifests itself in its totality. Only fragmented aspects come to view, which leads to schizophrenia.
I have the impression that a man controls more his extreme passions. Hence the idea of a transvestite is interesting. You become a woman and hence you reach a hidden part of yourself." Billie Holiday had an enormous influence on Winston Tong's way of singing: "I tried to re-incarnate Billie Holiday in the most intense possible way."
As to the use of dolls. Winston Tong: "Playing with dolls allows you to lay out your own activity outside of yourself (…) in the same way as you could contemplate another dimension of yourself in films (…) What the dolls reflects is naturally also what you live."
Bruce Geduldig: "We don't play, we are there, we live out something (…) we start out from our fantasies about other people's emotions, in this case Billie Holiday. We revive her experiences with the same intensity. Awareness of her past brings us back to awareness of ourselves here and now" (J. Landuyt, "De vrouw, de man. De

Page 113

**Winston Tong in *Frankie & Johnnie: A True Story*.
Photo Saskia Lupini.**

derde dimensie", *Vinyl*, 02/83 (translated from Dutch)).

10/31/80 TM plays (showcase) at the University of London Union, with Bauhaus & Mass.

11-12/80 TM (BLR, SB, PP, WT for a few days + Vicky Aspinall and Ali Robinson) records, at Jacobs Studio (Surrey, UK) with prod. TM/Joeboy Productions + Gareth Jones, the tracks that will constitute their album entitled *Desire*, namely: 1. "East" 2. "Jinx" 3. "..." 4. "Music # 1" 5. "Victims Of The Dance" 6. "Incubus" 7. "Desire" 8. "Again" 9. "In The Name Of Talent" 10. "Holiday For Plywood." *Desire* was published as a LP by Ralph in February 1981. Later it will be released as a Crammed (Cramboy) LP in May 1985 and as a *Desire/No Tears* Crammed (Cramboy) CD in October 1987. "Again" was also featured as B-side of the Les Disques Du Crépuscule 12" *Ninotschka* in 1982

Peter Principle: "The artist is the only one who knows what [his/her work] is about. The audience builds its own interpretation but that also is valuable. When you are being confronted with art, you find yourself facing a mystery that you have to try and solve. For the same reason, Tuxedomoon is not a real group where all the members would have the same ideas. The word "collective" is here more than relevant: we are a collective of individuals who, from their own inspiration, do totally different

Page 114

Urban Verbs cross paths with Eno, Robert Palmer with Funkadelic. Even Marianne Faithfull. We are back to the first grooves of the Floyd or Soft Machine. A new alchemy is taking place (…) Tuxedomoon is the precentor of the new subjectivity. Their music is one of pleasure and passion. One can hear its heart beat. Rather seductive, after all these years of hatred and coldness (…) Tuxedomoon brings back Emotion (…) Peter Principle and Blaine Reininger compose the "jingles" of dream, they explore mental spaces and sound dizzinesses. Psychedelic nostalgia and neo-hippie come back? Ridiculous! Tuxedomoon is so far away from all this. As to the hippies, they've now long had taxes and refrigerators. Afford yourself the Tuxedomoon experience. Take the midnight express with Tuxedo.'[69]

'Apart from a handful of straight faced pieces, this album is so camp it should have been sold with a free groundsheet (…) The title track comes rushing in at a rakish angle, bowling about the time like J.J. Burnel's "Triumph," and helter skelters through buckshot sprays of echoed vocals and keyboards. It spins faster and faster, Brown blowing a dark blue sax repetition on top before 'coptering up through the roof. Highly exhilarating!
But consider, dear reader, the two openers. "East" is a Gothic waltz for organ, bass and drones, with Brown blowing a pining sax feature in the middle of an empty dance floor. It phases into "Jinx," a mekanik *the dansant* in which greasy gigolo violins swoon around the potted palms to the accompaniment of Edmundo's drum machine and an organ that can only be described as very Bob Danvers-Walker (…)
As their debut *Half-Mute* showed, they're brilliant musicologists. Importantly, they're also artists before academics, and can always transcend their clever-clever sources. Their outlandish, take-it-to-the-hilt style just sends this album sashaying into ultimate somewhere elseness. But after that breathtaking debut, I just feel that by jamming their tongues in their cheeks for so much of *Desire*, they're underselling themselves.'[70]

Start of Tuxedomoon's love story with Italy. During the recording of *Desire*, Tuxedomoon (without Tong/Geduldig) performed two shows, one in Liège, Belgium (November 29th,1980) and another in Bologna, Italy (December 9th,1980), that did not go unnoticed. The show in Liège was part of the celebrations given for the 1000th Anniversary of the principality of Liège. It was filmed by the Liège division of the French speaking Belgian television (RTBf) and was broadcast as a 40 minute rockumentary, where the images of the concert were

interwoven with images that director Paul Paquay shot for a documentary series about famous train lines. Funnily enough this footage looks as if the director had had a premonition about Tuxedomoon's future wandering story through Europe. The Orient Express train is shown passing through landscapes, cities and countries that the band will later visit. The train went East – the title of one of the tracks on *Desire* – and South, which will become an obsession for most of the band's members after years spent in sunny San Francisco followed by an eternity in rainy Belgium.

The train featured in Paquay's *Tuxedo Moon - Le Train* visits several Italian cities and it was in one of those cities, namely Bologna, that Tuxedomoon performed their first Italian concert and started an everlasting love story with Italy. This first concert was organized by Natale Nitti, also known as Italian band Central Unit's frontman. 'In 1979, writes Nitti, I lived in Bologna where I had started the Italian branch of Recommended Records distribution (founded in England by Chris Cutler and Henry Cow) with a friend of mine, Giovanni Di Simone. I was also a DJ for Radio Città 103mhz [71] where I had an avant-garde music programme. In '79, we had already aired "The Stranger" single that someone had brought us back from a vacation in San Francisco. Tuxedomoon was then a totally unknown group in Italy but then suddenly a pirate pink version of the *No Tears* EP became available in some stores in Bologna. At that time we had an agreement with Ralph Records to distribute their acts in Italy and that was how Recommended Records distributed the *Subterranean* compilation and *Half-Mute* LP in Italy. In the meantime, I had contacted Time Release Records in San Francisco and also got to distribute the early singles and EPs that had not yet found their way to Italy. All those got frequent airplay on Radio Città and people started to call in, eager for some info about the band.

In the Summer of 1980, I read an article in the Italian magazine *Musica 80* that said that the band was in London for their next recording. Knowing that they were in Europe, I immediately decided that they had to come and play in Italy! So I called Ralph Records, they gave me their number in London where I learned that they were off for a few dates in France. Finally I reached Steven Brown in Bordeaux who was immediately interested in the idea of touring in Italy. I tried to arrange several gigs in some avant-garde clubs in Florence, Perugia, Rome and Bologna but to no avail: it was still too early for a name like Tuxedomoon. In the meantime however, me and the guys from Radio Città were resolute about setting up a gig in Bologna, where the band had already had large airplay. We demanded and obtained some support from the Culture Council Of The Town Of Bologna that in turn asked

things and often cooperate in view of a common project. Not just one vision, but a nice puzzle that consists in different pieces. Tuxedo Moon is a concept, where there's room for individual expression but also for interesting combinations. Not a limitation but a broadening of possibilities." (J. LANDUYDT, "Dolend langs de gewelven der kunst Tuxedomoon", Vinyl, 02/82, translated from Dutch)

'The night is long with many MOONS between them. But I remember the TUXEDOMOON vividly. It was HOLLYWOOD 1980, I was visiting friends in an apartment complex on SUNSET BOULEVARD near the famous drugstore, SCHWABBS where many film stars were discovered and later on overdosed!. IT'S A JINX! I was staying with friends Nancy and Richard who were producing early Punk bands in the vicinity. None of them became Internationally Famous but excitement and hype filled the air. Nancy was famous in her circles for her musical tastes. Someone who managed to collect important music releases and turned all her friends on to her latest treasures. She found…DESIRE… Now the morning had come, the smog was thick, the sounds of car horns danced in and out to my wakening. I walked down the steps to the aqua blue pool. Men stalked around in Speedos and women were all dressed up and hurrying to work. Perfume filled and disintegrated into the smog air. I dove into the clear pool and demagnetized my mind and body... We were young in that dirty city of LOST ANGELES... I laid back and closed my eyes when I began to hear what I thought to be a Modern Opera. The first sound I heard was a violin crying with a bass guitar seeming to prod thru a puddle. Could it be a polka? No. Could it be a Death March? What the hell was it? The music blared in the morning sun. A song of loneliness and fear, tears and lost dreams... and then began the entry of a tango beat… People started dancing, we all started laughing. So there we were, all getting a tan, burning in the sun around a pool. We all loved DESIRE: we were born wanting and needing and Tuxedomoon mirrored the culture we hated and so loved... We are still dancing to that album. I have it playing right now and if a certain person were to pass by listening, I would just turn it up and smile… "Makes you want one." Mark Nacker 2002

11/29/80 TM (BLR, SB, PP) plays at salle des fêtes du Palais des Congrès (with The Machines), Liège (Belgium), *Festival du Futur*. This concert was the subject matter of a 40 minutes documentary entitled *Tuxedo Moon – Le Train* shot by Paul Paquay for the RTBf (Belgian French speaking television). This gig was also photographed by Philippe Carly (see http://www.newwavephotos.com/TuxedoMoon.htm)

12/09/80 TM plays at Teatro Antoniano, Bologna (Italy). First Italian concert ever, delivered in front of an enthusiast audience of 2,000 people. Set list: 1. "East" 2. "Music #1" 3. "Dark Companion" 4. "Waterfront Seat" 5. "Nervous Guy" 6. "Volo Vivace" 7. "Litebulb Overkill" 8. "Desire" 9. "(Special Treatment For The) Family Man" 10. "Everything You Want" 11. "What Use?" 12. "KM/Seeding the Clouds" 13. "59 To 1" 14. "In The Name Of Talent" 5. "Pinheads On the Move" 16. "Incubus (Blue Suit)" 17. "7 Years" 18. "Tritone (Musica Diablo)"

Page 115

us to arrange the event in collaboration with Harpo's Bazaar (Harpo's Bazaar being the former name of Italian Records, fronted by Giovanni Natale).

We were a bit afraid that the band would refuse to come over for just one single date, so we offered them a higher fee and they luckily accepted our proposal. Then Harpo's Bazaar and Radio Città took over, arranging for all the details of the upcoming gig. A theater with a capacity of about 1,200 seats was rented (Teatro Antoniano) and a hammering airplay of Tuxedomoon's music began.'

The setting for the event was perfect as the teatro Antoniano is a quite peculiar place for a rock concert, being a venue controlled by the Order of Minor Franciscan Brothers, [72] coming complete with a convent in the vicinity, and most well-known for the organization of a children's choral singing festival.

'The day before the gig, remembers Nitti, the Tuxedomoon party (with Gareth Jones, their agent Michael Nulty and Reininger's wife JJ La Rue) arrived at the Pisa airport. The first thing they told us is that they wanted to see the Leaning Tower! So we went there and I remember three Americans rushing out of the car on our arrival at Campo Di Marte, running and dancing on the grass surrounding the ancient buildings, Peter embracing the tower…

On the day of the concert the venue was packed. We had sold 1,500 tickets and so hundreds of people had to stand through the concert. The gig was a genuine triumph: they played all their *répertoire* with fives *encores*! I remember Steven Brown the day after, writing a postcard to Patrick Roques that said: *Veni, vidi, vici.*'

Even before Tuxedomoon set foot for the first time in Italy, there was a buzz running about them as to their connection with the mysterious Residents. Peter Principle: "(…) it was the day after John Lennon was shot – and we flew over and did that gig. That was our first gig in Italy and how we discovered that the Italians loved us so much, because they had this pink version of *No Tears* they'd put out without anybody's permission and on the back it says "Thanks to The Residents." And they all thought we were The Residents. So of course Blaine got them going by singing "Hello Dolly" during soundchecks and talking like Homer all the time. That's how we got that going." [73]

More generally Italy was ready for Tuxedomoon when one considers the then prevailing socio-political context. Indeed from 1975, when Lou Reed gave a concert in Roma that was followed by violent clashes with the police, until 1979, when Patti Smith gigged in Firenze, Italy was quite starved out of rock concerts. By 1977 onwards, the political extreme left had become very active in the cultural arena, organizing

or supporting many concerts or musical events. [74] In this context Tuxedomoon seemed predestined to become Italy's *enfant chéri* as the band, touring in October 1980 – right before the presidential election in the USA – claimed that if Reagan would get elected, they would not return to America. Even if these statements were then intended mostly as a joke (Steven Brown: "At the time we jokingly said: "Well if Reagan gets elected president, we're not going back to the United States!" Because everybody knew that he was not going to be elected, right?" [75]) , Tuxedomoon's move to Europe was what happened next and glorified them with the halo of being American artists "in exile" in Europe.

Also Tuxedomoon's peculiar fusion of classical instruments (violin, clarinet, saxophone) with the use of electronics and a rhythm box immediately appealed to the Italian artistic sensitivity. Giampiero Bigazzi, who runs *Materiali Sonori*, an independent label that has worked a lot with Tuxedomoon through the years, explains Tuxedomoon's popularity: "They are very European culturally and this because they lived in San Francisco that in turn is very attracted to European culture and the Italian culture in particular. When they arrived in Europe, they immediately felt for European cultures and, in Italy, for the Fellini movies, for the music of Nino Rota and

Tuxedomoon at Teatro Antoniano, Bologna, 12/09/80: Blaine collapsing on his keyboard while the audience was demanding a fifth encore. Photo Natale Nitti

Italian painting. Also I think that the Italian audience, when they saw them for the first time, were quite intrigued by these characters, these "Martians" of some sort who were completely alien to what they knew, avant-garde included, but who nonetheless presented elements that were immediately recognizable to them, like their taste for melodies, for instance, something that goes to the "essence" of the music. We do have a baroque culture but in the 19th century we've had some "essentialist" music and Tuxedomoon is quite close to this kind of music."

Mirco Magnani, from the group Minox – a group with which various Tuxedomoon members will collaborate – summarizes what might be the Italian view on Tuxedomoon: 'I think that they've made one of the best example of contamination between electronic and classical music, between different cultures and different ages, "a meeting for all opposites."'

Red Ronnie, a "figure" of Italian musical journalism and also a well-known radio and television *emcee* (in those days in Italy, lots of concerts were organized by radios), announced their first concert in Bologna in terms that sound as if Italy had always known the band: 'Tuxedomoon's music is to be understood as a blend of influences coming from the past, from the romantic melodies of the films from the fifties to cold rock (…) All are however filtrated through the most futurist electronics. The final product is to be taken as a troubled testimony of an intermediary phase between human and mechanical music. The Tuxedomoons are also the reflection of a new way to conceive rock. No longer like the only form of creativity to which dedicate oneself but as one of a series of artistic interests to be developed (…) It's not by chance that Winston Tong (…) is mostly interested in theatrical performance, that Blaine Reininger comes from classical music and that Steven Brown is a polyinstrumentist (…) The minimum common denominator is however the synth that all of them can manipulate.'[76]

Preceded by such a flattering reputation, Tuxedomoon's first concert in Italy was meant to be a success, which it was, the venue being way too small for the audience. 'Blaine Reininger, Steven Brown and Peter Principle (…) made the audience go through delicate moments and wild emotions, confirming the technical dexterity and the creative enthusiasm that could be intuited from the start of their career.'[77] Probably willing to make Italy beg for more in the future, the concert ended with the invocation of an encore never delivered.[78] At this concert Steven Brown also met a young film-maker named Roberto Nanni, with whom Tuxedomoon and Steven Brown in particular will work later on.

Searching for a home in Europe and recording of the Joeboy In Rotterdam LP. At that point in time, the band had pretty much made up their mind about their intention to move to Europe. A combination of factors played a role in that decision. First of all they wanted to leave San Francisco where the magic had gradually evaporated since Milk and Moscone's assassinations. Steven Brown: "In the beginning in San Francisco, it wasn't easy because right when we started, doing our precious little theatrical cabaret, punk rock started and so finally when we got into the punk rock circuit, which was the only circuit and, we'd get on stage with Winston and Blaine and Steven, and people would be like fending off their beer bottles: "Where is the drummer, where is the drummer? Bam! Bam! Bam!" in the beginning. After a year people are lining up around the block to get in to see us. So our reputation grew, grew, and grew from zero to top. But San Francisco is a very small town. After two or three years we had already gotten to our *plateau*. And it's like: "Ok, what do we do now?" We stay in San Francisco and become a novelty act of famous local band or we get the fuck out of here and continue on our paths as wanderers, as gypsies, as artists… So what do we do? In our minds we thought: "Well there's LA, New York or Europe." And somehow we all just thought: "Let's go to Europe!" We were really naive (laughs) and literally we packed our bags, got on a plane and went to Europe and never went back to America… That's how it was…" New York could have been a choice but the band was already disenchanted about the local scene and, besides, the place was deemed too expensive and too insular. [79]

The band was also very impressed by the way they were received when touring in Europe. "I was amazed that people knew us! exclaims Brown. Everywhere we went, there was an audience. "Wow, how this happens ?" And also people were different. They seemed more interested in what we were doing generally. In the States, in San Francisco, we had audiences but the rest not really. In Europe, everywhere we went, small towns in Holland, in Germany, people would turn out, lots of people, to see us and hear us and enjoy what we were doing. That was the biggest shock to me which made us want to stay in Europe even more. And then we realized life was a little bit easier for artists here, in terms of government supported theaters, whatever, dressing rooms sometimes in theaters and venues. Sometimes they feed you even. It was just a different treatment. We realized that artists don't have to live like dogs, that there is somewhere in the world where they are treated like humans. So it was pretty appetizing for me to see this. And also, of course, the romance of being in Europe, kind of expatriate… I liked the people. I liked the culture. I liked the food. It just seemed right to me, pretty

Patrick Roques: 'I was trying to recall the various rented rooms Steven lived in around San Francisco back then. There was not a lot of personality to them as I recall. Sort of forlorn, like old hotel rooms littered with musical equipment, suitcases, books and crumpled notes. Usually off-white in color. Most landlords just painted all flats this way. Generic in color. There might be a TM poster or two on the wall along with the face of some young man torn from a magazine. All seemingly taped or thumb tacked at random. No sense of permanence. A ghost in a guest room. Soon forgotten. Steven didn't have his own place until Brussels. When I visited him there (1988?) it seemed very lived-in, very welcoming. It had some jumble of styles probably because so many people contributed to it, as in the *faux* painted walls and doors. The gypsy crash pad. Dirk Bogarde, a little on the down and out. Yet it had some feeling of home, some personality, some reality there. My feeling is that Steven was very depressed living in San Francisco and America. He was the most negative of all TM. He started to really brighten up in Europe. The movie Steven was making of himself in America was different than the one he started making of himself when he moved to Europe.'

Page 119

comfortable here."

The band felt like there was more respect for the so-called "avant-garde" in Europe, [80] Tuxedomoon being seen by many as 'the perfect common denominator between a sophisticated avant-garde and an "old Europe" artistic humanism.' [81] In addition, their base in terms of an audience was obviously larger in Europe than in the United States where the nature of their music would confine them to a handful of big cities. [82] Furthermore the traveling distance between big cities was considered smaller and the ease in circulating between different cultures greater. [83] Probably the group also felt attracted to a more antique – more backwards in a way – vision of the world. [84] Peter Principle: "America is very arid. Feet and the head are the strong part in the American culture whereas the heart is the weak part. In Europe it's a bit the other way around (…) At the time I came here, I thought: "OK, Tuxedomoon is a band based in the heart realm." And for myself as a mystical man, I smelled great possibilities here and so I was really motivated to stay in Europe. I knew German progressive music in 1971 when nobody in America would even have heard of this stuff until the eighties. I just somehow knew about that. We found each other. I always had that bend. We all thought that it would be England but it threw us out right away."

Also Tuxedomoon were seen by some as the expression of a "socialist" vision of art. Hence they could pretend to state subsidies allocated to culture. In that way they would be given the possibility to work with a certain amount of freedom with respect to the commercial game. [85]

Finally there was also another explanation for Peter Principle's enthusiasm about Europe: the fact that he fell in love with Dutch student Saskia Lupini. Blaine Reininger: "I suppose that a lot of it is down to the fact that Peter met a woman in Rotterdam. Peter wanted to stay there and the woman introduced him to her friends in Rotterdam," an impression confirmed by Principle himself: "I was one of the instigators, part of it related to the fact that I had fallen in love with a Dutch girl in Rotterdam."

Blaine Reininger was the only one not willing to leave: "I didn't want to leave San Francisco, I just loved SF. I didn't see any need to relocate. It seemed to me that Steven and Peter had a totally different take on things: "Oh we'll never go anywhere here. We need to go somewhere… Let's go to Europe!" But I had a reasonably comfortable life in SF and I liked it. I had a good job and living with a woman I loved dearly and we had a nice house and I liked the climate and I liked the way the town looked and I thought: "I could stay here…" But then I wanted to obey, I wanted to be staying with the band: I'm not going to convince them to stay here so I go with them! I better

decide I like it because I've got no other choice. But to tell you the truth I was reluctant, I didn't really want to hear about it. Those guys did all this preparation to leave town without me. They were building shipping crates, packing. I wasn't there because I didn't want to go! Once we were there, I couldn't admit it, I was: "I hate it here! I don't speak the language and I don't have a job, what the fuck am I doing in Holland?" So I had to come with some convincing lie to tell myself why I loved it so much (like the political explanation to the move) but I never did, I never did and that's the truth…"

On December 18th, Steven Brown and Peter Principle took a ferry to the continent and ended up in Rotterdam where New York no wave artist James Chance was hanging out. [86] [87] Steven Brown: "We didn't like England. We wanted to live and stay in Europe though. And so: "Let's see, England isn't all of Europe, there must be more." So we just went over the channel and had no idea of where we were going, landed in Rotterdam and went no further. Peter [had] met Saskia and drugs were plentiful and people spoke English. For a lot of reasons we ended up not leaving from that place there, communal dwelling for everybody…" Principle: "When we finished recording *Desire* me and Steven went to Rotterdam and we stayed there because there was a little scene there and a couple of people, mostly this Backstreet/Backlash [88] scene with Peter Graute and Martin Van Der Leer. They turned us to this Utopia commune [*an artists commune located in a "funny building, kind of a water tower," says Bruce Geduldig*] and they were giving us this place in their guesthouse (…) For sure we wanted to leave San Francisco that had become this real estate place and also we couldn't have gone international staying there. But we couldn't agree on where to live in America. I could have moved to New York and Steven as well but some other people couldn't handle it and for sure it was very expensive. So we just jumped on this Rotterdam thing. You know it's a typical Tuxedomoon way to take decisions: if everybody disagrees, we do something else…" [89]

Blaine Reininger: "Steven and Peter went [*to Rotterdam*]. They hung out for a while. I went back to the States, already with JJ by the time after we finished *Desire*. So they met people, hung out, recorded, partied, took drugs and found somewhere for us to go." "*Joeboy In Rotterdam* was made at an extended party, that's for sure, recalls Principle. We were just hanging out there in the studio with those people from Holland, our friends and we partied out and we jammed and we jammed and we just did not know that they were running the tape. So the next time we met, they were: "Oh yeah we taped the jam the other day, what do you think about releasing it?" We were: "What, what?"" Of course the Tuxedomoon *aficionado* will have noticed that the long jam constituting the title track

12/18/80 SB and PP take a ferry for the Netherlands to visit with James Chance then in Rotterdam. They whish to settle in the Netherlands where they are well received, "where the drugs are plentiful" (SB) and where PP has a girlfriend (Saskia Lupini) rather than in Britain (too expensive)

End of 1980 Recording by TM (SB, PP) of *Joeboy in Rotterdam*, Backlash Studio, prod. Martin van der Leer & Peter Graute. This piece will appear on the LP *Joeboy In Rotterdam/Joeboy In San Francisco*, Backstreet Backlash Records, released in September 1981. This LP also contains the previously recorded *Urban Leisure Suite* and the soundtrack to one of WT's theatrical performances: *The Wild Boys*

TM drop their bags at the Utopia artistic commune in Rotterdam.

"Joeboy In Rotterdam" contains the sketch of a piece that will be later developed as "Blind." The LP wasn't released under the name of Tuxedomoon for obvious legal reasons. [90] So the good old Joeboy moniker was called on for rescue, as he/she will be for the same reason much later on, when *Joeboy In Mexico* was released in 1997.

After the party was over, Peter Principle and Steven Brown dropped their bags in Rotterdam and left with the good news: they had found a home for Tuxedomoon in Europe, with a name that sounded like a manifesto for their future adventures, Utopia.

1981

Early 1981 TM temporarily returns to SF via NYC where they are filmed (live at Blank Tapes Studios) for the movie *Downtown 81* (aka *New York Beat Movie*) directed by Edo Bertoglio, writer Glenn O'Brien and Maripol, producer. The film, although completed in 1981, was released only in 2000. The band also played again at Hurrah's and at Peppermint Lounge (these shows might also have taken place in March)

1981: Tuxedomoon briefly returns to the US via New York City where they are filmed for the Downtown 81 movie and perform a few dates; shooting of the "Jinx" promo video clip by Graeme Whifler; Tuxedomoon plays a series of farewell shows in San Francisco and leaves for Europe for good via NYC

On their way back to San Francisco, the band stopped for a little while in New York City where they were filmed playing "Desire" live at Blank Tapes Studios by Edo Bertoglio (mainly known as a photographer) for his first feature film *Downtown 81*. Originally titled *New York Beat*, *Downtown 81* was written and co-produced by Glenn O'Brien (also produced by Bertoglio's partner Maripol, an art director and stylist best known for her work with Madonna). The film shows a teenage Jean-Michel Basquiat – *i.e.* one of Andy Warhol's *protégés* – wandering about New York City and encountering friends and bonds on his somewhat chaotic way. Tuxedomoon shares a bill will the *crème de la crème* of New York City's alternative music stars of the times: Kid Creole and the Coconuts, James White and the Blacks, DNA, the Plastics, Walter Steding and the Dragon People and also (for the soundtrack) Melle Mel, John Lurie, Lydia Lunch, Suicide, Vincent Gallo, Kenny Burrell and Basquiat's own band, Gray. [91]

Tuxedomoon being cast in this movie was quite an achievement: "The fact that we were included in the *Downtown 81* movie as one of the New York bands of the time while we were a California band, says Reininger, shows that there was something in our stand or our posture that was deemed acceptable in New York City." Glenn O'Brien recalls: 'I was invited to see them when they played in New York City. We met and hit it off. I became pretty good friends with Steven Brown and also knew Winston Tong. They came on TV Party [92] and we got them to be in *Downtown 81*. I don't know whether or not Andy [*Warhol*] was aware of them, but it's certainly possible. They had a following and were the sort of thing he would have liked. He wasn't very musically progressive – he

Page 122

liked opera and Motown – but he would have loved the way they looked. The No Wave movement is kind of a joke. I don't know if you can really call it a movement, although the bands that were chosen by Brian Eno to be on the *No* album certainly shared a certain aesthetic. Tuxedo Moon was a little more romantic and lyrical and "musical."'

Unfortunately the movie was of no immediate promotional value to Tuxedomoon as, due to financial problems and the fact that the tapes were lost for many years, the film was not released until 2000. [93]

Shooting of the "Jinx" promo video clip by Graeme Whifler. Back in San Francisco, the band shot a clip for "Jinx" (from the album *Desire*). It was directed by Graeme Whifler, a long time Residents' collaborator who also produced the promos for Ralph's new acts. [94] Interestingly Ralph had vetoed Pre's proposal to see experimental film-maker Derek Jarman direct *Jinx*. [95] Steven Brown: "Ralph had signed a deal with Charisma in England and part of the deal was to make a promotional video clip. That was like 1981, it was a new thing. So it was Graeme Whifler who directed it and he made all the clips for The Residents at that time and I admired the guy's work a lot. So he shot a 16 mm film and then had it transferred to video and that was the first time we'd ever done a so-called promotional video. Winston had to sing and of course he was balking at having to do some lip sync and so it took take after take after take to get him to mouth the words because we thought it was so lame and nobody wanted to do it. But of course before that we had been making our own movies that Bruce had and that I had. The shows always incorporated films and video from the beginning. Actually the "Jinx" clip was the first time that somebody told us what to do. It wasn't our film, it was Graeme's, he directed it… And we're still paying for it." [96]

Indeed this film will end up as a *jinx* on Tuxedomoon's UK career and this even though the film was itself quite brilliant and eloquently reviewed by Paul Petroskey:

'In some of the most disconcerting opening scenes in a music video, a man in a white suit has a bedpan full of what looks like it must be shaving cream, water, and old toilet paper. With a toothbrush, he spreads a red gel (toothpaste?) from a silver tube over the bedpan, brushes his teeth with the contents of said bedpan. He also shaves the palms of his hand. Did I mention his herky-jerky movements and pink vinyl gloves? No need to; the whole thing is so confusing and hurtful to the brain that you almost start to cry.

Three other men with unkempt clothes and hair smear dirt all over the walls of a completely white room, which our friend is compelled to try to clean with a dirty rag. The lead singer is

Early 1981 Graeme Whifler (Ralph) directs the *Jinx* video clip

Graeme Whifler's self-presentation (2006): 'Graeme Whifler (Writer/Director), notorious for twisted videos for The Residents, Danny Elfman, The Red Hot Chili Peppers, and screenplays for cult classics like SONNY BOY and DR GIGGLES, makes his feature directorial debut with NEIGHBORHOOD WATCH. Some find WHIFLER's vision and themes so troubling that his work often carries disclaimers, runs afoul with censors, or is banned outright.'

'Todd Rundgren's *You make me crazy* for Utopia bears a striking resemblance to *Jinx* (...)' (M. Shore, The Rolling Stone Book of Rock Video, London, Sidgwick and Jackson, 1985, pp. 134-135).

Some time in '81 Release of the short film *Traces Au Carré* (26 min.) directed by Daniel Lehman, music by Tuxedomoon, prod. Ministère de la Communauté Française/Image Video (Belgium). 'A visual sonata of an urban area in Brussels. The street, the view over the rooftops, the air, trees, house fronts, walls and paving stones. Reflections from the tones while camera movements play the melody. The movements are deliberate, accelerating and flowing immaculately into each other with sluggish zooms and static close up details. Each image is framed with extreme care in this camera quest through a city without people.' The soundtrack to that short consists in TM's music excerpted from *Half-Mute*.

Some time in '81 Release of the short film *Improvisation Trouvée* (26 min.) directed by Michaël Morris & Vincent Trasov, music by Tuxedomoon (unreleased), prod. Image Video. 'Sentimental journey of two Canadians in Brussels. A rose-tinted look at the charm of young people, unconcerned, drifting through apartments and other hangouts.' Belgian Frank Altenloh plays the role of one of the two youngsters. He will later briefly appear in SB's film entitled *The Super-Eight Years With Tuxedomoon*.

Some time in '81 Release of the bootleg *Darkness* with "Nur al Hajj;" "Jinx;" "..;" "Again;" "Nervous Guy;" "Volo Vivace;" "What Use?;" "Tritone;" "Desire."

Some time in '81 Recording of a demo of the track "Allemande Bleue" featured on *Lost Cords*, part of the *Unearthed* double CD/DVD included in TM's 30th Anniversary *7o7* box set released by Crammed Discs in 2007

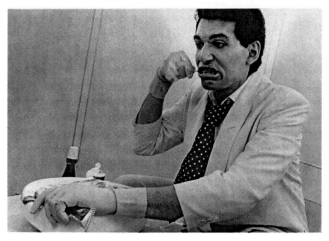

Blaine Reininger, during the shooting of the *Jinx* video clip by Graeme Whifler. Photo courtesy of G. Whifler

then seen shirtless, in some kind of harness or standing with a cigarette at various times. Back to the original guy – he's having his nice white suit ruined by the same slobs who filthier up his door. The closing shot shows these fiends watching a burning television set – and the camera pulls away to reveal the whole house on fire.

The song has some sort of Latin dance beat, but its unusual orchestration and growling vocals compliment the odd visions immensely. This less than three-minute video is so totally hypnotic, it felt like it was only a minute long.'[97]

Graeme Whifler: 'First I should say a little something about working with The Residents at Ralph and The Cryptic Corporation. Working with, and for The Residents was a dream come true for me, then a teething director. Even though they were essentially silent shorts, creating music videos under the Ralph Records label was unbelievably satisfying. I had TOTAL freedom. Nobody supervised the naughty little films I made. The situation was ideal, I was The Residents paid "on-staff" director. I was given a studio to shoot in, an office which I built myself, a room filled with film editing equipment, construction tools, a lighting package, money to buy materials, film and processing, camera and grip rentals, pay for a few crew members, and nobody asked me what I was doing just as long as it looked like I was doing something. I could spend three months producing a five minute short. I'd hunt for a song from their roster that inspired me, then, I'd cook up a concept for the film and never once tell anybody at the record label what I was working on. They'd have to wait till I finished to see even one frame. Of course I had to do most all the set construction and art department stuff, all the casting, all the costuming, most of the lighting, all of the cinematography, and all of the editing, and post production finishing, and promotion. It was like I had my own private filmmaking playpen to do whatever I wanted… as long as I also cleaned the office toilets, which was my other job there.

The first short film I did for Ralph and The Residents was *Hello Skinny* starring Bridget Terrace, followed by a short for Snakefinger titled *Man in the Dark Sedan*, and two *One Minute Movies* for The Residents. Up to this point we hadn't transferred anything to video, there was no MTV or rock videos yet, our distribution was via 16mm film rentals handled by Canyon Cinema in San Francisco. But then rock videos exploded on the scene. We transferred our film negatives to video and suddenly the Ralph shorts were on TV, around the world, and people either loved or hated them.

Things were looking optimistic for Ralph Records, the business was expanding, they had a band with a new album out that needed promotion, and an in-house director itching to film another music short. So the powers that be suggested I do a video for Tuxedomoon (…) Somehow the song *Jinx* was chosen to use in the film short, and I did as I'd always do with a new song in need of a visual concept, I went off and listened to the song a few hundred times while in a semi trance like state. Now the lyrics to *Jinx* aren't exactly full of sunshine and joy, rather quite dark and moody which struck a cord dear with me. Eventually I cooked up a vague concept made up of a few images, a drizzle of impressions, and a theme of torment, isolation, and obsessive compulsion which all would be consumed by fire. Having briefly met the band before, I worked up impressions of characters I wanted them to play. Clearly Winston was meant for part of the narrator /torture sufferer, Blaine was the paranoid obsessive-compulsive bedeviled by Steven and Peter, the merciless gremlin tormentors. I have no idea from what dark and festering part of my soiled brain these depraved images arose from, but the band seemed to buy the vision when I haltingly explained it to them. Of course nothing was ever written, I never put one word to paper back then, no treatments or scenarios, no storyboards, and no shot lists; it all just swirled around as some incubating plasma inside my head.

Working with Tuxedomoon was both a joy and intense. Of the bands in the Ralph stable, they were musically the most musical; their sound was sophisticated, hip, cool, seductive. And like their music, they were one terribly smart and cultured group of guys. But they also seemed inscrutable, closed and monolithic to an outsider perhaps because their bonds as a group were so tight and perhaps because they were just too darn cool. When I first pitched them some concepts for a video, I might as well have been speaking to the statues on Easter Island for all the reaction they displayed, throughout they remained silent and deadpan and showed not the least reaction to anything I said. It was kind of spooky having a conversation with mutes, but I knew they were listening and absorbing everything and I also discerned that I had the ears

of some very bright cookies. After our meeting, in private, among themselves, as a group they dissected and evaluated every word I had spoken, then came to an informed consensus which they presented back to me the next time we met.

Principal filming was done on the Ralph Records stage, while the back yard of the business office was used for the full scale fire sequence. I believe we shot it in one long day with a small crew headed by the wonderful and amazing Phil Perkins. I shot it with an Arri S 16mm, cut on film, and telecined conformed camera negative at Compact Video in Burbank, CA. The videos that are floating around today [98] seem fairly degraded but if someone were to rescan the cut negative, *Jinx* would look as good as the day we shot it.

Well, perhaps the lip sync wouldn't look perfect. As anybody watching the video can tell, we had a little problem with Winston's lip sync. Part of the trouble was Winston's fault, he didn't do his homework practicing singing along with the song so when we went film it, he struggled some with the lyrics. But even still, his performance was inspired, Winston is a major talent. The biggest problem was the equipment we used shooting the film was never intended for sound sync and we should have been put in jail for even trying. The camera ran at its own varying mystery speed, the cheap hand held tape recorder used for playback got within one octave of the intended speed, and the film editing was stone age. All I had was a teeny blurred screen to try and decipher what Winston was singing by the way his lips were moving, an impossible endeavor.

The good news was the band didn't get burned to death during filming. I had this one shot where The Boys gathered around watching Blaine on TV obsessively cleaning his hands while the room around them was in flames. We built a small living room set outdoors, seated the band inside, then set the furniture on fire. I waited for the magic moment when the flames were roaring and the band had not yet ignited before rolling the film. After twenty seconds of a great take, I yelled cut, the band ran and the crew holding the fire hoses doused the flames. I really should have been put in jail for that one too, but I have to say, Tuxedomoon proved themselves to be one tough bunch of guys. The flames were inches away, their skin was near burning from the heat, the shot was insanely dangerous with no trained special effects team involved, but they knew it would look cool on film so they sat there next to the fire, tough and determined. I'm convinced that the guts they showed getting that burning shot can be heard in the bold and uncompromising nature of their music.

We did get into some minor trouble playing with fire though. The very first and last shot of the piece involves a burning miniature. I had found a cheap wooden dollhouse, had loaded

it up with fireworks and other flammables, set the camera and stage lights, then put a match to it and filmed it burning. And did it burn, like the Challenger space shuttle it was smoking toast in seconds. But I had made a minor miscalculation, a really stupid one, we burned it up INSIDE the Ralph stage. Within seconds back smoke had filled the studio, nobody could see or breathe. Somehow we managed to get the giant rollup steel door open and clouds of smoke flooded out onto the street. Somebody down the block saw the smoke and called the fire department which arrived moments later sirens screaming. They saw the pouring smoke, then the baked and coughing "artists" and the charred dollhouse remains, and just turned off the siren, shook their heads in disgust and drove away.

The funniest segment to shoot was Blaine's toiletry torment, even if some people couldn't take the joke. I had constructed a set that was small, round and enclosed, and lit with practical wall lights. I had imagined this segment to feature a guy suffering an obsessive-compulsive disorder for cleanliness, and I wanted him to be bedeviled by dirt gremlins. I had blown a lot of prop money purchasing a pair of pink rubber dish gloves, a tube of red toothpaste, and an old fashioned "safety" razor. But the one missing set piece that really fueled all our sickness was a little something that had been kicking around on the back shelves at the Ralph warehouse for years, the notorious bedpan. It looked like a toilet seat and it was the perfect center to Blaine's character's universe. So there we were, sealed up in private in our tiny set, my camera and I, Blaine and his bedpan, and then we just started to improvise and play. And it was brilliant, because Blaine was brilliant; he was an amazing natural actor. He instantly found this bizarre character, and then kept it perfectly internal as we ran through our paces. For me as a director, he's been one of the best actors I have ever had the pleasure to work with.

By the way, the budget for Tuxedomoon's video *Jinx* was medium for a Ralph Records shoot. Below the line costs for one of our videos back then ranged from a low of $1,200 to a high of $2,500'.

Peter Principle: 'While shooting the video for "Jinx" at 440 Grove Street, Blaine, who had to gargle with soap as part of the plot, was about to gag and vomit and someone handed him a pile of new Residents t-shirts. The look on Jay Clem'[*of the Cryptic corporation*]s face as they were destroyed was hilarious and should have been in the video...'

Tuxedomoon plays a series of farewell shows in San Francisco and leaves for Europe for good via NYC.
In the middle of packing to leave for Europe, Tuxedomoon performed a few farewell shows in February 1981: one in

02/06/81 TM plays at Old Waldorf, SF (late show)

02/06/81 Jojo Planteen + Winston Tong perform *Opium* in SF

02/08/81 TM plays at Old Waldorf, SF (early show)

02/12/81 TM plays at Keystone, Berkeley

02/19/81 TM (with Joeboy Strings) plays a *Farewell Show* at Victoria Theater, SF. The show is dedicated by SB to "Dr Mark Schauss." Set list: 1. "Tune Up" 2. "Vivaldi - Holiday For Plywood" 3. "Jinx" 4. "Victims Of The Dance" 5. "Dark Companion" 6. "Blind" 7. "Again" 8. "Desire" 9. "Time To Lose" 10. "In the Name Of Talent 11. "What Use?"

02/26/81 *Farewell* show at Savoy Sound, SF. Two tracks – namely "Music # 1" and "Jinx" – appear on the (Various Artists) *Savoy Sound Wave Goodbye* compilation LP, prod. Gerry Gerrard & Olga Carpmill-Gerrard, G.O! Records, 1981, that was put out to commemorate the closing of this club.

02/81 Celluloid's premature release of *Desire*, which will have far-reaching consequences

03/81 Ralph's release of *Desire*

03/07/81 TM plays at Old Waldorf, SF (with Joeboy Strings)

03/81 TM left for Europe, *en route* on their Celluloid *California Dream* parckage tour, via NYC where:
- they played at Irving Plaza on the 14th;
- some of them met William Burroughs at the Bunker (on March 18th);
- they played at the Ritz on the 20th
- they played at Hurrah's and Peppermint Lounge (but these dates might have been in January). At Hurrah's they were filmed by Merrill Aldighieri and their rendition of "Incubus/Blue Suit" appears as a video bonus on Merrill Aldighieri's DVD entitled *Tuxedomoon – Seismic Riffs* (Crammed, Cramboy, 2004)

Page 127

'Celluloid Records, the French new wave label, made its New York debut Friday (20) with a hot swinging affair involving rival new music entrepreneurs Jerry Brandt of the Ritz and Jim Fourratt of the Blitz and Danceteria. Celluloid Records represents Ze Records, Ralph Records and other small American labels in France (...) Since September, Jean Karakos, head of its new American subsidiary has been scouting distribution opportunities here, signing with such distributors as Rounder, Win, Important, Disk Trading, Rough Trade and Green World.

According to Karakos, the Celluloid philosophy here is to develop and promote artists through the new wave distribution system to the level where they can get enough recognition where they can be signed with majors. To make an initial splash, Karakos financed a party and concert featuring his American acts: Indoor Life, Material/Deadline, Tuxedo Moon and Suicide.

For this event, *Actuel*, one of the largest fanzines in France and Radio Luxembourg, which can be heard all over Europe, chartered a plane to bring 150 journalists and scenemakers to New York for the event (...)

Originally the party and concert were to have taken place at Dancetaria, but the venue, run by Fourratt, has not been open since police raids closed it last year (...) and Fourratt (...) was forced to look elsewhere for a venue (...) he approached the Ritz (...) he says that though the Rings, an act on MCA Records, and Shock, an English avant-garde mime group were already booked into the venue, Brandt agreed to take the Celluloid show, promising, according to Fourratt, that he would be able to move the Rings and Shock dates. This ATI, Rings' booking agency, would not allow (...) "I had a commitment with ATI for three months before Celluloid," says Brandt. "I was trying to accommodate everybody and I got caught in the middle." Even during the soundcheck there was tension at the Ritz. Sources at the club say that the Celluloid acts were arrogant, very disorganized and late in their soundchecks (...) Fourratt says the acts were late because the monitors were not working at the Ritz (...) By midnight, there was a crowd of about 300, tightly pressed near the Ritz entrance, trying to get in (...) the Rings did not get off stage until about 12:50 a.m. The Celluloid show did not start until about 1:30 a.m., when Indoor Life and Material/Deadline (...) both did their short sets (...) Fourratt says Brandt told him he wanted this audience to see Shock (...) after Deadline (...) [*Fourratt:*] "I just informed the audience that Suicide and Tuxedo Moon would not play. There were a lot of people there and it was a hot, riotous situation. Then I walked offstage to a spiral staircase where Brandt was and he kicked me full force (...)" "I never hit him and I never kicked him" says Brandt. "I just shoved him into someone's arms and he got pushed into the fire escape" (...) Tuxedo Moon did get onstage after 5 a.m., but after making disparaging remarks about the club, their plug was pulled, witnesses say, and a long rock 'n roll night finally ended.' (R. Koʐʌκ, "French Celluloid has "exciting" N.Y. debut", *Billboard*, 04/04/81)

Berkeley (Keystone) and two in San Francisco at the Victoria Theater and at Savoy Sound (two tracks from Tuxedomoon's latter show can be found on the *Savoy Sound Wave Goodbye* compilation LP).

In March, Tuxedomoon left for the Celluloid [*the French label, licensee of Ralph for continental Europe*] package tour named *California Dream* (that would be readily re-baptized as California Nightmare), a tour that will bring them to Europe after a stop in New York city.

On March 18th, the band met William Burroughs at the Bunker, an eagerly awaited meeting when one considers that Brown and Reininger usually quoted Burroughs as one of their major influences [99]; in addition, one of Tong's theatrical performances was created after Burroughs's *The Wild Boys*. Bruce Geduldig remembers having spent some time in Burroughs's isolation tank, finding that everyone had deserted the room when he finally extracted himself from the tank. Peter Principle was not invited to the meeting. 'The New York meeting with Burroughs was one that was arranged by Adrian Craig I believe, writes Principle. For sure I was not invited for some reason and when it turned out they had bought copies of *Cities Of The Red Dawn* with band money so they could be autographed, but I got none, I was mighty peeved. Early days and many days since in Tuxedomoon were often competitive and since I had mentioned that I thought Burroughs a bit of a mysogonist and at that moment the politics in Tuxedomoon were fairly anti-women I think it touched a nerve. They wanted to teach me a lesson about who's in control of the coolness factor. I did meet Burroughs a few times later over the years in Brussels and Amsterdam but not New York and thought he was nice enough. He certainly was polite and witty. He always remembered people. For sure his casual treatment of drug use is hilariously funny in a stand up sort of way and the concept of cut-ups and viruses has been a major influence on the work of my generation. He is indeed a true icon...'

On March 20th, the Celluloid package tour made a quite chaotic *début* at the Ritz in New York city. The venue had been double booked and the evening ended up into a scuffle between Jim Fourratt (responsible for the Celluloid acts) and Jerry Brandt (of the Ritz). As a result Tuxedomoon did not get on stage before 5 a.m. and soon got their plug pulled after a few disdainful remarks about the club. [100] Doomed actor John Belushi was also reported to have made a dressing room foray in search for drugs. [101]

But Europe was waiting for Tuxedomoon and soon the band crossed the Atlantic with their *California Dream* companions, Indoor Life and Snakefinger, with a first date

scheduled in Nancy, France, on March 24th,1981.

PART II: EUROPE (1981-1988)

CHAPTER V
From the Ghosts of Nancy to The Ghost Sonata

1981: the Ghosts of Nancy; Tuxedomoon as artists-in-residence for the Midland Group at the Clarendon College in Nottingham, a prefiguration of The Ghost Sonata; the Celluloid fiasco; four years of Tuxedomoon: Blaine Reininger's car accident; eviction from Utopia; Tuxedomoon moves to Brussels, works with choreographer Maurice Béjart, Les Disques Du Crépuscule and releases the Une Nuit Au Fond De La Frayère single for Sordide Sentimental (the situationists return); US tour

When the band landed in Europe in the early Spring of 1981, they went through some initiatic experiences to establish themselves as "exiles."

Bruce Geduldig: "Concerning our move to Europe, I can tell you an interesting anecdote about traveling, about what traveling can do to you when you bring your own baggage, that is your own expectations.

We landed near the border in Germany. We were basically doing a tour of France [*The California Dream tour*]. It was a badly organized tour. We just came from NYC, all of us doing a lot of different types of drugs and all in different mindsets. We were making this kind of big move to Europe. We were all destabilized one way or another. There was a big strain on our collaboration, on our friendships. It pushed everybody to their own personal limits. We were finally moving to Europe and it meant a whole lot of things to everybody.

The day of the first concert – which was in Nancy, France – after a lot of waiting in the airport and just be totally frustrated for more than just hours, it was like a day and a half, finally we get to Nancy. It looked like the tour was going to be a complete disaster from every evidence that we had, including the guy who was driving the bus that showed up with a mini van that was way too small. "Our stuff will not go in the van with the people down here!" We were like: "What are we doing, what are we plunging into?" You know loaded misery.

I don't remember who came up with the idea but as it was the first day in Europe in a way – symbolic first day – we all decided to take acid on the day of the concert. Not all of us, I'm sure that Blaine didn't, but Steven and Peter and Winston and I all did. We did soundcheck. All seemed to be Ok except that a certain moment during the afternoon, Winston and Steven both started to flip out. They both started to say: "This tour sucks, we don't want to go on anymore. We're going to Paris. We quit the band and we're quitting now!" I'm sure

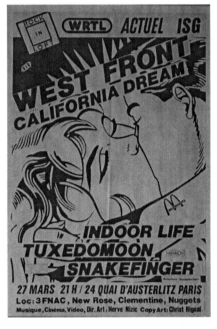

Poster for Celluloid *California Dream* tour date in Paris, 03/27/81

(Continuation of the *California Dream* tour)

03/24/81 TM plays in Nancy (France), in the absence of Brown and Tong, fleeing the Ghosts of Nancy

03/27/81 TM plays in Paris (probably at the Palace)

Other dates on this tour: Lyon, Bordeaux (04/01), Poitiers (04/03) and Reims

A video entitled *California Cauchemar* was shot by Anne Lainé and Jean-Louis Le Tacon ("Smoking de luxe", *Libération*, 12/01/81)

there are several different versions of this story but Steven at one point decided that he was not going to quit the band but commit suicide. He decided that he was going to jump off a bridge. I do dimly remember prowling around Nancy in the mini van looking for Steven because he was going to jump off a bridge and we did find him and this is like a running gag that he'll hate me for. We found him on a bridge that was about three meters off a canal and he was ready to jump."

Peter Principle: 'When he reached it he jumped right off and disappeared from view. We all ran up there to find that he had lain down at the same time as landing and that the drop was a mere three and a half feet. But from our side he just disappeared – a classic Hollywood trick and very much in character.'[1]

Geduldig: "I don't remember what happened next but maybe we brought him back into the van but then he said: "Anyway, it doesn't matter. I'm going to Paris" and Winston said: "Yes, I'm going too." So they left before the concert."

Steven Brown: "What these guys didn't tell you is that Winston and I couldn't stay in Nancy because there were GHOSTS in our room at the *hôtel de la Poste*."

Bruce: "So it was Peter, Blaine and me. We were all three backstage: "How can we rewrite this show, what songs can we do?" We were like: "Ok we can do this song, so ten minutes on that song" and then we can't play this song because Steven is not there and then we can't play that one because Winston is not there.

So we came up with like six or seven songs. We went out there on stage and it was huge and it was packed: 1,700 people easily standing into this room. We started off and it was a noise kind of concert. There was actually no concert. It was Blaine, Peter and me and I was doing visuals, so... We weren't really clocking with the audience, we weren't playing to the audience, we were just doing what we had to do and we were thinking: "Well instead of five people splitting the paycheck, there's only three of us."

At one point, after 15 or 20 minutes, I looked over – and that was a huge stage about two meters off the ground – and I saw that this guy had grabbed Blaine's keyboard and pulled it over himself into the audience, like the whole keyboard rack (two keyboards and all of the electronics). Obviously the music stopped at that point. Peter kept playing for a couple of seconds and then we were looking at this thing that happened and Blaine just dove off the stage onto this guy, jumped off head first onto this guy. Peter unstrapped his guitar and followed. And then there was just a fucking riot out there. People started punching.

For some reason I just stood on stage and watched it. I just didn't feel like doing anything. This is one of those moments

when time slows down and turns into this kind of surreal atmosphere. It was very funny and kind of poignant in a way. Then the security people came quickly and got the guy who did it. We stopped playing obviously and cleaned up the mess.

But then backstage they had the guy in some sort of office and the security person held his arms behind the chair. I passed several times doing something else and I looked in and I saw Blaine and Peter like taking turns in hitting the guy, yelling at him and hitting him. I went in and said: "Stop it, it's making me sick!"

Anyway, we ended up at an after-dinner restaurant for the after gig dinner and this guy was sitting across the table from us at the restaurant, the same guy! Sitting with a group of like 20 people, fans and people who worked on the show. And he was sitting right across from me! So I asked: "Why did you do that?" and he said: "Cos' your saxophone player wasn't there tonight." At that point I wasn't saying anything, I was speechless.

Of course we found Winston and Steven back in Paris. It was just one day off the road. And we had all of our equipment repaired. These are the kind of things that can happen when you travel, when you wander and then get too many things at a time and get overloaded. Strange things happen because you don't understand the rules or don't know what's going on. Big confusions all the time and often very funny in retrospect. The worst stories are often the funniest ones. Only disasters are memorable."

After this unforgettable first concert in Europe as Tuxedomoon's new homeland (on March 24th, 1981), the *California "Nightmare"* tour brought them to Paris (on the 27th), Lyon, Poitiers, Bordeaux [2] and Reims.

In Paris, French film-maker Patrick de Geetere was in attendance and remembers the concert as a "superb performance." The review for French magazine *Rock & Folk* was quite eloquent: '(…) Tuxedomoon scraped the evening's elegant and morbid *ennui* thanks to Winston Tong, a Chinese singer wearing a white spencer jacket. Winston Tong reels off "La Chanson Des Amants" from Jacques Prévert. Then a feeling of *malaise* spreads over the Loft. Above the group, a screen where ancient expressionist images are being projected whilst the *mise en scène* is splashing of muffled violence. The themes are deliberately diverted, contorted and raped from all sides, Vicky Aspinal's violin viciously twines. Blaine Reininger relentlessly generates the horrifying with his synths. As for Winston Tong, he crops up facing a mike stand way too high for him, like a petrified night butterfly, little sickly Chinese with cracked brains. Let's say that this was the most trying concert of the year, one of total suffering, a

Page 135

desolation set, toxic and venomous. Then in this suddenly hideous-looking loft, everyone seemed to be waiting for their dose of zyklon B.'[3]

Tuxedomoon as artists-in-residence for the Midland Group at the Clarendon College in Nottingham, a prefiguration of The Ghost Sonata.

In April 1981, Tuxedomoon settled at the Utopia commune in Rotterdam and performed a not yet recorded *Suite En Sous-Sol* (literally: *Basement Suite*, so named because it was composed in the basement of the Utopia commune) at a concert in Amsterdam (Melkweg).

Soon, in May, our Bohemians left their adopted Lowlands to answer another call of the road and crossed the Channel to take part in an artists-in-residence project for the Midland Group at the Clarendon College in Nottingham. Here's what Andy Gill & Bryn Jones wrote about this experiment in the *New Musical Express*: '(…) they were over here to work on an "experimental music and performance" project at Nottingham's Clarendon College, a week's residency which entailed a series of lectures at schools in the area and workshops sessions with local dancers, film-makers, performance artists and musicians (including a 16-year-old church organist and a string quartet of 12-year-olds) culminating in two performances at the end of the week which attempted to tie together the various themes and forms they'd been working with (…) the event (…) lacked in coherency (…) but it was never less than interesting, and a healthy change from the usual Pavlovian rockshow stimuli. "We went around the schools every day," explains Peter, "giving a lecture-cum demonstration in which we played some music and talked to the audience and tried to gather people who were interested in working with us on this performance."'[4]

"That was something that [*Michael*] Nulty had set up, recalls Peter Principle. We got to do some sort of residency, which meant that we were in this kind of art centre and we were supposed to use the talents of people who came there to make something in which we were to show to them our *modus operandi*. So that's what we did but of course our *modus operandi* is so unclear even to us that nobody learned anything by doing it (…) It was a little bizarre, like these 12-year old school girls asking: "Are you futurists?" because that was the big movement at the time. They wanted to make sure who we were. It was really entertaining. We shot some film, did some photo sessions at Victorian graveyards (…)"[5]

Nowadays Principle casts a retrospective glance at the experiment: 'I was thinking of what we had done in the Midlands in England and remembered a number of funny things…

04/81 TM is settled at their Rotterdam commune, Utopia

04/26/81 TM plays at Melkweg, Amsterdam. *One World Poetry* Festival (the set includes *Desire, Suite En Sous-Sol* and older pieces)

05/81 TM as artists-in-residence for the Midland Group at the Clarendon College in Nottingham. The Nottingham project is a prefiguration of *The Ghost Sonata*

The first was that at one of the day schools, we went to "demonstrate our instruments and the creative process." Part of the details of the residency had us going to grammar schools and doing an in-class demonstration/performance. We had recently written *Suite En Sous-Sol* in Rotterdam and we were playing the "Nur Al Hajj" track. Steven, during the song when he didn't really have a part to play, left the stage and went into a closet just off the area in the front of the classroom where we were set up and somehow changed his clothes into something he found there. He came out all dressed differently, maybe a woman's coat, and crawled around on the floor. It was pretty funny. Then in a question and answer period, one of the children asked Winston: "Is your bass player mental?" "Yes he's a mental giant," said Winston, and this became a quick catch phrase for a while.

The second relates to the "spheres and cubes" theme, which was just a convenient framework to use some of the art students' already existing props in a performance that we had to stage right on the spot and using local talent – that was the other prerequisite for getting the grant. The sphere/cube theme was the usual dichotomy symbolism, but where I was really trying to go was to introduce the theme of "disappearances," which Winston and Bruce as well as myself were working on and which I thought had the most potential for a multimedia Tuxedomoon.

Previously there had been *Cell Life*, which Winston and Bruce had performed with Tuxedomoon (myself as well of course) at the Eureka theater. [6] But it was a film/performance with music in the best sense. The theme of ideas and viruses very Burroughsesque was greatly expanded on into the disappearances thing, which was about a world we almost are in now, pretty ahead of its time for the period. It went something like: in the near future people will communicate using sort of avatars through something like a computer network and, as people will less and less meet in the flesh, often it will become possible for virus avatars to replace people. From there the story becomes a kind of mystery about a character who discovers that some people are missing and then discovers that he himself is missing/disappeared. The idea that as we are all so isolated, it's harder to tell what is real, especially with the interference of technology etc.

We were hoping to do something like this through Charisma and that was the tragedy in the failure of that as this is the kind of scope of project that they would have had enthusiasm for and which many people expected from us at the time (…)

Also I often wish we could find the video made at/for the concert at Nottingham where we performed with the locals in a show made up at the residency there. I remember we brought in an organist from the local pub, and he played

J. G. BALLARD: 'I wrote a short story called *The Intensive Care Unit* about a world where people never meet. They simply make contact via TV: marriage is conducted hundreds of miles apart. And in my story I visualize a man who actually decides to meet his wife and children in the flesh. Of course, it's a disaster. They just cannot bear the sensory overload. On a mere neurological level, they can't bear to be together – rather in the way that we can't bear to be too close to strangers. So I can believe that, in the future people won't be able to bear to be in the same room as others. Or even on the same street. Of course it's very difficult to read these kinds of aspects of the future.' (*J.G. Ballard Quotes*, quotations selected by V. Vale & Mike Ryan, San Francisco, RE/Search publications, 2004, p. 13)

05/15 or 05/16/81 TM plays in Nottingham (Midland Group) (two performances were planned but actually only one took place). The track "No Business Like Show Business" is featured on TM's 30th Anniversary box set entitled *7o7* (on the CD named *Lost Cords*) released by Crammed Disc in 09/07

Flyer: TM is 'one of the most important and exciting developments in modern music. That development has been dubbed "crossover" music and is a unique blend of contemporary art music and new wave rock (…) Dancers,

Page 137

musicians, film makers, video artists, and actors are invited to join the series of evening workshops given by Tuxedomoon at the Midland Group from which they will devise a new mixed media performance to be given at Clarendon College, May 15 & 16 8.00 p.m. Pelham Avenue Nottingham.
Also as part of the residency Tuxedomoon will be giving a series of lectures, demonstrations and workshops in schools and colleges throughout the area.'

Some time after the Nottingham residency, TM shoots a jungle sequence for the song "Desire" for the German TV programme *Rockpalast*, an excerpt of which can be seen in SB's film entitled *The Super-Eight Years With Tuxedomoon*.

05/18/81 TM plays to a sold-out house at Heaven, London

05/19/81 TM plays at Whispers, Nottingham. Set list: 1. "Gigolo Grasiento" 2. "Jinx" 3. "Music # 1" 4. "L'Etranger" 5. "Dark Companion" 6. "59 To 1" 7. "Nervous Guy" 8. "(Special Treatment For The) Family Man" 9. "Again" 10. "Desire" 11. "In The Name of Talent"

05/20/81 TM plays at Warehouse, Leeds

05/21/81 TM plays at Polytechnic, Sheffield

05/22/81 TM plays at Polytechnic, Brighton

05/23/81 TM plays at Rafter, Manchester

After this short UK tour with This Heat, Pre ceased to be involved with Tuxedomoon

06/04 till 06/81 WT/BG in *Frankie & Johnnie: A True Story* at Chapter Arts Center, Cardiff
Flyer: "Theater no longer satisfies us. It hasn't for a long time. Cinema is an expensive whore. Just can't be trusted. And we still have desire. For the magic that we can only imagine. The

while we got made up on stage. The song was a version of "No Business Like Show Business" that Blaine and I had prepared in a four-track studio and we had also made some video images for projecting along with the live interaction video which was controlled by some local people. This was a hilarious *mélange* of things from rockabilly to avant-garde performance with weird props etc. Probably not that memorable musically although it was the *premiere* of The Ghost Sonata suite...' [7]

Blaine Reininger: "A lot of this thing [*i.e. The Ghost Sonata*] had come out of what we did in England, in Nottingham. We went off for a while for this residency paid by the Arts council in England. They were largely persuaded by the letter I wrote – I was a pretty good letter writer – where I talked about all our academic credentials and I hyped them up a little and gave us all degrees that we didn't necessarily have. But we did this thing, it was kind of a community theater and we didn't know precisely what we were doing. We just wanted to do a big production, like a Robert Wilson kind of thing and call it an opera and also get people from the local community involved, which we actually did. I had an orchestra composed of school girls, which I found exciting. Their parents were always there, just to make sure nothing happened (laughs). They were wise to do so because I would show up after five or six pints of beer, show up for rehearsals: "Aaaahhhh, I'm ready…" But I wrote an orchestration for them. That's another episode but the seeds for *The Ghost Sonata* came from that: the idea of doing this production and some other things sort of overlapped…"

Also during this residency, Blaine Reininger ran into a strange-looking kid who asked him if it was hard to play a Casio keyboard, as he thought of buying one himself. Later Blaine discovered that the kid was… Marc Almond. [8]

The Celluloid fiasco. As previously mentioned, Ralph Records had signed a licensing deal with Pre (a subsidiary of Charisma) for the British market and with French label Celluloid for the rest of Europe. The *California Dream* tour (that saw Celluloid depicting Tuxedomoon as "The Pink Floyd Of The Eighties") turned out to be Celluloid's first and last dealing with the band.

"For about five minutes we almost had really good luck, remembers Peter Principle, because Derek Jarman almost did some videos for us and Tony Stratton-Smith [*i.e. Charisma Records' legendary founder*] was interested in a film development that Bruce had written about disappearances. We almost got there but then there was a big falling out over the record contract because in France Celluloid did violate their agreements and the English record company Charisma took that very seriously. Then we were out on the street essentially." What happened, explains Principle, is that

Page 138

"Celluloid had jumped the release date of *Desire* by like a month and there were already Celluloid *Desire* in America before Ralph had their own. The whole thing was fried by Celluloid who were crooks from the start. Ralph ended up in an unfortunate situation because of the Celluloid thing and because of the fact that their stuff was most brutally ripped off. The whole Residents catalogue was put out on Celluloid for which they didn't get any money, plus the market was flooded with these pressings. It was this release date hop that clinched the death of the Charisma/Pre deal." [9] [10]

Indeed Pre's parent company, Charisma, then stepped on the scene by disowning the *Jinx* clip: 'Charisma found that we had violated the "no political statements unwritten clause" in the music industry by making a video that included people spreading shit on the walls, somehow a statement about the protests of H-Block IRA prisoners in Northern Ireland spreading shit on their cells walls,' comments Principle.

'Yes, *Jinx* was banned from TV in the UK, writes Graeme Whifler. Yes, one little scene caused a shit-storm of controversy.

What happened was, at one point in the video, band members appear in Blaine's spotlessly clean hamster-cage like little room and begin smearing brown mud on the walls. Blaine rushes over to remove the offending stain. But the dirt devils reappear and smear their mud all over poor Blaine and his clean white suit.

Coincidentally at the same time, thousands of miles away over in the UK, they had caught a few IRA murderers and were holding them in jail. The bad guys from the IRA started a hunger strike in prison. At some point one of them began smearing his feces on the walls of his cell as a sort of brown protest. With all the terrorist bombings at the time over there, things were quite politically tense and somebody in charge of censorship mistakenly thought the Tuxedomoon video with mud smeared walls was a secret tribute to the IRA.

Nothing could have been farther from the truth. There was never any political content in any of my videos. In fact, the IRA prisoner who fouled his cell did so way after we had shot *Jinx*. Everyone at Ralph, including me was shocked that the video had been banned, but we also took it as a badge of honor.

At the time when everyone asked if I had intended the mud smearing to be a metaphor involving excrement, I hotly denied any connection. But I lied. The genesis of the Tuxedomoon video was drawn from my earliest childhood memory. Way before I was two years old I'd had some conflict with my parents that resulted in them placing me in my crib during the day. I was trapped. I was furious. I tried crying and yelling, but got no results. Then a wonderful wave of creativity rushed over me and I devised a plan. I reached into my diapers, took out a handful of brown, and smeared it all

fugitive kind that transforms. So we will always be becoming the object of our desires. And for the day I imagine that it would do us well enough to be the movies, since they were our latest infatuation.

We are making a visceral cinema. With the use of film and our lives replete with accidents we effectively recreate the half-dreamed and half-awakened state that we exist in all of the time. Dolls came into use when I was working alone. I'd compose shots of real life just as I might from those of a film. So if I, in my unmagnified state, was to be a close-up, a doll could be me in the following longshot. And when I needed others besides myself, I'd just go and make them. Though I always avoided surprise visitations, third parties (if at all possible) and crowd scenes" (Winston Tong).

'Their vivid use of films and other starkly visual techniques insinuate themselves on the mind like the after-image left by a direct gaze at the sun.

Frankie and Johnnie, A true story has a kind of black magic that is less stunning while watching the show than when it is over
(...)

The dolls have a sinister quality, especially when they interact with each other, but somehow manage to express larger-than-life human pathos.' (C. Webb, "Dazzling, vivid, fascinating – and infuriating", *Western mail*, 06/05/81)

06/10/81 TM plays at Ancienne Belgique, Brussels

06/13 till 16/81 WT/BG in *Frankie & Johnnie: A True Story* at the Cologne Festival *Theater der Welt* (venue: Schlosserei). WT/BG appear in the documentary *Theater In Trance* from R.W. Fassbinder

That summer WT/BG will be on a tour booked by their agent Maria Rankov

Nina Shaw – who had previously worked with WT/BG - starts collaborating (as lighting designer) with TM around that time

Anna Domino about Nina Shaw:
'Nina could sew and looked great in vintage finery. She and JJ had a lot of style and when they really got dressed up you couldn't beat them. A kind of ladylike punk, graceful and fierce. Two spots of bright color in the gloom.

Nina did lights for Tuxedomoon and me and Bel Canto and so spent a lot of time on the road for which, I think, you have to be tough or taken care of. Nina is smart and also shy and polite and the general awfulness of touring was hard on her but when she worked with me in Japan she was somehow able to bridge the language barrier, and every other obstacle, and do her job well.'

**JJ La Rue (left) and Nina Shaw.
Photo Saskia Lupini**

over the mahogany walls surrounding my crib. I'll never forget how good this act of rebellion felt while smiling to myself and thinking, "Now mommy and daddy, you're really going to pay for sticking me in this stupid crib." I'm sure the guy from the IRA was thinking the same thing.'

As a consequence of the turmoil, *Jinx* never appeared as a single, as originally planned.

Principle: "They told us all this weird stuff but these were just excuses to get rid of us…" In fact, it seems that Charisma/Pre were never too happy with *Desire* as marketable pop. [11] 'Charisma did complain to us about the mix of *Desire* and the fact that the vocals were "too low," recalls Principle. I assume we took serious offence at being questioned about our art, and that could have stimulated the mess (…) The last thing we did with Pre was the Midlands group thing. Right after this we did this little tour with This Heat [*i.e. British legendary post-punk experimental combo fronted by Charles Hayward*] (we went to Leeds and other places) with company support (they brought the PA and lighting and professional crew). We did five shows.'

Pre terminated the contract with Ralph Records in October 1981. [12] Around the same time, briefly after Tuxedomoon moved from Rotterdam to Brussels, Ralph's relationship with Tuxedomoon was terminated on a handshake agreement between Peter Principle and Jay Clem, *i.e.* Ralph's business person who actually left the music business shortly

thereafter.

Principle: 'Jay Clem came to Brussels when I was staying at rue Marcq and Saskia [*Lupini*] and I had dinner with him on the place Ste Catherine. In the process of describing his depression and disillusion with the music biz especially Karakos [*i.e. the head of Celluloid*], he broke out in tears. He said he could trust no one and took it personally that everything had gone so wrong. He was very distraught and was about to retire, I guess for life, from music although he had been an enthusiast.

So he quit, and when he quit Ralph Records became The Residents again and they didn't want to have anything to do but their own trip. We made a handshake agreement (which they graciously honored) to dissolve all relations and close the books. We negotiated with them so that we could take a European license of their material. So we licensed that stuff through Polygram for a little while and then we got it all on CramBoy [*i.e. the sub-label especially created for them at their future label Crammed discs*], which probably was a good move. We got the rights on most of our tapes in the end.'

Michael J. West, the author of a book about Ralph Records, presents the issue in its wider perspective: 'Ralph had wanted to become a big new-wave power player, but they managed to get into the game at the exact moment that the market was drying up. Residents' records did okay, but they couldn't give away albums by most of their other artists, at least not in the US. So Ralph decided in late '81 to cut their losses and invest in their money-maker, The Residents. And since they were contractually obligated to pay Tuxedomoon's studio and production costs, they were the first to go.'

Hardy Fox (from The Residents): 'To my mind we were all riding the New Wave publicity and when that fad ended there wasn't much support of independents. Ralph Records closed its doors and even The Residents signed with Ryko, leaving Ralph as only a mail order business and not a label. All artists were given their masters free and clear to exploit as they wished.'

In 1982, Ralph put out a 12" remix of "What Use?" – the most "commercial" song from debut album *Half-Mute* – with another version of "Crash" as B-side. Finally, in1983, Ralph Records released a compilation LP entitled *A Thousand Lives By Pictures*. Tuxedomoon had nothing to do with either of these releases.

Principle: 'We weren't actually involved in the "What Use?" remix (we were on the road already mostly in Europe at the time). They did propose it to us and ask our permission, which we gave without ever hearing it. Ditto with the alternate version of "Crash". Thing is that they had described their

desire to make "What Use?" "more dance floor friendly" in the way that Human League and others were doing extended 12" remixes of popish LP items, and so we were very surprised at how conservative their approach turned out to be.'

Same with the *1000 lives* compilation: 'I guess this was actually released on "New Ralph," the label The Residents sold to the guy who ran the mail order business, and we were a bit surprised by it, but a closer examination of our contract let them do it at a far less rate of pay to us and I am sure they felt justified in this act to recoup the losses they didn't recoup through the sell-off of existing *Half-Mutes* and *Desires*. At any rate they never did try to put it out in Europe and we had nothing going on in the States at the time and so accepted it as inevitable. We have no idea how many they sold.'

Four years of Tuxedomoon: Blaine Reininger's car accident. Back in the Netherlands after their British residency, the band experienced the not so exquisite delights of communal living at their Utopia(n) resort.

"I don't remember much of the time spent in Rotterdam, recalls Bruce Geduldig. A lot of drugs (laughs). We lived in this funny building (kind of a water tower). There was a lot of things going at the same time. Winston and I did another tour (in Italy, France…).

In Utopia, there were definitely instant frictions because of room choices. There was immediately a lot of hostility because there were several floors, some rooms were better than others and Blaine and JJ just said: "This is our room" and that was the best room, you know (laughs). I remember some grumbling about things like that."

"There were a lot of practical complications in having all of those egos together in the same group, says Principle. You've got to figure that I lived in San Francisco and I had been living there for years before I ever met any of those guys. I had a giant circle of associates and people with whom I had other ways to find entertainment outside of that circle. And after we moved to Europe, we became so much more desperately dependant upon each other and were so incestuous for so long. It was bound to have negative aspects and it certainly did…" [13]

They found themselves again in a situation of acute poverty, a state of affairs that was even more untenable for Blaine Reininger, as he had to support his wife, JJ La Rue, on his share of the band's meager income. Reininger also claimed that Brown was regularly turning down gigs that he deemed neither lucrative nor prestigious enough. [14] This was how Reininger came to set himself up a solo date in Amsterdam at the De Koer club on the fateful night of June 14th, 1981, the night of Tuxedomoon's fourth anniversary.

06/14/81 BLR plays at De Koer, Amsterdam, after which he is heavily injured in a car accident

06/20 till 23/81 WT/BG in *Frankie & Johnnie: A True Story*, Kobenhavns Internationale Teaterfestival, Copenhagen

Maria Rankov on the utility of an agent and about Winton Tong's personality. "An artist needs the connivance of an agent because the agent commits oneself for dates. I remember that *Frankie & Johnnie* would have never seen the light of day if there hadn't been THE date. One plans the date for the *première* and then they have to do it but however cannot do it all alone. There are all kinds of logistical and practical aspects for which they need the complicity of someone transposing what they think into practice. Especially that Winston was doing everything: the costumes, the backdrops… He was so gifted from so many viewpoints that he could do everything but needed someone to anchor him into reality. Otherwise his creation would have remained somewhere out there, in between the earth and where he is and that is why it would never see the light of day. There are so many layers in his personality and you would discover one at a time but then there are so many of them behind that he

Blaine Reininger: "This accident points into a certain amount of bitterness about being in Europe, basically being in an unsteady financial situation. I always had a job. If I had no money, I could go get a job in the States, which made me kind of unique amongst this kind of people. I mean Steven and Peter were not "workers" like that whereas I did anything I had to do. I worked in offices and I was used to having money at the end of the week etc.

In Europe, I suddenly I found myself living the life of an artist. And there was no fixed income and I was panicking. Also JJ and I were both drinking and alcoholism tends to get expensive. I was responsible for both of us, for both our food and booze as well and because I was two, I had a lot less money than the other guys. I began to devise some shows that I could do myself that would give me more money and I found someone to book this show for me in Amsterdam.

So I went because I needed the money, the money was the issue. I went to this club, somewhere in the center of Amsterdam, De Koer. Peter went with us and there was Frankie Lievaart [*who would later work with Tuxedomoon and solo members as a sound engineer*], who was just a friend of ours at the time. As it turned out, we didn't have any money with us and there was no food. There was booze but no food at the end of the show. So they went on and drinking, drinking, drinking and no food, no money.

About the time when the show came, I was pretty wasted. I was drunk and it was only for after the show that I was going to get some money to eat. I did the show. The show went Ok, it was real primitive. And I got paid.

I was really hungry by then and the only thing I was thinking of was to go to one of these little automats where you could get a *croquette*. I went out. I had 750 gulden and with this precious money I was looking for something to eat in the immediate vicinity. I saw some guy and I thought I recognized him from the show. I asked him: "Is there an automat over here?" And he said: "Oh yeah right over here!" A little skinny junky kind of guy. I was wearing a shoulder bag and he grabbed it and ran.

That was the precious money that I'd felt that I had given up so much just to get it. So I was: "You little fucker!" and I was chasing the guy. He was little and I was running really fast, also I was really drunk and I was catching up with him. My idea was really to beat the shit out of him and get my money back.

Then things got confused. I was running real fast and I remember that the guy threw my bag down, I scared him. He was not that committed to robbing me like a pro. I saw my bag and then… I don't remember anything… I've got vague vague memories of what happened. I don't have a clear

is somehow a mystery. This is his Chinese side, his coldness, his sharp edge but, all at once, like his voice, there's this warm side about him, like a child forsaking himself but very vulnerable at the same time. This is why he needs to protect himself and he's a very complex character. This feminine side that he has, this thing very round and beautiful… But when you come to see the Whole, you understand that this is complex and deep. And this is a very deeply wounded person who carries around a baggage of injuries of all sorts that he excretes through his art. He's one of these rare personalities who can express himself through many very different forms: the dolls are one thing but there's his acting also…"

06/26/81 WT/BG in *Frankie & Johnnie: A True Story*, at Palazzo Strozzi, Florence, International Theater Festival *In Teatro '81*, Polverigi 'The first American event to be seen at Polverigi was a performance entitled *Frankie and Johnnie* with a rather extraordinary drag artist named Winston Tong who has become something of a cult figure on the European theatrical avant-garde circuit. I don't know anything about Tong's background. When he is in drag he looks like a cross between Lena Horne and Anna May-Wong – which is quite a flattering thing to say about a man. Assisted by Bruce Geduldig who appears as a doctor, Tong interprets the story of Frankie and Johnnie as a schizophrenic fantasy. There are songs, there are film clips, there are dolls who are lovingly fondled and made to exchange roles like their creator. On a windy summer night in a park such as that of the villa at Polverigi. It may be just another psychodrama but it keeps you riveted for over an hour and leaves you feeling that you have stumbled into those woods like a peeping tom.' (J. F. LANI, "What's burning' on Adriatic coast", *International daily news*, 07/06/81)

"Proud of my country." Maria Rankov about WT/BG touring in those times: "I had organized a big tour all through Europe that they ended in Sarajevo. Then they were due to go to Skopje in Macedonia. At that time I was also working with French actor Farid Chopel and in August '81, the two groups went to Skopje for an international festival. Bruce called me up one day with a shattered voice: "We lost all of our money!" They told me that they had been waiting for their *chauffeur*. It was night time and they were very tired. Then their *chauffeur* had wanted to stop by a tavern to have a drink while they were waiting outside around the car. At one point, they lost patience and Nina [*Shaw*] went in to fetch him. Finally

he came out and they all happily and quickly got back into the car, forgetting in their haste that Bruce had left the pouch containing all the money that they had cashed in during the entire tour (there were currencies of all origins in there, for a total of 75,000 French franks [*about 11,500 euros*]) somewhere around the car. It was their entire wealth! And Bruce told me: "So he started off and I must have left the pouch on the road!" They went back to the place where they thought they had lost it and searched for it. Then Farid called me to tell me how crushed they were and that everyone on the tour had given out a bit of money to enable them to survive. Later they called me to tell me that a peasant had found the pouch on the road and had turned it, intact, to the police who gave it back to them. I felt proud of my country, it was really great as it is something that does not happen very often. Maybe they didn't know what to do with these foreign currencies but I like to believe that they did that out of pure honesty..."

picture... Presumably what happened is that I ran off on the street and got hit by a car and the car ran over my [*right*] hand and probably my ankle as well and I also hit my head. I have vague images of lying there in the street. I was wounded at the back of my head, my knee, I broke an ankle really severely and these fingers, all four of these fingers and not my thumb, which was a good thing.

The next thing I knew I was in the hospital. I didn't know what had happened to me. I knew that this had something to do with this robbery. I thought that this guy had stepped on my hand, had broken my hand with his foot or something. I didn't know, really didn't know. And I was lying naked in this hospital, with my hand in a sling and it hurt and I could see that something was dreadfully wrong...

I spent a few days trying to figure out what the hell had happened to me. I was in the hospital for ten days and JJ was coming back and forth from Rotterdam to Amsterdam. They did surgery on me when I first came in. I was extremely intoxicated when I got there. I had been drinking all day and I had been taking valium as well. So I was basically comatose for a couple of days. I woke up, naked and: "Well, where am I?" I had just disappeared. I had left after the gig and they didn't know where and they didn't have a clue. Then somebody said: "Oh some guy got hit by a tram!" They told me this later and they were: "Oh my god, it's probably Blaine!" And they started to be looking through the hospitals and they found me. So JJ was coming back and forth to see me and those guys were back to Rotterdam. I was in the hospital, I wasn't too flipped about things because I was reasonably stoned all the time with the drugs or morphine they gave me. After some days they put a few clothes on me, they shaved and washed me, established that I was alive and not just a low-life junky scum and they began to treat me somewhat differently. Then I had more surgery. I was in surgery for maybe a total of sixteen hours and this was really the best thing to do on my hand. They brought some kind of experimental procedure on it. The Dutch government was good about that: they paid for all of this medical care and physical therapy, also for my ankle. I couldn't walk and I was in a wheelchair. I couldn't afford a regular wheelchair, so this was just something that somebody found. They basically kicked me out of the hospital after ten days. I was a difficult case: I wouldn't stop smoking and that was driving them crazy.

So back in Rotterdam, I tried to come to terms with what had just happened to me and I wasn't really excited about it: breaking a hand, for a violinist. Then I sort of resolved it: "Well, this will not stop me, I can still use this hand!" Now I can't straighten out my hand and I don't really have much

use of this finger, the third, ring here. I can play the violin. I don't have the flexibility required to do certain things with the bow. It limits my guitar playing to a certain extent. One thing I can't do at all anymore is playing classical guitar, at least not as well. It limits my ability to play on keyboards as I can't play very large chords with the right hand and I can't move quickly with this hand. But I can do most things. I'm not happy that it doesn't look so great. It's obvious that when you look at it, for a while, there's something wrong there but…"

At Utopia, Blaine remained confined to bed, wheelchair and Casio laptop for about two months, composing some new songs like the accurately named "Broken Fingers" and sketching others like "Ash & Bone" and "Birthday Song." It took about six months for Reininger to recover from the accident and he was still walking with a cane the following April. [15]

In July, the band left without Blaine for four dates in Italy that included performances at the Polverigi Theater Festival. They were invited by Velia Papa, director of this festival. She was introduced both to Tong/Geduldig and Tuxedomoon by Maria Rankov, a Serbian theatrical agent based in Paris who first worked with Tong/Geduldig and then was persuaded by Tong to work with Tuxedomoon as well. Velia Papa later acted as Tuxedomoon's Italian touring agent on numerous occasions and hosted Tuxedomoon's next project, *The Ghost Sonata*.

The gang enjoyed themselves so much in Italy that only Principle returned to The Netherlands in time to play a date booked on July 25th in The Hague at Zuiderpark, with Depeche Mode as support act.

Reininger: "We were supposed to play in The Hague and Steven and Winston and maybe Bruce decided that they just didn't want to leave Italy: "It's too nice here, fuck the Dutch!" and Peter alone came back. So what are we going to do? Those guys don't want to come, don't want to do this gig! So he said: "Let's you and I do it!" I was just fresh out of the hospital and I had these steel wires sticking out of this hand with wine corks so that I wouldn't stab myself at night. [16]

I was quite skeptical. This was the time when our support group was Depeche Mode. I was in a wheelchair and I was drunk. Peter was playing the bass and we didn't have any songs. I was just sitting in my wheelchair reading my poetry, a man at the keyboard and I was playing some violin [*Saskia Lupini and a friend from Rotterdam apparently helped along*]. That was basically a fiasco but we had to be paid and we were paid reasonably well.

The guys from Depeche mode were so fresh and young and we were already such old wrecks and uhhhh… physically ruined and psychologically bankrupt but the fact that we got

07/81 TM (without BLR) went to Italy for four dates: two (including one on 07/04) at the Polverigi *In Teatro* festival, one in Piacenza on 07/20 and one in Falconera

Film-maker Elio Gelmini about the Piacenza concert: 'Piacenza is a relatively small town (population: 100,000) and the way I seem to recollect it is that it was as if the entire town was affected by Tuxedomoon's arrival. They came and stayed for more than a week and many things happened. One aspect that one should be aware of is that the 80s were years of a decadent time, drugs and heroin in particular were very much *en vogue*, I let you imagine. About a year later we organized another concert, this time at the teatro municipale [*on 11/01/81*], a very old theater. It was an astonishing concert: it was sold-out and people had come from all over Italy to attend. It ended up a bit as a bust as the theater ended up damaged and we got all kinds of crazy problems…'

Principle: "In Falconera we played outdoors in front of a Renaissance villa with Winston and Bruce throwing reems of burning toilet paper out of the top floor windows, which blew in the breeze as it settled down." (PP quoted by James Nice, *Tuxedomoon*, unpublished manuscript, 03/21/92, p. 19)

07/10&11/81 WT/BG in *Frankie & Johnnie: A True Story*, at Chapelle des pénitents blancs, Avignon

07/25/81 TM (reduced to BLR and PP) plays at Zuiderpark, The Hague, with Depeche Mode as support act

07/29/81 TM plays at SO36, Berlin

08/02/81 TM plays in Nijmegen at some festival, with Gareth Jones assisting as sound engineer. They played "Pretty Moderne," a piece later known as "Queen Christina" that they composed at the Utopia commune and that they played a few times on stage

Page 145

the money split between us, that's what kept me alive for the next few months…

And the guys from Depeche Mode, they came over to meet us. We probably scared the hell out of them as I was just a bloody drunken mess in a wheelchair."

In August, Brown, Tong and Geduldig returned to the USA on vacation and claimed on their return that they had gone away to urge Reininger into a faster recovery. Whatever truth may be, Reininger actually became a better violin player than before the accident. "My violin playing has actually improved. Violin was forced on me in my youth. Now that it was almost taken away from me, my love for it has increased, and I've become a better player." [17]

08/81 SB, WT and BG return to the US on vacation. Upon their return, being evicted from Utopia, TM starts searching for a new home

Eviction from Utopia; Tuxedomoon moves to Brussels, works with choreographer Maurice Béjart, Les Disques Du Crépuscule and releases the Une Nuit Au Fond De La Frayère single for Sordide Sentimental (the situationists return). By the end of the Summer of 1981, it had become obvious that the band couldn't stay on at their Rotterdam Utopia commune. Reininger. "We were a pretty crazed bunch. And they wanted us out. And they gave us the excuse that they can't have a crippled living in Utopia, YES: that was depressing them."

Of course as Reininger himself implies, what took place was more complex than dealing with someone in a wheelchair and had more to do with the cultural shock that went along with Tuxedomoon's move to Europe.

"The Utopians had lost a lot of their respect for the Tuxedos, says Saskia Lupini. Because they were too weird and too American for them. They liked the English bands better, that were really famous and dressed well. The Tuxedos were really different: they did what they wanted and what they thought they should do and they were real rebels in their eyes. Also they were too poor and they wanted them out because people in a wheelchair couldn't be around Utopia, because people who had not enough money all the time couldn't be around Utopia, just totally disgusting…"

Bruce Geduldig: "When we decided to live here, my first perception of it when we moved into the water tower, I felt really like getting anchored but not in a good sense, attaching big weights to us.

At the time Rotterdam was weird for all of us. We were all trying to cope with the Dutch mentality which we didn't have any conception of except things like: Dutch are hospitable, quite intellectual, they all speak English, there's good drugs there and they're very open. And actually they were very hospitable in opening their doors to us and offering us that space to stay. But one side to look at it was: "Well it's because

we're Tuxedomoon and we're so cool and fabulous that the doors are open." The other way to look at it was realizing that yes these people were generous.

We were coming from the *milieu* of the US which is so big and kind of harsh in a lot of ways. Like if somebody would open his doors and say: "You can stay here," you would usually go and check it out and say: "No thank you" because it would be some kind of garage and it's the only type of doors that are open. We certainly weren't in a position to have that kind of hospitality and generosity being offered in the US.

I think that for all of us it was kind of a shock in that sense. I'm sure that if Steven would be here, he would say: "Well, you know, at the Angels of Light's commune, the doors were open" and there were communities in San Francisco where the doors were always open. But I think that when you move to a totally different cultural situation, defined by a country or whatever, you're immediately outside of your familiar territory and so you are accepted as a visitor. That status carries certain responsibilities that were not always apparent and especially for us those kinds of things were not apparent at all. The Dutch hospitality is not hospitality just because they're fools but generally that's how it was perceived, with the kind of egos that artists tend to have: "Well, they just think I'm so great and I AM great. These doors are open because I'm great."

In fact some small bridges were burnt in Rotterdam. The attitude of Tuxedomoon as a unit was often really crude and rude to people who helped, just impolite and inconsiderate, just using people to help us, turning them into roadies. I tried to do the best I could to diplomatically participate on a more human level. I found that some behaviors were infantile, just stupidly egotistic. And certainly the Dutch are very hospitable and generous up to a point and then they just go: "Fuck you, you're out. I don't do this anymore for you," which was completely understandable and that's kind of the point we got to with the hospitality of these people. They were just fed up with us. In America people are way more up front about saying: "Pay me if you want me to help you" or "I'm willing to do this for you this time but please don't ask me this again." And so that kind of cultural shock is what sets in when you actually start to live somewhere, that kind of secondary culture shock of realizing that people's sense of time, sense of friendship, sense of giving is slightly different, so there's room for confusion. You're often in this state of not quite knowing, like is this the proper thing to say or did we abuse this?"

Expelled from Utopia, the band stayed with friends including Saskia Lupini for a short time while looking for a new place to stay. The aforementioned Maria Rankov then providentially came to their rescue: "I was in touch with

Frédéric Flamand's Plan K dance company in Brussels – I knew Frédéric since the time when I was working for the Bitef Festival in Belgrade – and Freddy had told me that they were going on tour abroad for about a year. So I asked him if he would agree to have the group sub-let their apartments to Tuxedomoon for the duration of their tour. That was how they moved to Brussels and it was also around that time that I started to work with them as an agent, finding gigs for them." Additionally the group was given permission to set up a rehearsal space in the Plan K complex. [18]

In October '81, the band moved to Brussels. [19] Bruce Geduldig's first impressions about the "capital of Europe" were pretty grim: "I remember being very depressed at the idea of moving to Brussels. I wasn't against the idea of living here but my first impressions of Brussels have been kind of bleak. Grey sky and dim lights and really creepy and old, dark, nothing going on there. Whereas Rotterdam is modern looking and well planned and more like an American city. So coming here was like going through some sort of medieval creepy nightmare (…) But the real reason why we left Rotterdam is because it was too provincial and too far. We knew we needed to move to a capital. Winston kind of wanted to go to Paris, I think. Peter wanted to go to Amsterdam. Steven or maybe Blaine talked more about London. Lots of ideas were floating around. Brussels just came up as the next project and people from the Plan K were going on tour coincidentally at the same period for six months and so they told us: "Take our apartments while you do this project with Béjart." So we said Ok and thought we'd figure it out afterwards. Then we realized that the rents were a lot cheaper in Brussels than in any other city in Europe that we knew of. Certainly a lot of us wanted to go to Italy but it seemed like so far away. And then immediately liaisons with record companies started to come about. There wasn't that much going on in Brussels, so anything that was alternative was immediately part of the family. It was a very small world, still is…"

The arrival of a group of the caliber of Tuxedomoon in Brussels did not go unnoticed. Firstly, it was extremely uncommon that a group of American musicians would move to Europe and, secondly, they would choose Brussels to establish themselves. Indeed Brussels might then already have been the "capital of Europe" but it was also a very strange town, in the center of Europe but laying there half forgotten, deprived from any of the attractions that made surrounding cities (like Paris, Amsterdam or London) so appetizing for many. Bruised by the gigantic works that had been necessary to erect the European institutions' buildings, pushing its inhabitants to emigrate to green suburbs and seemingly leaving the center of the town mostly to poor immigrants or

old people, Brussels then seemed to be asleep, depressed by the economic crisis that had been prevailing since the end of the seventies. A city in exile... Hence the arrival of Tuxedomoon had the resonance of thunder in the middle of a quiet afternoon under a grey rainy sky.

Many things happened for Tuxedomoon upon their move to Brussels.
First came their collaboration with celebrated French choreographer Maurice Béjart, who then had set up his base and ballet school – Mudra – in Brussels. Béjart, by a strange coincidence, had already collaborated with Hibiscus and the Angels of Light in the seventies. [20] He had been turned on Tuxedomoon's music as well as The Residents' by one of his young Belgian dancers, Jean-Claude Wouters (now more well-known as a film-maker and photographer) while they were rehearsing Béjart's homage ballet to Belgium *La Muette* in early '81. Later that year Béjart decided to use some Tuxedomoon music, from the *Subterranean Modern* compilation ("Everything You Want") and *Half-Mute* ("59 To 1") for his next creation, a ballet entitled *Light* that premiered in Brussels (Cirque Royal) on September 22, 1981. [21]
Béjart [22]: "I'm a great friend of dancer Carolyn Carlson. At that time she lived in Venice and she was pregnant. I saw her dancing pregnant in Venice and that had enthralled me because I loved her very much and she was very beautiful, dancing pregnant.
There was a place where I used to go a lot every time I went to Venice, an island that was called San Francesco del Deserto, where one can find a convent founded by San Francesco upon his return from the East. Also Carolyn was born in San Francisco, a town that I like very much and where I have many friends. So I built some sort of ethereal mental bridge between San Francesco del Deserto, which is Venice, and San Francisco.
I was in search of a musical universe when I discovered Tuxedomoon and fell deeply in love with their music. Then I found out that these people were very much related to San Francisco at that time. So for Venice I took Vivaldi and for San Francisco I took The Residents and Tuxedomoon.
The ballet painlessly came along, with these two towns and it was danced by one of my dancers – Shonach Mirk – who, deceptively pregnant, played the role of a pregnant dancer who gave birth on stage. *Light* is a ballet that has counted a lot for me and we showed it in a lot of places: Paris, New York, Japan... And the music was very well received."
When Tuxedomoon moved to Brussels, Béjart immediately got in touch with them. "We got a letter from Monsieur Béjart, remembers Steven Brown. So we went to Mudra one day for lunch. I had heard of him. He was like Balanchine, BIG name!

Page 149

He asked us : "You want to write ballet?" "Ok, we said, why us, why not the Rolling Stones? Why would you want to go some unknown bunch of geeks like us?" He said (Brown imitating Béjart's French accent): "Well, if I wanted the Rolling Stones, I would ask the Rolling Stones. I want you!" So, that's how that happened." [23]

"We started working right away at the Plan K, recalls Brown. The name of the ballet was *Divine*. It was to be an homage to Greta Garbo, the films of Greta Garbo. Béjart had a double album of excerpts from all of her films of her talking. He circled seven of these films and told us: "Listen to these seven films, don't listen to the male lead, listen to Garbo and that's all." That's the only direction he gave us. So we took the films and we kind of divided up amongst ourselves. Each of us took a movie to be taken charge of: Winston, Bruce, Steven, Peter and Blaine and then the remaining two we worked on collectively. So we'd finish them one by one, finished the piece, we took it over to the studio where Maurice Béjart worked, gave him the tape and he started to choreograph a dance to it and it just worked very smoothly.

Actually it was a very exciting, rewarding work to do that and then when it was all done – it was a *pas de deux* that was like 40 minutes long – it opened as a world premiere in Brussels at the Opera house [*from March 25th till April 2nd, 1983* [24]]. There were all these tuxedo-dressed, rich people and aristocrats who came on to see the new ballet. It was on a bill with another new one. We were all up there in little box seats and it was pretty exciting." [25]

However, it "was a bit of a rush job, Peter Principle recalls. Some preexisting tapes, dating from San Francisco, were used." [26] Béjart, whose way of working with composers has always been to give them *carte blanche* with as little direction as possible, expressed mixed feelings about the final outcome: "It wasn't as good as *Light*. It was less of a success because there was a discrepancy between my vision of their music, their music and Garbo's character. There were some very good things. I had then a female dancer, Marcia Haydée, who was really divine and formed an amazing couple with Jorge Donn. So I staged a couple and no one could tell anymore who was the guy and who was the woman. In the end it was Donn who appeared all dressed-up as a transvestite and was doing his Garbo. Haydée was tall and a bit mannish and this all worked very well together. It wasn't bad but it wasn't a great success. It was seven films, seven episodes. When they used the words of Garbo that they transformed and repeated, it was very successful but on others pieces… But it wasn't their fault, it was me who did not succeed in creating this ballet." [27]

Composing the music for *Divine* had a secondary effect: re-initiating a working relationship between Blaine and

Steven. Blaine Reininger: "I was still on crutches and I was to meet "Maurice" and all the dancers were scared to hell. Dancers, this is their worst nightmare, to break a leg or anything (…) During that 82-83 period in Brussels, Steven and I have done these Blaine and Steven's shows, classical thing. We had started doing that in Maurice Béjart's rehearsal space, at Mudra. We started to write little tunes just for piano and violin. We got ourselves a *répertoire* of pieces we wrote like "Music # 2" and these kinds of things came out of these little jams. A lot of this music that would later be part of *The Ghost Sonata*, like "Licorice Stick Ostinato," came out of this period of just Steven and I jamming in Mudra. Then we played at a place called La Papaye Tropicale in Brussels…"

Also immediately upon their arrival in Brussels, Tuxedomoon were approached by local label Les Disques Du Crépuscule whose boss, Michel Duval, had already promoted gigs in Brussels. Duval's assistant, Katalin (Katy) Kolosy took over booking and management duties for Tuxedomoon from Michael Nulty. [28] It was through the Crépuscule connection that young sound engineer Gilles Martin, [29] stepped onto the scene to become THE engineer whose name would become associated with Tuxedomoon.

09/21/81 Gilles Martin's first *rendez-vous* with Steven Brown

Gilles Martin: "I was born in Rouen, France. I arrived in Brussels pursuing a love story, following the girl and I stayed on. I wanted to be a sound engineer and in provincial France, work prospects were practically non-existent, so I had decided to leave. At that time the choice was for me between Brussels and Paris. I chose for Brussels as I knew more people there and I found Brussels to be less dreadful than Paris. I really had a vocation for being a sound engineer.

First my aim was rather to be working in the studio but then I met Michel Duval who told me: "You know Tuxedomoon is in Belgium now and they're looking for someone to tour with them!" [30] I had never done anything live but I was a great fan of the band in those days. *Desire* had just come out and I was very impressed. I was then 21 and that is the age when you get into things out of boast. So I went to meet Steven Brown [*for the first time on September 21st, 1981*]. Steven wanted to test me and see whether I could work live as a sound engineer. He would have liked to gather sound equipment, musicians and me to rehearse "live" at the Plan K. However we weren't able to achieve that and the date for departure on the first tour came and I left with them without ever having done a single date with them, not even a rehearsal and I was scared, totally flipped out.

The first date was in Sweden I believe [*on the mini Scandinavian tour that started on September 24th*] and later we toured in the United States [*Los Angeles on December 24th, 1981*]. I was hovering completely. I had never been on a plane in my life

Gilles Martin, circa 1982.
Photo Patrick Roques

Page 151

Scandinavian mini tour including:
09/24/81 TM plays in Göteborg (Sweden)
09/26/81 TM plays in Stockholm (Sweden)
09/29/81 TM plays at Hard Rock café, Oslo (Norway)

This tour also included a date in Bergen.

Blaine Reininger: "It was winter already, cold, and Michael Nulty turns up in a microbus. Seven people and the equipment were supposed to fit in this thing and drive all the way to Norway. My leg was still in a cast. Tong took one long look at this van and went back to bed. He said he'd follow on the train. He didn't. Nulty didn't have a customs carnet either, so he draped a couple sleeping bags over the gear and bluffed his way over every frontier. A bunch of guys in leather jackets and shades going camping in September, right?" (JAMES NICE, *Tuxedomoon*, unpublished manuscript, 03/21/92, p. 20)

Peter Principle: "We took a boat from Copenhagen to Oslo and that was in the middle of the Winter and that was like a ten hour boat ride. That was really great. It was freezing cold but I remember finding a place by the engine exhaust that was warm and I remember standing there and watching the snow fall and sailing through the black night. Then we had to cross the fjords on our way to Bergen where we had to play. There was one hotel where we had to get up at four in the morning to catch the boat across the fjords. We arrived in Bergen and we ended up in a mall where we were playing some bar with a country western theme. We were playing some sort of Bingo! parlor. They had this really obnoxious video game and we taped it and we used that tape for the opening music of our show and the guy who ran the local PA was

Winston Tong, photographed by Jean-Claude Wouters

so mad at us for doing that that he took the power amp. So we had no PA, the guy went home! When we ended up playing, there were like 40 people and only five of them ended up to stay and we did the concert with no PA in the middle of nowhere in Bergen. That was really funny! We made them pay though. And then Blaine stole a huge sausage, like a twenty pounds sausage from the kitchen and we had it hanging from the mirror in the van until it got kind of green. But we've been living of that sausage for days…"

10/81 TM moves to Brussels where they immediately start working with Maurice Béjart

and Tuxedomoon was going on tour in the United States! I had never seen the States either and so it was great for me of course. I don't know if I was good at doing this but they were obviously trusting me and things began to roll with them, one after another (…)

Steven introduced me to the band but I quickly became friendly with Peter who was also passionate about technology. Peter was a record producer as well and we found ourselves on numerous projects working together, producing bands in Belgium for Crammed discs.

We had begun touring together and, naturally, when they came to be willing to make recordings, they asked me to work with them. It's a good approach for starting out as a sound engineer: find a group, take up with them and then make recordings with them (…) Tuxedomoon was an extremely formative band. It was for me, a *débutant* sound engineer, landing with a group that had the nuttiest and most anti-conventional ideas as far as sound taking was concerned. If I had started working as an assistant in a studio, I would not have the sound that I have today. It's them who taught me to be delirious in the studio, I'm sure about that. It's them who taught me to do "things that shouldn't be done." You see in the studio there are such things that one should not do: a mike should be set like this and this other thing like that etc. These are highly regulated matters. There are books that tell you how to do these things right. With them it was the other way around: above all one should NOT do like it's written in the manual and meeting people like them was excellent, it was great luck for me. There was this edge, very open to experimentation, all the time and in all three of them: Blaine, Peter and Steven. It lays at their very foundation as artists. And I suppose that they must still be like that. I can't imagine them doing international pop and they do not correspond to the stereotype of the average American."

The first recording that Gilles Martin made with Tuxedomoon was a single for French label based in Rouen *Sordide Sentimental*, coupling Brown's "Egypt" with Principle-Reininger somewhat noise title track "Une Nuit Au Fond De La Frayère" (literally: "A Night At The Spawning Ground"). The latter title was meant to be a play on words as "frayère," in French, sounds very close to "frayeur," that is: fear.

The label had already released limited edition packages by Joy Division, Throbbing Gristle and Durutti Column. The originality of Sordide Sentimental's releases [31] comes from the multimedia approach sought by the label's main man, Jean-Pierre Turmel. His first interest was, by the end of the sixties, for science-fiction through its so-called "speculative fiction" or "new wave" trend (J.G. Ballard, Thomas Dish, Philip K. Dick, etc.). 'This kind of science fiction was way more ambitious

than its popular counterpart as far as the writing and the ideas were concerned, writes Turmel. And it also set up links with other artistic fields, like music and psychedelic music in particular.' Until 1974, Turmel belonged to a science-fiction club called "BEM" through which he organized exhibitions (of contemporaneous artists, comics and sci-fi documents of various kinds), film projections (Chris Marker, Karel Zemann…), presentations of various trends in the popular music and published a single issue fanzine accurately named *OneShot*, including articles about various bands.

'Sordide Sentimental was born in 1977 of the mutation of *OneShot* – main title was *Sordide Sentimental* and *OneShot 2* appeared in smaller fonts – and the focus was now solely on music, remembers Turmel. It proceeded from a double premise: 1) very few music columnists were real writers and 2) a whole musical sphere (that was born at the margins of the punk movement) was largely ignored. Thus there was a void to fill in and a strong feeling of emergency. The fanzine featured articles about Throbbing Gristle, The Residents, Chrome, MX-80 Sound, The Bizarros, etc. There was only one issue of this as readers often pointed out (that was in 1978) how hard it was to find the music(s) discussed. That was how the idea came about to have each article accompanied by a record and illustration in a large packaging (A4 format) to evoke a magazine rather than a recording. This concept had a precedent in history when the German romantics, under the denomination of *Gesamtkunstwerk* ("total work of art"), were simultaneously producing a painting, a text and a musical work by three different artists (as a matter of fact, the word "Gesamtkunstwerk" was printed on a blue warning that came with the Joy Division project, the second that was carried out by Sordide Sentimental). This concept (Music + Image + Text) was if not a premonition at least represented an aspiration to nowadays' "multimedia."'

Turmel knew Tuxedomoon through Ralph Records and The Residents with whom he was in touch. 'If I recall well, it was Steven Brown who wrote me when Tuxedomoon moved to Europe, to express their interest about Sordide and their desire to carry on a project with the label, writes Turmel. I needed an idea, a conducting thread to do this and I got it after viewing David Lynch's *Eraserhead*. The theme was *Ectoplasms*. As usual when I work with a group, I communicated with only one of its members, in this case Steven Brown. This recording with Tuxedomoon had, among other merits, the effect of teaching me one word: "Frayère." I remember that I did not understand when Steven dictated the title: "Frayeur?" "No, frayère!" Jean-François Jamoul (who wrote one of the texts and designed one of the covers) came to my rescue with an old 19th century dictionary.

(*Divine* ballet soundtrack), with Les Disques Du Crépuscule (Katy Kolosy replacing Michael Nulty) and with sound engineer Gilles Martin

10/81 Pre terminates the contract with Ralph. Shortly thereafter Ralph terminates their contract with TM (Jay Clem visiting PP in Brussels, handshake agreement)

10/02/81 TM plays at Plan K, Brussels

10/06/81 TM plays in Berlin

10/10/81 TM plays at Paradiso, Amsterdam, *One World Poetry Festival*, with William Burroughs

10/81 TM (BLR, SB, PP) records at Plan K rehearsal space (Brussels), prod. Joeboy, the 7'"Une Nuit Au Fond De La Frayère"/"Egypt", published by French label Sordide Sentimental and later to appear on the *Pinheads On The Move* compilation album (Crammed, Cramboy, 1987). First recording with Gilles Martin. Released in 12/81

Excerpt of Jean-Pierre Turmel's text about Tuxedomoon and ectoplasms, the latter being the theme chosen for this Sordide Sentimental release (translated from French) : '"Music above all" Verlaine. At art's heart lays music with its moving forms and so difficult to identify. Non-spoken words, both over and under-coded.

And the music of Tuxedomoon, like all art, expresses, materializes in a sound form, the unspeakable, the forbidden, the forgotten and the obsessive. But on top of this it does add the distinctive fact of evoking, with a disturbing clarity, the ectoplasmic phenomenon itself. That is its specificity, the probably unconscious cornerstone of the group's whole thematic, in their sound as well as in their gestural posture or as in the other disciplines to which they devote themselves as individuals (Steven Brown's drawings, Winston Tong's paintings and dolls).

Analogies and references to Ectoplasmy by the very structures of the music. At the edge of melody: parasites, noises, strange sounds are proliferating, insidiously.

Dirty noises, at the limit of perceptibility thus subliminal. They seem to be exuding from the melody and enjoying their own autonomy. Sometimes strident but always crawling, creating zones of uncertainty, obscure auras, slimy mists, around the themes.

(…)

Laments on the violin of course: haunted music distilling fear and

Page 153

repulsion, little by little. Blank, suffocating, whispering, equivocal voices. Immense sorrow, difficulties in uttering, in tearing but one sound from that blocked throat. Ghostly presence at the limits of perceptibility, coiling in the hollows of omnipresent nostalgic themes. Obsessive memory sticking to the skin, clutching the hair, mental and venomous vampire distilling regret and depression, re-opening ancient wounds, hindering healing. Saturnine music, essentially nocturnal. Music for gloomy, dark interiors of the turn of the century, for dusty and furtive rituals. Grey neo-Victorian mediocrity… hands touching in quasi-obscurity, anxiety, panting of the isolated medium, irritated hearts, crawling desires, cold and humid.
(…)
Winston TONG, finally, who sings and moans with TUXEDOMOON, who seems to be at the margin of the group, double and medium at once.
(…)
All therefore converge towards this secret center that is ectoplasmy. The whole personality of TUXEDOMOON irradiates from it, projecting their shadows and pleas within us through their sounds. To make us understand that what we all pursue is what pursues us.'

Tuxedomoon and Gesamtkunstwerk.
Steven Brown: "Before I was in Tuxedomoon, I worked with theater companies and I was not as committed to music as Peter and Blaine were. I saw a stage as something that was part of theater, film, ballet, not as some place where groups of musicians would perform (…) When you find yourself there alone playing an instrument it's so uninteresting (…) We wanted something musical and something visual: something to watch and listen to. We would ask friends to paint us backdrops, to project slides or films, everyone could participate. If that is the word that applies, then we are doing *Gesamtkunst* (…) In fact we don't like the term "multimedia" (…) It reminds me of schools, of something that one should study. It is journalists who put this label on us" (GROSSEY, "Steven Brown (Tuxedomoon) : de luisteraar is nooit verkeerd", *Kuifje*, 01/28/86, translated from Dutch). Blaine Reininger: "In Colorado, which is where I'm from, I often played in bar bands, with these badly dressed people standing as stiff as poles on stage. Me, I saw salvation in rather eccentric acts like the Velvet Underground or in the Tubes' absurd theatrical music. I thought that concerts had to be more spectacular. They had to provoke the same kind of excitement as a circus show stopping by in your village. What intrigued us also was the idea of bringing together all forms of expression. The 19ᵗʰ century *Gesamtkunst*

The whole project was sprinkled with verbal confusion and misunderstandings. Jamoul had not given a title to his written piece. So I called him up on the phone and Jamoul was hesitant: "De l'angoisse" (On anguish)… "De l'art et du temps" (On art and time) and I wrote "De l'angoisse de l'arrêt du temps" (On anguish at the stop of time). Ten years later Jamoul told me that it was better that way in the end.

As to the cover designed by Jamoul, I first discovered, when I went to his place, a painting that immediately attracted my attention and that I thought to be the one he had made for Tuxedomoon. It was a view in perspective of what seemed to be the inside of a Venetian palace, paved soil in black and white, and one could see someone from the back, leaning on a balcony, gazing at the outside. But finally Jamoul had reserved another painting for this project that, in my view, was evocative of Belgium – through the reference to Magritte – and of their expatriation. Years later, Jamoul told me that he originally had chosen the first painting for the cover but later had doubts about the accuracy of his intuitions and painted the one that was published. Too bad I was too well-bred to tell him about my preference…

The text I wrote for the flyer of their first *Nuit Sordide Sentimental* concert [*on December 2ⁿᵈ, 1981*] was also indicating my attachment, or my spiritual filiation with the situationist movement and, more specifically, with their predilection theme for *drifting* (…) Another theme that fascinated me in Tuxedomoon is the mirror effect between the old Europe and the USA. Curiously, I found about the same theme, but inverted, in a Belgian artist: Arno, who was then the singer of a band called TC Matic. I did not make a release with him but I organized a *Nuit Sordide Sentimental* with his band [*on September 29ᵗʰ, 1982*] for one of their very first concerts in France.'

US tour. December '81 was a busy month for Tuxedomoon. First they got to record the *Divine* soundtrack at Little Big One studio in Brussels. Then they continued with a long list of French dates that they had started out in November (with some glowing performances in Italy as well), culminating in gigs at Elysée-Montmartre (after a fierce battle with French customs agents) and a *Nuit Sordide Sentimental* in Rouen.

The year 1981 ended and 1982 started on a short US tour that brought them back to San Francisco for New Year's eve and also included dates in Los Angeles, Denver, Vancouver, Seattle (where they underwent yet another fierce battle with customs agents), Chicago, Boston and New York City.

At that time Tuxedomoon was at the peak of their early career [32] and, therefore, this tour had the bearing of some triumphant

Page 154

homecoming. For the occasion Blaine Reininger confided his impressions about the USA and Europe to journalist Michael Snyder: "I'm afraid for the United States. The country is rife with Christian geeks and warmongers. I see who has been elected President and I think, "My people, how could you do this?" Not that our existence has been easy.

We've been beset by endless travails. There was the accident (…) Our equipment was stolen. Our recording studio cleaned out. And Europe can be duller than shit.

On the plus side, we're respected over here. Europe is a traditional refuge for Americans who weren't accepted in the US, everyone from Hemingway and Gertrude Stein to Jack Johnson. We can make a living here like your average factory worker, which is better than our situation in the US. We live like humans. We eat, we pay rent, all through our art. We're accepted by reputable people like Béjart. He's the Balanchine of Europe. If we lived in San Francisco, we'd be lucky to get a gig at the Mabuhay these days (…)

We have more interest and more respect because Europeans are more literate than Americans. For instance, they remember how to read. TV isn't as all-pervasive as it is in the US.

We've traveled to the most out-of-the-way places to do what we do, the northernmost limits of civilization. In Bergen, Norway, we were the first contemporary music to play that area, except for AC/DC (…) they were thrilled. When we got to Bologna, Italy, we discovered that one of our first records had been bootlegged there with a bright red cover. We had 2,000 screaming fans at the show and a turn-away crowd. I'm sure the Communists were out in full force, thanks to the red cover.

We were the first new wave band to play Naples. They loved it (…)"[33]

All seemed to go well for Tuxedomoon at the end of the year 1981: they were touring and being reasonably paid for it, they weren't short on projects to carry on and their fame was growing. As Blaine Reininger observed in 2001 and 2004: "Artistically we were enormously productive, end of '81, '82. We were working all the time. First we did this ballet for Maurice Béjart. We were working in the studio all the time. We were touring, we were making good money. We were playing in France for *maisons de la culture* because Maria Rankov, who was booking us, was a high art agent, not a music agent, she was Winston's agent. So we were playing *la maison de la culture* all over France." In retrospect: "There was a time there where it seemed like we were in sync with the rest of the world and it seemed like what we were doing was going to carry the day, culturally. Then we went back out of phase with it, and the mainstream continued being the mainstream, like it always was."[34]

was not making any difference between art and science, between high and low culture. These are all expressions of the human drive to understand the universe" (D. Steenhaut, "Wij waren op het gevoel", *De Morgen*, 06/12/04, translated from Dutch)

Soon after this, Tuxedomoon got much of their (uninsured) recording equipment stolen from the Plan K (James Nice, *Tuxedomoon*, unpublished manuscript, 03/21/92, p. 21)

10/14 till 18/81 (according to Gilles Martin's archives) TM (BLR, SB, PP, WT) records in Brussels, prod. TM, the piece "Weihnachts Rap," published on the Les Disques Du Crépuscule's compilation album (various artists) first entitled *Chantons Noël* (12/81) then *Ghosts Of Christmas Past* (12/82, 12/86 and 12/88 for a CD edition). WT records "The Twelve Days Of Christmas" for the same compilation album that constitutes TM's first recording for Les Disques Du Crépuscule

Weihnachts Rap's lyrics (translated from German into English by Patrick Laschet):

O fir-tree; O fir-tree; you take pleasure in me; Silent night, holy night; I can't pay for this; Tomorrow comes the Christmastide; and the children full of greediness; Presents are placed under the tree; People buying worthless things; like a senseless shuffling crowd; Buy me; Buy for you; Buy me a new savor; I hate this ice and snow; Buy me a warm island; Resting-house; Guest-house; I stay here in the Holiday Inn; I burn down my fir-tree; and throw in the whole Christmastide

11/81 release on Subterranean of Minimal Man's LP The Shroud Of, with SB guesting on the tracks "Jungle Song" and "She Was A Visitor"

11/01/81 TM plays at Teatro Piacenza, Regio (Emilia) (Italy)

11/03&04/81 TM plays in Naples (Italy) In Naples, Tuxedomoon found themselves performing in front of a an audience of about 2,000 people out of which at least 300 didn't know at all what to expect (the band was then not very well known in Naples) or, rather, were expecting some hard rock. Therefore the audience started hissing and making a huge din, to which the band adapted by massively calling upon their rhythm box. The press compared them to Pink Floyd (see: G. Cesarini, "Il ritmo dell'elettronica", *Il Mattino*, 11/05/1981; L. Seneca, "Le paranoie della "new wave" al chiarore lunare di S. Francisco", *Paese sera/Napoli spettacoli*, 11/05/81)

11/06/81 TM plays in Gabbice (Italy)

11/07&08/81 TM plays 2 or 3 concerts (sources vary) at Trianon, Rome

Page 155

Steven Brown, Peter Principle and Winston Tong photographed in a theater somewhere in Italy.
Photo Gilles Martin

'(…) Tuxedomoon gave one of the most fascinating performances ever presented in Rome: a mix of cinema, theater and music that unleashed a justified enthusiasm of an audience of more than 2,000 yesterday at the Trianon Theater (…) Brings back reminiscences of the ancient East, the frontiers of the knowable, of a future full of uncertainties (…) a total work of art, in its most complete and best meaning. The moon of Tuxedo shone (…) and us, the pagans who were present, adored it and will always adore it.' (P. ZACCAGNINI, "I Tuxedomoon al Trianon. Tutto è musica", Il Messaggero, 11/09/81, translated from Italian)

Roberto Nanni: "This concert at Trianon in Rome was very interesting first because of the political context of the time (fear of terrorism) and also because Rome then wasn't very rock 'n roll. The cities where "things were happening" were then Bologna or Torino, mainly Bologna that was full of people who were listening to music in the Tuxedomoon style and also a University town. Rome was then more interested in Italian music and melodies. What then happened at the Trianon was like an electric shock treatment for the Romans, so intense… It was like a synergy between musicians, poetry, singers and film-makers. It partook to an alchemy that I had never seen at work in any other band."

The only big cloud over their otherwise blue sky was that they were label-less since the already described Ralph/Celluloid debacle. However the band was not short of labels ready to endorse some of their projects and also, at that time, subscribed to the vision that releasing numerous scattershot records on different labels was in keeping with some radical independent movement. [35]

1982: the Les Disques Du Crépuscule package tour; Blaine Reininger records his first solo album, Broken Fingers; Tuxedomoon records the Time To Lose 12"; another triumphant tour in Italy; Tuxedomoon records the double 12" Suite En Sous-sol for Italian Records; Patrick Roques' arrival in Europe; The Ghost Sonata; ending up into the school for the deaf, dumb and blind. Hear no evil, speak no evil and see no evil.

February 1982 will be a busy month. First, Winston Tong and Bruce Geduldig took part in Les Disques Du Crépuscule's package tour dubbed *Dialogue North-South* (with Isolation Ward, Marine, The Names, Antena, The Durutti Column, Richard Jobson and Paul Haig): 14 dates disseminated between Belgium, the Netherlands, France and one date in London. Tuxedomoon played the opening show in Brussels at the Beursschouwburg. Additionally Blaine Reininger and Steven Brown were also involved, accompanying Richard Jobson's verse readings (which can be heard on the souvenir album of that tour: *Some Of The Interesting Things You'll See*

Peter Principle, Blaine Reininger and Steven Brown photographed by Roberto Nanni

On A Long Distance Flight) and indulging into one of their legendary musical battles in Lyon where they performed an astounding improvisation on some equipment loaned by the group The Names. [36]

11/20/81 TM plays in Lyon (France)

11/21/81 TM plays in Grenoble (France)

Blaine Reininger records his first solo album, Broken Fingers. It was also in February that Blaine Reininger recorded his first solo album, *Broken Fingers*, for Les Disques Du Crépuscule.

At that time Reininger was contemplating leaving Tuxedomoon: "In the band, my ideas were not received well. I never got to sing. Nobody seemed to like my voice. Every time my lyrics found their way into the songs was when Steven sang them: "Dark companion," "No Tears" were my songs and Steven sings them. I began to resent that. Also by this time I had a body of songs that I had written and that I had tried to get the band to play and they were once or twice but they never sort of stuck. I had a lot of material that I had written that I just put away, that I did not even bother to present to them, thinking that these will never go, they'll never pass the censors. The censors were primarily Steven and Winston. I thought they'd never go for this, it's too poppy, there's a beat. It's too much me, it's too much Blaine." Also Blaine was not exceedingly happy with the *Divine* project that he found too opaque and arty. [37]

Consequently, Steven Brown tried to stop Principle from collaborating with Reininger: "I remember Steven telling me that I shouldn't help Blaine doing *Broken Fingers*, says

Page 157

Tuxedomoon in Grenoble. Photo Saskia Lupini

11/22/81 TM plays in Clermont-Ferrant (France)

11/23/81 TM plays in Montpellier

11/24/81 TM plays in Toulouse

11/25/81 TM plays in Bordeaux

11/27/81 TM plays in Nantes

11/28/81 TM plays in Brest

12/81 TM (BLR, SB, PP, WT, BG) records at Little Big One Studio, Brussels, prod. Joeboy, the following tracks: 1. "Intro" 2. "Mata Hari" [aka "Mata Hari Boys"] 3. "Anna Christie" 4. "Grand Hotel" 5. "Ninotschka" 6. "Conquest" 7. "Queen Christina" [aka "Pretty Moderne"] 8. "Camille." These tracks will compose the LP *Divine*, soundtrack to the ballet of the same name choreographed by Maurice Béjart, released by Operation Twilight (a division of Les Disques Du Crépuscule) for Britain and Philips for Europe in 05/82. Track 5 will also compose the A-side of 12" *Ninotschka*, released by Les Disques Du Crépuscule, *Why Is She Bathing?*, 04/82. This album will be later re-released as a CD on Crammed (Cramboy). Some track lists also comprise two "Entracte" and a track named "Freudlose Gasse" (see http://www.berlinwerk.de/tuxedomoon/)

12/01/81 TM plays at Elysée-Montmartre in Paris

Peter Principle: "One time at the French border, the customs officers confiscated our equipment because the carnet was incorrectly ordered, the pages had not been correctly stapled to one another and so they decided to confiscate our stuff and then sell it back to us and so we were not allowed to bring it back

Principle. Because he's going to quit the group. So I guess that there was some feeling about that already. I remember that Blaine was constantly in need of money and there was not always an agreement about the kind of material that we wanted to do, I suppose." [38]

That Reininger's ego was then deeply frustrated can be sensed from an interview with Martine Jawerbaum, a friend and future manager of the band, made in the Spring of 1982 to be included in the *Broken Fingers* press package. "An absolutely narcissist work in some way: Blaine from beginning till the end! exclaims Reininger. And that is an experiment that spoils you, you know: I was the director and I decided of everything that happened. The idea goes back to when I was 16. Then Paul McCartney released his first solo album and I was very impressed with the idea that he had done everything himself (…) I think that the very best art must come from narcissism. Narcisse fell in love with his own reflection. It's not at all about that kind of narcissism that I want to talk. I refer to an internal exploration, a meditation about one's own internal landscape. I think that the ultimate narcissism is the path leading to the divine (…) I think that if one is perfectly narcissist, and not only in love with oneself, but if one explores his own self sufficiently in depth, one gets to a point where everyone can relate and one can communicate ideas that everyone has, emotions that everyone feels. That is ultimate narcissism. That's what I'm trying to do and all the songs from that recording are like

different fragments of my personality." [39]

The reviews for Reininger's *Broken Fingers* were diverse:
'If Blaine L. Reininger could resist the temptation to twist his tonsils into shapes made famous by a certain lad from Beckenham, he might be worth a rave or two.
Reininger is the violinist from those San Franciscan exiles in Europe – Tuxedo Moon – and unlike those collective mysteriosos has largely avoided the pit of pretension in this solo outing.
Resisting the temptation to go ape-shit with massed violins, Reininger has assembled a collection of deviously constructed songs.
Most stimulating of these ventures is the chilling "Uptown," a high-strung tale of urban paranoia that effectively mirrors the proletarian violence of Suicide's "Frankie Teardrop."
"Nur Al Hajj (Fake Arab From New Jersey)" finds Reininger following Czukay on the Oriental trail with a high degree of success while "Les Nuages" and "Petite Pièce Chinoise" are low-key outings for desolate violin. It's sad, then, that Reininger has to blow it by not only dragging "Heroes" out of the album cupboard and attempting to emulate, but actually having the nerve to cover "Sons Of The Silent Age" in his best Bowie-sans-Newley voice.' [40]

'(…) an absolute *must* from Les Disques Du Crépuscule (…) an essential album that will make a lot of people happy.' [41]

'The disc is filled up with depressive moods, melancholy and fatalism (…) This lack of structural depth lets it be presumed that *Broken Fingers* was a rapidly fabricated product.' [42]

And in Belgian newspaper, *Het Laatste Nieuws*, the reviewer deems the recording to be taking too many directions at once and of not really deepening any of these. [43]

It seems however that the recording process worked as a valve releasing some of the ungoing pressure for Blaine. When asked by Jawerbaum whether his disagreements with Tuxedomoon could lead to his departing from the group, his reply was peremptory: "No, never. Tuxedomoon is like a marriage for me."

Tuxedomoon records the Time To Lose 12". In March, Tuxedomoon traveled to London to play live at the Venue and record their next EP for Les Disques Du Crépuscule. Immediately upon their arrival, their van was burgled outside Berry Street studio with Reininger losing his violin and Tong his clothing. [44] Reininger then called John Foxx for help, which he provided while they were in the UK.
Robin Denselow's review of their concert at the Venue is

into Belgium nor were we allowed to move it into France. So that had to stay on that little piece of grass. They had downloaded the van and it was all stacked on the side of the highway and in the mean time we were supposed to be playing in the Elysée-Montmartre and hours were going by. We missed soundcheck and everything… Finally we had gotten our agent, Maria Rankov, on the phone and explained to her what was happening and she was going: "Oh God, here the audience is getting ready to tear the place apart…" And then some minister that she knew in the government, a friend of hers, he called those customs agents. They loaded our van and sent us on the way…"

Jean-Pierre Turmel: 'After problems at the customs, they were extremely late. The atmosphere was pretty tense and Steven was quite stressed out. I remember that we had a walk together while their equipment was being set up. I remember having felt a great affective demand from Steven, a demand of being taken care of psychologically. This feeling unfortunately altered all of our subsequent relations as I was then unable to respond to such demand.'

(Anonymous), "Smoking de Luxe", Libération, 12/01/81: announces the end of Tuxedomoon as the band would be forced to interrupt their activities so that Blaine Reininger could recover from his wounds. The columnist goes on: 'Is Tuxedomoon to be listed amongst these "magnificent losers," who accomplish manifold musical miracles without ever crossing the frontier between a handful of unquestioning supporters and a larger audience?'

12/02/81 TM plays at Studio 44 in Rouen (Sordide Sentimental night). Set list: 1. "Allemande Bleue" 2. "Courante Marocaine" 3. "Sarabande En Bas De L'Escalier" 4. "L'Etranger" 5. "Egypt" 6. "Jinx" 7. "Dark Companion" 8. "Family Man" 9. "Everything You Want" 10. "Volo Vivace" 11. "Litebulb Overkill" 12. "Again" 13. "Desire" 14. "In the Name of Talent" 15. "What Use?" Impression from the gig: "Completely injected with coagulated blood, Steven Brown's sax does not stop falling like a wounded albatros."

Flyer for Tuxedomoon's Nuit Sordide Sentimental in Rouen, Dec. 2nd, 1981

Excerpt from the flyer that Jean-Pierre Turmel wrote for that *nuit Sordide Sentimental* (translated from French):
'Tuxedomoon is not only a key group of the eighties, but also, on equal footing with Joy Division, Cure of Throbbing Gristle, a fundamental and timeless band, as its preoccupations and approach are universal.
Tuxedomoon was haunting the nocturnal streets of San Francisco, confusedly searching throughout Drifting in a city of the reign of Urbanism, some lost and ideal City.
(…)
Tuxedomoon, like many American groups, is inhabited by a nostalgia for Europe. Nostalgia for ancient cities, with their apparent disorder, with their streets as convoluted as our thoughts.
(…)
Tuxedomoon's wandering from cities to cities, from America to Europe, from modernity to nostalgia, is an initiatic journey for which their music testifies. An attempt to bring the extremes closer, Future and Past, Closed and Opened, Immobility and Movement, Circle and Square.
(…)
Even if one cannot properly label the music as descriptive, it is undeniable that their music present a rather obvious ambulatory character. Likewise we will find this state of meditative solitude about it, rhythmed by the walking inherent to nocturnal Drifting.
Searching for the darkness and for the night get superimposed with a vertical and inner exploration.
Cracks and graffiti, dirty and wounded walls are the echo of our inner plagues, of our hidden wounds.
Enigmatic façades evoking these mental stratums covering the secrets haunting us, out of reach.
Tuxedomoon also translates this leprous animal that is the Human being, sick of his conscience because it gives him/her but only one certitude: the feeling of his smallness, when his/her aspirations are for the totality and the absolute.'

Jean-Pierre Turmel: 'I remember of Blaine, or rather of his silhouette, calling Elephant Man

a good illustration of British's then prevailing disdain for Tuxedomoon even though it rightfully points at some cracks within the Tuxedomoon unit:
'(…) since recording of their intriguing *Desire* album, the band have moved to Europe and seem to have lost some of their musical direction on the way (…) At the Venue, the best passages were the instrumental outbursts, but these were constantly interrupted by less impressive vocal wailing and ranting by the trio, and by two other singers who joined them. One, dressed as a technician in a white coat, spent much of his time organizing the band's rather dubious visual effects. They played in semi-darkness beneath a piece of cloth suspended above the stage, on which flickered abstract film images. As well as organizing this, the technician figure wandered around shining torches at different members of the band, or throwing glitter into the lights.
The results varied from the almost impressive to the rather silly.'[45]

The recording of the *Time To Lose* EP (title track plus "Blind" and "Music # 2") took place at Garden Studio with Gareth Jones back on board, producing.
The three recorded tracks, released by Les Disques Du Crépuscule in August 1982, illustrate three different sides of the band, evoked by their European drift. As Anaïs Prosaïc noticed in her review for French magazine *Rock & Folk*: 'Cultivated Europe takes Tuxedomoon's "art" very seriously, as well as their meditative explorations of internal landscapes. This EP seems to summarize the present drive in their inspiration with three tracks marking their fascination for European sentiment.'[46]

Another triumphant tour in Italy. The second half of March 1982 saw another short but dazzling tour of Italy. The opening show at Trianon theater in Rome presented excerpts of *Divine* and the then in pre-production *Ghost Sonata*.
In Bologna, their gig had to be cancelled and moved to a bigger venue in Massalombarda. "This concert, remembers Roberto Nanni, was particularly interesting, strong and long. I remember of Steven in the dressing room with a young gothic Italian boy who was his boyfriend for a while (…) Steven appeared a few times dressed as a woman in concerts (Massalombarda, Milan, Rome at the Trianon…). He would appear naked as an *ombre chinoise* wearing high heels and then he would appear as a woman. Blaine was not enthusiast…"

Italian journalist and radio/TV *emcee* Red Ronnie then made another attempt to capture what made Tuxedomoon so special to Italians and… the other way around: 'The preference that Tuxedomoon seems to have for Italy is not to

be explained solely by the climatic affinities with their San Francisco but also has musical roots. Lots of classical Italian melodies have infiltrated their fascinating mix of sonorities (…) In fact it's impossible not to be captivated by the ethereal atmospheres that Tuxedomoon succeed in weaving delicately. The typically nocturnal melodies of the sax melt into the contemporaneous versatility of the synthesizer and the curves of the violin. Electronics that comes to carpet classical soarings.'[47]

In Milan, Tuxedomoon played at Teatro Cristallo. "I remember of that gig at Teatro Cristallo, says Nanni. It was really fantastic. They had an audience partially made of junkies or ex-junkies coming from the suburbs. The audience in Milan at that time was darker, more toxic, more junky, more sex driven and more gothic than in Rome. To give you an idea, Lydia Lunch was then selling lots of records in Milan, not in Rome. Tuxedomoon loved Milan and Milan loved them. According to Steven, the gay scene was very hot in Milan and Bologna, not so much in Rome. In Milan there was fashion and hence to mind. He walked with difficulty, using a cane (…) So my minimal collage for the concert in Rouen took a new meaning (damaged hands on a flaking wall). My surprise was total. I don't remember much of the concerts (in Paris and in Rouen) apart from general impressions: of bewitchment mainly. I remember that I preferred the concert in Paris as the tension was extreme, or maybe was it my psychological state on that day?'

12/03/81 TM plays in Reims (France)

12/05/81 TM plays in Nancy

12/11/81 TM plays at the Plan K, Brussels

12/15/81 TM plays at the Palais des Beaux-Arts, Brussels

Some time in 1981 PP guests on the "At Home" and "Not At Home" pieces for Soft Verdict/Wim Mertens 12" published by Les Disques Du Crépuscule in 03/82. Re-released as a CD under the name of Wim Mertens in 1988. "At Home" also on (Various Artists) Crépuscule Collection 2: State Of Excitement compilation album released in 1986

Tuxedomoon (BG, WT, PP, SB and BLR) photographed by Roberto Nanni, 1982

Peter Principle, Saskia Lupini and Nina Shaw waiting for a train, somewhere in Italy. Photo Gilles Martin

US tour including:

12/24/81 TM plays in Los Angeles

12/27/81 TM plays in Denver

12/31/81 New Year's eve party at On Broadway Theater, San Francisco (continues in 1982)

1982

(continuation of the US tour)

01/04/82 TM plays in Vancouver

01/05/82 TM had to play in Seattle but played later because of an incident at the border

Peter Principle: "Once when we had been flying from Vancouver to Seattle, an American customs agent took our equipment off the plane. And when I went out in the middle of the night to take care of it with the promoter, the woman who represented the US customs got me in a little trap. She asked me who had bought my guitars and I said: "Oh, I owned them before I joined the band with them." Then she said: "How comes it says it's the band's property on your ATM carnet? You have lied on a federal document under oath!" So then they confiscated our equipment because we had defrauded the American government in some way. But then I had bought these guitars in America and I had paid the taxes there but the carnet was Belgian. But we had had to fake that the equipment was Belgian in order to get that carnet and in order to move around but because Tuxedomoon was legally organized as a unit, we were allowed to do that, there wasn't anything illegal in what we had done but the Americans didn't see it like that and so they took our stuff away and we missed the concert and etc etc. I almost got arrested on the spot

a strong gay influence. Milan was more Calvinist, more protestant whereas Rome was more catholic in the sense of more under the Church's control. Also they were often in Bologna because Italian Records was based there."

Tuxedomoon records the double 12" Suite En Sous-sol for Italian Records. In April, Tuxedomoon recorded *Suite En Sous-sol*, the name given to the "basement suite" that was created at their Utopia(n) resort, at Little Big One Studio in Brussels.

This recording was commissioned by an independent label based in Bologna, Italian Records, with Slugfinger Lipton *aka* guitarist Philip "Snakefinger" Lithman, guesting. Two Moroccan musicians, namely Miri Mohamed and Khessassi Mohamed, were recruited to give a distinctly unique Arabic flavor to already previously recorded tracks: "Courante Marocaine" (*aka* "Nur Al Hajj") and "L'Etranger" (*aka* the from Albert Camus's inspired "The Stranger").

Blaine Reininger: "I always felt kind of attracted to Arabic music. In San Francisco, I was a Sufi. Then we played at this party for *Actuel* in Paris [*in October 1980*] and they had these Master Musicians of Jajouka. They must have been at least 20 people on stage playing this music. That was amazing. They had an amazing effect on the public. The idea was that we would play, then these Jajouka guys would play and then we would come back. We said: "No way, we're going on stage after these guys!" Because they were so overwhelming. That

was such an amazing music and the energy was so high. The whole audience was dancing all night. And this made a lasting impression on me. And also that song, "The Stranger," part of the subtext of that song was supposed to be Arabic. So I just had this idea. We should find some Arab guys and put them in this song. But I didn't know where to go and how to approach some guys. So I called the Moroccan embassy and they transferred me to the cultural *attaché*. I said: "I'm a big record producer," which I was I suppose since I had a certain amount of money, and I said: "I need some musicians." So the guy said: "Oh, just come with me." We made a *rendez-vous* and we met at this Moroccan restaurant over in Sablon (Brussels). There was a band playing there and these guys were very good and the cultural *attaché* introduced me to the band. Then I called them. This guy wanted a piece of the money as he had been the middleman. So I asked the band: "Do you know this guy, has he ever done anything for you?" and they were like: "Pfff." So we dumped this guy right away. We made an arrangement to meet in the studio and that was very successful I think. These guys were very good musicians and they were inspired. In the studio I didn't speak enough French to be worth anything. So we communicated in German for one of these guys spoke a little bit of German and no English. It worked out really well. I didn't know exactly what they were going to do but the song was Arabic to the extent that they didn't have much trouble playing along with it and that was a good thing, I was pleased with it. That was very satisfying. We also paid them well as we paid about 5,000 francs [*i.e. about 125 euros*] to each of them for the session. That was more than they were making in the restaurant in a week, so they were happy."

The concept for this double EP corresponds with 17th century composer Johann Jacob Froberger's idea of a *Suite* as consisting of an *allemande* (represented by the piece "Allemande Bleue"), a *courante* ("Courante Marocaine"), a *sarabande* ("Sarabande En Bas De L'Escalier") and a *gigue* ("L'Etranger (Gigue Existentielle)"). A piece of another form like a *polonaise* ("Polonaise Mécanique") is permitted before the *gigue*. [48] For certain, this concept EP owed a lot to "old" Europe in its spirit and seemed a proper soundtrack for the band's little pranks at their Plan K playground, as is attested in a TF1 (French television) documentary. The film shows the band evolving on the roof and in the bowels of the Plan K derelict factory and recording *Suite En Sous-Sol*. From the footage it was obvious that Blaine Reininger was enjoying himself, reciting verses about some mysterious drugs or being served some pills with spectacular effects by a robotized waiter Steven Brown at a deserted *café* with his wife JJ La Rue lounging at the bar.

for my "lie," but the local promoter who I guess was fairly well connected got a superior agent to come to our aid. And things calmed down. The local concert promoter brought a case against the airline for loading our equipment off because we had actually passed the carnet in Vancouver but then the plane stopped on a little island before it came to America and it was at that stop that we would have had to stamp the carnet. In the meantime the airline had to pay us the full fee for that concert and yet we were able to do that concert two days later, so we got paid twice (but one part of that money took six months to arrive). The customs officers in America can potentially be more absurd than in Europe because America is a very hard border for people to cross. It's easier to cross in Europe on many levels. Unless you have a college degree in computer engineering or are a triple millionaire then you're welcome in America, everybody else should stay away, that's the idea…"

01/05/82 WT/BG in *Frankie & Johnnie: A True Story* at La MaMa Theater, New York city

01/07/82 TM plays in Chicago

01/08/82 TM plays in Boston

01/09/82 TM plays at Chase Park, New York city (with Bunnydrums opening)

Soho News, 01/09/82 : **TUXEDOMOON, BUNNYDRUMS** Dancetaria's opening has been delayed but Chase Park reopened briefly for T-moon, Frisco's brilliant post-wave sound painters, and B-drums (…)
great evening at Chase Park (599 Broadway), which is closed, but is opening just for this gig – Bunny Drums (the best band in Philly, sounding vaguely Echo and the Bunnymen-ish), and Tuxedo Moon, who now live in Belgium, in the US only four performances (the one New Year's Eve in San Francisco was extraordinary).'

Dave Goerk (from Bunnydrums) : 'We were the only bands on the bill… Jim Fouratt was the promoter (Hurrah's, Peppermint Lounge, etc.) and it was held at… if my memory serves me well at a Chase bank which was under construction. It was billed as "Chase Lounge" and I think it might have been either on Park and 54th or the Chase HQ on Park and 52nd? These were pirate shows, the venues were temporary. Huge stage and it held about 1200 people or so.'

Tuxedomoon torn between Europe and America. Peter Principle: "Another thing about European audiences that's interesting is, whereas American audiences are often largely young kids, there's old ladies, babies and married couples. They're all in the audience having a good time (…) they probably take us less seriously and that's why they enjoy it more" (L. G. CAMPLING, "Tuxedomoon : the brighter side", 01/01/82, unpublished); 'Bruce: "America's always been for entertainment and "easy" forms of art. I wouldn't say we're the Bee Gees. We *do* have our public in America. But audiences are more receptive here." Winston sums up: "There seems to be more respect for the so-called avant-garde in Europe"' (P. ZANGER, "The Neo-Dada performers", *The Bulletin*, 03/12/82); Steven Brown: "Maybe America is more modern… but it's here that one can live as an artist. In America artists are considered like drug-dealers, like shit! (…) There are a lot of bands in America that make avant-garde music. Think of The Residents, DNA, Tuxedo… but it's impossible to listen to that kind of music over

Page 163

there: no radios, no publicity, no money for avant-garde music" (G. De Marinis & F. Tomasetta, "Ghost sonata. Intervista ai Tuxedomoon", *Quindi*, 1982, translated from Italian); Steven Brown: "If we had stayed in America, we would not exist anymore today. What we do is far more based on European traditions than American ones" (C. Evers, "Tuxedomoon in : Rambo III", *Oor*, 09/21/85, translated from Dutch); Steven Brown: "One of the unusual things that we do with Tuxedomoon is that we travel all the time and nonetheless find ourselves at home everywhere. We like to travel, foreign countries. It's not exaggerated for me to say that America has become like a foreign country for us, as it's been so long that we haven't been there" (Grossey, "Steven Brown (Tuxedomoon) : de luisteraar is nooit verkeerd", *Kuifje*, 01/28/86, translated from Dutch); Steven Brown: "Europe (...) is not really new for me any longer. Although I'm never *home*. In America, I'm the stranger (...) I went tot the USA two months ago. We went on tour there with Tuxedo. I was scared by what I saw: all these big cities are the same. They are totally empty, new, dead, sad..." (Interview of Steven Brown, 06-07/87, origin unknown); Blaine Reininger: "Money is the main reason I can't return to the USA. That is to say, I have responsibilities here in Europe. I couldn't go back to live there, you know. I would only return to the USA if the USA became a socialist country, with free medical care, equality and egalitarianism for all its citizens. This will never happen in the USA. If there was someone who could change the country and turn it into a place of justice for people to live in, then the CIA would assassinate him. The USA is a fascist country, run by money. It is not possible for me to live there. I prefer Europe because it is so beautiful (...) I like to live in places where I don't understand the language people are speaking around me. When I am sitting in a crowd and don't understand a word they are saying, it is a sheer blessing. If I decide to shut out the sounds in a public place, it comes so easily, you know. In the USA I understand every word - it is so ridiculous! There is a certain loneliness in Europe. I am sitting somewhere, not noticing what people are saying, I am feeling happy and enjoying the sun" (I. Rallidi, "I'm a citizen in the demonic empire. Interview with Blaine Reininger", *Sholiastis*, 1988, translated from Greek by George Loukakis); Blaine Reininger: "I don't feel like an American nor like a European, even though I feel closer to Europe. America is so foreign to me... What I know is that America is fascist and I don't want to have anything to do with it. I've always wanted to go somewhere else. Now, I don't think there is a place I want to go to... Whoever I'm interested in is European (...) Only Burroughs is American (...)" (N. Triandafyllidis & A. Papadopoulos, "Wanted : the muses", *Sound & HiFi*, 02/88, translated from Greek by George Loukakis); Blaine Reininger: "I'm a sort of perpetual exile. Europe has taken over my soul. But I don't really belong here. I'm not really a European and I'm not really an American and it's increasingly more so. I'm a man without a country" (*Tuxedomoon – No Tears*, Greek TV documentary directed by Nicholas Triandafyllidis, Astra Show Vision & Sound, 1998); Peter Principle: In Europe, "the state is trying to find ways not to waste people, whereas here [*in the USA*] people are considered the least valuable commodity of all (...)" (N. Martinson, "Peter Principle", *Proof*, # 1, 1999).

Some time in 1982 release of a cover of "No Tears" (flexi 33 rpm) by Pretty poison. The Bob magazine, Svengali records.

In May, the *Divine* soundtrack was released by Philips. Peter Principle would have preferred Deutsche Grammophon ("That would have been a real *coup d'Etat* for me. That would have been a real joke. I can't read a note of music" [49]) but that could not be achieved. *Divine*'s release was surrounded with a certain amount of misunderstanding as many thought that this album was *Desire*'s follow-up album. Hence this recording was considered "difficult" as Richard Cook's thoughtful review suggests:

'(…) this must be an apotheosis of camp. Even more so as the seven excerpts are each named after one of Garbo's 30s pictures for Metro, when the breathtaking sensuality of her silent films was displaced by a distant, untouchable beauty.

Divine, though, is by Tuxedomoon, not a group to idle in the realms of rapture. The music they create (…) is virtually bereft of heartstrings plaintiveness. Glassy banks of keyboards ration prettiness in "Camille" and "Queen Christina" as if each were entrapped in a climate of famine, the gauche eradicated by a refusal to admit emotional garlands.

Tuxedomoon's contradictory make-up – an American fascination with European sentiment, strengthened by a penetration to the very quick of melancholy; the clash between sounds inside the group, organic of electricity, explodes the purity of their sour, difficult playing. This is chamber music of Bartokian intensity but it's also painfully littered with abstraction (…) They simultaneously enshrine Garbo as an icon and twist her horribly out of shape, like a memory disfigured by age. Her soundtrack voice intrudes in places: at the beginning of "Conquest," she imperiously rasps "What do I care for your orders, they can't frighten me" and it echoes over and over, finally walled up behind a black fog of noise. Then she speaks again, and Blaine Reininger adjusts his violins to spiral through a trance of kind remembrance, the one moment of untainted beauty on the record;

On "Grand-Hotel," the voice babbles as if through a vocoder: she is as distant from the music 'Moon have drawn round her as she was from her idolatrous moviegoers. In this unlovely and committed recital, they hold this expressionless madonna in a frozen esteem that rings acutely true.' [50]

Patrick Roques' arrival in Europe. Still in May 1982, Tuxedomoon performed a few dates, including one in Lausanne, Switzerland, on the 20th.

Shortly before that gig, Patrick Roques was called upon by Steven Brown and Katy Kolosy to reinforce Tuxedomoon's ranks. He came thinking it'd be for a month and ended up staying for about a year. His role fluctuated from the giving a hand to the tour manager while of course remaining the band's "official designer." Roques retains picturesque memories

Page 164

from his time with Tuxedomoon in Europe. Here are some of his recollections.

'S. F./New York/London/Lausanne/Roques

After selling almost everything I owned in San Francisco [tossing the rest of the last 7 years of my life in the trash cans behind my apartment building] and with the help of five hundred dollars Steven had found, "floating in thin air," I perched a one-way ticket out and boarded a plane for Brussels via New York and London.

After a month holed up across the street from old uncle Bill's bunker on the Bowery sampling the delicacies of Rivington Street. Sleepin' in 'till sundown, stayin' in the shadows at sunrise. Pac Man at Brownie Points. Living on "Green Tape for Lovers," "Doctor Nova," matza's and prosciutto bread. In the end it seemed that my host couldn't beat the devil. He was stabbed and then hit by a car. He was known for being light in the loafers but he couldn't run fast enough. It was time to leave.

Arriving in London on a wing and a prayer with a stolen checkered cardboard suitcase filled with a few wrinkled suits. About a hundred bucks to my name. There I was, standing on the banks of Thames near Putney Bridge, watching the garbage float by. It was as if the whole British empire was being washed out to sea bit by bit. "Look there goes some footballs and a plastic chair!" I heard a young boy say to his mother. She turned her head away.

A few weeks later I found myself wavering on the sidewalks of Brussels – on what turned out to be an unseasonably hot and very bright day – I was for all intent and purpose broke. The only thing I managed to bring with me from England was a very bad hangover. As I stood there, sweating [I had put on all the extra clothing that somehow wouldn't fit back in my luggage], I realized that I was lost. I watched a small dog shit on the pavement. Steven was supposed to meet me at the station. He never showed, didn't answer the phone. I felt homesick, but for what or where? "Why the fuck I'm in here?" I muttered. Then I accidentally stepped in the doggies stinky little pile. The village idiot had arrived. Oh, hooray!

When Steven did appear a few days later he nonchalantly informed me that he was going to Lausanne, Switzerland, for a Tuxedomoon show. Did I want to go? After seven miserable rainy days in Brussels, living on red wine, chocolate croissants and cigarettes I saw the prospect of spending a few warm sunny Spring days lounging about lake Lausanne as an extraordinary event, a manifestation of divine intervention and my official welcome to the continent. I could feel the warm rays of the sun shining on my smiling Sunny Jim face.

The next evening bags packed, spirits lifted an effervescent Blaine appears along with the rumpled Mr. Brown, wearing

Some time in 1982 WT, NS and Roberto Nanni work on *Opium*, a WT piece to be presented in Milan

Roberto Nanni: "The first time I collaborated with them was for *Opium*, in Milan, 1982. It took place when Winston, Nina and Bruce came to Bologna for [*a workshop on detective novels for which Nina had selected*] Alain Robbe-Grillet (*La Jalousie*). I went to see them and Winston then asked me – Bruce was busy doing something else – to make slides for a piece he was then working on, *Opium*. It was the story of Winston's family in China. Winston's grandfather was a rich man, a business man but also an opium addict who spent all of his money buying opium. His family fell into poverty because of this addiction and his mother decided to emigrate to the United States…

Nina did the lights and I did the slides and super-8 projections. The show was very nice. We performed it three times, I think, in Milan. The audience was very receptive to *Opium*. Winston played all the characters: the grand-father, the mother, himself. He had this schizophrenic point of view that he had in *Frankie & Johnnie*. I put some ancient photos into the show, some coming from my own family. Velia Papa was there also: she first hired Winston and Bruce to play at her Polverigi festival before she invited TM to the same festival (…) They lived in an old convent. It was the beginning of Milan as a fashion capitol, Milan the strange, the bizarre, the city of Bettino Craxi, of a strange socialism, full of shops, clothes etc. Nina was a "dark Lady," with her long black gowns, very elegant and Winston as well (…)

I remember, while we were doing *Opium*, of a late night venture with Winston going to score some drugs (I was then 22). We took a taxi, Winston told the driver the name of a discotheque the name of which I prefer not to mention here. We call the public relation guy who had the *rendez-vous* with the dealer. We undertook the journey in Milan at night by the suburbs' peripheral road. Winston talks to him in English very fast about what he intends to do in great detail. At a certain moment it was like a flash, the taxi driver let the wig he was wearing slide down to show an enormous patch of metal and addressed Winston sharply: "Hey boy, I'm from San Francisco too, I was wounded on my head during the second world war, so you're a nasty boy, you're going to buy some drugs…." I was really shocked, and Winston too… Fuck… Then Winston started a long conversation with the driver. The cab arrived at destination. Winston went out to go get what he had to and came back, thanks God.."

P. Zanger, "The Neo-Dada performers", *The Bulletin*, 03/12/82: 'It was afternoon at the Falstaff, the Art Nouveau café near the Bourse. The crowd was sedate and elderly (…) Through the dark wood doors strolled two young men. They glided in, one with hands jammed into the pockets of a stylish woolen jacket almost as black as his thick, bluntly chopped hair. The other, his reddish crew cut grown out a good three inches, wore a crumpled grey raincoat. A pocket bulged with a mini cassette-player, the wire snaking up his neck to tiny headphone. Both looked as though they'd just woken up. It was 2:30 p.m.' Further in the piece, when asked about the connection between TM and WT/BG: "We," Bruce says, nodding toward Winston, "collaborate with them, but they don't collaborate with us."

Some time in 1982 release of the *Best Of Ralph* compilation album (Ralph Records, 1982) with tracks "What use ? (remix)", "Jinx," "Incubus," "James Whale" & "Tritone"

Patrick Roques photographed by Gilles Martin

Some time in 1982 release of the *Sulla spiaggia, ogni ragazzo, ogni ragazza* compilation album with "Ninotchka," Base records (Italy), 1982

Some time in 1982 SB participates in Brussels in the *Waving Ondulata* project with Guy Marc Hinant and Frédéric Walter, recording of "Mozart's Love Letter" that is released on the (Various Artists) *Coal Heart Forever* compilation LP, Sub Rosa 1988

Some time in 1982 PP produces Marine (*Rive Gauche*, Les Disques du Crépuscule/Radical Records, 1982) and Isolation Ward (7" *Lamina Christus*, Les Disques du Crépuscule/Radical Records, 1982)

01/29/82 TM plays at Papaye Tropicale, Brussels

First half of February various TM members (WT/BG, BLR, SB) participate in a Crépuscule package tour *Dialogue North-South* with Isolation Ward, Marine, Names, Winston Tong (with Bruce Geduldig), Antena, Durutti Column, Richard Jobson and Paul Haig on the following dates: 02/03/82, Beursschouwburg, Brussels (TM played this opening show with pieces from *Desire*, *Suite En Sous-Sol* and a rough version of the *Ghost Sonata*); 02/04/82, Melkweg, Amsterdam; 02/05/82: Doornroosje, Nijmegen; 02/06/82, Montévidéo, Antwerpen and Galerie Bilinelli, Brussels; 02/07/82, Bloomdido, Brussels; 02/08/82, Der Hallen, Leuven; 02/09/82, Bains-Douches, Paris; 02/10/82, Bains-Douches, Paris; 02/11/82, Lyon, ENIPE (BLR & SB 'performed an astounding improvisation on equipment loaned by the Names': James Nice, *Tuxedomoon*, unpublished manuscript, 03/21/92, p. 22); 02/12/82, Bains-Douches, Paris; 02/13/82, Bordeaux, Alhambra; 02/14/82, Amphithéâtre Descartes, Poitiers; 02/16/82, The Venue, London. SB and BLR guest on Richard Jobson + Cécile Bruynoghe's pieces: 1. "Pavillion pole" 2. "India Song (1)" 3. "India Song (2)" published on the live

his actor's frown. We head for the train station, Gare Du Midi, utilitarian joy. We are leaving late night. Blaine carrying his violin and a small shoulder bag. Steven has a small war torn black canvas bag, a clarinet. I have a cardboard suitcase and a hounds tooth suit. Steve gives me the once over, an amused evil eye. I'm the greenhorn with moths in his pockets, traveling on the midnight train waiting for the other shoe to drop. "The way to do it is like this..." Blaine illuminates. "We'll get on board, buy our tickets, get our sleeping car, settle in and then order a large beer, that should help get us to sleep."

"Tomorrow we'll have a coffee and get off at the Lausanne station." Steven is silent, filming the next episode in his head. Blaine orders three beers and goes to sleep. Steven soon follows. I lay awake in the musty sleeping car staring at the ceiling wondering how green the hills of France really are. This is my first trip to Europe and it's pitch black outside. Trains sound like trains everywhere. Tomorrow I'll wake up in Switzerland. The truth is, I'm amazed.

The sunny, Spring morning finds us all standing in a flowering garden. Rooms rented in a 17th century chalet. Bird song, dappled, scented sunlight, soft-focus-fresh coffee, home made jams... [Mozart for some, John Barry for others].

"Monsieur Chapeau! Monsieur Chapeau!" Our hostess came tottering out into the courtyard beaming, smiling, rubbing her hands upon her apron. "Monsieur Chapeau! Monsieur Chapeau!" her voice high and shrill. We smile. We stare. We looked around. "Monsieur Chapeau!" she grabs a hold of Blaine. "Bonjour monsieur Chapeau!" "Well, yes, yes, of course,

'Monsieur Chapeau'... pleasure to meet you," replies Blaine bewildered, tipping his fedora politely. We all had the feeling that she had been expecting him. The French resistance perhaps? Apparently "Monsieur Chapeau" had come back. She whisked him off to the breakfast table leaving us ragamuffins shuffling behind. She offered him fresh baked breads, delectable fruits, *pain au chocolat*, cakes, ice creams, *café crème* and *le café*. "Le café!?" she finally screamed. "I shall have one very large, cold beer, if you please madame" was Monsieur Chapeau's saturnine reply. He lifted one crooked finger slightly like a drunken barrister ordering a night cap at his Club. "Mister Chapeau!" madame scolded. "Petit déjeuner! Petit déjeuner!" but then again, if he insisted... "I insist." Well he was after all the renowned and redoubtable "Monsieur Chapeau."

It was a beautiful day in what I was once told was the cleanest, most well scrubbed country in all western civilization. Somehow that made me want to spit on the streets.

Look! There goes "Monsieur Chapeau" wandering off to find solstice by the shore of great blue lake Lausanne.

Swanning the Ouchy.
Nearby at the Hotel d'Angleterre (Lord Byron slept here. So the story goes). Winston and Bruce hanging out at the compilation album recorded on this Crépuscule tour: *Some of the interesting things you'll see on a long distance flight*, released in 1982. An excerpt of the third piece also appear on Hommage à Duras, Inter LP, 02/88 and Interphon CD 05/88

02/82 SB and BLR guest on Richard Jobson's "Orphée", published on (Various Artists) *From Brussels With Love*, Les Disques Du Crépuscule, 1983 and on Richard Jobson, *The Right Man*, double LP, Les Disques du Crépuscule, 1985

02/18/82 TM plays in Bordeaux (perform "Pretty Moderne" *aka* "Queen Christina" from the *Divine* soundtrack)

02/82 BLR records his first solo album, *Broken Fingers*, at Little Big One Studio, Brussels with SB/PP/JJ guesting and BLR/PP/GM producing: 1. "Broken Fingers" 2. "Nur Al Hajj" 3. "Magic Time" 4. "Petite Pièce Chinoise" 5. "Right Mind" 6. "Gigolo Grasiento" 7. "Spiny Doughboys" 8. "Sons Of The Silent Age" 9. "Uptown" 10. "Les Nuages," released by Les Disques Du Crépuscule, Spring 1982 and 1985 (different cover) and as a Normal/Crépuscule CD in March '88 (with additional tracks). Tracks 1 and 5 were also released as a 7" (Les Disques Du Crépuscule/Radical Records, 1982) and tracks 4 and 10 appear on the *Instrumentals* album (mini LP) published by Inter in 1987. This album was re-released as a CD (with following bonus tracks: "Magnetic Life," "Playin' Your Game," "Birthday Song" (Tuxedomoon demo 1983), "Nur Al Hajj" (Tuxedomoon live 1988), "Broken Fingers" (Tuxedomoon live 1982)) by LTM Records in 2003

Patrick Roques photographed by Katy Kolosy

Brussels, gare du midi (South train station) in the eighties. Photo Gilles Martin

Reininger about Peter Principle's work: "Peter is a real tapes manipulator, he loves doing this kind of things. We use a lot of these techniques that haven't been used anymore really since the psychedelic era." ("Entretien avec Martine Jawerbaum", Spring '82, unpublished)

The track "Gigolo Grasiento" is an oblique "homage" to UK journalist John Gill who, in his review of *Desire* for *Sounds* magazine (see Chapter IV), pointed to BLR's "greasy gigolo violins." Hence this track and also the fact that Reininger wore a moustache for about 20 years. Funnily enough John Gill was actually a TM fan and still remains to this date

Reininger: ""Petite Pièce Chinoise" is a classical tune that I wrote in school (…) and "Les Nuages" is exactly the same tune but played backwards. I chose the title, "Les Nuages," after the title of one of Debussy's *Nocturnes* because that was the favorite music of my teenage years (…) Debussy is my favorite composer, with Bach and Vivaldi."

sidewalk *café*. White plastic sunshine Cinzano umbrella maypole. Friendly waiters. Home away from home. Two lovely locales had attached themselves to Frankie and Johnnie. Slinky androgynous girl-boy's. Suntanned new romantic euro-trash. A taste of things to come. Black sleeveless t-shirted ectomorphs soaking up ultra violets and la vita D. The maid said she'd meet me in my room at two. When I arrived was surprised to find her waiting there for me.

"Not enough silver and gold for a blood transfusion," Blaine mutters. Steven and I opted for a springtime stroll around the harbor of Ouchy. Sky blue peddle boats and three young men in molting suits. Steven in vampish repose, hand back, skimming the surface. Blaine, the reluctant man servant melting under the sun. Brow brim wet, peddling for his life. Swans glide by. Snobs. Each and everyone of them. They ignore us. In the distance out of the stillness we hear the rumble of a speeding motor boat. As we squint across the ripples of lake sparkles we see Bruce fly past in a flash on water skis waving.'

The Ghost Sonata. In the Spring Tuxedomoon had started pre-production work on a very ambitious project commissioned by Inteatro, [51] a yearly theater festival taking place in Polverigi, Italy. Velia Papa, who at the time acted as Tuxedomoon's agent in Italy, directed the festival and it was through her initial theater connection with Winston Tong that the project was conceived.

Page 168

Steven Brown: "We were being commissioned to do an opera. Winston was the prime motivator because he comes from the theater world. So he was kind of a director really of the whole thing. It was his idea to base it on Strindberg's *Ghost Sonata*. An opera without words, I liked that!"

Bruce Geduldig: "It started with a contact that Winston and I had with Velia Papa, an Italian agent who was liaisoning with Maria Rankov. She worked quite a lot with Maria and Winston and I and we had already toured in Italy quite extensively as she kind of followed Maria promoting Tuxedomoon. So an idea sprang up, specifically due to the Italian connection, probably from a conversation or a brainstorming. She was running a festival in Polverigi. The idea was of making a performance by Tuxedomoon that would incorporate all the elements of Tuxedomoon, that is theatrical, cinematic and musical elements and *première* it there.

As we all had roots in Italy from the very beginning, that form of a collaboration was an ideal of ours from the start and certainly when you travel clubs, it's not something that is workable. Multimedia rock operas already had a bad name. There had been several magnificent flops that everybody was well aware of. Certainly we knew that we were going into dangerous territory. We had even been criticized by the British press especially for having somebody like me on stage. They were only interested in music and having some other dimension to them was just: "What's this?" The Italians were just the opposite, they just flipped for that aspect of Tuxedomoon. I was probably much more appreciated in Italy than in any other country. The fact that Winston and I were there as a presence on stage for the Italians was perfect, corresponded to their personal idea of what should be. With that kind of success that we knew that Tuxedomoon had and being aware that we had a ready and willing public for it, we all went into it with a very optimistic and open attitude.

The inception of the project was Winston deciding on the title, that was a Strindberg play. We read the play and decided we didn't have anything to do with it, so we just kept the title."

Winston Tong: "The premise of *The Ghost Sonata* was I wanted everyone to imagine how it would be at the moment of their death. It was pretty interesting. It was therapeutic too because it made Blaine go to AA because his death was like drinking himself to death. I remember that JJ [*La Rue, Reininger's wife*] and I got a phone call in Italy where we were stranded from Blaine and saying that he just joined the AA."

Geduldig: "Right after finding the title came on its foot heels the idea that there would be a story of each person's suicide. So one thing led to another immediately along with the

03/02/82 TM plays in Brussels

03/09/82 TM plays at the Venue, London (support act: Sex-Sex-Sex)

John Gill announcing the gig at the Venue for *Time Out* (03/82): 'Shortly after the late Ronald Reagan charmed his way in the backdoor of the White House, Tuxedomoon (Venue, Tues) fled America – for good, they said. Europe can only benefit. Pals of the glorious Residents, Tuxmoon are one of Nino Rota's wet dreams; conservatory sensibilities gone amok in a library of styles. Their debut *Half-Mute* (Ralph) mixed contemporary jazz, chamber, electronics, Zappa, Residents, schmaltz and noirish soundtracks in a manner both inspired and arch. The follow-up *Desire* (Pre/Ralph) may have spent too much time with its tongue in its cheek, but it still measured Tuxmoon leagues ahead of the rest (…)'

03/82 TM (BLR, SB, PP, WT) records the *Time To Lose* 12" at the Garden Studio, London, with TM/Gareth Jones producing: 1. "Time To Lose" 2. "Music # 2" 3. "Blind," released by Les Disques Du Crépuscule, 08/82 and later in *Suite En Sous-sol* as Crammed (Cramboy) LP, 10/86, finally as a *Suite En Sous-sol/Time To Lose/Short Stories* CD released by Crammed (Cramboy), 09/88

03/16-20/82 WT/BG in *Frankie & Johnnie* at Trianon, Rome as part of a short tour in Italy

03/21/82 TM plays at Trianon, Rome. This concert's set list contained excerpts of *Divine* and *The Ghost Sonata* (SB dancing a sensual waltz with BG on stage) and was concluded by an encore entitled "Life After Life." Bitter and dark tonalities. It surprised the audience but was very well received (see G. Curi, "Invasione no-stop dei lunari", *Il Manifesto*, 03/23/82; M. Malabruzzi, "Riflessi sul muro di elettronica Luna", *LC*, 03/23/82)

03/23/82 TM plays at Teatro dell'Ateneo, Urbino (Italy)

03/24/82 TM's planned gig at Teatro Medica, Bologna, had to be cancelled, the venue being too small to contain the audience, and moved to Cine-Teatro, Massalombarda

03/25/82 TM plays at Tenax, Florence

03/27/82 TM plays at Teatro Cristallo, Milan E. Gentile ("Il rock dei Tuxedomoon", *La Repubblica*, 03/26/82) announcing the gig at Cristallo: '(...) Tuxedomoon, a California quintette that maybe better than any other group represent the new rock without frontiers: tough and hallucinated sonorities, creating biting and corrosive atmospheres, a disturbing and dark new wave…'

03/28/82 TM plays at Teatro Cristallo, Milan M.L.F. ("Finiti i concerti a Milano. Il rock dei 'Tuxedomoon' con fantasmi e ombre cinesi", *Corriere della Sera*, 03/29/82): 'Tuxedomoon's show (...) is not a sturdy rock cavalcade but an attempt to give life to an interdisciplinary form of expression in which music, theater, cinema, sculpture and graphic design flow together (…) The impression is that the music taken secludedly does not propose anything that hasn't been heard yet in experimental music (…) but has to be appreciated above all relatively to a visual message (…)'

03/29/82 TM plays at Teatro Nuovo, Torino (Italy) F. Ma. ("La musica "accetante" dei Tuxedomoon", *L'Unità*, 03/30/82): The group

filled up all the venues visited during that Italian tour

M. Reina ("Tuxedomoon", *Rockerilla*, 05/82): '[*Steven Brown*] "We start as soon as the lights are off" (...). To live and blossom fully, Tuxedomoon's music needs obscurity (...) that doesn't mean distress but rather mystery, it doesn't mean claustrophobia but sadness loaded with memories.'

03/31 till 04/04/82 WT/BG in *Frankie & Johnnie: A True Story* at Teatro dell'Elfo, Milan

Spring '82 Start of the pre-production work for the *Ghost Sonata*, to be performed at the Festival *In Teatro '82*, Polverigi, at the invitation of Velia Papa.

04/11/82 TM plays at maison de la culture, Bourges (*Printemps de Bourges* festival)

04/30/82 TM plays at Limelight, Kortrijk (Belgium)

05/82 release of the *Divine* soundtrack

Some time in 05/82 WT/BG at a theater festival in Sao Polo

05/01/82 TM plays at Paradise, Binche (Belgium)

Spring/summer 1982 TM (BLR, SB, PP, WT + Miri Mohamed, Khessassi Mohamed and Slugfinger Lipton *aka* Philip Lithman/ Snakefinger) records in Brussels, with TM+GM producing, the following tracks: 1. "Prélude" 2. "Allemande Bleue" 3. "Courante Marocaine" 4. "Sarabande En Bas De L'Escalier" 5. "Polonaise Mécanique" 6. "L'Etranger (Gigue Existentielle)" 7. "Shelved Dreams." Tracks 1 to 6 will constitute the double 12" *Suite En Sous-sol*, released by Italian Records, 07/28/82 and later as *Suite En Sous-sol/Time To Lose* by Crammed (Cramboy) LP, 10/86, finally as a *Suite En Sous-sol/Time To Lose/Short Stories* CD released by Crammed (Cramboy), 09/88. Track 7 will be made available on a cassette published with *Touch* magazine in the UK (1982), then will appear on LTM's LP *Les Heures Sans Soleil* (1985), then on *Minutes To Go!* (Interior LP, late 1987 and Interphon, 05/88) and, finally, on LTM compilation CD *The Night Watch* (2001). Some footage of TM recording *Suite En Sous-sol* can be seen in Steven Brown's film entitled *The Super-Eight Years With Tuxedomoon* and in a 1982 TF1 (French television) documentary entitled "Rock belge: Tuxedomoon" (dir. J.-N. Delamarre for *Pour Changer Megahertz*).

Some reviews for Suite En Sous-sol: '(...) In their mixture of gloomy, chamberish arrangements, camp strings, noirish saxophones and pulsing electronics, it's as lush and melancholy as Gato Barbieri's music for "Last Tango." Their dour laments can become somewhat self-indulgent, something the opening "Prelude" is prone to, but elsewhere there are mischievous hints of dancefloor funk, systems music, ravishing tangos and gypsy violins, plaintive melody and healthy robust electronic cacophony. While the majority of "avant-garde" records rely on initial shock, or at the best theory, Tuxedomoon survive repeated playing over long periods of time. Any further recommendation would be redundant.' (J. Gill, "Suite En Sous-Sol", *Time Out*, 01/07-14/87)

'If you'd had forgotten what Tuxedomoon sound like, the music is only a variation on the theme (plodding bass, violin solo and mournful vocals (...) "Suite" comes as a lazy combination

context of a sort of *fin de siècle* ambiance. We proposed that each person would write their own suicide and we'd film that. I was already dead because we were pretty overloaded with many things and we never got around to doing mine. I don't remember writing one for myself. My death got worked into the opening on stage which was me in a coffin on stage."

Nina Shaw: "We all had to write a suicide scene. The basic plot is that we're a group of people and one member has died and that turned out to be Bruce because he was behind the camera all the time, so you never see him. This was a working idea with all the projects that we did" [*it was to be the first of a series known as* OPERATIONS, *Ghost Sonata being* OPERATION I].

How did you come up with the idea of the suicide?

Steven Brown: "We're a gothic band, you know. It was right when gothic started. It was a theme. Blaine dies by alcoholism, Steven by possession of cult demons, Peter something else. Just a theme, like any other really."

Nina Shaw: "Probably because it was on everybody's mind all the time. It is something that constantly gets referred back to in a lot of their music, in a lot of people's personal writings. It was never very far away from everybody's consciousness. I don't think that anybody in the group was suicidal at the time but it was there and I think that a lot of that is alleviated for a while by drugs but then the drugs end up enhancing the problem that you've originally had. So we all composed suicide scenes. Some of them are not obviously suicides, some of them are very abstract. My suicide was slashing my wrist. Symbolically I'm using a lipstick to do it. There's my alter image that appears in the mirror. I don't have a clue where that came up from but I knew that if I would ever be going to commit suicide, I would probably do it by slashing my wrist. Blaine essentially drinks himself to death. JJ drowns. Peter is sort of dead by alchemy. We're not really sure that he dies. A lot of this you don't actually see the suicide. Maybe it was self destruction (…) So much of their music has to do with being isolated: the future is hopeless and one is never going to find one's dream. How many love songs have they written?"

Commissioned by Inteatro, the project was co-produced by two video companies: Image Video in Brussels and Soft Video in Bologna. The band was to create a body of music while shooting a story of everybody's suicide on video. The video would then be transferred to 16 mm film to be projected on a large screen during the live performances of the work in Italy. Taped *musique concrète* and the presence of an orchestra were to enhance the overall atmosphere.

Steven Brown: "Peter, Winston and Bruce were kind of in

charge of making the video, and me and Blaine were in charge of making the music. So what we did was that we wrote the music for piano and violin. Some of it had been written already by me and Blaine [*i.e. during the rehearsals for Divine* [52]]. And then basically Blaine's biggest work was to orchestrate it. So he would take these melodies we had done for clarinet, violin and piano and write it all out for the orchestra we later had in Ancona. It was the biggest work for him. He did it all by himself, the orchestration."

The creative process of *The Ghost Sonata* is not something that Blaine Reininger remembers fondly. "For me, *The Ghost Sonata* was not a very good period, says Blaine. There were things that mostly had to do with my personal life and I tended to transfer them, to externalize them, to the band. I was feeling uncomfortable in the band. During the period of *The Ghost Sonata*, I basically separated myself from the rest of the people. The idea was that I was orchestrating music. I took that music and orchestrated it, which was the first time I had done such a thing really. I had written occasionally for the band. I had written for a string ensemble, we were bringing a cellist, a viola player, possibly another violinist and we would have a string quartet. Also in recording *Desire*, we had a string quartet, a cello, another violinist and then me playing viola and first violinist. I was used to writing for strings.

For *The Ghost Sonata* I decided I would write for a kind of chamber orchestra, without brass really. So that's what I did. I had a book on orchestration by Walter Piston that was sort of my bible. So I sat there doing this orchestration for *The Ghost Sonata*. At that time I was on Cinzano and Whisky. I was mixing red Cinzano and Whisky and I thought I was making Manhattans. For Manhattans you are supposed to make them with Bourbon. I couldn't get Bourbon. These were really sweet drinks and I was getting fat and then drunk, very drunk. So I was sitting there all the time, working for hours and hours, most of the time getting drunk but I managed to get a lot of work done. I had this tiny little Casio keyboard, a really cheap thing, very interesting for the time. We didn't have a sequencer programmable. Hence the only keyboard I had to help in doing this orchestration was this little toy. I was sitting in my apartment rue de Stassart. And those guys were working on this video endlessly. I just didn't want to be involved…

First cocaine was never my drug of choice. The whole thing was very driven by cocaine, which was not my drug. I can't be anywhere near cocaine, just the sight of it makes me nervous. I hate and despise cocaine. I've seen people getting really messed up by cocaine. And I would rather deal with a junkie, heroin addict than a coke addict any day. Cos' when you take heroin you just go to sleep while people on cocaine

of noise and tunes, unfortunately a lot of foreplay without the climax.
On the second side though, "L'Etranger" – based on Camus' novel – shapes up with a few Moroccan musicians (…) "The Stranger" is a worthwhile exercise in angst (…) really for fans only.' (A. Hulme, *Leeds Student*, 02/27/87)

'Tuxedomoon continue their confusing mission in this God-forsaken earth: to wit, to boldly go where several other bands have gone before (…) 1972 (…) spiritually at least, that's where Tuxedomoon belong, amongst Faust, Gong and other early Virgin bands (…) unimaginative product from people who are acclaimed as "artists" by their small coterie of "intellectual" friends. Honestly, this music (…) is the aural equivalent of paintings you see hanging in world famous Art Galleries that look as if they've been scrawled by five-year olds (…).' (O. P. Sweeney, *The Hot Press*, 02/12/87)

'The atmosphere of this album is intertwined with lamentful, yet intriguing, melodies, courageous rhythms, and somewhat mournful vocals and lyrics, producing its own unique feeling. This record is haunting, tormented, and absolutely beautiful.' (K.T.G., *Ear*, 06/87)

'It's a suite in the true sense, a series of songs that form a most effective sequence. But these songs are quite a departure for Tuxedo Moon, being for the most part unrelated to pop songs formats. Earlier Tuxedo Moon works were quite radical departures from pop song conventions, but they did depart from these conventions to transcend them. Here we find more unprecedented and abstract approaches to composition. There are recognizable forms in these songs, but often In most unusual juxtapositions. "Allemande Bleue," for example, consists principally of fields of drifting, ethereal melodies organized around a hesitant, regular but tentative bass figure; Blaine Reininger's violins arc against the grain, moving from brooding, languid passages to a more agitated mood, then, suddenly, Blaine pierces the soft focus of the piece with a startling blues scream from beyond the planet of Robert Plant, framed with distant steely deltoid guitar. His wild blues growling and guttural phrasing and the shards of Elmore James' guitar tone work a strangely effective spell against this layered mood sketch, creating a new kind of blues, turning to the blackness of the void.
"Courante Marocaine" combines traditional North African progressions with a modified funk structure most effectively., percolating American dynamics matching perfectly with Eastern melodics. "Sarabande En Bas De L'Escalier" is a fluid dada piece melding soap opera church organ, sound effects and snatches of voice. "Polonaise Mécanique" follows, eliminating suggestions of melody and creating a dense rhythmic labyrinth of machine noise, then melody is suggested again as the noise abates, the tune seeming to be converted from the noises it replaces as though produced by a robot orchestra.
Finally there is "L'Etranger (Gigue Existentielle)" – another song rooted in North African music, using a Moroccan rhythm section and blending beautifully Western and Mid-Eastern scales. Very few Western musicians have been successful in their use of the sophisticated rhythms and melodies of North Africa: the usual result is schlock. But Tuxedo Moon has absorbed the feeling as well as the methods of this music and the results are quite lovely.' (G. O'Brien, "Tuxedomoon gone global", *Andy Warhol's interview magazine*, 1982)

Page 171

Mid May '82 arrival of PJR in Brussels, presented by TM as "manager of the company and official designer"

05/20/82 TM plays at Casino Montberon, Lausanne

Blaine: All I remember from Lausanne is me and Roques working out in a pedalos on the lake while Steven lay on his back in the passenger seat looking up at the sky, swans swimming by
Isabelle: Quite hilarious
Blaine: Bastard
Isabelle: Steven with his two slaves
Blaine: This was a lot of work for me at the time. I was quite out of shape
Isabelle: So I imagine the picture with skinny Roques…
Blaine: … and fat Blaine. This was just before *Ghost Sonata*. I had been drinking Cinzano every day

Patrick Roques: 'The place we played was a largish 1970's modern community center that was more like a university lecturing auditorium, up the hill with panoramic window views of the lake. An odd sort of place for the show, very conservative… Cinzano by the gallon no doubt monsieur Chapeau!'

05/22/82 TM plays at maison de la culture, Reims (*Festival des Musiques de Traverse*)

06/12/82 TM plays in Montpellier (France)

06/19/82 French television channel TF1 airs a 15 min. documentary ("Rock belge: Tuxedomoon", *Pour Changer Megahertz*, dir. J.-N. Delamarre, prod. TF1) featuring TM (with JJ La Rue) at the Plan K (interview and playing little sketches), drifting in Brussels or recording *Suite En Sous-Sol*

06/25/82 TM plays at Château de Franchimont, Franchimont (Belgium, for a festival)

'Tuxedomoon is a group discussed as well in mundane salons as in punk cafés (…) Tuxedomoon is to become a giant and they know it for that matter' (J.M.D.B., "Franchimont : le dernier bastion des petits festivals d'été", *Le Soir*, 06/18/82, translated from French)

become hyperactive. You can't always notice it but people on coke would get you involved in schemes and things, projects. I've seen artistic projects that were born on cocaine. But when cocaine ran out, the thing would disappear and you would be stuck with no money, no project and I just hated it. These guys would just sit there and talk about this production and take cocaine and then get really excited, talking way into the night about what we were going to do… These were the humble beginnings of this Inteatro festival but that was financing. That financed all of our foolishness in Brussels. That paid for our video work and so forth, paid for a lot of drugs too, once again.

Another thing that bothered me is that I was inclined to favor an American approach to post-modern multimedia which tended to be more ironic and funny. And I found that things were beginning to be so deadly serious, too much so in my opinion. In *The Ghost Sonata*, the thing of drinking myself to death, I felt like the bad boy, the drunk and actually if you look at the video, the things I do are kind of funny [*as a matter of fact Blaine appeared dressed in a stained flannel undervest wearing an absurd Chaplinesque bow tie, battling with empty bottles*], alone in this serious, Poe-faced, suicide. Peter also doesn't partake in this kind of romantic death (what he does has to do with alchemy), this path to destruction.

So indeed the things were just too damned heavy and way too serious and I didn't want to be part of it. My contribution to the band had tended to be humorous and tongue in cheek with songs I did like "Ninotchka" [*from Divine*], "Holiday For Plywood" [*from Desire*], "Pinheads On The Move" [*the single*]. Early on we had played with Devo and The Residents also made these kind of things. Steven and Winston primarily rejected this kind of campy humor. This sort of dark vision, it's already *passé*, it's a 19th century view of things, it's Baudelaire and Poe, dark gothic, black, too much eye make-up. It started to just annoy me and I wanted something else. I still do. I mean on stage now, swinging the microphone, shooting a ray gun, doing silly things, just trying to counter-balance the heaviness. We have this tendency to go this doomed, heavy direction and I don't want that.

However, I believe that my discomfort at the time had more to do with personal problems than it had to do with the band. At the time I was drinking very heavily. I was having big problems with JJ and there was some kind of crisis coming in our relationship and for one reason or another I didn't want to accept that that was the cause or the source of the problem. I was sure that there was something that I was doing that was probably disturbing her but there was an obvious problem between us that I wouldn't recognize and I had a tendency to blame it on other things and I blamed it on the band too.

Page 172

So during this period when everyone went to Italy, JJ and a few other people went as a sort of advanced party. They were there for like two weeks and I stayed behind in Brussels nominally to work on this music and to work on this video. It transpired that I found out that JJ had had an affair in Italy during the whole time and I was dimly aware that this was happening but I didn't want to accept it. My life at that time was so miserable that I did not want to accept it. I just thought: "Maybe if I stop drinking…" in order to say: "Look, look, I stopped drinking, come back to me…" That was an attempt to demonstrate my absolute fidelity and love for her because after *The Ghost Sonata* thing was over, she stayed behind in Italy. She told me she needed some time, she needed some space, and she sort of would not come back. She stayed behind in Italy to pursue this affair for about a month or longer, two months. She was just gone and I was in Brussels on my own, which I always found to be a frightened state that I just couldn't tolerate alone. So primarily for this, I found it to be a pretty miserable time and I suppose that the seeds for my leaving the band were sown during that period. But at the time I didn't want to admit that that was why…"

Geduldig resumes telling the story of *The Ghost Sonata*: "In the months it took to do all this pre-production work, things got hazy and crazy. It was unknown territory in a lot of ways. We were working with very little money, living in friends' apartments, working probably twice as hard as necessary if only we had known "how to" and "what" we were doing. The idea ultimately was to film the live performance, record the music, then put it all together to make a final video package and album." [53]

Early in July, most of the company transferred to Ancona to prepare for *The Ghost Sonata* live performances scheduled for the end of the month. For the occasion, Anne Militello, then already a star in lighting design [54] and who had worked before with Tuxedomoon in the early days in San Francisco, was called upon to participate in *The Ghost Sonata* adventure. In Ancona, they were given a theater to rehearse and went to work, editing, constructing costumes and wigs, *décor* etc., also rehearsing the orchestra and the live stage action. Immediately the situation got to no less than chaotic as Tong/Geduldig figured out the stage action practically at the last moment or literally created the piece on stage with practically no rehearsals, the unfolding of the piece relying on a lot of non-verbal communication between the protagonists. This working method surely worked between Tong and Geduldig but certainly proved less efficient within the larger Tuxedomoon group.

Nina Shaw: "All the deaths were shot in a very small studio

**Blaine Reininger in the train to Italy.
Photo Gilles Martin**

July 1982 *THE GHOST SONATA* (BLR, SB, PP, WT, BG, NS, JJ, SL, AM, GM, RN, FL, KK)

07/22 Trial run in Ancona (piazza del Plebiscito *aka* piazza del papa)

07/24 Short-lived *première* of the *Ghost Sonata* in Polverigi, drenched by torrential rain

07/25 *Ghost Sonata* performed in Polverigi

07/26 *Ghost Sonata* performed in Polverigi

07/27 *Ghost Sonata* performed in Giulanova (as part of *Agorà 82 – Contaminazioni*) on a football stadium, also drenched by the rain

07/28 TM plays a regular show to compensate for the night before

07/29 *Ghost Sonata* performed in Modena. It is from that performance that the basic tracks for "Licorice Stick Ostinato," "Basso Pomade" and "Music # 2 (Reprise)" were taken for *The Ghost Sonata* LP/CD released by LTM In 1991 and re-released by Crammed (Cramboy, 1997)

After the *Ghost Sonata*, NS stayed on a permanent basis to do TM's lights and, later some solo members as well

The Ghost Sonata was the first of a series of projects called **OPERATIONS**, each OPERATION being an attempt to merge all kinds of forms of artistic expression (theater, music, cinema…) into one single living art (Peter Principle *in* "Rock belge: Tuxedomoon", *Pour Changer Megahertz* featured on French television TF1 on June 19th, 1982, directed by J.-N. DELAMARRE, prod. TF1)

Blaine Reininger dealing with his addictions. "We went to the States to do a tour [*the Dec. 1981- Jan. 1982 US tour*] and we were being paid well, for the first time. So I had money in my pocket, and so I just drank all that I wanted. This whole tour was just sort of a continuous drinking spree. It started in LA and I was drinking and drinking and drinking. It was terrible and I felt terrible and I saw this woman who was in this band called Noh Mercy!, Esmeralda. She was also from The Angels Of Light and she said: "Wow, you look terrible, you're drinking, aren't you?" I said: "Yeah…" And she said: "Well I haven't been drinking for a year: I went to AA." I said: "YOU, you went to AA??" Because she was such a punk goddess, punk diva and I had the impression that AA was an organization for new-born Christians, fanatics of some sort. She was a nihilist and atheist. She said: "Yes, I went there and I stopped drinking and I feel so much better." At the time, I sort of laughed it off but it kind of planted a seed. *The Ghost Sonata* came after that tour. I was still drinking heavily but after I got back to Brussels from Italy that summer, I was alone (JJ didn't come with me). I decided: "Well, I've had enough with this: I'm fat and I'm stupid, I have to stop drinking." So I did, I just stopped. I stopped for a while then, it was in 82.

in Ixelles (Brussels). We all met up in the studio. Essentially it was playing dress-up, using fabrics and costumes and things and dress-up and turn the camera on and Winston would say: "Let's do this" and so a lot of the stuff that was shot was improvisation, nothing that was ever closely scripted at all. So we shot all of this. Then we went to Italy and we were in residence there maybe for a month to finish up working on the production. Everything that was shot and all of the costumes that we used in the video were black and everything that was done on stage was in white. And again all of the scenes in there, we found the cohesion after the fact.

It was a whole technique of improvisation. It was probably one of the strangest working experiences I'd had because I was coming from a theater background where things were very well rehearsed and there were directors. This was sort of everyone could do what they liked."

Bruce Geduldig: "Yeah, the staging and what was going to happen was quite chaotic. The help from Italians was there but the situation was all due to us, because our ideas were not clear. It was too big for us to tackle. It was too much for us to figure out what all these people were doing. It was the first time that Winston and I worked with other people. We always worked with ourselves and on that level we had a kind of instant communication and things were understood. There was a lot of uncertainty and a lot of us were a long way on drugs as well. There was just a whole lot going on. There was an orchestra and everybody was preoccupied with one thing or another in their particular sphere. And I think it just got away from us. We didn't understand. We needed to do it and then cut it a lot shorter. We needed a more defined process to get to something that was more valid."

Blaine Reininger: "I was the only dedicated alcoholic, not taking coke. So I felt like an outsider. The fact that I was apart to conduct the orchestra was on purpose: "I don't want to be part of this, so I'll do the music." Hence I sort of hid there. This was a behavioral thing. It's common to alcoholics to resent people and then to find a convenient excuse to drink more. So I had this resentment for everybody else because I was off in my alcohol, I was gone, I was alone in there and at the time I wanted to be alone. And the work was good: the orchestra and the orchestration. I don't know how I did that but I accidentally did some pretty good things. I didn't know how winds and strings interacted and that's one of the things I did and that's not bad. It's of course far away from perfection and this is *amateur* work when you compare it to real masters of orchestration but that's something I always wanted to do, to write for an orchestra, to write a symphony, a novel. The form I wrote that came close to these great forms are a LP or a

CD that are kind of analogues to those. Paradise lost…"

Patrick Roques: 'I think it's been documented that no one knew what the fuck this "opera" was supposed to be. Winston just didn't have a clue on how to direct.'

Roberto Nanni: "Winston and Bruce were directing but they were doing it a bit in the way they were used to for *Frankie & Johnnie* with way too many people around them. Too many people, too many ideas and a strong competition between them. I have the impression that, at a given time, in silence, Winston did let go and withdrew himself from it …"

This chaos also reflected the state in which many of them were individually:

Steven Brown: "There were a lot of tensions, we were fighting all the time. Patrick [*Roques*] was there with his girlfriend, I was jealous of her and we've been all living in this house in Ancona. It was hotter than shit. There was drugs and alcohol and the heat. Blaine and JJ was another one. All these couples involved really got me personally upset. I didn't need that extra confusion and so it really got me going and also it was just a lot of work! A lot of problems to solve every day and everybody was kind of scared, insecure: "What are we doing, maybe it's too big. Maybe we can't handle it. Maybe we're crazy to try to do something like an opera. What are we to opera…""

Patrick Roques: 'At the end of *The Ghost Sonata* tour, Steven asked – in a somewhat curt tone – where I'd been during all that time. He said he'd never seen me at the beach. I just stared at him in complete disbelief. Along with Katy [*Kolosy*] I was working 12-14 hours a day trying to hold the whole thing together. I wasn't sleeping much. I had just started my new romance with KK. Bruce was dating an American Penthouse (magazine) model [Lisa D…] who brought her red VW Beetle with her to Italy to cruise around in. The cops were always stopping us. She was sort of trying to manage Tuxedomoon at the same time as KK. We were staying in student housing in the great old building near the Dome, in Ancona. Then we were asked to leave. So we begrudgingly moved to "euro-modern" student housing near the center of town. The rooms were cramped and dark and filled with cheap plastic furniture that Steven would occasionally destroy in a dramatic attempt to get his point across. *The dungeons of the insane Caligula* [Roberto Nanni gave the name to Steven] as they were known. Steven wanted something like a 30 piece orchestra and there was only money for say, I don't know, 10 players. So he was told: "No." So he simply grabbed a very large glass table lamp and threw it through the third floor window of his room. It crashed to the narrow *via* below and made a hell of a lot of noise. Luckily it didn't kill anybody. So he got his 30 piece

I stopped drinking but I decided it was still Ok to take pills. So I was pretty far gone with pills for a long long long time. I was like a drowning man that sort of periodically surfaced and then sort of come to my senses and then try to clean up and then I would go back down, all through the eighties. In the meantime I started to flirt with heroin. In earnest I didn't really completely stop alcohol until 1992, another ten years. Then I stopped drinking first. Then I had to deal with my pill addiction. There was this c… which was a morphine, codeine, opiate kind of thing that I had been addicted to and was also available over the counter. There were a few times when I had to take enormous quantities of this stuff every time I traveled, cos' I needed it every day or I was sick. So before I would leave, I would go and hit ten or 11 pharmacies and get 20 boxes of this shit. Finally I was lucky enough to find a doctor who was specialized in addictions. It was like '94. I started to take another medication that would satisfy your body's cravings for opiates but there was no euphoria. So you got to a point when you got used to not being stoned. There was no pressure from him to stop at any given time. I was on this medication for a couple of years before I quit. So I was gone and I didn't take opiates anymore. This was much harder to deal with, this pill addiction. I had been on alcohol from when I was 14 until I was like 40. When I quit, so many things were different, to do things without that crutch of alcohol, that was almost like another world …"

Anne Militello: "I was raised in a poor Sicilian neighborhood in Buffalo, New York (very near Niagara Falls) in a large family of Sicilian immigrants. I was an artist and musician from a young age, being inspired by my heritage and the traveling shows that came through my town. I began going to the local theater to volunteer when I was 12 years old, and from that time, I always knew that it was home to me. I loved the magic and intrigue.

Staying in the theater since that time, I learned my trade from the older male technicians who were kind to me. I went to college for a few years for film and acting but quit after a year to pursue my own dreams... I moved by bus from my hometown in New York to San Francisco and began lighting work at clubs for punk bands and strippers.

One night, in 1977 or 78, I saw Tuxedomoon perform and I was blown away. They were very theatrical and mysterious. The lighting however, sucked! I approached Winston Tong and asked him if I could do lights for them (for free of course)! And from then on, I started to work with them whenever they performed locally. We experimented with theatrical techniques - this was no ordinary rock band.

Eventually, I moved to New York in 1980 to pursue a professional design career in the theater there, but we kept in touch. When they were commissioned to produce *Ghost Sonata*, they called and asked me to do it. I did, and had a fabulous time - I loved the work. When I did *Ghost Sonata*, JJ and Nina were doing costumes and acting. I did the lighting of the video (Bruce helped and was fabulous), and I did the lighting of the live show. Nina had an interest in lighting that was just beginning as I recall, and JJ didn't seem very interested at that time in it. They were too busy anyway attending to other things, such as being on stage. What I was doing took full concentration, organizing the equipment and the crews and running the lights as well as designing them. I knew there were

orchestra. [55] We paid for them and the large ugly lamp and a window too. Unfortunately a lot of them had nowhere to stay, so we moved them into the *Plastic Chambers of Caligula*, the other name of our hotel. A sink was ripped off the wall in the middle of the night. Then money started to disappear from people's rooms. By this point I was too tired to care. I went out to find a better dealer. It seemed like a good idea at the time…'

The only trial run of *The Ghost Sonata* took place on the famous piazza del Plebiscito (*aka* piazza del Papa) in Ancona on July 22nd and with it came the band's rather belated realization that the show lasted *way* too long and revealed many flaws. However this free performance passed without incident and it was during this show that Roberto Nanni shot the picture of a minuscule white Winston kneeling on stage against a backdrop of floodlit medieval castle that would be later used to illustrate *The Ghost Sonata* soundtrack's front cover when it was released.

The band then moved to Polverigi where they were to perform their real *première* of *The Ghost Sonata* on July 24th. Unfortunately the band was quickly forced off the stage by torrential rain. As Gilles Martin recalls: "Well, we worked two months on this show and then after about 30 minutes at the *première* at Polverigi a huge storm came and the screens blew away and it started to rain and we had to stop. We went and ate dinner afterwards I think." [56] The next day they were able to perform the show. Then they transferred to a football stadium in Giulanova where, again, their performance was rained out on July 27th. The next day they played a regular Tuxedomoon show to compensate for the night before and, finally, *The Ghost Sonata*'s last performance came in Modena on July 29th. Bruce Geduldig summarizes it all: "In the end the stage performance was, my memory is and I think that everybody's memory is that it was pretty catastrophic." Fade to black…

Roberto Nanni : "It was a beautiful project. I worked mainly with Bruce on the lights, another mess to organize. Moreover they wanted to film the live performance. So I went to Florence to find people who would be willing to give us the cameras because in those days it was very hard to film in video (the cameras were complicated and heavy).

So it was a mess but, on the other hand, my recollection is that we made a good shooting. We did Ancona, Polverigi and Modena but the problem was to find money for filming. For a lot of people, Tuxedomoon was already finished as the schism was very deep between Blaine who wanted to record a new album and Steven/Bruce who were pushing *The Ghost Sonata* project as much as they could as a video film. This was something that only film director Michelangelo Antonioni

Page 176

had been able to achieve in those days. The technique was indeed hard to use on long films. In Brussels they got money from Image Video and I found money for them in Italy from Soft Video. Bruce came to Florence to do part of the editing and I went to Brussels as well (I was staying at a by-the-hour hotel). Katy Kolosy was very involved in the production as well.

I worked like a madman on this *Ghost Sonata* project. So I was quite sad to find out that none of the individuals involved on the Italian side of the project were mentioned in the video's credits [*as a matter of fact only* COEL *studios, Firenze, and Soft Video, Bologna, are mentioned in the said credits* [57]]. I found this to be deeply unfortunate and I regret having to say that I thought the worst of them at the time. Of course they were the authors of this project but it was like they would have made a movie and then mention no one but the name of the director. Nevertheless I'm quite certain that without me and my efforts – and I was only 23 – to find money for them, they wouldn't have been able to complete this project. So we, in Italy, weren't very happy with this.

To sum up I think that this experience was invaluable for me professionally but a fiasco on a human level. They never recognized my input when I constantly traveled between Italy and Brussels to find money and gear for them and then I continued to work for months on post-production of the video etc. There was a very strong competition between them and ultimately I was the one who "paid" for this because I was young and inexperienced. They came in Italy like the Big Bosses, the Americans who were going to decide on everything but finally did not have the strength to decide an anything because of this raging battle between them.

Before *The Ghost Sonata* I felt like I was involved with the band. After *The Ghost Sonata* not at all anymore: too confused, too competitive. I became more a friend with some of them individually, like with Steven, Winston and Bruce for instance. When they later returned to Italy, there was not one single word uttered about *The Ghost Sonata*, ever."

It would be too easy a play on words to suggest that *The Ghost Sonata* transformed Tuxedomoon into ghosts but it can be submitted that it somehow killed the band softly.

Nina Shaw: "It did. It brought out the different factions. It brought out that Blaine really was interested in concentrating on the music and wasn't terribly interested in all the theatrical thing that was going all around it. It brought out all the internal tensions because the whole working situation was very difficult. People stopped speaking to one another for long periods of time. And most people had not very pleasant memories of the whole working process. It sort of destructured them in a way and the piece itself dealing with

lots of drugs around. I tried to do a minimal amount, as I was trying to quit, and I had to keep everything organized and running smooth. The guys always had a volatile relationship. It seemed they loved each other a lot, but tortured each other! When I worked with them in San Francisco, I remember one show where Blaine and Steven pretty much destroyed a bunch of equipment on stage after the set. I guess I got used to seeing it as it didn't strike me as odd at the time. I tried to stay away from being involved in personal dramas although towards the end, I couldn't help it [*there was a big fight between Anne Militello and Saskia Lupini and, consequently, between AM and Peter Principle*]. I took off after that, chalking the whole thing up to drama. I still am fond of them all really. Youth, drugs, angst and a real pouring out of artistic emotion mixed up to create melodrama!"

Patrick Roques about Anne Militello: 'When I met Anne M., she was standing in the middle of our rehearsal theater, yelling. "Luci! Luci! Luci!" That, I think, was the first word of Italian she learned. Makes perfect sense. She used it a lot. I don't remember saying a word to her the whole tour. Two months? She was a bit like a young, prettier Anna Magnani. She'd disappear after a day in hell and show up around two a.m. every morning. You'd hear a lone vespa coming up the hill, a young boy driving... Anna dressed to the nines, looking disheveled would slide off, the scooter vanishing into the night and then the lonely clacking of her high heels against the 1000 year old paving stones. It was always a sad sound to me. It was also a nightly reminder that I should be trying to get some sleep...'

A driver to Ancona. Peter Principle: "One person who approached us in Napoli, drove us around to Ancona to *The Ghost sonata*, ended up trying to put the PA in a truck of his own after a concert one time. Frankie [*Lievaart*] discovered it: "Wait a second, I had put this in the van already" 'cos we were loading our van and they were taking the stuff out and put it in between seats in the theater. And then Frankie saw something he recognized: "Wait a second I had put that on the van, how did it get here?" and there was some: "Oh, I don't know, there was some mistake" and then we went to look in their car and they had all this gear lifted from us. It wasn't our personal equipment and that was his argument: "You guys are a great band and we would never steal anything from you, we're only stealing from these other people and they must have insurance, so that's not a problem.." We were like: "Forget it man, you're fired" but we made them drive all the way back, me and Bruce rode with him in the car so that they wouldn't steal anything but we needed the ride ! (laughs). So even after we fired him, we rode with him. That person recently came up to us recently at a concert and was like friendly backstage: "Hey, remember me?" Like nothing had ever happened (laughs). He was a nice guy but, you know, we just had this problem…"

Page 177

Ghost Sonata snapshots (read by Steven Brown from his private journals)

'1982. Wednesday, 3:47 a.m. Sent equipment off to Italy. Wrote a few more parts. Spent evening with B.L. whom I gave some S to as he was sober and scattered (…) I copied parts, played some Casios together. He showed me an ad for a new Yamaha mini keyboard that writes the music you play onto a paper roll… (Steven adds: "He later bought that keyboard")

Ancona, Italy, 12:30 on Monday. Italy won the world cup and the noise seems to be abating now after two hours solid of cheering chanting mobs, car horns, boat horns, the whole city vibrates with electricity. Indeed one can imagine the whole country in like fashion. Went to beach alone today. Warm clear water, hot hot sun and sand and too many (…)

Ancona, 18th-7. Bitter sweet sweet. Each foray into the street was an adventure in a maelstrom of energy. Life energy. Sex. The human high humming contentedly round every corner. A heaven or a hell depending on your stamina…

Polverigi. Opening night of festival. La Scala on the main stage singing (…) for ninety minutes. Meantime the grounds are a blur of metaphors and imagery… myths and dream. Boys roam in gangs. A café at work becomes the most exciting of off stage events. Smiling boys serve you food. Anywhere else, they'd be flirting, not here… it's the only way they know to carry themselves….

21, 7th. Student musicians from the conservatories in Rimini, Parma, Pesaro and Ancona just played the three pieces B orchestrated this afternoon. First time they've been played. I got goose bumps. Sounded great. Two cellos, one basso, six violins, oboe, flute, two clarinets, all fine players. Listening, in the midst of it all, I'm struck with the power, importance of orchestration. A simple piano and violin duet can be mined for a myriad of (…) texture possibilities,

suicide. Yes it was the end of it. And the band stayed together for almost a year after that but it was the beginning of knowing that everyone was going to go separate directions."

Saskia Lupini: "*The Ghost Sonata* was the thing that broke up everything and it was sad because this was such a big enterprise and we were doing all these different things and Blaine conducting the orchestra. That was supposed to be really nice but somehow, I think that mostly through drugs and egos that they were a little bit lost at the time. Suddenly people started to accuse them of being assholes and of taking too many drugs. Suddenly they were all pushed away and this wasn't right because they were really interesting. A lot of their ingredients were coming from the sixties but they were presenting them in a totally new way and what they did there was very new and very refreshing. Now all these advertising and publishing companies are using these techniques but this is twenty years later. Those guys were doing that on stage with nothing. They invented so many things to do sound effects that at the time were totally new. Now you have machines to do those, not at the time. Every show was different and they always had to be very creative to solve the problems arising at every show."

Peter Principle: "*The Ghost Sonata* was probably the last thing we did with some kind of unique vision. After that it all started to dissolve. Then Blaine left the group. Then Winston left the group. Then Winston came back to tell everybody he had quit. Things went like that (…)." [58]

It's no wonder that both the video and album of *The Ghost Sonata* took time to see the light of day.
The Ghost Sonata video was screened on November 24th and 30th, 1983 in Lille (France) as part of an *Images Rock* festival [59] and, on July 9th, 1985 at the London's ICA Videotheque. [60]
In August 1985, the video was released by Doublevision but under rather shady circumstances it would seem. Bruce Geduldig: 'Ghost Sonata was released by an English company called Doublevision, headed by a certain Michael Schaumburg (who has gone on to produce Tarantino's *Pulp Fiction* among other fine offerings) in the early 80's; neither Tuxedomoon nor Polygone – the production company – received one centime, schekel, franc or other remuneration for that disaster. So be it.'
At any rate the video appears as a largely unfinished work. Nina Shaw: "I think there were little vignettes that were beautiful but the piece as a whole is scattered. I think that if somebody doesn't know how to watch it, it's sort of like Wagner, interesting five minutes but really boring half hour."
Roberto Nanni: "Bruce kept telling me over the years that he wanted to prepare a new edition of it. But no one seemed to

**The stage in Ancona, for the first and last *Ghost Sonata* run-through, before it premiered in Polverigi.
Photo Patrick Roques**

be pushing this, no one seemed to be really satisfied with the work. There was an attempt to sell it to the RAI [*Italian television*] but it did not work out. Also there was a belief that the product was not really a finished one and that work still needed to be done. Then years went by and it got really hard to do anything about it. Too many screenplayers, everyone was directing when for this kind of project you need to have some sort of dictator to get anything over and done."

Unsurprisingly *The Ghost Sonata* video received this quite terse review in the *Rock Yearbook*: 'Which sees the Belgian-based ensemble in a melancholic mood. *Sonata* is a performance piece based on suicidal themes from the Strindberg play of the same name. Imagine a collaborative work from Laurie Anderson, Eugene Atget and Bela Lugosi, and then don't look at it – the music's better by itself.'[61]

Philip Brophy's:

'Less specific in its chosen fetish is B. Geduldig & Tuxedo Moon's GHOST SONATA (1983) although it is just as overwhelmed by the effect of its imagery as NIGHT THRILLER. GHOST SONATA reconstructs the Ibsen theatrical narrative as a flow of visual ambience and mood that (incongruously) ranges from the gothic to the surrealist, evoking an aura of desire, memory, obsession and all those standard things that for some reason are meant to be rich in literary values. With occasional poetry by Tuxedo Moon's poet-collaborator Winston Tong, the whole scenario really doesn't rise above a bunch of art students in love with the act of being artistic (mannered gestures, delicate

perhaps partly it's deception amidst the seeming complexity of a twelve players… but isn't that part of the mystery and beauty of orchestral music? Again witness to a miracle Italian style, yesterday we were told "no possibility for an orchestra," and today…

Sunday, 25, Polverigi. Saturday night our *mondiale* is rained out. Tonight we did it. OK, long talk with Botu Japanese dancer (…) afterwards ballet criticism…'

Saskia Lupini and Nina Shaw in their *Ghost Sonata* video costumes. Photo Saskia Lupini

JJ La Rue and Winston Tong working on *Ghost Sonata* props. Photo Saskia Lupini

Peter Principle in the *Ghost Sonata* video.
Photo Saskia Lupini

Blaine Reininger conducting his *Polverigi Strings*.
Photo Saskia Lupini

costumes, bizarre connections, etc.). While Tuxedo Moon's music since 1980 has often been quite striking, GHOST SONATA appears thin in comparison. File with Greg Karn, David Sylvian, Richard Jobson, Bill Nelson, Ryuchi Sakamoto and sundry sensitive artistes whose love for passion gets in the way for their passion to create.'[62]

The Ghost Sonata video finally had to wait until… 2007 to be officially released as part of Tuxedomoon's 30th Anniversary box set published by Crammed Discs.

The destiny of The Ghost Sonata's soundtrack was even more convoluted and yet it stands today as one of Tuxedomoon's finest albums. At first the idea to have a Ghost Sonata album was simply dropped as a result of the deleterious atmosphere that clouded the group's relationships for some time after their return from Italy. Then Steven Brown and Blaine Reininger recorded versions of some of The Ghost Sonata pieces for solo albums [63] and performed them live as their Blaine & Steven duo. Things would probably have remained the same had Tuxedomoon not met with one of their most enlightened and dedicated fans, LTM Recordings [64]'s owner James Nice, [65] who finally released the album almost ten years after The Ghost Sonata performances. That was in 1991, at a time when there wasn't that much going on the Tuxedomoon front and money was cruelly lacking.

Nice: "I thought it would be a good idea to try and piece together The Ghost Sonata. It's a great lost Tuxedomoon album and we thought that at the end of the day we can make more money doing it through me than doing it through Crammed Discs [i.e. Tuxedomoon's record company] and that's what we did and of course it eventually came out on Crammed as a re-issue a few years ago but I did this album with Tuxedomoon because I can organize this. You can get quite a big advance. It can be done quickly and efficiently. I think the main reason for doing this record are number one money because I was offering them a good deal and two, as to The Ghost Sonata, we were only able to do what we did because of digital editing. There were so many sources of material on there, some of it was newly recorded, some was on cassettes, it was from all over the place. We had to run it in a huge digital editing sweep, which wasn't available in 1982-83. To try to make that album at the time would have been very hard because the technology wasn't there to assemble these various bits and parts. I think it could have been a better record but we had to go with what we had at the time. I think it's a fair representation of what the original project was. I thought it was a tragedy that it did never come out because they spent an awful lot of 1982 on that project and spent the summer in Italy performing it. And then nothing happened. Various tracks got used for solo projects but most of it disappeared into the wilderness. So my main

Page 182

Steven Brown photographed by Saskia Lupini

In white costumes, *Ghost Sonata* **Performance. Photo Roberto Nanni**

Steven Brown and Nina Shaw, *Ghost Sonata* Performance. Photo Saskia Lupini

**Nina Shaw, Winston Tong, JJ La Rue and Steven Brown. *Ghost Sonata* video.
Photo Saskia Lupini**

reason for doing this album was, as a fan, because I wanted to have a live album of Ghost sonata on LP/CD rather than the very poor video that was available." Initially released on Nice's label, LTM, *The Ghost Sonata* soundtrack was re-released by Crammed Discs in 1997.

Some reviews of *The Ghost Sonata* soundtrack:
'It took eight years to this band to have a sufficient self-conscience for releasing their best musical work.'[66]

'Perhaps the best work that Tuxedomoon produced in its (…) career.'[67]

'Off voices, sound effects, squeaking violins with a perfume of faded roses, this is the music of a stubborn nightmare that however escapes to grip but returns when one would think of it as forgotten. In the manner of symbolist painters, Tuxedomoon freezes time, crystallizes an instant that has the length of eternity. Like a walk amongst the statues in a cemetery, livings for ever petrified, masks whitened by the passing of time. *The Ghost Sonata* is Tuxedomoon's stupefied journey (…) Just like for August Strindberg or the symbolists, it's not important to know whether the works by (…) Tuxedomoon (…) are modern, passeist or futurist, one has to listen to them forever alive like the old stones in the middle of a graveyard.'[68]

Ending up at the school for the deaf, dumb and blind. Hear no evil, speak no evil and see no evil. Patrick Roques: 'I believe it was my idea to do a small Tuxedomoon tour to recoup our losses. I think Katy [*Kolosy*] booked it. One of the first shows we played was a soccer field in Modena. It was sponsored by the local Communist Commune or something like that. This nervous sort of scruffy guy appears all smiles, waving his arms. "We need our hotel and food right away," I tell him. A conversation in Italian ensues between the promoter and Katy. His first question probably being: "Do any of theses Americans understand Italian?" It turned out that there were a few problems. Seems that there is no hotel, there is no food and possibly no show (the concert was booked on the same day as the Italian *Grand Prix*). Other than that, *fantastico*! Then the obligatory 20 minute argument. Arguments are important, it's a form of socializing, of cultural bonding. It took us a while to learn that. It goes like this: "When in Rome…" Okay, seems we will at least have food. We go to a pizzeria and after the guy grovels for another 20 minutes he convinces the owner to give us, free of charge, five huge pizza's for the good of the Communist Party. Well fed and feeling better we are ready to see the hotel. Well, we are told, it's not a "real" hotel. It's a nunnery. A nunnery, we think he's joking. He's not. Turns out it's a nunnery that

After the *Ghost Sonata*, **a short Italian tour** followed, track was kept of the following dates:

08/01/81 TM plays at Stadio Communale, Giulanova

08/06/82 TM plays at Aleph Club, Gabbice, where they met Giampiero Bigazzi (from Materiali Sonori)

08/21/82 Peter Principle deejays at a *Settimo Cielo* party held at parco giardini Margherita in Bologna *Cartllone Emilia-Romagna*, 08/21/82) and produces the Italian band Central Unit's first album (*Central Unit*, published by CGD, 1983).

Reininger, Brown, Principle and Saskia Lupini. Photo Gilles Martin

Some of Roberto Caramelli's memories about Peter Principle producing Central Unit's first album. 'Peter was at the mixer most of the time, often suggesting the way we'd play a particular instrument, and occasionally playing some himself, writes Caramelli, Central Unit's drummer. He asked us not to include him among the musicians on the back cover though, and thus his job with

functions as a school for the deaf, dumb and blind. A very impressive 17th century mansion set back in a piney woods near some dusty fields. It's beautiful. The appropriate setting for the members of Tuxedomoon. Turns out that the nuns were away on holiday. The question amongst us was, where do nuns holiday? (Ken Russell's *The Devils* came to mind). We were lead to the top floor. The fourth I think. This was the nuns' sleeping dormitory. A large barren room with thick, faded yellow plaster walls and bare hand scrubbed wood floors. There were about 40 single metal, wire spring beds in there. One row to the right of 20. One row to the left of 20. There was a single black bead rosary hung above each one. The frozen image of solitary, surreal devotion. Of course no one wanted to sleep in there. Bruce began pulling the heavy, old, wool mattresses out a doorway that lead to a big balcony roof top. It was a camp-out on the roof of a nunnery under the stars. *Bella* Italian stars. Steven and I found the mother superior's bedroom. Simple with two wooden beds, a small library and a 400 year old shuttered window that looked out over a 3,000 year old landscape filled with pale yellows, reds and browns. Dusk with lots of varnish. I think Steven took a perverse pleasure with sleeping in the mother superior's bed. It suited him. The sheets smelled like nuns. The next morning Gilles [*Martin*] was screaming. The stage had not been built and the show was to start in two hours. We took Gilles very serious when he got pissed-off because he was not a boy to cry wolf. But the Italian workers didn't

care, after all It was the start of the Italian *Grand Prix*. Modena is home to Italian auto racing, no one cared how pissed-off anyone was, they were simply going to watch the race and we could do our show *domani*. I explained that there were already a few hundred people outside in the ticket line. They said it's Ok, they'll understand. To me this seemed impossible. God, please give me drugs! This argument went on for over an hour. Everybody was getting pissed-off when the Communist promoter pulled out a Bullhorn walked over to the ticket line and calmly told everyone that because of the race the Tuxedomoon concert would be postponed until tomorrow. There was some muttering and a few shouts then everyone just walked away. A hand written sign was posted saying: *Come back domani*. The next day we did the show. Peter had disappeared earlier and no one could find him. He showed up ten minutes after the show had started. When he got there Winston cut the sleeves off his black T-shirt. He picked up his bass and went on stage. In spite of everything that was a really great show. Bruce had found this battery powered kids' toy electric guitar that Gilles had plugged all these effects into so it sounded fantastic. At some point Bruce jumped on stage and did this completely amazing fuzzed-out heavy psychedelic solo and then went back to smoking us was called "artistic production." A track called "Grotesque," among the most intriguing of the whole album, started with Natale strumming on the piano during a pause; Peter loved it and was rapidly able to set up a song around it (…) Some of the sentences he loved to repeat are my most vivid memories.

One came from some technical problems we ran into while working at the studio, for instance a filter suddenly opening up and making noise in the middle of a track ("What was THAT?"), or the impossibility to get the exact effect we wanted due to budget limitations; he used to say: "You've got to be able to make strengths out of your weaknesses." Putting that philosophy into practice, he proposed to keep and emphasize a mishap that took place while recording "Grotesque," as very low noise of a studio door closing was discovered while re-listening to the pre-mix. It was impossible to erase it without re-recording the violin track, so Peter turned it into a deliberated four steps and a violent slamming that we all loved.

The school for the Deaf, Dumb and Blind. Photo Patrick Roques

Well, if you think that a masterpiece like *Half-Mute* was recorded on just eight tracks, he knew what he was talking about! He gave us the opportunity to practice and perform that kind of approach while recording that album and later in our lives more generally. Thank you, Peter.'

Letter, dated August 9th 1982, sent by Katy Kolosy to Velia Papa (excerpt, translated from French): '(…) In spite of the fact that *The Ghost Sonata* remained an artistic disappointment for most, at least in the state it has been presented in Italy, I know that all took an important lesson from that experiment, and will know how to use the resources of a stage with the elements they learned and did not even suspect before…
On my side, I'll do the maximum so that the existing sketch could develop in an optimal way and in the best conditions…
I hope that, after my departure, you had the opportunity to talk to Winston. I felt that, in a way, he was very solitary (…)'

a cigarette. Gilles did this massive 360 surround sound mix, setting up huge speaker columns in all four corners of the stadium grounds. After the stress of *Ghost Sonata* everyone was happy just to be doing Tuxedomoon shows. We never did see any nuns. The priests lived downstairs and it was a fucking palace. Seemed like we'd stumbled on a secret cache of Nazi loot. They found us snooping around and shushed us out.'

After this tour, the band drifted back to Brussels with Peter Principle staying on in Italy for a little while, notably producing the Italian band Central Unit [69]'s first album [70] (with Gilles Martin and later Frankie Lievaart assisting). The group's frontman, Natale Nitti, had organized Tuxedomoon's first concert in Italy on Dec. 9th, 1980.
The Ghost Sonata also had the side effect of seeing Katy Kolosy drifting away from Tuxedomoon, with Patrick Roques taking over as tour manager. "They didn't want to work with Katalin anymore after *The Ghost Sonata*, says Roques. And they sort of got rid of her. She had gotten completely fed up with them, thought they were ungrateful and so forth. So I just kind of stepped in for a while." "I have bittersweet memories from these times, says Kolosy. I invested a lot, also emotionally, into that band but then there has been an accumulation of small details that finally led to break-up: like family belongings – furniture, sheets and whatnot – I had lent to them that disappeared or were damaged. Also this lack of recognition of what was done for them. I'm not sure I would enjoy seeing them again, even today after all these years…"

CHAPTER VI

From "This Beast" to THE Beast in Dreux - Blaine Reininger leaves Tuxedomoon

1982: in August Reininger and Brown start to work on "The Cage" and "This Beast" in the absence of Peter Principle; each member of the group embarks on a myriad of solo projects, collaborations or productions; a German tour in the Winter; Tuxedomoon records a soundtrack for Dutch alternative film-maker Bob Visser's film Het Veld Van Eer (Field Of Honor); Michael Belfer arrives in Brussels; Tuxedomoon turns down an offer made by Les Disques Du Crépuscule to record an album with them

Back in Brussels, Brown and Reininger started work on two songs "The Cage" and the probably highly cathartic "This Beast," to be comprised on Tuxedomoon's *Short Stories* EP.
Peter Principle, then staying with his girlfriend Saskia Lupini since his return from Italy, felt quite dismayed if not excluded from the process, especially considering the fragile state that Tuxedomoon found themselves in after *The Ghost Sonata* adventure. The band had recently acquired a TR808 rhythm machine and their first proper sequencer, a Roland Bassline, and Reininger's joke that these had been purchased to replace Principle didn't contribute to alleviate the terse atmosphere. [1]
'Blaine was in charge of the new rhythm machine setup they had bought to somehow replace me while I was at Saskia's after returning from producing the Central Unit LP, writes Principle. Did Patrick [*Roques*] mention this? [2] He called me at Saskia's and said: "Hey the band (Blaine and Steven) are in the studio here with Michel Duval [*Les Disques Du Crépuscule's boss*] who just bought them some gear and they are replacing you. You should come now to Little Big One studio! [3]" I flipped of course and caught the next train to Brussels and arrived in time to play some guitar on "The Cage" and "This Beast" and a version of "Birthday Song" which was never released (Blaine and Steven recorded this for a Blaine solo LP [4]). The guys weren't exactly happy to see me with the exception of Patrick...'

Each member of the group embarks on a myriad of solo projects, collaborations or productions. Considering the quite venomous intra-band relationships at the time, it is

(Post-)New Wave and dance music. In an article published in *Keyboard* of 06/82, Bob Doerschuk scrutinized the then prevailing beat in pop/rock music and interviewed some of the "figures" of the times (Richard Barbieri, Scott Ryser, Rachel Webber, Layne Rico, Martin Gore, David Ball, Chas Gray, Stan Ridgway, Scott Simon and Peter Principle): 'What many post-new wave bands have in common with earlier stripped-down rock groups is an interest in playing more for dancers than for listeners (…) performances by Orchestral Manoeuvres In The Dark, Depeche Mode and their brethren usually work best in the more traditional rock setting – hot sticky clubs jammed wall to wall with bodies leaping about to an irresistible 4/4 rhythm. These new bands pursue a familiar formula – heavy on the second and fourth beats, with compelling counter-rhythms from the bass and as little adornment as possible (…) disco influence (…) even the dreariest, most nihilistic lyrics shout out in post-new wave ensembles over a bedrock beat that should set the most danced-out feet tapping (…) To further this effect, many bands have turned from live drummers to rhythm machines (…) more frequently in the works of Soft Cell, The Human League, Throbbing Gristle, Tuxedomoon and (…) Suicide, digital boxes have replaced trap sets. Sound familiar? This is the approach pioneered by the German techno-rockers Kraftwerk (…) Any consideration of the new style must acknowledge Kraftwerk, especially in their fusion of disco and techno, as the movement's musical godfathers (…)
Principle: I don't argue against dance-oriented music with lyrics like that, because one of the blessings of rock and roll is the fact that it describes your problem and also gives you the solution, which is to dance away into a dervish delirium. A lot of the world is in that mood right now (…) We started out as a drone group, but we've never really used the sequencer trip, maybe because it's sort of a familiar sound. A lot of sequencer music really makes me angry. We've never had one. If somebody gave one to us, maybe we'd do something intelligent with it.' (B. Doerschuk, "The new synthesizer rock", *Keyboard*, 06/82)

Page 189

From end of 08/82 BLR and SB start to work on "The Cage" and "This Beast" pieces in the absence of Peter Principle

08/23/82 SB meets Benjamin Lew at a party organized for his birthday at Brussels' Papaye Tropicale café. SB starts to work on what will become the *Solo Piano Music (Music For Solo Piano)* and *Douzième Journée: le verbe, la parure, l'amour* albums (the latter with BL)

09/82 SB & BL release (Crammed LP, later Crammed MTM 15 CD in 1989) *Douzième Journée: le verbe, la parure, l'amour* with Marc Hollander guesting and BL/SB/MH/GM producing (recording at Little Big One Studio, Brussels): 1. "Bamako Ou Ailleurs" 2. "Passage" 3. "De L'Autre Côté du Fleuve" 4. "L'Ile, L'Hôtel" 5. "Aveugle, Depuis" 6. "Elle Avança" 7. "Dans Les Jardins" 8. "Les Autres, Tous" 9. "Il, Les Quitta A L'Aube." An excerpt of track 7 appears on Crammed's (various artists) *It's A Crammed Crammed World* compilation LP released in 10/84. Track 2 appears on Crammed's MTM 16 (various artists) *The Made To Measure Resume* compilation CD and cassette released in 05/88. Tracks 1, 2, 3, and 7 appear on BL's *Compiled Electronic Soundscapes* compilation album published as a Crammed CD in 2003 SB/BL will tour together (with Belgian drummer Alain Lefebvre), their concert series including a gig at Belgian cultural center in Paris (Centre Wallonie-Bruxelles)

A review of Douzième Journée. '(…) In spite of the use of synthesizers and rhythm boxes, this music does not sound mechanical: Steven Brown's saxophone and Marc Hollander's bass clarinet confer a warm sonority to the pieces and the use of strident noises and "found

no wonder that each member then plunged into solo works.

Some wrestling seems to have taken place between Brown and Reininger regarding *The Ghost Sonata* material, Brown capturing at least some of it to recycle into a solo venture.

Indeed Brown quickly recorded a version of "The Fall" (*aka* "The Cascade") after which the inclusion of any more *Ghost Sonata* material on his solo project was vetoed. [5] Brown's work then evolved into what would become his *Solo Piano Music (Sex And Sorrow)* LP which, due to further disputes, would not be released until some 18 months later. [6]

Steven Brown: "I wanted to do something acoustic with the piano because in Tuxedomoon it was getting pretty electronic and there was no piano. And I always loved the piano. The first thing I did was *Solo Piano Music*, which in the end had Blaine on it too. So it wasn't really solo solo but it came into being mainly because I wanted to do something acoustic, namely something that wasn't being fulfilled by the work with Tuxedo. So that was how it started. The first record was acoustic piano and violin and clarinet. Kind of the complete opposite of what the band was doing. Then when I did that I realized: "Hey I can do records solo!""

Reininger in turn arranged versions of three *Ghost Sonata*

Steven Brown, with Tong as an *ombre chinoise*. Photo Saskia Lupini

pieces ("Music # 2," "Licorice Stick Ostinato" and "Basso Pomade") to be recorded by the Flemish Chamber Orchestra and produced by Wim Mertens. These tracks finally added up on Blaine's *Instrumentals* mini LP released in '87.

Both LPs feature quite situationist cover art as they represent a diversion (*détournement*) of classical Deutsche Grammophon design. [7] Principle had originally come up with this idea for the cover of *Divine* but his proposal was then apparently vetoed by the rest of the group… soon to be soon recycled on these solo ventures.

Meanwhile Steven Brown had met a young part-time bartender named Benjamin Lew. [8] The encounter took place at La Papaye Tropicale (already mentioned as the place where Blaine & Steven started to perform as a duo), then one of Brussels' trendiest bars where Brown had his birthday party set-up on August 23rd, 1982.

Lew: "I finished a school of photography when I was 17 and then I moved to Brussels where I settled with two friends with whom I got involved in design and photography. I made some posters for the Plan K. Then I worked as a barman. Around that time I had started to work on music as the first affordable synthesizers came about, like the Korgs, that still had analog plug-ins. I started out alone in my little corner and didn't have any formal musical training, apart from two years of sol-fa. I liked to be tinkering around with sounds. Sounds always interested me more than the final outcome into a piece. These were the ambiences generated by sounds that interested me. I saw it rather as the labor of a plastician on sound rather than as the work of a musician to come up with a melody.

So I was a barman but I also published a fanzine called *Fossile* with some friends. It was the era of fanzines (…) We were doing a lot of cut-ups: cutting up the articles and assembling the whole thing with illustrations that we made ourselves. Once I made a flexi disc with my little Korg and inserted it as a cut-up into the fanzine. It turns out that Marc Hollander [*influential Belgian label Crammed Discs's main man*] got the disc and called me up on the phone to tell me: "We could do a single." I was delighted as I had thought I could do some experimentation in music but I knew nothing about the recording world. So I started to work towards that at home while I was a barman at La Papaye.

One day my boss at the bar told me: "There's this guy from a band who wants to celebrate his birthday here, so you have to come early to prepare some cocktails and whatnot…" The guy was Steven Brown. After the party, Steven stayed on at the bar. He asked me what I was doing in life apart from being a barman and I said: "Photography and a bit of music." He said: "I'd like to hear it." So he came to my place, listened

voices" (perfectly inserted by Tuxedomoon's sound engineer Gilles Martin) impart to the whole an organic, even primitive, undertone (…)' (J. Landuydt, "Benjamin Lew – Steven Brown/ La douzième journée/Crammed", *Vinyl*, 01/83, translated from Dutch)

An interview with Benjamin Lew.
'In the Crammed press package issued for the release of this LP it can be read that you play naïve synthesizers…
You can compare it with the naïve piano pieces from Erik Satie or with the naïve Rousseau paintings. Maybe the terms "primitive" or "simple" would have been more appropriate (…) Music must stay raw. In this way it can be way more direct and emotional (…) Music must be open-ended, it may not give you the impression that everything has been said (…)
The title, La Douzième Journée, calls for funny associations. It could be the twelfth day of the creation…
I carefully chose the title because of its funny resonance but it's not really related to the creation of the universe. I found it in a book by Marcel Griaule (*Dieu d'Eau*) about the Dogons. They are West African people with a very rich astronomical knowledge. From their mythology and paintings, it appears that they knew quite a bit about the star Sirius and its two satellites and this long before these were discovered by Western science (…) The title (…) suggests a funny aspect, centuries old values, the most refined aspects of a human being, what you want in the end. [*The titles of the pieces*] They refer also to Marguerite Duras, who also gave intriguing titles to her films: very concrete but nonetheless completely open-ended.' (J. Landuydt, "Een nieuwe vaagheid", *Vinyl*, 03/83, translated from Dutch).

to what I had done (I had gotten an eight track TEAC from Marc Hollander to make some tests) and he simply asked me if he could just play over it. I told him: "Sure!" with a big smile on. Later I called Marc Hollander who almost jumped to the ceiling. I had about 15 pieces, so Marc said: "We are going to make an album."

So we went in the studio first with Daniel Léon, who didn't have time in the end, so Gilles Martin got involved. Marc Hollander played on it as well. I was working on the bases, establishing the climates, and then Steven adapted or proposed. So I came up with lines – as I'm not a great keyboardist or a great anything – and then I let the musicians have their importance. I'm not interested in working with a fake piano or a fake sax. What I like is to work with real musicians and give them total freedom to express themselves." The final outcome was Benjamin Lew & Steven Brown's *Douzième Journée: le verbe, la parure, l'amour* that still stands out today as one of Brown's very finest collaborations.

Brown and Lew will also tour together, with Belgian artist Alain Lefebvre contributing percussion. "I worked with images on stage, says Lew, projecting films a bit like what Tuxedomoon was doing on stage but it was more about setting up an atmosphere, creating some interludes with films and photos. It had of course a very *amateur* side to it as we couldn't afford to have more people touring with us to take care of the visual aspect. So we had set up a system of loops on super-eight projectors, a bit risky but that also was experimenting and it was fun."

Lew soon became the manager of L'Interférence bar on Brussels's Grand-Place (a bar that was to Les Disques Du Crépuscule what The Hacienda was for Factory Records), and from this position he witnessed Tuxedomoon's early times in Brussels.

"When I met them, says Lew, there was this mythical aura about them. But then Blaine and Steven soon met a lot of people so this mythical side vanished quite quickly. On the other hand Winston remained very secluded. I saw him a few times because after La Papaye, I worked as the manager of L'Interférence and there I got to be in touch with Winston and Blaine quite often as they came to ask me for some advances or claim their due… Steven, it didn't take six months before everybody would greet him with friendly slaps on his back. So they lost their aura quite quickly – also Brussels is a small town – and they themselves became "Brusselized" in some way.

Also it was a dope period at the time when they were rehearsing at the Plan K and I couldn't stand it. There was a whole group of people around them, parasites, who were sucking all they could from them. I remember of a gig we did, Steven and I at the Beursschouwburg [*in Brussels*]. I had asked

A meeting with Steven Brown. 'The first contact is cold and distant. Like so many avant-garde artists, my interlocutor doesn't like to talk about himself: "Listen to our music and you will know everything about us!" This Yankee is not very funny (…) But he got carried away after a second whisky: Reagan had just appeared on the TV screen: "It's him who made us leave!" he snapped, ready to throw the bottle of Scotch on my TV set. He is pale and slender, almost sickly (…) This vegetarian looks like a wax mannequin from eating too many sandwiches, nuts and dried raisins. But his eyes flash vivid lights. There's something about him of the doomed artist, of a down-and-out. Steven Brown is now at his fifth Whisky: "I hate this sort of generalizations but I can't help finding the Belgians quite cold. It's hard to make friends here. Very few parties. People don't talk to you in the bars or at the clubs. At concerts, people recognize me but hesitate to approach me. I get the impression that I scare them." Result: Steven Brown lives confined in his ivory tower, listening to the radio all the time, reading a lot: "I calmed down here. The rhythm of life is less crazy" (…) And who is going to replace my bottle of Scotch?' (M. Rozen, "Steven Brown: nous sommes des réfugiés politiques de l'Amérique de Reagan", *Le Soir*, 1982, translated from French)

Page 192

Winston Tong with Bruce Geduldig as an *ombre chinoise*. Photo Saskia Lupini

for a bottle of vodka backstage. The bottle was already gulped when I arrived by the 15 or so flock of Steven's "friends." It was getting very very heavy. We never had an argument really but I told him: "You are dragging along a court of not really interesting people there, Steven." And true enough that their apartment Galerie de la Reine was full of people eating and drugging at their expense."

In October, it was Winston Tong's turn to go in the studio to record a book and cassette package for Les Disques Du Crépuscule titled *Like The Others*. Winston operated some sort of *mise en scène* of his poetry against a backdrop of music supplied by the rest of the band. The suite formed by "In A White Room" followed by the medley piece "Going Out Of My Head/For Your Love" has a truly hypnotic power whereas the title track, "Like The Others," possesses the quaint charm of a counting rhyme.
End of the month Winston and Steven Brown performed a nebulous Tuxedomoon installation/event at the ICA in London. Brown: "That was essentially a Winston Tong performance with me as added attraction. No music was played live as I recall. It was very strange on stage. I can imagine how it was in the audience."

Also worthy of note for October was Blaine Reininger and Peter Principle's participation in a short Les Disques Du

09/12/82 TM plays at *Fête Annuelle Du Drapeau Rouge* (yearly party of Belgian communist newspaper), Brussels (concert promoted by Jean-Michel De Bie)

09/17/82 TM plays at Studio 26, Montignie s/ Sambre (Belgium)

10/82 WT records (at Little Big One Studio, Brussels, with GM/ PP producing and with BLR, PP, GM, BG, Daniel Link and Willy Van Der Linden guesting) the following tracks: 1. "In A White Room" 2. "Going Out Of My Head/For Your Love" 3. "Like The Others" 4. "Comme Les Autres." Tracks 1-3 released as a cassette+book by Les Disques Du Crépuscule in 1983 and as a CD in 1990. Track 1 appears on WT's 12" *Reports From The Heart* published by Les Disques Du Crépuscule, Summer 1985. Track 2 appears on LTM's compilation LP (Various Artists) entitled *Minutes* (released 03/87) then on Inter's compilation LP (Various Artists) called *Minutes To Go!* (released end of '87 and as Interphon CD in 05/88). Track 3 appears on Les Disques Du Crépuscule's compilation album (Various Artists) *Crepuscule Collection 2: State Of Excitement* (released in 06/86) and on (Various Artists) *Homage A Duras* LP released as a LP by Inter (02/88) and as a CD by Interphon (05/88). Tracks 3/4 appear on the 7" released by Divine (01/83)

Excerpts of the *Like The Others* little *Crépuscule* grey book:

a little death
the story of an overnight success a singer in a band
who can't seem to make the connections can't make the
changes
you know the story
play now
pay later?
yeah
la dolce vita
la dolce vita
"China" he said
they reeked of paradise/uncommon knowledge
present perfection/the sublime
ease that comes with total recognition of being/easy victims
"human" he thought trying hard not to be negative about
the horrible way the customs officials were treating them
"yes it's me" he insisted when the passport photo
didn't match his face again
"I was older then" he said hoping to break the hot ice
but every word was further indictment every movement
more suspect every look of the eye increased proof of
their guilt/they could be in nothing but trouble here
"where are you from?" they asked again & he repeated
the answer a little more wearily knowing that his kind looked
all the same to them, that the subtleties of paradox
were to be eternally overlooked or misapprehended
by the occident
& he murmured "never the twain" under his breath
a stupid mistake
"what was that?"
"nothing nothing" he said biting his lip
when would he begin to remember the purpose of silence,
that purpling invulnerability
cloak of a seeming ineptitude
those calling themselves "friends" should die
"best" friends
in the most horrible fashion we can imagine
i would like to pay the way
tong(u)e of love
so long withheld now the irrepressible slams forth
damn all you asinine easygoers
fuck meditation fuck god fuck the clench
god you fuck
god you fuck
god you fuck
god
get me out of here
get me out of here
get me to another sphere
ruthless as i came
want to see the truth sans protection sans care
want to bite the air
xplode on contact
hopelessness
if you have it you have it all
o the splendor of a soul in transit

Crépuscule package tour, *Move Back – Bite Harder* (with 23 Skidoo, Antena and the Pale Fountains) during which they jammed on stage with Cabaret Voltaire. At the Brussels date (at salle Albert), they were joined on stage by Tong and Brown. The "clash of the Titans," as LTM Recordings' James Nice put it, resulted in the disappointing "Last Words At the Scaffold" track. Obviously no alchemical spark spurted out from that meeting and their lengthy improvised confrontation was released only years later (in 1990) on the *Like The Others* CD reissue.

A German tour in the Winter. After a handful of dates in the Netherlands (one of which, in Rotterdam, was immortalized on the Target Video *Four Major Events* videotape) and in Belgium, Tuxedomoon will set off by mid-December for a short German tour. This took place in the middle of a Winter so cold that a still freshly debarked from San Francisco Patrick Roques retained some "frozen" memories from this adventure.

'Bats in the belfry.
Winston and Bruce lived in the attic of two rue Keyenveld when I first arrived in Brussels. Katalin [*Kolosy*] had a flat there and they lived above her, hidden up there at the top in an unfinished room. It was like something out of Ann Frank. It wasn't the hi-tech loft or romantic artists garret I'd imagined I'd find when I got there. It was more of a storage room, for the bats in the belfry. I don't know how long they'd been living there or if they were just sleeping there on and off. Since Tuxedomoon was constantly working in the studio (on their various music and film projects), out carousing, debasing themselves or on tour no one stayed "home" much. Home was for people who had no lives. Or in Blaine's case, he just never left home. He was kind of a shut-in.
As it turned out Katalin and I didn't get along when we first met. After a few days it was time for me to leave rue Keyenveld. Steven finally helped me find a more permanent place to live, he had invited me to Brussels in the first place... He introduced me to Martine [*Jawerbaum, Tuxedomoon's future Belgian manager*]. She tolerated me a little better. She had a sort of posh place and a dog, Buster who ate better than all of us, even Martine. Plastic Bertrand lived next door and there was always lots of 14 year-old girls hanging around. It wasn't bad there, a little out of the way. There was a bar nearby called the Montana where you were encouraged to speak English and eat hamburgers. Really shitty hamburgers. Blaine liked it there, he could indulge his "Homesick for American fantasies." I don't think the people a the Montana liked us. We weren't TV Americans. Heroes with crew cuts. There was a one-handed slide guitar player who performed there on weekend nights. I remembered him from when he used to busk down on

Steven Brown and Winston Tong. Photo Patrick Roques

Market Street back when we all lived in San Francisco. He was like a rock star now, playing in the Montana bar. We couldn't touch him. He really could play wailing blues like there was no tomorrow. Tuxedomoon used a "drum machine" and played a violin so they were therefore not real Americans. We finished our beers and went "home." Tuxedomoon were outcasts even in fake America.

Leaving Brussels.
By the time we started the German tour it was too late to turn back. We had probably spent the advance. We were becoming mercenaries by this point. It was a week before Christmas and Russian Front freezing cold. Our hippy-dippy promoter sat outside two rue Keyenveld in his battered, smoking 1962 VW van with no heater and doors that would fall off if you moved around too much, not likely since we all ended up huddling for warmth. I remember that there was a puddle of melted colored candles on the dash board. That was the only source of light at night to read the map by. I wanted to kill this guy. Turns out he was a masochist, so in a way we got along.

As usual we are late leaving. We were waiting for Bruce who's been up in the attic room doing some last minute packing. People started yelling up. By the way, people don't "yell up" in Brussels, not unless they want to have your knifes sharpened at five thirty in the morning, very quaint by the way... Finally I go running up to see "just what the fuck is going on." Bruce

Some handwritten notes by Winston Tong, circa 1982: 'What once was was no more what seemed a new turn of terror in the night was gone & left in its wake the inexplicable absence of action – perhaps no more than momentary derision of a will made bold by countless hours of nocturnal abandon. Loneliness will make a leopard out of any (...) of neglected spots given the proper conjunction in the penumbra. Witless as you were at birth you pounce on any moving shadow with a terrible mute hunger conjure the accompaniment of a precise howl made audible only by the faultless injury of remembered habits of pain, the slow hours spent in what seems some former life stalking the inevitable bounty of remorse the perfect food for a creature of self corrupted ability so crippled by indulgence that it can no longer even hope to dismember itself should it ever find the strength to consider a stealthy suicide, the bitter romance of a well educated polecat – is life even as stunning as this say for an illiterate housecat even given the predilection of felines to fancy & vice to verse. Is somnambulism the only way out of this catbox?'

Anna Domino about Winston Tong. 'I got to Daylight studios as Winston was finishing *Like the Others*. I think it is one of the best things he's done and he just came up with it, like that. Then someone suggested doing a monolog for the B-side and once again he just did it. He gave me many tips about doing interviews and how to move on stage. I think he really practiced somehow so when he was on things came out, seemingly effortlessly, just the way he wanted them.
Once I had a bout of drug sickness and Winston came over, helped me take care of myself and walked all the way downtown to get me food once I was able to eat. He was erratic and would sometimes do anything for money or drugs but then, when you really needed help – who shows up?

Winston moved into a flat I'd been in when I moved into my studio. All he had was bags of black clothes and the two handmade puppets he'd used in *Frankie and Johnnie*. Everything for Winston had to be black down to the cigarette pack and lighter. He would stay up every night arranging and perfecting his collection of black. After he left there was a pile of his belongings on the Crepuscule floor – empty black suits with the puppets sitting on top. Eventually it was all taken.'

10/03/82 TM plays at Beursschouwburg, Brussels. The gig was photographed by Philippe Carly (see http://www.newwavephotos.com/TuxedoMoon6.htm)

10/05 & 08/82 BLR and PP participate to Les Disques Du Crépuscule's short package tour *Move Back – Bite Harder* (with 23 Skidoo, Antena and the Pale Fountains), jamming with Cabaret Voltaire at Salle Albert, Brussels (photographs by Philippe Carly at http://www.newwavephoto.com/TuxedoMoon7.htm), with WT/SB joining for the 10/05 date. It is at the 10/05 date that the jam with Cabaret Voltaire will be recorded and later released as "Last Words At The Scaffold" on the Les Disques Du Crépuscule's (WT) *Like The Others* CD Version (1990)

10/07/82 TM plays in Leuven (uncertain)

10/16/82 TM plays at Paard van Troje, The Hague

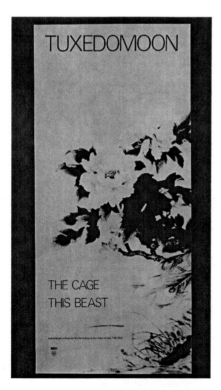

A poster for the release of the 12" The Cage/This Beast by Les Disques Du Crépuscule

is frantic. Spinning around in the middle of the cramped, low ceiling room. "I can't find my fucking sweater!" We started searching around. The place is trashed. It's only a 10 square feet space, how can you lose something in it. Exasperated I look up at Bruce who is staring at the mess under our feet. "What color is your sweater?" "Dark blue," he said. "It's tied around your fucking neck, you maniac. Let's go!" He'd probably had that sweater tied around his neck for hours.

Reluctantly we piled inside that freezing van, feeling like bodies into a morgue, and headed out into the blizzard swept hinterland's knowing that the worst was yet to come.

From Munich to Dachau.

Hours later we arrive in Munich frostbitten and sick. As it turned out the show that night was not in Munich but "a little ways outside the city in Dachau." Dachau? Now that has a certain familiar ring to it. Dachau, fuck, that can't be right. It was a sobering moment. "Where?" I asked. Smiling at my confusion the promoter assured us that Dachau was in fact a small, beautiful village nestled in a magic Bavarian forest. "What? Ok..." We would drive out, do the show and come back to our warm fluffy hotel beds and get a warm, well deserved good night's sleep. German hotel beds can be very nice. Nice blankets. I stole a lot of hotel towels while I was there too. The Germans make nice towels.

Driving out of Munich it began snowing big, beautiful, floating Kris Kringel snow flakes as we slipped out into the darkening pastoral beauty of the German countryside. Christmas was just of few days off and the twinkling of the colorful holiday lights festooning the distant cozy cottages was hypnotizing me. Suddenly looming out of the twilight was the black walled skeletal remains of the infamous death factory, Dachau. It was as if a giant hand had reached out and slowly brought our tiny caravan to a halt at its gates. We stared out the windows in silence. This was the first time any of us had seen a Nazi concentration camp in person. Soulless and decaying on a dark, deserted country road in the middle of nowhere. Snow falling around it. "They leave it up as a reminder of the atrocities," the promoter somberly informed us. A black hole of anti-matter looking like a bashed-in skull. "Abandon hope all ye who enter here." We drove on slowly.

I was driving the van and got us lost. It was getting late. The night was clear, crisp, and dark as hell. Somehow I got wedged in trying to turn around on a small arched stone bridge. The roadway was solid ice.

We are all standing around grumbling — with our hands shoved deep into the pockets of our WW II Belgian army surplus overcoats — arguing over what to do next. Then we heard voices. Turning around we were surprised to see jolly Saint Nicholas sauntering over the bridge smiling, drink in

hand. Following behind him was his joyous red faced wife and a few other clamoring hearty souls. Behind them a soft-focus snow covered cottage bedecked with glittering Christmas lights, windows blazing with golden candles. There was a roaring fire. The smell of smoke from the chimney mixed with fresh pastries baking. Round men in red suspenders. Women wearing milkmaid bonnets, flour on their aprons. Ruddy cheerful holiday faces. The Christmas tree shining, twinkling at us through the open wooden doorway, beckoning: "Come in friends all of these fine gifts are for you..." Was I hallucinating. A 19th century Christmas card had come to life.

Within two minutes of reaching us Saint Nic had spun the van around with just one hand as easy as a child spinning a top. Waving goodbye they shouted "Fröhliche Weihnachten!" as they scurried back down the path to the warmth of their cosmic gingerbread abode [der Winteraufenthalt]. "Thank you!" we said. These folks where obviously professionals. They where from Dreamland after all. Accordingly we had gone from the Inferno to the land of the sugarplum fairies in five miles. The irony was noted by all with silence.

I'm not sure we saw the promised Magic Village but we saw the muddy parking lot of the ramshackle Bavarian roadhouse sitting in the middle of a cow pasture that had been taken over by raging punk squatters that Tuxedomoon were soon going to play a really fucked up show in.

The first person we ran into was a hulking hardcore punk who — to prove he liked us — smashed a very thick glass beer stein over his head. Great. He said he was not a Neo-Nazi. I don't think Steven really believed him. There were also a couple of very old guys at the end of the bar. Pickled ex-Nazi bar flies or maybe alcoholic concentration camp janitors? Steven demanded lighting rigs and the screens for the film projections. The Punks explained that this is a Punk club. Fuck the details. Just do the show. This is a 15x30 foot meat locker littered with six or seven broken chairs with a single light bulb hanging over the stage, the rest are bright neon.

Sturm Und Drang. Winston picked up on it right away. He saw the possibilities, turn it into the Wild Boys burned out bunker. Bare bones. Get crazy with it. And it was Winston the noble ghost who stole the show. First strutting the stage like Lola-Lola the Blue Angel. Intense, sadistic. Then a Chinese Jacques Brel convulsing in his sweat soaked tuxedo, vomiting at the side of the stage, waiting for his encore. Now Billie Holiday, fingernails chipped, stale cigarette, a smoky shower. Next, Egon Schiele masturbating in a brown paper bag. Dancing like a spastic prize fighter, shadow boxing the demons of Dachau. Meanwhile the psychopath in red suspenders and buckled black jack boots beats out a ragged splintered rhythm with the broken leg of a chair.

10/17/82 TM plays at Hal 4, Rotterdam. The Target Video (*Tuxedomoon: "Four Major Events"*) features an excerpt from that gig (a great version of "59 To 1")

10/21/82 TM (BLR, SB, PP, WT) record (at Little Big One Studio, Brussels, TM producing and GM engineering) "The Cage" and "This Beast" released as a Les Disques Du Crépuscule 12" (*Short Stories*) in 04/83. These tracks will later be re-released on Crammed Discs (Cramboy)'s *Suite En Sous-Sol/Time To Lose/Short Stories* CD (09/88) Note: Brown got the inspiration for the song named "The Cage" from a gay bar/night club located in Brussels and named "La Cage"

10/26/82 TM plays at Grand Theater, Groningen

10/30/82 SB & WT play at ICA, London for a "Tuxedomoon Event," sharing a bill with Glenn Branca (a recording of this performance is available at the UK Sound Archive: http://cadensa.bl.uk/)

The travails of Nigel, a fan from Scotland, in his attempt to attend the ICA performance.
'As a pimply, doped-out teenager at the end of the seventies, I worked in a (now-defunct) record store on the Royal Mile in Edinburgh. At the bottom of the food chain there, I spent days on end in a dank basement destroying records to send back to distributors for credit – dropped multiple copies of Abba, Rod Stewart, Boston etc... into puddles of water, leaving them stacked against radiators, tearing and bending sleeves, scratching vinyl etc...
Amongst the piles of dross awaiting destruction, for some inexplicable reason, one disc stood out and was set aside for a final listen to pass the time of day – a thick black card sleeve with no label information – Tuxedomoon's *New Machine* twelve-inch. A single hearing blew me away and the disc was swiftly removed from the pile, taken home and played repeatedly for anyone who would listen.
UK press for T'Moon was minimal, I didn't even know what they looked like let alone how or why they made the music they did but I was hooked, swiftly tracking down an import copy of *Half Mute* and eagerly devouring "Special Treatment" and *Desire* as soon as they were released.
Sometime in 1980 or 1981, I discovered that they were due to play at London's ICA. Persuading my girlfriend that this was an event not to be missed, we spent twelve hours on a freezing-cold overnight bus, then all day wandering around London with no money and nothing to do. By the time we arrived at the ICA we were totally knackered and slumped down in a corner for a quick snooze before the show. I became dimly aware of two men on stage, slide-projections, saxophone, electronics, sketching on plates of glass… Exhausted, I paid little attention, and was gutted to hear a track I recognized closing their brief set – without being fully aware of it, I'd just missed Steven, Winston and Bruce (I think) performing a Joeboy-style improv set.
My worst suspicions were confirmed when, an agonizing several minutes later, a new headlining act took to the stage – a bunch of guitarists, probably Glenn Branca et al, I can't remember. All I can recall is them being so LOUD that they completely cleared a packed room in less than twenty minutes. By that time, I was past caring.'

From 11/82 until Spring '83 SB records (Little Big One Studio, Brussels with SB/GM producing, BLR guesting) his *Solo Piano Music (Sex And Sorrow)* LP: 1. "Piano # 1" 2. "Waltz" 3. "The Ball" 4. "Hold Me While I'm Naked" 5.

Page 197

"Close Little Sixes" 6. "Fanfare" 7. "Egypt" 8. "The Fall" 9. "Fantasie For Clarinet & Violin" 10. "R.W.F." 11. "Rotterdam Lullabye." This LP will be released by Another Side (a Crépuscule sub-label ran by K. Kolosy) in the Fall of '84. It will later be re-released as *Music For Solo Piano (Sex And Sorrow)* by Les Disques Du Crépuscule as a LP in 06/88 and as a CD in 02/90. Finally it will be re-released by LTM in 2004, as *Music For Solo Piano* with the following bonus tracks: 12. "The Ghost Sonata # 1" 13. "The Ghost Sonata # 2" 14. "Music # 2" 15. "Basso Pomade" 16. "Licorice Stick Ostinato" 17. "Music # 2 (Reprise)." Track 2 also appears on *Subway To Cathedral*, a SB compilation album released as a CD by Arteria Records in '99 and on *Decade*, a SB compilation album released by LTM in '02. Track 3 also appears on the (Various Artists) *Operation Twilight: Crepuscule Instrumentals* LP released by Inter in '88 and on the *Subway to Cathedral* compilation album. Track 5 and 10 also appear on the *Decade* compilation album.

Track 10 is dedicated to Rainer Werner Fassbinder who had just recently passed away. Steven Brown: "(...) he died at the time I was doing this record (...) it was such a shock when he died, he was such a tragic fellow. I don't know how to explain why I like this maniac's work (...) but the bottom line is that his films are so morbid (...) I guess that's why I like it, anything good has to make you sick, like "Theater of cruelty" right, you have to shake people out of their sleep (...) At least he did it: he shook people up and spoke from the heart" (K. MUYLAERT & C. WINDELS, "Brussels – California", 12/84)

Some reviews for Solo Piano Music (Sex And Sorrow). 'On this record, contrary to what the title of this album suggests, three instruments have the lead role: clarinet, violin and piano. The three clarinet compositions (together on one side), thanks to their repetitive character, will quickly have a bewitching effect, like in "Fantasy For Clarinet & Violin." The tension induced by the fragile duet between clarinet and violin/piano bringing about melancholy, is missing on the seven piano compositions that compose the other side of the album (...) The real strength of this album resides in the use of the clarinet and violin. Maybe could the title still be changed?' (L. IJZERMANS, "Steven Brown/Solo Piano Music", *Vinyl*, 06/84, translated from Dutch); 'A secret journey, where all is but only... ideal music. Like a sonic omniscience embracing in one single album centuries of music. There is no recipe, Steven and Blaine are unlacing all the strings, of music and genres. Music/paradox: troubling/light, quaint/learned. Well-being/nostalgia...' (J.P.E.D., "Music For Solo Piano", *Open System Project*, 09/84, translated from French). See also the reviews for *Night Air* below

The purple hell.

Exhausted. Back in Munich around three a.m. Winston, myself and the Anarchist booking agent found ourselves alone needing a drink. A warm Brandy or Cognac, something nice to take the deep winter chill off. Some place we can go relax and gather our wits. The Anarchist suggests a place not far from our hotel, a penthouse bar at the top of a mini skyscraper. Off we went.

Riding up the elevator De Palma's *Dressed To Kill* flashed through my mind. When the doors slid open we were confounded by a electric madhouse. A *über* euro-trash hell of glittering excesses. Stunned, we recoil in horror. The disco was deafening. We had landed on planet Coke Whore where ten thousand faked multiple orgasm had come to life like a bomb. Populated by fur clad pre-mature ejaculating, wife swapping corporate middlemen with flavored condoms in their wallets. A rotating dance floor of hysterical, distorted faces reflected in sex shop mirrors, chrome, smoked glass and blue light. Wrapped in a million miles of purple naugahyde. How many naugahydes did they have to kill to build this monstrosity.

The sight of Wolf Hounds gorging on bowls of raw meat was not very appetizing. A small, nervous poodle was yapping and humping at a drunk woman's high heels. A loud, square headed man with a geometric hair style lobed a chunk of raw meat across our table to his red-faced friend who fed it to his slobbering bulldog.

Walter Gropius would have committed suicide in this place.

Our drinks arrive. Winston takes a sip. We leave. We sleep in our fluffy beds. There is no room for nightmares. A day in Dachau. A night in purple hell.

The road to Berlin.

"There are now two new ways," he said. "This is the last, the third way." The third way seemed to run through No-man's land. It's a narrow road of deep pot holes that keep the speeds down, like land mines. I was told that if you drive too slow snipers could appear. Drive too fast and you may never get there at all. It was pitch black. Rusted, illegible road signs loom up out of the darkest. 1949, 1948, 1947, 1946, 1945, 1944... every 20 kilometer is a year back in time. The cheerful holiday lights of the West with its high speed *autobahn* are forgotten, left behind. "Don't stop, Gilles says, it's not a good idea." Precisely, after all we had been detained for hours at the boarder. French soundmen should always remember to bring their passports when entering the Eastern Block.

We need gas, to take a piss, some food. Blurred gas station in the rain ahead. A decaying outpost. We pull in. We've landed, Blue haired invaders from the mutant future. Americans stinking of money and drugs. A dilapidated car sits near by, the doors are made out of plywood, its rusted body hand-

painted in patches of sky blue and bright yellow.

There is a commissary on the other side of the road, over a cement walkway 300 yards away. It looks like a concrete airplane hangar. Winston and I entered through a side door. The room is cavernous. Looks like a life-sized black and white silver gelatin print of the last prison camp on earth. It's filled with motionless souls bundled up in grey overcoats, hats and scarves eating their grey soup. Steam, sweat and the stench of boiled meat and cabbage. Winston goes to take a piss.

Outside sits in a brightly lit Carny trailer. East Germans are buying boom boxes, fake gold chains and huge bags of pretzels with what looks like Monopoly money. We find Blaine there happily speaking broken German with the Barkers and black marketers. All sales are final.

We crank the heat up in our recently rented Audi and navigate slowly towards Berlin.

Purgatory be damned. We're on the road. Steven is filming it in super-eight.

[the roadway is paved with tombstones]

Flyer for Tuxedomoon gig at Plan K, Dec. 4th, 1982. Courtesy of Annik Honoré

11/82 BLR/SB record "The Ghost Sonata" and "Music # 2" for the RTBf (Belgian French-speaking radio)

11/12/82 TM plays at Surplus, Hasselt (Belgium)

11/23-27/82 WT/BG in *Frankie & Johnnie: A True Story* at Plan K, Brussels

12/04/82 TM plays at Plan K, Brussels, for the end of the year Party of Antenne Rose (Brussels gay radio)

German Winter tour:

12/11/82 TM plays at Batschkapp, Frankfurt

12/12/82 TM plays at Zur Post, Munich (in fact near Dachau). Helmut Josef Geier (later known as DJ Hell) was in attendance: "It was amazing but it was more like a punk area and it seemed to me that Tuxedomoon did not really want to be part of it. I was in the back, not in the front because there was a lot of action as I remember. People were kind of dancing crazy. There were some fights also…"

12/15/82 TM plays at SO36, Berlin

12/16/82 TM plays at Graffiti, Hamburg

12/17/82 TM plays at Alte Mensa, Cologne

12/19/82 TM plays at Logo, Essen

Bavaria. "The best thing about Bavaria is the beds. I must get me an Eider down. Met a guy named Darius from Germany near Bremen, Bavarian father, French-German mother. Cheerful dinner conversation. Takes the viewpoint that he is happy to see people with all the money and the technology doing such shit, meaning that there's still time for the rest of us. He also says he knows the guy who stole our videos, photos and carnet in Bremen. He says the town is known for its crazies, its "fan-attics" who will break into your house to steal our Tuxedomoon records. He says he has a single of Winston Tong that he doesn't even tell anyone about. He says he's gonna give us our videos back and…' (read by Steven Brown from his private journals, the entry bears no date as seems to be mostly the case for Brown's journals).

About Berlin and traveling in Europe in the eighties. Steven Brown: "Every time we went to Berlin, it was a nightmare…. Hours in line, you know: you've been there… Hours in line and they look at you and they look at your passport and they look at Winston… It took us hours to get into East-Germany. And then you're on the highway and there's control everywhere and they stop you and, you know, the cameras… Just a nightmare…. Well all of Europe was like that, it was just that East-Germany was a little bit more extreme…"

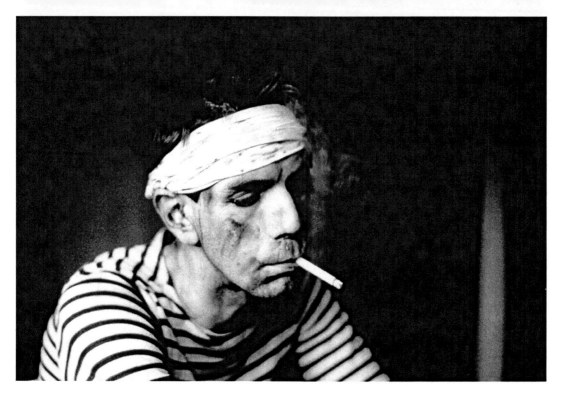

Peter Principle, "Karl Marx With A Lump Of Coal." Photo Saskia Lupini

Late night.
The snake pit. We are inside a gigantic ball bearing. Gareth [Jones] is striding around in lederhosen, fingernails painted in red high gloss polish. This is soundcheck in Berlin. Dear Mr. Madman do you know were I can get some speed? No. That's impossible I'm told.

Peter brews up a concoction. Snorting, hollow head. This shit smells like stale perfume and motor oil. "...holds over 50 million people, even when it's empty." What was that? Did you say that the pharmacist who made this was murdered?

Bruce climbs the ropes and riggings, swirling in warped skeletal figure eights. "Trying to raise the main sail old man!" Suspended 100 feet above the stage. Feet bleeding. Duct tape and a switchblade. Tools of the trade. The crows nest sways just out of his reach. Finally the sails unfurl. The ship buckles and creaks. Near collapse, he comes down.

Curtain call. 1,000 ball gowns soaked in gasoline go up in flames. Stage door Johnnie needs a fix. Looking for a cat burglar with a pocket full of glass.

Outside sick and shaking I'm pissing into the freezing wind and rain. I want to jump into the river. Is that a river or a parking lot?

Backstage little miss angel dust takes off her shirt. The pit is filling up. Rolling from side to side.

On stage Blaine is crouched under his contraptions, a discarded jumble of arcane electronic devices. He is twitching in slow motion, a cantankerous, menacing mechanical bird.

Hunching than prancing, black eyes like shattered marbles. Terrified and blind he pokes and prods at broken switches and hot wires. He shrieks and mumbles. He waves off unseen attackers, arms flailing, broken fingers splayed, distorted talons. He's crossed over. All communications are down. The machines start dying. We watch helpless. We will wait. a minute, an hour, a day, a year, forever, who knows, who cares. We've seen it all before.

Winston, the *prestidigitateur* is getting frantic, roaming the stage, frock coat flying. A magician with a thousand secrets hidden in a thousand secret pockets. Ageless man. Ageless woman. Chinese eyes start to melt under the limelight. Is it the fakes or the faker? Tonight he's the paranoid object of unwanted affections [afflictions?]. Desire, Winston this song's for you.

Steven sleep-walks in his thrift store suit and bowery boy shoes. Licorice stick pressed to his lips. He's the priest, bastard son of Benny Goodman. Forever Aschenbach in search of Tadzio. Tonight it's 1930 and life is a Cabaret old chum. With his Head hung down, right profile, he's conjuring the holy hallucinations of Howl. Out in the pit vultures become swans. Alchemical Peter, bass in hand stands silent in the shadows, eyes peeled, Karl Marx with only a lump of coal in his pocket. Blaine like Doctor Frankenstein on Valium's flips a switch and finally the noise begins.'

Tuxedomoon records a soundtrack for Dutch alternative film-maker Bob Visser's film Het Veld Van Eer (Field Of Honor). It was in 1982 also that Tuxedomoon collaborated for the first time with Dutch alternative film-maker Bob Visser: 'I met Tuxedomoon during their time at the Utopia commune. I was then making the post-punk programme named *Neon* for the Dutch VPRO television. I then shot a little super-eight film there with Bruce Geduldig on a beached wreck. Unfortunately this footage got lost. In 1982, I made my first feature film, *Field of Honor*, about a honeymoon trip at the WW I Verdun battlefield. Tuxedomoon scored the music [*i.e. the tracks named "Fanfare," "No One Expects The Spanish Inquisition" and "Driving To Verdun"*] for that one. After this Bruce worked on one of my other programmes: Tape-TV, that was a collection of clips and video-art. That was in 1984 for VPRO TV.'

The three *Field Of Honor* tracks will later be featured on the first volume of the celebrated Crammed *Made To Measure* series.

Michael Belfer arrives in Brussels. About Christmas '82 saw Michael Belfer's arrival in Brussels.
What made you go to Europe?

End of '82 TM records in Brussels for BRT (Belgian Dutch speaking radio) the following short intermission pieces: "Jingle # 6," "Jingle # 7" and "Jingle # 10," all appearing on the *Pinheads On The Move* compilation album (Crammed, Cramboy, 1987)

End of '82 PP produces (with GM, SB guesting on pieces 1 & 2) Minimal Compact's soundtrack for a Pierre Droulers ballet named *Pieces For Nothing*: 1. "Bat-Yam" 2. "Too Many Of Them" 3. "Immer Vorbei" 4. "Animal Killers" released on MTM vol. I, Crammed Discs LP '84, re-released as a Crammed Discs LP/CD in 1988

12/82 TM (BLR, SB, PP) records (at Little Big One Studio, Brussels, with TM & GM producing) soundtrack music for Bob Visser's film *Het Veld Van Eer (Field Of Honor)* : 1. "Fanfare" 2. "No One Expects The Spanish Inquisition" 3. "Driving To Verdun." All tracks appear on (Various Artists) Crammed Discs' MTM, vol. 1 LP (released end of '83) and re-released as LP/CD in '88

12/82 TM record their last demo with BLR , with: "The Birthday Song" (later featured on BLR's *Night Air* album, 1984); "Watching The Blood Flow" (later featured on and TM's *Holy Wars* album, 1985); "Heaven And Hell" (this track was finally released by Crammed Discs in 2007 on the *Lost Cords* CD forming part of the *Unearthed* double CD/DVD included in TM's 30ᵗʰ Anniversary *7o7* box set)

Page 201

Make-up time. Photos Saskia Lupini

Belfer: "I had worked really hard with San Francisco band The Sleepers for the previous couple of years. We were doing a tour on the East Coast and while we were on that tour, the band self destructed. The singer wouldn't stop taking large amounts of drugs and alcohol and would be showing up at the gigs completely wasted and we were being threatened by all the club owners of the places where we had gigs. They were threatening to cancel the shows. And this really upset the drummer and the bass player (they were brothers). The bass player was a pretty straight guy and he couldn't tolerate that.

They quit while we were in the middle of the tour. The guy who was putting out our record fucked up with it and couldn't release it. Patrick [*Roques*] had booked this whole tour for us and was coming on the road with us, to be a tour manager. But the record wasn't coming out.

The guy, Eric, who owned the record label followed us on tour even though we had fired him and ended up causing all these problems. He followed us around with a guitar – he couldn't play the guitar – and then pretended he was playing with us, so they would let him in the clubs. We weren't talking to him, we were so mad: "Why didn't you put out the record?" At one point he had nowhere to stay and he gave my girlfriend's neighbor money for drugs so that she would let him to stay in his apartment. So I found out that Eric had become my neighbor in Manhattan and he still had the guitar.

One day, the girls told him that's it, you have to move out because it was upsetting me so much. He said : "Ok, I'm going to look for a new place, can I leave my guitar here in the meantime?" We said: "Yeah" and he didn't come back later and the girls got antsy: "Let's go sell his guitar." So they took his guitar and went up to 48th street to the pawn shop and they sold it without me knowing about any of this.

I went back home and the phone rang. It was Eric: he had my neighbor and my girlfriend in jail and he was pressing charges. The only way he was going to drop them would be for me to come up there and bring my guitar for these two girls. I got the cop on the phone who told me that if I could do anything to help those girls, I'd better do it because it was Friday and they were going to send them to this really bad prison of which they wouldn't come out until Monday or Tuesday and then they wouldn't be the same persons again. I couldn't believe that this was happening because I'm left-handed and so my guitar is backwards, like I couldn't use anybody's guitar. Anyway I didn't have anything else to do, so I took a cab to the police station and Eric was with Heather! [*i.e. Paul Zahl's ex girlfriend: see Chapter II*] Heather was his girlfriend, I couldn't believe it. I gave him the guitar and he released Kim and Ryan.

At that point I was like nothing was going to stop me to finish up the tour. I didn't care that the rhythm section had quit, now this guy had taken my guitar and we still had three really important shows to play, club 57, Mudd club and this place called Hurrah's in Manhattan, where Tuxedomoon had played before. So we did all the shows and it was time to go back to California. I had had to borrow a guitar to finish the gigs and I had to play it upside down for the last shows. But it was so important to me that The Sleepers would finish what we had started.

We did get a bit of press and attention but then the band broke up. Nobody would even sit together in the plane. When we landed in San Francisco, people didn't even say good bye to each other, everybody went their separate ways.

Then not too long after that I ran into Winston Tong. Winston asked me if I would come with him to Europe to work on some new Tuxedomoon music. It just seemed like such a great idea because there was nothing for me here and the project that I had been working on so hard had just gone. I looked at it as an opportunity to continue to be doing some work. I was at a point of my life that when anybody wanted to do some recording, I'd go and do it.

So I left and I ended up in Gilles Martin's apartment sleeping on the floor and Winston telling me how great it was going to be. So I got there and it was like not at all what he described. Winston got busy, ringing around with some of his friends. I tried to contact Patrick and his response was: "Why did you come over here?" You know like: "We'd left San Francisco to escape some people like you and now you're coming over here!" He wasn't friendly at all at that time.

The only person who was very positive was Blaine. Blaine and I always have gotten along. He was just happy to have a new person over there because the social circle they had was very small. Blaine didn't talk with Peter that much. He didn't talk with Steven that much. He probably was the most welcoming person once I got there.

Steven seemed to have no opinion, he was kind of curious. He was like: "Why did you come, did somebody invite you over here? Winston told me you wanted to come over here, that you have all of these things that you want to work on with him…"

It ended up to be total bullshit. I never did anything with Winston. I think he just wanted company on the plane from San Francisco, he didn't want to take the flight by himself. I really had to fan for myself, man, once I got to Brussels, like nobody was going to hand me a gig. Certainly not Blaine or Steven. I believe they still had some attitude about me because in San Francisco I would go in and out of the band. Thinking back on it there's nothing wrong with that. It was

kind of curious all of their attitudes…"

Belfer was precluded from rejoining the band for another term [9] but he was with Tuxedomoon on their following 1983 tour and furthermore started to tour and work a lot with Reininger on the latter's solo ventures.

Tuxedomoon turns down an offer made by Les Disques Du Crépuscule to record an album with them.
Tuxedomoon had been without a label since the Ralph/ Celluloid disaster. This situation had its advantages as they could work on several projects with a handful of small independent labels still enjoying the freedom to go with whoever they liked. However, as Winston Tong put it: "It is becoming urgent for us to sign with a major label, as we don't have the means to produce an album. This is why we are solely making EPs." [10]
Apparently an opportunity came and went with Les Disques Du Crépuscule. According to James Nice: 'Towards the end of 1982, Crépuscule struck up a marketing deal with Island Records in London, initially to shoulder the expense of kickstarting Paul Haig's solo career. Unsurprisingly, Michel Duval was keen for Tuxedomoon to record an album under this arrangement. After all, despite being the biggest name associated with the label, all the group had given to Crépuscule in the past year were three singles, the British rights to *Divine*, and a slew of lesser solo projects.
Brown and Reininger held a formal meeting with Duval, who offered $25,000 dollars for the project. Yet although this amount was double the budget assigned to *Desire*, Brown apparently considered it too low. In contrast Reininger was keen to sign, as apparently were Tong and Principle, although neither was properly consulted. Yet since Brown held sway over the rest of the band the proposal was vetoed.' [11] However, it is not certain whether the acceptance of this proposal would have led to a break-through, as Nice himself admits: 'Whether or not the band would have broken big given access to such a budget and marketing push is debatable. Neither Paul Haig nor Antena achieved any real success through Island – two acts with infinitely more mainstream potential than Tuxedomoon.' [12]
However the rejection of Les Disques Du Crépuscule's offer fueled Blaine Reininger's resentment and growing desire to leave Tuxedomoon to pursue his solo career.

1983: French tour including a fateful date in Dreux, after which Blaine Reininger states his intention to leave Tuxedomoon; Martine Jawerbaum becomes Tuxedomoon's manager and Luc van Lieshout becomes a member of the band; Blaine Reininger records his second

Around xmas '82 MB arrives in Brussels, accompanying WT on the plane back from SF

Some time in '82 SB records, probably at Little Big One Studio, with SB and GM producing, an audio trailer for the film *Chinatown* (dir. Roman Polanski) adapted from the original theme by Jerry Goldsmith. The track "Chinatown" appears on the (various artists) *Crepuscule Collection 2: State Of Excitement* LP released in 06/86 and on Steven Brown's *Composés Pour Le Théâtre Et Le Cinéma* LP/CD released by Les Disques Du Crépuscule in 01/89

End of '82 TM turns down a deal proposed by Les Disques Du Crépuscule to record an album with them

1983

Some time in '83 TM records a demo of a track entitled "Somnambulist" featured on the *Lost Cords* CD, part of the *Unearthed* double CD/DVD included in TM's 30ᵗʰ Anniversary *7o7* box set released by Crammed Discs in 2007

Page 205

01/04/83 recording (Brussels, Studio 4 of the BRT: Belgian Flemish television) by the Flemish Chamber Orchestra (under the direction of Arie Van Lisbeth, arrangements by BLR) of the following (*Ghost Sonata*) pieces: 1. "Music # 2 (Reprise)" 2. "Licorice Stick Ostinato" 3. "Basso Pomade (Dogs Licking My Heart)." All tracks appear on BLR's *Instrumentals* mini LP, Inter '87. Track 1 appears on (Various Artists) *Operation Twilight: Crepuscule Instrumentals*, LP released by Inter in '88. All tracks later appear on LTM's re-release of BLR's *Instrumentals* and on LTM'TM compilation album entitled *Soundtracks/Urban Leisure* released as a CD in 2002

solo album, Night Air.

Considering the peculiar atmosphere in the band since *The Ghost Sonata* adventure, it was also in a peculiar state of mind that the band set off for another French tour. Brown: "There was a lot of tension in the group. It didn't go down very well. There was always this conflict between the two factions in the group about music and theater and somehow Blaine would always be in conflict with Winston's ideas, more theatrical side things (...) I knew something had to blow, something was going to blow any fucking minute..." [13]

The tour was a *Maisons de la culture* tour that saw them playing to local cultural centers, again thanks to the theater connections of their agent, Maria Rankov. Reininger: "We were playing *la maison de la culture* all over France. And some of our audience would be sort of *grande dame* with diamonds and furs and folks who just had a season ticket for *la maison de la culture*. Some people didn't like it much: in their eyes we were just some sort of rock band playing in that situation."

At that time, the socialists and President François Mitterrand had taken over central power and substantial amounts of public money were allocated to culture. However, on this socialist ocean, Tuxedomoon had the misfortune to accost on the very first island in France's contemporaneous history where power had been taken over by ultra right-wing party the Front National. This island was Dreux, a small town where FN scored at the 1982 elections. This first electoral success was followed by others and stories of artists being oppressed in their freedom of expression by locally elected FN members have abounded since then. Maybe what happened to Tuxedomoon in Dreux was the very first of these stories...

Patrick Roques takes up the story...

'DREUX. I hope you get everyone's story on that. It's the most brutal of all.

INTRO

Maisons de la culture tours have their upside. The venues are well equipped with great sound and lighting systems. You load in at six p.m. and a very nice rotund Frenchman pays you with a very nice rotund wad of *francs*, shakes your hand and goes home to dinner. Then the grumpy unionists, roadie your gear and tell you not to touch anything which makes it hard to do soundcheck. But by seven p.m. they want to get home too, so you are left to your own devices.

The downside is that these shows are sponsored by French Government, monies that have been allocated to the Arts so the venues are creased into the margins of the far flung frontiers. In other words: they are sometimes off the beaten path. On the other hand audiences show up promptly at eight p.m. They are for the most part well-dressed polite families who are attentive and respectful. They clap very heartily, and

it makes you feel good. The fans don't like it because they live in larger cities like Paris and find it difficult to drive down through the Pyrenees mountains in a snow storm to see a Tuxedomoon show. It can be an educational trip though seeing all those Catholic cathedrals positioned solidly on top of gnostic and druid temples. Impressionist landscapes and the best wine in the world.

AND THEN THERE IS DREUX.

Dreux was a smudged black and grey hole that was filled with neo nazi national front scum. But hey, that was a long time ago. For all I know it could be paradise now, but that's how I remember it that day. Dreux was one of he last shows of this *Maisons de la culture* tour. That particular Winter's evening it was a cold, rainy, damp place that seemed lost and empty.

Myself, Steven, Winston, Nina, and Deborah Valentine [a friend of ours visiting from San Francisco] arrived first in the lead car. Peter always rode in the equipment van, which was always late because they did a lot of sightseeing, smoked hash and generally had more fun. When we got to the theater – a beautiful 1920's era music hall – it was in stark contrast to the surroundings. Al Bowley or Noel Coward would seem right at home leaning up against the shiny black grand piano. Reds, golds and black. Velvet and musty old glitter. The perfect place to end the tour.

Winston was well known in the experimental theater circles of New York and San Francisco for his decadent portrayal of Billie Holiday and his inspired performance piece based on the murder ballad "Frankie & Johnnie." Seeing the theater in Dreux we thought this would be the perfect place to incorporate some of that material into the usual Tuxedomoon set. We decided to dress to the nines in our vintage junk shop finery, 1950's gangster suits and the girls in trashy low-cut evening gowns.

The 70 year old proprietor from the City Counsel and his wife had set up a card table in the entrance hall with stale pastries on it. It reminded me of going to Baptist Church lunches with my grandma when I was about 7 years old. Sort of creepy. I bumped into some local Rockabilly kids milling around who wanted to know about the band. They seemed up for a good show. I found out that the last band that had played there was Steve Miller! "When?" I asked. Some guy answered, "uuuuummm, 1973..."

They kept pointing at my suit and saying: "You're a rockabilly band!" I said, "No, more like Pink Floyd." "Pink Floyd..." they muttered. They seemed disappointed. I said: "Pink Floyd... but more rockabilly." I lied. "Tell your friends, it'll be a great show!" As predicted the rest of the band showed up late and in good spirits for soundcheck. As we started to set up the equipment I told the band that Winston and I had this great idea, you

TM French tour with MB aboard including the following dates:

01/28/83 TM plays at Théâtre Municipal, Poitiers

01/28/83 BLR plays at Auditorium Ste Croix, Poitiers
'(…) Gilles Martin, the sound engineer who works with Tuxedomoon and with Les Disques Du Crépuscule, is the *maître d'oeuvre* of a sonic set-up approaching perfection (…) [*Reininger:*] A classical musician or a crooner from Colorado, interior dandy or sophisticated rocker, techno-bopper or *chanteur de charme*, with the stature of a giant, a truly unique voice, a huge theatrical format generating images' (Concert review by A. P., "Blaine Reininger – Poitiers (28/1), Minimal Compact – Tuxedomoon – Bataclan (1/2)", *Rock & Folk*, 05/83, translated from French)

Page 207

The Flyer for the Sordide Sentimental nights of 01/31/83 (Tuxedomoon) and 02/01/83 (Virgin Prunes), courtesy of Jean-Pierre Turmel

01/31/83 TM plays a Sordide Sentimental night at EXO 7, Rouen (prom.: La Machine A Sourds)

Patrick Roques: 'Jean-Pierre Turmel put out a bunch of limited edition 45's with booklets in the early 1980's under the label Sordide Sentimental. He lived in Rouen (France) which has a church made out of cats skulls. Jean-Pierre Turmel is the guy you want to show you around, he's a very knowledgeable sort of person. He was booking good shows in a club near there. One night it was Tuxedomoon, the next the Virgin Prunes, the next the Cure... I don't remember much about the show except that there was an opening band, which was supposedly forbidden via TM's contract. After the show TM went out to eat at a great Spanish restaurant. We all were in a gregarious mood, which was a little out of character for us, unless you think being self-destructive is gregarious. The Virgin Prunes were there and spent most of the evening staring daggers at us. Bruce approached them in his Cannery Row raw-boned American hobo way. Shaking hands with the lipstick smeared, paranoid artists. They were cold fish. I don't think they liked us at all.'

02/01/83 TM plays at Bataclan, Paris

'(...) it probably was one of their best concerts lately (...) and an account of the group's actual maturity. With a musical and geographic origin like theirs, one asks oneself where this is going to end: three instrumentists who take us wherever they want, from neo-classical chamber music to compositions for modern ballets, in a perfect balance between rock pieces, crepitating of rhythm machines like only them can program them, destructured improvisations and synthetic puddles. And naturally greeting the return of Michael Belfer and his glistening and metallic guitar (...) Let

know, let's have some fun. I explained the cabaret concept to them. We'd have Nina, JJ and Deborah V. playing vamps slinking around on stage, Steven playing the grand piano while Winston would appear in drag dressed in a sheer black floor length evening gown, full makeup and wig. He would do his Billie Holiday, swaying provocatively in the fallow spot, the gorgeous Lady Day. Everyone seemed to be in agreement. Sure. Why not.

By eight o'clock the place was packed with a couple hundred drunk teenagers done up in full Rockabilly attire. There were families mixed in with really old people, maybe a few student types. It seemed like the whole town had shown up. I was at the very back of the hall in the upper balcony manning the fallow spot [usually I was at the side of the stage, or backstage]. The rockabilly kids were getting drunk, smoking and occasionally smiling up at me and yelling, "rockabilly!" really loud. The joint was jumping. The house lights go down. Total silence. Steven starts do a long improvised piano intro, very softly. When I see Winston enter stage right I hit him with the fallow spot. He lights up in the darkness and saunters towards center stage, a sultry striper. Wow! I'm thinking to myself, this is really beautiful, this is working better then I'd expected. The Harlem Renaissance... Josephine Baker at the Théâtre des Champs-Élysées...

Blaine and Peter pick up the song. The crowd is clearly digging

it. Winston and the girls camp around in the blue light and cigarette smoke. The rockabilly kids are getting crazier, they start hooting and hollering.

About 5 minutes or so into the number Winston – in classic drag queen fashion – rips off his wig and reveals to the stunned audience that he is in fact a man. For a second I thought that was a bit too obvious – even for this crowd – I really wanted him to do the whole show in character, but in a split second a major riot had broken out in the crowd!

It was a total outrage. Pandemonium broke out. The poor fools had been completely duped. A few rockabilly kids came over threatening to attack me, they thought they were getting a good old fashion strip show, some tits and ass. What they got was a skinny Chinese queer in a old thrift store dress that was getting their dicks hard. Nobody likes being humiliated especially 200 drunk homophobic right wing neo nazis.

I tried to fight my way through the mob and get to the stage but I was trapped. I saw Peter holding his bass guitar like a baseball bat ready to crush the head of anyone who got on stage to attack Winston. He was fearlessly facing the enemy. The show had come to a dead stop. Later Peter told me he was high on LSD that night.

A shouting, screaming match ensued. Steven standing on the stage trying in vain to explain in French that this was just part of the show. Just sit down and be cool. There was no reasoning with them. Blood was going to flow. Winston, Nina, Deborah and JJ were hiding backstage, most likely freaking out. Blaine had disappeared.

A middle-aged woman stood up in the crowd and bravely confronted the outraged patrons. I have no idea what she said but after about 15 minutes the crowd did disperse. And the band did finish a short set for the hundred or so people that stuck it out. Things, to me at least, seemed to be relatively copascetic considering.

Backstage this was not the case. Far from it. Blaine was very, very pissed off. He came unglued, thinking JJ or Winston might have been killed. He blamed everyone but fixated all his rage on Steven. This was the straw that broke the camels back. The spark that out Blaine and Steven's full hostility towards each other. It was really ugly. A lot of resentment and pent up rage spewed out that night. It was palpable, you could feel it in the air and it affected everybody. Blaine quit the band, fired Steven on the spot. Steven quit the band and told Blaine to go fuck himself. Blaine said he was going to kick Steve's ass. I think he did give Steven a good hard boot in the ass. Steven screamed that he was going to kill Blaine, whirled around and threw a full unopened beer bottle at Blaine's head as hard as he could. It smashed to pieces on the wall right beside him. If it would have hit him, I think it really might

us hope very hard that this band will find the economic means to pursue their extraordinary creative itinerary.' (Concert review by A. P., "Blaine Reininger – Poitiers (28/1), Minimal Compact – Tuxedomoon – Bataclan (1/2)", *Rock & Folk*, 05/83, translated from French)

Patrick Roques: 'Bodies dragged off the floor out into the night, hospital, morgue? The stage in Paris was littered with dealers at soundcheck. Purses filled with diamond sized chunks of Brown Persian Gold. Tin foil dragons. Blacked spoons tossed from hotel room windows onto the paving stones of *Rue de Seine* tinkling like tiny invisible bells under carts filled with beautiful red strawberries… [scribbled in the back of an old address book from the time]'

02/02/83 BLR plays at Ubu, Rennes

02/02/83 WT/BG in *Frankie & Johnnie: A True Story* at Maison de la culture, Rennes

02/03/83 TM plays at Maison de la culture, Rennes

Patrick Roques: 'I think this is where I found Blaine drinking with the bass player and drummer from the Cure at nine a.m. "Blaine, we have to leave now." He drained his breakfast beer and bid farewell. As we were crossing in front of the hotel two guys passed by carrying a body wrapped in a blanket. They opened the back doors of a panel van and tossed this body in. Presumably it was Robert Smith. "I was just drinking with two of them in the bar, a little hair of the dog for me." Blaine laughed. "Those guys have been downing double shots of Scotch since eight this morning."'

02/04/83 TM plays at Salle des fêtes, DREUX (place Mézirand 28000 Dreux), a concert that ends into a riot and a fight between BLR & SB

Part of Deborah Valentine's own wandering story. 'When I left art school in 1977 I moved from Oakland CA to San Francisco and was assimilated by the punk rock scene. Resistance was futile! LOL! I saw the movement grow and industrial music emerged. I went to many punk and industrial shows, did some performance art and showed my work in underground galleries. This was one of the most exciting times of my life!!! I met many Bay Area artists and musicians. I was a security guard for a while and also worked in a *café* making espresso drinks.

In 1980 I moved to New York City with $1,000. and a suitcase. I stayed in a funky 5X13' room in a hotel at 30th and Lexington with a view of the Empire State building and down into the painting studios of Parsons school of art. There were no drapes on my window. Four months later I moved to Alphabet City (9th and av. C). I wrote an article for *re/search magazine* when it was just printed on newsprint, right after its re/birth from the punk magazine *search &*

Page 209

destroy. I was a bartender.

I left New York after my apartment was broken into too many times. The final straw was when they tied my cat to the fire escape in the dead of winter and he froze there. Oh and they took my door off. Ripped it right out of the wall. I had a beautiful old underwood typewriter, that because it was heavy and not of use to them, they smashed it... So I went to Iowa with my cute boyfriend for a few months to rest and let go of my freak out. Moved in with my bizarro family in L.A.

In 1983 my family thought sending me to London with $3,000 with a 6 month visa was cheaper than psychotherapy, but most importantly, I would be out of their hair. I spent most of that time in Paris and did lots of art. Initially went to Paris to stay with my friends in the band Tuxedomoon. I toured with them and learned the basics of stage lighting.

We caused a riot at one venue because I and a man wore opposite sex clothing and make-up. During one song, we stripped and changed clothes on stage. We thought it was a very French idea, but this was really too *avant* for a small working class town (Dreux) with a gothic church on every corner. they didn't understand the music anyway (…)'

02/06/83 TM plays at Rex Club, Paris (uncertain as PJR does not remember of a second show in Paris)

02/08/83 TM plays at Maison de la culture, grand théatre, Amiens

02/10/83 TM plays at Centre Culturel, Tarbes
Patrick Roques: 'Beautiful place. We stayed in cabins and it was snowing. My father's grandmother is Basque. Don't fuck with me.'

02/11/83 TM plays at CAC, St-Médard-en-Jalle

have killed him or blinded him at the very least. It scared me. It was so out of control. Way over the line. I looked at Steven and I really couldn't believe it, he became a monster. It just shocked everyone into a kind of stupor. Disbelief. Madness begot madness in Dreux that night.

In contrast I have a vivid memory of Peter ordering *Coquilles St-Jacques* and being very happy and I swear I thought it was also in Dreux but I must be wrong.'

Blaine Reininger: "Dreux, this home territory of Jean-Marie Le Pen. Winston came out wearing a dress to sing one song or another and the audience just went nuts. "Pooooohhhh, fuck you! Get off the stage!" and there was some kind of riot. And, you know, there were people thinking: "Who are these people coming and taking the money from the French State and doing such shit!" And I just thought: "Oh man, fuck this… This is just too stupid."

I wanted to please the audience. I like to entertain, I wanted to entertain even though I didn't want to be one of these mindless pop whatever. But when this group began to be too obscure, began to sort of say: "Fuck you!" to the audience, that always irritated me. I wanted to retain some links with common music, pop music. This idea of shocking *bourgeoisie*, I considered old hat, *passé* for a long long time as an artistic stance because there is no *bourgeois* anymore to be shocked. So I thought that was silly. The audience was already not with us, so when Winston came out wearing a dress, I thought: "Oh god…" "Do you like me pointing at my dick on stage?" I thought it was silly. It was an empty gesture. It was disgusting.

As the events of that night unfolded, everyone was upset and we were blaming each other. I was supremely angry, I was enraged. And Steven was just as drunk as could be. Steven was throwing beer bottles: "Fuck you!" and then crash! And then he came that close to hit JJ in the head, really close. And I just saw red. And this is one of these one or two times since I know Steven that I was provoked to physical violence. I just started to kick Steven: "You little son of a bitch!" and I kicked his ass and that was just one kick after another: "You – pooohhh – almost – pooohhh – hit JJ – poohh…"

Maybe he remembers that, maybe not. That was just the end for me: "Fuck you! I don't want to have anything more to do with you people." I wanted to succeed in this business. I wanted to make money. I wanted to be rich and successful and not cut my own throat on stage and I didn't want to be with people who evidently did. I thought if I would cut myself from these people, I would make popular music and be like David Bowie: I could be a rock star without these guys…"

Michael Belfer: "My version of the Dreux story was that

Winston was antagonizing kids who were like real French red neck kids, real uptight homophobic red necks… Once Winston took the wig off, they stormed the stage and we had to go backstage and they kicked it and smashed every door all of the way up to the dressing room and when they got to the dressing room, they were like six or seven of them and they were trying to smash the door down and we were all like holding on the door and they were coming through, like pieces of the door were like breaking off. And they got through, partially. I don't know how we got rid of them…

After everything cleared away and we were out in the parking lot, Blaine kicked Steven real hard and Steven threw a bottle of beer that almost hit JJ and that upset Blaine even more. He was like: "Brown, I'm gonna kick your ass!" He looked so stupid doing it and then Steven was like (imitating an affected voice) "Aow! You kicked my ass! You gonna hurt my back!" You know Debra Valentine was there too and I remember that after that show I ended up getting a hotel room with Nina and Debra, it was great… We went to Paris, got a hotel room and stayed there for like three days and spent all the money that we had made on the tour, drinking and taking bubble baths. And then finally having to go back to Brussels and face reality, broke, sleeping on the floor, no food, eating cans of mackerel…"

Peter Principle: "Starting from *The Ghost Sonata*, there came a discussion as to the importance of music compared to the importance of theater. I'm not a theater person but I always liked that aspect, so I was on "that" side. But they wanted to have a division in the range of paying amongst the participating members according to who was the musicians and who wasn't and that already started trouble. I mean: a band is like a marriage. When you get to discussing money when you don't already have a plan before you got in it, it's going to be problems. Either you're going to go for 50/50 or you're not but you've got to know. So we started out with even sharing things but in fact we never really made a business plan amongst ourselves.

For sure, doing the theater side was the source for a large percentage of the money, like for *The Ghost Sonata*, it was given for a theater project. Usually it's easier to find the money to make a record and there's a record company that's used to putting up for that. But finding the money to do a new theatrical production without knowing what it was and without having the enthusiasm of the band members to actually sacrifice some of their share of the cash to do it made it a real struggle for the people who were into the theatrical part to keep up with the changes. We could write music faster than they could shoot new film or preserve old films which would be damaged.

Dreux was really a great example of how theater can provoke an audience to challenge its own self value system etc. Debra Valentine, a friend of the band was traveling with us and Michael Belfer was with us. Blaine and Michael [*Belfer*] would do their own show, [*pre*] *Night Air* show, and also Tuxedomoon had some concerts. So we shared the van and the trip. In Dreux, after Winston had performed his drag act that got the audience into a riot, Blaine was very upset by this event. Both Steven and I were enthusiastic about what had happened because Dreux is kind of a center for the National Front in France, so a whole lot of the audience were these skinheads nazi punks. So we thought they were assholes and the fact that they revealed their assholeness to themselves, that they got all hot and that they couldn't deal with it that they were hot, that made us think: "Ah ah, you see we've held a mirror up to you and now you're offended by your own image." That was a good thing: that's one of the things that theater is really good for, or all art in fact.

So we thought it was a successful show but Blaine was like flipping out that we didn't get to finish the show, that the equipment was perhaps at risk of being destroyed and that it was all because of theater. We all thought that this was really a great show because we got everybody on their edge. Blaine was saying it wasn't the music that got them on their edge, it was something else which we were doing. And that was in fact true. He didn't want to have any more theater involved into Tuxedomoon, kind of like the Emperor in Mozart, you know: "There's no dance in my opera," and so: "No theater in Tuxedomoon." That was like not acceptable and so he was chasing Steven around the block. They were both drunk, fighting and finally Blaine quit, he quit! They were hitting each other. And Blaine is bigger than Steven and Steven didn't really want to fight with him anyway, there wasn't much to fight about, that was just Blaine being drunk and obnoxious. But he did quit the band there, that was the story why he quit. But I think that he already had in his sights that he would be able to go his own way…"

Anna Domino: 'There was some desperation to our lives in Europe, for many reasons. We were young and resilient but it could wear you out. Especially us girls. The cold, the suspicion and alienation, the pennilessness, the promises that never manifested and the drugs. Crépuscule boss Michel Duval, "the most bored person alive," liked nothing better than manipulating everyone around him. He wanted to split Blaine off from TM with promises of recordings and production deals and a salary that he then whittled down to nothing. He loved to tell one person what

Reininger's actual announcement that he was leaving Tuxedomoon came shortly after this "last straw" Dreux episode. Oddly Michel Duval, Les Disques Du Crépuscule's boss, seems to have been the first to spread the news, around the time of Tuxedomoon's next release ("The Cage"/"This Beast" EP) in early 1983.

Steven Brown: "When Blaine made this announcement, I was surprised because Blaine is a very sedentary kind of person, it's not easy to get him to change (…) I would have expected it from somebody else. I don't know who but… But I do remember that before Blaine made his announcement, Duval made it for him and announced to the English press that

Page 212

Blaine was quitting, that Blaine was signing as a solo artist for Crépuscule and that Tuxedomoon was finished. This is all before Blaine opened his mouth (…) I was about ready to kill the man (…) I just didn't like the whole sticky attitude about it and especially the way Duval was capitalizing on it, saying that he was getting Blaine as a solo artist and that he was all proud and happy, kind of his revenge thing because we wouldn't do an album with him. He was breaking up the band and taking Blaine. Just this whole attitude, that just stank! And I was appalled Blaine was working with somebody like him (…)." [14]

Reininger: "I wanted to be a rock star. That's why I started to pursue my solo career in earnest (…) I didn't talk to Steven much about this and I still haven't talked to him about how he felt about that. But I found out that he felt betrayed, he felt lost when I decided to quit because to a certain extent I had seduced him down this path anyway. This idea of being in the music business, I don't think he ever wanted that. He never wanted to be a rock star, like me. I had that obsessive desire to be that for whatever reason… I know he blamed it on Crépuscule and Michel Duval that I left. He thinks I got seduced away by this guy, slime bag which he really was, a slimy guy but…"

Reininger's departure now confirmed, a discussion took place as to whether or not the remaining members should continue under the *Tuxedomoon* moniker.

Principle: 'I do remember that there was a discussion about whether we would go on together and also a lot of thought about changing the name and or getting new members...
I was living in rue de la Fourche and Blaine and Michael were writing the [*Night Air*] album in our rehearsal space attached to my "living quarters" and I remember Saskia and I trying our best (as they were) to avoid painful contact. It struck me that Steven was very surprised and even in shock that Blaine had actually left for good. I think he expected him to get over it, but I think that some unscrupulous "insiders" like Michel [*Duval*] and maybe Katie [*Kolosy*] had Blaine's ear and pushed him knowing how proud he is.
I remember being pretty panicked myself until we decided to continue the band under the Tuxmo moniker as this was a sure way to survive as we had no income except Tuxedo gigs. Also I didn't want my little life with Saskia [*Lupini*] to be endangered as I already had been forced out of relationships by geography. I do believe that Martine [*Jawerbaum*] encouraged Steven to stay and also to continue. Me with my non-existent language skills wondered right away if I should take the opportunity to go back to the USA. As I remember it, Steven did just that for some weeks...'

Patrick Roques: 'We had a final band meeting at avenue du

others were saying and watch the reaction. The truth was relative, support non-existent. He did not understand this as he truly could not care and assumed everyone had family and money to go home to like he did. Or perhaps we were some lesser life form, like tropical fish, exotic but without souls or feeling to be kept in a tank and deprived of food till we tore each other apart.
Crépuscule controlled the bank account. Sometimes pots of money sometimes none dependent on whim. Everything, gas, electricity, rent bills and cash for food went through the label. We worked occasionally and slowly starved (…) At Crépuscule your only hope was a "special relationship" with the boss, Wim Mertens was the only one who could make that work. And the rights to our work and royalties, eaten alive. Live and learn, if you live.'

Patrick Roques: 'This is my recollection of a dream I had in Paris, Winter 1983.
Peter, Saskia and I are late for the train. Frantic, we run down the stairs of the nearest metro station. Coats flapping. Bags in hand. The sounds of our shoes stomping out echoes over shouts. Peter leads the way. "Just fallow me." Out of breath we blunder on careening, falling. "Slow down! Just fallow me, it's this way to the seventh level!" Freezing air and fog rising from the gratings. Peter searches through his bag clutching crumpled metro maps. Suddenly he starts accosting the elderly that are shuffling by. He is shouting gibberish and flailing semi-empirical hand gestures like spastic semaphorical salutes. "Peter this can't be right. These people are vagabonds down here. There aren't even any trains running on these tracks. This station has been abandoned for years. Saskia concurs. "Peter let's go." "No! I know where I'm going! We need to go down to the seventh level." "Are you sure?" Peter stomps off down the darkening metal ramps. We fallow him through the musty hallways, the thickening fog turns into steam. The walls and ceiling are humid and perspiring. We are tired

and sweating. We shed our winter scarves and jackets. Intermediate overhead light bulbs are flickering. Alone, we find ourselves deep in the bowels of Paris.

We have reached the seventh level. The platform here is engulfed in swampy undulating mists. Walls decayed and covered with moss. We hear the muffled reverberations of chants, Turkish ney flutes and ouds that sound like the dull buzzing of bees. As we carefully make our way along the dark walkway by the edge of the abandoned metro tracks strange men began emerging from the haze. Silent, wrapped in brightly dyed cloths, turbines, belts, beads and bangles. Some with fine headdress of gold. Others adorned with piles of woven scarves in silks and velvets. Bearded and brooding, their sparkling black eyes burning. They are all standing in a row that trails off into the darkness. We realize that they are some kind of venders, their hands at rest on top of large glass boxes that seem to be illuminated aquariums that are swirling with damp hot smoke. Peter approaches the first vender and whispers in his ear. Saskia and I hang back. Peter moves down the line peering in each box, sometimes clearing the smoke with a quick wave of his hand for a better look inside. We move on. Finally at the very end, we reach the last merchant barely visible in the half-light, Peter mumbles a few words in his ear. Money is exchanged. Peter unbuttons his pants and pulls out a very long cock which he hangs over the edge of the box, dangling it in the steaming hot smoke. We look on baffled. It's impossible to see what is happening because the steam is so thick. After about five minutes Peter raises his spent wet cock out of the aquarium and tucks it away. The vender smiles. "Very good," he says. "This is the best one. Remember me for I always have the best." "Peter what the hell was that?" "That was the Snake, the ultimate in sexual satisfaction. The snake wraps itself around your penis and through a series of constrictions gives you the best orgasm imaginable. I knew this

Congo to decide our fate. Blaine was adamant about leaving the band. He said the marriage was over. Tuxedomoon was his band, his band name and that he could end it because he started it. Steven wanted to carry on with or without Blaine. I suggested they'd change their name to Urban Leisure, a name they had once used. Steven wanted to keep the name. I guess Blaine let him. From a recognition point of view, keeping the name made some sense. But it was a chance to make a clean break and a clean start. Escape from the past. It turned out not to be. I'm not sure in the end it made any difference. Psychologically it might have been the thing to do. Is Tuxedomoon the albatross?'

Martine Jawerbaum becomes Tuxedomoon's manager and Luc van Lieshout becomes a member of the band. Of course Reininger's departure lead to consequences, the first of which being the arrival of a new manager for Tuxedomoon in the person of Belgian Martine Jawerbaum. This energetic woman had been a friend of Steven Brown since the early days in San Francisco. Jawerbaum: "My dad wanted me to study medicine. I went to San Francisco instead and this is where I met Steven Brown."

Steven Brown: "I don't even remember meeting her the first time. She said I was always pretty rude, not real friendly. We met in San Francisco. We had a friend in common: James. He was kind of the link between us. And then finally after years of sort of knowing each other, we became really good friends only in Brussels. She had lived in the States for years and then moved back to Belgium. And then when we moved to Belgium. Eventually, not too long after we moved into Brussels, I moved in with her, lived with her in her apartment and we just became soulmates, after all these years of weirdness and ambiguous sort of relationship. And eventually she became the manager of Tuxedomoon and produced *Holy Wars* [*Tuxedomoon's next album, released in 1985*]. We did a lot of work together for a few years. She was my best friend in Belgium, one of my best friends in the universe…"

Patrick Roques: "I never went to the Spanish tour [*that took place in May '83*]. That's when Martine got involved and she was better than all of us. She just had it more together and was willing to do all that really really hard work and was more driven and probably had a better business sense and Tuxedomoon people seemed to like her a lot. So people kind of gravitated towards her and it was a relief for me…" Roques returned to the United States around that time and that was it for his time on the road sharing the destiny of Tuxedomoon.

James Nice: "I think that one problem that Tuxedomoon always had was that after they came to Europe, they never really had any management worthy of the name, partly because they

were an unmanageable band, but they had no management so they lost that kind of business direction. They also lost just someone who was pushing them forwards as a band rather than people throwing various ideas, just painfully drifting into oblivion. It's what happened until Martine Jawerbaum came along. I think she obviously did a pretty good job in getting the band back together and getting them a deal and things like that and absorbed a lot of the un-going tensions. I think that as she perhaps lacked as a manager with a capital M she was nevertheless able to do things which a normal manager wouldn't and couldn't have done…"

Luc van Lieshout: "She was really tough in the sense that she knew very well what she wanted and was trying to impose her will, her vision. They needed it, also. She was a woman who could get things organized while they couldn't at all. She was very good in organizing concerts, establishing contacts with promoters and the like and this was enormously time consuming for us."

Peter Principle: 'For a little while, we toured rather often and made quite a good cash from the door, actually something that Martine helped us with although Velia [*Papa*] and Maria [*Rankov*] pushed our fee to the stratosphere quite early on. Martine always helped out with food and the like. Even I stayed in her attic for a few weeks in the Winter of '83 or '84 after being evicted from rue de la Fourche. And when I got the apartment on Parvis de St Gilles, she signed for the gas and electricity as I was an illegal. She was very energetic and certainly a fan. She helped us borrow money to get the *Holy Wars* demo and recording together and for that I am eternally grateful (…) She did negotiate the deal with Crammed Discs for the back catalog releases as well. And if Steven hadn't been living at her house when Blaine quit there's no telling what might have happened…'

Jawerbaum's first moves were to incorporate Tuxedomoon as a Belgian A.S.B.L., *i.e.* a non-profit organization often used by artists, [15] arranged for legalizing some of the musicians' residence in Belgium and secured membership with the Sabam, the Belgian institution responsible for the distribution of royalties. Prior to this the band hadn't even been collecting mechanical royalties! [16]

Another consequence of Reininger's departure was that Steven Brown and Peter Principle found themselves working alone (as Tong had then returned to the United States for a little while). Brown: "So we just put out an announcement on the radio. Got a bunch of letters and phone calls, people coming over…" It turns out that 23 year-old Luc van Lieshout showed up amongst these people. The story of his arrival in Brussels is a true wandering story as this entry from Steven Brown's private journals (written some time in the eighties)

place. I'd been down here once before."
We walk back to catch our train. I started freezing again. I'd lost my coat. I woke up.'

Roques: 'Thinking back of this dream, first Dante's Inferno (*Circles Of Hell*) came to my mind, then the Jungian allegory or metaphor for gnostic serpent Kundalini.'

Peter Principle: 'Maybe there is yet another possibility for interpreting this dream… Patrick intuits that things are not right with the band and we (the travelers in the dream) are the concerned parties. We are on a quest for the force to muster a next step on the path, and for whatever reasons this task has fallen to me the ever ready map reader. As we go farther it seems perhaps that my own agenda or something like that intrudes, at any rate in the end we don't get to catch the train… That's really quite amusing as I had a dream of my own that overlaps in symbolism with Dante as well: I and Saskia and Steven are on top of a train, like subway surfing together and Steven asked where are we going and I said to the ninth circle… Somehow we were later separated and I was by myself on a crowded road conducting to a bridge leading to an island and I was somehow fighting with all of this resistance (ever saw Cocteau's *Orpheus*: I am often in dream states where forces are trying to protect) and I lost and was thrown over the bridge into a moat full of like lost people or something. I remember looking up at the bridge and wondering how I was going to get back there when I awoke. Later I described this dream to Steven and much of the imagery was incorporated into the lyrics of the song "The Train" [*a song featured live on the Ship Of Fools Mini LP – released in '86 – and in a studio version on the You LP/CD released in '87*].'

03/83 Luc Van Lieshout arrives in Brussels to join TM. Martine Jawerbaum had become Tuxedomoon's manager around that time.

Page 215

vouch for:

'The new Tuxedomoon member is here!

Peter P's surprise birthday. I've never seen his apartment so animated and full of folks. The drinks flow till five and then Peter threw us out.

Luc is very high and relates to me how he came to meet me and join Tuxedomoon. He was washing dishes in a hospital when he heard Richard Zeilstra's radio show and our plea for a new musician. He quit his job, bought for about 5,000 florins worth of hash and hitched to Brussels, landed at the *gare du nord* and early evening called Martine who said: "Come on over!" He (…) walks as far as Porte Louise, takes a taxi to rue Mignot-Delstanche. On arriving, he can't find his money and the caby says: "No problem." Now this is clearly destiny in the guise of a cab driver. He goes on, saying Martine answered the door in night gown – it was midnight – and lounged around provocatively. He said he tried not to look because he thought I was Martine's lover. I arrive home. Martine gushes up to me saying: "The new member of Tuxedomoon is here!" I'm not exactly bold over with enthusiasm, especially when I ask Luc if he knows Tuxedomoon. He replies he knows one song: "What Use?"… Luc said he thought I was an asshole and how he lived in an attic for a month or so and we would take the tram to rehearsals together and I wouldn't say a thing and wore my shades all the time. He said it took two years before I was nice to him…'

Luc, tell me how you joined Tuxedomoon…

"It was in March '83. I smoked a lot during that period. It was during a VPRO radio broadcast – a radio/TV channel in the Netherlands, very liberal and alternative, only channel where they would air good music. Before then, a year before, I had heard "What Use?" by Tuxedomoon and I liked it: I taped it on cassette but apart from that piece I did not know Tuxedomoon. So it was on an afternoon on VPRO radio that I heard an interview with Steven and Peter. They explained that Blaine had quit and that they were desperately seeking new musicians but no guitar player, no bass player, no sax player and no violinist either since it would have been a bit tough as Blaine just quit.

At any rate they were not looking for the usual instruments in a rock band and would have a preference for people who could play several instruments. It turns out that I could play a bit of harmonica in addition to my trumpet playing, so I thought: "You've got nothing to lose." At this time I was a follower of Bhagwan. He was a spiritual leader of some sort . He made a mixture of all religions and I was deeply influenced by him. I had read his books and he said that everything was possible, that your ego is just some piece of clothing that you can take off. At the time I used to smoke with a friend and we

Martine Jawerbaum. Photo Saskia Lupini

Indian-American artist living in Brussels Kiran Singh about Martine Jawerbaum: "I had some difficulties to approach Martine. I was a bit intimidated by her, as I was by Blaine. There was something imposing about her, an inner strength and she was very present, also, with her dog Buster following her everywhere. I have memories of parties at her apartment, with everyone lounging around, with drinks and company, an orgy for all senses. There was something of the creation of an aura or a shield around them that made some people envious and willing to slide themselves into that ambience. They had like a wall around them, a clique and if you became part of it, you were part of their court, you were cool with them. And I could often see that people were, sometimes naively, longing for their presence, as if it would nurture some fantasy of their own… In the midst of all this Martine was a bit like the "Guardian of the Temple," a silent

Page 216

read his books. So when I heard this interview on the radio, I interpreted this as a sign and that I had to go.

So the next day I gave up my room and quit my job. I called the VPRO people to ask for Steven or Peter's number. They gave me Martine Jawerbaum's number because Martine had then become their manager. I hitch-hiked to Brussels as I didn't have money to travel otherwise and when I arrived in Brussels, I called Martine who told me to come over. I got there around 10-11 p.m. Auditions were scheduled for the coming Monday. It was Saturday, so I stayed over at Martine's apartment where Steven also lived at the time, rue Mignot-Delstanche.

A bit later Steven returns completely drunk and Martine tells him that there's a musician who wants to play with Tuxedomoon. Steven comes up to me… At the time I was totally ignorant of Tuxedomoon as the only piece I knew was "What Use?" Before I left I listened to *Half-Mute* that started out with this piece on the saxophone that sounded totally *free* and I thought to myself: "Shit, I will never be able to do that but I'm going anyway: one never knows. If that doesn't work, I can still go down South and I'll play on the streets, I'll figure it out." So Steven comes up to me and tells me something of the kind: "Ah, so you think you're going to play with Tuxedomoon? Who do you think you are?" I reply that I don't know, that THEY are asking for musicians and that he's pissing me off with his attitude.

On Monday we took the tram together to go from rue Mignot-Delstanche to the center, at their rehearsal space rue de la Fourche. It's a long journey with the tram. So here we are, Steven sitting in front of me with his shades on, like always, looking at me suspiciously. Then he asks me a question: "If you had the choice, would you prefer being famous now, or being even more famous after your death?" I reply: "Listen, after my death I don't care. If I have to be famous, rather now than after my death." For Steven, this answer was the totally wrong one, so he stopped talking to me: he already knew quite well who I was.

Then we got to the rehearsal space and there was Peter in there. Fortunately because if there would have been another Steven I don't think I would have passed the audition, what a pretentious prick! But Peter was exactly the opposite: very open and talkative. Then we played some sort of blues that would become "The Waltz" and this is the kind of music that I'm best at. This sort of music belongs more to my *répertoire* than jazz or avant-garde. So I played non-stop for about an hour and a half an in the meantime we smoked joints. I had brought a lot of hash from Holland and so I was welcome for that too. So we played the same piece for about an hour and a half and it was clear that Steven was pleased with result. So

colossus of some sort, who possessed the rigor, which was appreciable in a body doomed to chaos. She could see to make it functional and worthwhile from a financial viewpoint."

Anna Domino: 'Martine looked after TM for some time. It seemed to me she did a great and pretty selfless job. Making TM a more independent and self sufficient entity and putting a lot of her own money and life into it. Many of us lived with her and Buster [*i.e. Jawerbaum's dog*] at one time or another. I'd always stay at her house after I'd left for good ('90). She had a nice house with real furniture and a great big bath! She was also good to be around. She had a happy dog and plants while the rest of us were just trying to feed ourselves. In Martine's house you could feel sane, almost normal. She knew how to negotiate and navigate life in Brussels and that was something. Things weren't easy for her, people needed help and attention and there were those drugs. Most days she was full of energy but some times she felt she would be crushed, amount to nothing. Like all of us -great highs and a terrible low.'

Luc van Lieshout: "I was born in The Hague but my parents moved South, to a small village near Tilburg, Haren, when I was six. I lived there until I was 18. I started playing trumpet when I was ten because my two older brothers played in the village's brass band (every Tuesday night they left for rehearsals with the band and I wanted to do that too). And since I had already been at the music academy to learn sol-fa with a fipple flute, I wanted to do something with my musical knowledge and the most obvious instrument for me to play was the trumpet because in that way I could also go to drink beer and play billiard. My teacher was the conductor of the brass band: he played saxophone and worked in the factory. I started out with a trumpet that had holes in it and a piston that wouldn't work. Then my instruments gradually improved *et voilà*… So we played at all kinds of local celebrations (like for people celebrating their 50th wedding Anniversary) and we were marching in the street. I ended up first trumpet in the brass band. At one point I started to play in bands playing at weddings or in orchestras doing Tyrolian music, things like that.

So around 13-14, I had decided that I would be a professional trumpet player. Back then I was rather thinking of playing in a symphonic orchestra. I started to take lessons with a guy who could give me a training preparing for the *conservatoire* but when I was 17 he advised me against going to the *conservatoire* because I didn't have the right mentality. Later I understood what he meant: there's only about one position every five years that becomes available to play in a symphonic orchestra in Holland. Hence this is a highly competitive world where one has to pull strings for and I wasn't ambitious enough for that, wasn't interested in doing this kind of things. So he advised me against going to the *conservatoire* because the only alternative was to become a teacher in a music academy and I didn't want this at all as I wanted to be a trumpet player. So, at 18 I enrolled with the school of musicology of Utrecht. The only trouble is that I did not really know what musicology was about: I just wanted to get a scholarship and move away from my parents' house. So I did that for two years but then my grades were not good enough to maintain the scholarship so I lost it. At that time I had started to smoke a lot of hash and I had other things on my mind than reading books, so I stopped musicology.

Then I had to get a job because I smoked a lot and needed money. So I got interim jobs in factories, hospitals, doing the dishes and

Page 217

whatnot. I played in bands – rather funk, rock or blues – but it wasn't very professional. I also played in a contemporary music *ensemble*. I played a Haydn opera for a few months – and realized that it indeed wasn't for me as you could stay for one hour without playing, awfully boring –, played in 20th century music brass orchestras but it was never really professional as at that time it was impossible to earn one's living as a trumpet player…"

From the Proust questionnaire. *If Heaven exists, what would you like to hear God tell you when you arrive at the Pearly Gates?*
Steven Brown: "That I'm really dead and that I won't have to go back. That's it's all over and I'm on permanent vacation with God, in paradise. A one-way ticket…"
Luc van Lieshout: "Fuck you! I don't want to hear what you have to say. I'm going back!"

03/83 TM (SB, PP & LvL) records a demo including the following pieces: "The Waltz," "St John," "Hugging The Earth," "A Fez Goes To Brooklyn" (instrumental, never released), "Some Guys"

PJR returns to the USA

Spring '83 BLR records in Brussels (prod. BLR & GM) with Alain Goutier & MB guesting: 1. "Magnetic Life" 2. "Playin' Your Game." Both tracks appear on the Les Disques Du Crépuscule 12" named *Playin' Your Game* released in Summer '83, on Normal's CD re-release of the *Broken Fingers* album in '88 as well as on the LTM's re-release of *Broken Fingers* in '03. Track 2 appears on (Various Artists) Les Disques Du Crépuscule's *Crepuscule Collection 3 : The Rough With The Smooth* compilation album released as a LP in '86

Some reviews. '(…) Two soiled romances, picked over by passionless music of wide space and hesitant eloquence, are all he has to offer: his singing voice is poor, a raven's croak (…)' (R. Cook, "Blaine L. Reininger: Playin' your game/Magnetic Life", *N.M.E.*, 09/17/83); '(…) I would like to say that this is "very good" but when I listen to – almost – anything from Tuxedomoon, I feel like this is shit in comparison. Blaine is not Tuxedomoon but he's the guardian of its heritage and may not just come up with half successful outcomes' (Zéro, *Second News*, 09/02/83, translated from French); '(…) and *Playin' your game* from ex-Tuxedo Blaine Reininger (who very politely re-visits a lousy ballad from Barry White before indulging into a neo-funk so un-comical that it becomes archeo-funk lately). That was our "special nostalgia": next week we'll move on with *Les Mémoires D'Outre-Tombe…*' (*Le Soir*, 09/83, translated from French); '(…) Blaine Reininger creates a compelling sound that owes as much to naïve pop songs as to the most experimental pieces of TM's répertoire' (E.T., *Le Peuple*, 10/03/83, translated from French); '(…) A perfume of dismay that the enigmatic BLR vaporizes in melodious waves cut by the master's voice, like a long cry in the night of his solitude. Not to be missed.' (*Le Rappel*, 09/83, translated from French)

04-06/83 BLR records in Brussels (Daylight Studios, prod. BLR & GM, final mix by Gareth

the deal was entered. They had auditioned other musicians before but it didn't work out. I've been living in Brussels ever since."

Two days after van Lieshout's audition, the band went to the studio to record a demo of some pieces ("The Waltz," "St John," "Hugging The Earth" and "Some Guys") that will later appear on their *Holy Wars* album.

Blaine Reininger records his second solo album, Night Air. In the meantime, Reininger lost no time in consolidating his solo career. After the *Playin' Your Game* 12" for Les Disques Du Crépuscule, Blaine began the recording of what many consider his best solo album to date: *Night Air*. In fact, this album shouldn't have been credited to Reininger only as this was Michael Belfer's baby almost as much as Blaine's.
Belfer: "After that last tour with Tuxedomoon, Blaine wanted to go solo. He asked me if I wanted to start working with him. I said: "Let's try it." We had a rehearsal space. We started practicing like three-four days a week. In a period of three weeks we wrote *Night Air*."
The conditions for recording this album were quite harsh. 'Night Air was done in April of '83, writes Belfer. And for all these years I've never forgotten that, because it was one of most trying four weeks I've ever lived through.
You see Crépuscule was happy to pay for all the studio time we needed, but wouldn't cough up any cash for the musicians (nothing!!!). So we didn't eat. At one point I remember going a solid three weeks with nothing. And that was after I had even gone through a box of corn starch, which I was making soup from. I remember Blaine and JJ eating cans of mackerel night after night, because it was so cheap. But I couldn't stomach it after a very short while, and so I was left to my corn starch soup. And then nothing. It was really pathetic… Blaine and I riding the tram out to the studio... And we'd put in really long days recording. I really don't know how we did it…
I'll never forget the day Blaine took me over to the Deutsche Grammophon offices in Brussels, where we proceeded to beg for some royalties due on a Tuxedomoon recording (…) It was excruciating to hound this guy behind the counter (he kept saying this was so unusual for the artists to just come in the office like that, and that they had no cash to pay royalties with). So I think what really happened was he just gave like 2,000 francs [*i.e. about 50 euros*] out of his pocket to get rid of us...
Anyway Blaine and I went out for the most glorious meal. It was like the first hot meal I think either of us had in weeks. And then we bought some tobacco with our change and, man, we were like on Top of the World, for a minute that is, until we had to face the next day...' [17]

Page 218

How come Night Air wasn't credited to Blaine and Michael?

Belfer: "JJ talked Blaine into putting his picture on the cover. I don't know. It really upset me. I saw it just when it came out and it really hit me hard, I felt kind of betrayed. We both really worked so hard on that. So to make it look like it was all him, yeah I couldn't believe that he would do something like that."

In 2002, Blaine Reininger sent the following to James Nice, from LTM Recordings, who was then working on the re-issue of the album as *Night Air plus* (Nice used some excerpts from this text for his sleeve notes):

'I have been putting off writing these notes for longer than I care to admit. I have felt that notes for a CD booklet of a re-issue should be sparkly and upbeat and I have been unable to summon this sort of hyperbole for the sleeve of *Night Air*. Enough hemming, enough hawing, here we go.

Orwell's year, 1984, the year of *Night Air* was a defining time for me, both as an artist and as a human being, if the conditions can be separated. I had decided to leave the fold of Tuxedomoon for reasons I still don't clearly understand and I found it more difficult than I had imagined to go it alone. It is hard for me sitting here now to remember the arrogance and egoism which fired my ambition in those days. I suppose that this is the perpetual song of the "mature" artist when confronting his younger self, remembering the inner fire and the desire to prevail at all costs which enabled me to ignore the tightrope I walked and the precipice over which it was stretched. In those days I still believed that I was immortal and life had yet to demonstrate effectively that I was wrong. The music on *Night Air* was written during the shadowy transition phase between full membership in Tuxedomoon and my solo career. I still used the band's rehearsal space and other communally owned facilities, though I felt it necessary to skulk around. I remember writing *Night Air* itself, the title track, in Tuxedomoon's attic studio in the very heart of Brussels. The watery grey light of that desolate haunted city drizzled in through the skylight down on Michael Belfer and I as I wove the fake Arabic melody and the Brusselophobic lyrics around Michael's bass line. I suppose I should be grateful to the capital of Europe for providing a seed around which so much of my spleen could crystallize for so many years. When JJ and I finally left Brussels in 1998, I spat on the ground at the frontier, perhaps I should have thanked Belgium for providing me with such a rich source of melancholic poetry.

In trying to get a handle on this period of my life, I have realized that I have lived as though I were in an epic novel or a film written and produced by Blaine and starring Leslie Reininger. It thus seemed inevitable that the character who began this project, clean, sober, filled with a lucid vision of

Jones in July) with MB (Alain Goutier, Marc Hollander, Alain Lefebvre, SB and WT guesting) the tracks that will compose his *Night Air* album: 1. "Night Air" 2. "Birthday Song" 3. "Beak People" 4. "Mystery And Confusion" 5. "Intermission" 6. "Ash And Bone" 7. "L'Entrée De L'Hiérophante" 8. "A Café Au Lait For Mr.. Mxyzptlk" 9. "Miraculous Absence" 10. "El Mensajero Divino." Tracks 1-10 constitute the *Night Air* LP released by Another Side in 04/84. Tracks 1-3/5-10 compose the *Night Air* LP released by Les Disques Du Crépuscule in 1985, also published as a CD by Normal/Crépuscule in the Spring '88. This album will be re-issued as *Night Air plus* by LTM in 2002 with following bonus tracks: 11. "Mystery And Confusion" (7" Mix) 12. "Bizarre Bizarre" 13. "Windy Outside" 14. "Broken Fingers" 15. "Crash" 16. "Crash (Remix)." Tracks 11 & 12 constitute a 7" recorded in 05/84 and released by Another Side in the summer '84 (track 12 also on the LP/CD). Track 11 also on the (various artists) *Crepuscule Collection: The Quick neat Job* compilation album released by Les Disques Du Crépuscule as a LP/cassette in 1985

Some reviews. '(…) Reininger's music owes to Glass and inevitably to Gershwin. But it's less jazz, more minimalist. *Night Air* is a nice overview about a city and about people in withdrawal (*Kuifje*, 07/01/84, translated from Dutch); '(…) *Night Air* is a magnificent album from an American in Brussels' (MAG, *Humo*, 05/10/84, translated from Dutch); '(…) there is something floating above this record but that later disappears (…) a recording reserved to an elite (…)' (*Stik*, 05/84, translated from Dutch); '*Night Air* seeks to combine modern classicism with a new approach to atmospheric chanson (…) Blaine Reininger is ahead of his time. Run to catch up with him' (E. TORDOIR, *Rock This Town*, 06/84, translated from French) ; 'An atmospheric recording, a little dark but strong. The expression of an introverted, of an exile torn between his native America and old European bricks. A remarkable album (…) that unfortunately is at risk to pass un-noticed (…)' (MARCO, *Oxygène*, 05/84, translated from French) ; '(…) this recording will make the happiness of Tom Waits or Tuxedo Moon amateurs, along with Frank Sinatra and Laurie Anderson's fans, to sum up: of all those who would like to listen to something beautiful and different' (J.-M. W., *La Meuse*, 06/05/84, translated from French); '*Night Air* is more than a confirmation, it's a major album. An atmospheric album, with a perfume of sad and smoked-out nights; of this kind of nights that never end and calling out for memories printed by Dashiell Hammet or Tom Waits; or even Brian Eno with a latino croon: Blaine R. has the look and the voice, rich and warm, although a bit disturbing. This leads to slow pieces (of the style that one calls "inspired"). It's heavy and oppressive, in part autobiographical also: Reininger reveals how Brussels inspires him; rather negatively ("Brussels is a dead city" he says) or better: in black and grey as illustrated by the sleeve for *Night Air*, where one can see some twilight that could be finishing dawn, with Reininger, hat folded over with the collar of his overcoat lifted-up, lighting up a cigarette on the *Grand-Place*.' (S. JOKSNI, *La Libre Belgique*, 09/05/84, translated from French)

About Night Air and Steven Brown's Solo Piano Music: 'Two sides of what happened to the survivors from the legendary Tuxedomoon and, for the most part you'd never believe it. From this Reininger would appear to have been the source of Tuxmoon's arch camp: keyboards, machine rhythms, lead violin and very Jack Bruce vocals suggestive of the *dansant* disco, menacing fairground music, outlandish latin pop tunes, calliopes slewing out of control,

Page 219

and none of them better evidenced than on the new single "Mystery And Confusion," the delightfully titled "A Café Au Lait For Mr. MXYZPTLK" or "Ash And Bone," the subtitle to which says "au revoir Tuxedomoon, can't say we didn't try." Brown has turned out to be an entirely different kettle of fish. While heard to great effect while duetting with Benjamin Lew on last year's "Douxième journée," here he affiliates himself with the serious arid of 20th Century classicism, somewhere west of rockers like Art Zoyd and Univers Zero and somewhere east of anyone from Satie to Birtwhistle (a purely wilful simile). Haunting music for a empty room with the windows open, and admirable for its stretching of boundaries, but his classical superiors have done it better already. I, now of course, expect Mr Brown to embarrass me into eating my own hat.' (J. GILL, *Time out*, 08/16/84) ; '(…) As much as Steven Brown's solo work appears to me as personal and innovative, the work of his partner in Tuxedomoon seems to me conventional and little inspired (…) from the whole emerges a palette of sounds already heard, of more or less worn-out *clichés*. From start to end, one travels in a post-Bowie atmosphere that gives me a bitter impression of fake emotion, of cardboard backdrop (…) like a photograph made with the flash light (…) without nuance or depth' (J.L.R., *Open System Project*, 09/84, translated from French)

art and poetry should erode slowly into a toxic shambles, punished by a pack of very minor gods for a miniature hubris. Perhaps it is best to submit a series of vignettes which can illustrate the times.

I remember how amazed Alain Goutier [*a Belgian musician who collaborated a lot with Reininger on his solo undertakings*] was when I pulled an old trick from electronic music class out of my hat and set up a two meter tape loop across the studio, played backwards. To our delight, we discovered that the name of a music industry type of our acquaintance sounded like "asshole" when heard in reverse.

Friends of electronica may be amused to know that when we first began to use the now-classic Roland TB 303 and TR808 we went to great lengths to make them sound like bass and drums, since they are now prized for their own electronic voices. Gareth Jones set up at least three sets of speakers and amplifiers to make the now-prized kick drum of the 808 sound like an acoustic instrument.

I remember how pleased I was when Gareth told me I had started to "look European" in my long coat and my prized Italian black fedora.

I remember how annoyed I was by Steven's non-linear synth playing on "Birthday Song." Upon later listening I recanted, of

Blaine Reininger with Peter Principle as an *ombre chinoise*. Photo Saskia Lupini

course. At that time, melody was all, system was all for me. I remember the sight of Marc Hollander earnestly laboring behind his bass clarinet on "Intermission" playing along to a tune I had compelled a Yamaha home organ type keyboard to play. This keyboard would write musical scores on cash-register type paper tape with strange little ballpoint pens which had to be replaced weekly. I was in love with the emerging gadgetry of the times, on fire with the technological millennium I had anticipated most of my science-fiction reading life which I felt was surely just around the corner. I was a willing infidel to emerging microchip culture, gladly sacrificing ease of execution and musical grace in order to spend more excruciatingly long hours coaxing sound out of these rudimentary devices. I was addicted to the crystalline transcendent buzz of union with machinery. I still am, but don't tell anyone.

I have felt guilty all of these years for not giving Michael Belfer his due. Michael, you had and still have a gift for melody that is instinctive and sure as a Zen archer's arrow. Of course my envy would never allow me to admit this at the time.

Keeping in character, I was massively disappointed that *Night Air* did not go on to win the Grammy that year, or any other year. I did not know then and I do not know now how to view the products of my practice as a *soi-disant* "artiste." I cannot separate myself from the life which caused the art and further verbal analysis is useless. How tragic, how comic, how compelling, how boring, how frustrating, how annoying, how sexy, how well lit, how low down and slimy my life in Brussels was in 1984. I cannot attempt to convey this except by my chosen means of music. Even this tepid verbiage is a pain. Fie! Fooey! A pox on this paragraph! If this music says something to you, how very excellent. If not, not.'

Reininger and Belfer also toured (once with The Lounge Lizards) with that material but then the grim reality of living as expatriate impoverished artists took over.

Belfer: 'A tour did finally come and things would get better when we could perform, because we at least got paid for that. But then, the tour money would go and in a short time it would be back to more of the same. And so we turned more and more to drugs and alcohol to deaden the hunger and the pain of the day to day existential misery. Like Blaine sang in "Birthday Song"... *There's nothing… Nobody home, nowhere to go... Brussels is just one big drug store*... Which it kind of was. I mean there were like hundreds of pharmacies just in the center of town alone... So we went out with the Lounge Lizards and did some live dates (on a couple of occasions, we got the drummer of Lounge Lizards to sit down with us). And then poof, we were done. There's really a lot in the lyrics that tell what was really happening... "Birthday Song," "Mystery

Birthday Song (Reininger)

Sitting in the half light, waiting for a ring on the phone with its promise of redemption from person or persons unknown
Switching through the channels, don't look like there's nothin' on
Well of course not, look out your window, in a minute it'll be dawn
So I go to the window, look at the people below
What's wrong with those half-witted morons? Ain't they got no place better to go?
Just shuffling along on them cobbles, getting uglier every day
No, they don't celebrate your birthday here
Get with it or just go away
There's nothing, nobody home
Nowhere to go, no one to see
Give a franc to a living legend
Give all of your money to me
Maybe I'm looking for meaning
Maybe I'm looking for crash
Maybe there's a place for me, rooting through your trash
Relax, old boy, pull your socks up
Go out and buy you some pills
Brussels is just one big drug store
There's something to cure all your ills

Ash And Bone (Reininger)

Ash and bone and green glass in the churchyard
Sunshine, autumn in the country
Three men casting shadows, remembering England
Find me backstage, waiting for the sound check ,waiting for the show to start, waiting for my entrance
Waiting for my wife to come walking through the stage door, smiling
Light snows fall on young men's memories, cover their tracks and leave not traces
Everything takes on a luster when viewed from a distance
Anxious years spent living from a suitcase
Airports and stations and customs inspectors
Landscapes whiz past dusty train windows
Vaudeville troupers in exile, pursuing that big break
Don't look back, don't turn around, have no regrets, there's more where that came from
When you think your dreams are shattered, it's time to dream new dreams
Ash and bone and green glass in the churchyard
Sunshine, autumn in the country
Three men casting shadows, remembering England
Light snows fall on young men's memories, cover their tracks and leave no traces
Fill in the rough sports, everything takes on a luster, when viewed from a distance

Blaine Reininger: "When I lived in the USA, I was trying to have European manners and when I got here I found out that I was not European at all." (P. Cornet, "Amitié belgo-américaine", *Rock This Town*, 05/83, translated from French); "When I left Tuxedomoon, it has been very hard to convince people around me that I could do things by myself. Everyone knew me as the drunk in the band, who would blackout after every gig. "Birthday Song" is one of the last pieces from that period (…) [*About the sentence 'Homesickness is our only guide' in the track "Café Au Lait…"*] This line is borrowed from Herman Hesse (*Der Steppenwolf* is one of my favorite books). There are two meanings to "Café Au Lait." From the surface, it looks like a fiction about someone who came from another planet, some sort of *Man Who Fell To Earth*. I wrote this song in a *café* (…) People in this *café* would not stop staring at me; maybe because I wore an earring and two blond locks in my hair. I also had my violin on my side, which of course makes you peculiar. Hence on a second

Page 221

level this song talks about me as I will always be a stranger here" [About "El Mensajero Divino"] The "Divine Messenger" is a song about the withdrawal, the waiting for this miraculous messenger who would change my life (...) I do deeply believe in God and that has an influence on my ideas and my work. All life is religion. All I do is the expression of my religion. A long time ago I very seriously considered becoming a priest. I was a choir child. A performer and a priest have a lot of things in common. Religion is theater. Religion is rock 'n roll and rock 'n roll is religion.' (G. MAHIEU, "Blaine Reininger: ik will sterven als mijn tijd daar is en niet als Reagan zin heeft om op een knop te drukken", *Humo*, 1984, translated from Dutch). '*Night Air*, the whole LP is about Brussels. It's a diary of all the things I've seen and felt there. First I felt like I was a prisoner in that city, at any rate during the period that followed my departure from the group. Since I could not play, I had to get along without money. My only output at the time was music. There is a sort of moody veil lingering above this album. Brussels is not the most exciting town either: it's grey and it often rains there. On the other hand, Brussels is more than clearly the capital of Europe and is very central. For me Brussels is a city where I can afford living and make music. Apartments are cheap and easy to find. And what is equally important, as I'm a true TV addict, Brussels is the city in Europe where you can the most TV channels: like 13 or 14' (C. EVERS, "Blaine Reininger", *Oor*, 09/07/85, translated from Dutch).

03/24 till 04/16/84 WT/BG in *Frankie & Johnnie: A True Story* at Théâtre de la Bastille, Paris (NS doing the lights) (in collaboration with

And Confusion," "Beak People"... It's all there. That was our life then.'

Some time afterwards Michael Belfer returned to the United States: "A number of things had happened, recalls Belfer. It was becoming increasingly difficult to make any money, having income happening. I just couldn't go and get some in Brussels because I was there illegally. I was just there on my Canadian passport. And I was running a risk – because I had been there for so long – of being deported.
Finally within a one-week period, I was singled-out by the *gendarmes* on the metro and my ticket wasn't valid or I had lost it. So they were going to write me a ticket and when they looked at my ID, they saw that my visa was expired and that I'd been in the country way too long. They said that if I didn't make arrangements to leave the country within 72 hours, they would come looking for me and I'd be arrested. I took it very seriously. Besides it was time to leave. I could have stayed and hidden out from the police. Blaine did it, I don't know how he managed to stay there for so long and not get deported..." This was the end of Michael Belfer's wandering path with Tuxedomoon to this date.

In April 1983, Reininger was contractually obliged to rejoin

Blaine Reininger with Michael Belfer. Photo Patrick Roques.

Blaine Reininger photographed by Saskia Lupini

Tuxedomoon for a few gigs in France. Interview footage shot at La Rochelle made it clear that the show to be performed that night was perceived by many to be Tuxedomoon's last waltz. [18] But that wasn't the case and this in spite of the Les Disques Du Crépuscule press releases that accompanied the release of Tuxedomoon' *Short Stories* EP (featuring the "The Cage" and "This Beast" tracks) on the same month announcing that the group had disbanded. [19] Tuxedomoon had just completed its first Chapter. The second was soon to open in Spain, in May 1983.

Fréquence Gaie radio)

03/25 till 04/02/83 *Divine* is being performed at Théâtre Royal de la Monnaie (Brussel's opera house)

04/83 SB produces Cosy Corner's recording entitled "Buon Viaggio" (Cosy Corner: a French group based in Bordeaux founded by Laurent Dailleau)

Last concerts of TM with BLR (and LvL, but the latter and BLR were never on stage together, LvL playing on the newer pieces) as the latter was contractually obligated to perform with TM:

04/19/83 TM plays at Théâtre de Poitiers, Poitiers

Luc van Lieshout: 'I do have memories of Blaine and JJ with us in the van driving to Poitiers. I was surprised by the number of words per minute, hour etc. that Blaine could pronounce. He was so incredibly talkative, even more than nowadays.'
A short reportage (Fabienne Chauvière, dir.) about Tuxedomoon was broadcast on the same day at the 7 o'clock news of French TV channel FR3, Poitou-Charentes region: Tuxedomoon is shown rehearsing "Nervous Guy," Blaine Reininger playing and singing, with Luc van Lieshout standing to the back of the stage holding his trumpet (not playing). During a short interview, Steven Brown is asked whether Tuxedomoon is going to be the same without Blaine: "I don't know yet, for the time being yes. Now we are three musicians like before, with a trumpet player. But he does not replace Blaine, I'm not interested in that."

04/20/83 TM plays in Angoulême

04/22/83 TM plays at Maison de la culture, La Rochelle. The Maison de la culture then shot a video doc. of the band in an alleged "Country & Western" style from which it seemed obvious that TM was then playing their "Last Waltz"

… After which BLR leaves TM for good

04/27/83 TM plays in Rotterdam

WT/BG were then in Italy, composing "In A Manner Of Speaking," when they learned that BLR was leaving the band.

05/14/83 BLR & MB play at Halles de Schaerbeek, Brussels

Tuxedomoon with Luc van Lieshout (extreme left above and third left below): ready to face the storm?
Photos Saskia Lupini

CHAPTER VII

Tuxedomoon's Holy Wars – Winston Tong leaves Tuxedomoon

1983 (from May): a new live show entitled Music In Four Suites Based On The Times Of Day, performed in Spain; Steven Brown in the Zoo Story play and Peter Principle provides music for the Pandemonium short film… while Reininger is having thoughts about leaving Europe; Winston Tong collaborates with Niki Mono (Theoretical China single and Theoretically Chinese album); Tuxedomoon tours in Italy; various Tuxedomoon events in Lille; Steven Brown creates soundtrack music for Jean-Pol Ferbus's Jean-Gina B movie

With the departure of Blaine Reininger, Tuxedomoon soon had to face a problem of credibility as it took time for the audience and promoters to accept the new formation. Therefore a brand new live show, entitled *Music In Four Suites Based On The Times Of Day*, was quickly put together and the band set off for Spain to present it. They played six times in Madrid at Cultural Center Colon between May 17th and May 22nd for the occasion of a *Festival Internacional De Teatro*. The show was highly visual, as future live presentations would increasingly become. [1] It included most of the material that would be later featured on Tuxedomoon's *Holy Wars* album plus classical pieces such as "The Cage," "This Beast," "59 To 1," "(Special Treatment For The) Family Man," "Egypt," "Mata Hari" and the "Martial/This Land" segue. The band was also broadcast on Paloma Chamorro's TV show, *La Edad De Oro* [Chamorro is a Spanish journalist whose name is closely associated to La Movida Madrileña cultural movement. Her Edad De Oro show (1983-1985) featured most avant-garde acts of the time, especially in music].

Tuxedomoon's *modus operandi*, i.e. of performing new material on stage well before its release is certainly not new within Tuxedomoon. Indeed this had been happening since their time in San Francisco. But it certainly was something that made Tuxedomoon quite special, as Bruce Geduldig recollected in a 1994 interview: "In Tuxedomoon, everyone was associated in everything. There was no leader, no management, no record label. Everything was taking place in a very chaotic way. We were doing what we wanted: this is how we often took on stage pieces that we would record

05/17-22/83 Six concerts, *Music In Four Suites Based On The Times Of Day*, in Madrid at Cultural Center Colon as part of the *Festival Internacianal De Teatro*. The track "This Land" was recorded during one of these gigs to later appear on the *Pinheads On The Move* compilation album (Crammed, Cramboy, 1987)

05/24/83 Madrid TV show. First TV show with Paloma Chamorro. An entire show was broadcast with following set list: "Crickets;" "Hugging The Earth;" "Egypt;" "Martial/This land;" "59 To 1;" "The Cage;" "In A Manner Of Speaking;" "Some Guys;" "Octave;" "Mata Hari;" "This Beast;" "(Special Treatment For The) Family Man"

Peter Principle: "'Crickets" was really just that: the sound of crickets. Some electronic and some recorded "live" as it were. This was played to challenge the audience and orchestrate the fact that we were all waiting for something. We all stood behind projection screens checking our watches and acting nervous. Lighting cigs and whatall. Bruce would manipulate our shadows. The stage would be empty of all. We would do this for as long as we thought it bearable (probably longer). You can see some photos of this staging in various places. At least one pic on the *Pinheads On The Move* compilation album cover.

"Octave" was a piece of guitar and taped moog never recorded for release. There was some specific staging and/or projection for it (I was the only musician playing). This was done by myself and Bruce and maybe Winston and was performed only in Spain on this tour I believe…'

05/27/83 TM plays at Parkzicht, Rotterdam

05/29/83 TM plays in Sens, France, as part of a *Sens International Festival of Improvised Musics* (as per a Steven Brown cv)

06/02/83 TM plays at *Festival Mondial Du Théâtre*, Nancy. As a side note all contracts entered into by the band for gigs at the time had Tuxedomoon referred to as "la compagnie" (the company), a term that in French currently designates theatrical groups

Page 225

Summer '83 till Nov. '83 Steven Brown acts and plays music in Guy D. Len's adaptation of Edward Albee's play *Zoo Story* performed at Brussels' yet unopened gare du nord subway station (cast: Daniel Charlier, Jean-Claude Adelin, Steven Brown, Greta Carbonez & Martine Doyen) from 09/16 till 10/29/83 at least. SB composes the soundtrack for *Zoo Story* (with: 1. "The Apartment – Jerry's Theme;" 2. "Chinatown;" 3. "Alone On The Bridge;" 4. "42rd Street;" 5. "All Night long;" 6. "Central Park;" 7. "Jerry's Theme – The Zoo;" 8. "Samba In The Subway;" 9. "Death Of Jerry"), released as an LP by Soundworks, 1984 and re-released as a CD by Materiali Sonori in 05/89. The track "A Spirit Ditty" composed by SB and Drem Bruinsma, appears as a bonus on the CD re-release of *Zoo Story*. This track originated in the recording sessions for SB's *Steven Brown Reads John Keats* LP/CD releasesd by Sub Rosa in 06/89

only years later. Most bands do exactly the contrary." [2]

Steven Brown in the Zoo Story play and Peter Principle provides music for the Pandemonium short film... In the Summer, Steven Brown started to work on a French adaptation of Edward Albee's classic play, *Zoo Story*. The drama unfolds in some New York City subway station, transposed to a yet unopened subway station at Brussels's gare du nord. The audience sat, shivering [*as the "venue" was un-heated and the Winter season started quite early that year in Belgium*], on the other side of the railway, helplessly watching the tragedy unfurling between the two male leads (played by Daniel Charlier as "Peter" and Jean-Claude Adelin as "Jerry").

Steven Brown: "In the final scenario for this play, the director [*i.e. Guy D. Len*] had added three roles to the cast, including the part of a saxophone player. That role was given to me. It was before I was asked to provide the soundtrack music as well." [3]

The part played by Steven Brown was that of a musician/ street wanderer witnessing, with compassion, the drama following from incommunicability between two completely opposite men, stranded at the subway station. His presence

The cast for Zoo Story (sitting on the bench from left : Greta Carbonez, Daniel Charlier, Jean-Claude Adelin, Steven Brown and, standing behind, Martine Doyen). Photo Studio Parallaxe.

on the cast added a truly hypnotic and emotional quality to the unwinding of the story, as Brown kept on discreetly pacing around, eventually playing an at times plaintive at other times gentle tune on his saxophone, remaining at a slight but attentive distance from the main action. Hence he became a mediator of some sort between the audience and the cast. 'Brown plays the role of a spectator/street musician in a way that is evocative of John Lurie in *Subway Riders* from Amos Poe or else *Permanent vacation* from Jim Jarmusch,' wrote Dutch journalist Jan Landuydt. [4]

Greta Carbonez who, with Martine Doyen, played one of the two girls in the play retains quite fond memories of this work: "The play was such a success that we played it longer than expected, for as long as we all could possibly carry on. I remember of Steven as a most delightful work companion and friend, caring and sensitive…"

"*Zoo Story* was a truly great experiment for me, says Brown. Doing this play in the subway corridors was such a great moment. This is the kind of work that I really enjoy doing." [5] "Also I discovered that I could do things alone, interesting experience." [6]

During the same summer, Peter Principle worked with his companion in art/life Saskia Lupini and provided music for her *Pandemonium* short film (in which Nina Shaw and Steven Brown appear).

The premise for this short was summarized on the flyer that accompanied its release:

'Pandemonium is a reconstruction of the Ancient myth of Pan and Syrinx, mixed with references to present day situations. The God in love with the nymph payscourt her. To escape him, she transforms herself into a reed and he has the idea to assemble reeds to make a flute which he calls Syrinx in her memory.

We are concerned with iconography of myths ancient or modern and video techniques [*which*] permit the creation of illusion and evoke the magic of these myths. It also permits simultaneous transmission of social, political and artistic informations.'

This work proved seminal for Principle as it formed the basis for his forthcoming first solo project *Sedimental Journey*.

Blaine Reininger has thoughts about leaving Europe.
In August 1983, Reininger wrote the following :

'Well it has happened at last. JJ and I have been thinking about the unthinkable, that is, forsaking Europe, instigator of and mother to all our American conceits and delusions, becoming EX-expatriates and running back to the land of the free, the land of Taco-shaped bubble gum, the National Enquirer, all-night movie-go-round, Howard Cosell, food

Summer '83 PP works on and provides soundtrack music for Saskia Lupini's short film (color., 26 min., music PP, prod. by Image Video – Mirror Production) entitled *Pandemonium*. NS, SB & WT also collaborate. Frankie Lievaart works on special effects

08/08/83 BLR plays at Melkweg, Amsterdam

10/24/83 BLR plays at Théâtre du Forum des Halles, Paris

11/06/83 BLR & SB play at Salle des Congrès, Caen, *Festival Transit Urbain*

11/08/83 BLR & SB play at Melkweg, Amsterdam

stamps, the almighty DOLLAR, free enterprise, free surplus cheese, '57 Chevy's, Elvis, apple pie, Ronald Reagan, Santa Claus.

(…)

Oh America, oh Americans, the great raw-boned frontiersman lurking in the outward packaging of an overweight dentist bound in Nikons, the great innocents, strangers to all this passport fumbling, money changing, border crossing, nothing-to-declare anachronistic nationalism. Hell, back where I come from, you can drive six days, any direction and encounter nothing more foreign than the fact that some 7-11's are not yet 24 hours, speaking the liturgical language, God's own *English*, with a few minor regional variations, the whole time. Endless gasoline for the Chevy, godless sons of the Crescent notwithstanding, hell, whut they wear them DRESSES alla time fer? I ast ya.

Oh, Europe, oh our big ol' war-torn harlot mother, your hordes of solid burghers getting in the Renault and heading for Spain or Italy every year at the precise same time, gonna get us some sun and sand and get a tan that will last all of three days by the time we get back up north to our secure positions of responsibility, dreaming about next year, scarcely a ruin left, all risen from the ashes again and again and those that remember because they were there, tipping the forelock to German conscripts who were frustrated tourists bent on world conquest so they would have a safe place to vacation and, above all, finally *accepted* in Paris society, or by Gott und Himmel we put the boot in good and hard and spare not the Eisen fist, those that still remember dying off or too old for anyone to listen anymore. Oh, God! To leave you with your Pensions and your clean Swiss lakes and your garlic-breathed and crazed hordes of Italian football fans, your deeply ingrained traditions of culture, literacy, and your sometimes-overwhelming etiquette ("Un café , s'il vous plait. Mais oui, Monsieur. Au revoir Madame et Monsieur. Au revoir, monsieur, bonne travail.") All this for a simple transaction in a store, a cigarette shop, buying a subway ticket, translated into the American "Whaddya *you* want, bud?" The train rides, everywhere ready to fill the romantic with nostalgia for a past older than his grandfather's grandfather, all the Shangai Express and Twentieth-Century Limited elegance, dead and buried and exhumed and reburied in America. Watching the cows out the windows crossing the Alps in your Wagon Lit, listening to Vivaldi on your walkman. The sheer age of everything! Touching a ruin in Rome that is not even on the tourist maps, just there, twenty feet below modern street level, reading the proclamations of ancient Emperors and Kings, still legible, but nothing special, after all, we got a million of 'em. "Avanti, ragazzi!" Great lumbering ego beast called TUXEDOMOON

steps off the plane, gonna git us some of this here culture, gonna take this continent by storm, telling the press we are choosing to live here because the population is far more LITERATE, ready for our brand of weirdness, getting away from Reagan and his shock troops, gonna live it up, yessir! Three years later, having a hard time getting a gig to pay the rent, we have been superseded by hordes of well-dressed and hyper conscious English kids, fresh off the Dole, dressed to the teeth "Sure, mate, I know where I'm going. Anywhere but HERE!" They sing the songs, they wear the clothes, bleached-blond coifs growing from heads pleasantly emptied of any notion of political, philosophical, intellectual content, scrubbed-clean lyrics extolling the virtues of dancing while post-industrial Europe collapses, little thought given to the "weighty" philosophical and even religious concerns my contemporaries seemed to find essential to songwriting or any other discipline. I don't mean "Save the Whales," either. I mean, a good, good but old, analysis of the world in existential terms, questioning why we are here in the first place and where we are going and what is the nature of the soul, the consciousness, trying to drag out Nietzche's time-worn warhorse concept of the superman, the beings we could eventually become, if our artists and scientists and thinkers and our selves can live through the century unscathed and still thinking and questioning away.

(…)

The point is, Mr. Reininger, that you have been REPLACED by younger men (…)

Contemplating an early retirement, a mid-life crisis, a change of careers, what have you, I am only thinking the unthinkable. I am thinking of moving back to California and learning electronics while I still can, with an eye on designing my own musical instruments, with an eye on making some money for once. I am contemplating leaving the carrot and stick proposition of chasing the Zeitgeist down ever-seedier alleyways until the highway with its glittering lights is too far back there to ever find my way back. Dying donkey chasing a dessicated old *papier mache* mock-up of a carrot tied to the shit end of the stick. How did I ever lose sight of my ideals to the extent of actually giving in to this two-bit con, anyway? It's just so tempting, my friends, so tempting.'

However the thought of leaving Europe seems to have been short-lived. Reininger seemed to have come to terms with "old Europe" as an interview he gave about a month later to French newspaper *Libération* makes clear.

"(…) I prefer to be living in Europe. The idea of returning to the United States is depressing as it would be returning on my footsteps rather than moving forwards: it would be a statement of failure. There are too many things in Europe

that I've grown to find natural and that I would miss returning to the States. Here people are generally more cultivated and they are more possibilities for artists. Here artists are considered as respectable people whereas in the US you are always perceived as an outlaw or a marginal." [7]

In early November Reininger resumed working with Steven Brown and the two of them gigged as a pair. Their artistic collaboration will never come to a complete stop. Neither will their friendship, a friendship of such a strange nature that it appears as an enigma for many, maybe even for themselves.

Winston Tong collaborates with Niki Mono (Theoretical China single and Theoretically Chinese album). Tong wasted no time in pursuing his own agenda to become a "star," on his own via his second solo venture. It probably was with that aim in mind that he collaborated with Belgian singer Niki Mono (also known for her collaborations with Snowy Red and, later, The Neon Judgment). He was instantly impressed by her: "I knew immediately that Niki possessed the same qualities that people told me I have, and I imagined that the two of us alone on stage would be quite hypnotic." But his intention seemed to have been to collaborate to serve his personal goals, rather than seeing it as a true equal partnership. Some analogies could be found between this collaboration and his previous dealings with Victoria Lowe.

Niki Mono was herself aware of this but didn't really seem to care.

"I met Winston in 1983 for a Wonder Products video shoot with Patrick de Geetere, *Fugitives In Black And White*, where me and Winston danced to Jacques Brel's "La Chanson Des Vieux Amants."

Our first night out was at the Plan K and I do remember that it got really smoked out there and we got really drunk and Winston and I must have signed a piece of paper. A couple of days later I received a letter: it was a bloody contract! I said: "Winston, what the hell is this?" And he goes like: "I think we signed a contract at the Plan K, they've asked me to play there for their 10th Anniversary" [*on 11/12/83*]. And I was : "Winston, what have you done!?" And he was: "Well, you've probably signed it as well, you know." And I was: "Winston, we have nothing, we only just met!" I panicked. Actually it was a brilliant idea, as we had nothing and we were only about nine days away from this concert. After us, Echo & The Bunnymen were playing. We asked Micky Mike – who was part of the band called Snowy Red – if we could use his studio. So we recorded a backing tape. I think it was six covers and two songs that Winston wrote and two songs that I wrote. We didn't have more than maybe 32 minutes of music.

I remember that on the evening of that concert we were

Some time in '83 Niki Mono & WT meet when shooting Patrick de Geetere's short film entitled *Fugitives In Black And White* (40 min., Wonder Products, released in '85). WT & Niki Mono sing Brel's "La Chanson Des Vieux Amants" and WT contributed music to this film. See http://www.art235media.de/index.php, for a description of the argument of this film

11/12/83 WT & Niki Mono play at the Plan K's 10th Anniversary party in Brussels: first act in their collaboration

Some time in '83 BG participates in *New Facts About Cement*, a film directed by Patrick de Geetere. Bruce had been introduced to de Geetere by the latter's girlfriend Catherine Maes who was herself a friend of Niki Mono. Patrick de Geetere: "This film is a compilation of poems from writers who had in common to be all living in NYC's lower East Side and of being all related to the rock scene, one way or another. I made this film with my partner Catherine Maes. We had staged all these poems clip-wise, with some reading out the poems. I was into an activity that now has become common as I was remixing those readings. Bruce intervenes on three poems: "Looking For Love," "Skin" and another one. On "Skin" I asked Bruce to sing the poem like a nursery rhyme. I had sampled a piece from Brian Eno and I mixed it with Bruce's voice. For "Looking For Love," an eight minutes sequence, I filmed Bruce a bit in the guise of American *films noirs.*"

Some time in '83 PP participates in editing (with Frankie Lievaart) and music of Saskia Lupini's film entitled *Landschap, Mensen, Stad, Cultuur*, a 20 min. short, Mirror prod. This film was shown in various video festivals

Some time in '83 PP (with GM) produces Belgian band Isolation Ward's 12" entitled *Absent Heart*, released by Les Disques Du Crépuscule in '83

Some time in '83 BLR records (at Little Big One Studio, Brussels, prod. BLR): 1. "Contempt," 2. "Les Choses De La Vie," 3. "Le Dernier Amant Romantique," pieces that will later appear on the *Instrumentals* mini LP, released by Inter in '87. Tracks 1 and 3 also appear on (various artists) *Moving Soundtracks*, vol. I, a CD published by Les Disques Du Crépuscule in '91. Track 1 appears on (various artists) *Operation Twilight: Crepuscule Instrumentals*, LP released by Inter in '88

Page 230

shaking like leaves, and just before getting on stage, Bruce arrived in the dressing-room, coming from the States. He had this Sinsemilla stuff with him and we had a smoke just before getting on stage. And honestly I remember it like if it was yesterday: I couldn't move, I was: "I can't do this and there's no way we're going to be able to do that," warming up for Echo & The Bunnymen, just the two of us and a backing tape and one or two evenings of home rehearsals! (laughs). Result of this concert was, at the end of it, I don't know why but people liked it so much that we had to play the whole tape all over again."

On January 15th, 1984, the pair recorded a demo at Soundworks including rough versions of "Move Me," "Zimbabwe," "Play The Game," "Said And Done," "To You," "Incubo," "Theoretical China," "No Regrets" and "1984." It was enough to convince Les Disques Du Crépuscule to sign the project for an album, the forthcoming *Theoretically Chinese* [released in 10/85], which was credited to Tong alone. Mono: "Then it went real fast. The next thing is that we had to sign for a record deal, there again with Winston's big ego, that Winston wanted to be mainly HIS project (laughs). There again I didn't really mind. You know some people know the truth and it doesn't matter."

As Crépuscule was then being funded by Island Records in the UK, [8] Crépuscule could afford to send Tong and Mono to London in April 1984 to record the electro/funk/dance track "Theoretical China" – released as a single and as an EP – that featured a dream cast of guest musicians (ex Associates Alan Rankine, ex Magazine Dave Formula, Jah Wobble, Simon Topping from A Certain Ratio and Steven Morris from New Order). The track was produced by Alan Rankine [9] and Dave Formula.

By mid-April '84, Tong/Mono did a short Les Disques Du Crépuscule tour in Japan with Mikado and The Durutti Column [10] during which they presented most of their upcoming *Theoretically Chinese* album material.

Niki Mono: "We took this plane from Brussels to Japan, it was on the 17th of April of 1984. I remember making a drama because I didn't want our backing tape to be scanned because we had no copy of it. So we had these tapes and the plane went off and landed… in Alaska. We didn't have any luggage really and it was really bloody freezing before we left again for Japan.

I remember the press conference. There were Vini and Bruce from The Durutti Column, there was this French band, Mikado, and then Winston and I. And this press conference was huge, too huge for me, Winston liked it a lot. I thought: "We cannot make any mistake here"…

Touring with Winston was amazing. We weren't often

Some time in '83 BLR guests on The Pale Fountains's piece named "We Have All The Time In The World," published on (various artists) Les Disques Du Crépuscule's *Moving Soundtracks* compilation double LP (later published as a CD) and on (various artists) Les Disques Du Crépuscule's *From Brussels With Love* compilation double LP, released in 09/86, released as a CD in 04/89

Some time in '83 BLR plays with the Dream Makers (probably with Wim Mertens) and records (Brussels, prod. Wim Mertens) "Helen's Song" published on Les Disques Du Crépuscule's *From Brussels With Love* compilation double LP, released in 09/86, released as a CD in 04/89

Some time in '83 BLR guests (a.o. with Luc Van Acker) on Anna Domino's following pieces (recorded in Brussels, BLR and Anna Domino prod.): 1. "With The Day Comes The Dawn;" 2. "Land Of My Dreams;" 3. "Review;" 4. "Everyday (I Don't);" 5. "Trust, In Love;" 6. "Repeating." Tracks 5 & 6 appear on Les Disques Du Crépuscule's 7" *Trust, In Love*, released in 11/83. Tracks 1-5 will be published on Anna Domino's *East And West*'s mini LP released by Les Disques Du Crépuscule in 02/84. Track 2 appears on Anna Domino's *L'Amour Fou* LP/CD published by Les Disques Du Crépuscule in 06/89

Anna Domino's initial wandering stories with TM in Europe. 'In 1982 Belgian label Les Disques du Crépuscule flew me to Brussels to make my first record. The studio is under construction and the one cassette recording of my songs is missing. Everyday the label sends over anyone they can think of to help. The effect is chaotic: three drummers show up one day while I'd planned to program all the beats on a machine. Virginia Astley appears, briefly, like a vision. Many are sent with the command to produce – Blaine stays! He has a million great ideas and some cool gear and plays sweeping solos and talks about his wife JJ who he swears I will love, and I do.

We have ten days to record and mix. But the engineer quits and Gilles Martin, with his sensitive ears and generous spirit steps in to help us finish this first odd, fragile record. We work at night and never leave before we have to. Blaine works at his portable keyboard that prints out score on cashier's tape. The studio has a room full of broken glass that sounds massive when you run the drums through it. I want to use this everywhere but it's way too big – stampeding elephants. Is like having the laboratory to yourself every night after the scientists have gone.

I'm staying in a by-the-hour hotel near Blaine and JJ and she and I spend a lot of time stomping around Brussels exploring her favorite places. JJ keeps telling me about Nina [Shaw] and I plan to go to Paris to meet her. Walking from the North Station to Left Bank [in Paris] takes six hours as I have to explore every side street. Find a cheap room and head out to the Théâtre de la Bastille where Bruce and Winston are performing *Frankie & Johnnie* [in 03-04/84]. This is the show where Winston channels Billie Holiday. It was a dreamy mesmerizing event. Afterwards Nina came out from behind the lights and we all went off to the house Winston was staying at to wait for the dealer – a beautiful blue eyed North African named Etienne. Deborah Valentine was there, very elegant in a 1930's *negligé* and Winston took out a collection of toy soldiers and told stories with them. The mood created in the theater continued through the night. As if we were cocooned in our own world. Snowed in. Marooned. I spent the week with them. There

Page 231

was a lot of heroin in Paris then and unlike NY it was treated as a social drug so groups of kids were nodding out at *cafés* and museums. Etienne told me he would show me Paris but first he must have his breakfast – laid out by his mother: coffee, spoon, syringe.

Then I went home. Almost two years passed before I got the test pressing of my debut recording in the mail. Duval, who runs the label, titled it *East And West* and put a photo he took of magazines on a coffee table on the cover. Keeps the cost down (…)

Blaine and JJ

Once, staying over at Blaine's and JJ's on rue Stassart I woke in the night to see Blaine, wreathed in cigarette smoke, writing by his bed lamp. In the morning there was a note by JJ's side saying how much he loved her. He said it often.

Blaine played the violin with his broken hand as if the break and resetting of bones that followed were done to better conform his hand to the instrument. He loved new technology, still does, and had the most fun in Japan music stores where he got himself a skeletal electric violin.

Blaine's gracefully frenetic solos on my first record remain the defining sound that brought the recording out of its shell (…)

In Brussels you could buy a number of narcotics over the counter: o(…) pink; the little blue morphine pills, c(…), with or without vitamin C. They weren't much fun but they were cheap and plentiful and a lot of people couldn't resist them, especially old folks and Americans. Blaine turned it into a science and with a library of physicians desk references knew more about Belgian pharmacology than anybody. Then there was brown heroin – suddenly, with the Russian invasion of Afghanistan, everywhere. You could burn it or cook it – though it needed lemon to dissolve. Then came the happy speedball – heroin and coke cooked up, with lemon, and shot. Absolute bliss for a few minutes. Drugs were everywhere. Blaine and JJ had a dealer living one flight up. At the Indian restaurant near me the owner would bemoan the lack of white heroin: "So much better for the heart." Dope removes guilt and desire and fear. It doesn't stop pain but it enables you not to care. A warm weight, not entirely comfortable, presses you down. Enough of it and you drift into dreams – a little less and you are ready to watch TV or fold origami but not put sentences together or fill out tax forms. Taking trains is good, eating unnecessary, sitting over a cup of tea for hours kills time as does organizing your bead collection but reading is impossible. So that's what we did. Not everyone got taken with drugs, by any means, and everyone kept working.'

Some time in '83 BLR guests for the piece "Regrets Eternels" and WT guests for the piece "Loneliness" published on Karl Biscuit's mini LP entitled *Regrets Eternels* released by Crammed Discs in 1984

Karl Biscuit: "My encounter with Tuxedomoon took place around my *Regrets Eternels* album but it was mostly the story of a human encounter. For about six months, I shared a house with Winston Tong and Peter Principle. I had a little studio in there. From time to time, Winston was making some nocturnal appearances, according to a very special timing. Sometimes he'd disappear for days and we were worrying about him: "Is he dead?" He lived on the upper floor in a totally black room. He had re-painted it all himself in black, including the windows. All the things he had were black: his clothes, his sheets, his

together because Winston went out a lot shopping in Japan. While he was shopping, I was meeting many musicians. One night, we went to this club called Pithecan Thropus Erectus. This club was very interesting: Japanese underground, David Bowie would land there sometimes. I met people there who had been working with Devo (…)

I remember my meeting with this guy who produced our song "The Hunger" [*i.e. either Atsuo Suzuki or Satoshi Kadokura*], one of the kindest men I ever met…

I remember that our last day before flying back to Brussels was a complete nightmare. I got to the point that I felt so paranoid that I spent part of the day under my bed. I wrote a song about the crazy center of Japan. I remember conversations that I had with Bruce and Vini from The Durutti Column. They were fucking great people. I remember having Winston on my right side and Vini on my left side, on our knees, invited in a temple in Japan. That was one of these magical nights… All my respect for these guys (…) But Winston and I haven't toured apart from Japan. We split up before…"

It was during this Japanese tour that Niki Mono composed and recorded "The Hunger" with Tong. This piece is a most haunting soundscape, recorded with Japanese musicians, instrumentation and producers. It was inspired by the 1983 Tony Scott film of the same name, and became the B-side of the 7"/12" *Theoretical China*. The track still stands as one of Tong's finest recordings, although it owes way more to Mono than Tong.

Niki Mono: "An afternoon in Japan, while Winston was out shopping, I wrote a piece of music in my hotel room. It was originally 32 minutes long. I remember having sticked five pieces of paper together horizontally. I made a structure and indicated how it should be, at what part it should break, what kind of instruments should be used. So basically, I wrote most of the musical part of it, with maybe 10 % written by this divine man… [*either Suzuki or Kadokura, both producing the piece*]. He was that sort of man that you didn't need to talk to, which for me was probably the best thing that could happen to me as I'm very bad to express myself with words. Winston had written 95 % of the words, maybe one small percentage by myself and 1% came out of the movie called *The Hunger*, starring Catherine Deneuve and David Bowie. My intention was to write a soundtrack of how I had seen this movie. And "The Hunger" is an exact reflection of how I saw this movie, Winston equally. I don't know what it was that we had in common with "The Hunger"…

Only problem with the song was that it was 32 minutes long and so when I got to the studio with Winston I had to shorten everything to about 16 minutes. "The Hunger" was produced by Winston, me and [*Suzuki and Kadok*ura]. As to the lyrics…

Page 232

Someone some day sent me a postcard after we had had a one night stand. On it he had written: "He who falls in love with himself, will have no rivals." On the postcard there was a picture of a man holding a gun! This sentence appears at the beginning of "The Hunger."

The deal with Winston was that I could bring out a B-side that would consist of how I saw music at that time and I would work on the A-side, where I would be part of him. He had a very different potential than I had and so the two of us could do something together.

I wasn't very proud of *Theoretical China* because the A-side was quite superficial to me. It was about going to producers and: "You'll make me a star!" I found these words quite disgusting. I was thinking: "Who the fuck do you think you are?" I thought that this was very arrogant. But I thought: "I'll get my time" and we'll be equals.

I was very proud with "The Hunger." For me it was a grand-piece of anti-music because it had nothing to do with a song. It wasn't a soundtrack either. I don't know what it was. It was quite heavy shit. We improvised most of the melody line mainly. We didn't have time for rehearsing at any time…"

Due to the fundamental differences that Tong and Mono had in their respective quests, Mono soon found herself quite estranged from the recording process of the album *Theoretically Chinese*.

Mono: "After the recordings of the album, I decided to take mainly all my vocals off the album! I remember that I was quite violent about it: "If you do not take my vocals off this album, I'm gonna burn these tapes!" And at that time I was mad enough to do so because I had absolutely no frontiers. I did not agree that all the songs were turning into sort of superficial dance tracks as I found Winston so much better when he did stuff like "In A Manner Of Speaking," "Like The Others," "Move Me" etc...

So in the end I didn't mind it became Winston's project as I saw it very differently and did not really want to be part of something I did not feel good about anyway…"

The album saw Alan Rankine holding sway over the production, transforming the pieces into, as James Nice put it, 'glossy electro-pop miniatures,' [11] to such extent that many consider the finished album as much Rankine's work as Tong's. [12] The recording sessions took place in Brussels and stretched over several months, from the Fall '84 until into 1985, and yet, the finally delivered album was found to be under length, with "Yellow Peril" and "The Quotidian" hurriedly recorded in a couple of days. [13] Of course this had to do with Mono's eviction. Her excellent "Dream Assassins" was dropped from the album and remained unreleased until Mono recorded a new version of the piece for one of her later

lighters, even his cigarettes were black. It was very strange. On one night that I was in my studio, wandering through some sound search, I heard the door opening slowly and Winston, like a shadow, silently glided into the room and whispered something like: "That's great!" into my ear. I asked him whether he wanted to do something. "Yeah..." he said, "I'll sing…" So I set him up a mike and he uttered some noises that sounded quite appalling to me. The piece came to an end and I proposed we'd do another take. "No, he said, it is over." He left me very disappointed and thinking to myself: "this guy was so stoned that he totally fucked it up!" On the next day I listened to that tape again and it was just magnificent. This piece is still in my archive. I never released it.

Winston remains one of the greatest artists I encountered in my life. By his charisma, he's a poet. There was something Rimbaldian about his self-destruction also. Winston is a mess but he possesses this delicacy of truly exceptional beings, of someone who masters such an extraordinary capability of expressing himself artistically…"

Some time in '83 BLR & SB guest on Richard Jobson's *Ten-Thirty On A Summer Night* LP released by Les Disques du Crépuscule in '83, later as a CD in '90

Some time in '83 SB provides the track "La Valise De Flora" (recorded by Luc Debugher) for Severine Vermeersch's film of the same name. This track appears on SB's *Composés Pour Le Théâtre Et Le Cinéma* LP/CD released by Les Disques Du Crépuscule in 01/89

Page 233

solo recordings.[14]

Belgian musician Alain Lefebvre (who played with Marine, Digital Dance, Snowy Red, The Durutti Column, Polyphonic Size, Kid Montana, Anna Domino, Isabelle Antena and others), played the drums on the album and considers that Niki Mono was indeed unfairly treated: "I believe that it was her who pushed Winston to record this album. I'm pretty sure that she actually wrote three or four of the pieces. I'm convinced that hadn't she been there, the album would have never existed. And she also was the one who brought all these people aboard because she knew Jah Wobble and she had met Dave Formula when he came to play in Belgium with Magazine. She really was the one who pulled Winston all the way through that project…"

In the end *Theoretically Chinese* sold reasonably well but probably not enough to meet the huge costs generated by its production for such a small independent label as Les Disques Du Crépuscule. Indeed, with the Island Records connection long since severed, the album lost the label a small fortune. [15] However the opinion of German licensee Normal was that the record could have sold more had Tong toured on the strength of it. [16]

Such a tour had actually been planned but Tong decamped before it could materialize. Alain Lefebvre remembers: "A tour was planned. I was looking forward to it because there would have been Dave Formula, Alan Rankine, Jah Wobble, Steven Morris and me at the drums. It was to be a nice tour of the European capitals and it was relatively well-paid. What apparently happened is that Winston absconded with a certain sum of money that I understood to be an advance. He ran away with it and went back to San Francisco. That was such a story that when I went to San Francisco in the nineties and eventually ran into Winston on the street, he ran away from me thinking that I had been sent by Les Disques Du Crépuscule to collect whatever! I had to run after him for a while before I could convince him that I had nothing to do with this…"

Tuxedomoon tours in Italy. We left Tuxedomoon back in 1983. By mid-November, the band left for another successful Italian tour (Reggio Emilia, Bologna, Milan, Florence, Gabbice, Naples, Bari and Rome), somewhat tempered by the theft of two million Italian lire from Martine Jawerbaum's hotel room, with little interest from the police. [17]

Around that time Maurizio Palazzi published a quite thoughtful piece about Tuxedomoon for *Dry* magazine:

To him Tuxedomoon belongs to that generation of groups who are seeking 'a response to the solitude and the feeling of insecurity resulting from a frustrated and desolate relationship

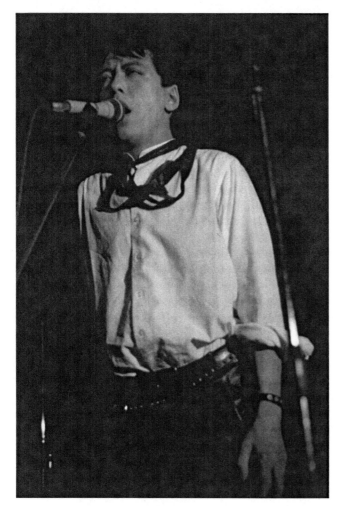

Italian Tour:

11/18/23 TM plays at Teatro Ariosto, Reggio Emilia

11/20/83 TM plays at Teatro Tenda (under a big tent), Bologna

11/21/83 TM plays at Rolling Stones (an old cinema transformed into a club), Milan

11/23/83 TM plays at Tenax, Florence

11/24/83 TM plays at Aleph Club, Gabbice

11/26/83 TM plays at Teatro Tenda Partenope, Naples

11/28/83 TM plays at Teatro Petruzzelli, Bari. The track "Martial" was recorded during that concert and is featured on the *Pinheads On The Move* compilation album (Crammed, Cramboy, 1987)

11/29/83 TM plays at Palladium, Rome

Martine Jawerbaum's set list was the following: "Waltz" – "Crickets" – "St-John" – "Bonjour Tristesse" – "Martial" – "This Land" – "Hugging The Earth" – "Watching The Blood Flow" – "Egypt" – "59 To 1" – "The Cage" – "In A Manner Of Speaking" – "Some Guys" – "Mata Hari" – "This Beast" – "(Special Treatment For The) Family Man" – "Italian Western"

Winston Tong with Tuxedomoon at Aleph Club, Gabbice, 11/24/83. Photo Minny Forino

to one's city (…) The track "Loneliness" stands as a testimony of our eternal conflict: we will most certainly follow our endless course inevitably leading to the paths of death ("Km"), but it's precisely in that state that resides the secret of our everyday life (…) The research project proposed by Tuxedomoon centers the attention on another kind of culture, coming from the Far East, more generally an attempt to fuse musical technology (…) and sonorities stemming from folk music in the Chinese and Japanese traditions (…) one can also note influences from other forms of art like theater (…) the relationship body/music that sets up during a theatrical performance: the first depends on the second in a somewhat circular relationship (…) this is a project mediating theatrical and musical forms.'[18]

Various Tuxedomoon events in Lille. On their way back from their Italian tour, the band stopped in Lille (France), already frozen by an early Winter, for various Tuxedomoon events. They consisted of a showing of *The Ghost Sonata*

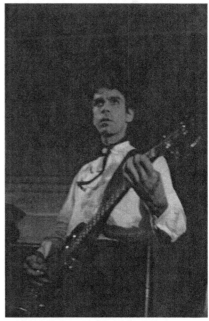

Peter Principle, with Tuxedomoon at Aleph Club, Gabbice, 11/24/83. Photo Minny Forino

Various events in Lille, France:

11/24&30/83 *The Ghost Sonata* video is presented in Lille as part of an *Images Rock* festival

12/01/83 Press conference in the afternoon and, at 7:30 pm, opening of an exhibition of paintings by Winston Tong (33 portraits of celebrities). Radio Fréquence Nord night radio special. TM followed by radio France Culture for a few days for one of its *Nuits Magnétiques* shows

12/02/83 TM plays at Théâtre Sébastopol, Lille (promoted by Jean-Pascal Reux). The show was recorded by Fréquence Nord and France Culture

Lille – A concert – A dinner – Slaughtered dreams. A lost soul of a young girl went wandering in a park around 3 a.m. Stone benches. Frozen. She lied down waiting for the cold to seize her in eternal sleep. Seconds, minutes – tic tic tic – passing by. Then from a distance she could see her own self rising up from the bench, leaving a frozen dead self behind. She went into another life for 17 years

12/16/83 BLR & SB play at Centre Culturel Wallonie-Bruxelles, Paris

12/25/83 BLR participates in a VPRO radio show

12/26-27/83 BLR guests (at ICP, Brussels with prod. Mikel Rouse) on the track "Under The Door" appearing on Tirez Tirez's *Under The Door* 12" released by Another Side in the Spring '84

End of '83 SB works on the soundtrack to J.-P. FERBUS' film entitled *Jean-Gina B* (released in 1984). The tracks "Jean Gina B. – (Main theme)," "Voiture Jean Gina B.," "The Harbour," "Cage Muzak," "The Garden," "Piano Trilogy," "Life Gone By," "Cocktails," "Jean Gina B. – (Finale)" appear on SB's *Composés Pour Le Théâtre Et Le Cinéma* LP/CD released by Les Disques Du Crépuscule in 01/89

video (on Nov. 24th and 30th, 1983) as part of an *Images Rock* festival, an exhibition of 33 paintings by Winston Tong and, on December 2nd, a concert at the Théâtre Sébastopol. The band was also followed for a few days by French radio France Culture for one of its cult late night *Nuits Magnétiques* shows that was aired some time in December '83. The radio show included some cruising around Brussels with the band eventually reaching Plan K neighborhood, where Peter Principle remarked that one could be watching blood flowing down the streets in the early morning, due to the presence of a nearby slaughterhouse.

Paul Grosclaude's review of the gig at Théâtre Sébastopol captures the beauty *and* the fragility of the band's performances back then: '(…) the audience is disparate and colorful: *blasé* intellectuals, survivors from the psychedelic brotherhood, retarded cool people and, still, *amateurs* of a non sectarian rock.

Since their *début*, this San Francisco outfit understood the fascination that their strange and exacerbated music exerts on the audience. On stage they don't abuse the public by having recourse to crowd manipulation means. They even appear quite fragile and vulnerable in their nostalgic meditations. Being invited to a Tuxedomoon concert is taking part in a game of questions and answers about the unfathomable, the incomprehensible. On a screen images unroll, deprived of any connection with one another (a cross on a tomb, a truck, a child etc.) but summoned to facilitate the osmosis between the audience and the musicians. But couldn't it be another obstacle in the end? (…) There is something of a *happening* in this way of aesthetically frustrating the spectator to force him out of his passive attitude during the concert.

The audience does not always follow (…) especially at the start of the concert. Steven Brown and his friends give by their attitude the impression to isolate themselves (…) On other moments, at the impulse of Winston Tong, the five Americans find themselves together and then it is as if a new style was born under our eyes after a slow and painful maturing process. Then even a deaf person can understand what holds these musicians together, beyond a from the start wilfully sought for harmonic disorder. Maybe that is the kind of *happening* expected by the audience?' [19]

Steven Brown creates soundtrack music for Jean-Pol Ferbus's Jean-Gina B movie. The remainder of 1983 went by with each Tuxedomoon member going by his own business. Reininger and Brown gigged together in Paris. Peter Principle got involved in the production of Minimal Compact's *Deadly Weapons* LP. Reininger participated in a radio show in Holland and guested on Tirez Tirez [*i.e. an American band fronted by Mikel Rouse who had then struck a record deal with Les Disques*

Du Crépuscule]'s EP entitled *Under The Door*.

Steven Brown also composed the soundtrack for Belgian (now deceased) film director Jean-Pol Ferbus's feature film *Jean-Gina B*. The theme of that film had everything to capture the Angel Of Light that, deep down, Brown probably never ceased to be. The film is based on the true story of Jean Bella, who served as an officer in the Belgian Marine while being convinced, from an early age, that his male identity concealed a woman. When he retired, he decided to live the rest of his life as a woman.

Director Jean-Pol Ferbus's camera follows Jean Bella and makes him talk about his life, his spiritual experiences and ultimately reveals the true poet that Bella has been for most of his life. The film isn't about transsexuality but about loneliness one can experience when he/she feels very deeply that she/he belongs to the two sexes in a deep, almost religious, fashion, to such an extent that it can lead to sexuality being ultimately erased from one's life.

Steven Brown: "I wanted to make this soundtrack out of fascination for this film's main character, a retired radio operator in the merchant marine now aged 70. For years now he's been living dressed as a woman, puts make-up on and wears a wig. Before then he lived with the belief that something went wrong in his head. One day he understood. He's not a homosexual, he even possesses a mystical side about him…" [20]

Steven Brown's discreetly expressed concern to assert his identity as a genderqueer person can be found in quite a few of his solo ventures/song lyrics. Notably when, in 1990, Brown was commissioned to work on the *Croatian Variations* project (see Chapter IX), the required work was to provide soundtrack music to a ballet portraying "the process by which a being chooses to become a woman." Brown: 'I think like a woman I talk like a fool and I act like a man in this black iron prison. [21] Yes you could say there is a recurring theme here... Angels Of Light, Jean Gina B, *Croatian Variations*... I might wish to be more in touch with my feminine side. I never got the desire to be a woman though as I believe we are all made up of at least two sexes...'

1984: recording of the Soma single; some tours and scattered gigs; Fifth Column; recording of the Holy Wars album; more gigs; Scandinavian tour; work starts on OPERATION Revisionaries; Tuxedomoon signs with Crammed Discs

Having learned some harsh lessons over the past two years, Tuxedomoon was now actively seeking a long-term relationship with a large label in the UK through Martine

1983/84 PP produces (with GM) and guests on the following tracks (recorded at Daylight, Brussels): 1. "Next One Is Real;" 2. "Losing Tracks In Time;" 3. "The Well;" 4. "There's Always Now;" 5. "Nada;" 6. "Not Knowing;" 7. "Deadly Weapons;" 8. "Burn-Out Hotel;" 9. "The Howling Hole." These tracks constitute Minimal Compact's *Deadly Weapons* LP (1984) and CD (11/88) released by Crammed Discs. BLR also guests on track 8

1984/85 WT collaborates with French based in Brussels choreographer Pierre Droulers. He provides the lyrics and co-writes – with Sussan Deyhim – the music for a performance entitled *Miserere* (Mercy) subtitled *Les Reflets D'Orphée Et D'Eurydice*, a modern ballet based on the myth of Orpheus and Eurydice, a descent to hell. The production was staged at the Festival Du Marais in Paris in 1985 and featured Tong, Deyhim, Adriana Borriello, Kazuya Sato and Pierre Droulers. It was performed at Centre Culturel Wallonie-Bruxelles (Paris), Châteauvallon summer festival, Rouen summer festival, in Liège, Brussels, Amsterdam and in Italy. The master tape of the soundtrack music composed by Tong/Deyhim was lost for many years until it was rediscovered during my interview with Pierre Droulers in Brussels end of 2002. As a result, this long lost tape (recorded at Daylight, Brussels, 1984, produced and engineered by GM) was finally released as WT's *Miserere* CD by LTM in 2003 (with full lyrics by WT, translated in French for the performance by Martine Jawerbaum). The album features the following tracks: 1. "Prologue;" 2. "Orpheo Walks;" 3. "Vicious Circle;" 4. "Song;" 5. "Lovers;" 6. "Soliloque;" 7. "Metropolises;" 8. "Cobalt Room;" 9. "In Turning;" 10. "Penumbra;" 11. "Egypt;" 12. "The Way To Me;" 13. "Burdens Of Passion;" 14. "Beyond;" 15. "Miserere;" 16. "Compassion"

1984

Early '84 TM (SB, PP, WT, LvL, BG) records (at Kitsch Studios, Brussels, prod.: Soundworks/ Joeboy) the following tracks: 1. "Soma;" 2. "Hugging The Earth." Both tracks constitute the 7" *Soma* released by Soundworks, Summer '84 and are featured on the *Holy Wars* CD released by Crammed (Cramboy) in 07/86. Track 2 also appears on the *Holy Wars* LP released by Crammed (Cramboy) in 05/85

Page 237

Early '84 BLR guests on the track "Dignity" appearing on Richard Jobson's *An Afternoon In Company* LP released by Les Disques Du Crépuscule in the Fall '84. This track is also featured on Richard Jobson's *The Right Man* double LP released by Crépuscule in 1985

Blaine Reininger in 1984, about his departure from Tuxedomoon: "We would then only seldomly rehearse: everyone was concerned with their own projects. The performances were less and less enthralling, they were becoming sort of a routine (…) We were intellectualizing too much, we had lost the bond with the audience. We spent our time staring at our navel and looking down at people who didn't like our music (…) First I had proposed my own songs to the group but nobody was really enthusiast about them. There were clear tensions concerning who was going to be the lead singer (…) The music that they're doing right now, I would not want to play it. It sounds so empty to me, intellectual. Like jazz music played for musicians, with the audience as mere spectator and not as participant (…) But leaving Tuxedomoon was like a divorce. Since 1977, I had lived entirely for the group. It was a community life and I still don't know how I would have survived otherwise in San Francisco. We were a very strong group. We worked and composed together, in some sort of collective inspiration…" (L. Vander Taelen, "Blaine Reininger : uit Tuxedo Moon stappen was als een echtscheiding", *Topics magazine*, 01/84, translated from Dutch) "I didn't want to be part of a group taking a distance from music anymore. Nobody from Tuxedo feels really at home in the world of rock music. They are strangers living in another world, closer to a visual approach (slides, videos…). Our concerts were becoming visual performances with musical accompaniment whereas the visual aspect, that I was the first to introduce in the group I admit, should remain a complement." (Th. Coljon, "Blaine L. Reininger direct from Brussels", *Le Soir*, 08/21/84, translated from French)

Tuxedomoon at Arena, Rotterdam, 02/05/84. Photo Inge Bekkers

Jawerbaum, [22] with no immediate results. They found themselves in the urgent situation of releasing a new recording in order to demonstrate that they were still alive. [23]

A new single entitled *Soma* was recorded early in 1984 and released in the Summer by the tiny Brussels label Soundworks. The B-side was "Hugging The Earth," a piece that the band had been working on since around the arrival of Luc van Lieshout. "Soma" was hardly new, as it was the climax piece of the famous 1980 San Francisco *Soma* show. As hypnotic as this track probably was in concluding a show that had been building on some sort of spiritual ethereal atmosphere, it appeared as a rather unlikely chart stab and hence a dubious choice for a release as a single. However *Soma* is an item not to be missed by collectors, as it came out as a limited edition package including a poster displaying the "map" of an imaginary city that seemed to summarize Tuxedomoon's wandering story so far as it was made of cut-ups of several cities including San Francisco, Rome, Paris, London and Brussels.

Steven Brown: "(…) I thought: well it's 1984, everybody is doing George Orwell. Hey we wrote a song on Huxley once. Let's be different!"

Apart from this recording, Tuxedomoon busied themselves during the first half of 1984 doing a TV show in Madrid, playing some scattered dates in France and The Netherlands and touring in Germany. Unfortunately, the tour proved miserable and lost money, many promoters being still reluctant to accept the band's new lineup. [24] Meanwhile Blaine Reininger performed a date with Brown as their Blaine & Steven duo in The Hague in January and did a short tour of Italy in March.

In May, a fugitive live reunion of Brown, Principle and Reininger as Fifth Column took place in Brussels for a party thrown for Italian artist Cavelinni. Older Tuxedomoon material mixed with several Reininger solo songs composed a set which probably had more to do with financial needs rather than nostalgia. [25]

In the meantime the quest for a new (major) label was still proving unsuccessful. Steven Brown: "It's a really a bad time now for record companies, nobody wants to take any risks, speaking of the "majors" so-called. They're giving you the sob stories of about how records are down, nobody's buying records and they want a chart guaranteed hit. Yes we tried the majors. Of course they were all interested. They all knew the group. They all love the music but they didn't want to give us any money! So we kind of fell into that game for a while and then we just realized that it was all bullshit and so we decided to do it ourselves…" [26]

So the band started to record their upcoming *Holy Wars* album at Studio Pyramide in Brussels from June till way into July 1984. Since they did not have the means to finance

such recording without the help of a record label, Martine Jawerbaum invested her own savings in the undertaking. [27] The tracks were however left unmixed for a while as a deal with a producer was sought. John Cale was approached but he proved too expensive at $1,000 a track. [28] Ultimately Tuxedomoon were left to produce their record alone with the help of sound engineer Gilles Martin.

A bit more than mid-way through the recording of *Holy Wars*, the band performed their first hometown show since Reininger's departure at the Ancienne Belgique on June 26th. Unfortunately the show was not well attended.

In sharp contrast, the band played before twelve thousand people at the Massenzio film festival in Rome on August 8th, 1984. The show was labeled a "video-concert," with music and a live mix of pre-recorded videos and images shot during the performance. [29] [*Singer/musician, friend of the band and label mate at Les Disques Du Crépuscule*] Anna Domino and Roberto Nanni's memories waver between the colorful and the tragic.

Anna Domino: 'Tuxedomoon heads out on tour. Everyone meets at the *café* in the gare du Midi (BXL). Winston arrives at the last minute and breathes on the glass that encloses the terrace. Once is steamed up he writes I hate vodka with hate spelled backwards so I can read it. I know what he means.

So we all pile on the train and travel south to Rome, I'm along for the adventure and am sleepless with excitement as is my first time back in Italy since I was 10 (my mother, brother and I lived in Florence in 66/67). The train ride is glorious even in the dark and in the morning we watch Santa Lucia float by and drink strong sweet coffee and laugh.

At the Circo Massimo in Ancient Rome the band sets up and I give everyone, except maybe Peter, a hair cut. The show proceeds with much excitement and some chaos as the sound board is miles from the stage and Bruce must run back and forth for some reason and Frankie [*Lievaart*] has disasters to deal with.

Afterwards I take many photos backstage of Steven and Winston mostly – they hold still. I recorded an interview with them as well but the tapes are long lost which is a shame because Winston was full of stories that night and kept up a stream of consciousness monolog on alternate histories of Rome while I took his picture. Nina did the lights that night but after the show she is out cold backstage with the respectful roadies stepping over her.

Back at our hotel which was old and very nice and between the Piazza del Popolo and the Spanish steps a dealer appears and I am chosen to go with him to score.

So off we go – taxi to the suburbs, walk a few miles, make a call, get on a bus, walk again. He leaves me at a crowded *café*

01/03/84 TM leaves for Madrid

01/06/84 TM participates in a TV show in Madrid

01/12/84 BLR & SB play at 't Beest, The Hague. The set includes: "Birthday Song," "The Cage," "Litebulb Overkill," "Ghost Sonata," and a long piece that sounds like a variation on the "Hugging The Earth" track

01/15/84 WT & Niki Mono make a demo at Soundworks, Brussels, including the following pieces: "Move Me," "Zimbabwe," "Play The Game," "Said And Done," "To You," "Incubo," "Theoretical China," "No Regrets" & "1984"

02/02/84 TM plays at salle de Robien, Saint-Brieuc

French DJ (between France and New York City) Gilles Le Guen, about TM in Saint-Brieuc: 'On the day of this concert I spent some time with Steven Brown. I went for a coffee with them after soundcheck, coffee-calva for them. It was great.

I probably shot the best photo in my life on that day. Winston was in the dressing room after the concert. He was endlessly staring at his own image in the mirror. I took the photo from behind him. It's only years later that I realized how powerful that shot was. Totally narcissist, lost, very *diva*. I had not realized that I was also photographing him as I was totally concentrated on his image in the mirror. I had not realized that it was also him, physically, in the frame. This photo must be somewhere in an attic in France. As for the negative, well, forget about it...

The way things were presented at the time was that Winston was NOT part of the group! Which, technically, was true... I realized it later on. He was always like some sort of guest on some selected pieces, and how selected! He was such a *diva*, showing up just for a couple of songs but always the most amazing ones...

Still in Saint-Brieuc, I remember that shortly after soundcheck I found myself outside with Steven Brown and, out of the blue, he asked me if I had a car! He wanted to go see the sea... Saint-Brieuc is on the coast. You will never know how much I hated not having a car on that day...

Later in the dressing room, there was like a fire roaring between Steven and some visitors. Two girls had just happened to say that they were from Brest. Steven told them that he knew Brest, of course. The two girls were surprised. Steven screeched very loud: "Jean Genet!!!" The two girls have never heard of him. He screamed: "What?! You're from Brest and you don't know Jean Genet? *Querelle De Brest*!!! Jean Genet!!!" In the midst of this turmoil, Winston, very much in his own world, was endlessly staring at himself in the mirror...'

02/05/84 TM plays at Arena, Rotterdam, as part of a film festival

02/06/84 TM plays in Amsterdam

03/13-19/84 BLR's short Italian tour promoted by Centro Inteatro de Polverigi (same that commissioned *The Ghost Sonata*), with BLR playing alone, his wife JJ La Rue taking care of the lights, and Frankie Lievaart as sound engineer:

03/13/84 BLR plays at Porta Romana, Milan

03/15/84 BLR plays at Aleph Club, Gabbice

03/16&17/84 BLR plays at ITC Teatro, San Lazaro

03/19/84 BLR plays in Bologna. The

Page 239

show starts with a parody of "Frankie Goes To Hollywood" ("Frankie goes to Bologna... Frankie goes to Rotterdam ..." etc.); "Arrivederci Roma;" a very electro-orientalizing version of "Gigolo Grasiento;" "Volo Vivace" introduced by: "a band, Tuxedo or something I don't remember the name... Pink Floyd...;" "Ash & Bone;" "Night Air" dedicated to SB; "Birthday Song" is said to be about Brussels. Other songs performed: "Magnetic life," "Sons Of The Silent Age," "Mystery And Confusion," "Broken Fingers," "Uptown," "Café Au Lait…"

Blaine Reininger: "My approach is a reaction to what I was doing with Tuxedomoon, where there was a lot of film and theater involved. What I do is essentially *cabaret* for the 20th and 21st centuries. I sing. I talk to the audience. There aren't big visual gimmicks or costumes. I break this barrier that existed between the audience and the artist with Tuxedomoon. It's more relaxed" (BLR interviewed for *Libération*, "Tuxedo Moon, l'après Reininger", 10/83, translated from French)

03/19/80 TM rehearses at Chaussée De Wavre, Brussels

German tour (this tour proved miserable as the band's new line-up was not fully accepted yet):

03/29/84 TM plays at Odeon, Münster

03/31/84 TM plays at Fabrik, Hamburg

04/01/84 TM plays at Pankehallen, Berlin

04/03/84 TM plays at Schlachthof, Bremen

04/04/84 TM plays at Zeche, Bochum

04/06/84 TM plays at Alabama Halle, Munich

04/08/84 TM plays at Arena, Vienna. Show recorded by local radio O.R.F.

04/11/84 TM plays at Batschkapp, Frankfurt

04/84 WT & Niki Mono record in London (prod. Alan Rankine & Dave Formula, with Alan Rankine, Dave Formula, Jah Wobble, Steven Morris and Simon Topping guesting) the track "Theoretical China" which was released as the A-Side of the *Theoretical China 7"* and 12" released by Les Disques Du Crépuscule. It further appears on the Les Disques Du Crépuscule *Theoretically Chinese* LP/cassette (1985) and CD (1986). The latter album was re-released by LTM in 2004 (with bonus tracks)

From mid-April '84 WT & Niki Mono set off for a Les Disques Du Crépuscule tour in Japan with Mikado and The Durutti Column during which they perform the following dates:
04/21/84 Unryu Hall, Nagoya
04/24/84 Banana Hall, Osaka
04/26/84 Kyoiku Bunka Kaikan, Toyama
04/28/84 Shibuya Kokaido, Tokyo
04/30/84 Fukuoka Tsukushi Kaikan, Fukuoka
05/02/84 Pithecan Thropus Erectus, Tokyo
05/04/84 Pithecan Thropus Erectus, Tokyo
05/05/84 Pithecan Thropus Erectus, Tokyo
05/06/84 Ink Stick, Roppongi, Tokyo

for a while then retrieves me and we walk, eventually passing a couple that follow us and pass us at the next corner. My guide says we can go now but we keep walking, get to a bus to a taxi...

Several hours have passed but some are still awake at the hotel. I'm fed up and the tiny packet we've returned with is really miniscule but everyone is glad to see me and the guide is given his share and sent off and someone hands me some, I take a small amount and go to my room. Then I wake up on the stairs. Then I wake up halfway through my door. The drugs were very very strong.

The next morning I have convulsions but they're more funny than scary. Everyone files through my room to say goodbye and everyone leaves a little something to help me get better. Now it is just Bruce and Steven and me in Rome. We all head out to Bari to see friends of theirs and they take us to the family farm house surrounded by vineyards where we sleep under the vines and wake up to cannon fire in the distance. They shoot at the sky for rain.

Every night aunts arrive with food and drink and we are in heaven. Everyone is so kind!

One night go to a party in the country and everyone heads off into the night for a walk. We follow and end up at moonlit ruins. Swimming in the blue blue sea, jumping off white rock Under the water the rocks are covered in bright colored plants and creatures waving.

I'm afraid till Steven says "pretend it's soggy shag rug." This little idea cures me of a lifetime of sub aquatic fears. It is such a glorious time we talk about buying a house together, our own moonlit ruin, but we have to go back to work and that means Brussels.'

Roberto Nanni: "I remember of this concert at Circo Massimo, that is a huge antique theater. It was very crowded. Very big screens, big projections. Complicated with these enormous projectors. "The Cage" had been released not too long before and, before the concert, Steven had asked me to do the second voice on stage with Winston. So I was that stupid guy on stage on that night. It was fun. It got me a photo in *La Repubblica* or some other newspaper.

After the concert Winston asked me and my girlfriend to bring him back at his hotel. This is when we had a terrible accident – we had a collision with a car of *carabinieri* – that left me in a coma for several days. I remember doctors saying that I was about to pass away and me unable to react to their speech. I saw Bruce three weeks later when my head looked like *Elephant Man*'s. It took me about eight months to recover. I never saw Winston again."

By the end of August, the band left for three gigs in Israel. In October, a planned Greek tour fell through as impractical at a

technical level.[30] Instead the group briefly toured Scandinavia for the second time. Upon their coming in Copenhagen, journalist Allan Sommer described Tuxedomoon as 'An eclectical forum that gathers influences from jazz, electronic *avant-garde*, the francophile ballad tradition and (…) chamber music (…) The contact with rock lies in the beat that is centered around one person, Peter Principle.'[31]

Steven Brown was called to yet another attempt to capture Tuxedomoon's specificity: "Generally speaking our music is esteemed to be rock. Especially because of the surroundings in which the music appears. Tuxedomoon's music originates from rock, but also from a lot of other things. When I was a kid, I did not care about rock. For instance, I did not like The Beatles until *Sgt. Pepper* came about. The rock I am influenced by is untraditional rock like The Velvet Underground. We are not based in the Chuck Berry tradition. But there is pop music I like. In fact I can like any kind of music. What we are doing in Tuxedomoon is to pluck music history of all that we like and use it, be it from Beethoven, John Cage or The Beatles."[32]

For these expatriates, being on tour was paradoxically a way to feel "home," as Nina Shaw explains, even if that process ultimately deepened feelings of insecurity even more. "Brussels was a city that we all loved to hate and the place

A video (JP 1984 - Comstock TE M747) entitled *Musique Epave* was released featuring WT & Niki Mono ("Move Me," "Zimbabwe," "Incubo" and "Theoretical China") along with The Durutti Column and Mikado performing during two of the dates of that tour

During this Japanese tour Niki Mono records the "The Hunger" in Tokyo (prod.: Niki Mono, WT, Atsuo Suzuki & Satoshi Kadokura, with WT, Atsuo Suzuki, Satoshi Kadokura, Sachiko Kadokura, Hiroshi Kamazu, Masao Suzuki, Shi-on Matsuba guesting) that will appear as B-side to the *Theoretical China* 12" and on the *Theoretically Chinese* cassette (1985) and CD (1986) released by Les Disques Du Crépuscule. Finally this track appears as a bonus track on the LTM re-release of the *Theoretically Chinese* album (2004)

05/84 BLR reunites with SB & PP as *Fifth Column* for a birthday party given for Italian artist Cavelinni

05/26/84 Joeboy plays at 't Beest, Goes

06/84 TM plays in Paris as part of three days centered on the group's activities, press conferences etc.

06/84 BLR collaborates with Mikel Rouse (from Tirez Tirez). They compose and record together the following tracks (recorded at Studio Kitsch, Brussels): 1. "Side Wind;" 2. "Windy Outside;" 3. "West Wind;" 4. "Sun Study" that constitute the *Colorado Suite* album, released as MTM 3 released as a LP by Crammed Discs in 10/84 and as a CD by the same label in 02/89. Track 1 also appears on the (various artists) *The Made To Measure Resume (MTM 1 to 16)* released

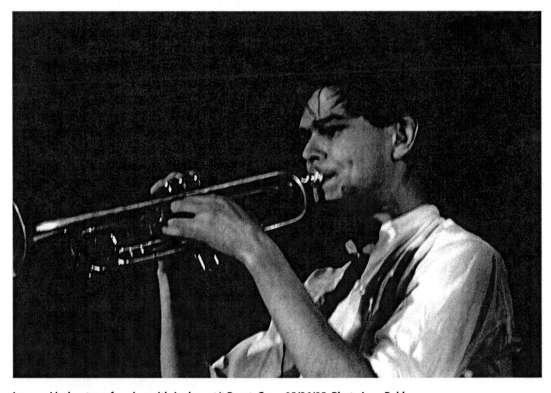

Luc van Lieshout, performing with Joeboy at 't Beest, Goes, 05/26/85. Photo Inge Bekkers

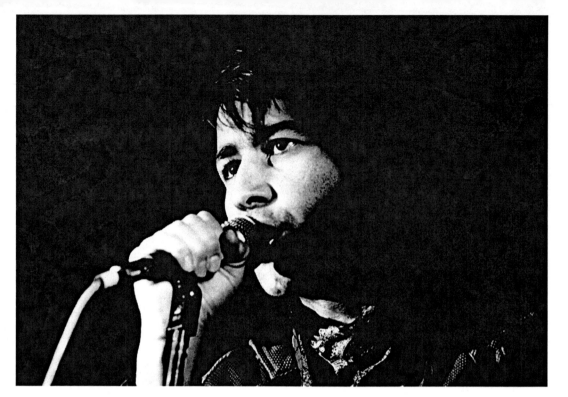

Steven Brown, Goes, 05/26/84. Photo Inge Bekkers

by Crammed as a CD/cassette in 05/88

Blaine Reininger: "With Mikel Rouse I collaborated only once. He was in Brussels and my friends from the record company thought that it would be interesting to do an album together. That's how *Colorado Suite* came about (…)
In Colorado Suite, one can see minimalist influences. Does minimalism generally influence your music?
Mikel Rouse is quite influenced by minimalism. He has composed some minimalist works and is a friend of Steve Reich's. I always liked this kind of music. It is a serious genre, that was first mentioned in the 50s and 60s. In minimalist music there is a melody, there is a healthy direction. However, I believe that it is a rather complicated area and I could characterize it as music for mathematics." (Th. Vamvakaris, "Just a boy from Colorado – Blaine Reininger", *Cine7*, 05/22/88, translated from Greek by George Loukakis) [*About the track "Windy Outside"*]
"It's autobiographical… I am the lonesome Cowboy (…) It's a self-parody (…) I wanted to write a synthesizer-cowboy-song." (Blaine L. Reininger, "Die Wahreit über Tuxedomoon", *59 to 1*, 1984, translated from German)

Some reviews for Colorado Suite: 'The lyricism of a violin, the fullness of synthesizers and the magnificence of constructions meet in a foaming and limpid wave, of a radiant beauty shattering on the shredded coast of exile, of the sadness of a wind that blows expatriation. Fascination grows and nothing prevents the mind from wandering from sands to hills, from metals to rivers. Fever grows and delirium settles in a perfume of essentiality. Crazy and blissful. One has to go meet this pleasure, all senses awake and let oneself be carried away' (L.B., "Made to measure, vol. 3 : Colorado suite", *Télémoustique*, 11/08/84, translated from French); 'Music for the beautiful hours of November, to take tea with by the fireplace,

where we all lived but there was a resistance to be calling it "home." This was the place that one went to wash socks, buy new toothpaste before setting out again even if we'd be there for long periods of time. It was very difficult to accept the idea of Brussels as being home, it was a stop-over. It was a base but it was never really home.

So when we'd leave – we were traveling by train a lot – we would get into our *couchettes* car and start decorating it and get to the dressing room and do something to the dressing room to make it "home." Also in hotel rooms, especially if we were going to be there for a couple of days. We needed, every place we went, to do something to make it ours.

Living on tour as much as we did, there was this feeling that what we all had in common was this idea of traveling. There's a lyric in one of Steven's song that goes: "Is it the destination or is the will to travel?" [33] and I think that for us it was the will to travel that mattered even if some of us do not travel well. It was the need to keep going: what was the next town going to be, what are we going to discover there. Also it negated a certain amount of responsibility as most of us would remain single and not starting families. And there are good things and bad things in that. There's a very definite insecurity in traveling all the time."

Work starts on Operation Revisionaries. In November 1984, work started on another *Ghost Sonata* style Operation project, entitled *Revisionaries*, that lead to a new show

premiered in Lille at Théâtre Sébastopol on March 15th, 1985 and then taken on tour. Contacts had been established with the audiovisual department of the University of Valenciennes who promised the latest state of the art visual equipment. The band's expectations were high.

Steven Brown: "The chairman of the audiovisual department said that in a theater you have to do something that's never been done before, find new techniques, new ways of lighting the stage, setting the *décor*, make somebody disappear, make somebody fly. You want robots, we've got robots. You want lasers, we've got lasers, you know. It's a great challenge because it'll be a combination of two things: a rock band doing a major performance using video art and lighting technology." [34]

Again Winston Tong was to be the *Deus Ex Machina* on the project, THE keystone around which everything would revolve. Unfortunately Tong chose to record his *Theoretically Chinese* album, leaving Bruce Geduldig in charge. From here, *Revisionaries* became another, unexpected, story.

Nina Shaw: "We started to work on a project called *Revisionaries*. We had done various videos that we had put together and we had played at film festivals, invited by fans who found Tuxedomoon music to be very cinematic. We had started this whole video project and in the midst of it the University of Valenciennes got in touch because their communication department had access to all of this wonderful new technology that included three-dimensional projection and they wanted a group of artists to use it. We all went down and we were told about all these wonderful possibilities, like we would be able to project holographic images on the stage. It was like: "Let your imagination go and design something and my department will do all the technology behind it." We were: "This is our dream come true."

The idea originally was that we would shoot for two weeks at the University and we would have three weeks to edit. And time got closer and closer, and things started like they wouldn't return phone calls and time was running away. We needed to have a few more specifics about what sort of equipment there was going to be and we didn't hear anything back. Then it appeared that we wouldn't have as much time as we thought: we would have a week for shooting and two weeks for editing and then the time kept getting cut back and cut back and cut back. We got in touch with a dance company in Paris called Lolita Danse to ask them to be a part of the project as well. [35] And it came down to: we were going to have two days to shoot and four days to edit.

We all went down to the University of Valenciennes. Martine [*Jawerbaum*] had a mercedes at the time to fit all of us in. So me, Bruce, Steven, Peter and Luc were in the car with Martine

enjoying the raining outside' (S. HINTZ, "Colorado suite – Blaine Reininger Mikel Rouse", *Nuovox 1*, 11-12/84, translated from German); 'The piece is constructed around cyclical violin lines, what Rouse calls "system music." He comments : "Blaine and I thought it would be interesting to set machines to work in various meters, while triggering other machines." The effect is at once hypnotic and unpredictable, involving what Rouse calls a "reciprocity" between musician and machine (…)' (M. HUNTER, "Moving from the margins into a genre of their own", *Passion*, 11/85)

06-07/84 (from 06/01/84 till 07/19/84) TM (SB, PP, LvL, WT, BG, with Jan d'Haese & Alain Lefebvre guesting) records (at Studio Pyramide, Brussels, prod.: TM & GM, 178 hours of recording) the following tracks: 1. "The Waltz;" 2. "St-John;" 3. "Bonjour Tristesse;" 4. "In A Manner Of Speaking;" 5. "Some Guys;" 6. "Holy Wars;" 7. "Watching The Blood Flow;" 8. "Egypt." All tracks appear on the *Holy Wars* album released as a LP by Crammed Discs (Cramboy) on 04/05/85 and as a CD by the same label in 07/86

06/04/84 An evening with Maurice Béjart. 'Went to see *Messe Pour Temps Future* at Cirque Royal tonite. Quite liked it. Some *fantastique* music. One piece made from short wave radio "be be bop beep bee be bop beep" (MB did that one), the rest of the music was ethnic. Seemed to detect new style in the solo work – sanskrit jazzy kind of moving, very nice. Afterwards met Maurice backstage and Jorge D. dropped us off at his house. On entering Maurice asked: "Did you like my penguins?" Upstairs met Koji who is living in small adjacent flat where Maurice's brother used to live. M sends K to get Indian food. K is studying acting at the conservatory. We sit and chat a bit and I'm fairly at ease though a bit wary of M going blank on me as he is wont to do from time to time – I take it embarrassedly personal. He says this year's NYC run was the 7th and the most successful because, as he explained the previous six years were handled by a "nice young man…honest." Well this last time a new impresario a "racketeer" a "shark" was contracted and the theater was packed every night…"You have to work with sharks," M tells me with a smile.

He opens a bottle of champagne (M&C). I had asked for a beer when he offered and he hadn't anything but one coke and champagne. Dinner of bright red chicken and Indian tortillas delicious after M plays me some of the 200 records he's gone through to find the music for "Messe." He says he's given most away to the dancers but there are still some left. He begins to play me some tracks and says if I like it I can have it, one by one he plays and looks at me – I can't meet his stare…piercing blue steel. Of course I like everything and he gives me four discs one by one before he stops. He sadly tells me of his accident – points up to where he used to sleep – about three meters above the floor and says he fell in the night and broke some bones in his back and cut his head open. He turns over lifts his shirt and shows me bandage on his back. He says fortunately K, sleeping downstairs heard him fall and came up otherwise he could have been lying there all night – he's sad. At dinner he downed his champagne in a quick gulp – I thought he was very thirsty but he did it only to empty his glass and run for a can of coke in the frig – "Coca Cola is better than champagne!" he says and we laugh. M says I can come over any time and make cassettes of any of his 2000 records. "I'll give you keys and you can come when you want." As I'm leaving he says he has a *cadeau* for me that he got in Japan and has been keeping

for months. He goes to the bookshelf and picks up a blue plastic penguin watch… fishes a paper out of a vase … "See it says 't u x e d o.' I thought of you." He puts it on my wrist…' (excerpt from STEVEN BROWN'S private journals)

06/08/84 TM plays at NL Centrum, Amsterdam

06/26/84 TM plays at Ancienne Belgique, Brussels

07/03/84 BLR plays at *Festival Mallemunt*, Brussels (with Alain Goutier)

07/22/84 TM at VPRO omgevallen Bandenkast (Dutch radio show)

08/84 Planned concerts in Greece (Athens, Saloniki, Patras) cancelled for technical problems

08/08/84 TM plays at Circo Massimo Massenzio, Rome, *Half Live Film Festival*

Mini Israeli tour (three dates) including:

08/23/84 TM plays in Tel Aviv

08/25/84 TM plays at Dan, Kolnoa

09/12/84 TM plays in Linz (Austria)

09/22/84 BLR plays in Rotterdam

10/04&05/84 Anna Domino + SB + Jean-Marc Lederman play at Interférences, Brussels

10/10/84 La Mama, NYC: *Cuori Strappati*. Conceived , Directed & Performed by: La Gaia Scienza. Composer: Winston Tong & Bruce Geuldig (+ Andrea Vagnoni & Flavio Bertozzi)

Fall '84 till some time in '85 WT records in Brussels, ICP (prod. Alan Rankine, with Alan Rankine, Alain Lefebvre, Pietro Lacirignola, Niki Mono and Sussan Deyhim guesting) the following tracks: 1. "Big Brother;" 2. "Endgame;" 3. "The Quotidian;" 4. "Yellow Peril;" 5. "The Principles Of Movement;" 6. "Reports From The Heart;" 7. "No Regrets;" 8. "Broken English". All tracks will compose, with "Theoretical China" previously recorded, the *Theoretically Chinese* album released as a LP and cassette in 10/85 and as a CD in 1986 by Les Disques Du Crépuscule. Tracks 4 & 6 will form the *Reports From The Heart 7"* released by Les Disques du Crépuscule in 1985. Track 6 also appears on the *Reports From The Heart 12"* released by Les Disques Du Crépuscule in 1985 and is further featured on the (various artists) *Crépuscule Collection 4: Death Leaves An Echo* LP released in 06/87. Remixes of tracks 1 and 8 appear as a *Broken English* 12" released by Fuzz Dance ZZ in 1987. Finally the *Theoretically Chinese* album was re-released as a CD by LTM in 2004 with "The Hunger," "Broken English" (12" remix) and Niki Mono's "Dream Assassins" as bonus tracks

Some time in '84 Now renowned French film director Olivier Assayas shoots a short film entitled *Winston Tong En Studio*

Niki Mono about "Dream Assassins": "Dream Assassins are nomads, living in the desert, dressed in black with some red on their turban. You can see them

Page 244

and, as we are approaching the border between Belgium and France, it got very very foggy. Martine had slowed down and she turned around to talk to somebody in the back. The fog suddenly cleared and there was the *douane* [*i.e. the customs*]! Which we smashed right into. We weren't going very fast luckily but all the customs officers came out and they were all… Martine just sort of rolled down the window: "Sorry!" And I think they were so amazed, you know with this car appearing out of nowhere and everybody was sort of confused, so they let us through.

We got to the University and we had like three hours of day light. There was a group of students to take care of us – Bruce had told them we needed an industrial site near railway tracks, we needed all these different sights to shoot things. And they've got these video cameras that we hadn't even used things that old in ages! So where's this new stuff? Surely it has to be shot at professional level at least... We had three hours. We went out and shot at a couple of sites. And everyone except for me and Bruce were going back to Brussels the next day. So we had to make the most of this.

Then it's time to go to the hotel. We had gone to dinner at the school *cafétaria* and we kept asking about our hotel room. We wanted to shower and change and Bruce and I were going to go in and look at what we'd shot and whatever we needed to do before the next day before the musicians left. And the head of the department kept putting off until eventually someone insisted. Then we got into a couple of students' cars and off we went in the countryside and we got to a place where there was a building with a *café* on the ground floor. We went into the *café* and one of the students went up to the person behind the bar and asked where we were going to stay: "Is there a hotel here?" And the woman at the bar starts laughing: "Maybe you should go see for yourselves!" So we went upstairs and yes there HAD been a hotel there. The woman behind the bar kept saying the word "peste," like "la peste"?! And all the wallpaper was down. The mattresses had all been ripped up and were piled up against the walls as they were fumigating I think. Maybe they had had a problem with insects…

So we had a quick conference and we were: "Ok, this really sucks. Fuck this, there's something wrong here." So we went out, the Professor had arrived at this point and we said: "We're going home, we don't need this." "No, no, no, no, we'll find some place else for you!"

And eventually they drove us to a hotel near the train station, not nice to look at but that would be Ok for the night.

Then we left and went back to the University to look at the rushes. We came back, late at night and Peter and I went to our room. And we couldn't get the door open, the key would

not work and it wouldn't work because there was a key on the other side of the door! There was a very very old man who came to the door and opened it and there was a very old woman in the room as well. We were like: "Fuck this!" We went downstairs and said: "There are people in our room!" "Oh don't worry about it, that's great uncle Pierre and his wife and they're a bit out of their mind…"We went up and they had been through all of our stuff. Nothing had been taken but they had just been these "other" presences. The next day, we went to the University, again, and said: "We're going home! Where you put us up last night was not acceptable and Bruce and I are not going to stay there." They then finally found some decent place for us.

We shot some more with the band and then the band left. Bruce and I stayed and we were going to edit and all of their equipment is ancient! They were not even working with Betacam. I was: "Where is all that stuff?" A friend of ours from Paris, film-maker Patrick de Geetere, came up to help us. We had access to their archives and already existing footage that we could edit. The three of us spent the next 72 hours editing something together. We had to abandon a lot of the ideas we had. Every day that we were still at the University of Valenciennes, Bruce and I would go to the head of the department and say: "Fuck this, we quit!" It turned out that the camera we had been using didn't work right and we couldn't re-shoot the footage. So we just decided to deal with that. But every single thing was turning into a nightmare of some sort…

At a certain point one night, it suddenly occurred to me that when we had been in the car that smashed into the *douane*, it had been much more of an accident than we thought and we were actually dead and this was what hell was going to be like and we were going to be endlessly stuck in this impossible situation.

In the end, we had three projectors, a series of slides projectors and we had like four dancers from Lolita. Tuxedomoon was a lot about trying to have a framework from which other people could do things. I remember having been so exhausted after that one…"

Peter Principle: "To my opinion *Revisionaries* didn't really happen. There was a lot of work put into it and Bruce did a lot of video in Valenciennes but nobody ever knew what we really were doing. It was noticeable that Winston wasn't there to give us an overall explanation in some enigmatic way.

The chemistry in groups is very subtle. It's hard to say who did what, but when you take a member away you can see what kind of influence he had on the others. It's like soup, it's like that one pinch of pepper that you don't really taste, but which changes the whole flavor. So the chemistry of Tuxedomoon

coming from far away in a kind of haze. They started coming when I was 12 and when I got to art school, it got really bad. Maybe it was a bad dream that had marked my imagination but I remember they followed me from age 12 up to the start of 1983 when I wrote the song. So they used to come in my dreams, quite regularly. I could see them coming, I could smell them. And their horses, they had that silver shine because the sun gave them that silver color when it's really hot in the desert. And they killed the people in my dreams and I was like outside watching this…

So there were three of these Dream Assassins and one was wearing this very nice desert South cross…"

10/16/84 BLR plays at Mensa, Aachen (Germany)

Scandinavian tour:

10/26/84 TM plays at Studentkaren, Gothenburg (Sweden)

10/27/84 TM plays at Stadt Hamburg, Malmö (Sweden)

10/28/84 TM plays at Saltlageret-Tivoli, Copenhagen (Denmark)

10/31/84 TM plays at Vikateateret, Oslo (Norway). The night when Indira Ghandi was assassinated.

11/84 Work starts on the OPERAtion project called *Revisionaries*, a collaboration with University of Valenciennes (France), Lolita Danse (Paris) and Patrick de Geetere's Wonder Products. This lead to the 03/15/85 show in Lille and the music specially written constitutes the quiet side of the *Ship Of Fools* mini LP

12/84 Tuxedomoon signs with Crammed Discs

From 12/13/84 till 03/13/85 Mixing of the *Holy Wars* album

12/25/84 SB plays at a BLR solo gig in Brussels and meets Antoine Pickels with whom he will later work (on a.o. the *Mythical Puzzle* video shot during the Reunion tour and the *La Grâce Du Tombeur* soundtrack released in 1990; Pickels will also stage TM's performance at Ancienne Belgique on 04/03/86)

12/29/84 BLR in a French ɪᴠ show (*Avenue Du Rock* on France 3) with "Birthday Song"

Some time in '84 (or '83) SB guests on the following tracks (recorded at Soundworks, Brussels, prod.: Mike Shelter, S.P.Y. & Paul Delnoy): 1. "No Sign;" 2. F. TH. F. III;" 3. "Last Time" featured on Esquisses's *Esquisses* LP released by Soundworks in 1984

Some time in '84 PP produces (with GM) the following Minimal Compact tracks: 1. "Next One Is Real (Radio Remix);" 2. "Not Knowing (Remix);" 3. "Hole Version (Accidental Remix);" 4. "Next One Is Real (Extended Remix)" released by Crammed Discs as a 12" in 1984 and as a CD in 11/88. All tracks are featured as bonuses on Crammed's re-release of the *Deadly Weapons* CD in 2003

Some time in '84 SB guests on the track "Breakdown" (recorded at Soundworks, Brussels, prod.: Paul Delnoy & Micky Mike) appearing on Snowy Red's *Vision* LP released by Soundworks in 1984 (this recording also features Niki Mono)

Some time in '84 SB guests on the following tracks (recorded in Brussels): 1. "Jericho;" 2. "The End Of An era;" 3. "Under The Rain Clouds;" 4. "India Song;" 5. "The Lover." Tracks 1 & 2 appear on Richard Jobson's *An Afternoon In Company* LP released by Les Disques Du Crépuscule in the Fall of '84. Tracks 1-4 are featured on Richard Jobson's *The Right Man* double LP released by Crépuscule in 1985. Tracks 3 & 5 appear on the (various artists) *Hommage A Duras* album released as a LP by Inter in 02/88 and as a CD by Interphon in 05/88

Some time in '84 (or '85) SB guests on the following Anna Domino tracks (recorded in Brussels, prod.: Marc Moulin & Dan Lacksman for track 1 and Anna Domino & GM for track 2): 1. "Rhythm;" 2. "Half Of Myself." Track 1 was released as the *Rhythm 7"* released by Les Disques Du Crépuscule in 1984. Tracks 1 & 2 constitute the *Rhythm 12"* released by Crépuscule in 1984. Both tracks also appear on Anna Domino's *Anna Domino* LP/CD released in 10/86 and 01/90. Track 1 also appears on Anna Domino's *L'Amour Fou* LP/CD released by Crépuscule in 06/89 and on the (various artists) *Non Peut-Être!? /Les Disques Du Crépuscule Presents New Music For America* compilation album released in the Spring '89

Anna Domino: 'Steven was great to work with in the studio because he's a great musician and is sure of himself. He's calm and doesn't suffer too much from the insecurity that makes many of us angry and defensive at work. Working with St. on "Half of

Page 246

changed at an unfortunate time, because we'd committed ourselves to that big production and there was no real vision behind *Revisionaries* about why we were doing that.

The idea behind it was that we were going to do the *première* of this thing that would later tour. And it was going to tour with this fancy new video equipment coming from this school and they were going to send their technical crew as some kind of advertisement for them that they had the best equipment (laughs). In the end it didn't happen at all like that but in the meantime we wrote the music which we conceived also as a touring show and we did tour the music of the *Revisionaries* show although it probably was never called like that again. All this material developed into the two records that would come next, especially *Ship Of Fools*." [36]

In fact the specially written music consisted of the five quiet pieces that would later compose the second side of Tuxedomoon's 1986 *Ship Of Fools* mini LP, along with the track "You" featured on the album of the same name released in 1987.

Tuxedomoon signs with Crammed Discs. Around December Tuxedomoon signed with Brussels-based Belgian label Crammed Discs headed by Marc Hollander.

Marc Hollander: "I started to distribute Tuxedomoon's records around the release of *Half-Mute*, so 1980 or so. I started out as musician. I had made a recording under the name of Aksak Maboul. This record allowed me to meet a lot of people who were setting up small independent labels at the time. There was a guy named Chris Cutler (from Henry Cow, a band I admired very much back then) who had put together a small structure of distribution to demonstrate that things were happening, outside from England, outside from Anglo-American countries and also outside from the so-called "majors." So Chris liked my record and he distributed it through his small network. He was also close to The Residents. So I gradually found myself in the situation of distributing my own record and their records finally to open a branch of ReR/ Recommended records over here. I started to import directly Ralph records outings and that was how I came across the first Tuxedomoon LP that I loved very much. First came *Half-Mute*, then the *Subterranean Modern* compilation. Then they came over. I wasn't the first person they met but contacts were established little by little.

Our first collaboration was with Steven Brown and Benjamin Lew for the album *Douzième Journée* that was recorded in 1982. Then, one after the other, they all came up to us for various things. So we first got them for more adventurous or solo projects. We've had Blaine Reininger with his *Colorado Suite* and we've had Peter Principle with his (Made To Measure) *Sedimental Journey* [*to be discussed later*] solo album. And Peter

and Gilles Martin produced the first Minimal Compact album [*Deadly Weapons*] in 1984. Before that, there had been the first Made To Measure – it had to be a collection of music made for dance, screen and other medias – that was a compilation of tracks from four artists [*i.e. Tuxedomoon, Minimal Compact, Aksak Maboul and Benjamin Lew*] and Tuxedomoon provided three pieces that they had composed for a film [*i.e. Bob Visser's Het Veld Van Eer*].

So ties had been strengthened and, around 1984, they were seeking a label with which they would be able to accomplish better work than with the people they had been dealing with until then. For *Holy Wars*, that would be their third *real* album, it wasn't enough to just make a recording. Means were needed for promotion and whatnot. We were then a lot smaller than now but we already were striving to make things happen in a truly professional and international way. So we decided to make this album together and then we decided to create Cramboy, that is a division of Crammed, devoted to the re-issue of their back catalogue.

So the spirit of the deal was that a contract was entered into for a collaboration between the entity named Joeboy [*i.e. the alternate name for Tuxedomoon*] and Crammed Discs, hence the name Cramboy.

As James Nice [*of LTM Recordings*] wrote, the 'deal with Crammed had been struck as a last resort, although Hollander's contract was more than generous, allowing for the staggered reissue of the scattered Tuxedomoon back catalog, much of which was by now unavailable. *Half-Mute* quickly reappeared (...) followed by *Desire* and *Scream With A View* (...) Indeed the group were even awarded their own label, Cramboy, and awarded a highly advantageous percentage on publishing.'[37]

From December 13th, 1984, through March 13th, 1985, the band mixed their *Holy Wars* album with Gilles Martin.

> ***1985: Peter Principle records his first solo album, Sedimental Journey; Steven Brown releases his second collaboration with Benjamin Lew: A Propos D'Un Paysage; the Revisionaries performance in Lille on March 15th, 1985, and release of the Holy Wars album; in Spain, on Paloma Chamorro's TV show; in the meantime: Reininger's ventures, alone or with Steven Brown; Bruce Geduldig starts The Weathermen; Steven Brown meets Antoine Pickels; Winston Tong fades away***

In January 1985, Peter Principle set up to record his first solo album, *Sedimental Journey*, a purely instrumental work the basis of which had been sketched while Principle was

Myself" I wanted this pre-solo "car accident" moment. Gilles made the sound with distorted mics and voice and Steven played around it so beautifully it remains one of my favorite songs.'

Some time in '84 BLR guests on the track "Wild Life" (recorded at ICP, prod.: Jean-Marie Aerts) appearing on Luc Van Acker's *Luc Van Acker* LP released by EMI in 1984

Some time in '84 PP produces (with GM) the following tracks: 1. "Don't Walk Away;" 2. "The Storm;" 3. "Can Never Say Never Again;" 4. "Das Leben;" 5. "Secret Lips;" 6. "Lullabies" appearing on Rank Z'Heroes's *Heartbit* mini LP, Big Heat, 1984

Some time in '84 BLR guests on the track "Without Mercy" (recorded at Strawberry Studios, Stockport, prod.: Anthony Wilson & Michael Johnson) featured on The Durutti Column's *Without Mercy* album released by Factory in 11/84 and on *The First Four Albums*, Factory CD, 02/88

1985

01/85 PP records (also using home recordings that he made) the following tracks (at Daylight, Brussels, with SL guesting, prod.: GM & PP): 1. "The Anvil Chorus;" 2. "Pandemonium-Spring;" 3. "Friends Of Extinction;" 4. "Tippi Rider;" 5. "The Eleventh Race;" 6. "Werewolves At The Gate;" 7. "Dawn;" 8. "Noon-Ain't Superstitious;" 9. "Dnieper;" 10. "Before The Wind." Tracks 1-5/8-10 compose the *Sedimental Journey* MTM 4 LP released by Crammed Discs in the Spring of 1985. Tracks 1-10 constitute the re-issue as a CD of the *Sedimental Journey* MTM 4 album by Crammed in 1989. Tracks 2/4 also appear on the (various artists) *Made To Measure Resume (MTM 1 to 16)* released by Crammed as a CD/cassette in 05/88

01/05/85 BLR plays at Ancienne Belgique, Brussels

Page 247

Blaine Reininger: "I'm a misanthrope. Generally I don't like people. Being at home for me that is the good life. I don't go out very much, I'm not very sociable (…) but I also believe in people's humanity (…)" (KIMBLE/A. CUYPERS, "Interview mit Blaine Reininger", *Bierfront*, 01/85, translated from German); "People would often think that you must make a lot of money when your head pops up in the newspaper or appear on the television screen. Nothing is farther from truth. Chances that you would really have a break-through are very dim" (MW, "Blaine L. Reininger, een nieuwe halve belg", *Het Nieuwsblad*, 01/05/85, translated from Dutch)

03/85 Benjamin Lew & SB release the *A Propos D'un Paysage* (Crammed, MTM 16 LP, released as a CD in 1989) album (recorded at Daylight, Brussels, with Alain Lefebvre, Marc Hollander, Rami Fortis and Vini Reilly guesting) featuring the following tracks: 1. "Moments;" 2. "Les Enormes Et Pourtant Invisibles;" 3. "Profondeur Des Eaux Des Laques;" 4. "Une Telle Richesse;" 5. "S'Ignorer;" 6. "Au Sujet D'un Paysage;" 7. "Face A Ce Qui Se Dérobe;" 8. "Nouvelles Observations;" 9. "La Vie Aussi;" 10. "Etendue". Track 6 also appears on the (various artists) *The Made To Measure Resume (MTM 1 to 16)* released by Crammed as a CD/cassette in 05/88. Tracks 1, 3, 4, 6 also appear on Benjamin Lew's *Compiled Electronic Soundscapes* compilation album published as a Crammed CD in 2003

03/15/85 TM plays at Théâtre Sébastopol, Lille (promoted by Jean-Pascal Reux, Opération Coup De Talent). OPERATION II: *Revisionaries*. Set list: "Stars On 45 Medley (East, Desire, Seven Years, No Tears);" "Reeding, Righting, Rhythmatic;" "No New York;" "Holy Wars (Intro);"

collaborating on Saskia Lupini's *Pandemonium* short film. This recording explores a variety of sound waves and musical climates. It also makes it clear that, within Tuxedomoon, it is Peter Principle who builds the soundscapes that serve as backdrop and give depth to many of Tuxedomoon pieces. Also being the only Tuxedomoon member with no particular language skill, Principle's attention to his environment as a pure sonic source had probably sharpened since being in Europe. "Living in Europe means savoring the fact of being a stranger, said Principle once. Savoring the fact of not understanding what people say around you, to disconnect from banality, from everyday life." [38] Hence the recording teems with sounds inspired from Principle's experiments in Europe, like these "fake" hispanic sonorities or what sounds like mock references to *spaghetti westerns*. The sleeve design for *Sedimental Journey* was borrowed from celebrated Belgian comics designers François Schuiten/Benoît Peeters's *La Fièvre D'Urbicande* [39] (that forms one of the volumes of their *Cités Obscures* series), proving that Principle kept his eye on whatever cultural resources that his living environment had to offer.

'This is at the very least an interesting record, wrote Peter Claesz. (...) "Tippi Rider" (Trippy Higher, should I say). To these pieces I bestow an honorary certificate of cut-up music to go to sleep by. Then a sea of musical richness opens up." [40]

Steven Brown releases his second collaboration with Benjamin Lew: A Propos D'Un Paysage. March saw the release of *A Propos D'Un Paysage*, Steven Brown's second collaboration with Benjamin Lew. For the occasion Belgian drummer Alain Lefebvre brought The Durutti Column's guitarist Vini Reilly aboard (as Lefebvre was then playing with the band). Reilly's instantly recognizable guitar sound left its mark on the album. However, despite a few highlights, the recording was not as successful artistically as Benjamin Lew/ Steven Brown's first collaboration, *Douzième Journée*, was.

Benjamin Lew: "There were tensions between Steven and Vini as Reilly considered himself as the "star" and it was a little tedious as there never had been questions of egos between us before. I don't remember of a single argument of that kind with Steven, Blaine or Peter."

Alain Lefebvre: "Yeah this recording was a misfire: there were conflicts between Steven and Vini, then Benjamin got sick and, on top of this, the studio got flooded at one point. So everyone was doing a bit whatever. There wasn't any real preparation of what we were doing…'"

The Revisionaries performance in Lille on March 15th, 1985, and release of the Holy Wars album. In the

Page 248

meantime, the mix of *Holy Wars* had been completed. Hence the laboriously put together *Revisionaries* performance in Lille (Théâtre Sébastopol) on March 15th, 1985, doubled as a gala launch for the new album, as most of Europe's musical press was invited along.

Unfortunately Winston Tong, who was already absent from the preparations for the show, was gone. Again. Consequently Lolita Danse's member (and French musician Karl Biscuit's life partner) [41] Marcia Barcellos, [42] was called upon to replace Tong on some vocal parts.

Barcellos: "My first real meeting with Tuxedomoon was in Polverigi where I danced and sang with my Lolita Danse collective on a theater piece. Bruce was at this festival and I believe he was fairly impressed with my singing. Gilles (Martin) knew me as well, so they kind of naturally came to think of me when they needed someone to replace Winston. At the time Winston had disappeared and since they had this *Holy Wars* tour ahead…

For me it was really strange because I had never been a singer. I had made some demos with Karl (Biscuit) and had some musical projects but I was then deeply involved in my artistic path as a dancer. When I got their call, I was very impressed because I loved Tuxedomoon. I loved their dark side. I knew that Karl had invited them on his first album. [43] For me they were stars… So I went to Brussels all by myself (I was around 24 then) at their rehearsal space that was set in an abandoned and very bleak loft. It was cold. Steven was turning his back on me when I entered and when he turned to face me, he made such a face! Kind of scary. He asked me whether I had some lyrics to sing and since I had none Bruce told me not to worry and he quickly wrote me some words to sing and that was it for my first rehearsal with them. Then the next day they made me sing "In A Manner Of Speaking," and I felt more at ease working on that song, especially with Peter who was nice with me. They just slightly changed the tonality and everyone started to relax. Steven got closer little by little. He's a very kind person in fact: it was just this first vision that was very impressive as he was angry then.

The main reason why I was brought aboard was that they wanted someone to sing "In A Manner Of Speaking" as none of the other members wanted to sing it, for obvious reasons. I remember that some people around me were very impressed: "You are part of Tuxedomoon!" but I knew I wasn't really part of the band. For me it was just a temporary adventure and it was fine and I had the desire to live it fully."

Nevertheless, with Tong missing the band found it difficult

"A Piano Solo;" "Lowlands Tone Poem;" "Music For Piano And Guitar;" "An Afternoon With N;" "The Waltz;" "In A Manner Of Speaking;" "Egypt;" "Up All Night;" "Holy Wars (Intro);" "Some Guys;" "Watching The Blood Flow;" "Hugging The Earth;" "You." Note: the track "Up All Night" was finally released (live version) on the *Lost Cords* CD, part of the *Unearthed* double CD/DVD included in TM's 30th Anniversary *77o7* box set released by Crammed Discs in 2007

St-John (lyrics adapted by SB from St-Juan de la Cruz)

I live yet do not live
And wait as life goes by
This life I live alone
I view as robbery of life
And so it is a constant death
With no way out at all
God hear me what I say is true
I do not want this life
I'm so removed from you I say
What kind of life can I have
I pity me yet my fate is that
I will keep up this life
The fish taken from out the sea
Is not without reprieve
Its dying is a brief affair
And then it brings relief
But what pathetic death can be
As bad as my own life
The more I live the more I die
The more I live the more I die
I live yet do not live at all
I die yet do not die at all

03/85 BLR tours Germany, with Alain Goutier and Daniel Wang:
03/16/85 BLR plays at Sputnik, Berlin
03/17/85 BLR plays at Cheetah, Bielefeld
03/18/85 BLR plays at Unikum, Cologne
03/19/85 BLR plays at Aladin, Bremen
03/20/85 BLR plays at Lassdas, Hagen. BLR meets Uli Bösking from The Virulent Violins
03/21/85 BLR plays at Batschkapp, Frankfurt
03/22/85 BLR plays at Alabamahalle, Munich
03/24/85 BLR plays at Fabrik, Hamburg

to explain the concept at work on the *Revisionaries* OPERAtion show and on the *Holy Wars* album. This led to some misunderstanding with the press and caused much debate within its ranks. And sometimes the debate even appeared to be within the same individual…

In March, for instance, Jack Barron wrote the following review of the *Revisionaries* show for *Sounds* magazine: '(…) the two elements most memorable are a brief flickering video image of a penis thrusting lustily into a vagina, along with Moon's Bruce Geduldig hand-projecting a scratchy monochrome film onto a white sheet worn by new addition Marcia (…) Was this Tuxedomoon's new rising, or waxing and waning, in front of half Europe's music press?' Author then lingers on the 'questionable movements of the Lolita dance troupe from Paris' and goes on: 'Tuxedomoon have sculpted exceptional music. Tonight's presentation, however, was too choreographed for my taste. And like a penis ramming painfully into an unlubricated vagina, after the gig Europe's junket journalists screwed each other with arguments until dawn.'[44]

In May Barron published, still in *Sounds*, a somewhat more measured review of the same gig:'Ah, last night's performance! A multimedia affair synthesizing the movements of the Lolitas, the videoisations of a Paris based outfit entitled Wonder, and Bruce's ingenious use of hand-held projector, all set to the soundtrack of *Holy Wars*, the group's imminent Crammed album.

For my taste, neither the music, the visuals or the dance were totally successful. That, in one sense, doesn't matter. What matters is Tuxedomoon are combining artistic elements in a unique fashion, and these sometimes explode into intense beauty. Bruce projecting black and white footage of a couple tangoing onto a white sheet Marcia held as she moved was surreal.

Pretentious? Perhaps, but also occasionally stunning.'[45]

(From Brussels) Thierry Coljon: 'It is true that this *chiaroscuro* project lacked in preparation, that the Lolita Danse's ballets lacked in precision and that the videos from Wonder Products lacked in cohesion. However there remained the inspiration in black and white of a music for which *Holy Wars*, the new album, painlessly confirms all the good one might think about it.

On stage (…) we're back with this unique atmosphere, diabolically stirring the warmth from Steven Brown's sax, more pathetic than ever, and the coldness of synthetic metal (…) Only Winston Tong appeared to be really missing, timidly replaced by a charming but transparent Brazilian woman singer.'[46]

For Parisian boho press, Tuxedomoon was no longer exotic

news and, certainly, their living in Brussels was not hip at the time. 'In Operation 2, the characters from Operation 1 (?) come back to life in the last decade of the 20th century, that is in a not too distant future where men and machines will concentrate on filling the theoretical gap between life and death, wrote Christian Perrot for *Libération* newspaper. They come back when all the sexual boundaries have been gone beyond, when the threat of a castrating technology is hovering about. Television has become a sexual instrument (…) Of course, nobody understands anything from this verbiage.' [47] Further in the piece, Perrot presents *Holy Wars* as a work combining the ridiculous ("Bonjour Tristesse," "The Waltz") and the blissful (Steven Brown's diction *à la* Tom Waits, "In A Manner Of Speaking," "Watching The Blood Flow") 'but, adds Perrot, this is played with remorse by these Californians who, hateful of the sun and the good life, came down to weep where Europe is just but a heap of mud, Brussels. Sad.'

Two Dutch journalists sought to obtain clarification about the *Revisionaries – Holy Wars* project but their attempts proved somewhat frustrating.
First was Gérard J. Walhof who collected various band members' statements for Dutch *Vinyl* magazine.
What does the title to your album means? asked Walhof.
'[*Bruce Geduldig:*] "(…) what we are constantly fighting against is this recurring question of the label to be attached to the group (…) we don't fit into any category (…) that is our holy war." Then Geduldig goes on to observe that THE holy war nowadays is one of communication. As to the Gods, everyone has one's own, from Elvis Presley to Jesus Christ.
[*Peter Principle:*] "Any conception of a divinity relies on the idea that there is someone who would be responsible for your future (…) What Bruce means when referring to the "new" Gods, like Elvis Presley, Marylin Monroe or heroin, is that people should grow and step away from this idea (…)"
So your intention is to stress upon the free individual?
[*Peter Principle:*] "Yes it has to do with 'respect.'" Principle then refuted various individualistic ideologies and concluded: "*Holy Wars* is not a lesson that we would be willing to teach but only the title of a song, so… erm, you know what I mean…"'

Second Dutch journalist was Corné Evers for *Oor* magazine. The author first described the very tense climate between the band and journalists that ensued after the Lille *Revisionaries* performance. Evers was obviously exasperated by what he experimented as the group's pretension as well as by their numerous contradictions (which was noted by all journalists present, he added).
'[*Bruce Geduldig:*] "We are pirates. We ransack the vaults of art and make our own assembling that we then rework. We

Page 251

are reworking the history of the USA – a country that actually has no history."' Steven Brown opined on the use of the word "pirates." Geduldig goes on stressing the fact that Americans perceive the world (WWII, Vietnam war, Reagan and South America) as nothing more than a soap opera, a television show.

Author concluded:'I turned off my tape recorder, as I suddenly had had enough from this.'[48]

It is therefore not surprising to see a diversity of opinions in the collection of reviews of the *Holy Wars* album.

'If Mallarmé possessed the inner gift of translating into appropriate and heavy words such feelings as spleen, Tuxedomoon remains – in spite of Blaine Reininger's departure – an absolute master in screen setting with notes.

(…) In spite of years passing by and of a sometimes off-putting intellectualism, Tuxedomoon still hold this touch of amateurism and this intrinsic fragility that make up their charm. Finally, aside from the perpetual *Holy Wars* that Tuxedomoon has to fight against the business and skepticals, the band is probably tackling with another prey: the Large Audience who might very likely fall for the quaint beauty of "In A Manner Of Speaking." I swear to you!'[49]

'Holy Wars continues the band's tradition: where diverse musical styles (jazz, electronica, funk and Arabic sounds) are precisely brought in a disciplined manner to collide with one another. This is the specificity of Tuxedomoon's music: the tension, the *malaise* that resides into this fusion music. Sometimes they sound as archaic as a Spanish radio orchestra, sometimes as radical/fascinating as once The Pop Group (…) Sometimes one can't help the feeling that Tuxedomoon are taking themselves a little too seriously.'[50]

'Compared to their earlier recordings, *Holy Wars* seems more conventional, more commercial maybe. Their fascinating side, *avant-gardiste* if you will, that is the fusion of "known" musical material with strange sounds borrowed from free jazz or sonorities stemming from the punk wave era, is there like before. Cannot be reduced to one single style.'[51]

'(…) uniformly marked by despair and *ennui*. This is chilly, rebarbative stuff, containing some of the ugliest vocals I've heard in a while, especially Steven Brown's wearily affected croak, verging on the hysterical (…)

To their credit, Tuxedomoon has created a world that's not simply depressing but also unsettling. But (…) Tuxedomoon actually make it very hard to care about their vision. Songs like "Bonjour Tristesse" and "In A Manner Of Speaking" adopt a parodic high romance style (pace Ferry's "A Song For Europe")

to bemoan the inadequacy of the language of love.
As distressing a treatment of the pop song as anything since Wire's *154*, *Holy Wars* stakes out a place that's alienating or seductive, depending on your point of view, but it's not a place this listener particularly cares to be drawn into.' [52]

'(…) a return to the more song-oriented approach of *Desire*. If it lacks a certain final impact, its dust-filmed romantic scenarios, world weary langour and exotic strains are more than enough to draw in the passing interest (…) the LP comes across as a <u>travelogue</u>, albeit a heavy-hearted one-melancholy in motion (…) *it's just one big Euro city… I was cruising my decay.* Touching, quaint and cynical, the LP is a collection of emotional cameos, set against a background of conflict.' [53]

'(…) Tuxedomoon have yet to say "there's no place like home" (…) The concentration on the "song" format rather than the more avant-garde meandering of Tuxedomoon's childhood at least makes it more accessible (…) but still there's nothing as simple as a pop song here.
Songs like the jarring electro-pop of "St. John" and "Bonjour Tristesse" and the aloof melodrama of "In A Manner Of Speaking" are haunting messages of disarray and dislocation (…)
But somehow Tuxedomoon overcome their depressive state with dignity, aided by a superbly arranged score of suspended electronics, impatient rhythm tracks and some wonderful ensemble playing. The way Tuxedomoon conjure up perfect *film noir* soundscapes on the brilliant forboding "The Waltz" is evidence of their artistic ascent, even if the spirits are at gutter level.' [54]

'This "new style" is lighter than older Tuxedomoon, but not less interesting. A horn section adds an edge to some of the songs, but gives other ones a *cabaret* sound that isn't consistent with the rest of the music (…) Fans of old Tuxedomoon may not like this pop style, but the music is self-assured and balanced and represents an interesting change for this group.' [55]

'All the pieces are built around a rather stiff rhythm section deprived of the hypnotic power that was so typical of Tuxedomoon (in spite of the content, one never gets the impression to hear moanings here – more music than confession, rather reasoned than passionate and only because of that a new direction). But the poignant grip returns with "In A Manner Of Speaking" where the instrumental elements are pushed to the back to give room to Winston Tong's voice (…) for one of the most beautiful love declarations I've ever heard (…)

"Some Guys" reminds of Tuxedomoon's best moments. There is no break-up from the past but clearly more attention given to melodies and harmonies.'[56]

'Art rock in the best form (…) The British art rock from their predecessors Pink Floyd and Van Der Graaf Generator must be familiar to them – "Watching The Blood Flow" sounds exactly like Peter Hammill. However if that group does quote, they never copy (…)'[57]

The release of *Holy Wars* having been somewhat of a flop as far as… communication with the press was concerned, it was a very tense Steven Brown who took part to a Belgian Dutch-speaking radio interview with Gust De Coster in May 1985.

Holy Wars is some kind of Tuxedomoon reunion. Everybody is there with one exception: Blaine Reininger. How come he's not there?

SB: "Blaine left the group two years ago to work solo. He had been five years with the group and he just thought it was enough. He wanted to try something else. Tuxedomoon, since the beginning has always had changing personnel. We've probably gone through 40 musicians since we started. We're still doing it now. The last show we did was with a Brazilian girl singing whom we met in France. That's the thing that people find hard to understand with this group, it's more of a collective of artists more than like a "band." We're always open to meet new people, whether it's a painter or a film-maker, a musician, an actor, so it's always open. If we meet somebody we like and who likes us, we'll work together. The main difference with Blaine of course is that he was one of the founding main men but when he left there were still four other original members, we just saw no reason to stop so we kept going."

In the sound, what's the main difference to you between with and without Blaine?

SB: "Well, there's no violin on this record, that's one thing. It's probably sort of a more direct sound, I think it's a more sparse sound, plus there's the element of the trumpet, which kind of immediately will shift a sound in a certain way, and the harmonica which is really strong in this one. When Blaine was in the group, he would play multiple keyboards, violin, viola, cello, guitar and bass, he's like a one-man orchestra. Now he's gone and the sound has opened up a little bit. Not that it's any better or worse, it's just different."

Am I wrong if I say that now Tuxedomoon might appeal to a bigger audience but that the band is less innovative than in the earlier works?

SB: "Why do you say that?" (answer preceded by a short and very tense silence)

Steven Brown: "Most people say that *Holy Wars* is more commercial (…) For me [*commercial music*] is music that was exclusively and only made with the purpose of making money. Such music is consciously made keeping in mind that it has to reach the widest audience (…) We do not think of the people we are playing for at all as we are only playing what we take pleasure in playing (…) Even if that LP would

I'm asking you if I'm wrong or not ?

SB: "I don't know. I don't think we're less innovative. The thing is that we still feel the same way about what we do. What we do is making things that we like first and if other people like it, great! But… sights deeply (audience laughs)… less innovative, no. Times change, people change, people's ideas of what is innovative change. Sometimes you are more inspired than other times" (short tense moment, scattered nervous laughter comes from the audience)

More "pop" if not more mainstream than its predecessors, *Holy Wars* sold quite well even though it did not mark the big break-through that the band members most likely secretly hoped to achieve, especially after the hardship of Reininger's split-up from the band. Two tracks from the *Holy Wars* album became particularly notorious.

"Some Guys" was selected by film director Wim Wenders to be part of the soundtrack of his masterpiece *Wings Of Desire* (1987). Steven Brown: "I was at Crammed's when the telex came in. It was great!" [58] Allegedly Wenders had been introduced to Tuxedomoon by his spouse, Solveig Dommartin, who was a fan of the band. Over the years some Tuxedomoon members and notably Blaine Reininger maintained contact with Wim Wenders until some time in the nineties.

Tong's "In A Manner Of Speaking" will be covered several times (from Martin Gore on his 1989 *Counterfeit* EP to Nouvelle Vague on their 2004 *I* album, not to mention Frédéric Truong/Laurent Esmez's version for their 2005 *Renaissance/In Memoriam* album).

In Spain, on Paloma Chamorro's TV show. On March 26th, 1985, Tuxedomoon – this time flanked by Lolita Danse - did their second TV show [59] with Paloma Chamorro in Spain, who invited them on her famous/controversial *Edad De Oro* programme.

Both Spanish shows left lasting memories.

Bruce Geduldig: "In the early eighties, after Blaine had quit the band, we started to work more and more on visual things.

We got an offer from the Spanish television to do a live national show. It was one of the only live television broadcast in Europe at the time. It was called *Edad De Oro*. It was run by these two great girls/producers. The director [*Paloma Chamorro*] was a woman as well and they were really wild.

They were very much in control of the show and so they asked us: "What do you want to do?" We wanted to combine video images with a live performance. So I went to Madrid a couple of weeks before the band came and worked with the television people and accumulated a lot of images. I took

sound commercial, I don't think it is commercial because the intention behind behind it is totally different" (SB interviewed by Grossey, "Steven Brown (Tuxedomoon) : de luisteraar is nooit verkeerd", *Kuifje*, 01/28/86, translated from Dutch)

03/26/85 TM in Spain for Paloma Chamorro's *Edad De Oro* tv show, with Lolita Danse. Set list: 1. "Stars On 45 Medley (East, Desire, Seven Years, No Tears);" 2. "Up All Night;" 3. "Reeding Righting Rhythmatic" 4. "Some Guys;" 5. "No New York;" 6. "You"

some images from the Spanish television and re-broadcasted them. At that time there were floods in Spain. I didn't know that they were so devastating. I associated these images with a song that I had always associated with floods and natural disasters called "Seeding the clouds."

The performance was great because we kind of took over the studio. After the concert, that provoked a lot of response from the TV audience, we did a live interview and somehow this wandering thing came up and I said : "Well, we see ourselves as kind of traveling, traveling through time, traveling through places, we see ourselves as some kind of gypsies."

That was to explain the whole floods thing because lots of people called in and they were horrified that we had shown these images of the flooding of Spain. They were like crying on the phone and I was trying to explain that in a way: "We just came in into this situation and, you know, like gypsies we saw what we saw and now we're here." But the people in the audience were just laughing at me when I said that we were gypsies and I didn't know at the time that the Spanish translation of "gypsies" is like niggers, the lowest class, despised people. And I think they were laughing because they thought that I was just being pretentious or something like that: "You're saying stupid shit. What are you talking about?" I didn't know how to take it but it was this kind of malicious kind of laughter. It's only much later that I understood the situation."

Peter Principle: 'The second Spanish TV show was probably the one where we were on with Stiv Bators (ex Dead Boy and current – at the time – Lords Of The New Church. Bators met a tragic death after being hit by a car in Paris) and he said to Paloma : "Is this broadcast live?" and she said : "Yes" and so he pulled his pants down...

From the second event I also do remember going with John McGeoch, the Siouxsie guitar player who was with Richard Jobson at the time, to a night club where there were no less than four Boy George impersonators three of them girls. And that there was a huge row of some sort later in the hotel...

I also remember Tuxedomoon upon arriving at the TV taking our seats at a fancy catered press conference and being forcibly ousted by the management of China Crisis. Even though it was a festival press conference, we weren't Brits and so they hated us for some reason and insisted that we be removed (I think because we didn't have British management). Jobson and them all looked on embarrassed but of course didn't intervene on our behalf...

I also remember meeting Davy O'List who was playing in one of the bands at the festival (I can't remember which) but I knew of him from being in groups like Jet, the original Roxy Music and The Nice. That was interesting. He's a survivor who

is still going...'

Nina Shaw also recollects: "One time we were in Spain doing Spanish television. This was after the 03/15/85 gig in Lille. We used basically the same elements adapted for television. It was Spring, we hadn't worked in a long time, we all had been stuck in Brussels and Steven and I were getting fed up and decided : "Let's go some place!" Then Steven said:
- Let's go to Spain!
- Steven, I don't have very much money…
- Let's take a bus, it's only a couple of thousands franks and we'll find a cheap *pensione* and we'll go for a week."
I said: "That's wonderful, that's exactly what we need to do."
So Steven was going to go, get back and call me to tell me where to meet.
So time went by, I had gone home. No Steven. So eventually I called him: "So, what's up?" And he said:
- I thought we'd fly to Spain instead and we're leaving the day after tomorrow.
- But Steven I don't have the money to do this…
He went on:
- We're going to spend a couple of days in Madrid, five star hotel.
- What did you do: win the loto?
And it turned out that in the time that I'd left, Spanish television had called and invited us to this television show and so we had our trip to Spain and we were getting paid for it.
So we went down and the Spanish television obviously had a budget.
So we did that and after the gig, Bruce was raging on Martine [*Jawerbaum*] about something that I considered to be petty. So I told him to shut up and stop and he did. Then we went to the hotel, me and Bruce and a couple of people from the dance company. We were standing in the lobby and the elevator arrived and Bruce grabbed me and pushed me into the elevator, told them to stop and then pushed me against the wall. It was: "Don't ever tell me to shut up again!
- Well don't ever talk to Martine that way!"
We had a raging fight going up, nothing physical but I think we were both under a lot of stress and we needed to yell at somebody.
After the television show, Steven and I still wanted to take a holiday and I wanted to go to Sevilla because this is where my parents met and I wanted to go to Granada to see the Alhambra. The next day we were leaving and at breakfast that morning, Bruce came and sat down at the table: "Can I go with you?
- I thought 'no, you can't'. But then said 'well, maybe.'"
But he wasn't to meet us right away. He gave us a phone

Page 257

number of where he was going to stay in Madrid.

Steven and I went to Sevilla. We spent a couple of days there and then took a train to Granada and got in touch with Bruce and told him where we were and he told us the time when he'd be arriving on the train.

So we went down to meet him and no Bruce, no Bruce. And then this girl comes up to us: "Are you Steven and Nina?" Gives us a note and walks away. That was Bruce saying that he couldn't have gotten on that train and was coming on the next one. It was funny to think about how Bruce got this girl – because it wasn't somebody that anybody knew.

And he showed up the next day and we wanted to go to the coast and we took a bus maybe to Alicante and we went to the tourist information because we wanted to get somewhere on the coast but, you know, a small village.

Here's the perfect place, it's called San Jose, a bus goes there twice a week and that's it. So we got there. We hadn't booked any place to stay but we found something. We went to the *café* on the *piazza* and we were sitting there having drinks and a group of four-five people were sitting at the table: "You're Tuxedomoon, aren't you?" And this is a tiny fishing village! And it turned out that they had a vacation house there and that Cabaret Voltaire had a vacation house there as well…"

In the meantime: Reininger's ventures, alone or with Steven Brown; Bruce Geduldig starts The Weathermen.

Spring 1985 also saw the release of Blaine Reininger's mini LP *Paris En Automne*. It wasn't really a solo album as this recording was as much Alain Goutier's baby as Blaine's. This time Reininger did not commit the mistake of omitting his collaborator from the credits.

Goutier is Blaine's oldest Belgian friend (they met in 1982). They had already worked together quite extensively before as Goutier guested (playing bass guitar and other instruments) on many of Reininger's prior outings and also went with him on tour. Blaine: "Alain is perhaps the only person, after Tuxedomoon, that I have worked really closely with. *Paris En Automne* is my only album that contains music I haven't written (out of the five pieces of this album, three are by Goutier)." [60] In fact, the whole B-side from *Paris En Automne* features songs written either by Goutier alone or with a back then rather famous Belgian pop/rock figure: Klaus Klang.

In April/May, both Reininger and Brown left for Japan for a series of Les Disques Du Crépuscule showcases in Japan, with Paul Haig, Wim Mertens and Anna Domino also performing. Reininger had brought his band along and Steven Brown played in Anna Domino's backing group. They found themselves, a bit by chance, performing as a piano-violin duo, a line-up that they had re-started when working together at

Spring '85 Release by Les Disques du Crépuscule of BLR/Alain Goutier's mini LP entitled *Paris En Automne* (recorded at ICP, Brussels, with Thierry Plas, Marc Bonne, Bob Di Marco, Werner Pensaert, the Atomium choir guesting, prod.: BLR, Alain Goutier, David Avidor) featuring the following tracks: 1. "Paris En Automne;" 2. "Singular World;" 3. "Raise Your Hands;" 4. "Burn Like Rome;" 5. "The Homecoming." Track 1 also appears on BLR's *Night Air* Normal/Crépuscule CD (1988)

A review for Paris En Automne. 'Not masking two major influences (Bowie's voice from the *Lodger* era and Mick Karn's bass on the B-side), Reininger certainly produced his most accessible album. The song "Paris En Automne" (this Francophile obsession, again) perfectly summarizes the approach set up for this American in Brussels by the best musicians from our soil: Thierry Plas, Werner Pensaert, Bob Di Marco, Klaus Klang (who co-wrote two pieces), even Jef Bodart who directs an at the least electric Atomium Choir.' (E.T., "Paris en automne par Blaine L. Reininger/Alain Goutier", *Télémoustique*, 08/13/85)

Spring '85 BLR records in Brussels (with Luc Van Acker and producing) the track "Traveling", originally featured on Luc Van Acker '12" entitled *Zanna* released by Wax trax! in 1984 and later appearing on the *Instrumentals* mini LP, released by Inter in '87

04/85 BLR & SB participate in a series of Crépuscule showcases in Japan (with Paul Haig, Wim Mertens and Anna Domino), BLR being there with his band and SB being part of Anna Domino's backing group. BLR & SB will also perform as a minimalist piano-violin concert as a duo. This tour includes a.o. a BLR/SB gig at Sogetsu Hall on 05/02/85 and a BLR concert (same location) on 05/03/85.

An international terrorist. 'Went to a department store TV interview. Blaine says out of the blue to the cameras: "I'm an

Page 258

Béjart's ballet school.

Alain Lefebvre, who also was part of that tour, remembers: "I did this tour in Japan with Anna Domino and Steven also played with Anna Domino. Blaine was there as well. Then Blaine and Steven found themselves playing together. Originally I was to do something with Blaine and Alain Goutier but we hadn't had time to rehearse. Alain was Anna's bass player and Steven played piano and clarinet for Anna, then Blaine was joining us on stage for a piece. So everybody was mixing with one another. And since there was a possibility to do two gigs, in Tokyo they decided to have two performances one of which included Blaine & Steven only (it had not really been foreseen that way but there was a demand). I was then kind of juggling with bands. This was the time when David Bowie was recording at Brussels' ICP and you could go to the Falstaff [*a famous art-nouveau café near Brussels Stock Exchange and one of artists' favorite joint*] and be sitting at the next table with Echo & The Bunnymen. Artists were then accessible and would actually meet and talk to each other."

Anna Domino: 'Our first trip to Japan with other Crepuscule artists: Paul Haig, Wim Mertens and Blaine. Blaine has brought JJ to do his lights and I've got Steven playing horns and keys. They keep us working from eight a.m. till 11 at night so there is no real time to explore. One night there is a cocktail party and JJ is luminous. There is a picture of her from that night eating raspberry sorbet. We have one day to collect souvenirs and end up with a lot of silly electronic pets and hello kitty things and expensive music gear. The music stores are scary – they are full of stuff that is much more advanced than what we usually see and this is possibly our only chance to get some. But how to choose?

The tour starts in Tokyo and goes on to Osaka and Nagoya.

The promoters have hired a stage designer who has come up with elaborate sets for each of us – someone got a forest of showroom dummies – another falling "snow." None of it is practical with a stage full of people and equipment. We meet with the designer and are handed a book of instructions on what to wear and how to behave and what kind of music to play. Is a complete misunderstanding all round. Kind of funny really – more like a game show. Things get nowhere until Blaine saves the day by offering to be the master of ceremonies and Wim tells everyone to just agree with the designers and then do what you want. Act like an artist. So, we all agree to enter from the audience and make jokes and wear black and cut our hair and start with a song like the Beatles and end with the Rolling Stones... And then we just play what we play and everyone is fine. It is true there is no Japanese way to say no. Blaine is hilarious as the star of the show. He makes up stuff on the spot and doesn't stop once

international terrorist and I have come to your country to foment revolution. I have committed heinous crimes around the planet etc." The interview was shown live on scores of monitors in and outside the store. He was introducing himself in turn after Anna Domino and myself, Tokyo, 1985' (excerpt from STEVEN BROWN's private journals)

Life on planet Tokyo. 'The Emperor is out talking to the trees. *Nuit blanche* in the land of the rising sun. 29-4-85, the Emperor's birthday. First show of the tour in big (…) hall. Eleven hundred well behaved young people sit quietly as we march down the aisles, on to the stage, take and then rehearse (…), then leave after B's greeting. All in all, not too terrible, considering AD and company are a big shaky. Paul got a group of girls to their feet (…) Friday night press conference, 26-4. Sat at a table in a big convention hall. All have name plates, English and Katakana. Microphones, Crépuscule tour poster along the table. Feel like astronauts in the right stuff. Bright white lights. We stand on a podium for five minutes of flash bulbs, then sit down in front of some three hundred people. Three dumb questions managed to ask out of quiet (…) crowd. Well, so much for the press. Then down to the real business at hand. In groups of ten, the fans come up and stand behind us to have their picture taken! It's like Disneyland. The members of each group of ten receiving a slip of paper with their group number on it. We sit through twelve groups. Stage right file on, stage left file off. This is Japan, very organized. Doing nothing can be exhausting after interminable length…. More files as lines form in front of each of us for autographs. Dutifully, bashful, one after an other come up with white record size cardboard squares for us to sign. In general they have "Solo piano," "The Cage," "Time To Lose," even one "Zoo Story." I receive a lovely book of all fan reproductions from a girl and a tube of painting. Another one brave girl asks for a kiss! This is the autograph handshake session stated in the itinerary and it seems

Page 259

Tong and Marcia Barcellos at Noorderligt, Tilburg, 05/16/85. Photo Inge Bekkers.

to be a time on earth tradition or ritual here.' (excerpt from STEVEN BROWN's private journals)

Holy Wars promotional dates (with WT & Marcia Barcellos):

05/15/85 TM plays at De Lantaren, Rotterdam (Perfo III festival, theme: Beauty)

05/16/85 TM plays at Noorderligt, Tilburg

Local boy makes good. 'Tilburg, 16th of May. Old cinema. Nice big hall. Capacity: a thousand more or less. Little dream world, happy *ville*, ten kilometers from the Belgian border. Only farms and small towns. Places filled though not packed. Later the promoter says about five hundred and fifty. Well I don't know where they would have stuffed another four hundred and fifty. Great audience. Bring us back to the stars again (…) Luc's native stumping ground. His brother and sister are there, local boy makes good scream the local rags. Chinese catered one a.m. dinner. Not hungry. Little blonde girl from near Antwerp has hitch-hiked alone from home to see the show. Backstage appears with tickets and posters, photographs. We've got no discs so I give her my plate and she eats with it. Three or four other girls show up in the dressing-room with photographs. May be they're the local sex squad, I think now. Nasty

the show is over. He's discovered a drink called Pokari Sweat and composes jingles for it.'

It was also around this time that Bruce Geduldig started a pop/electronica outfit named The Weathermen [61] with Jean-Marc Lederman (former Digital Dance, Fad Gadget and one half of Kid Montana). The duo signed with the Play It Again Sam label, both Geduldig and Lederman concealing their true identities behind the pseudonyms Patricia H. And Suzanna Stammer. [62] Since 1985 The Weathermen have released, at times, quite successful EPs and albums, pausing between 1992 and 2002. In 1987 they even scored a hit single in Germany with the track "Poison."

Steven Brown meets Antoine Pickels; Winston Tong fades away. In May Tong took part in a series of high-profile *Holy Wars* promotional dates in the Netherlands and France. Consequently both him and Marcia Barcellos found themselves together on stage. Barcellos: "Winston was so inhabited on stage and it was interesting because that was similar to my own experience of the stage as a dancer, which was less direct with the audience in some ways. I remember that it was difficult for me on the first concerts when I only had to sing. When you dance, it's totally different as the spectator's glance appears then way less focused: first on your entire body and then on the dancers forming a whole. But when you sing, everyone looks at you in the eye just like if you were about to talk to them! That was quite overwhelming and one needs to be very at ease to do that. When I was on stage with Winston, he came to invite me for a waltz and I let myself be guided by him as his theatrical presence was so intense. He put me in the same state and carried me away with him."

This small tour also saw van Lieshout's triumphant homecoming in his home town Tilburg.

At Tuxedomoon's performance in Paris (Théâtre Eldorado, 05/21/85), Brussels playwright and performer [63] Antoine Pickels was present. He would later collaborate with Tuxedomoon and solo members in various capacities. He sums up the way Tuxedomoon was perceived in Brussels, particularly in some alternative gay circles.

"My story with Tuxedomoon is essentially the story of my friendship and collaboration with Steven Brown. I met Steven on the evening of December 25th, 1984, at the Plan K where I was performing with five/six actors. Steven played there with Blaine, who had a solo gig on the ground floor. As it turned out I then had in my team of performers two close friends of Steven Brown: Luis Alvarez and Alain Renard. It was one of the last great parties at the Plan K and there was something happening on each floor. So we stayed on for a while, talking,

sitting in one of the backdrop's sofas with Steven, Luis and Alain. Steven had liked my performance that reminded him of things he had done in San Francisco. It was a parody of *La Petite Fille Aux Allumettes* but with characters such as transvestites, hookers, killers and handled in the German expressionist *cabaret* style.

I believe that the first thing I did with Steven was his portrait. I was a bit of a painter back then. The painting was inspired from a book by Kipling entitled *The Light That Failed* [i.e. *La Lumière Qui S'Eteint* in French] where there was a painter who became blind. And so I used Steven's face for that painting… that was stolen later on.

Six months later, that is in June 1985, I invited Steven to play me… I think it's been a long time since we have signed autographs…' (excerpt from STEVEN BROWN's private journals)

05/17/85 TM plays at Paradiso, Amsterdam (sold-out) as part of *Tegentonen Festival* organized by *Vinyl* Magazine. The show was recorded by VPRO radio and a live version of "In A Manner Of Speaking" was recorded to be later featured on the *Ten Years In One Night* Live compilation double LP/CD released by Playboy PB in 10/89 and re-released by Materiali Sonori in 1998 (the date 05/07/85 indicated on the sleeve notes is wrong)

Concert reviews. PETER BRUYN ("Verfijning overtroeft vernieuwing", *Haarlems Dagblad*, 05/20/85, translated from Dutch), on reviewing the 05/17 gig, talked about a pleasant reunion

***La Lumière Qui S'Eteint*, after R. Kipling (*The Light That Failed*), a painting by Antoine Pickels, with Steven Brown serving as model**

with Tuxedomoon and their superb new album *Holy Wars*. 'Melancholy is the key to a very refined show with which the group should be in a position to reach much wider audiences;' PETER KOOPS ("Extreme muzieksoorten krijgen alle kans op Tegentonen-Twee", *de Volkskrant*, 05/21/85, translated from Dutch) did cast a more critical glance. 'Tuxedomoon recently made a strong come-back after a series of disappointing ventures (…) but the former magic is gone leaving for a quite written even somewhat banal performance as reflected by this medley of old successes, some sort of *Stars On 45* with a disco beat to it, that could not take away the ambivalence of Tuxedomoon live.'

A swell job. '11 a.m. Train to Saint Quentin. Amsterdam-Paris express. Beers, more coffee, cognac with Winston and girl-friend singer, Au Pairs, Leslie, crazy girl (…) she gets out in Rotterdam. Also Frankie and Saskia will. Frankie, great help he was, did radio mix in Amsterdam. Belgian *douane* appears at Midi and zero in at our portion of the train. First, thorough searching two young guys. Fat stupid *douane* are taking the cute one off to the W.C. Strip how perverse this man having a license to take off a young guy's pants and have a look at something anyone else gets arrested for. They don't stop with the searching through wallets, magazines, then Gilles's off to the W.C., then Luc. There the slob really has a swell job!' (excerpt from STEVEN BROWN's private journals)

0518/85 TM plays at maison de la culture André Malraux, Reims (France) (*Festival Des Musiques De Traverse*)

05/21/85 TM plays at Théâtre Eldorado, Paris, with Lolita Danse (a co-production of Centre Pompidou and Productions Garance)

French rock journalist François Gorin ("Smoking de luxe et guerres saintes", *Le Matin*, 05/21/85, translated from French) announcing the show (that was supposed to take place with two giant screens, video screens, slides projections, 16 mm films, latest electronic equipment + Lolita Danse): 'Purpose: achieving an optimal fusion between image and sound, which brings us right back to the psychedelic happenings from the end of the sixties (Pink Floyd at the Roundhouse in London) (…) five individuals who declared a war against the true absurdities and oddities of current rock consumption.'

06/85 Steven Brown collaborates with Antoine Pickels for a performance at *atelier geste*. The evening also saw a gig by Niki Mono (with Winston Tong joining her on stage)

Summer '85 WT returns to the USA to work on a new performance piece: *Winston Tong Sings Duke Ellington*

07/09/85 The *Ghost Sonata & Time To Lose + The Stranger* videos were shown at London's ICA

at a performance at the *Atelier Geste*. It was for a party during which there also was a gig by Niki Mono (I believe that Winston Tong came to sing with her at one point). The performance was a sort of *vaudeville* with three characters.

In the mean time I had seen Tuxedomoon for the very first time in Paris at Théâtre Eldorado [*05/21/85*]. It was the *Holy Wars* tour with Winston and Marcia Barcellos doing the singing. I was quite impressed as, not being particularly into music, I did not know Tuxedomoon and had only vaguely heard from them through Marc Hollander and other people I knew at Crammed Discs. I must say that I was a bit suspicious as my friends Luis and Alain were in a state of total adoration of Tuxedomoon and of Steven who, for them, was some sort of reference of someone pushing forward lyrics with gay content and the rock side of the pieces at the same time. I met a lot of people for whom THAT was important. It was important for people I'd call "alternative gays." I think I also was fascinated by that side of Steven Brown. Being an alternative gay meant that you would not recognize yourself in the business that had been created around the gay imagery and being able to live your identity knowing that it would not be in accordance with the canons of the times, namely of the brawny young dandy listening to Jimmy Somerville etc., so not necessarily falling for disco. So in a sense Steven and Winston really were some kind of icons, *different* ones.

I was seduced by Steven although, unlike my comrades, I wasn't fascinated by this doomed side of Tuxedomoon, heroin, this drugged out side. I had been told that they were seen in various states around the city. It created a fascination for some sort of Brussels margin who could identify with that. But I must say that Steven's whole cultural background appealed to me as well: being alternative, with references to performance, literature, films etc.

I very rapidly perceived this court phenomenon that there was around Steven (around Tuxedomoon in general but around Steven particularly). I mean that there was a whole series of satellites around him, who were not really doing anything, parasites who lived at Steven's expense, sometimes, when he had some money. However I must say that it kind of went both ways as whenever one of these persons had an artistic gift of some sort, he/she generally got exploited by Steven who, with all the respect and friendship I feel about him notwithstanding, was a vampire who could suck people's energy in his own interest. I for one was way too gay-centered and convinced of my own importance to submit to that. So I never really was part of this court and I believe it created some mutual respect between us as he understood that I was not someone he could manipulate. In fact I was mostly trying to bring him to do *my* projects…"

In the Summer, Brown was in Italy to produce Italian band Minox's first album, *Lazare*, a work that he would complete later in the year

And in the meantime Winston Tong, following the *Holy Wars* promotional dates, returned to the USA to focus on his upcoming show: *Winston Tong Sings Duke Ellington*, which basically was just Winston Tong singing (stabbing? [64]) some Ellington standards over a backing tape. As such, the show didn't impress the critics nor the audience much when Tong eventually performed the show a few times in London and on the continent.

'This was, well, Winston Tong singing Duke Ellington songs, writes Paul Mathur for the *Melody Maker*. No sense of danger or outrage (...) The man is an incredible vision, snakehipped, sexually indeterminate with a grace most girls (and boys) would kill for.

Unfortunately, though, his voice is not really suited to this sort of thing except on the slower numbers (...)

The signs were there – the carefully lit cigarette, the right profile – but the performance was never wholly theatrical or dangerous enough to hit its mark.' [65]

"It was pathetic, says Antoine Pickels who attended an October 1985 performance at Brussels' Beursschouwburg. He was just able to sing two-three pieces and could not remember the lyrics of the others."

During the 1984/85 period, Tong also devoted quite a bit of time to a collaboration entitled *Miserere* with French based in Brussels choreographer Pierre Droulers.

Droulers: "I was trained at *Mudra*, Béjart's school of ballet. After that – around 1979/80 – I went to New York City where I got to meet Bob Wilson well before he presented his new creations in Paris. A bit in the Wilson via Andy De Groot vein, I was interested in the direct confrontation with the spectacle, of art and life, of professionals and non-professionals. In New York I only went to see things that were underground, a lot of jazz also. In New York it's only through jazz that you got a bit of human warmth. I went back to Europe in the Winter and lived for a long time between Paris and Brussels and met sax player Steve Lacey. In Belgium I was the first to stage a *Solo* with Steve Lacey (people's minds were then still totally into the dance *companies* system). I presented this *Solo* at the Plan K. I started to make *mise en scène*/choreographies where I didn't quite know at what moment they ceased to be *mise en scène* to become choreographies but there would always be some dance presented. All these pieces were the consequence of encounters. And this was how the work with the people from Tuxedomoon or Minimal Compact [66] came about. At one point in time at a certain location I would

Videotheque (*Sounds*, 09/85)

07/85 & 11/85 SB produces (and guests on) Italian band Minox's first album entitled *Lazare* (recorded at Studio M in Florence in 07/85 and at Daylight, Brussels in 11/85, mixed by GM) and featuring the following tracks: 1. "Purgatoryo," 2. "Preludio," 3. "Hybrid," 4. "Lazare;" 5. "Psiche." The album was released by Industrie Discografiche Lacerba in the Spring '86 (about Minox and related ventures, see http://www.suiteinc.com/)

07/30/85 & 08/07/85 WT plays at ICA, London, *Winston Tong Sings Duke Ellington*

10/85 WT plays at Beursschouwburg, Brussels, *Winston Tong Sings Duke Ellington*

Probably some time in '85 BLR records 1. "The Sea Wall" and guests on The Durutti Column's 2. "La Douleur" (Bruce Mitchell guesting on track 1) featured on the (various artists) *Hommage A Duras* album released as a LP by Inter in 02/88 and as a CD by Interphon in 05/88. Track 2 also appears on (various artists) *Operation Twilight: Crepuscule Instrumentals*, LP released by Inter in '88.

Some time in '85 BG forms The Weathermen with Jean-Marc Lederman

Some time in '85 BLR guests on the Paul Haig track "Love And War" (recorded in the UK, prod.: Alan Rankine & Paul Haig) featured on *The Warp Of Pure Fun* album released as a LP/cassette by Les Disques Du Crépuscule in 11/85 and as a CD in 1986

Excerpt from the *Miserere* lyrics, written by Winston Tong for the ballet directed by Pierre Droulers:

the distance between two stars
might be the distillation of emotion
& chagrin the rush of flame
between a comet & a nova
the vicious circle
the destiny of love
living only to relive the past
the vicious circle
a camouflage of death
clotted rhythms bearing
the weight of a divine hopelessness
the destiny of love
virgin truths in chariots of pain
the dead moments of living
romance
to be lived again & again
the vicious circle
the destiny of love
the resuscitation of passion
in a desert of lost love
the vicious destiny
the circle of love
but why have you recalled me
when I have to go
now the day is broken
the exquisite spell is broken
& i am victim once again

Page 263

of a broken will
retracing steps
is not an act of love
to persevere
is to continue in a state of grace
& lest we lose our face
in the face of fate
please let me go

Luc van Lieshout, what is your perception of Winston Tong ?
Kind of a sleek person, a bit like an eel if you will. At the beginning he gave me the impression to be a *poseur*. Before we would do some takes in the studio, he would do his "great singer" act a little. On one hand there was Winston The Great and, on the other hand, there would be Winston the junkie. And I didn't really have anything to do with the junkie. In Holland, I once lived in a house full of junkies who had very low life plans and I didn't like their mentality or lifestyle at all. In the end I had only but very few contacts with Winston. So what I think about him? Not much except that he was very gifted for certain things…
What is it that qualifies the behavior of a junkie from your standpoint?
It is someone in constant search for money to pay his dope. It is someone who should be there at three but then would show up at five, unreliable. However Winston would always show up in time when it was his interest to be there. Fortunately when I came into the group, Steven was not taking heroin anymore or at least no longer as a junkie. Neither was Peter. So I was not surrounded by junkies. Ok, from time to time when we had a gig in Italy, they would shoot some heroin. But I didn't care: everyone is free to do what he/she likes as long as it doesn't bother me. But Winston it was all the time. And to my view, that's why he stopped to be involved. When you have such a relationship to heroin, there's absolutely nothing else that matters. It is very hard to be addicted and remain creative at the same time: there will always be a point in time when you will slide into nothingness.

meet people I'd like very much and then I'd be: "Well, let's do something together. I've got a bit of cash so let's share" etc.
I met the people from Tuxedomoon through the Plan K but I did not get to know them very well personally. I was mostly fascinated by Winston Tong and his one-man shows. The first time I saw him was in 1979 at the *Festival International Du Théâtre* here in Brussels where he was manipulating his dolls. Then I saw him in *Frankie & Johnnie*. Finally I saw him singing with Tuxedomoon at the Plan K.
As to my collaboration with Winston Tong… We were both very fond of Rainer Maria Rilke's writings and of his *Sonnets To Orpheus* in particular. When we talked about Rilke Winston and I had the impression to be really on the same wavelength. We talked about Blanchot as well, who had written interesting things about the myth of Orpheus, transmigration of the souls, the question of life, death, rites of passage. At one point I asked Winston to concentrate exclusively on the theme of Orpheus, on the *Descent To Hell*. I thought that this was a good theme for Winston. He finally decided to write a dozen poems and made some proposals for the staging.
I remember of wandering at night, searching for Winston to make sure that he indeed was writing his texts. Against all odds, he turned everything in time. He had it like meticulously thought of and organized in his mind I believe. I was very happy with his work except for the recording of the music that was kind of difficult. Thinking back of it I see now that I had my own *Descent To Hell* with Winston while accomplishing this work. The process of recording was very long and quite frustrating for Sussan [*Deyhim, then still mostly a ballet dancer. She co-wrote the music for Miserere with Tong and later moved to New York City where she embarked on a successful music career including collaborations with composer Richard Horowitz*] but she very much mothered him throughout that process."
It turned out that, for whatever reason, Tong seemed to have found himself short of budget when it came to record the soundtrack for *Miserere*. As a consequence, it would have to be recorded without musicians, with Tong and Deyhim's voices acting as the soles "instruments" at work. So it is by accident that Tong came to invent and orchestrate a polyphony of voices that would make up for the absence of other musicians and hence introduce a truly unique and haunting flavor to this experimental work. It sounds as innovative today as it most probably was more than 20 years ago.
Pierre Droulers: "Winston got along great with Sussan. They were creating a polyphony with their voices, using guttural sounds to create some sort of rhythm. But of course it was taking a lot of time and sometimes it was hard for Sussan to be waiting all these long hours. She was the total partner to him. She was very impressed with him and took care of him.

Page 264

She was constantly on the listen with him. He took a lot of time to decide that he was happy with one piece and that was quite a bit of work indeed.

Winston was very mysterious and very open at the same time. He was by himself quite mysterious but then appeared as very open once we started talking as I sensed that he was listening very well and had the desire to respond (…) Through these timeless things that we had in common, we were touching *something* very intimate and very secret. Even I did not exactly know what we were talking about. We had an intimate question about life, death, art, poetry, wandering… Winston was perfect in the myth of Orpheus. It was something that I felt about him, in his voice, this echo… It fascinated me. Our relationship was very much based on intuition. He impersonated the crossover between East and West. Winston was this frontier: man/woman, East/West, life/death (…) He was this gap, this voice from beyond the grave, something dangerous but yet totally submitted. In this text he wrote, "Slaves Of Intuition," he showed his receptive side, as he does not try to control situations or impose things. He could receive and I thought that this ambiguity about him opened one's perspectives to much wider horizons and I was very attracted to that. And at the same time there was this relationship to tradition, ancient subjects, his dolls – small dead characters. He was in this life/death relationship all the time, he always belonged to that fringe.

He would appear and disappear and when he would appear he was such an extraordinary presence, that had something of the mirage. There was also this weight of suffering. As soon as he came in I could see it. It was strong and had nothing to do with arrogance or rebellion against whatever. He was always suffering but considered it to be part of himself. He had no particular demand that he would exteriorize through his art. He was a mystic.

He was also a Dandy figure in the sense stressed by Françoise Dolto in her *Le Dandy Solitaire Et Singulier*. Dolto's dandy is chaste, he does not calculate, he's between man and woman, lives a reconciliation of the extremes, the opposed, the mother and father figures reconciled. Everything that he is and is seductive about him is related to his deep solitude and a certain chastity. I don't know but I've never felt a taste for worldliness about him. I had the impression that his ego consisted in being a filter, a funnel of sort for the world to go through and from this process he would produce these small miracles that were his performance pieces…"

As to the staging of *Miserere*, Winston was totally involved in the show. There were Sussan Deyhim, Adrianna [*Borriello*], me and Kazuya [*Sato*] (who also was a character between man and woman). Winston danced less than they did but it wasn't

a heavily choreographed piece. Winston was part of the piece as a border wanderer who would come up to us and then leave again. At one point he and Sussan were disguised practically as Egyptian mummies contortioning themselves. He was very active physically and was not pushed at the margin as a performer..."

Tong/Deyhim's soundtrack to *Miserere* will experience its own *Descent To Hell*. According to Droulers, a release with Les Disques Du Crépuscule had originally been expected. Then tensions arose from the fact that Tong needed a lot more studio time than expected and Crépuscule seemed to be facing trouble with the Daylight recording studio. Some were inclined to think that the master tapes had been destroyed by the studio but I discovered, by chance, during my own interview with Droulers in 2002 that a master tape of the work was in fact sleeping in one of Droulers's drawers and probably had been for many years! Thus happily rediscovered the long lost Winston Tong tape finally was released in 2003 on James Nice's LTM label.

Tong's touring with *Miserere* in the Summer of 1985 did not leave untainted memories as Tong's heroin problem was then deep and introduced some disturbances into the touring party's community life. "We did not understand very well what was going on with this heroin thing, confesses Droulers, but we got to realize that when one is really taken by heroin, he/she ends up doing anything for it. But, after all, these drug stories are part of him as well. These were extreme states but also ways to work for him."

By the time Tong was finished with *Miserere* in the Summer, his break-up with Tuxedomoon was official. His *Theoretically Chinese* album was about to be released. A decisive push towards a solo career was very much expected from touring the album, which was planned and then abandoned. Instead, Tong chose to return to the United States, for good this time, before his album even hit the stores. Allegedly, he was to be auditioned for a role in Bernardo Bertolucci's film *The Last Emperor*.

Winston Tong photographed by Renaud Monfourny.

CHAPTER VIII
The end of Tuxedomoon's second era

1985 (from August): *Ivan Georgiev joins in time for Tuxedomoon's German tour in September; recording of the Ship Of Fools mini LP; Tuxedomoon at Oslo's Opera House*

In August Tuxedomoon recorded a NDR TV show in Germany thanks to the promoter of a German tour that would follow in September. However, after Tong's departure, the band was again compelled to seek out new blood. Auditions were organized after which 19-year old Belgian multi-instrumentalist Ivan Georgiev was chosen to become Tuxedomoon's new member.

Ivan Georgiev: "I was born in Brussels. My father was from Bulgaria and my mother was born in England, from an Italian father and a Flemish mother. My father's roots were diverse as well.
I left my parents' home when I was 14, lived in friends' apartments, squats or in communes. I played tenor sax in my first band when I was 12 – the sax was bigger than me – and later, thanks to my brother, I played at parties. I started to

From 08/08/85 till 08/13/85 TM records a NDR TV show in Hamburg (initiative of Blindfish promotion, that also put together the German tour that follows) at Messehalle, Hamburg. The recording will form TM's 3x5 minutes participation to a NDR video-Nacht

08/09/85 BLR plays at De oude vismijn, Lokeren, as part of the *Lokerse Feesten*, with Stage Fried & Twee belgen. The gig was very well received, which led to BLR declaring: "There are at least some people interested in my existence" (*Het Nieuwsblad*, 08/12/85)

08/23/85 IG meets SB through Anna Domino at venue Ancienne Belgique, Brussels. On the same day BLR plays at Ancienne Belgique, with La Cosa Nostra. All the TM members attended to the exception of WT

Early September IG becomes a member of TM, just before the German tour that follows

German (and Swiss) tour (Blindfish promotion) entitled *The Early Risers Tour*:
Traveling party : Chris Brosch (tour manager), SB, PP, LvL, IG, BG, Nina Shaw, GM (sound), Dirk Holzhaüser (monitor), Ludger Helmig (lights), Michael Wichmann (backline)

09/08/85 TM plays at Batschkapp, Frankfurt

09/09/85 TM plays at Alabama Halle, Munich

Tuxedomoon facing the Berlin wall. Photo Saskia Lupini

09/10/85 TM plays at Maxim, Stuttgart

09/11/85 TM plays at Capitol, Mannheim

09/12/85 TM plays at Volkshaus, Zurich

09/13/85 TM plays at Palladium, Geneva

09/15/85 TM plays at Tempodrom, Berlin

09/16/85 TM plays at Markthalle, Hamburg. Live versions of "The Waltz" and "No Tears" were recorded to be later featured on the *Ten Years In One Night* Live compilation double LP/CD released by Playboy PB in 10/89 and re-released by Materiali Sonori in 1998

09/17/85 TM plays at Zeche, Bochum

09/18/85 TM plays at Audimax, Aachen. "Tuxedomoon bind together different forms of expression into a whole: light/films/mime/theater/music (…) Through the more intensive use of reeds, their style has changed (…) Also Winston Tong is not there (…) One can notice some degree of unpreparation (…) Their old songs do not sound anymore as original as they used to (…)'(*Bier Front*, # 5, 1985, translated from German)

09/20/85 WT records an interview that will be featured on the B-side of the 7" labeled as *Documento Sonoro Supplemento Al N. 2/1988 Di Stampa Alternativa* released by Nuovi Equilibri/Materiali Sonori in '88 and appended to *Tuxedomoon*, a book of Tuxedomoon's lyrics with historical notes by James Nice (then calling himself Neiss) published by Nuovi Equilibri/Materiali Sonori in 05/88

09/28/85 TM plays at Tivoli, Utrecht (with Blurt opening)

10/85 WT at Beursschouwburg, Brussels, *Winston Tong sings Duke Ellington*

10/11/85 BLR plays at teatro Masaccio, *San Giovanni Valdarno Festival* (with Durutti Column & Stockholm Monsters playing on the 12). Prom.: Materiali Sonori

10/11/85 TM plays at Messe Palast, Vienna, *Töne Und Gegentöne festival*

10/14/85 TM plays at Palazzetto dello Sport, Scandicci (Florence) as part of various events promoting various independent labels: *Independent Music Meeting* (2ⁿᵈ ed.)

10/15/85 BLR plays at Vidia Club, S. Vittore di Cesena (with Durutti Column)

10/16/85 TM plays at Palasport, Messina

10/16/85 BLR plays at Theatersaal, Aachen (Germany)

10/21/85 TM plays at Teatro Medica. A live version of "Reedin'- Rightin'- Rhythmatic" was recorded to be later featured on the *Ten Years In One Night* Live compilation double LP/CD released by Playboy PB in 10/89 and re-released by Materiali Sonori in 1998

10/22/85 TM plays in Milan

10/31/85 TM plays in Haifa. A recording of this gig is available at http://postpunkjunk.com/?p=129 Peter Principle: "I believe that was a museum concert up the coast"

10/31/85 BLR radio show in Oslo

Page 270

compose music very early on and played several instruments: guitar, bass, keyboards and piano. I had received a classical music training but I couldn't really get into this form of music that I found a little boring, formal and too starchy to my taste. But, on the other hand, I couldn't relate to hard rock at all, I didn't like pop music, didn't like the music I heard on the radio either. Sometimes I would hear things I liked and, when I was around 15-16, I heard some Tuxedomoon songs, some of which I enjoyed very much. At the time I listened to Joy Division, Bauhaus…

What happened next is that I met Yvon Vromman from the Honeymoon Killers [*a band that comprised Marc Hollander, Vincent Kenis and Véronique Vincent; they split in 1985 and Vromman died tragically in 1989*]. The guy liked me and I started to rehearse with the Honeymoon Killers. I learned the bass lines of all of their pieces as Vincent Kenis had just quit the band. At that time I was 16-17 and then the band split. But by then I had decided that playing music was going to be my profession and I was convinced of all the possibilities that could arise from meeting up with people. I was audacious and reckless enough to follow my desires, like going on an international tour. So that's what I did for about three months: I wandered around with my bass guitar and I remember of a quivering intention, to be going everywhere and be involved in all the things that happened.

Then Nina Shaw's boyfriend, who knew Anna Domino, told me that she was seeking a multi-instrumentalist musician. He told me: "Come at this concert at the Ancienne Belgique [*on August 23ʳᵈ, 1985*] and we'll all meet up there." So I went. It was the day of Steven Brown's birthday. I met him backstage and he thought I was cute, so he told me to come along with them at the restaurant after the concert. I did not realize on the spot that he was chatting me up as I thought it was just obvious that they would invite me along. I talked a little with Anna but then Steven really insisted to speak to me. At that point I realized what he was about. So I was constantly asking: "When are you going to rehearse? When is it that you have these auditions?" Indeed they were also seeking a new musician. So I ended up dropping my initial project with Anna Domino and went to Tuxedomoon's audition.

For me their music formed a very strong universe. At the time when I would listen to a piece of music, the external world did not exist anymore and I would dissect everything that was happening within the piece. I remember that there were two guitar players at this audition: a jazzman who seemed to be doing his little practicing and everyone seemed to wonder what he was doing there and then there was another one who was very much into some sort of *neo new wave* style, with typical rock 'n roll riffs. None seemed to possess this typical

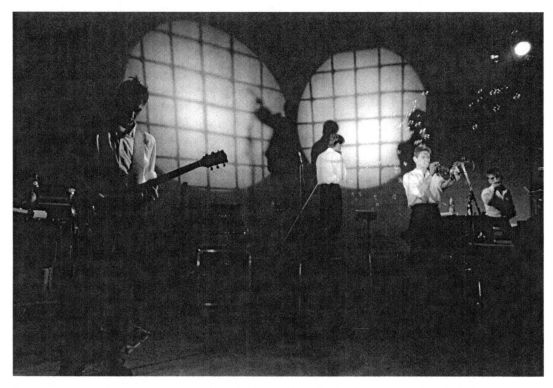

Tuxedomoon at Audimax, Aachen, 09/18/85 (PP, BG, LvL and IG to the right). Photo Hans-Peter Habicht

Peter Principle and Ivan Georgiev, Audimax, Aachen, 09/18/85. Photo Hans-Peter Habicht

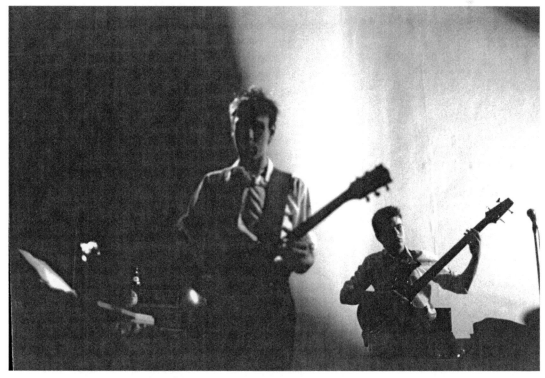

11/04/85 TM plays at Mann Auditorium, Tel Aviv

Ten years before... Yuval Shkedi (a fan from Israel): 'This 1985 concert was in Tel Aviv at the Mann Auditorium *aka* "Culture Auditorium." It is a big venue of 3000 seats, very similar to the Royal Festival Hall in London. It is used mainly as the home of the Israel Philharmonic Orchestra but is also used for other type of performances once in a while. I couldn't attend that concert because I was doing my military service at that time. Now that I come to think of it, it took place exactly ten years before the assassination of the Israeli Prime Minister Itzhak Rabin which was on 11/04/95. It was also less than one kilometer away from there.'

11/08/85 TM plays at Vooruit, Gent (Belgium), *So What 85!* (with Aimless Device & The Neon Judgment)

11/15/85 BLR plays at Cinema S. Marco, Mestre (near Venice)

11/85 Recording at Anything But Studios, Brussels, of Minimal Man's LP *Slave Lullabyes* (released by PIAS in the Spring '86, prod.: Patrick Miller & Ludo Camberlin) on which SB guests on the "Rue Du Cinéma" and "Fun!" tracks, PP on the "Far Away" and "I Wish" pieces, LvL guests on "I Wish" and IG on "Rue Du Cinéma"

Steven Brown, Audimax, Aachen, 09/18/85.
Photo Hans-Peter Habicht

Page 272

inventiveness that one would expect in Tuxedomoon's music. At that time I had already been a composer for some years and was thinking to myself: "What are they doing? This has nothing to do with their universe…" So I hung about, looking at the instruments (I had never seen as many of them in the same room before).

At the end of the audition, they dismissed the other musicians. I had heard "Some Guys" and so I started to play around. It's been like 16 years since I last played this song but I could still do it. Also back then I still had "clean ears." I had an absolute pitch and my classical training. They made me play other pieces and it worked out well. They were quite happy with me and needed someone for their upcoming German tour. So they looked at each other and that was it: I was a member of Tuxedomoon…

So we left for that tour of Germany and Switzerland and that was a complete shock for me on all levels. It was my teenager's dream come true. It was giving every sign of something grandiose. I remember the mini-bar and quadruple-glass windows at some modern tower hotel, the 2,20 meters wide German bed all for myself. I landed there coming from tiny apartments, squats or communes I was living in with some friends. It was like another world. It also was kind of tough for me because if I had an ear for English – since my mother was born in England – I could not understand them very well and what they were expecting from me. My accent was better than my understanding. For some months I got the impression to be like mentally retarded. Anyway this was how things got started…

I was 18-19 at the time and I hated the fact that I was so young because I always felt "old" somehow. That was particularly irritating because until I turned about 27, I looked like I was about ten years younger. That really exasperated me and I was always trying to pretend that I was older than I actually was. That was leading to absurd situations like on this US tour that we did later [*in 1986*] when I was not allowed to go into bars because I wasn't 21 or so… I don't remember of the fact of being a lot younger than the other TMs to have been a "problem" of some sort. At the time I was rather confused emotionally and my girlfriends were usually older than me [*Ivan Georgiev went on to share Nina Shaw's life for about three years*]. So I was permanently around people who were ten years older than me. It seemed just obvious and right for me because those were people who knew how to function. I had left my parents' house when I was 14 and I thought that I could get along. I couldn't have been in a group where the others would have had to learn everything. I did not have as much experience as them but I had my musical baggage, I was a composer and I didn't feel any gap between us except for the

fact that at the beginning I could not handle the language and did not know all the codes that you have to assimilate in this environment.

It took me a while to assimilate the tricks of the profession and learn how to manage things that can be contradictory. In the morning you'd be on a plane, a bus, a truck or a train. Then you'd get to your hotel. There you'd could cool off a bit and have a walk in the city for an hour or two. Then you'd go to the venue. If everything went smooth, it was great. In Italy you would never know. Then we'd soundcheck and after that there would be the waiting. Then the tension would grow with the evening, before the concert. Tuxedomoon was a band that scored rather well at concerts compared to the sales of their records. It could be rather phenomenal. It was never like a hundred people, except in the USA where we went in 1986 and did a couple of very small venues. We generally had like a thousand people showing up, in Italy 1,500 or 2,000.

On my first year with them on stage I did not understand that these were people like you and me in the audience and you'd be on stage and it was them in the audience who made it happen. There's the temptation for the artist to be high up there, floating on his/her little cloud, a way to disconnect from his/her responsibility towards the audience. Then there

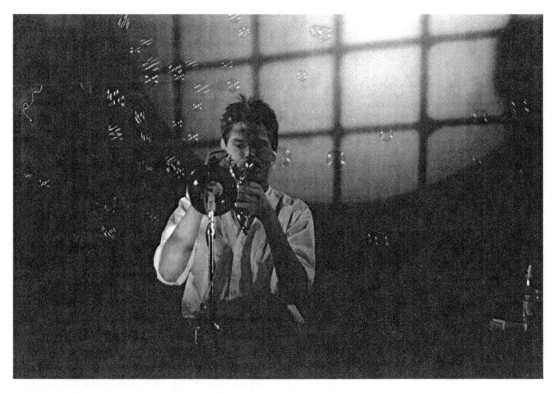

Luc van Lieshout, Audimax, Aachen, 09/18/85. Photo Hans-Peter Habicht

is the temptation to become a big ego: "I'm here because I'm worth it." But a concert is not about showing up big egos. I remember once talking to Luc [*van Lieshout*]. We were in Berlin. They were building a tent for us. It was still East-Berlin back then. I remember of the tension when crossing the border, passports that disappeared. Then there was this tent and Frankie [*Lievaart*] was having a hard time with the reverb, that was too long and sounded bizarre. I was talking to Luc and then all at once I *saw* these people working, setting up this tent for the gig. I had this feeling that they were working for us, so that we could play the night and I realized that I wasn't in any way more important than them as we were all part of a whole in which everyone had a part to play. Once you'd realized that, you can find something right in yourself in order to respond to the expectations. From then on it became enjoyable. Because the problem with the floating on your little cloud is when you're being brutally dragged off it. I remember of the first concert with them at the Ancienne Belgique [*Brussels, on 04/03/86*]. Coming out of it was painful for me: you'd go out and see friends, people you've known for years and it does not click anymore. Because some imagine that you believe you have become this or that and you think you can see what they believe, all these unsaid incomprehensible things put me in a state of shock."

Georgiev's input to Tuxedomoon would not be limited to playing with them on stage. Indeed as a composer, he will contribute excellent tracks like "Roman P" and "Celebration Futur De La Divine" (*aka* "Burning Trumpet").

Recording of the Ship Of Fools mini LP. In October and November, Tuxedomoon was busy touring, with gigs in the Netherlands, Austria, Italy, Israel and Belgium. Predating what now takes place for many musicians, Tuxedomoon always derived most of their income from touring and not from the sale of records. Steven Brown confirmed as much in an interview that was published in November by the Italian magazine *Il Mucchio*. During the same conversation, he spoke concerning the future of music, sounding like a prophecy for the group's approaching fate: "Arrivati ad un certo punto di saturazione, l'ultima spiaggia della musica sarà il silenzio" ("When a certain point of saturation will be reached, the ultimate musical track will be silence").

From December through January 1986, the band recorded their *Ship Of Fools* mini LP, composed of a quiet side (B-side) and a more energetic one. All tracks had been developed and polished on stage since early 1985, in keeping with their customary *modus operandi*. This recording, again, set the band apart from the usual "rock" circuit. Indeed if tracks like "Reedin'- Rightin'- Rhythmatic" and "Break The Rules" do "rock" in some

12/85 TM (SB, PP, IG, LvL + Thierry Sfyzer guesting on drums on track 5) records the following pieces (live at Archiduc, Brussels, prod.: TM & GM): 1. "A Piano Solo;" 2. "Lowlands Tone Poem;" 3. "Music For Piano + Guitar;" 4. "An Afternoon With N;" 5. "The Train" featured on the *Ship Of Fools* mini LP released by Crammed (Cramboy) in 04/86

way, most of the quiet B-side tracks escape classification, most of them being instrumental, with elements coming from jazz and chamber music. Furthermore the track "Atlantis," an instant Tuxedomoon classic, is clearly reminiscent of the atmospheres of their San Francisco period.

The *Ship Of Fools* reviews were mixed. Some expressed lassitude or incomprehension regarding the group's musical intentions. Some furthered British contempt for a band that was once dismissed as a "California band," now criticized for being "too European," *i.e.* too continental for British ears. The "continental" reviews tended to be more appreciative.

'*Ship Of Fools* is another strange Tuxedomoon record. There's a marked difference between this LP's two sides – "A" is dominated by an electronic workout while "B" makes elegant use of piano, zither, flügelhorn, trumpet and clarinet – and this empathic division initially seems to indicate an overall immersion in the pretentious self-indulgence that is more commonly known as the "leisurely theoretical wank."
Steve Brown's ludicrous vocal on the opening of "Atlantis" where he's presumably trying to sound like a vamped-up version of a camp 1930's Berlin *cabaret* singer is a further suggestion of contrivance. And "Atlantis" might still emerge as this year's theme song for those parties where you have to wear a *beret* to be allowed in and where haunted students celebrate the free-form catharsis of post Michael Clarke, pre-apocalyptic dance movement. But after this first flippant response, "Atlantis," "Reeding, Righting, Rhythmatic" and "Break The Rules" cut through remaining suspicions – if a comparison had to be made, Tuxedomoon sound like a rougher, more serious version of Yello inventiveness. The second side's song-titles – "A Piano Solo," "Lowlands Tone Poem," "Music For Piano And Guitar," "An Afternoon With N" – not only stress a "quasi-classical" divergence but also suggest that Tuxedomoon are victims of one too many coach journeys from Luxembourg to Belgium. The European influence on their music now runs so deep that it's difficult to remember that they're originally from San Francisco. However an extended stay in Belgium is recommended because these acoustic tracks are strangely compelling. This Tuxedomoon, far more than The Cocteau Twins or Durutti Column, offers a sublime alternative to the abysmal Coda crap called New Age Music.' [1]

'In this *Ship Of Fools* the Tuxedos appear once again like a pool of free artists, perfect musical dabblers and damn enthralling (…)
Thus "Atlantis" is an excuse for a most invigorating sonic delirium. "Reeding, Righting, Rhythmatic," more electronic and more in phase with today's taste, is evocative of lyrical

soarings *à la* Yello (…)

The B-side is at risk of raising referential issues (…) ending up into a baroque jazz that might make purists scream (maybe that's the reason why I like it).

So what about the new Tuxedo? Two small marvels of good taste in one, to put it simply.' [2]

'The second side is an hymn to old Europe for these Californian exiles in Belgium. Long tracks with piano and reeds, an atmosphere of degenerate European *cabaret*, cheap and smoke-out. Superb!' [3]

'Tuxedomoon maintain their taste for bizarre beauty and their status as a band apart, severed from rock. *Ship Of Fools* (…) presents these trends in two complementary and contradictory movements. The first displays the broken violence of their rhythm box and their squealing synths make up for sirens neighboring voices stamped D.A.F. or Front. The second shares a balmy voluptuous pleasure with Soft Verdict that would soon turn into distress *à la* Peter Hammill. A quite intense summary in its best moments of the raging tumor of the most Americans of Brussels's inhabitants.' [4]

Tuxedomoon at Oslo's Opera House. On December 1st, 1985, Tuxedomoon gigged at the Opera House in Oslo, Norway. It was the first time in the history of this venerable institution that it was used for purposes other than opera and classical music. [5] The genesis of this event was of a kind often seen in Tuxedomoon's history, as it rested entirely on the crazy initiative of a fan, Casper Evensen.

One day 23-year old Evensen decided that it was time to introduce "serious" music audiences to more contemporary forms of artistic expression: "It is important to draw the so-called "serious" part of the music audience to what happens in contemporary music and present it in an accurate form. Tuxedomoon is used to play opera houses, theaters, museums and the like. They prefer that the audience might be given the opportunity to sit undisturbed, listen and rest their eyes and ears against what occurs on stage." [6]

So Evensen simply borrowed $15,000 from the bank and for two months worked day and night to get the thing organized. The response from the audience was fantastic as all the tickets were sold in just a few hours, with the consequence that a second gig was rapidly organized on the same day in the afternoon. Both were sold out. [7]

However Evensen's intention to have a "serious" audience coming at a Tuxedomoon concert was a bit at odds with the band's own intention to disintellectualize "serious" music and bring it to "popular" audiences. As Steven Brown recollected in an interview with the Norwegian press: "It was music that

12/01/85 TM plays two sold-out concerts at Opera House, Oslo, promoted by 23-year old Casper Evensen. Set list: "Reedin'– Rightin'-Rhythhmatic;" "Today;" "St-John;" "The Train;" "The Waltz;" "Atlantis;" "Some Guys;" "Watching The Blood Flow;" "Hugging The Earth;" "Break The Rules;" "You;" "Egypt;" "59 To 1." The gig was broadcast on Norwegian radio NRK

Bruce Geduldig during the concert: "Liberate the Opera Houses of the world!"

Steven Brown: "Depending on how much money there was, the visual aspect of our shows has varied to a degree. But it's always been there and our experience is that by presenting a visual dimension you open up the audience to listening at the same time" (J. Rustad, "From San Francisco to the Opera", *Nye Takter*, # 144, translated from Norwegian by Eiliv Konglevoll)

'Peter Principle is someone who plays bass and guitar in a really UGLY way, so ugly that it has become one of the great characteristics of Tuxedomoon' (O. Haanes on Oslo Opera House programme presenting Tuxedomoon, translated from Norwegian by Eiliv Konglevoll)

12/10, 11 & 12/85 BLR plays at Théâtre De La Bastille, Paris

Page 276

moved us and we saw no reason that it should remain inside the narrow limits set by a sterile intellectual *milieu* who listened to it (…) We could have continued to play our music in art galleries and Universities till we would have gotten old and grey. We (…) took our eccentricities to the nightclubs and the bars, that had been the domain of blues, boogie and heavy rock. The spirit of the time was that it was possible to renew these places (…)." [8]

Consequently what happened was that instead of having a "serious" audience coming to see Tuxedomoon, it actually was a rock audience that for the first time throdded the Opera House's distinguished floors, a fact that was commented on by the local press:

'Similar tunes had never been heard before in Den Norske Opera, writes Yngve Ekern. When the American/Belgian rock avant-gardists Tuxedomoon took the stage yesterday, it was with a form of music that was as unusual in the Opera as the rock audience that showed up.' [9] 'You sense Kurt Weill, French *chansons*, German electropop, English academy jazz, comments Tore Neset. All in all, almost everything they produce is outside the English and American standard rock. No wonder that they live in exile and thrive on it.' [10]

Another notable event to take place around the end of 1985 was Martine Jawerbaum's withdrawal as Tuxedomoon's manager. Jawerbaum was then overstrained by the task of taking care of a bunch of sometimes ungrateful guys like Tuxedomoon and her health had been affected by the environment she had found herself immersed in. However she will remain a close friend to the band and to Steven Brown in particular. In the nineties Martine and Luc van Lieshout fell in love, against all odds as they didn't get along very well when she was Tuxedomoon's manager. They had a baby girl named Zoé. Steven Brown: "It was pretty ironic that Martine and Luc would end up living together and having a kid. No one would have guessed. I never would have thought that ten years later it was going to happen. It was actually nice. When I found out, it was like discovering a diamond amongst dead leaves and the gutter kind of thing…" Tragically Martine suddenly died of an aneurysm in January 1996, shortly after having given birth to her child. Steven Brown dedicated the first CD he released the same year with his Mexican group Nine Rain to her ('a small gesture for a grand human being. This record and everything I've ever done is dedicated to the living memory of Martine Jawerbaum') and, later, his *Subway To Cathedral* compilation CD (1999). After her, no one ever took the task of managing Tuxedomoon again. As Steven Brown often half-jokingly says: "Tuxedomoon is an unmanageable band."

End of '85 Martine Jawerbaum quits as manager of Tuxedomoon. She will remain a close friend to the band and to SB in particular

1986

12/85 & 01/86 TM (SB, PP, LvL, IG, BG & Marcia Barcellos) records the following pieces (at Daylight, Brussels, prod.: TM & GM): 1. "Atlantis;" 2. "Reedin'- Rightin'- Rhythmatic;" 3. "Break The Rules" all featured on the *Ship Of Fools* mini LP released by Crammed (Cramboy) in 04/86

Early 01/86 BLR plays in Groninger, *Pandorra Festival*

Spring '86 SB (+ Nikolas Klau), PP, BG and WT contribute to the (recorded by various artists including Minimal Compact and Niki Mono) soundtrack for Patrick de Geetere's video film (Wonder Products, 35 min.) – a tribute to Syd Barrett – entitled *Fuck Your Dreams This Is Heaven* (recorded at Soundworks, Brussels) for covers of songs by The Velvet Underground, Syd Barrett and The Jefferson Airplane: "Venus In Furs" (SB, PP, Klau); "No Man's Land" (PP); "Coming Back To me" (SB); "Ocean" (PP & BG); "Late Night" (WT) and PP produces and guests on Minimal Compact's piece "Still I'm Sad" (Niki Mono also appears on various pieces). The LP was released by Crammed Discs in 11/86

SB & Anouk Adrien both act in *Fuck Your Dreams This Is Heaven*. Start of a friendship between SB and Anouk Adrien.

Excerpts from *Fuck Your Dreams This Is Heaven*'s storyboard (translated from French)
Description of character Sal (Steven Brown)
Instinctive intelligence. One does not know about his occupation although he appears fascinated by the artistic *milieu*. Fragile, awkward, no sense of humor. Does not talk much or else with passion to demonstrate, attack or defend. Enjoys double or triple meanings but always behaves according to first meaning. Takes extreme sides, despises compromise, fashions annoy or fascinate him. His idea of love is often perceived as childish and out-of-date as it is exclusive, passionate and unyielding. He's uncertain and the improbability he associates to all things creates a void in him that he fills up, like a chameleon, at the contact of characters he admires.

Description of character Che (Anouk Adrien)
A sensual skinniness, an ambiguous face that could be either ugly or of a fascinating beauty. Magnificent eyes and lips she can use to express a multiplicity of feelings. Androgynous, she can be childish, provocative or mischievous, *femme fatale* or motherly and tender. She knows how to arouse a man's desire to protect her, to caress her gently like a child, to profane her until he tears her apart or to love her passionately to the point he adores her. Sacred and adorably pagan. She's got the strength of experience and the childish frailty that translates into a moving desire to assert and constantly prove the reality and tangible existence of her territory. Of a passionate nature, she freezes away and is afraid of passion out of a very painful experience buried into her past. She has become paradoxical and contradictory; sensitive to love and art, she despises their extreme side, their frailty because of their uncertainty. That leads her to consider loving relationships independently from sexual contacts and real life independently from art. In this way she brings back all things to a playful activity, civilized in which she excels and appears as extremely enticing. She lives it

1986: various Tuxedomoon members act in and/ or work on the soundtrack of Patrick de Geetere's video film entitled Fuck Your Dreams This Is Heaven, a tribute to Syd Barrett; Blaine Reininger records his Live In Brussels album and Steven Brown his Me, You And The Licorice Stick EP; the Ship Of Fools show at Ancienne Belgique, Brussels, 04/03/86; Dutch journalist Jan Landuydt's attempt to define Tuxedomoon; American tour; more dates in Spain and Scandinavia; Reininger records his Byzantium solo album; Tuxedomoon participates in Bob Visser's Plan Delta film project; recording of the You album and last concert of Tuxedomoon second era at Elysée Montmartre on November 27th, 1986; No Tears '88 project

1986 saw the involvement of various Tuxedomoon members (Steven Brown, Peter Principle, Bruce Geduldig and a last glimpse of Winston Tong on record) in film-maker Patrick de Geetere's production, a 35 minutes video film entitled *Fuck Your Dreams This Is Heaven*. All contributed music (along with Minimal Compact, Niki Mono and Nikolas Klau, the latter being Steven Brown's partner for a short while and to remain his on and off assistant ever since) composed of covers of The Yardbirds, Syd Barrett, The Velvet Underground, Patti Smith and The Jefferson Airplane. Also Steven Brown got to make his *début* as lead male actor, opposite French actress Anouk Adrien for whom it also was her first significant part in a movie.

The story was much in the vein of Bertolucci's *Last Tango In Paris* or later released Patrice Chéreau's *Intimacy*. In *Fuck Your Dreams…*, Sal (Steven Brown) falls in love with Che (Anouk Adrien) but the two of them are too different – as Sal is obsessed with death while Che is concerned with life – for their story to last. Che leaves Sal. One day Sal accosts Che on the street, jumps on her grasping her shoulder and, without a word, shoots himself in the head with a gun and collapses slowly with his arms embracing Che's legs.

Patrick de Geetere: "I met Anouk Adrien in 1986, on the casting I had organized for *Fuck Your Dreams This Is Heaven*. Steven Brown accepted to act in that movie with her and the shooting took place in Brussels, with the whole team staying at Steven Brown's apartment in Ixelles.
I also asked Steven, Peter Principle, Bruce Geduldig, Nikolas Klau, Niki Mono and Minimal Compact to record the soundtrack for that movie. Steven dared a particularly baroque and flamboyant cover version of "Coming Back To Me" from The Jefferson Airplane. I had some money for the production and that was a bit of a dream come true for me to make them

work on an original soundtrack. The idea was to make covers of mythical tracks from the sixties. I remember that one night Winston and I being particularly stoned, we found ourselves in a studio almost by breaking into it at three o'clock in the morning. Winston recorded a blitz cover of Syd Barrett's "Late Night" and I did the mixing with a sound engineer filled with consternation."

Was this film meant to be an evocation of Syd Barrett?
"Yes it was in an indirect way. Barrett is a character that always fascinated me as he was close to something one might call "genius" but, at the same time, he was also close to something bordering on disaster and failure."

In that sense it could also be an evocation of Winston Tong [the storyboard reveals that Tong had originally been cast as the male lead]…
"Yes Winston is undoubtedly the most Barrettian of all (…) But in a way they all were. I always thought that there is, within music, some sort of a family that grew through the ages, geography and fashions notwithstanding, all of its members being related through some kind of conducting thread. I could see a galaxy that, through The Velvet Underground and Syd Barrett, could include Tuxedomoon. One could see this thread with the same characteristics of, all at once, a great generosity when working together and, paradoxically, something very self-centered at the level of the individuals involved. So they were constantly flirting with disaster, the fall, like holding their balance on a thin rope…"

So could your work be described as one of approaching this "family" to which Tuxedomoon belongs?
"Exactly. At the time I worked on *Fuck Your Dreams* I found myself at the bottom of the abyss. Of course it had something to do with the fact that I was then taking a lot of heroin. In these moments you are obviously less in control of things. However consorting with this absence of control can lead to moments of grace, fragile ones bordering break-up. In the end for me what makes up for a great work of art resides in this paradoxical relationship between something that is of the order of the abyss and something that is of the order of serenity."

Nowadays de Geetere does not want anyone to see *Fuck Your Dreams This Is Heaven* as he considers the film as "unfinished and immature." That explains why it has become so hard to find copies of the said film.

Fuck Your Dreams This Is Heaven also marked the start of a great friendship between Steven Brown and Anouk Adrien, that would later bring about an artistic collaboration between

out like an assumed maturity that pertains to an unquestionable absolute.

Che
The distress one can constantly feel about Sal scares me. He's always so serious and withdrawn. What kind of intimacy could arise between us?

Sal
We were lying, pressed against each other. She was expecting words of tenderness. I knew I was in some lost paradise, and I knew that I was going to be chased away from it. I wanted to be reassured… She remained pressed against me for a long time. Both of us wanted to ignore sadness, of the kind one feels after a missed *rendez-vous*. I fell asleep with my face in her hair…

Che
I detest weak people and their slimy need of affection. But Sal is different. He's not weak at all. It's rather that his strength is tainted with confusion.
I love Sal, I love what he is but we paralyze each other. He's concerned with death while I'm concerned with life. Sometimes we scare or annoy each other in our face-to-face. I cannot translate his universe into mine.

Sal
Che always talks as if life, suffering and death would not exist. As if life's horizon would be clearly defined by a multitude of encounters that she'd pin up like butterflies in her memory: a whole collection of relationships that comforts her in a vision that she deems mature and definitive.

Che
Sal considers that there's no normality outside of social normality and this normality is unbearable for him. He says that compromise is the driving force of such normality and this is disgusting to him. In fact I think that he's withdrawn and selfish. His exclusive extremism is a scary weight for me. He constantly talks about love but I believe he's incapable of loving.

Some time in '86 SB did some concerts with Italian band Minox (that he also produced: see preceding Chapter)

Some time in '86 SB guests on the B-side of Lara Fabian's first 7" for the track composed by Marc Lerchs entitled "Il Y Avait" (recorded clandestinely at night in the Rtbf – French-speaking Belgian radio/tv – studio Paradoxe in Brussels). This track is available on http://www.larafabian.ch/pagehtml/inedits.htm

Some time in '86 BLR records the track "Some Fine Day" (in Brussels, with BLR prod.) that will be featured on his *Byzantium* LP/CD released by Les Disques Du Crépuscule in 04/87

Some time in '86 BLR guests on Montana Blue's LP *Compliments And Roses*, released by WEA

Some time in '86 BG shoots a 14 min. short film with WT entitled *Narco And Ecola*

Steven Brown and Anouk Adrien. Photo courtesy of Anouk Adrien

them on Brown's *Decade* solo album [*released in 1991, where Brown and Adrien covered Edith Piaf's "A Quoi Ca Sert L'Amour"*].

Anouk Adrien: "I would sum up the making of *Fuck Your Dreams This Is Heaven* as the story of my encounter with Steven Brown. At the time I was way more into Crammed Discs Minimal Compact's music than in Tuxedomoon's as I related to their energy much more. So I was glad at the idea of meeting them for the making of the film. Finally it's not the guys from Minimal Compact that I really got to meet but Steven Brown."

02/13&14/86 BLR plays at Beursschouwburg, Brussels (with Alain Goutier, Daniel Wang and Klaus Klang). It was during this concert that the following tracks were recorded: 1. "Volo Vivace;" 2. "Night Air;" 3. "Birthday Song;" 4. "What Use Indeed?;" 5. "Uptown (extremely long concert version);" 6. "Broken Fingers" to compose the *Live In Brussels 02/86* album released as a LP by Les Disques Du Crépuscule in 06/86 and as CD by the same label in early 1987. This album will be re-released by LTM in 2004 as *Live In Brussels Bis* with following bonus tracks: "Ash & Bone;" "Paris En Automne;" "Radio Ectoplasm;" "Burn Like Rome;" "Mystery & Confusion"

Note: the band then playing with BLR (composed of Alain Goutier then Leon Van Den Akker & Daniel Wang) was called Linear B, *i.e.* an anagram for Blaine R

Some reviews of these concerts.
Jacky Huys ("Blaine live: meevaller", *De Morgen*, 15/02/86, translated from Dutch) clearly sees BLR as a has-been, declaring having to force himself to go to the concert. He describes the venue as scantily crowded (about 250 people), 'the audience being mostly composed of Brussels French-speakings that constitute the *milieu* of predilection of the American community living in Brussels.' Author writes that BLR reminds him of Gary Numan and, when he plays violin, looks like a cross between Charlie Chaplin and Eraserhead. As to BLR's spoken interludes they are, still according to Huys, either annoying, irritating or funny. WS ("Blaine Reininger oververmoeid tijdens opnamen van live-elpee", *Het Nieuwsblad*, 04/86, in Dutch) describes BLR as exhausted after the first of the concerts. "I've worked so hard," says BLR. WS: 'After all this stress, lack of sleep and the mysterious effect of ingestion of lots of little bottles of sparkling water, the 250 people in the audience did not witness an image of self-mastering at work.'

Reviews of the Live In Brussels LP.
'Versions of "Night Air" and "Birthday Song" reach a perfectly mastered and great level of density. "Uptown" unfurls to reveal its treasures the most beautiful of which is undoubtedly an unbelievable imitation (homage) of

Blaine Reininger records his Live In Brussels album and Steven Brown his Me, You And The Licorice Stick EP. In February Reininger played two gigs at Brussels' Beursschouwburg the recording of which would constitute the basis for his *Live In Brussels* LP (released by Les Disques Du Crépuscule shortly thereafter).

The journalists who attended the show were generally not enthusiast, indicating that Reininger had become some sort of "has-been" already. However, and this was an element of Tuxedomoon's exile in Belgium that probably wasn't very clear to them, some Dutch-speaking journalist present expressed an opinion somewhat biased by the fact that, to his view, the American community of Brussels seemed to be more acquainted with the French-speaking *milieu* rather than with the Dutch-speakings. As already noted Tuxedomoon's *état de grâce* had come to an end around the same time in France as a journalist from *Libération* obviously did not understand why the band had "chosen" Brussels, a "heap of mud" in his words, instead of Paris to establish their base. Now it seemed quite plain that the band and its members individually had also lost the mythical aura that surrounded them for a while when they moved to Brussels. From then on Reininger and friends would have to cope with Brussels's complexity as a city historically created by Flemish people but that culturally had since long been taken over by a majority of French-speakings. Brussels in that sense focalizes the tensions between Belgium's two main communities and an intricacy that is hard to understand for outsiders and especially for the Tuxedomoon people who chose Brussels as a mere base from which they could extend their activities throughout Europe.

Steven Brown had not remained inactive as he united

forces with Nikolas Klau to record his delicate *Me, You And The Licorice Stick* 12." Unlike Reininger who, in his own words, formed an "American co-dependent bubble in Brussels" with his wife JJ La Rue, Brown was more firmly anchored in Brussels, even though he seemed to hate the climate and lack of a cultural life comparable to what he had known in San Francisco. Hence the piece "Besides All That" sounded like a collection of snapshots of his life in Brussels, through which filtered more serenity than most of Reininger's lyrics, which appear obsessed with expatriation and overall lack of acceptance of the fact that he lived in Brussels. Also the lyrics of "Besides All That" contain a questioning, "I wish somebody would tell me what is happy music," a jibe at journalists asking him why his music or lyrics would often be characterized as "depressing" or "unhappy." [11] Brown: "It's quite logical that lyrics would lean towards nostalgia. What should one in God's name write about happiness? All the good pieces of music stem from a certain lack, on the feeling that you'd wish something to happen. The best music and most beautiful poetry would all encompass that kind of element." [12] On that particular issue, Brown and Reininger seemed to agree as Reininger would declare in a 1988 interview: "Pain can bring inspiration (…) Either way I write depressing music. These are the emotions I feel strongest. If I am happy, I don't feel like writing music. I want to be happy! But when I am depressed or repressed, I feel a strong emotion that must come out. Catharsis..." [13] The other pieces on Brown's EP, composed of largely instrumental soundscapes or soundtracks to non-existent films, constituted a thread that Brown would further explore on his upcoming *Searching For Contact* LP.

The Ship Of Fools show at Ancienne Belgique, Brussels, 04/03/86.

April saw the release of the *Ship Of Fools* mini LP, an event that Tuxedomoon celebrated with the *première* of their new show at the Ancienne Belgique in Brussels. Antoine Pickels also performed a *Fools Gallery Interlude*, a piece that was designed to bring the show away from the confines of the stage into the audience itself.

Antoine Pickels: "There were four fools wandering around the venue: a fool of love, a fool of God, a fool of death and a fool of sex surrounded by young girls. Also, tickets were distributed in the audience and there was a lottery at the end of the show. All of this was quite ironic, very baroque. From my standpoint the performance went relatively well although some told me that it weakened the show somehow to have them all come back on stage after playing to take part in this lottery happening. However the most unpleasant thing I had to face was, as often when dealing with Tuxedomoon, that there was an overall reluctance to have an outsider performing which

Captain Beefheart, another genius' (LP, "Blaine L. Reininger: *Live in Brussels*", *La Meuse/La lanterne*, 07/02/86, in French); 'The extraordinary thing about this recording is its freshness and relevance. You can hear all the Bowie, the Scott Walker, the (later to become) Jeff Buckley passion for European high art. A real plunder chest for any contemporary band on the lookout for fresh ways of upping the pop-rock ante. It would sit well in any serious collection that doesn't already know about this stuff' (*Whisperin' & Hollerin'*, 03/04)

Later on, Reininger will declare the following about the Live In Brussels album: "This project was a disaster from the start. On top of this these were bad concerts and I was in a conflict with some people on the stage, Mr Klang and the others. This record should have never been released (…) I'm certainly not happy with it. I then fired my manager, as it was his idea…" (J. Heins, "Blaine L. Reininger: rock in het bloed", *De Morgen*, 04/30/87)

03/22/86 TM plays as Joeboy in Apeldoorn (Netherlands). The set list comprises mostly pieces featured on the forthcoming *You* album + some never released ones: 1. "Opening" (noises + "Mi sono innamorato di te"); 2. "Sample Trumpet;" 3. "Roman P;" 4. "Sample Drum;" 5. "Funeral Song;" 6. "Bongoes" 7. "Never Ending Story;" 8. "Never Ending Process;" 9. "The Creative Process;" 10. "Waltz/Laughin';" 11. "Roman P"

03-04/86 SB records (at Anything But Studios, Brussels, with Paco Rosebud aka Nikolas Klau guesting, prod.: SB) the following tracks: 1. "Am I Home Yet?;" 2. "Gone With The Winds"; 3. "Besides All That;" 4. "A Gift", all featured on the *Me And You And The Licorice Stick* 12" released by Sub Rosa in 07/86

04/86 Release of TM's *Ship Of Fools* mini LP (see previous entries). According to Michael Belfer, the front cover photo was shot in his apartment when he lived in Brussels, located in a strange building

04/03/86 TM's *première* of the new *Ship Of Fools* show at Ancienne Belgique, Brussels with performances by Antoine Pickels. A piece entitled "Michael's Theme" credited to Nino Rota was recorded and was published as the A-side of the 7" labeled as *Documento Sonoro Supplemento Al N. 2/1988 Di Stampa Alternativa* released by Nuovi Equilibri/Materiali Sonori in '88 and appended to *Tuxedomoon*, a book of Tuxedomoon's lyrics with historical notes by James Nice (then calling himself Neiss) published by Nuovi Equilibri/Materiali Sonori in 1988

Note on "Michael's Theme" (that also appears, in another live version – Eindhoven, 05/02/86 - on the *Ten Years In One Night* Live compilation double LP/CD released by Playboy PB in 10/89 and re-released by Materiali Sonori in 1998): this piece is alleged to be the Nino Rota track of that name excerpted from the soundtrack to the first *Godfather* movie (1972). In fact the piece played on stage by TM at that time to open their shows is not Nino Rota's

Page 281

"Michael's Theme" but Carmine Coppola's "Connie's Wedding"

would result into costing the band some money (about 125 euros). Only the band members who supported the visual part of the show most strongly, that is Steven and Bruce, were in favor of my performance whereas Luc, Peter and Ivan were not very hot about it, to say the least."

Pickels' mixed feelings echoed with the press' own impressions about the gig. Even Thierry Coljon, a French-speaking journalist from Brussels who has always been quite supportive of Tuxedomoon and solo members' acts, was a bit reserved: 'this single Tuxedomoon concert attracted a big crowd, an all-in-black mob (...) *Ship Of Fools*, a ship that pitched and rolled between fascinating drowsiness and dadaist vaudeville. The visual aspect of Tuxedomoon's concerts was never designed to illustrate a music of a perpetual ever-changing nature. But our Americans in Brussels had never separated both modes of expression as much as for this *Ship Of Fools* show (...) Bruce Geduldig (...) continues to dress up the music with his backdrops and impressionistic films (...) that sometimes would push the audience into some sort of languor that Steven Brown's haunting sax and clarinet playing do nothing to alleviate (...) One finds him/herself constantly pitching and rolling in the unreal, between irritation and seduction (...) It's up to you to board on the ship, or not, to be part of the journey.'[14]

Journalist Olivier Stockman again captured Tuxedomoon's fragile essence somewhere between "professionalism" and the situationist happening-like amateuristic spirit that originated in their *débuts* with the Angels Of Light: '(They) set up a tasteful hour and a half moment where philosophy never ceased to rhyme with poetry. The approach was of a total work of art and eclectic (...) in an impressionistic manner (...) A feeling of dread naturally crops up, enhanced by at times boring at other times incantatory and lamenting vocals, where pleasure

**Steven Brown and Peter Principle backstage,
Ancienne Belgique (Brussels), 04/03/86. Photo Saskia Lupini**

Bruce Geduldig conducting the *Ship Of Fools* lottery, under the eyes of one of the four fools wandering about the stage and audience. Photo courtesy of Antoine Pickels

and pain do not live apart. Some of the pieces are irritating, but in spite of this Tuxedomoon still expresses and preserves this peculiar charm of always being somewhere on the frontier between professionalism and eyewash.'[15]

Other reviewers were a lot less lenient. 'Blaine Reininger and, more recently, Winston Tong's departures have deprived the group of their direction and like drained them out of their blood (…) The hurly-burly started already about half an hour before the show. Ten or so insistent fools, straight from the ship of fools, wandered about the venue, squealing and yelping. All with tickets in hands, printed by the fool of love, God, sex and death. You had to fill in your name and give it back to get the chance of winning a gift. Enough with this bullshit of an introduction. The concert itself (…) was a mix of new and old material. The new songs, with a few exceptions, are not really worth anything (…)'[16]

'"Maybe we expected a little bit too much of it," said Steven Brown. "We worked too much on this also: two months long, seven days a week, at least ten hours a day. In any case no one is going to participate in this event again. It was a one shot deal."'[17]

Dutch journalist Jan Landuydt's attempt to describe Tuxedomoon. By then many journalists had attempted to define Tuxedomoon, and many are still trying to this day. This is probably doomed to failure as Tuxedomoon's main characteristic is of an open collective making the music that

04/12/86 BLR plays at Boerderij, Zoetermeer, with Leon Van Den Akker (playing with BLR since about three weeks) and Daniel Wang. First of three concerts in The Netherlands

Some concert reviews. The Boerderij concert is described as 'one of the best in the year', BLR appearing like 'a Willy Deville's little brother'. Unfortunately most of the 150 people composing the audience were not from Zoetermeer ("Blaine Reininger: meestermuzikant", *Zoetermeersche Courant*, 14/14/86, in Dutch); Peter Bruyn considers that BLR has a problem with his image: '(...) black suit with tie and formal shirt, lacquer shoes, *chic* case and cigarette holder. This image of a gentleman play-boy does not fit with his music and melancholic lyrics that probably reflect the real Reininger' BLR's profile is of one of these individualists in the line of John Cale, Tom Waits, Peter Hammill, David Thomas etc. (P. Bruyn, "Melancholieke sfeer bij Blaine Reininger", *Haarlems Dagblad*, 04/14/86, in Dutch)

04/14/86 BLR plays at Het Witte Theater, IJmuiden

05/01/86 TM plays at Paradiso, Amsterdam

05/02/86 TM plays at Effenaar, Eindhoven. The track "Michael's Theme" (see note above) was recorded to be later featured on the *Ten Years In One Night* Live compilation double LP/CD released by Playboy PB in 10/89 and re-released by Materiali Sonori in 1998. The concert was recorded for a VPRO radio show

05/03/86 TM plays at Arena, Rotterdam

05/09/86 SB records "Anonymous" & "Men Of Mercy" with Richard Jobson. These tracks appear on the (various artists) *Minutes* LP released by LTM in 03/87

05/08/86 BLR plays in Reims, *Festival Des Musiques De Traverses (An VII)*

A review. BLR appears as 'mid-way between King Crimson but harder, an Alan Parsons project but more barebone, or like an Emerson, Lake and Palmer with a disturbance in all notes (...) This concert, all at once distinguished and boisterous, elegant and heartbreaking has been one of the great moments of the beginning of the festival' ("Traverses 86 – Une première journée de contrastes", *L'Union*, 05/09/86, translated from French)

05/10/86 Richard Jobson + SB play at 't Beest, The Hague

05/13/86 BLR plays at Metropol, Aachen

05/14/86 BLR plays at Hochschule Fûr Technik, Bremen

05/30/86 BLR plays at Odeon, Münster

pleases the actual "here and now" members with no effort to delineate or stick to a definite style. However the person who probably was best at trying to describe Tuxedomoon was a Dutch journalist named Jan Landuydt. Here's an excerpt from his long article published in 1986. [18]

Tuxedomoon's sound appears at first glance as '(...) electronic music endowed with a stiff rhythm section played low key on portable instruments (as Steven Brown values the group's characterization as proletarians in the artistic world). But the electronic component is combined with other instruments, essentially winds and strings (...) In this manner, their somewhat bony rhythm (often originating in a pre-programmed rhythm machine) gains a coloration resulting from the use of, among others, the violin and saxophone, not to forget the voice that tends to gain in importance.

This was how their basic specific recipe was born, made up from a variety of styles the downswinging of which results from high tension between the Art and Big Beat poles. This music's heart remains contemporaneous but starting from there, it goes off on a side path mixing classical elements, big band, pulp and kitsch: '"We just exploit everything at our disposal," Winston sums up. "I like to think of us as renegades ransacking the vaults of art, throwing things in the pot and letting them stew, then feeding them to people"' (Winton Tong in *NME*, 09/19/81). This leads to timeless music (thanks to its eclectic and universal features) but adopting ever changing forms as Tuxedomoon's heart continues to beat (...)

In Tuxedomoon normality and strangeness meet (...) Hence the music is never esoteric (...) The music possesses an inner openness and there will always be an aspect of it to which the listener will relate (...) it is an attempt to build something that had never been heard before while never losing touch with emotion.

Furthermore Tuxedomoon escapes from the differentiation between popular and so-called "serious" music. The group was given all kinds of labels, ranging from "twisted and icy post-psychedelia" to "industrial *cabaret*." The group perceive themselves as a concept with no *a priori*, a cooperative venture without a contract, from which something can arise only when something "clicks" amongst the various members, when individual momentums merge into a crossroads at which a common project can burst from all the energies put in common. That explains why the band goes through long periods of silence as nothing will be produced as long as no collective desire would generate anything. There's a form of sincerity that finds its expression through music. The people from Tuxedomoon perceive themselves as artists, with all the connotations in terms of tortured mind that such designation implies. The kind of art they pursue does not

rest on theories but on intuition. It is passionate as born of desire. That explains why Tuxedomoon continues to exist, against all odds and in spite of all the crisis and their state of perpetual research like a suffering conscience of the artist's position in society. Some uncertainty about the meaning of the artist's function, that the group lets filter through their music, where distress mutates into creative expression, weakness becomes a strength (…) The questions remain however and confer a tonality of alienation to the music (…) Tuxedomoon succeeds in inventing a new ride through a thousand times already paced path. The means they use do not really matter, what matters is the world they reveal (…) Tuxedomoon's music is moving in the primary sense of the word (…) And Tuxedomoon's tracks could be characterized as movies without images as the images would be the ones coming to the auditor's mind when listening to it (…)'

In some way, Landuydt's piece bears some explanatory value regarding the long period of silence towards which the band was indeed sailing.

American tour. In May Tuxedomoon played a few dates in the Netherlands before embarking, from end of May until end of June, on a 15-date tour of the United States that brought them to New York City, Washington DC, Minneapolis, San Francisco, Los Angeles, Atlanta, Houston, Boston and Chicago. In San Francisco, Winston Tong joined them on stage for "In A Manner Of Speaking."

Jeffrey Surak, a fan who attended the show in Washington DC, remembers his first and only meeting with the band: 'The concert took place at the 9:30 Club, on 930 F St, NW in Washington DC. It was a cloudy Saturday, May 24, 1986. I went with several friends from high school, we had all just recently graduated. The club was sold out, and it was interesting to note that hardly anyone smoked. Usually (back then at least) the club would be filled with the stench of smoke and bodies, but the audience was particularly civil. Tux was the only group performing. For the few hours before Ralph videos were played on the monitors, I remember seeing MX-80 Sound, Residents... all of the then Ralph videos that they had released. Tuxedomoon started around midnight with the Boxman stories. The stage was small (…) This was the first time I saw what the members of Tux looked like, apart from the Ralph video. So I was guessing at first who was who, but it all became quickly apparent. The show was fantastic! Afterwards we went downstairs to the dressing room and hung out with the

05-06/86 TM's American tour. 15 dates including:
05/22/86 TM plays at Palladium, New York City.
05/24/86 TM plays at 9:30, Washington DC. Set list (courtesy of Jeffrey Surak): 1. "Boxman (Mr Niles);" 2. "Michael's Theme;" 3. "Atlantis;" 4. "Some Guys;" 5. "The Train;" 6. "Boxman (Home);" 7. "Never Ending Story;" 8. "Roman P;" 9. "Boxman (Home) Reprise;" 10. "Reedin'- Rightin'-Rhythmatic;" 11. "St-John;" 12. "Hugging The Earth;" 13. "You;" 14. "Break The Rules;" 15. "59 To 1"
05/26/86 TM plays at Downtown Danceteria, Minneapolis
05/30/86 TM plays at DV8, San Francisco, where WT joined them on stage for "In A Manner Of Speaking"
05/31/86 TM plays at (Charley's Obsession

Ivan Georgiev and Nina Shaw on the train to one of Tuxedomoon's US dates. Photo courtesy of Steven Brown

according to one source, Ballroom of Alexandria Hotel according to another), Los Angeles. First meeting with Carlos Becerra
06/15/86 TM plays at 688, Atlanta
06/20/86 TM plays at Phideaux's, Houston
06/23/86 TM plays at I-Beam, San Francisco
06/26/86 TM plays at Limelight, NYC
Other dates include: Boston (at Boston's Paradise), Chicago

No maps of Cuba... 'Dream I'm in Cuba, buying methadone over the counter, a thousand something pesetas equals a hundred dollars. Out in the sunshine, green hills, trying to think how to fill in a form. An address: Colorado. Rural route box. Anyway, I'm finished and I'm waiting for the responsible person to come down the hall and fetch the form. A fighter jet with United States air force logo glides silently right overhead. Finally I move out, through an airport like reception center where we were offered refreshments and free coffee. In another room, I see Nina and Ivan at a table. I don't want to see. Continue out, pass the US marine and a bunch of electric colored maps of parts of the USA air force style. No maps of Cuba...' (excerpt from STEVEN BROWN's private journals)

Silent films. 'My name is Brently Pusser. I live in San Francisco. Back in 1986 I drove a van from Houston to Dallas, Texas to pick up Tuxedomoon and bring them back to Houston for one show. That's about a five hour drive each way. I picked them up around midnight band and their entourage. They offered us drinks and food. I had a good long chat with Steven. We discussed Greek clarinet music and some other things. Peter was really cool too. When I left he patted me on the shoulder and said thanks for coming to see them.'

Bruce Geduldig recalls the hotel they stayed in on their stop in Los Angeles: "We played on top of this hotel and the gig went well. At the time crack was the new hot thing and in this hotel it was crazy! I remember that a police station had been set up in the hotel and from the hotel you could see all the blacks outside wandering around selling crack. There were police cars equipped with loudspeakers blaring: "Move! Move!" in their direction. They would just nonchalantly walk around the block, and come back to where they were before. Once I was in the elevator going down, doors slid open and I saw a bottle of vodka hurled into the corridor while two terrified youths rushed into the elevator: "Help us! Help us!" I was trying to calm them down, saying that we would now go down, when suddenly a huge black guy appeared: "Are you taking MY kids?""

It was in Los Angeles that the band would also meet with Carlos Becerra, who then worked as a correspondent for a Mexican music magazine. He would keep in touch with Steven Brown and collaborated with him for the release of his *Subway To Cathedral* compilation CD in 1999. Also, some 15 years after his first encounter with the band in LA, this Mexican-American would start to work with Tuxedomoon as a tour manager, which he still is to this date.

After having been away for so long, Tuxedomoon's homecoming turned out to be a hazardous venture. 'As might be expected after such a long break, Tuxedomoon's first American tour for almost five years broke few box office records, wrote James Nice.[19] Indeed the conception still lingered amongst many who remembered the name that Tuxedomoon were variously junkies, or dead. And though the band were paid well, the fact that the 15 dates were spread over a seven week period meant that the tour lost money. Also despite Cramboy's licensing deal with Enigma Records Tuxedomoon records were thinly spread in most American stores and attendances were therefore uneven – the Houston gig turning out to be little more than a private party thrown by an avid fan.'

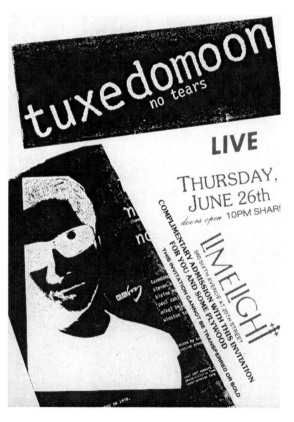

Flyer for Tuxedomoon gig at Limelight club, NYC, 06/26/86

More dates in Spain and Scandinavia. After the American tour some band members took an extended "home leave" during which, for instance, Bruce Geduldig and Winston Tong found themselves and work together again.

By the end of August, the band was back in Europe and played some dates in Spain and Scandinavia. In Spain they played a festival for an unreceptive audience. Half of the attendance of 1,000 vanished during the show. [20] Their Scandinavian journey this time took them to Oslo, Trondheim, Bergen, Malmö and Stockholm.

In October the band also took part in a WDR radio RockNacht recorded in Bonn, Germany.

Reininger records his Byzantium solo album. From October 1986 till January 1987, Blaine Reininger set off to record his next solo project entitled *Byzantium*, with a cover photo that made him look like a clone of Willy Deville, which was a conscious move. This was part of Reininger's attempt to be part of the popular mainstream, which was noted by some of the reviewers for the album: '(…) he's more cheerful – should I dare say more pop? – evoking (among others) Telex or The Sparks. Furthermore humor is given large leeway' [21]; '(…) he seems to be in lack of inspiration (…) Byzance: decadence?' [22]; 'A master piece, the testimony of an artist in full maturity' [23]; 'Reininger binds together the electronic music of his time with pop and Arabic sounding forms of music, far Eastern or South American with electronic pop, electronic *chanson* with acoustic ballads in a brilliant synthesis of intellect and emotion' [24]; 'David Bowie would sound like this, wouldn't he have given in to the dance mania' [25]

For the release of *Byzantium*, Reininger conducted another self-interview (03/87) in which he, once again, returned to the reasons why he left Tuxedomoon. Selected excerpts:

- What was your primary role in Tuxedomoon?

"I was the violinist. I wrote or co-wrote all the songs, and most of the lyrics, but I was doing very little singing at the time, I'm not quite sure why. Winston (Tong) was the other lyricist, and Steven (Brown) gave it a good try. Most of the time, he used lyrics by me or Winston, sometimes quoting outright from whatever dismal book he was reading. In all fairness, he's doing better now, though he still lifts from other people."

- What made you leave Tuxedomoon?

"I left because I had given the thing five years to achieve certain objectives when it started, one of which was some kind of lasting success. The five years went by, the objectives had been bypassed or ignored, so I quit. I decided to try going solo. It's as simple as that."

and we drove back to Houston all night. One of the members played me some cassette tapes of the most haunting and beautiful music I have ever heard. I think it was Steven but I'm not absolutely positive. Anyway, he said it was soundtrack music to silent films from the 20's and 30's…'

07/86 WT/BG work together

07/14/86 BLR plays in Ferrara

07/18/86 BLR plays at Palazzetto Dello Sport, Messina

07/20/86 BLR plays at Aleph Club, Gabbice

08/30/86 BLR plays in Leiden

08/28/86 TM plays at Ciudadela, Pamplona, *Festivales De Navarra 86*

Scandinavian tour:
09/04/86 TM plays at Rockefeller, Oslo
09/05/86 TM plays in Trondheim
09/06/86 TM plays in Bergen
09/07/86 TM plays in Malmö
09/08/86 TM plays in Stockholm

Fall '86 BLR records (at Soundworks, Brussels, with SB guesting on track 2, prod.: BLR) the following tracks: 1. "Japanese Dream;" 2. "Bismallah." Both tracks will be featured on *Greetings One* released by Materiali Sonori in 1987. Track 1 appears on *El Paso*, 12" and CD released by Normal in 08/88. Track 2 appears on (various artists) *The Greetings Compact*, a CD released by Materiali Sonori in 01/89

10/07/86 TM plays at Biskuithalle, Bonn. Recorded as part of WDR radio *Rock Nacht* (with The Mission, Cassandra Complex & Rio Reiser)

From 10/86 till 01/87 BLR records (Brussels, Daylight, prod.: BLR & GM, with Eric Sleichim and Leon Van Den Akker guesting) the following tracks: 1. "Rolf & Florian Go Hawaiian;" 2. "Blood Of A Poet;" 3. "Teenage Theatre;" 4. "Japanese Dream;" 5. "Too Cool To Die;" 6. "Bird On A Wire;" 7. "Rosebud," all tracks to be featured on the *Byzantium* LP/CD released by Les Disques Du Crépuscule in 04/87. This album will be re-released in 2004 by LTM with the following bonus tracks: "Paris En Automne;" "Singular World;" "Burn Like Rome;" "Raise Your Hands;" "The Homecoming;" "Bizmillah;" "Radio Ectoplasm (demo);" "Rolf & Florian Go Hawaiian 7" remix"

About the "Rolf & Florian Go Hawaiian" track. "The piece contains an inside joke. It is a satire of a TV commercial for a soft drink in America. Donny and Mary Osmond are playing and, at one point, one can hear a languid voice whispering: "Donny and Mary go Hawai-a-a-iian." In my song Ralf (Hütter) and Florian (Schneider) from Kraftwerk go to Hawai" (J.P. FORIER, "Blaine L. Reininger - De grootste idioten hebben nu ook een synthesizer", *Het belang van Limburg*, 08/19/87, translated from Dutch)

Page 287

- What is it that Europe brought to the USA and vice-versa?
"Most important to me is the fact that Europe gave the world Mozart and Magritte, Vivaldi and Voltaire, Beethoven, Bach, Goethe, Dante, Bartok, Stravinsky, Satie, Schönberg, Sartre, Socrates, Kafka, Alexander The Great, Napoleon, Caesar, Marx, Fellini, Jean Cocteau, James Joyce, Picasso, Surrealism, Dadaism, Art Nouveau, Art Deco, the Bauhaus, opera, the Coliseum and the Eiffel tower, Wagner, Freemansonry, and on and on and on. What did America give us? McDonald's? Ernest Hemingway? Don't make me laugh."

Tuxedomoon participates in Bob Visser's Plan Delta film project. The rest of 1986 was devoted to another collaboration between Tuxedomoon and long time friend Dutch film-maker Bob Visser on an ambitious project called *Plan Delta*.

Bob Visser: 'This film is a Time Fiction about humankind's fight against water, one of the greatest battles fought by humanity and by the Dutchs in particular. It takes place in 2230, when the warranty on the Easterschelde dam expires. Indeed that sort of work was guaranteed for 250 years…'

What happens then is that water submerges the lowland country and some survivors are left to live on the works themselves, forming a strange city that seems to have been taken straight from some science-fiction book. [26] These survivors form a superior people who, however, find themselves in a dead-end, both spiritually and fertility wise. Hence they need the primitive people living outside of the city's boundaries to re-found themselves. Eventually a little girl was chosen amongst the primitive people to become a princess and the key to the city's rebirth.

The film is remotely evocative of Wim Wenders' *Wings Of Desire* as it stages an "angel" in a human form wandering about between the superior and primitive communities. It also casts Bruce Geduldig in a lead role as the narrator of the story.

Tuxedomoon's involvement was not limited to contributing the four tracks that appeared on the film's soundtrack (*i.e.* "The Bridge,""Celebration Futur De La Divine" *aka* "Burning Trumpet," "Nimrod" and "Lop Lop's People"). They also participated in the completion of the film itself. Bob Visser: 'The film was projected as a work in progress with Tuxedomoon present on stage in various venues and theaters. The band was standing behind a large transparent screen and hence could be seen at the same time as the film was projected (sometimes it was just the film that was visible, sometimes it was only the band and at other times both could be seen simultaneously according to the type of lighting that was used). Bruce as the narrator in the movie was standing in front of the screen.'

This *Plan Delta* tour, that visited venues in Utrecht, Ijmuiden

TM starts to work on Bob Visser's feature film project entitled *Plan Delta*. Their contribution includes the following tracks: 1. "The Bridge;" 2. "Celebration Futur De La Divine" (*aka* "Burning Trumpet"); 3. "Nimrod;" 4. "Lop Lop's People" (these tracks, recorded at VPRO studio were released only much later on the *Soundtracks/Urban Leisure* compilation CD released by LTM in 06/2002). TM also performs live during presentations of the film as a work in progress on the following dates:

09/18-19/86 TM plays at Tivoli, Utrecht, a *Plan Delta* performance. The live version of "Celebration Futur De La Divine" (*aka* "Burning Trumpet") featured on the *Ten Years In One Night* Live compilation double LP/CD released by Playboy PB in 10/89 (and re-released by Materiali Sonori in 1998) and on TM's *Soundtracks/Urban Leisure* compilation CD released by LTM in 06/2002 might have been recorded then or at the Rotterdam (Lantaren) date on 11/23/86

Working together… 'Friday, 14th of November 1986
As tension begins to mount with the recording session, finally it blows away like a cloud of bad air and we're mixed in the train and everyone later agrees it was a remarkable evening and that everyone felt relaxed working together.
That was the key: working together. Once you get over that hill, it's so smooth…' (excerpt from STEVEN BROWN's private journals)

11/22/86 TM plays at Het Witte Theater, Ijmuiden, a *Plan Delta* performance

11/23/86 TM plays at Lantaren, Rotterdam, a *Plan Delta* performance

Note: a live version of "Lop Lop's People" was recorded during one of the aforementioned performances to be featured on *Lost Cords*, part of the *Unearthed* double CD/DVD included in TM's 30th Anniversary box set released by Crammed Discs in 2007

The finished *Plan Delta* movie will include BG as narrator and also as part of the cast. The film features excerpts of TM's *Plan Delta* performances mixed with

Page 288

and Rotterdam, was a great success. Bob Visser: 'People still talk about that tour today.' The press described an 'enthralling experiment' that 'reminded of the association of live music with silent films.' [27] Journalist Ton van der Lee described a full venue at Utrecht's Tivoli (on 09/18-19/86) and portrayed Visser as an underground crazy film-maker, always an outsider but also a genius. [28] Peter Slavenburg mentioned a more than full auditorium at Rotterdam's Lantaren, the mix of images of Visser's still incomplete film with Tuxedomoon's live music making an event that went well beyond the film itself. [29]

Bob Visser: 'Later, that is in June 1987, we filmed this *Plan Delta* show in the then not yet fully built Danstheater in The Hague (a project by architect Rem Koolhaas). These images then constituted added scenes into the completed movie.'

Unfortunately the completion of the project took quite a while as the film was *premièred* at the Rotterdam film festival in February 1989. Visser explained this delay as resulting from a combination of technical and financial problems that considerably slowed down the fulfillment of the work.

The four tracks composed by Tuxedomoon for *Plan Delta* can be heard in their entirety in the movie, mixed with some added sounds recorded during the band's live performances. These tracks were finally released in 2002 by LTM Recordings, as part of Tuxedomoon's *Soundtracks/Urban Leisure* compilation album.

Recording of the You album and last concert of Tuxedomoon second era at Elysée Montmartre on November 27th, 1986; No Tears '88 project.

From November through January 1987, Tuxedomoon recorded what became their last studio album in a very long time. Entitled *You* (containing an eponymous title track), this album is perhaps the weakest ever recorded by Tuxedomoon and in that sense perfectly reflects the "end of the show" mood in which most of the members were back then. Indeed, the end of the shows came with Tuxedomoon's last gig in the post-Reininger formation at the Elysée Montmartre in Paris on November 27th, 1986.

However interesting some of the individual songs featured on the *You* album may be, it is clear that the whole lacked a cohesion that had seemed to have deserted the band 'In the wake of the disappointing US tour live performance had become less and less stimulating for everyone involved – as apparently Tuxedomoon itself, wrote LTM's James Nice. [30] Indeed the recording of the new album *You* (…) would effectively finish off the group, the troubled sessions bringing to a head the internicine problems which neutralized the band as a creative force.

Recorded at Daylight Studio, and again self-produced, the

the images of the movie. Due to technical and financial reasons, the film (produced by Neonfilm) will not be completed and released until February 1989

From 11/86 till 01/87 TM (SB, PP, LvL, IG, BG) records (Daylight, Brussels, prod.: GM + Frankie Lievaart + TM) the following tracks: 1. "Roman P;" 2. "The Train;" 3. "2000;" 4. "Never Ending Story;" 5. "Stockholm;" 6. "Boxman (Mr Niles);" 7. "Spirits & Ghosts;" 8. "Boxman (In The City);" 9. "You;" 10. "Boxman (Home)" all to appear on the *You* LP/CD released by Crammed (Cramboy) in 04/87. Tracks 2 and 8 also compose the *Boxman* 7" released in 04/87

New York DJ Mark Kamins, dreaming of living in Brussels. 'Recorded "You" on a full moon, 16th of December. Could see it, the moon, through the skylight over my head in day light studio. As I sang tonight, Hanna [*Gorjaczkowska i.e. Crammed Discs' boss, with Marc Hollander*] comes over 3 a.m. with Mark Kamins. Mark Kamins is Madonna's producer. Both are in their cups. He says we should do a gay club mix of "No Tears" before someone else does. He says he's thinking of moving to Brussels. "I'm paying $1,500 a month in New York for what ??? I look out the window and see bums peeing… There are guys sleeping on my doorstep. Here I could have a house, a nanny, lease a car, make disco mixes $40 an hour at ICP, London is an hour away" etc.

etc. "You guys have lost your edge" he says. Tonight I told Karen Finley that she was better than Artaud. She said "thank you!" We shook hands at the Plan K after the show.' (excerpt from STEVEN BROWN's private journals)

11/27/86 Last concert of TM second period (before the Reunion Tour) at Elysée Montmartre, Paris

Idealism. 'Thinking of how the internal group history of Tuxedomoon reflects the micro history of the world. Seven or eight years we all worked in common, studio, democratic. Today we all have our own little work nests at home: recording studios, computers (…) from self to public. How TM seems to have been locked into a wave of idealism, a group vision which has now gone the way of so many countries and governments. The commune, new left politics, coop shopping, recycling… How far away these things seem as if from another lifetime…' (excerpt from STEVEN BROWN's private journals, circa 1987)

Wandering Music. 'I was thinking the other day about the "old days" in San Francisco and the "new wave" and Tuxedomoon. What made the "new wave" new, at least in our case, was the fact that we would go out of our way to produce new songs… We censored ourselves. If something sounded too *cliché* or obvious, it was out.
We took the long way around, the scenic route. Always looking for that alternative riff, that unusual drum beat. I remember how strongly I reacted at the time we were writing a song called "Nervous Guy" and Blaine had programmed a standard B-S-B-B-S pattern into our little mail-order electronic drum machine. I felt he was somehow committing treason! This is how Tuxedomoon came up with its music.
Today, as back then, most bands start from the opposite tack and begin by writing music in the style of "x" or "y." Everybody has influences, we just didn't want

set was a sadly lacklustre effort that bore more than a hint of contractual obligation. By now the group had split into warring factions, with certain members even unable to tolerate the presence of others in the studio. As a result the record lacks stylistic and technical cohesion, with Geduldig's superfluous *Boxman* trilogy an especially unwelcome distraction. Not that the album is devoid of merit, with "Roman P" and the charming title track standing beside the band's best work (…) Despite being produced at Daylight – essentially Crammed's own studio – the sessions ran up an enormous bill, the money pit deepened by a full week spent remixing the title track as a single. "You" would be remixed yet again in 1991 for the *Solve Et Coagula* compilation, though sadly none of these versions do justice to this fine Steven Brown song. Indeed, if further evidence were needed that Tuxedomoon had lost track of the plot, the appearance of "Boxman (The City)" on forty-five as an "aural cartoon" provided it in spades. With no live dates to support it, and housed inside an untidy sleeve, *You* slipped out in May 1987 to a distinctly lukewarm reception (…)'

Of course the reviews for this album were, again, quite mixed and combined the UK's traditional ignorance of all things Tuxedomoon (one reviewer obviously thought that Tuxedomoon was a Belgian band) with France's relative leniency in considering Tuxedomoon's European works. Selected pieces:

Review of "Boxman," released as a single: '"JACKANORY" meets "The Twilight Zone." "Mr Niles" is persuaded by his television set to live in a cardboard box, or maybe to become a cardboard box (it's hard to be sure with so much echo on those Belgian accents). This makes him sad. Blue Niles. Eventually he gets taken out with the garbage (which is how it must feel to win a night on the town with the cast of "EastEnders"). While all this goes on, Tuxedo Moon confirm their status as one of the world's finest off-centre collectives by making "twinkly twinkly" noises aplenty. But what does it mean? "That's easy," say the cats. "Dinner."' [31]

'Unclassifiable! (…) the "Boxman" series, narrative pieces with sound effects, that the band nicely define like aural cartoons. Besides more experimental tracks, the album features distinctly more accessible pieces like the delightful "The Train" or (…) "You." So what we end up with in the end is a record with a carefully stricken balance between audacity and – yes indeed – seduction, Artistic pretensions (with capital A) and listening pleasure inasmuch that the auditor is open to attraction for novelty.' [32]

'What is left of the semaphore that the Tuxedos from five years ago represented for the new wave intellectuals? A few crumbs

that one can find back in the inspiration of some of the pieces. But the epileptic sound and the mysterious dimension have left room for bronzed revelations, for a showing off kind of introspection.' [33]

'Ex-pats in Brussels, Tuxedomoon have for the best part of this decade married their, originally, jerky, experimental rhythms with Europe's more *avant-garde* sensibilities, producing an unsettling spread of electronic laments, *cabaret* dance and brilliant soundtracks for great cities.
Usually Tuxedomoon are possessed by the decaying – moral and physical – condition of their European environment but on *You* they've written a wonderful animated cartoon for the ears in the four-part Boxman, eerie but darkly humorous, that almost parodies the alienated tones of their past work. Elsewhere, Tuxedomoon have added luscious, commercial edges to their last-chance dances.' [34]

'Tuxedomoon have a long story of… irregularity. This long player is bizarre but inconclusive – sketches, musical and lyrical notes, echoes of 60s tijuana brass, the soundtrack to a surrealist version of *Taxi Driver*, half a tune you have heard before but don't quite know where. Themes appear – long journeys (usually by train and river), dreams, Europe – never quite how it used to be. There are three pieces about Mr Niles – a man who decides to live in a box. I am thinking of trying to get into the record sleeve, maybe that will help me understand this strange world. But perhaps I should accept it as it is – as the song says – "this is only the beginning of a story that will take many more songs and situations to tell."' [35]

Another ill fated project was the *No Tears '88* EP released in the Summer of 1988 that nearly represented Tuxedomoon's actual last effort on record, although not under their name.
Steven Brown: 'The 1988 "No Tears" remixes were made by Mark Kamins (NYC), Peter P, myself and Nikolas Klau assisting…'
Marc Hollander: '*No Tears 88* by the so-called Creatures Of The Night is a remake or cover version rather than a remix: the track was entirely re-recorded by several Tuxedomoon members, and produced & mixed by dance music producer Mark Kamins, who had produced the very first Madonna single (!), later founded his own Pow Wow label, and produced the Karen Finley records which came out on Crammed (…) It came out (in '88) both on vinyl and CD single, but has been deleted for years now.'
James Nice: 'Crammed having set up their SSR dance label, asked the group to produce an updated version of "No Tears." Noted New York deejay Mark Kamins thought it was a cool idea too, since the original was still a favorite in the clubs.

ours to be so obvious… (excerpt from STEVEN BROWN's private journals, 1987, that was also used for a presentation of SB at the 4th Bari International festival entitled *Time Zones '89 – Sulla Via Delle Musiche Possibili*, in 1989)

Tuxedomoon duly obliged – and with chequered results. After Kamins endlessly toyed with the tapes, *No Tears '88* appeared as a maxi single in the Summer under the transparent pseudonym Creatures Of The Night. Despite the time and expense, however, not one of the six new versions bettered the original while only those suffering from a severe nervous disorder might truthfully claim to find it danceable.

As Principle commented later: "I was against it and only came because I thought I'd be paid as a session player! Little did I know that we were paying for it, and it lost a lot of money. And, it sounds like shit."' [36]

As a matter of fact,' by the time *You* appeared Tuxedomoon was already on ice. Principle: "As the classic line-up gradually disintegrated there were fewer wells to draw energy from, and the combinations were becoming samey. The group was already floundering before we recruited Ivan. Steven wanted to move to Italy. I didn't want to move to Italy. Neither of us was enjoying touring Tuxedomoon. And since Blaine and Winston left Tuxedomoon the whole thing has become very apologetic in the press as to why we don't call it something else. It's boring."' [37]

Luc van Lieshout: "Back then we didn't work as we could and should have. The reason for that state of affairs are difficult to summarize. The group would blame it on the record company as they wouldn't promote enough or find us gigs. The last concert we did together was in November 1986 at Elysée Montmartre, after which Steven and Bruce said: "We are going to stop doing this as we've done it for so long and nothing really changes…" I know that by then Steven and Bruce were sick and tired of Tuxedomoon. As far as I'm concerned, as nothing really happened when *You* was released, I had the impression that the soul was gone somehow.

In my opinion, there has been two different bands: before 1983, there was Tuxedomoon with Blaine and after 1983 came Tuxedomoon with me. From my standpoint I consider that the band from before 1983 was much stronger in terms of musical material, inspiration and influence. We were able to last until 1987 but it wasn't the same thing. Because even if we were making good music, you can't really compare a record like *Holy Wars* or *You* to *Desire* or *Half-Mute*: it's not as revolutionary. So in my perception – and I believe that many people who knew the band before 1983 do share the same viewpoint – Tuxedomoon ceased to exist in 1983, that is when Blaine left. After this, the band went on but perhaps it would have been a better idea to do it under another name. I find the music from before 1983 to be quite different. Also it rarely happens that a band that would have come up with two extraordinary albums in a row could then continue

1987

Some time in '87 PP collaborates to the soundtrack of Saskia Lupini's video entitled *Innocence*

Some time in '87 SB guests on Anna Domino's track entitled "Chaos" (recorded in Brussels, prod.: Flood) to be featured on Anna Domino's *Lake* 12" released by Les Disques Du Crépuscule by the end of 1987

In 1987, BLR's band, Linear B, is composed of: Leon Van Den Akker (guitar + bass), Jan Pijnenburg (drums), Luc Duerinck (keyboards and programming)

Some time in '87 BLR collaborates with French band Tohu to present a show entitled *Le Train Fantôme* presented at the Rennes *Tombées De La Nuit* festival . See http://users.skynet.be/rockrennais/tohu.htm

Page 292

recording things at the same level. Generally bands make one or two really good recordings and after that it's not the same anymore as they would either grow tired of being together or would have exhausted the ideas that they had in their youth.

So I believe that there's a big difference between the two formations. Of course there are people who think otherwise as some, for instance, believe that *Holy Wars* is Tuxedomoon's best album. But I think that there are more people out there – and I would include myself in the bunch – who consider *Half-Mute* and *Desire* to be real landmarks in the history of popular music and *Holy Wars* way less so."

In the Summer of '87, when James Nice interviewed Steven Brown for his historical introduction to an upcoming *Tuxedomoon* lyrics book, published by Materiali Sonori, he bluntly asked him the question whether Tuxedomoon still existed or would exist in the future. In the end Brown's answer exactly reflected what would happen to the band next: "I think they'll exist in many forms as long as records and films and videos exist (…) As far as any sort of live manifestation I really couldn't say (…) I was tired of it all and I am tired of it now but it's not the first time I've been tired. You know what seems totally obsolete, totally pointless one day, the next day you're back on doing the same exact thing, thinking it's a whole new exciting *situation de vie*. So myself I don't like to predict things because whatever happens will be the exact opposite of what I would say. So I just play it safe and not make any attempt predicting anything like that…"

1987 through 1988: release of the Pinheads On The Move compilation album; May 1st, 1987 Andy Warhol's Workers Party Day at Brussels's Résidence palace; Steven Brown's next solo recordings: Searching For Contact and Brown plays Tenco; Tuxedomoon's 10th Anniversary meal; the Reunion Tour

The Spring of 1987 saw the release of Tuxedomoon's *Pinheads On The Move* double LP, a compilation made by Peter Principle of the band's early and hard to find material. This album is a truly invaluable document for anyone interested in looking into the band's roots, particularly their San Francisco period. However some of the pieces will sound crude to those who got to discover the band through their *Half-Mute* and *Desire* albums, something that Steven Brown readily admitted in an interview with Brussels *Radio 21*: "The first time I heard the tape that Peter [*Principle*] gave me, I did not want this recording to be released because it was like exposing our roots somehow. It was the start of the band and one can

Some time in '87 Release by Inter of BLR's *Instrumentals* mini LP including the following tracks: 1. "Contempt;" 2. "Les Choses De La Vie;" 3. "Le Dernier Amant Romantique;" 4. "Les Nuages;" 5. "Petite Pièce Chinoise;" 6. "Traveling;" 7. "Music # 2;" 8. "Licorice Stick Ostinato;" 9. "Basso Pomade." The Les Disques Du Crépuscule 1991 CD re-release feature the following additional tracks: "La Douleur;" "La Belle Epoque;" "Side Wind;" "The Sea Wall;" "Metallic Mosquitoes;" "Bay Bridge." This album was re-released by LTM in 2002

James Nice: 'Instrumentals caused no mean amount of consternation *chez* Cramboy since it included the three BRT *Ghost Sonata* orchestrations from January 1983. Yet while it's true that the material more rightly belonged on a Tuxedomoon record rather than on Reininger's solo project, it's equally true that without the Mertens/Crépuscule link the material might have never been cleared for release by the conductor, Arie Van Liesbeth. (JAMES NICE, *Tuxedomoon*, unpublished manuscript, 03/21/92, pp. 39-40)

Some time in '87 PP and Saskia Lupini collaborate at a distance with WT (the latter in San Francisco) for Saskia Lupini's short film (12 min.) entitled *Picasso's Balcony* based on B. KAUFMAN's poetry read by WT

Spring '87 TM (SB, PP, LvL, IG and Malka Spigel guesting on track 2) records (Daylight, Brussels, prod.: GM, Frankie Lievaart & TM) the following tracks: 1. "Atlantis (remix);" 2. "You" (other version than the one on the preceding album). Both tracks compose the You 7" released by Crammed (Cramboy) in 04/1987 and track 1 also appears on the (various artists) It's A *Crammed Crammed World*! 2 compilation album released by Crammed Discs in 09/87 and on the *Lost Cords* CD, part of the *Unearthed* double CD/DVD included in TM's 30th Anniversary *7o7* box set released by Crammed Discs in 2007

This recording exacerbated the band's internal conflicts

04/87 Release of TM's *Pinheads On The Move* compilation album, a collection of TM's rare early material (San Francisco and early times in Europe). Note: the pieces marked by an * appear only on the double LP version, not on the CD: "Pinheads On The Move;" "Joeboy The Electronic Ghost;" "The Stranger;" "Jingle 7;" "Love/No hope" *; "In Heaven;" "I Heard It Through The Grapevine;" "Fifth Column;" "Touched;" "Waterfront Seat;" "Une Nuit Au Fond De La Frayère;" "I Left My Heart In San Francisco;" "Everything You Want;" "Next To Nothing;" "Egypt;" "Over His Head;" "Martial/This Land;" "Rhumba" *; "Jingle 6" *; "How Strange" *; "Straight Line Forward;" "Jingle 9" (referred to as "Jingle 10" on the LP), "Pinheads On The Move (Reprise)"

04/08/87 SB participates in a *Clinic Music* concert at Beursschouwburg, Brussels, with Benjamin Lew, Ninove, Catherine Jonio, Daniel Schell & Karo

Page 293

04/11/87 BLR plays at Beursschouwburg, Brussels

04/17/87 BLR plays in Amsterdam

clearly hear it…" [38]

Obviously choices had to be made with the result that unreleased or rare tracks as remarkable as "Crash," "Shelved Dreams" and the *Urban Leisure* suite were omitted from the selection. [39] Even stranger was the fact that the later CD release discarded pieces such as "Rhythm Loop," a track quite representative of Tuxedomoon's pre Belfer period and "Rhumba" that Blaine Reininger had mentioned as one of his favorites for that period. [40] Still, as it is, this compilation stands not only as a living testimony of the band's *débuts* but also as a precious document about the San Francisco (post) punk scene.

The already quoted *Radio 21* interview was interesting not only for the retrospective glance that Brown and Reininger cast on early Tuxedomoon but also as further evidence that neither of them was then contemplating the continuation of the band. *Morceaux choisis…*
When you first arrived in Europe, was it to stay on for good?
Steven Brown: "Not really…"
What did you think of living in Europe at the beginning?
Blaine Reininger: "It was very strange…"
Steven Brown: "When we first got to Europe, we were young and much living by the day. So I was not thinking of going back to the US or staying here. At the time no one considered returning to the USA."
Blaine Reininger: "And now that I'm in my thirties, wouldn't it be time to think of some sort of security?"
Steven Brown: "What security? My mother recently asked me: "Steven, what are you going to do when you'll turn 40?" I don't know, *maman*, no social security for musicians…"
Blaine Reininger: "We are strangers, always, even in our country we are now strangers…"
No feeling of exile then?
Steven Brown: "Not really…"
Blaine Reininger: "As far as I'm concerned, I'm a romantic. A bit like these Americans who came to Europe to write and create after the first world war. I feel closer to these Americans than to today's Yuppies…"
When asked to talk about their future projects, Brown and Reininger mainly expanded on their solo ventures.
Blaine Reininger: "I do have a life outside of Tuxedomoon."
Steven Brown: "So do I. We all do have a lot to do outside of Tuxedomoon…"

05/01/87 SB co-organize and participates (with PP, LvL, Benjamin Lew, Patrick Miller and others) in the *Andy Warhol's Workers Party Day* at Résidence Palace, Brussels

05/87 PP (on track 1) and LvL (on tracks 2 & 3) guest on Minimal Man (Patrick Miller)'s following tracks (Anything But Studios, Brussels, prod.: Patrick Miller & Ludo Camberlin): 1. "I Can Tell;" 2. "Her Heart Is Alone;" 3. "Christine Says." All tracks appear on Minimal Man's *Mock*

May 1st, 1987 Andy Warhol's Workers Party Day at Brussels's Résidence palace. On May Day, Steven Brown brought his legendary penchant for throwing parties to a new level, celebrating both International Workers' Day and Andy Warhol (who had recently passed away on February

Page 294

22nd) at Brussels Art Deco jewel Résidence Palace building. The event is still remembered by Brussels's partygoers and was the result of a collaboration between Brown, theater playwright Nancy Guilmain (who originally got the idea), visual artist Stephen Sack, Antoine Pickels, Benjamin Lew and others. As far as the musical part of this party was concerned, Brown, Principle, van Lieshout, Lew and designer/musician/ performer Patrick Miller (*aka* Minimal Man) [41], an old friend from the San Francisco days, were involved.

Benjamin Lew: "It was truly extravagant. We had called up the people from Campbell and they had sent us 3,000 cans of soup. And there were performances in every room, and films projected. That was really a great success. Steven is very much into parties. He likes to get involved putting some together a lot. His birthdays have been memorable, often. In that way he's a real queen, it has a lot to do with his festive gay side…"

Steven Brown's private journals contain the following entry about the event: '*Andy Warhol workers party, May 1, 1987.* Résidence Palace. Well it happened three days ago now and I'm still descending. It was magical (…) I stood at the *entrée* and watched these people flood in and dutifully paying their two hundred franks. One of the handsomest crowds I've ever seen. The whole thing started as an idea for a super eight party among friends and then Andy Warhol died and then 520 people paid, over two hundred guests…'

Steven Brown's next solo recordings: *Searching For Contact* and *Brown plays Tenco*.

In June, Brown released perhaps his most underrated solo album, *Searching For Contact*, in which he took his idea to make music for non-existent films to its most accomplished form.

Steven Brown: "In that album, I tried to make a film for the ears, an audio film with dialogue, music, effects. We had tried something similar in *You*, Tuxedomoon's last album, with the track "Boxman." "Boxman" was the equivalent of a cartoon, set in music. I always found it interesting to work on albums as if they were films. It is something that reminds me of the radio in the older days." [42]

Some of Brown's very best solo compositions, such as "This Land," "In Praise Of Money" and "Last Rendez-Vous" can be found on this album.

During the summer of the same year, Brown spent some time in Italy where he got the idea to record an album of covers of Italian singer/cult figure Luigi Tenco.

Brown: 'One lazy summer in Italia with time on my hands and feeling nostalgic about a period I never even knew, that is the sixties in Italia, I asked Velia Papa (ex Italian agent for Tuxedomoon and *directora* of Polverigi Festival)

Honeymoon 12" released by PIAS in 1987 and on the *Hunger Is All She Has Ever Known* LP/CD released by PIAS in 1988

05/10/87 BLR plays at Glasshaus, Bad Salzuflen (Germany). BLR then played in Hamburg (Markthalle) and probably in Bremen (Schlachthof)

05/17/05 BLR plays at Luxor, Cologne

06/87 Release by PIAS of SB's *Searching For Contact* LP/CD (recorded at Anything But Studios, 1987, prod.: SB & Luc Tytgat, with Marcia Barcellos, Samy Birnbach, IG, Terry Trondheim, Nikolas Klau guesting) including the following tracks: 1. "Habit;" 2. "Audiences + Stages;" 3. "Doe's Day;" 4. "In Praise Of Money;" 5. "Manner Of Means;" 6. "This Land;" 7. "Scene 1: The Street;" 8. "Scene 2: The Bar-Last Rendez-Vous;" 9. "Scene 3: The Ship;" 10. "De Hamburger Veermaster;" 11. "Voxcon 1." This album was re-released by LTM in 2004 with following bonus tracks: "Gone With the Winds;" "Am I Home Yet?;" "Besides All That;" "A Gift;" "A Spirit Ditty;" "Tori;" "Last Rendez-Vous" 7" edit

Marcia Barcellos: "I improvised a few lines on Steven's album and he was happy with the result. On the day of the recording Steven was getting ready or sort of and so he rolled up an enormous joint. Smoking dope is not something that dancers usually do outside of festive periods. I took a drag of it and it was so strong that I fainted. Steven was a little surprised. He got me some water and asked me if I was all right. I just felt great! We did record and he loved it: "You sound just like Billie Holiday!" I was beyond caring…

After this, the guy from Play It Again Sam wanted me to record something in the style of Niagara, a French pop group that represented

Page 295

all that I and Karl (Biscuit), my partner, hated and, besides, I had my own project with Karl to be released on Crammed Discs, but that never came to fruition. Maybe Steven had talked highly about me to this guy from PIAS and might have taken offence with my refusal. Also Steven contacted me a few times later for concerts he had in Paris during which he had to sing the song that we had made together but then I had other commitments and could not attend. So we gradually drifted apart. At one point he wanted to make a recording of Italian songs with me but that didn't work out. At the same time, it's difficult to have an artistic association with Steven as he's such a solitary being himself. He has such a tremendous charisma but he's so elusive at the same time…"

Summer 1987 (excerpts from Steven BROWN's private journals). 'Tonite after dinner at Festa di l'Unita, Mirco says Lounge Lizards are playing in Firenze. We end up driving there vowing not to pay to get in … I just want to see Evan – a bit apprehensive on the way I finally resign self sure Giampiero has record stand at door we get in for last LL number – see Evan exchange addresses talk about nothing in particular he's pretty potted hanging out with big bearded American guy… Roberto Benigni walking around – see John briefly they show *Down By Law*. A roadside cocomero bar sells cold slices of perfectly ripened sweet and delicious watermelon deftly served up iced by energetic waiter. All around scattered tables of watermelon or cantaloupe eaters. It's late most eaters are male 20's on up to grey haired gentleman in fashionably unfashionable black jacket working on a slice of… I asked Eno what *New Age* music was in his opinion. He said above all it represented a new way of listening to music that today people were willing to listen to music that goes on for 20 minutes with no text or rhythm or any pretense at being a song. He said it was even possible to interest producers in such music I said

to recommend some singers/songwriters from that period. She pointed me to Gino Paoli and Luigi Tenco. I liked Paoli but really went for Tenco's sound and legend. His melancholy songs stood out from the majority of the commercial Italian fare in go go girl 60s. Then I thought: "Well, why not sing his songs... in Italian!" Of course Tenco's suicide adds a certain resonance to his melancholy *répertoire…*'

Indeed Tenco's story had everything that appealed Steven Brown's dark romanticism. In the sixties, the promising young Luigi Tenco wrote the song "Ciao Amore" for Dalida, an Egyptian/Italian/French singer and actress. They fell in love and announced that they were both going to present "Ciao Amore" at the 1967 San Remo festival song contest. They didn't win the contest, as the song's somewhat socially engaged lyrics did not fit in the easy listening love song format usually appraised in such festival. Tenco, extremely dismayed and allegedly under the effect of various substances committed suicide in his San Remo hotel room. Shortly after Tenco's suicide, Dalida in turn attempted to take her life and remained for a while between life and death. Eventually she carried on with a long career that lead her through all trends of French pop and *chanson* until well into the eighties. In May 1987, she committed suicide for good at age 54, leaving just this note : "Forgive me but life is unbearable to me." Nowadays Dalida has become an extremely popular figure in the gay community.

Recorded mostly in Italian in Brussels and Florence, with the help from some Minox musicians (a band earlier produced by Brown) and Nikolas Klau, the *Brown Plays Tenco* mini LP compiles the legendary "Ciao Amore" track along with a few other Tenco classics. It was released in April 1988 by Italian independent label *Industrie Discografiche Lacerba* that was a joint venture between Paolo Cesaretti and Minox's Mirco Magnani and Marco Monfardini. [43]

In the Summer of 1988, while Reininger was touring Germany with rock act Montana Blue, Brown embarked on a memorable Italian tour with his *Brown Plays Tenco* material, his band including Luc van Lieshout (trumpet), Nikolas Klau (bass guitar and synths) and Belgian musician/composer Marc Lerchs (piano). Lerchs is better known in French *chanson* for having "discovered" singer Lara Fabian, even getting Brown involved as guest musician on her first recording in 1986. He has delighted memories of their agitated *dolce vita* lifestyle on that tour. He also dissected everyone's way of working with a great sense of humor.

"When I met Steven in the eighties I played at a piano bar to pay up for my studies, says Lerchs. I believe that what he thought to be interesting about me was that I couldn't play in

Page 296

the sense that I never learned and was playing the piano by the ear. He was not looking for someone with an academic or music school background. So I learned all of Tenco's tunes by listening to the recording and we all rehearsed in my basement in Brussels.

Then we left for that tour. As a side note, when *Brown Plays Tenco* was released, it was a great success in Italy: it had been broadcast on the RAI and had been # 1 in hit-parades for a while. [44] That was why the audience that came to attend the Tenco shows turned out to be quite a mix. What we got was a mix of drug addicts, hyper cool underground fellows wearing leather jackets and shades and… a fair bunch of Fellinian Italian *mammas*. The latters came obviously attracted by the poster mentioning Tenco and were bringing along their kids and baskets or tupperwares full of sandwiches and eggplant fritters that they would generously give around, feeding the drug addicts/hypercools in the passing. And this kind of atmosphere would grow in intensity the further we went down South. The venues were not very big, of a 200 to 500 people capacity, but they were always packed.

Steven was smart: these were *plays Tenco* shows but half of the numbers on the set were *his* songs. The backing tracks were very elaborate, they sounded a bit like the soundtrack to Fassbinder's *Querelle De Brest*. [45] Then came "The Prize Of Money," "Egypt"… all played acoustic-style… We played in Bassano del Grappa (near Venice), Grado (close to the border with Yugoslavia), Bari, Rome, Milan, Sienna, Messina...

For that tour we had chosen to travel by train with just the sax and accordion with us so that they wouldn't get stolen, while all the rest of the equipment was being transported separately by truck. So we would arrive at a train station and there would be like ten to 20 young boys/girls waiting for us with their tiny *fiat* cars. They would respectfully ask if they could carry the saxophone or the accordion. We had requested to be hosted in family *pensione* rather than in anonymous luxury hotels. We wanted to have a small car available for us to move around when we wanted. All of our demands were scrupulously satisfied, well a little less the further we went down South but that was all right.

So we would be brought to these charming *pensione* around noon. Sometimes one of the fans would say: "Well my mum cooked you some lunch!" So we would all get to an usually modest apartment and we would find ourselves there with the whole family (father, grand-father, brothers…) at the table. Then the courses would come up one after another and there seemed to be no end to this banquet. The mother and the daughters would serve us, sometimes stroking some musician's hair when passing by. Then we were back at the hotel. We were tired so we would make a nap until four in

what is the difference between this and music of say Debussy or Satie before – also 20 minutes of seamless music… The difference is we sort of agreed is that one is being done today. The music was coming out of little car stereo Bose speakers tucked into bushes Andrew Logan had a big Cosmic Egg mirror sculptor and not so big Excalibur sword coming out of the pond. Pegasus was there the same shimmering sculpture I had filmed on super 8 7 or 8 eight years before in Logan's studio loft over London. Rome botanical gardens where I did solo show on the hill sharing bill with Terry Riley.

It was a Sunday night we were going back to Casa Chiara after some hrs preceding twilite at Villa Borgese. Pincio the view was called. Anyway no stores open so we have to stop at a bar I ask what wines they have the cashier goes to cooler pulls out a Gioioso its 6000Lit. I ask if there's anything cheaper he looks, another waiter looks in earnest…No, Gioioso is the cheapest and looks good finally this kind soul charges me 5500 invece.

di 6.

32 years in line per prenotazione at Roma Termini beautiful dark young latins I guess SA they after ticket to Madrid the male scowling in harmless sexy macho shield/ standing so close no turf problems/ eventually as our destination (ticket window) approaches they break into smiles joking about other mid aged Bourg. Latins N starts talking to an american boy we both clocked as marine vaguely concealed contempt as he asks, hearing he is going to Frankfurt, if he is in the army.

So the Madonna is a rehash of fertility goddess and the baby gesu is every baby – Correggio painting of baby G reaching out in wonder for outstretched finger captures *the look* of baby. The whole cavalcade of baby jesus imagery is all a racial or instinctual self gratification process…celebration of this wonder – an infant. Quello che voi siete noi eravamo Quello che noi siamo voi sarete. Come from the 4 winds o breath and breathe upon these slain that they may live. Ez.

37,9
What Use, Cage, Last Rendevous,
B-sides, Lowlands Egypt This Land
R.W.F. Gift Mi sono innamorato,
Vedrai Lontano…'

06/87 BLR records (Daylight, Brussels,
prod.: GM & BLR) a remix and an instrumental
version of the track "Rolf & Florian Go
Hawaiian." Both tracks will compose a Normal/
Crépuscule 7" released in 12/87 and the first
track will be featured on a Les Disques Du
Crépuscule *Rolf & Florian Go Hawaiian (Remix)*
12" released in 12/87

06/02/87 BLR plays at La Cigale,
Paris (with Passion Fodder), *Soirée Les Euro-
Américains* as part of a *Rock-Création Festival*

the afternoon.

Then the little *fiat* would take us all to the venue. We'd soundcheck and then Steven would appear, usually gloomy as that was part of his personal movie. He'd come up on stage and at that moment everyone was afraid of him. Nobody would interrupt him and everyone would neatly take one's position on stage. He would snappily say the title of a piece, talking Italian, very concentrated on his acting out as he had totally embodied Tenco in some way. So we would be starting out playing a piece, he would stop us with some imperious gesture and we would play it again from the start. Sometimes he would make us play it again five or ten or 15 times. At one point he would hear what he wanted to hear, stopped us again abruptly in the middle of the song and we would move on to the next track. Obviously he had his own mysterious logic about those things that we all respected and no one would have dared to play one more single note than what he requested.

I must say that I had kept some bad habits from my piano bar playing. I liked the right pedal a lot and had a tendency to add more flourishes than necessary by the ending of the songs. Then Steven would bark: "Nicht so schmalz!" in German. Of course that meant I was being too syrupy and I believe I must have heard that one at least 20 times while Klau was chuckling from his corner of the stage. Then I learned. The most important thing I learned from Steven is that you should not strike too many notes but every note you strike you have to definitely go for it. On the other hand I was very good in harmony and took pleasure in organizing acrobatic dissonances that drove Luc van Lieshout crazy. I was playing by the ear, so every concert was slightly different whereas Luc was as precise as a Swiss clock.

But Luc's hardest time was with Klau. Niko held a bass guitar and constantly had a seraphic smile on. He was a presence on stage. He was like a sublime Christmas tree and would look at the people in the audience, very seductive. He'd catch a string, whichever he could reach, would pinch it and there would come a note - bong! - that would surprise everyone, him included. And he was happy, would smile like a kid, delighted that he had been capable to generate such an unexpected note. And I would see Luc's furious gaze behind him, trying to make up for it, staring at me like if I was his life jacket: "Try not to get away from the thing too much so that I could manage!" Then if I'd have hit a wrong key myself on that precise moment, he'd desperately blow into his trumpet, look at Steven to realize that he was like floating around on his little cloud, carried away on the stage, and find out that things weren't so bad after all. It was like that on stage. It was a fantastic game, and a very happy one.

After the concert, about half of the audience came backstage since that was the organizing committee plus boyfriends and girlfriends. Then the mammas were gone, but lots of the hypercools were left.

In Messina it ended up into something like: "Oh my friend Gabriela's father is the wealthiest alcohol merchant in Sicily. They have a palace up on the hills above Messina's harbor. We threw a little party for you!" Every night we ended up in parties where about half of the audience was waiting for us and would greet us with standing ovations and then a whole night of drinking followed. I remember that in Messina the girl Gabriela had had a piano set up and cushions spread on the palace's terrace. We had come with the accordion, sax and trumpet and Niko was "singing" the notes that he should have been playing on the bass – that sounded amazingly right then – and we ended up playing the whole concert again, without mike and just acoustic with the audience lounging around on the cushions. Then Gabriela's father unexpectedly showed up at four in the morning, threw everybody out and sent Gabriela to her room (that kind of incident happened once or twice). So the next morning – we had slept no more than one or two hours – we'd drag ourselves to the train station, some of us with a very bad hangover, and move on to the next city and start it all over again."

Tuxedomoon's 10th Anniversary meal; the Reunion Tour. Meanwhile, we left Tuxedomoon at the point when they released the *Pinheads On The Move* compilation album, in April 1987. Apparently Reininger had been moved to tears by the flood of nostalgia unleashed while listening to a rough edit of the *Pinheads* project. [46] Consequently, when Steven Brown put together a *Tuxedomoon 10th Anniversary birthday meal*, on June 14th 1987, Reininger proposed a reunion tour to mark these ten years of existence. However, rather than a "reunion" in the true sense of the word, it was rather thought of as a *farewell* tour right from the start as Tuxedomoon ceased to be active for a long time after that adventure. [47]

Beyond romanticism, Reininger's decisive motive was of a financial nature and his at times overblown ego lead him to dictate his conditions to the rest of the band. Reininger: "That tour was sort of my idea. I think that at that time they had given up on Tuxedomoon too. I think that Peter said something like: "All we need now is for Blaine to come back" and that's precisely what happened. But that was also a strategy to get money. For me, my solo career was kind of reaching an impasse, which was of my own making to a certain extent. I was heavily into these pills at that time: I was a mess really. So I needed to do something, hence this idea of a "come back" struck me. That's primarily what we had for

06/14/87 Tuxedomoon's 10th Anniversary meal at SB's. It was then decided to organize a *Reunion Tour* after which an ending would be put to Tuxedomoon's story. BLR would be part of it but only pieces from before BLR quit the band would be performed.

Summer '87 SB tours in Italy with a band comprising IG, LvL and Nikolas Klau

08/03/87 BLR plays at Théâtre Romain, Fréjus (with musicians Leon Van Den Akker; Jan Pijnenburg and Luc Duerinck). The following tracks were recorded: 1. "Rolf & Florian Go Hawaiian;" 2. "Teenage Theatre;" 3. "Mystery And Confusion" to be featured on the *Rolf & Florian Go Hawaiian (Remix)* released by Les Disques Du Crépuscule in 12/87

08/22/87 BLR plays in Nieuwerkerken (Belgium), *Neurorock Festival*

09/87 PP (on track 1), SB (on track 2) and Michael Belfer (on track 1) guest on Minimal Man's following tracks (Anything But Studios, Brussels, prod.: Patrick Miller & Ludo Camberlin): 1. "Interviews;" 2. "Say." All tracks appear on Minimal Man's *Hunger Is All She Has Ever Known* album released by PIAS as a LP/CD in 1988

10/87 BG has a hit - "Poison" - in Germany with The Weathermen. During a tour in Germany, BG meets Paul Zahl in a hotel lobby, Zahl being then on tour with The Flamin' Groovies, and this at the moment when TM was trying to locate PZ to ask him to participate in the *Reunion Tour*. In November PZ arrives in Brussels after epic misadventures with The Flamin' Groovies

10/14/87 SB participates (with Niki Mono, Patrick Miller, Marco De Gueltzl and Patrick de Geetere) in a private viewing/*concert*

Page 299

dedicated to *Fuck Your Dreams This Is Heaven & Hiding In Dust*, a video installation dedicated to Syd Barrett and to Belgian beer (to take place from 10/14 till 10/21/87) at Espace Donguy/Apegac, Paris

11/01/87 BLR plays in Bonn, *Lovestyle Festival*

11/11/87 BLR & SB play at Archiduc, Brussels

11/26/87 BLR & SB play at Archiduc, Brussels

11/28/87 SB & friends play at Het Patronaat, Haarlem (Daniel Schell & Karo playing on the same night) as part of *Het Eigenwijdse Festival*

12/16/87 TM (with BLR & PZ) plays two concerts (one at 7:30 and one at 22:30 pm) at Pallas Theater, Athens. Set list includes: "Prelude;" "Allemande Bleu;" "Courante Marocaine;" "Egypt;" "Everything You Want;" "Nervous Guy;" "Volo Vivace;" "Litebulb Overkill;" "The Cage;" "59 To 1;" "Dark Companion;" "Desire;" "What Use?;" "No Tears;" "Italian Western;" "Pinheads On The Move;" "In Heaven." Nicholas Tryandafyllidis attended both gigs

12/19/87 BLR plays at Luxor, Cologne

12/87 SB returns to the USA for Xmas and meets WT to convince him to participate in the upcoming *Reunion Tour*. In San Francisco he also shoots images of Gregory Cruikshank as an emcee that will be projected on stage during the *Reunion Tour* and that later will appear in his *The Super-Eight Years With Tuxedomoon* short film

Blaine and Steven playing at Archiduc, Brussels, photo courtesy of Steven Brown

Page 300

sale on that tour: I came back. And I sort of laid down the law: "Ok we can't do any songs from after I left; we can't involve any of those people: no Luc van Lieshout, none of these tunes from *Holy Wars*, only stuff to do with me." I was enormously arrogant. And they were going to do some of my solo songs that were never on any Tuxedomoon record. Because I don't sing enough in this band. So that's what we proceeded to do…" Reininger also imposed his soundman, Luc Gerlo, and requested that his wife, JJ La Rue, would do the lights *in lieu* of Nina Shaw.

Since Peter Principle had come to Tuxedomoon's 10th Anniversary meal with a bottle of Champagne and a similar idea, plans were sealed on the spot and an agent was hired. However no immediate action followed and the various solo acts continued their course for a while. Also James Nice, already mentioned several times for his Tuxedomoon related releases and who then worked for *Les Disques Du Crépuscule* in Brussels, completed his short Tuxedomoon biography. It was published in English and in Italian by Nuovi Equilibri/Materiali Sonori in 1988 as a book/7" package containing the lyrics of Tuxedomoon's songs (also in English/Italian) and various sound documents many of which were compiled by James.

In the meantime the Reunion Tour project developed into a far grander outing than originally envisaged. The idea was now to put the classic lineup – Brown/Reininger/Principle/Tong/Geduldig – back together and this plan proved to be far more marketable than they had first imagined. Tong, back in San Francisco since 1985, remained to be convinced but optimism seemed to be prevailing as promotional flyers and posters were printed featuring Tong's face as a backdrop.

As a matter of fact, this idea of presenting a lineup as close as possible to the original San Francisco one was even brought a step further, by sheer chance. In October 1987, Bruce Geduldig, then touring in Germany with his Weathermen project, ran into someone in a hotel lobby who turned out to be… Paul Zahl, Tuxedomoon's original drummer. Since his time with Tuxedomoon more than eight years before, Zahl had played in SVT with former Jefferson Airplane Jack Casady and at that time was on tour with blues/rock/proto-punk act The Flamin' Groovies.

Bruce Geduldig: "I was in Cologne in a hotel and just ran into him. We didn't recognize each other at first but I recognized a West Coast accent and I knew that there was another band staying in the hotel. So I just started talking to him and then I realized after a couple of seconds that it was Paul! I said : "When you're done with your tour, come to Brussels and meet Blaine and stay for a while instead of going back to San Francisco!" Finally his band left him with no money in London,

so he didn't have that much choice…"

Paul Zahl's adventures since his time with Tuxedomoon had been quite a wandering story itself. "When SVT's singer Brian Marnell died that was the end of the band. I started another band but couldn't get a record deal and was getting nowhere. Around that time, in 83-84, I started to think: "I've got to get out of here…" The music scene was changing, the clubs were closing, everything was failing. I was hanging around, ended up taking speed, which was not a good thing for me as I already was a "speedy" person.

One day I went to visit my sister who lived in Spain and I started to think that I had to find a way to get to Europe. At one point I seized an opportunity and went to… Australia. I tried to stay there but it didn't work out. With Tuxedomoon it had been a complete black-out since they moved to Europe. I did not even know that they still existed.

Then I was just a member of The Flamin' Groovies. Several European tours were planned until one of these projects worked out. We went to London and continental Europe. The second to the last gig on this tour – that was a seven/eight weeks tour – was in Cologne. I had just come back from soundcheck, getting my keys at the front desk, when someone looked at me. It was Bruce. He had played there the day before with The Weathermen and I was to play there on this very night. Bruce told me that Tuxedomoon had been trying to find me for a while as they were planning a Reunion Tour.

The next day The Flamin' Groovies were playing Antwerp, from which I called Steven in Brussels. Then the Reunion Tour was thought to begin six to eight weeks later. I asked Steven if he could find me a place to stay until then. Brown said Ok but that he wasn't sure that he was going to be able to cover my living expenses during that period. I said: "No problem! I'm getting paid for the tour with the Flamin' Groovies tomorrow."

It turned out that I was a little too optimistic as two of The Flamin' Groovies stole all of the tour money and flew away, leaving me alone in London facing the band's creditors at the BBC recording studio. So I found myself on my own with just about 200-300 pounds in my pocket as the BBC people had pity on me and gave me the session money.

I spent two weeks sleeping on the floor of some vague acquaintance in London. I found a guy who accepted to drive me to Brussels with all my equipment in a van for the 50 pounds I had left. I had called Blaine who had given me his address.

We arrived in Brussels at three o'clock in the morning, got lost and had no map. I called up Blaine and he was completely out of it. We finally got there at four, unloaded the equipment

1988

Some time in '88 SB (on track 1) and BLR (on tracks 2 & 3) guest on Benjamin Lew's following tracks (Daylight, Brussels, prod.: Benjamin Lew & GM): 1. "Tori;" 2. "Partout Du Sable;" 3. "Qu'il Fasse Nuit" all featured on BL's *Nebka* LP/CD released as Crammed Discs's MTM vol. 17 in the Summer of 1988

Some time in '88 SB is commissioned (with LvL, Nikolas Klau and BLR guesting) by Claudia Skoda to provide music for a fashion show entitled *Dress eater – Dressed to thrill* organized for the occasion of *Berlin Kulturstadt E. 88*

Some time in '88 BLR guests on Montana Blue's LP entitled *Chained To An Elephant* released by Pinpoint, released in Spring '89. This LP contains a version of the track "Zeb & Lulu," written and composed by BLR that will be later featured on his *Songs From The Rain Palace* album, released in 1990

Some time in '88 Italian band Minox records a never released "ghost album" entitled *MondoMinox* involving BLR & LvL and mixed by GM

01/88 + 09/88 BLR records (at Daylight, Brussels, with PZ guesting) the following tracks: 1. "El Paso;" "Bay Bridge;" "El Paso (Remix)." Tracks 1 & 2 appear on the *El Paso* 7"/12"/CD released by Normal in 08/88. Track 3 appears on BLR's *Book Of Hours* LP/CD released by Les Disques Du Crépuscule in 04/89

Tuxedomoon's 10th Anniversary Reunion Tour (with SB, BLR, PP, BG, PZ):

Notes. Were also part of the traveling party: Jonas Van Espen (tour management + merchandise), Jeroen Van Beeck (sound engineer monitors), Luc Gerlo (sound engineer front), JJ Larue (light engineer). Also Antoine Pickels & Nancy Guilmain followed the band on this tour to film images that will later appear in Nancy Guilmain and Serge Simon's film entitled *Mythical Puzzle* (released in 12/90, prod. Wannabee, Brussels and included on the *Found Films* DVD forming part of Tuxedomoon's *77o7* 30th Anniversary box set released by Crammed Discs in 2007)

02/10/88 TM plays at Paradiso, Amsterdam

02/12/88 TM plays at Ancienne Belgique, Brussels

Paul Zahl: "We did that gig at the Ancienne Belgique, which was great in a lot of ways: the show was great and it was like rapturously received and also because I had been broke since what happened with the Flamin' Groovies. Whoever it was who was making the deals for TM had made a deal with the Ancienne Belgique that it was such and such and such amount of money, unless it'd sell out. If it'd sell out, it was such and such and such amount of money plus some percentage of the gate. The people at the Ancienne Belgique were sure that TM were has beens and that there would probably be 800 or 900 people. And it was as sold-out as you can get, which meant that we got a shit load of money, like a real barrel full of extra money. And after the gig, everybody was champagning and partying backstage… And thus everybody was buyant: this was just the start of the tour and we had many more gigs to go.."

Page 301

In an interview given to *Het Volk* newspaper, Bruce Geduldig stressed the difference between their earlier shows featuring mainly new pieces and the Reunion Tour where, according to Steven Brown, the band would play all the songs usually requested by the fans (L.G., "Tuxedomoon opnieuw samen", *Het volk*, 02/10/88). Journalist writing for *La Nouvelle Gazette* observed that the Ancienne Belgique show conveyed an impression of energy that contrasted with their earlier Lille show [*i.e. their Revisionaries gig of 03/15/85*] that had more to do with a visual and theatrical event than with a rock concert. Author considered that the use of a real drummer contributed to make the gig more powerful while Reininger pointed out that the songs had been shortened in order to make the show more compact and lively (A.B., "Le dixième anniversaire de Tuxedomoon", *La Nouvelle Gazette*, 02/19/88)

German part of the tour (with additional dates in Austria, Switzerland and France)

02/25/88 TM plays in Vienna

02/28/88 TM plays at Metropol, Berlin. Set list (the pieces weren't played in that exact order) includes: 1. "Everything You Want;" 2. "Dark Companion;" 3. "Courante Marocaine;" 4. "Litebulb Overkill;" 5. "Desire;" 6. "In The Name Of Talent (Italian Western Two);" 7. "Nervous Guy;" 8. "Pinheads On The Move;" 9. "Heaven"; 10. "Egypt;" 11. "The Cage;" 12. "59 To 1", 13. "What Use?;" 14. "No Tears." Tracks 1 to 9 are featured on the *Ten Years In One Night* Live compilation double LP released by Playboy PB in 09/89. Tracks 1/3-5/7-9 appear on the CD version of this album reeased by Playboy PB in 09/89. Tracks 1 to 9 appear on the Materiali Sonori double CD re-release of this album in 1998 Note: the date 02/26/88 indicated for this concert on the aforementioned releases is wrong

02/29/88 TM plays at Grosse Freiheit, Hamburg

03/01/88 TM plays at Zeche, Bochum

03/02/88 TM plays at Capitol, Mannheim

03/03/88 TM plays at Theaterfabrik, Munich

03/04/88 TM plays at Rote Fabrik, Zurich

03/06/88 TM plays at Longhorn, Stuttgart

03/08/88 TM plays at Elysée Montmartre, Paris (Jazz Butcher opening)

Belgian choreographer Thierry Smits: "It was a nice gig but I saw it as a reconstitution of what probably had been a great performance some ten years before and in that sense I found this approach to be a little bit weak. I recall that there was a girl in the audience who wouldn't stop yelling: "I want Winston!" and I remember that Blaine got angry. I thought of it as the sad ending of a group that had been really cult."

03/09/88 TM plays in Lille (uncertain)

Scandinavian part of the tour

03/13/88 Departure

03/14/88 Travel + check-in boat from Kiel to Oslo

03/15/88 Arrival Oslo + travel to Trondheim

03/16/88 TM plays at Studenter Samfunnet, Trondheim (Norway)

and climbed the few floors to Blaine's apartment with it. I slept on Blaine's couch for about three weeks until I got the apartment that had been Nina's apartment until she moved in with Ivan Georgiev. I was glad to leave Blaine's place as it was quite weird over there, lots of drinking and heroin abuse as well…

Bruce lived around the corner from my place, so we got together a lot and became very close friends. Life was very social: dinner at Bruce's on one night, dinner at Steven's the next day etc. It was all functioning very well and we were writing lots of music at the rehearsals and the rehearsals went smooth, as far as I could tell… So that's how I ended up being in Europe…"

Zahl hasn't left Europe since. Professionally, he collaborated with various Tuxedomoon members but then found it hard to find work in Belgium as Dutch or French-speaking musicians were systematically given priority whenever he would audition for a job. However he ended up playing with a Belgian band named The Gallery for a little while. Then Zahl met Belgian singer Cathérine Vanhoucke (from the band Flesh & Fell), fell in love and married her in 1989. Zahl currently resides with her and their two children in Oostende, a city on the Belgian North Sea Coast that reminds him a bit of his native San Francisco (it's also known to have been Marvin Gaye's last haven). Zahl still occasionally plays with local bands and set up his private home studio where he and Cathérine record their own music and eventually invite friends to come and work on their personal projects. [48]

In the end the Reunion Tour did not start until February 1988. Meanwhile and still without any firm commitment from Tong, Tuxedomoon flew to Athens in December for two successful shows that attracted over 3,500 people. Although the band had never played in Greece before, the vintage set received a rapturous reception. 'Geduldig's staging, writes James Nice, was simple yet effective, as was the band's straight-ahead musical performance. Where employed, the addition of live drums in place of the rhythm machine gave many of the songs a drive and power seldom previously displayed, and though the effect could occasionally be overpowering Zahl's presence gave a whole new dimension to a set that consisted, after all, of wholly familiar material. Brown and Principle played well and played cool and held the whole show together, while Reininger strutted around the stage with a variety of instruments, every inch the consummate showman.' [49] At Athens' Pallas theater, a 21-year old journalist for *Sound & Hi-Fi* magazine named Nicholas Triandafyllidis [50] attended both shows and for him it was the start of a deep fascination for Tuxedomoon and for Blaine Reininger in particular. Later, Triandafyllidis will work both with Reininger and Tuxedomoon

Page 302

as a film and documentary maker and will promote many Tuxedomoon and solo events in Greece through his Astra Show Vision and Sound production company. "What impressed me about Tuxedomoon, says Triandafyllidis, is that they could be a punk band and intellectuals at the same time, intellectuals on the road. They were cyber before one realized what cyber was about. What they represent is abandoning the US to rediscover themselves, an utopic, romantic vision of Europe. For me it was very inspiring in my own discovery of the world."

After the shows in Athens, Steven Brown flew back to the States for Christmas. He met Tong in San Francisco and apparently was given the assurance that he would fly over to join the tour in January. While on the West Coast, Brown also shot a humorous short film featuring Gregory Cruikshank as a presenter introducing the spectators to the various places were Tuxedomoon thrived back in their glorious days in San Francisco. This footage will later be projected on stage during the Reunion Tour and will be used as a basis for Brown's future short film entitled *The Super-Eight Years With Tuxedomoon*. However when the Reunion Tour proper got underway on February 10th in Amsterdam, followed by a sold-out date at Brussels' Ancienne Belgique on February 12th, Tong was not present. Although he had been issued with a ticket, he never caught the plane to come participate in the tour. Tong did return to Europe that year, in June, but only to film Patrick de Geetere's version of Marguerite Duras's famous novel *The Lover*, with Benjamin Lew providing soundtrack music for the movie. That project turned into a fiasco. Benjamin Lew: "That movie was produced by Canal plus but I believe it was never released as de Geetere had obtained the rights for free but then Jean-Jacques Annaud bought the rights from Duras to film his well-known version of the story. [51] So de Geetere learned after he had shot the movie featuring Winston in the lead role that he could not use Duras's words. So he called on a writer of his acquaintances to re-write something that sounded like a painful sub-Duras piece. I once had a cassette of rushes that I gave to a journalist to watch but I never saw it again." [52]

The Reunion Tour proved successful, with almost every gig selling out. However this tour carried the flavor of a 'bitter victory,' to paraphrase Belgian journalist Jean-Michel Mostaert, [53] as the band did not appear as a creative force on stage, solely playing older pieces whereas they always toured with new songs in the past. Furthermore Tong's defection occasionally caused angry reactions from audiences that somehow felt cheated by posters and flyers advertising Tong's presence on that tour. Journalist Viseux, reviewing their March 3rd gig in

03/17/88 TM plays at Sardine's, Oslo

03/18/88 TM plays at AF, Lund

03/19/88 TM plays at Vandvaerket, Copenhagen

A review: 'Talented means at art rock concert at Vandvaerket (…) The music and the visual means melt without friction into a higher entity that rather has the character of architecture or sculpture (…) Beautiful, graceful and effectively underplayed to a degree that transforms so much of the so-called art rock into a bombastic hopelessness (…) Blaine Reininger and Steven Brown on a constant cross cruise from A to Z, namely from Amon Duul to Zappa without conventional stops underway. In short, dazzling and gifted. But also perfectionistic and arbitrary (…)' (A. R. Jensen, "Brilliant somking moon", *Politiken*, 03/21/88, translated from Danish by Eiliv Konglevoll)

03/20/88 Travel back to Brussels

Italian part of the tour

03/22/88 Departure to Roma with coach

03/23/88 Travel

03/24/88 *DOC* TV show (Rai due) in Roma

03/25/88 TV Roma

03/26/88 TM plays in Guricia

03/27/88 TM plays in Guricia

03/28/88 TM plays at Palazzo Congressi, Bologna. A live version of "The Cage" was recorded to appear on the *Ten Years In One Night Live* compilation double LP/CD released by Playboy PB in 10/89 and re-released by Materiali Sonori in 1998

03/29/88 TM plays two gigs in Roma, *Geotenda Di Euritmia*

For Gino Castaldo, the theatrical aspect of the show does not bear the importance it had in their past shows, the music having taken the foreground. 'Tuxedomoon celebrate ten years of a work marked with an irreducible geographical as well as cultural nomadism.' ("Con i Tuxedomoon il rock è di nuovo musica 'colta'", *la Repubblica*, 03/31/88). Flaviano DE LUCA described the start of a Reunion Tour concert: images of a white cake with inscription "Tuxedomoon- X" with a narrator telling the story of the group's *débuts*. Then the musicians took the stage, playing a very rough version of "I Left My Heart In San Francisco." Tuxedomoon are vagabond gypsies made in USA (…) on a continual search for their cultural roots but enlarging their own horizons at the same time. Author mentions that Reininger ends the concert with a long vocal *divertimento* between rap and yodel then goes on: 'the group's musical frontiers have become non-seizable as the muezzin chants muddle into jazz references, classical harmonies and contemporaneous dissonances, traveling through this avant-garde dimension that forms the band's stylistic imprint' ("Una luna lunga dieci anni", *Il Manifesto*, 03/31/88). Reviewing the same gig, Alba Solaro qualified Tuxedomoon's music as the expression of a 'technological romanticism' ("Dieci anni da Tuxedomoon", *L'Unità*, 04/01/88)

Page 303

Steven Brown and Bruce Geduldig, Reunion Tour. Photo Hans-Peter Habicht

Snapshots from Venezia. 'Venezia. Today walked at Peggy Guggenheim's old house. On the way had a glass of *Fragolino* with Anita and Anne. After a long sun drenched walk in search of *il ghetto* up and down canals, crossing bridges three times, saw the same two *raggazini* in a *gondola*. Niko shoots time laps trip super eight. Then we walk to the *pizzeria* for the best *pizza* in Venezia. The best *pizza* in Venezia as Holly Johnson says in his autograph on the wall, where my own will soon be also. Out to an (...) apartment built right at and below the river, at the bank of a canal where Monica lives with a rabbit and a hamster and Bo, from Copenhagen, who knows Tuxedomoon only because he's the boyfriend of the girl that Luc sees every time we go there. Incredibly Monica has lived here four years. It is oppressively humid, floods often and has been declared uninhabitable. She must move. Before being an apartment, it was a boat garage...' (excerpt from STEVEN BROWN's private journals)

The "hot dinner after the show" clause. 'Any European musicians tour guide would have to inform bands touring Italy about the promoter fulfilling the "hot dinner after the show" clause. Invariably this adventure takes on mythological if not epic proportions. Just getting out of the venue is generally an odyssey of its own. Once on the road (even getting that far is a quantum leap forward) you will invariably get lost and after a substantial discussion by any native present in the car, you proceed to drive in what you will perceive to be circles but being new in town you will assume you are mistaken, then directions must be asked by passers by, one-way street signs are ignored, treacherously narrow street maneuvered and finally, after anywhere from one to three hours after the show, you will arrive at an immensely crowded restaurant and proceed to stand and wait for a table, then sit and wait for a waiter, then sit and wait some more for something you didn't order. Early on, you would have a faint suspicion that perhaps those who opted for immediately returning to the hotel were on a truer path... but the food IS great.' (excerpt from STEVEN BROWN's private journals)

04/88 Release of SB's *Brown Plays Tenco* mini LP by Industrie Discografiche Lacerba. This recording (made at Global Art System, Florence & Daylight, Brussels, prod.: SB & Daniele Biagini, with Daniele Biagini, Gabriele Gai, Nikolas Klau, PP, Alessandro Agostini, Luca Gai, Marco Monfardini, Mirco Magnani & Sergio Salaorni guesting) includes the (originally from Luigi

Munich for French newspaper *Libération*, humorously captured this atmosphere of disenchanted triumph:
'"Ver iz Winsdon?" A German fan bellows the question until Reininger would shut him up (...) It was obviously Blaine Reininger who was conducting the Orpheon. A peculiar fellow indeed! Willy Deville for the poxed glamour, Porthos for the musketeer goatee hanging out from a fat chin. Buffalo Bill in *The Greatest Show On Earth* version for the rest. And the muscle is still supple under the hotel mattress-ironed *zazou Sentier* suit (...) His range is the "big voice" but he's also a prankster. He's not a singer but the hell with it. Neither are we. For that matter, he's better when he grabs his electric violin, wedging it under his goatee, enjoying himself like crazy. There we get Mephisto, nasty, not at all Catherine Lara [54] like. The rest of the time he'd batter three synth keys, vigorous in the effort ("Bim! Bim! Bim!") or he'd grab a guitar that he'd play in a G-string fashion, like Elvis. And on with the music! (...)
As is often the case it was the drummer who made the effort to dress up in a rock style. Long hair hiding hamster-like cheeks, tight leather pants and Zapata boots: at a distance he looks like a young lady whereas from near he resembles Alfred Hitchcock with a Bon Jovi wig. Yet quite frustrating for him as Tuxedomoon's allusive *répertoire* often forces the guy to neglect his drums to stroke a manner of xylophone that he'd be brandishing around (...)
The bass player does not have that sort of problem, he's got the easy part. Excellent and grinning all along, holding a Spaten beer bottle in each hand between the pieces, this mature man who does not look like he's doing much accomplishes good work. It's he who knocks the nails in that hold the whole thing together.' [55]

The end of the Reunion Tour was particularly remarkable as it marked Tuxedomoon's first and to date only dates in Japan. In fact these dates were the result of Alain Lefebvre's efforts. [56] "I lived in Japan for three years, says Lefebvre, and I did all I could to have the Reunion Tour in Japan and they came to play four times in Tokyo. I battled for months to that aim. I then worked for a company called *Conversation* that was one of the biggest promoters of alternative events. There were not that many people who came for the first gig and everyone was quite worried. It was the end of the tour and they were quite tired

also. Then it got better every night and the last gig was as sold-out as could be. The gigs all took place in the same nice small venue that could host 500 to 600 people."

With the notable exception of Paul Zahl, Tuxedomoon's members are not very loquacious about the Reunion Tour. As a matter of fact the atmosphere between them was a bit peculiar, as Antoine Pickels and Nancy Guilmain – who followed the band on tour to shoot images that would later compose the *Mythical Puzzle* documentary [57] – were in a position to observe.

Nancy Guilmain: "I made this Tuxedomoon video entitled *Mythical Puzzle*. The band financed us in part, Antoine Pickels and I but it was difficult with them, not with Steven but with Peter and Blaine.
First they thought of asking Bruce to direct it but finally Bruce did not want to do it and proposed the work to us. I had some experience but was not a trained technician in the use of cameras like Bruce. So I hesitated a bit but then Bruce told me that I could use all of their pre-existing material and they had tons of it at Image Video in Brussels: images from concerts, rehearsals, video clips etc. Then Bruce told me that I would be allowed to film during the tour.
I suggested that Antoine would participate as he had won some super-8 prizes and had an aesthetic that was closer to theirs. Finally I asked that our project would be an independent one and not based on any of their pre-existing material. We got the idea to make four portraits. We chose one city per musician and we filmed the portraits in the selected cities. We decided not to conduct interviews and not to film the usual concert images. At any rate we didn't have the technical means to do things of the kind *and* make the portraits the way we wanted to film them.
Steven's portrait was set in Venice, based on Luchino Visconti's *Death In Venice*. Blaine's portrait was based on his relationship to dandyism. He was telling us about Oscar Wilde, when he went on his grave at Père Lachaise in Paris. Peter walks like a mad man, so we decided to follow him on an imaginary walk between Bilbao, Barcelona and Madrid. For Bruce, we did something based on his relationships to women and on Wim Wenders's *Wings Of Desire* as we filmed it in Berlin. We mixed the portraits with scenes filmed backstage in the dressing rooms and some little concert vignettes.
What we did was very European, not at all the kind of things that Bruce would do. So I believe that Blaine and Peter weren't happy at all with the final result. Maybe there was a misunderstanding because we were always clear about the nature of our project. So I was a bit disappointed that they would react like that. All in all we got about 600 euros from

Tenco) following tracks: 1. "Lontano, Lontano;" 2. "Un Giorno Dopo L'Altro;" 3. "Ciao Amore Ciao;" 4. "Vedrai Vedrai;" 5. "Mi Sono Innamorato Di Te." This LP was re-released as a CD by LTM in 2007 featuring the following bonus tracks recorded live in Italy on 07/08/88 (Festival Delle Colline, Florence): 6. "Lowlands Tone Poem;" 7. "Besides All That;" 8. "What Use?;" 9. "Vedrai Vedrai;" 10. "Egypt," and recorded live in Italy on 09/24/88 (Milanopoesia Festival, Milan): 11. "Intro;" 12. "What Use?/Lowlands Tone Poem;" 13. "Lontano, Lontano;" 14. "Un Giorno Dopo L'Altro;" 15. "R.W.F./Mi Sono Innamorato Di Te"

A review for *Brown Plays Tenco*:
'Between rocaille and velvet, the result is deliciously touching...' (L. Dieutre, "Steven Brown – Brown plays Tenco", *Les Inrockuptibles*, 10/88)

04/09/88 BRT (Belgian Dutch-speaking) radio show with BLR & SB, transmitted from the Fnac Forum in City 2 shopping mall, Brussels

Israel part of he tour

04/88 TM plays in Israel, including one gig at Cinerama, Tel Aviv on 04/16/88

Spanish part of the tour

05/02 or 03/88 TM plays in Madrid

05/04/88 TM plays in Bilbao

05/05/88 TM plays in Barcelona

05/21/88 BLR plays at Rex, Thessaloniki (with 3 musicians: bass, guitar, drums)

05/22/88 BLR plays at Rodon, Athens

05/28/88 SB & PP participate in a *Made To Measure* party at Grand Manège, Reims, as part of the *Festival Des Musiques De Traverses*

**Blaine Reininger, Reunion Tour.
Photo Hans-Peter Habicht**

06/88 WT is in France to shoot a version of Marguerite Duras's *L'amant* with Patrick de Geetere. Unfortunately Jean-Jacques Annaud acquired the rights on this work before de Geetere, so the film, entitled *Premier Sang*, was hastily re-written and the final result not a success

06/03/88 SB and PP + Saskia Lupini perform as part of a *Fait Sur Mesure Festival* (as announced on a Fnac flyer), the said festival featuring John Lurie, SB, PP and Benjamin Lew

06/18/88 TM plays in Umbertide (Italy)

Japanese part of the tour (Alain Lefebvre's initiative)

06/22/88 TM plays at Club Quattro, Parco Space, Tokyo

06/23/88 TM plays at Club Quattro, Parco Space, Tokyo

06/24/88 TM plays at Club Quattro, Parco Space, Tokyo

06/25/88 TM plays at Club Quattro, Parco Space, Tokyo

Tuxedomoon meeting Tokyo's mafia.
'Tokyo, some time, somewhere in Tokyo… Arrival, Monday, 5 p.m. local time, 20th of June. Fifteen hours of jet and little sleep. Teru meets us at the airport, driving us to Tokyo at sixty kilometers. I nod off into half willed dreams of erotic mythology. Less than thirty minutes after installing in hotel room, Sachiko calls Molavi. I go down to interview with radio in one of Parco buildings. Hideko is there at the TM fanclub and two representatives from Victor, crépuscule's licensee. After business, we all end up in a restaurant (…) At one point during dinner and drinks, Sachiko's partner informs me

Bruce Geduldig, Reunion Tour.
Photo Hans-Peter Habicht

Page 306

them to finance some of our costs. The rest was financed by a production company and the camera rentals by myself."
What was the atmosphere like on that tour? Especially between them?
It was very diverse. It depended on the places where they were. Antoine and I were both close to Steven. So if there was a room to share, we would share Steven's, we went to eat with him and, in Italy, we would see his friends. You can feel this closeness we had with him in the film. With Blaine and Peter there was more of a distance.
Between them the atmosphere was not very warm. Steven would know people in every city, so he would have people to go out with after the concerts whereas the others were rather staying at the bar with sulky faces. There were very tense moments and rather dreadful scenes but we weren't kamikazes and we often waited for them in the next city. True enough that Steven wasn't always easy to be around either, so it was heavy sometimes. Also at times they would be nice with us but at other times they seemed to ask themselves what we were doing there *again*. I believe that since Steven was aware of the peculiar relationship they had to money, he was not necessarily telling them when we were going to be there, so we sometimes came as a surprise. But there was never any reluctance on their part to be filmed and so the production company has hours and hours of after concert video footage. I did the editing alone with the help of Serge Simon as Antoine thought that it was better to have only one director at this stage because of the choices to be made."

Antoine Pickels: "I worked on Nancy Guilmain's film that she shot about the Reunion Tour. I worked on the scenario. I participated in the shooting and hence went along with them in Berlin, Paris, in Italy and we filmed in Venice and in Spain. The idea was that we would go with them in Japan but it wasn't financially feasible for them. I find the finished product to be rather modest but interesting.
However it wasn't such a great experience on a human level as it was a reunion of people who, for some of them at least, were going through very difficult phases in their lives and among whom existed some never resolved conflicts. In a way I understand why Winston never showed up. I remember of an evening at Anna Domino's when the tension between them reached an absolutely appalling level as the rough moments they had been through together would wipe out the respect and esteem that they had for each other.
Other than that it was a tour context with all that implies in terms of tiredness. Steven was psychologically going through a dark phase and had constant temper tantrums, really terrible. He'd disappear and nobody would know where. And it was getting worse and worse. Berlin was still Ok and then

some sort of decadence set in as the tour was progressing. Also, maybe was it related to the fact that they were together again and on tour, the dope was back – in Spain, in particular, everyone was into cocaine, very heavily – and alcohol also: Blaine who had quit drinking had a relapse while he was taking pills at the same time and so set himself in really dreadful states, his wife also…

Nancy was then very much into their myth and, for the scenario, we worked on the mythology of each character with references to cinema. And they did, indeed, correspond to their myth. Bruce was into that seductive relationship with all the women he would encounter, with his official mistresses and all the ones he would run into; Blaine was this romantic character, with this Fitzgerald side about him and JJ, drowning into alcohol; Peter was Don Quixote because he *is* a Don Quixote. The ideas we got finally corresponded quite well to what they really are. And Steven was this dark Wildian character of a slightly aging homosexual, an aesthete consuming gigolos, with a dark side about it: "In any manner, my life is over."

There was a pathetic side to all of this and there were good moments, also. I'd say that the real moments of tenderness and friendship were rare and the clash of personalities – at least as far as Blaine and Steven were concerned – had taken a dimension of it own. Also the group dimension was gone. Personally I found it a bit sad that they were playing only pieces that belonged to their past, so there was something funereal about it all. You got the feeling that all the artistic stakes were gone apart from the pleasure that they had playing together. I found the formation with Luc and Ivan much more alive. They were conforming to their myth to the point that it was as if that implied for them to return to the situation that they were in before they split, which translated into abuse of illicit substances and family crisis.

I don't know how it was before but I've always known Tuxedomoon carried by Steven: even when Winston was still there, Steven played the role of the leader. That was the case also on that Reunion Tour and he was the one who wanted this film to be done and he was the one who had made what was necessary for the Tuxedomoon project to live on. So I think it was tough for him, the way that this tour unfolded. He'd disappear, get drunk in an absolutely dreadful way, would not say a word for a day or else just

the other clients around us are members of the mafia. I look at one Japanese man and perhaps it's a part of suggestion but he looks like someone who's lived in fact… I think he could have killed a man, just by looking at his face. My friends tell me you can tell mafia by haircuts as well as jewelry, clothes etc.' (excerpt from STEVEN BROWN's private journals)

Tuxedomoon, Reunion Tour. Photo Hans-Peter Habicht

utter rumbling noises.

Also maybe that our mere presence, of Nancy and I, on that tour created tensions as well as frankly we were a bit acting like parasites as there were absolutely no means to work on that film. Nobody was willing to use any of the money made on that tour to finance it and we had no money on our own. So indeed we ate what they ate and we were traveling on the band's bus as often as we could. Maybe also the fact that we were filming encouraged some sort of theatricalization of their relationships..."

In Paul Zahl's opinion, Tuxedomoon at the time of the Reunion Tour was still viable musically and artistically but the band couldn't go on considering the clash of egos, particularly between Steven Brown and Blaine Reininger.

"The tour was booked in a bizarre way. It was just stretched out over an immense period of time. The set list was pretty much set in stone for the entire tour. Because Steven and Blaine were bickering like old ladies throughout the entire rehearsal period and tour, they could never agree to change anything in the set. I felt that we would have been way better off if they had been more flexible and we could have added new stuff that we were coming up with every day and changed the structure of the set. I always felt that the show would have been better served if it had started out "drums free" for the first third or so, which would have allowed them to play more material that didn't lend itself to "real drums," and allowed me to do "electronics" and whatnot like in the old days. But they were way too stubborn and always too busy fighting to listen to anybody's suggestions. Although Steven usually "won" the fights because Blaine was too fucked up to talk let alone make a sensible argument...

As it went on, we soundchecked every day, we jammed every day, the relationships were all pretty positive. There was none of the old kicking over the keyboard rags, smashing. You know there was this

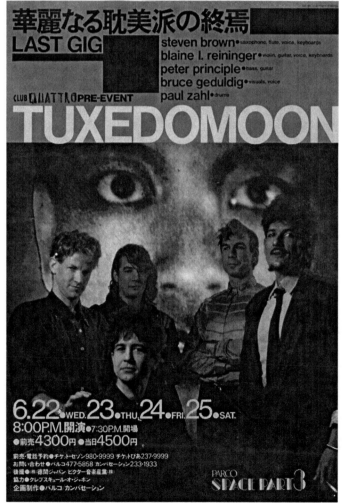

Flyer for the Reunion Tour in Japan

Blaine Reininger, Reunion Tour. Photo Hans-Peter Habicht

Steven Brown, Reunion Tour. Photo Hans-Peter Habicht

Spring/Summer 1988 SB and PP work (in Brussels, prod.: Joeboy) on new versions of "No Tears" for Crammed SSR (Sampler & Sans Reproche) sub-label, namely: 1. "No Tears 88 (Radio Mix);" 2. "No Tears 88 (Electronic Ghost Version);" 3. "No Tears 88 (Tearsapella);" 4. "No Tears 88 (Victims Of The Dub);" 5. "No Tears 88 (Bulb Guitar Overkill Mix);" 6. "No Tears 88 (Sheik Fawaz Club Mix)." The tracks will be mixed with assistance of New York DJ Mark Kamins and will compose the so-called Creatures Of The Night's *No Tears '88* 12" and CD released by Crammed's SSR sub-label in the summer of 1988

Summer '88 SB tours Italy as *Brown Plays Tenco* with LvL, Nikolas Klau, Belgian musician/composer Marc Lerchs (+ Nina Shaw doing the lights). The tour will include a performance at the *Milano Suono '88 Festival*, another concert in Milan on 09/25/88, performances in Bari (at an open air club), Bassano del Grappa, Grado, Roma, Sienna, Messina. The tour is a big success

Summer '88 BLR tours small clubs in Germany with Montana Blue. BLR guests on their *Zeb & Lulu* 12" ("H7" remix. William Lee Self: 'the name came about from the Stern magazine s+m article that just happened to be laying around the studio...') released by Pinpoint/Independent in 1989

Summer '88 PZ is fired from BLR's band and later tours the USA with The Weathermen (with BG)

Summer '88 Nuovi Equilibri/Materiali Sonori publish *Tuxedomoon*, a book of Tuxedomoon lyrics with historical notes by James Nice (then calling himself Neiss). The book comes with a 7" labeled as *Documento Sonoro Supplemento Al N. 2/1988 Di Stampa Alternativa*. A-side of said 7" features the live (at Ancienne Belgique, Brussels) version of "Michael's Theme" recorded on 04/03/86. B-side, entitled *Interview* , features: 1. an excerpt from James Nice's conversation with SB; 2. SB & BLR performing "Volo Vivace" in Brussels on 11/11/87; 3. BLR singing "Amore" live in Bologna in 04/84; 4. William S. Burroughs, "The do rights;" 5. PP & BLR radio interview, Brussels, 1980; 6. a WT interview (09/20/85)

07-08/88 BLR produces and guests on Séance's *Blue Dolphin Blue* LP/CD (Daylight, Brussels) released by 150 BPM in 1988

famous story of when Steven wrecked his clarinet around his keyboard, his priceless clarinet or his saxophone, bent the shit out of it, continued playing it bent to shit anyway. There was none of that temper tantrum stuff happening. There was still this occasional "who gets the last note on the song" thing going on but other than that it was great, discounting the late night drunken rages, Bruce doing wolfman and his drama of who he's in love with, the regular stuff. But the music part was, to me, going really really well, which is why I expected it to continue afterward…

When we got to the point of having almost an entire album with new material, I started to gently suggest that when the whole tour would be over, we should continue with Tuxedomoon. All three, Blaine, Steven and Peter were adamant: they had solo careers and they didn't need this anymore and this is just to put an end to Tuxedomoon, or at least brackets around Tuxedomoon. "We will not be working as Tuxedomoon ever again because we're all going to be successful in our solo careers: Peter will go into video production and Blaine and Steven will go into their separate solo thing…" And that was it. So I was sort of disappointed…

I always loved the music I did with Tuxedomoon. I always found that something magical happened when I was sitting between Blaine and Steven. I don't know why. It just happened. Even on the Reunion Tour the magical stuff happened a lot at soundchecks etc. But they were all in other mental places than me. And didn't want to do anything "serious" because of all their so-called "solo" careers. It all seemed strangely idiotic to me at the time because we were becoming this giant powerful musical thing that sounded wonderful and could conjure up the magic at will. The thing we had turned into at the end of the Reunion Tour was as powerful and magic as anything we had ever done. Sadly Blaine and Steven's EGOS just wouldn't fit in the same country at the same time. Too bad for the rest of us. Once again Tuxedomoon managed to snatch defeat from the jaws of victory. Pathetic…"

Tuxedomoon's second period had reached its end, the European one that strangely found its conclusion in… Japan. In the years to follow individual members slowly scattered themselves around the world before initiating a renaissance as Tuxedomoon.

Paul Zahl, Reunion Tour. Photo Hans-Peter Habicht

PART III: THE WORLD (1988 till present)

CHAPTER IX

From the eighties into the nineties (1988-1997) or Tuxedomoon's Dark Age

1988: in July, Peter Principle records his Tone Poems solo album; Blaine Reininger records his Book Of Hours solo album; Steven Brown records his Steven Brown Reads John Keats solo album and works on his Greenhouse Effect show

In July 1988, Peter Principle recorded what might be considered his most successful solo album to date: *Tone Poems*. The recording features some found sounds captured during one of his camping trips with Saskia Lupini to the Belgian Ardennes, a hilly region covered with forests and filled with legends, certainly the type of environment most appreciated by the mysterious and mystical Peter Principle.

The album was chiefly intended to be a soundtrack to Saskia Lupini's videos. Principle's stage performances at the time were actually shows by Principle and Lupini whereby each presented a sound/visual backdrop to the work of the other, "a film to listen to."[1]

Principle attempted to define the message of his music: "I would like to affect people like surrealism did. In surrealism an everyday element is always present (…) I use sounds from the quotidian that generally pass unnoticed. What I do is to bring them to the fore. It is transforming the benign into something important. That changes the face of the world!"[2] It was in that spirit that Principle/Lupini later (in 1989) incorporated the *Tovaritz* foundation, *i.e.* a production company for videos, films, photos, live performances and installations centered on esoteric themes. Principle: 'After the group [*Tuxedomoon*] officially broke up, I was still with Saskia and there were gigs for us to do. We got some grant money from Shell Oil and some Dutch governmental agencies and we were working on video art projects in Brussels and Rotterdam, some of which would make the international gallery circuit.'

Experimental, but very listenable as a psychedelic wandering of the mind, *Tone Poems* received laudatory reviews:

'Volume 18 in the series [*i.e. the Made To Measure series*] comes

07/88 PP records (at Daylight, Brussels, with LvL and Vincent Kenis guesting, prod.: PP) the following tracks (also based on pre-existing home recordings): 1. "Le Maka" (in three parts named "28 Day Snake," "Theme" and "Sgt. Rock In The Ardennes"); 2. "Sphinx;" 3. "Sub-lunar Folly;" 4. "The Observatory; 5. "Independence Day;" 6. "Pillar Of Salt;" 7. "Orval;" 8. "Orion's Shadow;" 9. "Dolphins;" 10. "Riding The Silver Chord," all featured on PP's *Tone Poems* album released by Crammed (MTM vol. 18) as a LP/CD in 01/89

About Tone Poems:

'(…) there's so much activity and hard-edged sound that they can hardly be called ambient or ethereal (…) Peter Principle's works have an air of surreal strangeness.' (Dean SUZUKI)

'*Tone poems* is sure to satisfy a thinking person's yen for an occasionally disturbing aural dream world.' (Steve HAHN)

Peter Principle: "I like to experiment without investing money into it. I'm afraid of big-budget productions because in a way it's too easy. That's what I liked the most when I joined Tuxedomoon: they were into electronic music without the gear of, say, Tangerine Dream. At this stage that is really experimenting!" (Peter Principle interviewed by A. AZZOUZ, *Spirit Of*, 06/89, translated from French) "I'm always working with sounds or strings of sounds which I interpret as sonic glyphs. My music is a kind of primal music, attained through primitive media or by primitive means, found objective music, assemblages, filtered through the nearest technologies (…) I'm also interested in working in a kind of mediumistic way in which I'm not specifically conscious of what I'm doing, but I'm counting on technology to document my improvisations so that I can later see what it was. Kind of like tape recording a trance (…) I have ideas similar to Scriabin [*i.e.*

Page 315

an early 20th century Russian composer known for his acquaintance with Theosophy] about music stimulating moods and I have studied some theories about musical glyphs and the like, as I am well aware that music is greatly a question of ratios and relationships, similar to architecture only on another plane.' (Peter Principle interviewed by N. MARTINSON, "Peter Principle", Proof, # 1, 1999, note: the interview was made in 1991)

Some time in '88 Paul Zahl quit Reininger's band to join Bruce Geduldig in The Weathermen with whom he accomplished a more than arduous tour of America in a transit van that nearly finished off the band

07/08/88 SB plays in Florence, Festival Delle Colline, with a quintet featuring some of the musicians who played on the Plays Tenco recording. The Brown Plays Tenco CD re-release by LTM (2007) features the following excerpts from this concert: 6. "Lowlands Tone Poem;" 7. "Besides All That;" 8. "What Use?;" 9. "Vedrai Vedrai;" 10. "Egypt"

09/88 BLR guests on Devine & Statton's following pieces (probably recorded at ICP, Brussels, prod.: Ian Devine): 1. "Friend Of The Family;" 2. "We Deserve It;" 3. "I Wish I Was;" 4. "You're Almost There;" 5. "Break Up Your Heart," all featured on the The Prince Of Wales LP/CD released by Les Disques Du Crépuscule in the Spring '89

BLR & Devine also toured together in Belgium and in The Netherlands

Fall '88 PP guests on the following tracks (recorded at Daylight, Brussels, prod.: GM, Samy Birnbach & Benjamin Lew): 1. "Pourquoi Que Je Vis;" 2. "Kommt;" 3. "An Upbraiding;" 4. "Men With Coats Trashing;" 5. "Response;" 6. "Mandorla," all tracks featured on Samy Birnbach/Benjamin Lew's LP/CD entitled When God Was Famous released by Crammed (MTM vol. 19) in 05/89

09/25/88 SB plays in Milan, Milanopoesia Festival (with Plays Tenco and TM pieces in his set list). The Brown Plays Tenco CD re-release by LTM (2007) features the following excerpts from this concert: 11. "Intro;" 12. "What Use?/Lowlands Tone Poem;" 13. "Lontano, Lontano;" 14. "Un Giorno Dopo L'Altro;" 15. "R.W.F./Mi Sono Innamorato Di Te"

From 11/88 till 02/89 BLR records (at Studio Square, Brussels, with SB, IG, LvL, PZ, Niki Mono, Eric Sleichim, Ian Devine, Iben Larssen & Jo Moens guesting, prod.: BLR) the following tracks: 1. "Zombie Pop;" 2. "Sainte Thérèse;" 3. "Letter From Home;" 4. "Software Pancake House;" 5. "Pavane;" 6. "To The Green Door;" 7. "Salad Days;" 8. "Come The Spring;" 9. "Marchand De Ferraille." All tracks appear on BLR's Book Of Hours LP/CD released by Les Disques Du Crépuscule in 04/89. Track 4 appears on the (various artists) Mmm Ahhh Ohhh cassette released by Les Disques Du Crépuscule in 09/89. The album was re-released in 2005 by LTM as Book Of Hours bis with the following bonus tracks: "Bay Bridge;" "El Paso" (7" mix); "Black Out;" "Cosy Little Planet;" "Burnsday"

About the track "Sainte Thérèse" on the Book Of Hours album: "This song could have been named "A Love Song For Brussels." I wrote that song while we were recording in a studio near place Sainte-Catherine. When the sun was finding its way through the clouds

from Peter Principle and is subtitled Tone Poems. Reputedly recorded in a tent between Russia and America, Tone Poems is an intoxicating mix of sound samples played off against each other with an irresistible rhythmic mix making it all the more effective (…) it's a sunburst that satisfies.' [3]

'Environmental in the guise of Brian Eno's ambient albums, Peter Principle's music is at times evocative of the landscapes sketched by David Sylvian in his instrumental works. With humor always latent, Principle succeeds in the tour de force of presenting music beautiful and useless at the same time, not taking himself seriously.' [4]

'(…) it's not some sort of simple muzak with linearity about it. It is, as its title suggests, sound poetry swarming within the space of imagination and meditation.' [5]

Blaine Reininger records his Book Of Hours solo album. As for Blaine Reininger, the second half of 1988 proved to be a busy one. First he collaborated on Devine & Statton's album, The Prince Of Wales [Alison Statton was one of the founding members of British post-punk act The Young Marble Giants]. Reininger and Ian Devine also toured together in Belgium and The Netherlands.

Then Blaine embarked on another adventure that was the recording of his next opus, Book Of Hours, assisted by Devine and a flock of Tuxedomoon members, namely Steven Brown, Luc van Lieshout, Ivan Georgiev and Paul Zahl. Niki Mono was also included in the cast. The album, originally published by Les Disques Du Crépuscule, was re-released by the LTM label in 2005. However and in spite (or maybe because?) of these many collaborations, the album is quite uneven and lacks of coherence.

Some reviews for Book Of Hours:

'Blaine Reininger's fourth studio solo album is one of the more so-so items in his considerable career – not quite as misdirected as the troubled Byzantium, but it's an album that most beyond hardcore fans could probably easily skip (…). It doesn't help that the opening track, "Zombie Bop," is little more than generic end-of-the-'80s bar band yupfunk (…) Thankfully, "Sainte Therese" is a distinct improvement, though still not ranking near his best, a ballad that calls to mind David Bowies's late-'80s dry gulch, and from there Book of Hours makes its hesitant way. To its strong credit there are moments where the experimentation with late-'80s state of the art turns out all right, suggesting a parallel course to the work of then label mate Anna Domino – the lush, moody arrangement of "Letter From Home," and the dreamy psychedelia meets late Japan of "To The Green Door" (…) Elsewhere, things are fair without always being involving, while "Come The Spring"

revisits the same follies of "Zombie Bop," making the album a bit of a flawed jewel. Slightly emblematic of the album's neither here nor there state would be the cover of Marty Robbins' classic "El Paso" – the song survives well enough, but it's delivered in a drowsy, narcotic fashion on the verses, which a more bravura turn on the choruses doesn't quite spike up. LTM's reissue once again shows that a little care never hurts – five bonus tracks make an appearance, including the two cuts from the previous year's "Bay Bridge" single, a late-'90s selection from a film soundtrack, and both sides of the 1997 "Cosy Little Planet"/"Burnsday" single.'[6]

'Reininger is a consummate *bricoleur*, and even though they are usually anchored to an electronic beat, his roma/jazz/cowboy/film-noir themes are rooted in mythical North America. It might almost be a drag act; Melville, Hemingway and Chandler rolled in to one. Perhaps the most important point of Reininger's work, though, is that it manages to be both humorous and beautiful at the same time; witness the wistful "Letter From Home" and the Zappa-like mania of "Software Pancake House" with its surreal lyrics and parping brass arrangements.'[7]

However J.-F. Ducrocq's review for French influential magazine *Les Inrockuptibles* was revealing of the fact that Reininger was probably never forgiven for having left Tuxedomoon: 'The after Tuxedomoon or the fear of the void. The Chicano crooner is in search of himself, groping around, hunting down his destiny after he grazed myth with his band. Minimalist attempts, obscure new wave, pallid techno-pop… Exploration or lack of personality? With the release of the miserable *Byzantium*, the man was taken off his pedestal (…) He's back today with this lame new wave recording that one gets firmly bored listening to. Sure one would always take some pleasure, listening to scarce reminiscences of the old days' talent. But Reininger is so much in love with his own voice that he dangerously self-parodies himself and spoils his own brew in the passing. He's certainly neither the first nor the last brilliant guy not to age well but it's just always so hard to get used to it…'[8]

The lyrics from the song "Letter From Home" stand as another poignant testimony to Reininger's favorite theme of expatriation/exile:

<div align="center">

Feels like a letter from home
God I miss the old place
Though I know it's changed
Will you still remember
the man I was ?
After all these years
After all these years

</div>

during breaks, I'd go sit at the terrace of a *café* and enjoy this little square where the city gets this delicious old Europe radiance. First I wanted to name this song "Sainte-Catherine" but then I thought of it being too obvious' (G. Van Den Troost, "België/U.S.A. Blaine L. Reininger", *Fabiola*, 07-08/89, translated from Dutch)

I call you on the phone
but it's not the same
Be sure to give my regards
to good-old what's-his-name
just like the man say
you can never go home
you can never go home
these crumbling snapshots
from a distant place
haunt me when those winter nights
stare me in the face
"when are you coming back ?"
I just don't know
I just don't know...

Steven Brown records his Steven Brown Reads John Keats solo album and works on his Greenhouse Effect show. From the end of 1988 until the first half of 1989, Brown worked on two projects, namely the *Steven Brown Reads John Keats* album and a show entitled *The Greenhouse Effect.*

The idea of having Steven Brown reciting verses from early 19th century English poet John Keats against a musical backdrop of his own making was not Brown's idea, but a commission from Belgian label Sub Rosa. Fronted by Guy-Marc Hinant & Frédéric Walheer, the label publishes anthologies of electronic music or *musique concrète*, avant-garde archives (Dadaists, Marchel Duchamp, William Burroughs…) and some traditional music (Inuit anthology, sacred music from Tibet etc.).

Steven Brown: "I didn't choose John Keats. Others chose him for me. The album was a deal with Sub Rosa. Until then, I didn't know of Keats. So, I bought his collected poems, read them, chose the pieces that I liked and made the album." [9]
"I only took fragments of poems that talked to me, recorded them several times, mixed them and… there it was! I worked on each poem in the manner of William Burroughs: I recorded, then cut the tape into pieces and put it back together in a *collage* of some sort. Keats has a very nice way to use words, a beautiful melody and frequently refers to extreme emotions like joy and regret. I recited part of the recording in Rome, on Keats's tomb [*Keats died of tuberculosis at age 25 and was buried in Rome, at the Protestant cemetery*] (…) the first time I recorded, I was tense and I did it quickly. I went back home only to realize that the whole tape was fucked-up. Just like if Keats, from his grave, would have told me: "Fuck you!" So the next day I did it again but then I was much more tranquil and concentrated, and everything came out fine. The master was happy." [10]

When asked about his affinities with the poet: "Yes, there are

From 12/88 till 01/89 SB records (at L'Echo Des Montagnes, Brussels + recordings made on John Keats's grave at acatolico (protestant) cemetery in Rome during the Summer '88, prod.: SB, Drem Bruinsma & Marc Lerchs) the following tracks: 1. "Ever Let The Fancy Roam;" 2. "Upon A Shore;" 3. "After Dark Vapours;" 4. "Song Of Opposites;" 5. "Fill For Me;" 6. "Amid The Wreck;" 7. "Arms Of Melody;" 8. "You Say You Love;" 9. "Writ In Water: The Japanese;" 10. "Writ In Water: The Warm South;" 11. "See, Here Is;" 12. "What The Trush Said;" 13. "The Purple West;" 14. "To Hope;" 15. "To Follow One's Nose;" 16. "More Happy Happy;" 17. "Those Cruel Twins;" 18. "Halo Of My Memory;" 19. "What Can I do;" 20. "A Spirit Ditty;" 21. "Bards Of Passion And Of Mirth." Tracks 1-19 constitute SB's *Steven Brown Reads John Keats* LP/CD released by Sub Rosa in 06/89. Track 20 is featured on Materiali Sonori's CD re-release (in 05/89) of SB's *Zoo Story* soundtrack album. Track 21appears on SB's 7" entitled *You Say You Love* released by Sub Rosa in 1989. The *Steven Brown Reads John Keats* album was re-released by Neo Acustica in 2006 including some remixes by Alike and Parks

Page 318

similarities. We probably have the same melancholic style. One of my favorite poems by Keats is "Solitary Heart" (...) A lot of his work is especially modern. It seems that the guys at Sub Rosa had a terrific idea, in the end.'[11]

Marc Lerchs, who produced the album along with Brown and then Tuxedomoon's pal artist Drem Bruinsma, recalls: "I had bought a multi-track tape recorder for my home studio and Steven was to read out Keats's poems and we would mix them with street noises and atmospheres of various kinds in order to compose musical interludes of a few seconds each. He had to make two-three voice tracks on each text. For instance, on one track he would say: "Bubble" and on the other track he would utter a "Bbbb" so that in the end one would get the impression to hear bubbles blowing up. He was like making music with words and it was magical as we were working together on the voices takes.
It took about four-five days of recording. I did not understand English very well and I was astonished that all that talking in a monochord tone was music, even without any clue of what the words meant. I think that that was the idea behind the *Steven Brown Reads John Keats* album. There was a text that in itself was music and the soloist instrument was a human voice reading Keats. So the *signifié* wins over the *signifiant*. The atmosphere was very contemplative. Steven was given a good mike, looked pensive and started out reading. We didn't talk much in the studio. We would rewind the tape, we'd listen to it and at some point he'd say: "Stop! Stop!" and we would wind back to where we would insert a second track. We mixed it all together and added sound effects etc. This album was made on four tracks and is a beautiful recording indeed.'

Soon after recording this album, Brown started to work on an ambitious new show entitled *Greenhouse Effect*, commissioned by the *Time Zones* music festival, which took place in Bari, Italy, on May 1st, 1989. [12] Steven Brown, in 2006: "I had just read about the so-called "Greenhouse Effect" in the news. It was "news" at that time, late 80s..."
As the show was to incorporate some of *Reads John Keats* material and since Brown thought that he didn't have such a great voice for reading out poetry, he decided to build an elaborate set with an emphasis on visual and theatrical elements. [13] Friend (and *Ghost Sonata* companion) film-maker Roberto Nanni was called on for help in bringing the show together with his images and cinematography.
Roberto Nanni: "The show was staged in Brussels during the first months of 1989. I remember that it was rather cold when I went there. I stayed at Steven's apartment at # 5, rue Longuevie, in the African neighborhood of Brussels. It was a

'LONGUE VIE BY THE SEA

I had just rented the apt on rue
Longue vie
and I dream I'm with you
looking it over
it's at the seaside now
and I keep discovering new rooms
it's much bigger than we had
originally thought
I find a bedroom on the second
level
with a ramp going down to the
backyard
by ocean and decide
to take it for my room
we/I am ecstatic
I awake at 7:15 a.m.
after 3 hrs of sleep
to be mildly disappointed by the
'reality' of the real Longue vie
in middle of Bruxelles'
Steven Brown, circa 1983

1989

Early '89 SB works with Roberto Nanni, LvL, IG, Drem Bruinsma & Luis Alvarez to set up his upcoming *Greenhouse Effect* show

Greenhouse Effect. 'The wind from nowhere, kept me trapped, appalled where I was picking up reverb shards of glass and roofing tiles whistling by the walk with difficulty down the street. At Paul [*Zahl*] and Cathérine's, the whole apartment shakes, like a long earthquake. Paul covers the windows. If there was only a way to use this as publicity for Greenhouse which is of course the cause of the whole scenario. Ski slopes green again in winter with ten degrees. Wind from nowhere. Keep thinking of the film *The Day The Earth Caught Fire*. Meanwhile Belgian TV news tells me how it will be easier to get license plates for the six thousands daily applicants as they will soon be using computers! Great! More cars, quicker! Meanwhile two persons are killed as a tree blows over their car on avenue Louise. Stupid racist little man with big gun hassling Algerian grocer from Dublin street for parking his van right in front of *chez moi* and *à côté* where they will build the garage… A *gendarme* shows up, probably 25 with stringy greasy hair in face, looks like a goon in a cop suit. Terry and me watch from the balcony. Terry yells: "He's only moving!" to the cop.' (excerpt from STEVEN BROWN'S private journals)

very nice apartment, very warm, filled with photos, postcards, lots of *souvenirs* from the Tuxedomoon era (…) I often saw Luc van Lieshout there as he was to be part of Steven's band for that show, along with Ivan Georgiev, Drem Bruinsma, Nina Shaw taking care of the lights and myself in charge of the cinematography.

I'm not sure why Steven called that show *Greenhouse Effect*. At that time he was obsessed with the warming-up of the climate and pollution. The link with Keats may reside in that his poetry appears like some "way of the world" through nature, not in some sort of illuminist way but in a rather mysterious and romantic fashion.

So I was invited to Brussels and I went there with some films I had previously made. The rehearsals with the musicians took place in the afternoon and I worked on the films in a little room aside from their rehearsal space. We used super-eight to film TV shots and then we reworked them. We did it all with practically no money. Even myself was very poor as I was not working at the time. The 72 mm film was a lot of work as the projections on stage were made on three different screens. We used a lot of little tricks that cost us nothing to achieve nice visual effects, like we once painted tree leaves in white and projected on them while they were in movement.

I was also involved into the organization of the tour as many of the gigs took place in Italy in 1989 and 1990. I remember that we left Brussels in a van containing me, Steven, Luc, Ivan, Nina, Drem and a performer/dancer named Luis Alvarez (in charge of theatrical performances, nicknamed "The Ghost" as he tended to disappear). Steven drove the van practically alone (as my driver's license had expired) on the two-day journey that took us to our first gig in Bari on May 1st, 1989. The show was very well received. Then we went to Prato, Longiano…

Later on, in 1990, we performed two shows in former Yugoslavia. I remember that these two gigs – in Zagreb and Varazdin – took place just when the war was starting there. In Varazdin – a beautiful town near the border with Hungary that was unfortunately devastated during the war – we played in a beautiful theater. We saw lots of soldiers and armed police passing by backstage to control us for drugs. But we eventually succeeded in scoring some from some traffic policeman, which was quite funny (…)"

The show was an anthology of Steven Brown's past works (*Music For Solo Piano, Zoo Story, Steven Brown Reads John Keats, Composés Pour Le Théâtre Et Le Cinéma*) and upcoming album (*Half Out*) delivered in shimmering atmospheres of light and images, in a constant interplay between Nanni's screens and the "actors" on stage. It was clever, visually brilliant, with some theatrical sketches sometimes a bit clumsy but usually touching inserted into it.

1989: Tuxedomoon's misfired attempts to come to life again; Steven Brown's various solo undertakings; Blaine Reininger & Steven Brown work together and release two albums: De Doute Et De Grâce (with Delphine Seyrig) and 1890-1990: One Hundred Years Of Music

'In January 1989, writes James Nice of LTM Recordings, Tuxedomoon again regrouped for a nostalgic show in Rotterdam [*on 01/31/89*] – and here the plot gets complicated. With Geduldig and Zahl on tour in America [*with the Weathermen*], Brown, Reininger and Principle were now reunited with Luc van Lieshout and Ivan Georgiev. Now latter-day songs such as "Atlantis," "Reedin' Rightin' Rhytmatic," "Some Guys," "Roman P" and "The Waltz" were worked into the set, alongside a sprinkling of Reininger solo numbers. The chemistry was successful enough to provoke serious consideration of a long-term reunion that would move beyond re-hashing former glories with new technology. However though the spirit was apparently willing the muse proved weaker. Several tentative rehearsals produced no new themes that the core trio hadn't exhausted several years before, and certainly the strongest sketch – known loosely as "I Was An Apple In The House Of Orange" [*released in 2001 on LTM's The Night Watch compilation CD*] – would not have sounded out of place on *Suite En Sous-Sol* way back in 1982. So for better or worse, the notion faded quietly away.' [14]

In fact, as the Reunion Tour had been a success, the release of a live album was the next logical step. Plans were made to record the set before an invited audience in a rehearsal studio shortly after the final Japanese part of the tour. [15] Unfortunately Zahl broke his collar bone the day after he returned from Japan and remained incapacitated for many weeks.

The next plan was to record the one-off show that Tuxedomoon performed on June 18th, 1989, in Umbertide, Italy, an event promoted by label Materiali Sonori and actually Tuxedomoon's last concert until 1997. However, for mysterious reasons, the recording that was made proved unreleasable.

Finally the *Ten Years In One Night* double live LP (later double CD) was released more than a year after the Reunion Tour mainly through James Nice's perseverance. Given that the band did not have an exclusive contract with Crammed, they realized that they could make more money – and their situation of financial need was then acute – by releasing the album through Nice. Indeed he offered them a reasonable cash advance and half of the profits made on the sales that approached 20,000 copies. As a matter of fact, Nice was

Some time in '89 Nuovi Equilibri/ Materiali Sonori publishes *Coast to coast: Punk/Rock images*, a book/7" package including a song by BLR ("Radio Ectoplasm") and a photograph of SB by Stefano Paolillo

Some time in '89 Release of BLR's *Expatriate Journals* compilation CD by Giant (USA), featuring the following tracks: 1. "Mystery And Confusion;" 2. "Un Café Au Lait For Mr XYZPTLK;" 3. "Birthday Song;" 4. "L'Entrée De L'Hiérophante;" 5. "Contempt;" 6. "Volo Vivace;" 7. "Rolf & Florian Go Hawaiian;" 8. "Teenage Theatre;" 9. "El Paso;" 10. "What use?"

A review for BLR's Expatriate Journals: 'That's both good and bad; good for obvious reasons (singularity of vision) and bad because Reininger's music is only marginally interesting (…) the best numbers are the mostly instrumental ones (…) Fans of Tuxedomoon's meandering grooviness will dig this, though in its own way, this is easier on the ear than anything from their *oeuvre* – and better for it.' (L. O. DEAN, "Blaine Reininger: Expatriate Journals", *Option USA*, 11-12/90)

Some time in '89 SB, BLR + French cult actress Delphine Seyrig record (at Daylight, Brussels & Vox Populi, Lyon, with Nikolas Klau, Walter Curias guesting + Patrick de Geetere & Cathy Wagner providing tapes) the following tracks: 1. "L'Arrivée Dans Le Jour;" 2. "Prunelles D'Ailleurs;" 3. "Souffle Coupé;" 4. "Golems Grisâtres;" 5. "Palais Ecaillés;" 6. "Comme Des Fruits Soyeux;" 7. "Aux Quatres Coins De La Vue;" 8. "Baghavad Song," all tracks featured on SB & Delphine Seyrig's *De Doute Et De Grâce* LP/CD released by Crammed (MTM vol. 22) on 04/23/90 (LP) and 05/90 (CD). This album is the soundtrack to a Patrick de Geetere film (Wonder Products). The words spoken by Delphine Seyrig against a musical backdrop by SB & BLR are excerpted from Carole Naggar's book entitled *La Cité Du Sang* (published by Pierre Fanlac)

Some time in '89 PP & Saskia Lupini incorporate the *Tovaritz* stichting (Dutch foundation) presented as 'a communications based collective exploring and working with the semiotics of the Holistic Paradigm.' In other words *Tovaritz*'s purposes are the production of videos, films, photos, live performances and installations centered on esoteric themes.

Some time in '89 PP (on all tracks) and LvL (on track 2) guest on Complot Bronswick (featuring Nikolaï Ada, Paolo C. Uccello, Tristan Marke, Teking O, GM, Michel Deloris, Anneli Drecker & Etienne Jesel; recorded at Daylight, Brussels & Studio du Val d'Orge, prod.: GM)'s following tracks: 1. "A Chaque Instant;" 2. "She Brings The Rain;" "A Kind Of Blue;" 4. "Ces Garçons Sauvages;" "Blue Sensation," all tracks featured on the *Au Bout Du Monde* CD released by MS, Spring 1990

01/89 Release of SB's *Composés Pour Le Théâtre Et Le Cinéma* LP/CD by Les Disques Du Crépuscule featuring the following tracks: 1. "Jean Gina B;" 2. "Voiture Jean Gina B;" 3. "The Harbour;" 4. "Cage Muzak;" 5. "The Garden;" 6.

"Piano Trilogy;" 7. "Life Gone By;" 8. "Cocktails;" 9. "Jean Gina B – (Finale);" 10. "Chinatown;" 11. "La Vie Est Belle;" 12. "Modern Times;" 13. "La Valise De Flora;" 14. "Sangemar Mar." Tracks 1-9 compose the soundtrack to Jean-Pol Ferbus's *Jean Gina B* film (recorded in 1983). "Chinatown" (adapted from the original theme by Jerry Goldsmith) was recorded in 1982 as an audio trailer for Roman Polanski's film. "La Vie Est Belle" & "Modern Times" were commissioned by Nancy Guilmain for theater pieces of the same name (recorded by Patrick Collari in 1987). "La Valise De Flora" was commissioned by Severine Vermeersch for her film of the same name in 1983 (recorded by Luc Debugher). "Sangemar Mar" was recorded by Nikolas Klau & Marc Lerchs for Belgian TV in 1988. The selection of titles was made by James Nice

01/31/89 Joeboy plays at Nitetown, Rotterdam, in a formation including SB, BLR, PP, LvL and IG. Tracks from the *Holy Wars* album were included in the set list. The gig was a success hence the thought to compose music together again. However the band then found itself short of inspiration and the only significant track from that period, "I Was An Apple In The House Of Orange" was later included on LTM's *The Night Watch* compilation CD released in 2001

02-03/89 PP (on tracks 1 & 2), BLR & PZ (on track 3) guest on the following tracks (recorded at Square, Brussels, prod.: Stéphane Kraemer): 1. "Soldiers On Acid;" 2. "In A Rush;" 3. "Dream Assassins," all tracks featured on Niki Mono's LP *Contradictions Are A Luxury* released by Antler, Summer 1989

02/16/89 SB plays at Melkweg, Amsterdam, with Dutch band A Modest Proposal. SB also gigged in Utrecht with the same band in 02/89

02/20&22/89 BLR guests on the recording (at Luxor, Cologne, 02/20 and at Kulturzentrum, Mayence, 02/22, prod.: Montana Blue) of Montana Blue's *Showcase Of Many Delites* CD (released by Pinpoint/EFA, 1989) including the following tracks: 1. "Foolish Man;" 2. "Backroad;" 3. "Trains;" 4. "Second Hand Rose;" 5. "For What It's Worth/Waiting For My Man;" 6. "Zeb & Lulu;" 7. "Wheels On Fire;" 8. "Thousands;" 9. "Texas (Motorcade)." Montana Blue's fine version of BLR's "Zeb & Lulu" released as a single scored a sizeable airplay hit. BLR toured small German halls with Montana Blue, a band led by BLR's longtime friend and fellow expatriate William Lee Self

03/89 SB, BLR, PP & BG collaborate to Nancy Guilmain's production of Sam Shepard's *Buried Child* play. Saskia Lupini also participated with the video *Buried child/Stage Prod. For S. Shepard Play,* 1989 (75 min.) and JJ La Rue worked on the lights

03/25/89 Performance by PP/Saskia Lupini somewhere in a Dutch-speaking area

04/04/89 First and only performance of Nancy Guilmain's production of Sam Shepard's *Buried Child* at Beursschouwburg, Brussels, involving the TM members mentioned above. Huge fiasco

04/21/89 BLR participates in Les Disques Du Crépuscule's *Le Beau Bruxell* showcase. NYC DJ Mark Kamins also present

05/01/89 SB plays at Auditorium Nino Rota, Bari, Italy, first of the *Greenhouse Effect* shows, as part of the *Time Zones '89, Sulla Via*

incredibly lucky as German fans miraculously appeared with a digital master tape of the Berlin Metropol show of February 28th, 1988, a tape that will constitute the main source for the double live album. Released as a double LP and single CD in September 1989, the album was re-released in the nineties by Italian label Materiali Sonori as a double CD, restoring the tracks that were dropped from the original CD version due to space restrictions.

In March 1989, Brown, Reininger, Principle and Geduldig, along with Saskia Lupini and JJ La Rue participated in Nancy Guilmain's next theatrical project, *Buried Child*, unfortunately with disastrous results.

Nancy Guilmain: "Before the *Buried Child* project, an adaptation of Sam Shepard's play of the same name, [16] I had mostly worked at home on self-financed projects [*with Steven Brown occasionally providing soundtrack music* [17]]. Since these "home" projects had been quite successful, I found myself in a position to seek some grant money. So I applied for my *Buried Child* project that slowly evolved into a mega project, which was something I had never done before and that implied a lot of production and post-production work etc., a lot of money in fact. The idea was to have Shephard's piece played by Tuxedomoon, namely by Steven Brown, Peter Principle, Blaine Reininger and Bruce Geduldig [*who also was in charge of the American actors' direction*], as miraculously everyone could be given a role in the cast [*with Saskia Lupini providing images and JJ La Rue in charge of the lights*]. [18]

I gave the play a twofold orientation. The play itself was acted in English. Besides, there was a simultaneous translation made by other actors into several languages. It was not so much a translation but rather the expression of Europe's way to look at the United States. Many people were involved, also on the second cast of "translators" that was a mix of local Dutch and French-speaking actors [*including Rudi Bekaert, now a renowned Belgian theater playwright and friend of Brown/Reininger*]. There was a TV screen displaying images typical of the way that we, Europeans, would look at Americans, from the man on the moon to Kennedy's assassination, with Marylin Monroe in the passing. Those images were Saskia Lupini's work.

Regrettably the people working on the financing of the project had staked everything on eventual co-productions with theater festivals. So they managed to finance just one public performance of the play that all the theatrical programmers were supposed to attend and be convinced to "buy" the project. But it turned out that programmers never go out of their way like that to attend "test" performances as they generally wait to see a finished product that's already been played, got some reviews etc. So the expected people

Page 322

didn't show up and there was just this one performance of *Buried Child* at the Beursschouwburg in Brussels on April fourth, 1989.

A lot was expected from a possible production made with the Brussels Flemish Kaai Theater. But, unfortunately, at the time I developed my project, my way to conceive it as multimedia with a twofold approach did not fit into the kind of aesthetic that was then prevailing in Flanders. My approach was sort of "cinematographic" in the guise of Jean-Luc Godard whereas the Flemish approach back then was more comics-like and more political at the same time. These people got unsettled by the simultaneous translation that kind of "covered" the American text that was not the central element for me. Also the "translation" was totally anarchist, took place in all languages at the same time and the translators would make their own comments and would get delirious about the meaning to be given to a sentence in this or that language, to the effect that the spectator would have to *choose* and build his/her strictly personal understanding of what happened on stage. It did not correspond to the Kaai Theater's vision at all and their answer was "neen."

So it ended up into a big fiasco. Personally I consider that this work was still unfinished but yet promising. The Beursschouwburg was packed on the day of this unique *Delle Musiche Possibili*, 6th *Festival Internazionale* (also featuring Caetano Veloso, Holger Czukay, Can & Arto Lindsay). With: LvL, IG, Drem Bruinsma, Nina Shaw, Roberto Nanni & Luis (The Ghost) Alvarez at theatrical prod., sound: Frankie Lievaart

Bari : Muses were with us... 'Guiding my fingers to the right notes. I was unconscious. They took over. Everyone raved except Pier Luigi. Of course is normal must listen to tape but God we did it and I expect it was a precious show. On the way to the hotel just before the show I learn Sergio Leone died two days ago and Morricone is not coming as planned but then later they say he's coming today. They've sent a car to Roma, he doesn't like flying. Leaving *il teatro* after the show, the *ragazzi* applaud as I pass...' (excerpt from STEVEN BROWN's private journals)

Lunch with Holger Czukay.
'Lunch with Frankie and Claudio and Holger Czukay, who said he had done three concerts in twelve years. I asked him if he had been doing a lot of recordings. He says: "Well, I'm very lazy. I like to sit on the beach and twiddle my thumbs and wait to die."' (excerpt from STEVEN BROWN's private journals)

From 05/25 till 06/02/89 SB (drawings), BLR (poetry reading), PP (sound installation), BG (drawings) + Saskia Lupini (photographs and videos), Al Martel

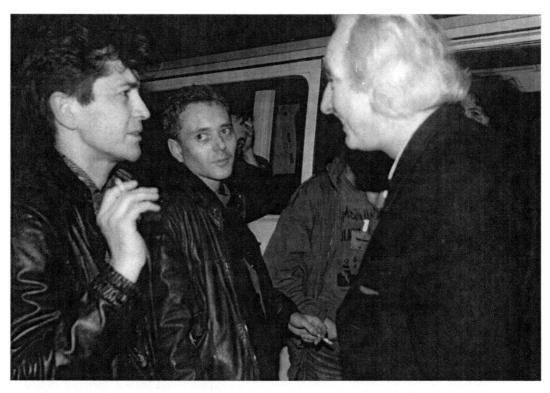

Steven Brown, Roberto Nanni & Holger Czukay, May 1989. Photo courtesy of Roberto Nanni

(sculptures) and others participate in *A Walk On Dinosaur Hill*, an artists' path (*parcours d'artistes*) curated by Nancy Guilmain at rue Vautier, rue Wiertz & rue Godechale, Brussels. PP's sound installation will later be featured on his *Conjunction* album (1990)

06/18/89 TM (with BLR, LvL and IG) plays at Teatro Tenda, Umbertide as part of the *Rockin' Umbria Festival* promoted by Materiali Sonori. Last TM concert until 1997

Summer '89 SB records (at L'Echo Des Montagnes, Brussels, prod.: Nikolas Klau & Walter Curias) the following tracks: 1. "Ebony Mix," 2. "Vaderland Mix," 3. "Drown Mix," all tracks featured on SB's *Love Yes* 12" released by Sub Rosa in 11/89

07/13/89 BLR plays at Villa Serena, Bologna

07/22/89 Both BLR and PP + Saskia Lupini play at Sala Boldini, Ferrara, as part of the *Bruxelles In Estate Festival* devoted to Les Disques Du Crépuscule and Crammed Discs, promoted by Arci Nova in collaboration with Materiali Sonori

07/26/89 SB plays a *Greenhouse Effect* show at Anfiteatro del Museo d'arte contemporanea Luigi Pecci, Prato. Set list: 1. "Intro," 2. "In The Still Of The Night" (from SB's upcoming *Half Out* album); 3. "Jean Gina B (Main Theme)" (from SB's *Composés Pour Le Théâtre Et Le Cinéma* album); 4. "Jerry's Theme," (from SB's soundtrack album *Zoo Story*); 5. "Chinatown" (from SB's *Composés Pour Le Théâtre Et Le Cinéma* album); 6. "La Vie Est Belle" (from SB's *Composés Pour Le Théâtre Et Le Cinéma* album); 7. "Out Of My Body" (from SB's upcoming *Half Out* album); 8. "Voodoo" (from SB's upcoming *Half Out* album); 9. "Arms Of Melody" (from SB's *Steven Brown Reads John Keats* album); 10. "You Say You Love" (from SB's *Steven Brown Reads John Keats* album); 11. "To Hope" (from SB's *Steven Brown Reads John Keats* album); 12. "Here It Is" (from SB's *Steven Brown Reads John Keats* album); 13. "And She Forgot" (from Drem Bruinsma's *Six Reels Of Joy* album); 14. "Piano # 1" (from SB's *Music For Solo Piano*'s album); 15. "The Waltz" (from SB's *Music For Solo Piano* album); 16. "Fanfare" (from SB's *Music For Solo Piano* album); 17. "Lowlands Tone Poem" (from Tuxedomoon's *Ship Of Fools* album); 18. "The Harbour" (from SB's *Composés Pour Le Théâtre Et Le Cinéma* album); 19. "You" (from Tuxedomoon's *You* album); 20. "Nite & Day (Hommage à Cole Porter)" (from Tuxedomoon's *No Tears* EP); 21. "The Thrill" (from SB's upcoming *Half Out* album), followed by two encores probably including some of Drem Bruinsma's compositions

The show is a huge success that will be followed by others in Longiano, Cagliari and two gigs in former Yugoslavia in 1990. Some of the gigs were filmed by Roberto Nanni

07/27/89 SB & LvL play with Italian band Cudù at Sala Boldini, Ferrara as part of the *Bruxelles In Estate Festival* devoted to Les Disques Du Crépuscule and Crammed Discs (see above)

09/89 Release of TM's *Ten Years In One Night* live compilation double LP and CD by Playboy PB., re-released as a double CD by Materiali Sonori in 1998. This album contains excerpts from concerts performed in Berlin (Metropol, Reunion Tour, 02/28/88, the main source for this recording), Eindhoven (1986), Bologna (1985 and 1988), Hamburg (1985), Amsterdam

performance but on an invitation sent to people from the business, not to journalists and critics and that was a mistake. If at least we would have gotten some reviews…"

As a matter of fact this project looked, at least on paper, as some sort of Dadaist statement, at least in its "translation" component, [19] and hence well acquainted with Tuxedomoon's references. Was the disaster of the production solely to be explained through this peculiarity of tiny Belgium to have within the same city, Brussels, two cultural communities, namely the French and the Flemish that eventually would adopt radically different aesthetical approaches? It would seem not to be the only explanation as a previous fiasco in which Guilmain took no part, namely *The Ghost Sonata*, might have exerted an influence on the professionals' mixed reactions, to say the least that followed *Buried Child*'s one-shot performance.

Nancy Guilmain: "I remember that there was a presentation of the project, based on some small video excerpts shot during rehearsals, at some theater fair in Ghent and there were some people from the Polverigi Theater Festival who seemed to be kind of shocked as the project did not look underground enough to their taste…"

Theater playwright Antoine Pickels, who also worked as an assistant on the *Buried Child* project, concurs: "There was a double discourse of some sort within the play that was very interesting but it probably was too baroque for the time. I do also believe that *The Ghost Sonata*/Polverigi experiment had been so catastrophic that things that could have been done on that side, in terms of using Bruce/Winston's previously toured circuit, were compromised from the start. Indeed theater is a small world that I know quite well and I'm pretty sure that there had been talks about this previous disaster."

Furthermore Guilmain does not seem to entertain fond memories of this collaboration: "Dragging along some of the Tuxedomoon members on this project proved tiresome. There was their peculiar relationship to money again ("When are we getting paid and how much?" "What happens if it does not get sold?" etc.) and very little time was devoted to talk about the aesthetics of this project. Bruce was happy to work on the direction of actors but didn't understand the project as a whole. In a way we were reproducing what was taking place in the play: there were the Americans on their side and the Europeans on the other side, everyone working in one's own little corner. We rehearsed separately and the first time when the two "factions" met, Blaine suddenly stopped playing, wondering where he was in the middle of all these people translating. However this twofold aspect was clearly stated in the story book, so I wonder if he ever took the pain

to read it (…)"

Pickels would find another part of the explanation for the *Buried Child* fiasco into some "failure syndrome" he saw at work within Tuxedomoon at that time: "What I also found a bit discouraging when working with them is that they were all into some sort of failure syndrome that they might have spread around them. It's always been hard for them to capitalize on the wonderful things they have done. Nancy's project was interesting and she was working with people whose music had been used by artists as famous as theater playwright Patrice Chéreau, film-maker Wim Wenders and choreographer Maurice Béjart, and she was working on reinforcing the band's image in a rather positive way. But there's always been such a great deal of self-destruction at work within each member of the band. I don't know if that was always there or was slowly built in, little by little, as things started not to happen as they should have. The only moment in their career when they could have capitalized a bit on what they were doing was when Martine Jawerbaum was managing them. But she found herself also sucked into it and started to frighten people off whereas, at the beginning, she had been an extremely dynamic, efficient and competent person. When she ceased to be there, things started to be managed in a somewhat erratic way. And many people would get fed up with the unevenness of people (…) And it is true that there was something of a black hole with them, a propensity to let oneself fall, to get into a logic of the kind: "It will never work anyway as we are doomed to fail." You can feel it in Blaine's lyrics: there's an unbelievable cynicism about them even if the discourse is instilled with a great deal of humor. People would start to get away from them as, in a certain way, they could have found themselves sucked into that strange dynamic as well."

Steven Brown's various solo undertakings. Discographically, Steven Brown was very active in 1989. First Brown released his *Composés Pour Le Théâtre Et Le Cinéma* LP – a collection of various soundtrack music tracks for films and theater pieces that Brown composed through the eighties – followed by the *Love Yes* EP.

For Brown, 1989 was also the year of a collaboration with a Dutch band named A Modest Proposal. Willem Schipper, a Tuxedomoon fan from the Netherlands, provides details about Steven Brown's collaboration with this band: 'A Modest Proposal came from Utrecht, Netherlands. They were four schoolmates who made a self-titled LP which clearly showed Tuxedomoon influences. Upon hearing this great LP, the local community, in an act of unparalleled generosity, gave them

(1985), Tokyo (Reunion Tour, 06/25/88)

Some time in '89 SB meets 19-year old dancer Lucius Romeo-Fromm in NYC (through mutual friend Carlos Hernandez) at Patrick Miller's house in Harlem

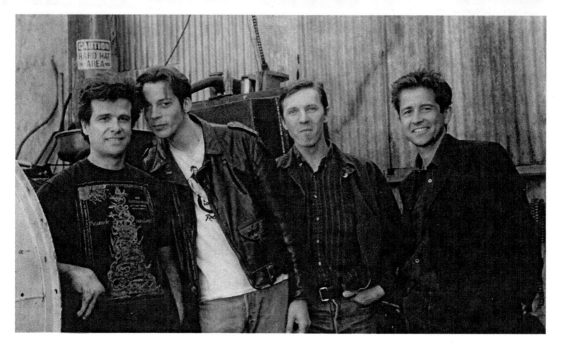

A reunion in San Francisco, 1989. From left to right: Mark Pauline, Patrick Roques, Michael Belfer and Steven Brown. Photo Lamar St John, courtesy of Steven Brown

a grant to work with a guest musician of their choice. Being huge Tuxedomoon *aficionados*, they called Steven Brown who came over and did two shows with them, in Utrecht and Amsterdam (in February 1989). It's a true collaboration between Steven Brown and A Modest Proposal, with some pieces conceived by the full line-up but also including "Roman P" and a wonderful version of "The Bar," featuring A Modest Proposal singer Nicolet Theunissen on the female vocals part. Steven stuck around long enough to contribute some stuff for their second album, *Contact*, an ambitious if somewhat unfocused undertaking with half a dozen of truly brilliant tracks. But also two versions of a lame song which is best described as a failed attempt at jazz. The album was probably too ambitious. "Miccacuicatl" is one of the best songs from that collaboration.'

Nicolet Theunissen: '"Miccacuicatl" is an original poem in Aztecs. I found it when I followed a course at the University in Middle American Religions. We had a piece of music that seemed somewhat mystical and ancient. So I used the poem for the lyrics, in combination with a translation into English. At first (A Modest Proposal's) Ton Coolen did the part Steven did on the CD. But we thought that it would be better with a native English speaker and so asked Steven.' Seen in retrospect "Miccacuicatl" bears a strange prophetic resonance for Steven Brown as he would leave Europe to live in Mexico a few years later.

Willem Schipper: 'I remember seeing A Modest Proposal perform in bars around town in an acoustic setup, trying in vain to be louder than the bar's patrons' half-drunken conversations, with me sitting through the whole thing trying to restrain myself from shouting "Shut up you morons!"

This acoustic setup was actually much better suited to the music and also very much reminiscent of Brown/Reininger's performances.'

Also in 1989, Steven Brown met 19-year old dancer Lucius Romeo-Fromm in New York City. This personal encounter also contributed to the creation of an artistic project in which Brown and Reininger were involved, along with Brown's friend Anouk Adrien. This project was Patrick de Geetere's film centered on Andy Warhol's legendary Factory. The title – *Les Contaminations* – of this 60-minute film (released in 1992) refers to the influences exerted by this universe on some artists who will be considered as spiritual heirs of the Factory "family." The film features interviews with John Cale, Sterling Morrison, film-makers Jonas Mekas and Paul Morrissey, video-maker Nam June Paik, Factory photographer Billy Name, James Chance, dancer Lucius Romeo-Fromm and his friend Carlos Hernandez, Steven Brown and Blaine Reininger. Brown and Reininger can also be seen performing together and Brown sings his song "Decade" alone at the piano.

Lucius Romeo-Fromm: "I was born in Milwaukee, Wisconsin, in 1970. I grew up in Tennessee, studied at North-Carolina's school of the arts as a ballet major and I arrived in New York City in 1988. I was 18 years old and very poor. When I moved there, dance became sort of secondary as I was discovering NYC and also because of the fact that I had to work if I wanted to stay alive. So the ballet myth, of dancing-dancing-dancing and then of going straight to the top into a big company or living in an institution was not the case for me. I started working for a punk salon that was doing hair extensions and colors.

I had met people through friends and that was sort of how

Returning "home": Steven Brown and Patrick Roques at the House on 3645 Market str., S.F., in 1989 (the house no longer exists). Photo Lamar St John, courtesy of Steven Brown

I was making a living for a while. Life was deciding for me. What became a real interesting thing for me at that point was that I wanted to be a FREAK. In American culture and in NYC at that time, the term classes you as anybody surviving in a non-existent world, just sort of colorful in the dark. I was a young homosexual who was totally curious and totally into this scene that was sort of creeping up into my life and I just kind of took it and ran with it.

I met Steven Brown through my good friend Carlos Hernandez, who was actually an old buddy of Steven. There was also this heroin culture that was happening for me and he was very much involved with that. So through Carlos, I stumbled upon Steven Brown in 1989 at Patrick Miller's [from Minimal Man] house in Harlem. Steven was just passing through, on a trip coming from Brussels. We hooked up there at Patrick's place and there was some sort of chemistry immediately and I was of course totally fascinated by what he was doing, where he was coming from.

Tuxedomoon was a thing that had just entered into my life and that I really enjoyed and appreciated. I thought: "God I missed it all!" All these people around who were from another generation were feeding me all this information about the past. Steven and I hit it off and we had a pleasant time together on that trip and then he was gone and I was still there on Avenue C and feeling like shit, doing extensions to pay my rent, to get my dope and I wasn't dancing and my studies were over. I wasn't even thinking of working with classical companies at that time. Steven and I kept contact and were exchanging letters, phone calls every now and then. Later on, like a year or six months later in the Spring, somebody called me home. It was Patrick de Geetere who told me: "I know who you are but you don't know who I am. We are making a film and it's about the retrospective of Andy Warhol and we want you to be involved." For me, it was such a wonderful situation. That was the first interest ever. That was the first job I ever had that I was actually doing what I'm here to do.

He and his partner at the time, Cathy Wagner, came over like within hours. They were working at the Kitchen, a theater space that hosted famous artists for probably over 30 years. There were some excerpts of John Cale's album and de Geetere wanted me to improvise while he would film. Anouk Adrien was there to be like my female counterpart. They just wanted a male and a female spirit to be around and throw in their interviews and editing. Steven was kind of there and not there at the same time.

That was the turning point. I was: "God, that's exactly what I want to do." It was the first time that I had met people who were able to give me an idea of what was possible. They wanted to hear what I had to say too and that was really

bizarre because I was 19. I was this trashed-out young boy on a lot of drugs who was feeling it hard. When they left and it was the biggest absence in my life and I was: "What am I doing here in the junk?" So I said to myself: "That's it and I'll do whatever I have to do to get to Europe." At that point, I kicked drugs off as much as possible and I managed to get a plane ticket to Brussels. I arrived in Brussels on September 12th, 1990. It was the King's birthday and Steven was: "It's the King's birthday and you're here and look it's just like it always is!" It was pouring down rain in Brussels.

Of course Brussels was like outer space for me but I was in love with Brussels immediately because it was so unlike anything that I had ever experienced: the trash on the street, the cobblestone, the African neighborhood in rue Longuevie… I believe that everything has a reason and already rue Longuevie [*Longue vie meaning long life in French*] meant a lot for me. I was around people who were doing what they wanted to do without anything sort of hanging over their head, like a million dollars of rent for instance. It was like freedom.

In maybe ten days, I was thrown into a situation when I was working with a choreographer, Thierry Smits. At that time, Thierry and Steven had just finished Thierry's first solo work that he had ever done [*namely La Grâce Du Tombeur to be dealt with later in this Chapter*]. Steven was doing all he could for me to meet people who were in the dance world. So I was like living happily ever after in no time at all. I was working and on the edge of life and enjoying it.

Steven and I had this chemistry and that fondness for each other. For me it wasn't some sort of physical lust situation. I was in awe of what he did and what he was about, also that he was a homosexual and he was a poet and a singer, that he had his demons that he was fighting… There was romance, definitely but I was loving the artist and the person and it didn't feel to me like some sort of typical situation. And Steven was falling madly in love and I was… not and it was really difficult. To me he was like an icon, some sort of figure that was meant to be there. It was pure. There are some people with whom you feel physical attraction but it was much more than that with him, I was showing with him what I had never shown before. It was like cracking open something that nobody had ever cracked open. He did this song called "Song for L" [*aka "Violorganni"*] which he was playing with Blaine at espace Senghor in Brussels (on 02/19/91) and I was taken to dance into Steven and Blaine's show. Things were getting complicated because it was becoming clear that I was going to settle my life here and I had been turned on all these things by Steven but I wasn't looking to become Steven's boyfriend.

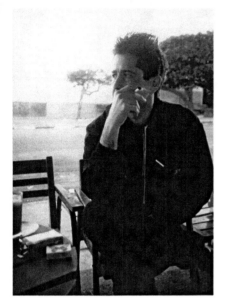

Steven Brown in Morocco, 1991, photographed by Lucius Romeo-Fromm

09/89 PP produces Sprung Aus Den Wolken's following track (recorded at CCAM Studio, Vandoeuvre-les-Nancy): "Rhythm & Mood" featured on the (various artists) *Out Of Nowhere Copulation* compilation CD released by Out Of Nowhere in 1990

Fall '89 SB plays a gig at Bassano del Grappa (Vicenza)

10/19/89 PP & Saskia Lupini present *Nazca* at Teatro Bucci, San Giovanni Valdarno, *Greetings '89 – Le possibilità Della Musica Festival* (also featuring Beau Geste, Where's The Beach & The Residents) promoted by Materiali Sonori

10/24/89 BLR plays at Elysée-Montmartre, Paris, as part of the *Les Inclassables De 7 A Paris Festival* (with In The Nursery et The Grief)

11/21/89 BLR & SB play at Teatro San Luis, Lisbon. The following tracks were recorded: 1. "Iberia;" 2. "Egypt;" 3. "The Fall;" 4. "L'Arrivée Dans Le Jour;" 5. "Music # 2;" 6. "Fanfare;" 7. "The Waltz;" 8. "Piano # 1;" 9. "Salad Variation;" 10. "Licorice Stick Ostinato;" 11. "Volo Vivace;" 12. "Litebulb Overkill;" 13. "Les Odalisques;" 14. "Souffle Coupé." These tracks constitute BLR & SB's *1890-1990: One Hundred Years Of Music* LP (tracks 1-5, 7-9, 11-14)/CD (tracks 1-12) released by Les Disques Du Crépuscule in 03/90 and re-released (all 14 tracks) as *100 Years Of Music: Live In Lisbon 1989* by LTM in 2005

12/19/89 BLR plays in Cologne

12/89 *Première* in Paris of Patrick de Geetere's film *De Doute Et De Grâce* (soundtrack by SB-BLR and Delphine Seyrig)

Steven and I went to Morocco right after Christmas that year. We had a good time. Neither of us had ever been to Morocco. It was super adventurous. We were robbed and cheated and abandoned in the Atlas mountains in the middle of the night of New Year's with a full moon and drunk as skunks and rolled and ruined. We learned a lot I guess but I remember telling him on the way to the plane: "Steven, when I get back, I'm going to live alone. I'm going to go and that I want to be very clear about and I want you to understand." And it was hard. It was not that there wasn't something very strong there but it was to avoid heartbreak or to deepen any sort of heartbreak..."

Blaine Reininger & Steven Brown work together and release two albums: De Doute Et De Grâce (with Delphine Seyrig) and 1890-1990: One Hundred Years Of Music. 1989 also saw Blaine Reininger & Steven Brown's collaboration take a new dimension as they started to record and tour together regularly until Brown left Europe for Mexico in 1993.

Their duo, mainly an acoustic one, was somewhat a departure from Tuxedomoon as perceived as an "electronic" venture.

Steven Brown: "It is true that Blaine and I have been following parallel paths since our separation from Tuxedomoon and that somehow we live some sort of bizarre continuation of the band by finding ourselves regularly working together." [20] "I suppose that Blaine and I must have a destiny in common." [21]

When asked why the duo Reininger/Brown was mainly acoustic whereas Tuxedomoon was known as an electronic combo, Brown's reply implied refusal to be labeled or trapped within a category. "It had started out in Japan in 1985, when the Japanese proposed that me and Blaine would perform together. [22] We enjoyed it a lot. Then nothing happened until Portugal asked us to do a similar performance [*on November 21st, 1989 at Teatro San Luis in Lisbon*] (...)" [23] "What we like is music, not the identifications or labels. After Tuxedomoon the idea was to make something more simple, more intimate, new. At first we didn't know how this would sound like. Acoustic music was something entirely new for Tuxedomoon's fans. But on the other hand I liked it that way as I only had to take care of my saxophone, not encumbering myself with a dozen of these shitty electronic boxes. It's very pleasant to be playing with Blaine or for a small number of people, making something new in this way. It looks like we had accomplished a full circle as Blaine left Tuxedomoon in 1983, I stayed until 1989 but at the beginning we were only two people: me and Blaine. 16 years later we are these two persons again: me and Blaine. We are very different from one another, we've been fighting constantly but it was in that way that something new always sprang up between us." [24]

Reininger himself described the music he then produced with Brown as quite inspired by Erik Satie and somehow close in spirit to what the duo started to compose back in 1977, when they were thinking of some sort of environmental music: "The classical music I make with Steven Brown is also very Satiesque (…) Lots of his ideas were ahead of his time like, for instance, his *musique d'ameublement* (…) The idea of music as a mere environment is very much praised nowadays, it was revolutionary back then. When he played his music and people would insist on listening to it, he would tell them to go on with their talking and not to take notice of his music, as if it was part of the furniture. Satie's influence on contemporary music is absolute over today's music and John Cage is one of those rare composers who fully understands his message (…)." [25]

The first recorded collaboration between Reininger and Brown was the soundtrack to Patrick de Geetere's film *De Doute Et De Grâce*, a project that saw French cult actress Delphine Seyrig deliver one of her very last works before she passed away in October 1990.
Patrick de Geetere: "In 1989, I was in Benares to shoot a film after Carole Naggar's magnificent book, *La Cité Du Sang* (*City Of Blood*). The film was called *De Doute Et De Grâce* and some text excerpted from *La Cité Du Sang* was read by Delphine Seyrig. My dream was to bring about an encounter between Delphine Seyrig and Steven. Well the encounter did not take place physically but I went to Brussels with the tapes of Delphine's voice recorded at Beaubourg in Paris. At Daylight Studio in Brussels, Steven and Blaine composed superb music to her voice and my images. The cherry on the cake was this duo between Delphine and Steven reading out extracts from the *Bhagavad-gita* practically *a capella*."
To paraphrase Dutch journalist Corné Evers, the magic of this album rested mainly on Delphine Seyrig's intriguing voice [26] to which Brown and Reininger provided a skilled accompaniment.
Strangely enough the album was credited to Steven Brown and Delphine Seyrig only, not to Blaine Reininger, the reason remaining unclear. "De Geetere told me that there was not enough room left on the cover to put my name!" Reininger commented.

Reininger/Brown's concert at Teatro San Luis in Lisbon formed the duo's first production proper. Entitled somewhat pompously but surely ironically *1890-1990: One Hundred Years Of Music*. It was released by Les Disques Du Crépuscule in March 1990. A mix of Tuxedomoon oldies, tracks from *The Ghost Sonata* and a series of recent compositions, the album was greeted as a successful enterprise:

'(…) the musical compositions of a classical limpidity are sufficiently convincing (…) I believe I'm not the only one to be thinking that the Tuxedomoon connection hadn't been *that* convincing in a long time.' [27]

'Under a pompous title (…) 12 very beautiful tracks of an extreme sobriety.' [28]

Later, in November 1990, Brown and Reininger used their *One Hundred Years Of Music* material, along with some original music, to provide a soundtrack to a ballet without a name featuring five female dancers and choreographed by Gaby Agis for her London based company, Gaby Agis & Company. Agis was then considered as 'one of the leading exponents of post-modern experimental dancing' who 'specializes in collaborative works that blur the conventional distinctions between dance, visual art and theater.' [29] Agis, in fact a gifted *dilettante*, started out working as a model before she founded her dance company in 1985. Interestingly enough, Agis always 'consciously fought against forging a style with which she can be typecast' [30] and worked with artists from various disciplines, including sculptors, painters, writers and composers including David Sylvian and Thomas Dolby. This transversal artistic approach is again reminiscent of Tuxedomoon and The Angels Of Light's Dadaist and multimedia approach. Brown and Reininger got the commission after Michel Duval (Les Disques Du Crépuscule's main man) had sent some tapes to Agis. [31] Agis: "Because they come from a rock background they still produce two and three-minute bursts of music. And that's pushed me into making lots of short dances that come together to make a whole" [32] "I haven't worked with live music since 1986; and theirs is incredibly haunting and emotional." [33]

The event would give Blaine and Steven the opportunity to meet again with an old pal, British journalist/writer John Gill but, other than that, did not leave lasting memories: "the music was great, says Reininger archly, but the ballet was pretty lame…"

1990

Some time in '90 SB's first collaboration with Italian choreographer/ theater playwright Julie Ann Anzilotti for *Horizon Of Dogs*

Some time in '90 Release by Sub Rosa of SB's compilation CD *Besides All That* featuring the following tracks: 1. "Besides All That;" 2. "A Gift;" 3. "Am I Home Yet?;" 4. "Gone With The Winds;" 5. "You Say You Love;" 6. "Weltschmerz;" 7. "Bards Of Passion And Of Mirth"

Some time in '90 PP co-produces Sprung Aus Den Wolken LP/CD *Round And Around* released by Les Disques Du Soleil Et De L'Acier in 1990

1990: Steven Brown works with Italian choreographer Julie Ann Anzilotti, Belgian choreographer Thierry Smits and releases his Besides All That compilation CD; Blaine Reininger releases his Songs From The Rain Palace album; Peter Principle releases his Conjunction album and returns to the USA

In addition to his work with Reininger, Brown continued on his personal artistic path as 1990 saw him starting to work with two choreographers: Italian Julie Ann Anzilotti and Belgian Thierry Smits.

Brown collaborated with Smits for just one work, that resulted in the release of the *La Grâce Du Tombeur* CD, the soundtrack to Smits' ballet of the same name, based on the myth of Icarus with Antoine Pickels also involved for dramaturgy.

Thierry Smits: "I got to meet Steven Brown through Antoine Pickels (…) We met regularly. Before then I knew the band Tuxedomoon as I saw them playing at the Plan K in the early eighties. For me this band was of the same caliber as Joy Division, mythical in many ways. After I studied at *Mudra*, Maurice Béjart's ballet school, I found myself working for the Plan K dance company in 1985. However I was a dancer for only a short while as I soon started to choreograph.

The creation of *La Grâce Du Tombeur* went like this: I was working at the Plan K in the cold, creating bits of material that we would film and give this footage for Steven to watch. So he worked a bit like for a film soundtrack, on the basis of what he saw. I was just a beginner in that career while he had this long artistic track behind him and his music was really really good, very elaborate, whereas my choreography was quite basic. And indeed I remember of some people's comments after the show: "Yeah, the *music* was *really* great!""

Brown's collaboration with choreographer/theater playwright Julie Ann Anzilotti, in contrast, was to be of a long-term nature, still ongoing.

Anzilotti: "I was born in Florence on January 19, 1956. I was raised in a family where culture was the main thing. I took a major in psychology and specialized in family therapy. I studied classical ballet since I was four years old and then I studied it professionally when I was 17. Then I quit for two years because I had a crisis with classical ballet and started modern dance. In 1978, by chance I started to work with a theater group and from 1979 on I never ceased to work for theater, first with a group called Magazini Criminali and then with a troupe I founded with other dancers and, since 1992, with the company I still have now, compagnia XE. I am currently a choreographer in residence at the teatro Niccolini in San Casciano near Florence.

My first encounter with Tuxedomoon was between 1979 and 1981. I was then traveling a lot with Magazini Criminali and saw Tuxedomoon perform somewhere in Europe. Also I had met Winston Tong and Bruce Geduldig as a theater company in Milan. I had all their records which I treasured.

I met Steven Brown personally in 1989. I was about to start working on a new piece called *Horizon Of Dogs* for the festival of Montalcino (1990). I had been rehearsing with music I could find and I noticed that the pieces of music made by Steven were the best ones for what I was doing. So I thought of asking him to join us in this festival to compose music for

01/90 Release of Materiali Sonori's *Itinerari Oltre Il Suono* CD/booklet containing *a.o.* contributions by SB & BLR ("Prunelles D'Ailleurs" *aka* "Souffle Coupé"); PP & Nazca ("Let's Call It A Day"); BG & Drem Bruinsma (for the not otherwise published "Turkish And American Blend"). Matson's booklet Sonora (01/90) contains a short story ("The Jewel") written by BLR

01/28, 02/04, 02/11, 02/18 & 02/25/90 SB presents classics of world cinema at the Mukalo (Ixelles, Brussels): *The Criminal* from Joseph Losey; *Giulietta Degli Spiriti* from Federico Fellini; *Fedora* from Billy Wilder; *Dr Jekyll & Mr Hyde* from Robert Mamoulian & *Vrouw Tussen Hond en Wolf* from André Delvaux

02/90 SB records (at L'Echo Des Montagnes, Brussels, with PP, PZ, LvL, IG, Nikolas Klau & Drem Bruinsma guesting) the soundtrack to Belgian choreographer Thierry Smits's ballet *La Grâce Du Tombeur* (dramaturgy by Antoine Pickels) featuring the following tracks: 1. "The Labyrinth;" 2. "The Flight;" 3. "The Fall," released by LTM in 03/90

A bird coming down and carrying them off. 'I did a music on *La Grâce Du Tombeur*, a ballet from Thierry Smits.
Nira, a black guy, next door friend of Dany met in Madagascar, and hearing "The Flight" from *Grâce Du Tombeur* for the first time, said it was very similar to an old folk song, nursery song his mother sang to babies to put them to sleep, about a bird coming down and carrying them off (…)' (excerpt from Steven Brown's private journals)

Upon Nelson Mandela's release. 'Monday, 12th February 1990. Yesterday Mandela was released from jail after 27 years. Photos of pure happiness as black people and kids and women dance in the streets. Such an incredible amount of energy from around the globe for years focused on this one man. In a way it's rather discouraging the balance of energy, all that expenditure for so many years for one man in one prison. Imagine if there were five Nelson Mandela, how much more energy would be needed. It's like using a nuclear reactor to start a camp fire. Still the world is changing, fast in the last six months and it's all generally good energy. Tomorrow at 8 a.m. go to work at the EEC video meeting…' (excerpt from Steven Brown's private journals)

Some time in '90 BLR guests on the track "In The Rain" featured on Devine & Statton's LP/CD *Cardiffians* released by Les Disques Du Crépuscule in 1990 and re-released by LTM in 2006

Some time in '90 BLR guests on Italian band Militia's *Dunarobba* LP/CD (recorded at Gas & Matson studios, Italy, prod.: Giampiero & Giancarlo Bigazzi) for the following tracks: 1. "Notturno;" 2. "D'Aria;" 3. "Dunarobba;" 4. "Ottoemezzo." Album released by Materiali Sonori in 1990

02/12/90 BLR plays in Verona, first of a series of concerts with Mary Kelly

02/14/90 BLR plays at Auditorium Flog, Florence, with Mary Kelly

02/17/90 BLR plays at Teatro Petrella, Longiano, with Mary Kelly, as part of *Il Terzo Orecchio Festival*

04/21/90 SB plays a *Greenhouse Effect* show at Teatro Petrella, Longiano, as part of

Page 333

Il Terzo Orecchio Festival. Set list: 1. "And She Forgot;" 2. "Interlude;" 3. "In The Still Of The Night;" 4. "You;" 5. "Chinatown;" 6. "You Say You Love;" 7. "To Hope;" 8. "Here It Is;" 9. "Piano # 1;" 10. "The Waltz;" 11. "The Ball;" 12. "Lowlands Tone Poem;" 13. "Shabazz" (from Drem Bruinsma's *Six Reels Of Joy* album); 14. "Out Of My Body;" 15. "La Vie Est Belle;" 16. "The Flight" (from SB's *La Grâce Du Tombeur* soundtrack album); 17. "Jerry's Theme;" 18. "The Thrill." Encores: 19. "Voodoo" probably followed by one of Drem Bruinsma's compositions and finally: 21. "Nite & Day (Hommage à Cole Porter)."

In 1990, SB will also present his *Greenhouse Effect* show in former Yugoslavia, in Zagreb and Varazdin

'Brussels to Zagreb. Leave Mortville [*i.e. the nickname given to Brussels by most members of the TM tribe*] 11:30 Thursday. Arrive in Zagreb 4:30 Friday: 17 hours on the road… In fact it's not so bad, due to us organizing three drivers: me, Drem and Guy [*Copain*], our new sound engineer. Two hours shifts, very smooth: even Ivan said it was a great system. Already near Austrian frontier, we stop at a *café* open at 2 a.m. and as indeed Ivan says it's a kind of a *Bagdad Café*. One guy, whom I instinctively dislike on first sight starts talking to me in Austrian and turns out to be a simple kind of down-to-earth guy with a tragic face right out of a Fassbinder film. Then, once in Yugoslavia it's really another world, sort of East Germany South of the border is my first impression. A bunch of guys sitting around in shirt sleeves I realize are the customs officers and the air is festive here with gipsy energy. Taxi guy with bass guitar jam into the back seat. Takes us to the hotel where we are told hotel has been changed and drive back where we had just been, the center to Hotel Panorama and there is a taximan parked in front of the hotel. Right on queue the soundtrack to *Time Of The Gypsies* comes on the radio in the taxi as we're accompanied by a huge electric lightning storm that continues for hours.' (excerpt from Steven Brown's private journals)

07/07/90 BLR & SB play in Bologna, Crevalcore

07/25/90 LvL plays in Empoli

09/12/90 US dancer Lucius Romeo-Fromm moves to Brussels

11-12/90 TM records the tracks "The Ghost Sonata;" "Music # 2;" "Cascade;" "Les Odalisques" and "An Unsigned Postcard" for *The Ghost Sonata* LP/CD released by LTM in 1991 and re-released by Crammed (Cramboy, 1997)

From 11/06 till 11/10/90 BLR & SB play for the dance group Gaby Agis & Company at the Place Theatre, London (presenting material from their *1890-1990: One Hundred Years Of Music* album + original material). Rock journalist/writer John Gill in attendance

11/22/90 BLR plays at Botanique, Brussels, as part of the *Botarock Festival*, in replacement of Anna Domino

12/90 Release of the *Mythical Puzzle*, Nancy Guilmain & Serge Simon's short film shot on the Reunion Tour (prod.: Wannabee). The film is included on the *Found Films* DVD, part of the *Unearthed* double CD/DVD included in TM's 30th Anniversary *77o7* box set released by Crammed Discs in 2007

Page 334

this piece and Nina Shaw was to take care of the lights. We met at a friend's house, costumes designer Loretta Mugnai's, in Florence where I had brought the video of the work I had done using some of his music to show him. He fell asleep after a little while, watching the video! But we had already decided that we were going to work together.

So we started and I would call him when I was working with the dancers and actress to explain what I was doing and he would listen but I had the feeling that he didn't understand very much what I was saying until like a week before he was going to come. I had this phone call and I told him the same thing as ever and he said : "Why didn't you tell me this before?? NOW, I understand…" Sincerely since I had always been telling him the same thing, I don't know what had touched him this time. He came over with a lot of music. He had so much material working on animals and it was very beautiful. He played some pieces live and this was the first time we worked together.

After that the next show that we did together was called *Lame* (1991), which was inspired by contemporary American poet Robert Lowell's *Prometheus Bound*. Steven expressed the wish to be in the show not only as a musician but also as an actor. So we rehearsed for a week in the countryside and we put up some pieces. In this show Prometheus had two faces: a male and a female and it was him and me who were doing this. And then there were dancers. And a recording came out with the Italian label Materiali Sonori.

After this, there was a pause because he left for Mexico in 1993.

A few years ago, I had this project called *La Strana Festa* (1999), [34] inspired by the book *Le Grand Meaulnes* by Alain Fournier, working on adolescence. I felt strongly that it would be very good if Steven could work on the music and be there. We understood each other pretty well and he came over from Mexico. We did this show in Castelnuovo Garfagnana, which is outside from Sienna, not in a theater but in an abandoned factory. It was a beautiful show and he played live some pieces on his sax.

After this, he worked on the music for our next show that was *Appunti Furibondi* (2000), [35] based on the film *The Rage* [*La Rabbia, 1963*] by Pier Paolo Pasolini and then lastly he composed the music for *W Gep-eTTo* (2001), [36] based on the book of Pinocchio.

Steven works on music exactly in the same way as I work on dance, movement. It's a stimulation about a situation, about a feeling, about emotions and about a climate. So it has always been easy to work together. I always tell him what I'm working on, on themes and feelings and communicate with him on these. Sometimes it helps sometimes it doesn't

mean anything to him. Sometimes I may suggest that I feel an instrument better than another. But usually it's mostly him who proposes some music. Sometimes it's already done when he'd come over here, sometimes it's composed here directly. He always worked watching rehearsals, except for the last one, *Gep-eTTo*: he didn't see it while we rehearsed. He did it by himself with Peter Principle in Cagli in the summer of 2001 and, incredibly enough, it worked anyway."

1990 also saw the release by Sub Rosa of a nicely packaged compilation CD entitled *Besides All That*, gathering seven of Brown's recent tracks that were originally featured on the *Me, You And The Licorice Stick* EP (1986) and on the *Steven Brown Reads John Keats* LP (1989), both previously released by Sub Rosa as well.

Blaine Reininger releases his Songs From The Rain Palace CD. Of course the "rain palace" referred to by Reininger was Belgium, the place he continuously loved to hate, but ultimately fostering his inspiration. The album reflects, once again, Reininger's fascination for Europe's *Belle Epoque* and composers such as Ravel, Debussy and Satie. [37] It also encompasses a vibrant homage to his life companion JJ La Rue ("Song for JJ") along with an evocation of his father in "One-Way Man.""In this song, said Blaine, I sing about my father with nostalgia. I was a very unhappy kid and no one could stand me because I was an ugly little fat one. I was already an adult trapped into a child's body. I probably was the oldest child in the world." [38] The CD also features Reininger's own version of "Zeb & Lulu," although it probably suffers from the comparison with Montana Blue's previously recorded version of this Reininger-composed song.

Songs From The Rain Palace reflects some sort of dark age in Reininger's career and life and a sense of unease is reflected in some of the reviews for this album:

For Dutch journalist Corné Evers, the magic always present in Reininger's previous albums is gone. [39]

According to Belgian rock critic Jean-Luc Cambier, 'In a few years, the Tuxedomoon constellation has lost all of its *aura*, if not all of its interest (…) (Reininger) is back with a dark and nostalgic album, where his voice wanders like a splendid ghost. Those acquainted with his rainy and poetic universe won't be surprised, but the pleasure of this reunion is not to be disdained.' [40]

'His music? A cold threnody, upon which floats Bowie's spirit from *Low* run across by gypsy flashes. In brief: "*le son solitaire de la tombée de la nuit.*"' [41]

'(this album) leaves us with mixed feelings as it very rarely

BLR & SB tour Italy (prom. Materiali Sonori)

12/13/90 BLR & SB play at Sala Politeama, Cascina di Pisa

12/14/90 BLR & SB play at Kryptonight Club, Baricella

12/15/90 BLR & SB play at Teatro Mediterraneo, Naples, *Mostra d'Oltremare* (with Wim Mertens, Bisca, N'Diaye, Marco Pierno)

12/17/90 BLR & SB play at Auditorium Tarentum, Taranto

12/19/90 BLR & SB play at Auditorium RAI . Live concert for RAI I AM's *Audiobox* show

Some time in '90 Release of BLR's *Songs From The Rain Palace* LP/CD by Les Disques Du Crépuscule (with Stephan Kraemer, PP & Eric Sleichim guesting) featuring the following tracks: 1. "My TV;" 2. "Song For JJ;" 3. "One-Way Man;" 4. "Justice;" 5. "Zeb & Lulu;" 6. "Between K-Mart And Paradise;" 7. "Voice Of The Hive;" 8. "Europe After The Rains (A. Winter In Wien; B. La Tombée De La Nuit; C. Père Lachaise);" 9. "Spaziergang"

Some time in '90 PP releases his *Conjunction* album (LTM) featuring the following tracks: 1. "Choc Mol 1746;" 2. "Day One;" 3. "Day Two;" 4. "Sphinx Variations;" 5. "The Evening Country;" 6. "Realm Of Shades;" 7. "The Pavillion;" 8. "Maya;" 9. "Ceremonial Polka" 10. "Le Feu Vert;" 11. "Jean-Louis And The Prodzj Gang;" 12. "A Walk On Dinosaur Hill;" 13. "Choc Mol Rotterdämmerung." This album was re-released by LTM in 2005

End of 1990 PP returns to the USA

Page 335

rises to the level of dramatization present on *Broken Fingers* or *Night Air*.'[42]

Interestingly enough, Reininger didn't seem to be himself that supportive of this album. When he performed live at the Botanique (Brussels) in November 1990 supposedly to promote his new opus, he played no less than five pieces from his masterpiece, namely *Night Air*.[43] He seemed to be reconsidering his artistic direction, willing to take a turn towards more theatricality whereas, ironically, the predominance of theater over music had precisely lead to his departure from Tuxedomoon. Indeed, responding to a review by Belgian journalist Thierry Coljon in which the author asserted that "Rocking has never been his strong part. He should leave this to others,"[44] Reininger expanded: "I find myself in a transition period. I wish to flesh out a bit my live performances. With humor, a real spectacle, a ballet. It is true, as you said in your review of my album, that I was not meant to be a real rocker. I should leave this to others."[45]

Peter Principle releases his Conjunction album and returns to the USA. By mid-1989, Peter Principle provided a sound installation to an artists' path (*parcours d'artistes*) entitled *A Walk On Dinosaur Hill* extending over some streets of Brussels. Brown, Reininger, Geduldig and Saskia Lupini also participated, providing drawings, poetry readings, photographs and videos. Some of the music will find its way on Principle's next release with the LTM label, *Conjunction*, an album compiled from tapes recorded by Principle at his Brussels home on Parvis de Saint-Gilles. *Conjunction* was re-released by the same LTM in 2005. Here's what journalist John Gill had to say about the work:

'The most curious detail about this re-released 1990 solo project by Tuxedomoon bassist Principle is the almost total absence of, er, bass guitar. Described as thirteen "sonic sculptures" derived from his own dreams, it might best be compared with recordings such as Holger Czukay's *Movies* or John Cage's *HPSCHD*.

Clearly branching off from that mixture of whimsy and menace that marks the work of Tuxedomoon, this is almost pluperfect with references: "Claire de Lune," movie dialogue snippets, ambient electronics, percussive marches, *thé dansant*, mechanical repetitions, Durutti-like drifts, found sources, sly allusions to 20th century atonalism, even, really, and I mean really, mutant disco.

Principle is reported to have said that, in retrospect, *Conjunction* might have been a little too long or busy. This could be seen as a blessing as much as a curse; the feral post-modern ear will find this CD sublime. Where Czukay's post-Can masterpiece grabbed pieces out of the air on short-wave

radio or nicked stuff off Hollywood movies on TV ("Positively amazing, doctor!"), Principle's project constructs a vast collage of uncountable styles and sources.

That dizzying array of references might also be a weakness, rendering any sense of coherence meaningless, although that could itself be dream-like, a jumble of tropes that echoed the composer's passages of rapid-eye movement. Which is why I invoke the memory of Cage's monumental *HPSCHD* of 1969. *HPSCHD*, the computer codename for "Harpsichord" (and pronounced "Harpsichord"), was a three-hours-plus multi-media piece in which a primitive computer random-sampling programme juggled live and pre-recorded snippets of piano works from Mozart to Schoenberg in a seething mess of noise to the accompaniment of space footage on giant screens. This ain't Mozart, it ain't Schoenberg, but it is very much in the spirit of *HPSCHD*.'[46]

However it was a time of turmoil in Principle's life as he and Saskia Lupini, his partner since Tuxedomoon's early days in Europe, broke up, which ultimately led Principle to leave Europe and return to his native New York City.

Here is Principle's personal tale of the nineties, underpinned by the necessities of survival: 'Around the time of Nancy Guilmain's *Walk On Dinosaur Hill* exhibit Saskia and I broke up. It was obvious to me that my support group and language skills didn't presage a great future for me in Brussels.

I had two ideas about what to do next. One was to go to Prague in Czechoslovakia (then) and set myself up as some sort of music *entrepreneur* as I owned some gear and I had heard that my reputation was good there. But at the same time I had this opportunity to go back to visit New York City in April 1990. I couldn't resist that as I missed NYC and the USA in general and I still think that part of my karma as it were is to do something there.

I came to NYC and almost immediately got involved with a girl there and so in the end I let my love life decide for me what happened next, which was I put my things in storage in Brussels at Colin Newman's [*of The Wire*] house, and jumped into the NYC environment... The girl, Pilar, was a costume designer who had lots of connections in underground film and theater, as well as a normal overpaid job for Carsey-Werner which kept her in Los Angeles a lot and so we had at first a three-city life: NYC, LA, Brussels, and then a two-city life. I thought one way I would be able to connect with work in the same environs through which she moved (some things did happen but less than enough) and so it didn't look as risky as it turned out to be to move from the rather inexpensive environment of Brussels to the overpriced world of NYC/LA... Anyway not only didn't I get my great gigs, but also the relationship fell apart within weeks of my shipping of all my

Page 337

stuff from Brussels in the summer of 1992. In that period of time I ate some humble pie...

In 1991, I was playing in a loose musical group called Pookah, with Bond Bergland of Factrix and Saqqara Dogs fame, Fritz (Freddie) Fox of The Mutants fame and Scott Jarvis of The Workdogs fame. We were a mediocre super group at best.

I also got involved with time sharing at a midi production studio formerly connected to Deelight, and there I taught myself midi as I was computer illiterate until Andrea Shaw asked me to help her do the database for her 1993 released movie review book called *Seen That Now What*, for which I received credit in the book and a computer (my first)...

While at the midi studio I got involved in doing demos for 30 and 60 second spots for which I finally found an agent and for a year I did try to land a commercial but was so disillusioned with the type of people one came in contact with, and all the smoozing necessary. I failed to make a sale.

Meanwhile I had made contact with some people who were developing a multimedia yuppie satirical current events magazine to be distributed on computer discs and made in macromind director. I was involved at first as a sound designer. But after seeing the software I realized it wouldn't be hard to learn to do that for myself, and so I started my life as a multimedia evangelist. Saskia and I already had written some things (for ourselves) about interactive television as we were developing in the same direction. I and a partner of mine Rick Morgan bought the software and set off to develop some sound design utilities (he was also a musician and sound designer) for other developers working in macromind software, and to this end we were successful, even having some of our sound products used to promote the launch of Apple Macintosh operating system 7.

At the time we thought that the future of DIY art was going to be on CD-rom. But then came the development of the internet, and so everything went differently than hoped. CD-roms had no distribution network and almost all the non-game non-educational projects failed miserably. Meanwhile we got involved in internet development, but the speed of access was so much less than kiosk/hard drive or CD-rom source materials that in the end graphics and sound were almost non-existent on the internet of the mid-nineties, but anyway there was some money to be made. Now we are into the new century developing the technology of DVD-rom which will be much closer to what I fantasized for the CD-rom back in 1992.

Anyway, I have done all kinds of sound design and reinforcement activities. I worked on live sound for a list of clients from the Mingus Dynasty big band to Pierce Turner. I've recorded documentaries and MTV interviews, worked

sound at the amazon club and fez in the early nineties.

In the meantime, the band Pookah broke up due to lack of initiative etc. I had been invited to play in Anna Domino's band for some shows which ended up to stretch out over a year and even resulted in a trip to California. In the beginning I had hoped that we would write some music together. We did try, but nothing came out of it and in the end I was hired to more or less play parts written by other people and as it became apparent that we weren't really creating anything, this came to an end.

Around 1993, I met an interesting street musician named Bradford Reed who built his own gamelan out of electric guitar parts and I proposed to produce a record [*i.e. LIVE! At Home, Ft. Lb. records*] which was released in 1996. Also during this time I worked on a recording by a group called Vardo which we almost completed when the band broke up around 1998. The band was rather interesting having electric harp and a very dynamic female vocalist...

I worked on many projects with Phil Kline who is almost famous for his yearly Christmas piece [*every year since 1992, Kline presented his Unsilent Night project i.e. an outdoor ambient music piece for a number of boombox tape players*]. I played on/helped record on location his previous album and also played guitar in his live ensemble for many gigs. Kline was an acquaintance of mine, sometimes friend, for many years. We had already worked together in the early eighties [47]. I recorded many demos of his in the early 90's and I am credited as a musician on the CD *Glow In The Dark* [*1998, CRI label*] as well as recordist. I played in his live ensemble for years and recorded a few of the earliest *Unsilent Night* events which I participated in the first six or so, but I am not involved in the actual released version (which was recorded by aforementioned Bradford Reed). I haven't worked with him recently.

I did contribute a track to the *We're All Normal And We Want Our Freedom* CD tribute to Arthur Lee of the legendary group Love, which was released in 1995 on Alias Records. I did a Martin Dennyised version of "Emotions" and instrumental from their first album.

For a number of years between 1996 and 1999 I performed with Ecco Bravo at a bunch of venues in the area. This group was formed from the bass (Dave Kennenstine) and drums (Josh Matthews) of Vardo and we had a DJ (Jeff Davis) as the fourth member sound-generator. It was very successful musically for me. We spent many hours recording improvisations live, an edited project of which would be forthcoming [*on Principle's CD entitled Idyllatry, released by LTM in 2005*]. The best gig was with Colin Newman [*i.e. Colin Newman & Malka Spigel's duo named Swim*] at the Knitting Factory...

It was in the mid-nineties as well that some sort of music that I

A promotional Japanase postcard for Steven Brown. Courtesy of Steven Brown

had always been collecting (I'm known for being a notorious record collector) became *en vogue* for a minute and so I found myself in demand as a DJ for parties etc. We are discussing the space age bachelor pad/lounge/easy listening revival. For years I collected soundtracks and music library records as well as my beloved psychedelic and no wave rock. I always loved muzak and even Tuxedomoon had concepts about this all. We actually had songs with titles like "lounge-zak" which we performed at the Savoy Tivoli in San Francisco in 1980.

By the mid nineties the chirpy stuff was back in style and there were lots in my collection. There was at this time a renewal in the industry of reissues and compilations and I found myself as a consultant to a few of these like *Electronic Toys* (volume 2) [*Qdk Records, 2000*], *Hush Little Robot* (the music of Bruce Haack) [*Qdk Records, 1998*], *Pepperisms* (international Sgt Pepper's imitators) [*Qdk Records, 1998*], *Doob Doob O' Rama* (60's Bollywood filmsongs) [*Qdk Records, 2000*], *Asian Takeaways* (Malaysian 60's pop) [*Qdk Media, 2001*]...

The internet activity had slowed due to my own lack of interest, but I still needed food and so I continued to be involved with the clients' sites with my partners. We have done sites for educational institutions and various commercial agencies as well as nonprofits like the Shakespeare Society etc. My role in these was as an image manipulator/processor and consultant on layout and overall conceiving and design.

I also have been spinning music in a kind of lounge environment and made various sound installations for art galleries and the like.

I even tried to distribute crammed world, and the *Made To Measure* series but that didn't work out for various reasons...

So much about the nineties being a hard period to recreate for myself as well. Sometimes I wonder "what was I thinking..." But I'm basically an optimist: even if I haven't found the fountain of whatever, miraculously I have survived...'

When Principle left, there weren't many people who believed that Tuxedomoon would eventually reform. Bruce

Geduldig casts an interesting retrospective glance on the band's move to Europe, which enabled them to gain the cult status that they're still enjoying today but also killing them softly at the same time. Geduldig: "There was always a sense of a curse that followed us, probably because we were outcast and nobody could characterize us. We often felt like celebrating outcast. I don't think we had really bad luck. I think we didn't quite fit in to every little niche that came along. We weren't new wave, we weren't post new wave, we weren't this or we were just slightly outside of that category, which makes Tuxedomoon unique and one of those bands that didn't make it to that type of status that other people got to before and after. I think that there were a lot of bands that came in the late seventies that were brilliant and didn't last longer than three or four years. Tuxedomoon did and in that sense it's worth talking about because it lasted. I think it's because we traveled to Europe that we survived as long as we did. Nothing would have really happened if we had stayed in San Francisco. The fact that we moved to Europe all together really held the band together for a long time. Also, on the other hand, you could say that the stress of moving pushed the band apart and that at some levels it was too much strain. Peter and Winston have gone back to their own hometowns and in a way Peter and Winston were kind of the most stable members in the band…"

1991: Brown releases his Half Out album, co-founds Act Up Brussels, gets filmed for Julien Bosseler's documentary entitled Steven Brown – L'Autre Chez Moi and tours with his band; Blaine Reininger works with the Virulent Violins

Meanwhile, Brown had been working on his next album, entitled *Half Out*. Brown: "Many of the pieces composing *Half Out* were born during an Italian tour [*i.e. the Greenhouse Effect tour*]. This time I consciously sought to make a more accessible album (…) The title refers to Tuxedomoon's first LP, *Half-Mute*, and from there to myself: half of my life is behind me and so you could assert that I'm actually sanely half out of my mind. Another explanation can be traced in the division of the songs between covers [*i.e. Edith Piaf's "A Quoi Ca Sert L'Amour" that Brown sings with Anouk Adrien on the latter's idea; BB King's "The Thrill;" Billie Holiday's "Moaning Low" and Cole Porter's "In The Still Of The Night;"*] and my own compositions [*i.e. "Decade," "San Francisco" (with N. Klau), "Voodoo," "Out Of My Body" and "Violorganni" (aka "Song For L," with B. Reininger)*]."[48] "As opposed to *Searching For Contact* that was more experimental, *Half Out* is (…) more commercial (…) It's a compromise between what I've been doing before and

What is European in your music and in Tuxedomoon's music?
Steven Brown: "When Tuxedomoon was in San Francisco, I found it odd when people were saying that Tuxedomoon sounded European. I didn't understand why they were saying that. When I arrived in Europe, I understood it all. In the USA Blaine and I were listening to the first Bowie, Roxy Music, Brian Eno. The music we preferred was British whereas Peter Principle was a fan of German music, Can in particular. Also the composers of the soundtracks to the films I watched when I was 16 were European: Rota and Morricone were my faves. The pieces composed by Morricone for Leone's westerns were my introduction to music…" (Steven Brown interviewed by R. Nanni, "Brown", *Dolce Vita*, 04/19/89, translated from Italian)

1991

Some time in '91 Release of SB's *Half Out* CD (recorded at L'Echo Des Montagnes and Daylight Studio, Brussels, with LvL, IG, Nikolas Klau, Chris Haskett, Drem Bruinsma, BLR, Anouk Adrien, late Ulf Maria Kühne and Marc Lerchs guesting, prod.: Nikolas Klau & SB for Kobold Prod, mixed by GM) by Les Disques Du Crépuscule featuring the following tracks: 1. "Decade;" 2. "A Quoi Ca Sert L'Amour;" 3. "San Francisco;" 4. "The Thrill;" 5. "Moaning Low;" 6. "In The Still Of The Night;" 7. "Voodoo;" 8. "Out Of My Body;" 9. "Violorganni." The album was re-released by LTM in 2005 with following bonus tracks: 10. "Boom Boom;" 11. "Miles In Moskow;" 12. "The Way;" 13. "Love Yes (Ebony Mix)." Note: Anouk Adrien & Bob Eisenstein shot a video clip together for "A Quoi Ca Sert L'Amour."

About the song "Moaning Low." "It comes from *Key Largo*, the film by John Huston [1948]. In the final scene at the hotel, Edward G. Robinson is chatting up his alcoholic girlfriend, promising a drink in exchange for a song, after which the girl will sing an ode to her man. On stage I reproduced that scene with a play on shadows behind a white sheet with the silhouettes of a man and a woman acting their parts. At the moment when she started singing, I was coming out from behind the sheet dressed as a woman. I do like this theatrical exchange of sexual roles very much. That's why I left the lyrics as they were." (Steven Brown interviewed by L. Gilinck, "De melancholie van het dagelijkse leven", *De Morgen*, 08/14/91, translated from Dutch)

Page 341

About the track "Voodoo". ""Voodoo" harbors a political tonality: unified Europe-to-be gets a critical comment. I believe it's necessary that someone for that matter would play the devil's advocate. I can see a lot of enthusiasm about what's going to happen next but I fear that such unification is presented in a somewhat too rosy way. One can already sense that all this is essentially going to serve the interests of the wealthy and big businesses. I believe in Europe but I can also see that this continent tends to absorb wildly all kinds of American bad habits and influences." (Steven Brown interviewed by L. Giulinck, "De melancholie van het dagelijkse leven", *op. cit.*)

"Voodoo," again. 'A lot happens when you go to see an Andy Warhol's retrospective... Went to Cologne – Köln – with Ulf [*Maria Kühne*] and Véronique [*Danneels, a friend of Steven Brown*] to see the Andy Warhol retrospective spread alongside the Dome in Ludwigsmuseum. Great show (…) But seeing Andy Warhol's last supper, which is hardly more than a photo blowup of Da Vinci's painting, I had a religious feeling. I felt something more religious than I ever felt seeing the original. Intentionally or not, Warhol's work do jerk your eyes to a different perspective of what you've seen before. I saw the route of his magic, the clue, the secret, in a pencil drawing of a Campbell soup can with a dollar bill sticking out, an alchemical occasion, a dumb cheap little can of soup turned into millions and fame…
Rue Wautier – Brussels. Explosion. Three doors down from # 32. House blew up and away. Two babies die. Apparently a gas line was broken at construction down the street. People smelled gas and called UNERG [*a gas distribution company in Brussels*] who ignored them. Then … BAM ! UNERG says that was some careless resident but 20 witnesses say no! E.E.C., death machine. Murder for the capital. Speculation fever breeds death. Gas companies lie, babies die. Sinister six story now guarded by black guard in closed off street parked in van in front of Anne's house. US invades Panama. Four thousand die under guns of people's army this time in Romania. A lot happens when you go to see an Andy Warhol's retrospective…' (excerpt from Steven Brown's private journals)

Some time in '91 SB provides soundtrack music + acts (as Prometeo) in Julie Ann Anzilotti's piece entitled Lame – *The Cutting Edge*. The soundtrack music will be released by Materiali Sonori in 1993 (as Lame – *The Cutting Edge*, music composed and performed by Steven Brown) featuring the following tracks: 1. "The Chaining;" 2. "Aggression;" 3. "Nothing Overlooked Nothing Understood;" 4. "Il Fuoco;" 5. "To Hope;" 6. "Oceano;" 7. "La Danza Delle Voci;" 8. "Fan;" 9. "They Had Ears And Heard Nothing;" 10. "Avvicinamento;" 11. "Love ᴢᴢᴢᴢ;" 12. "The Cutting Edge;" 13. "Hermes;" 14. "Finale Sospeso"

Some time in '91 Materiali Sonori releases Italian band Cudù (Palo Lotti's project)'s LP/CD entitled *Waterplay* with SB, LvL & Christian Burchard guesting

what I'm exploring right now." [49] "It's an album of songs, the most "normal" I have ever made (…) It should reach a wider audience." [50]

This album contains a small gem of nostalgia: the song "Decade" in which (the about to turn 40 years old) Brown looks back on his decade, in fact almost 15 years, in the music world.

Lyrics from the song "Decade":
I've got a million things to say but I forgot
I could write a book but I lost my pen
I'd walk the line for you. I'd waste my time for you
He's lonely, he takes a pill. A special affection for you, a new direction for we too
Has the destination disappeared or is it the will to travel?
The sky is blue and I'm falling. The weather's fine and I'm falling
The idea that it's all a capitalist plot, Gorbi siding up to the West spawning so-called "freedom movements" around the globe
I suppose that's one of the attractions, your name and his are the same
I looked up in the sky and I saw Jean Cocteau
Mi facho fuori e cosi il mio spirito sara da te in un minuto, said Roberto on the jammed autostrada
I was lamenting the passing of the 80's, the decade I had claimed for mine, so much happened. In a way it was my whole life, until now... so I thought
The bus driver's going down to meet her mate in Napoli
Willy Loman with his Flemish Reader's Digest
The older English gent chatting up the younger, first class
And Sashas' new play "How a Being Chooses to Become a Woman" [51]
They say we're going forward, but all I can say is, "Now that the commies are gone they're after the artist and the gays"
The 'environmental president' says "Let's go to Mars"
That's pretty good timing.
But I think the rest of us should try to keep this planet together.
That's pretty good timing.

Brown: "(…) there are many things I forget and I don't know why this is so. Perhaps I just have a bad memory (…) sometimes I don't even remember the good moments. Perhaps I have also been infected by the amnesia of modern life. Bertolucci once said that amnesia is an epidemic of our times. Everyone seems to forget their past and their history, which is something particularly bad and dangerous." [52]
About the line "Has the destination disappeared or is it the will to travel?": "Brussels is still an interesting place to live and

a fruitful spot for someone willing to be creative. But, on the other hand, the scene here did not take off as I had hoped it would at the start of the 80's. This city really had the artistic potential to become the New York City of Europe but that didn't happen. Brussels remained a provincial town. For the time being, I'm still feeling at home here. But my gypsy blood is naturally pushing me towards where I can't go." [53]

About the line "I was lamenting the passing of the 80's": "It was a very active period in my life. Everything happened then. Personal dreams came to fruition, goals were achieved... I don't feel trapped though. When something is over, you feel nostalgic certainly, but you mustn't stop there. You re-evaluate and move on to something new. So, when I was writing these words, it was more of a declaration of how important the 80's decade was for me, rather than a lament for its passage." [54] "A lot of things changed around the world in the 80's and, for, me these years encompassed the richness of an entire life." [55]

Half Out brought Brown's widest press coverage ever for the release of one of his solo albums, which gave him the opportunity to expand on his sources of inspiration and ways of working.

When asked where his ideas came from: "From the horror of everyday life… From the instruments I play on: mostly the piano and sometimes the synthesizer. When I play an instrument that I like, it is it that composes (…) It's hard to be working alone, I prefer to do it with other people (…) I like to work with Blaine. Every time we get together, something does come out (…) To me it's obvious to keep working with Blaine. Some would call it laziness, I would call it a necessity." [56] "One should always be seeking the unreal about these things that surround us." [57]

Regarding his way of composing: "It depends. Sometimes it'd come from my private journals, that I have been keeping for ten years. I would sit at the piano, play some notes and merge the music into the lyrics originating in my journals. Or some ideas would come up and I'd then be searching for the music to go with them, or the other way around. But the lyrics would come first most of the time. For that matter when you talk you already have a melody and every language has its music…" [58]

Half Out's reviews were quite welcoming:

'Steven Brown unfolds his melancholy in the idleness of melodies mixing languor and voluptuousness into a deliciously poisoned brew (…) an universe of disillusion and cynicism of a depressing darkness (…) Bathing into the muggy and strained atmosphere of a thunderstorm day (…) The ideal soundtrack to your rainy afternoons.' [59]

'Now on *Half Out*, Brown weaves the various strands of his musical past into a new pattern, an intellectual cross of jazz, R&B and post-modern kitsch. In contrast with his last three recordings (…) this is a pop album (…) There is a strong homo-erotic sub-current to *Half Out*, but the theme remains secondary, however hard to overlook (from the nude male centerfold of one of the best designed record covers I've seen, to Brown's enthusiast belting out "he's the kind of man who needs the kind of woman like me" in "Moaning low") (…) this is the summing up of a life in music'[60]

Also worth to quote is John Gill's review of the album's re-release by LTM Recordings in 2005: 'Brown (…) is so Europeanized I've nicknamed him Baudelaire, and he ain't complained so far. He now tends his small farm outside Oaxaca in Mexico, but his heart is still in Brussels, where Tuxedomoon exiled themselves after the ascent of Ronald Reagan. His reeds recall the keening of John Surman or Jan Garbarek, his ravishingly simple grand piano the spaciousness of Satie. But when he plugs it in his sequencer kicks like a *burro*.
Brown is also a closet romantic. He has a *penchant* for lyrics resembling automatic writing; his gravity counterbalances Reininger's wackiness in Tuxedomoon. His fuck-off-and-die sublime brass/electro "Miles in Moskow," which blows both Lalo Schifrin and the titular trumpeter out of the water, is actually a Whitmanesque rumination on love (…)'[61]

Unfortunately, and in spite of the French trendy newspaper *Libération* proclaiming that 'If things were right in this world, this album would go straight up to the top of the Top 50,'[62] *Half Out* did not earn Brown the commercial success that he was probably longing for. The venues he toured through Europe at the end of 1991 (with a band comprising Luc van Lieshout, Ivan Georgiev, Nikolas Klau, Marc Lerchs and Chris Haskett) were sometimes scantily attended.

Some time in '91 SB founds *Act-Up Brussels* with Thierry Smits, Antoine Pickels & Eric Stone

What attracted you to Act Up? Steven Brown: "Many friends of mine have been infected with the illness, some of whom are already dead. Many people are ill in America, especially in the art world. It was a matter of direct interest to me and I wanted to know as much as possible about the immune system and health." (Galateia Zota, "The loneliness of activism", *Pop Rock*, 1992 – translated from Greek by George Loukakis)

Steven Brown: "In the sixties, sex had become a pleasure. So the state felt threatened as it rests on this miniature state that is the family. So they came up with AIDS. Now everyone is afraid of sex and it's perfect for a system of control. It goes beyond the gay cause, it's political." (Ph. Franck, "Steven Brown ou le malaise urbain", *Le Drapeau Rouge*, 04/08/87, translated from French)

In the meantime, Brown and Thierry Smits, who had remained close since their collaboration on *La Grâce Du Tombeur*, founded Act Up Brussels in 1991 (with Antoine Pickels and friend Eric Stone). Thierry Smits: "After we made *La Grâce Du Tombeur*, Steven and I kept in touch. I met Lucius and we were hyperactive in militantism with the founding of Act Up Brussels, that took place about a year after our artistic collaboration. It was then a strange period for Steven. I believe that he had started questioning what he was doing in Brussels somehow…" For Brown this was yet another of his militant acts induced by the fact that he saw many of his friends die of AIDS on both sides of the Atlantic. The Brussels Act Up squad was then quite tiny. However, it made itself quite visible in the media with some spectacular actions including a noisy unsolicited interruption of the RTBf (Belgian

Page 344

French-speaking television)'s evening news on March 11th, 1991, [63] a collective chaining to the fences of the building of Belgian's department of labor in protest of pre-recruitment blood tests, [64] the distribution of condoms to kids on their way out of school and the complete blocking of one of Brussels's main streets in the European Union district, rue Belliard, on a morning's rush hour in an attempt to attract the public opinion's attention on the every day problems of HIV-positive people. Regrettably (for them) the action didn't last very long as they stopped the flood of cars at the precise moment when a van full of police was coming along. Brown and friends were promptly removed from the street – the police being extremely cautious when touching them – and taken to the nearest police station where they were kept on detention for a few hours.

Many of these Act Up actions were filmed by an 18-year old Belgian guy named Julien Bosseler, now a renowned journalist in Brussels. Bosseler met Brown when he was around 16 and was immediately fascinated by Brown's personality, which led him to devote one of his very first journalistic works to Steven Brown: a 30-minute documentary entitled *Steven Brown – L'Autre Chez Moi* (*Steven Brown – The Other Home*). The film consists of a mix of archive footage with images shot in Brussels during the Summer of 1991, Brown taking the spectator to the various places in Brussels that had meant something for him or Tuxedomoon. The "other home" referred to in the title of the film originated in the fact that Brown, at the end of the shooting, first expressed the idea of leaving Brussels to go "somewhere South, somewhere socialist."
Julien Bosseler: "This film was like an outcome of my relationship with Steven Brown as I had known him for quite a while already when it was shot. I met him at the start of 1990 through Thierry Smits when Steven was working on the soundtrack of *La Grâce Du Tombeur*. I then had the idea to work on a video about Thierry's show and soon became totally enthralled with the music and decided that I should interview the composer. I was 16 then and knew nothing about Steven Brown or Tuxedomoon. Our very first conversation took place with me behind the camera, filming him. He didn't tell me anything really interesting about Thierry Smits's show but I found him to be a very curious fellow. There was something bizarre, mysterious, intriguing, very appealing about him. He was very exotic also: an American in Brussels making this extraordinary music…
I was a withdrawn teenager in those days and felt out of place with the people of my age. I was deeply bored with them and in school. Also I didn't really like the music that was trendy at the time and so a whole universe opened up to me. It was like a revelation that made everything else sound tasteless.

Lucius Romeo-Fromm: "When Steven and I split, it was difficult, it was hard. But at that same moment, I was in a party in Paris, I was on the dance floor having a good time. I suddenly just passed out cold and hit my head on the floor and woke up with fever. I went home and felt like shit. I didn't know what was going on. Anyway to make a long story short, I was HIV-positive and found that out here. I didn't know what the hell to think. I didn't know what was going on. I was very naïve and… So I decided I was going to take care of myself and Steven was willing to be there and be around and be a part of, which I found really great. He was feeling like that hadn't changed anything. I remember that there was a huge argument and I was like: "Can't you see? I need to take care of *myself* right now and I don't need anything else but that!" But anyway we split and I was living with Niko [*Klau*] and his girlfriend and children in a huge house, porte de Halle, with a bunch of people: Bruce Geduldig, Nina Shaw and all kinds of people (…)"

Eric Stone (a friend of Steven Brown and Brussels Act Up co-founder): "I remember going to *cafés* on place Liedts with Steven's gang. We went to very working-class *cafés*, even a bit shabby. They liked that. Steven also enjoyed going to gay bars but the most squalid ones, transvestite shows but the most pathetic ones, cheap bars where cheap beer was flowing for working-class people. He didn't like voguish *cafés* or trendy gay bars. So we were frequenting the underground of Brussels's gay bars (laughs), not the underground in the artistic sense. We've had a few drinking bouts but I believe he's never had big problems with alcohol. Steven is not a suicidal or self-destructive person. He always took care of himself and of the others, being very committed and active."

Some time in '91 Release of Drem Bruinsma's *Six Reels Of Joy* CD by Materiali Sonori with SB, BLR, PP, LvL and IG guesting

Some time in '91 release of Beau Geste/Africa X *Chaka* CPI 300016-2 CD with SB guesting

Some time in '91 SB & Benjamin Lew compose the music of Belgian film-maker Rudolf Mestdagh's short film entitled *Vol-Au-Vent* (prod.: Alcyon Film, Kosmokino & Rudy Kris)

Some time in '91 BLR plays the violin on Daniel Wang's "Sandrose" piece (which can be heard on Wang's website at www.wangway.net)

Some time in '91 Release of *The Ghost Sonata* LP/CD by LTM, later re-released by Crammed (Cramboy, 1997) at a time when LTM had temporarily ceased to exist

02/13/91 VPRO (Dutch Radio) *Ghost Sonata* special

02/19/91 BLR & SB play at Foyer culturel (Espace Senghor), Etterbeek (Brussels), *Festival De Musiques Nouvelles – Musiciens Et Instruments Insolites*. During that performance, Lucius Romeo-Fromm dances on "Song For L" *aka* "Violorganni"

03/15/91 BLR plays at Bad, Hannover, with The Virulent Violins as support act

03/22&23/91 BLR & SB play at Chapelle De L'Oratoire, Nantes. Set list: 1. "Violorganni;" 2. "Iberia;" 3. "Egypt;" 4. "The Fall;" 5. "L'Arrivée Dans

Page 345

Le Jour;" 6. "Music # 2;" 7. "Close Little Sixes;" 8. "The Waltz;" 9. "The Ball;" 10. "Ghost Sonata;" 11. "Voguet Stuff;" 12. "Salad Variation;" 13. "Volo vivace;" 14. "Litebulb Overkill;" 15. Gange theme from video *De Doute Et De Grâce*; 16. "Licorice Stick Ostinato;" 17. "Les Odalisques (Japanese Dream);" 18. "Pleasure"

Around the Spring of '91 18-year old Julien Bosseler shoots a 30 min. video film in Brussels about SB entitled *Steven Brown – L'Autre Chez Moi* (prod.: Image Video). The film received a special price from the jury at the *Brussels 18th Super-Eight and Video Film Festival*.

A review of Steven Brown- L'Autre Chez Moi. "It's been almost ten years now that Steven Brown stands as one of those endearing figure of Brussels's cultural heritage, giving the capitol a reason to be proud although the latter does not always deserve it (…) (the film) is a very well-made portrait of an American turning back on each of the stages of his exile (…) In a city empty of its inhabitants in the middle of the summer, Brown talks and moves around, sings and play with this distinguished charm that characterizes him. *L'Autre Chez Moi* ends up on a smile from Steven who considers leaving Brussels very soon for a new adventure. A man has passed, the music remains…". (Th. Colon, "Un américain à Bruxelles", *Le Soir*, 10/28/91)

Steven Brown: "Ten years of living here in Brussels. There's always something that I miss, wherever I might be. I'm longing to see what happens in the world, of leaving for something else. I believe that everyone is in such a state. Who's really *at home*? Who does really feel home? I do have more of an emotional connection with a souvenir, a situation, rather than with a place. I still dream of San Francisco and I often think of the life I was leading there. Yet when I'm there, I'm not home. In Chicago, I'm not home. With my family, I'm not home. I am never home. I believe that all of the Tuxedomoon members entertain similar feelings" (E. Therer, "Steven Brown – Une décennie en exil", *Ritual*, 03-04/92, translated from French) "It's high time to go now, but whereto? South America I believe, maybe Mexico…" (E. J. Harmens & W. De Bruijn, "A poet stuck in Brussels", *Poezie nieuws*, 03/92, translated from Dutch)

It was mind shattering as I discovered an intellectual/cultural environment that was totally new to me, with people who were quite the opposite of everyone I had met until then: people who lived at night, who had curious ideas, strong socialist beliefs and a peculiar vision of the system.

First I was just a spectator. I was the guy with the camera, filming. Then I progressively fell into this universe and was documenting all of their public outings such as the Act Up squad acts or Steven playing with his band…

When *Half Out* was released in 1991, promoting the album was an issue and shooting a clip would have cost way too much money. [65] So I decided to do things differently and shoot a documentary about him. The idea was to show him as an uprooted person and put some emphasis on the release of the new album.

So just fresh out of high school and with the meager means I had available I shot this film in Brussels during three weeks in the summer of 1991. I remember that the atmosphere in the city was very strange. It was a hot summer and we got the feeling to have the whole city just for ourselves as there seemed to be no one left around. It was quite peculiar and Steven, as well, was intrigued. When we were done, I showed a sketch to the RTBf that pre-bought it, which allowed me to finance post-production. The documentary was aired on Télé 21, a sub channel of the RTBf, in the Fall of 1991.

This immersion in the Tuxedomoon universe is undoubtedly the strongest memory of my adolescence and never since in my life have I encountered a similar situation. There's been a before and an after. My life was different afterwards as I learned to be with people of my age. At one point I had to leave this world behind me as somehow I felt some danger about it. Yes these people were a bit adrift and they were in a dark state of mind. There was something poetic, depressing and fascinating about the Tuxedomoon galaxy. The darkness wasn't negative. The art they had to cultivate melancholy was really their trademark of being in a parallel and unclassifiable universe. I'm still unable to tell what kind of music Tuxedomoon plays but I felt something very strong in its substance, something running deep in time. It wasn't pseudo underground. It wasn't obscure or esoteric either, to the contrary: the music was very accessible (…)

Steven is someone who has been seeking for a long time and I'm not sure he's found yet what he's looking for. He's been looking for his home.

Brown and Crew (Julien Bosseler to the left) shooting Steven Brown – L'Autre Chez Moi. Photo courtesy of Steven Brown

Steven did not really live in Brussels, he was navigating through the underground, the true and pure one. He was attached to some people, not to the city. Maybe that was his form of root-taking. I would define Steven as a deeply poetic person in the sense that he really has his head in the stars, he's not quite from here. He presents this curious mix of poetry, with some childlike flavor about it, as totally opposed to a deeply dark side, a disenchanted side, faded one, worn out by life, by the things that happen in life, a deep form of disillusion and yet always this perky poetic side about him, a child's one. He is very cyclical also, with his head traveling constantly between the stars and the underground. I think that made up for his strong personality. That might have lost him also. But I believe he always sort of played with his cyclothimia."

Blaine Reininger works with the Virulent Violins. At this point of Reininger's life, things were quite hazy. His solo career had not taken off as expected and he was finding it hard dealing with his addictions. Reininger: "It was a strange period for me. Not quite here, not quite there, limbo…"
He continued collaborating with Steven Brown as the pair gigged together several times in 1991. Also worthy of note on that year was his collaboration with a German strings band named Virulent Violins (Blaine would call them The Virtual Violins) led by multi-instrumentalist Uli Bösking. 'I met Blaine Reininger for the first time on March 19, 1985, when he played in Bremen at Club Aladin, reminisces Bösking. I was then just a 25-year old fan with my head full of Tuxedomoon and Blaine's discographies. We chatted. He invited me over in Brussels but nothing really happened next.
In 1986, I met him again at another concert of his in Bremen (on May 14, 1986). Around that time my girlfriend and I passed through Brussels, on our way to a vacation in Spain. It was like a social meeting of two bourgeois couples: JJ La Rue and my girlfriend conversing about kitchen and home themes, Blaine and I left to beer, cigarettes and music.
Years passed. In 1991, I planned a tour in Germany for my band The Virulent Violins. I managed to get us the opening act for Blaine's gig in Hannover at Club Bad on March 15. Blaine was Ok with it, which was unusual as he tends to dislike bills with opening bands. So he watched us doing our gig on that night. As we headed backstage after our performance, Blaine greeted us yelling "Fiddle Warlords Rule!" and wrote that down on the wall where it still should be. This time the invitation to Brussels was seriously contemplated.
So on the week-end of May 25, 1991, I went to Brussels along with The Virulent Violins' bass player Stefan Walkau and viola player Tom Bennett. We talked and jammed for the whole weekend.

Birthday flood. 'Rudi [*Bekaert, renowned theatre playwright, friend of Brown*] has a new Moroccan chauffeur/dealer, B, who picked Rudi up at the *hotel central* after work. I came along for the ride (…) We drive around the world trade center area, eventually score from an Arab taxi driver, fifteen hundred for a thousand pack. Finally, B drives Rudi at his apartment and we are met at the door by the manager of the building who is a little flipped out, saying there is a flood in Rudi's apartment. Indeed there's about two inches of water on his floor. No one can really explain it. I was the last one to leave at noon. And meanwhile Rudi is sick and it's like a comedy, he's trying to take his fix sloshing around a flooded apartment and someone at the door every five minutes, plus it's his birthday…' (excerpt from STEVEN BROWN'S private journals)

Life microcosm. 'The reconciliation, the alienation, the mountains, the babies, the full moon, the alcohol, the coke, the bar, the dreams, the loneliness, the nostalgia, the bliss, the memory, the vertigo. This trip is becoming a microcosm of MY LIFE!' (excerpt from STEVEN BROWN's private journals)

04/21/91 BLR & SB play at Cinema Astra, Rome

04/22/91 BLR & SB play at Teatro Adua, Torino, *Musica 90 – Dalle Nuove Musiche Al Suono Mondiale Festival*

04/23/91 BLR & SB play at Teatro Nuovo, Ferrara

05/25&26/91 BLR jams the whole weekend with The Virulent Violins: http://www.uli-boesking.de/xtrpages/blaine/

06/29/91 BLR & SB play at Le Transbordeur, Lyon

07-08/91 SB guests (sax on "Tango" and clarinet & vocals on "Miccacuicatl") on the recording of Dutch band A Modest Proposal's album entitled *Contrast* (released by Barooni, Utrecht, PIAS distrib.) at "The Plan" – Utrecht and Muziekcentrum Vredenburg in Utrecht

Lyrics from "Miccacuicatl" (A Modest Proposal with SB on vocals and clarinet)
Dear mother, when I die
Bury me in your fireplace
And when you make maiscakes again
Cry there over me
And when a stranger asks
Madam, why are you crying?
Tell her the firewood is green
It's the smoke that makes people cry

10/23/91 BLR & SB play at New Morning, Paris, with Daniel Schell & Karo

10/28/91 & 11/02&04/91 Julien Bosseler's film *Steven Brown – L'Autre Chez Moi* aired on Belgian TV (télé 21)

11/07/91 SB + band (composed of Nikolas Klau, LvL, IG, Chris Haskett + Marc Lerchs for the Italian and Dutch parts of the tour that followed in December) play at Théâtre 140, Brussels, *Belga Jazz Festival*
According to M. Z. ("Steven Brown au théâtre

140, 07/11", *Jazz in time*, 12/91), the gig almost ended up in a total flop as practically no tickets had been sold before the event, leading *Belga Jazz Festival* promoter, Jean-Michel De Bie, to book a second gig of Marisa Monte (a big hit on this festival) before Brown's concert to the effect that SB + band played the first of their *Half Out* tour performances for a packed audience.

11/09&10/91 BLR plays with The Virulent Violins (& Drem Bruinsma playing keyboards) at La Villette, Paris. Festival commemorating the 100th Anniversary of Arthur Rimbaud's death
Later (on 12/14&15/91) BLR records a demo with The Virulent Violins in Drem Bruinsma's studio: http://www.uli-boesking.de/xtrpages/blaine/

SB + band (including LvL, IG, Nikolas Klau, Marc Lerchs and Chris Haskett)'s *Half Out* tour
12/07/91 SB + band play at Postholf, Linz (Austria)
12/10/91 SB + band play at Havana Club, Naples
12/11/91 SB + band play at Kryptonight, Bologna
12/12/91 SB + band play at Castello, Roma

Marc Lerchs about the *Half Out* tour. "I was on the Half Out tour in Holland and in Italy. We played a magnificent track by Ivan Georgiev that was called "Awakenings" [*so far unreleased but can be found on some bootleg recordings*]. It was very romantic at the piano, with Luc [*van Lieshout*] playing the flute… Steven really fell for that track and so he decided to make this piece part of the gig. Ivan, so desperately straight in the eyes of most people in the band…
There's an anecdote worth telling about the gig in Rome. We arrived there two hours before the concert with the truck transporting all the gear, only to learn that the concert had been forbidden by the local authorities (it seemed that no one had asked for an authorization in the first place) and so the gig was displaced to a night club. So off we went with the truck in the streets of Rome, to find our new venue only about an hour later. Arriving there, we saw about 50 people queuing to get in when the night club was not even open yet. We were told that the club was to open half an hour later. "What? We need two hours to set up the gear!" We were told "No!" and to bloody well get a move on. So we rushed in like loonies and we had only just about removed the gear from their cases that people started to flow in. Steven took the mike and said something nice to the crowd, explaining that we had learned about the change of venue only an hour before and they all laughed. When the cables were plugged in, we had a five-minute mini soundcheck in front of the audience. Then, well, we made it and, in my opinion, it was the most inspired concert of the whole series. As our stress went down and the audience's fervor went up, we got like "inhabited" and it was a beautiful gig."
12/13/91 SB + band play at Bloom, Milan (a 500 people venue)
12/14/91 SB + band play at Utopia, Innsbruck (a 300 people venue)
12/16/91 SB + band play at Westerkerk Theater, Leeuwarden (a 400 people venue)
12/17/91 SB + band play at Ekko, Utrecht (a 300 people venue), with A Modest Proposal opening
12/18/91 SB + band play at VPRO studio, Hilversum, radio broadcast

In November of the same year, Blaine called me up to ask me and Tom to be in his band, along with his pal Drem Bruinsma, as he was scheduled to play in Paris, at La Villette at some festival commemorating the 100th Anniversary of Arthur Rimbaud's death. Tom and I wrote some strings arrangements listening to Blaine's CDs and went to Brussels on the first week of November to rehearse with Blaine. The event was a bit of a chaos but we got to play two short gigs on November 9 and 10. That year again, in December, we recorded some demos at Drem Bruinsma's studio in Brussels. Then we got to play in Paris again with Blaine at a very nice basement club called Passage Nord/Ouest.'

That wasn't to be the last artistic encounter between The Virulent Violins and the Tuxedomoon galaxy.

1992: Reininger and Brown release their Croatian Variations CD; some Tuxedomoon related events in Brussels and Athens

1992 saw the release of Brown/Reininger's second album together, *Croatian Variations*, by the Italian label Materiali Sonori. This work resulted from a late 1990 commission to compose the music for a dance/theatre piece by Aleksandra Turya (known as Sasha), a young actress/choreographer from former Yugoslavia. The piece was supposed to illustrate the *Process By Which A Being Chooses To Become A Woman*, again a gender theme that is reminiscent of Brown's artistic roots with The Angels Of Light.

Brown: 'Sasha saw my performance of *Greenhouse Effect* in Zagreb, at the University where she would eventually produce her work. She approached me after the show and asked me to work with her. I returned to Bruxelles and invited Blaine to work with me. As for two men doing the music for her piece it was originally one man: me and, who knows, maybe she picked up something from me or my show or maybe it just wasn't an issue for her…

I don't know where her theme, *The Process By Which A Being Chooses To Become A Woman*, came from. Choreographers tend to cultivate rather profound and abstract themes. It would appear that the more intellectual or poetic an idea is the more apt it is to inspire movement. Interesting idea, *n'est ce pas?*'

As for how the music was created : 'Blaine and I worked out the majority of the music in Brussels in his attic studio. A tiny percentage of what appears on the CD was originated in Zagreb working with Sasha tailored to her needs. Specifically the "perfumes" which were transitions between scenes. The music on the CD that eventually came out was recorded in one of Europe's finest studios, located in Zagreb. Sasha worked with a dub of the master tape that would become

Croatian Variations...'

However, bad luck struck again as war began in the area shortly after completion of their work, with the result that a planned European tour of the dance/theatre piece fell through. It also caused severe financial hardship to Steven Brown. 'I was never paid, remembers Brown. I was promised payment by bank transfer once back in Brussels. However a few weeks after completion of our work war broke out. The official story we were given was that the banks were shut down. This may be true but Blaine and I both believe a corrupt University official in charge of paying us absconded with my money. He had a good cover in the war. Blaine was paid automatically by my bank as I was out of town and had left instructions with my bank to pay half of money coming in from Zagreb to him. Well the bank paid him without waiting for the money to come in! So I lost twice you might say...'

Although the collaboration didn't better the duo's everyday's finances, the artistic result was brilliant, as highlighted in Michael Draine's review: '(...) *Croatian Variations* opens with "The Lorelei," a ravishing bel canto solo by Sosija Ahmed. The purity and transparency of the coloratura's voice is so abruptly displaced by an arching, majestic organ progression, succeeded by a whirlwind montage of themes and melodies to appear later in the album. "Tarantella" adopts the jaunty rhythm of a Neapolitan dance, and counterpoints it with finely nuanced, archingly romantic violin. The spikey, kinetic "Tarantella" riff forms one of several recurring motifs that lend *Croatian Variations* its cinematic sweep. "Ombre Chinoise," a reflective interlude for piano, violin and clarinet, exposes a tenderness sometimes lost in the busy energy of Brown and Reininger's more electric and avant-garde excursions. On the sultry "Pleasure," Reininger exults in the gliding, rapturous violin phrasing that is the highlight of all his recordings. Some of the synthesizer parts strike me as effects-crazed knob-twiddling (particularly on "Kali" of the five-part "Women") but Brown's warm, throaty reeds come to the fore just in time to re-establish the human link. Distinguished by a wealth of musical detail and invention, *Croatian Variations* extends a compelling invitation to repeated listening.'[66]

Some Tuxedomoon related events in Brussels and Athens. The *Ghost Sonata* album was finally released in 1991, nine years after the performance of the piece in Italy. Tuxedomoon was of course still there in everyone's mind even though the band was now reduced to its core Reininger/Brown duo, occasionally performing with some "newer" members like Luc van Lieshout and Ivan Georgiev.

In June '92, two gigs were billed as Tuxedomoon or ExTuxedomoon.

1991 – VPRO radio broadcast. 'Went to Hilversum to do live recording broadcast with Gerard Waldorf. Got there at 5 and set up to do the interview at 8:20, polishing off a bottle of Bourbon in the course of things, introduce the members of the band, then rant about William Reich's definition of economy being a flow of energy and not necessarily how the car sales are dropping inspired by the GM layoffs in the news. Also said something about everyone talking about the fall of communism and not a word about the ills of capitalism, Gerard the cynical telling me to give my sermon in a church and he cuts me off. We do "Decade," "Miles In Moscow," "Awakenings," "Out Of My Body," Frankie [*Lievaart*] outside, in the mobile studio.' (excerpt from STEVEN BROWN's private journals)

12/19/91 SB + band play at Paard, The Hague (a 600 people venue but with very few attending)

12/20/91 SB + band play at Patronaat, Haarlem (a 500 people venue but with very few attending)

'There was a time when Tuxedomoon filled up venues in the area. This time is gone and it's a shame (...) Steven Brown creates an atmosphere somewhere between Gavin Friday and Lou Reed. Movie soundtrack music allowing every listener to think of his own movie (...) And, during the concert, Steven Brown was the actor of his own movie, *An American In Europe* (...) At the crossroads of two eras. "Has the destination disappeared or is it the will to travel?"' (P. BRUYN, "Een melancholieke Amerikaan in Europa", *Haarlems dagblad*, 12/23/91, translated from Dutch)

12/21/91 SB + band play at Burgerweeshuis, Deventer (a 500 people venue)

12/22/91 SB + band play at Noorderligt Theater, Tilburg (a 1000 people venue)

12/24,25&26/91 BLR & SB play *The Blaine L. Reininger and Steven Brown Christmas Extravaganza* at Plateau, Brussels. Set list: 1. "Violorganni;" 2. "Iberia;" 3. "Egypt;" 4. "The Fall;" 5. "L'Arrivée Dans Le Jour;" 6. "Music # 2;" 7. "Three Pieces For Solo Piano;" 8. "Ghost Sonata;" 9. "Voguet Stuffed;" 10. "Salad Variations;" 11. "Volo Vivace;" 12. "Litebulb Overkill;" 13. "Le Vieux Boulevardier;" 14. "Ganges (Golems Grisâtres);" 15. "Licorice Stick Ostinato;" 16. "Les Odalisques;" 17. "Pleasure." Encores: 18. "Tarantella;" 19. "Gigue/Lancaster County"

1992

Some time in '92 Release of Patrick de Geetere & Cathy Wagner's 60 min. documentary (prod.: Ex Nihilo, CICV of Montbéliard-Belfort, Wonder Products) entitled *Les Contaminations: Fly Me To A Star*. Exploring how Andy Warhol's Factory in NYC had "contaminated" surrounding artists and freaks, the film features *a.o.* Anouk Adrien, Lucius Romeo-Fromm, SB & BLR (interview + music played by SB – "Decade" – and by BLR & SB), John Cale and James Chance

Some time in '92 SB composes soundtrack music for a Belgian short film entitled *Viva* directed by Bart Van Den Bempt

Some time in '92 SB (for the tracks "Settemari" & "Waters") & LvL (for the track "Strange Guy") guest on Lord Chapeau (Firenze)'s CD entitled *The Clown* released by Dischi Impero. This album also contains a cover of TM's "(Special Treatment For The) Family Man"

Page 349

Reininger on the day of his performance at the Notre-Dame du Bon Secours church in Brussels. Photo courtesy of Steven Brown

Some time in '92 SB guests (for the track "Zephir") on Drem Bruinsma's CD entitled *Eros Délétère* released by Body (France)

Some time in '92 BLR guests (for the tracks "Shine Ola" & "Again And Again") on Trisomie 21 (Belgium)'s album entitled *Distant Voices* released by PIAS (Play It Again Sam)

Some time in '92 Release of BLR & SB's CD entitled *Croatian Variations* (Materiali Sonori, re-released in 2001) featuring the following tracks: 1. "The Lorelei;" 2. "Overture;" 3. "The Hidden Sea;" 4. "Perfumed Silk 1 – Rose;" 5. "Tarantella;" 6. "Perfumed Silk 2 – Citronella;" 7. "Ombres Chinoise;" 8. "Perfumed Silk 3 – Chypre;" 9. "Gaia;" 10. "Luna;" 11. "Marylin;" 12. "Kali;" 13. "Kwan-Yin;" 14. "Perfumed Silk 4 – Myrrh;" 15. "Pleasure;" 16. "Perfumed Silk 5 – Lavender;" 17. "Tarantella (Reprise);" 18. "The Morning After;" 19. "Perfumed Silk 6 – Frankincens;" 20. "Beyond the veil"

Some time in '92 Release of (various artists) *The Materiali Sonori Guide To Intelligent Music*, including "Iberia" by SB & BLR. SB & LvL guest on "Sonata Per Gabbiano" from Cudù & BLR appears on "Dunarobba" from the album of the same name by Militia. Finally SB (with Nikolas Klau) guests on "All But One" from Drem Bruinsma

01/10&11/92 SB band plays at Passage Nord/Ouest, Paris

01/15-19/92 WT writes, co-produces and plays *First Generation Stigma* (with text, music, puppetry, and video. It concerns growing up in America as the first-born son of immigrant parents) at Asian American Theater Center, San Francisco. Link: http://cemaweb.library.ucsb.edu/aatc_app_a.html

02/14/92 SB band plays at Effenaar, Eindhoven

02/25/92 PP & Phil Kline for Context gig in NYC, the Bowery

02/29/92 BLR plays at Passage Nord/Ouest, Paris, with The Virulent Violins & Drem Bruinsma (keyboards). Some mp3 recordings of tracks played on that night can be found here: http://www.uli-boesking.de/xtrpages/blaine/

The first was an intimate event gathering Brown, Reininger and van Lieshout (with Ulf Maria Kühne as guest singer) and taking place in Brussels's venerable Notre-Dame du Bon Secours church right in the historical center. Julien Bosseler was in attendance: "I remember this concert at Bon Secours, *Facing The Sun*. They were all dressed in white gowns with hoods. Steven was playing the organ and there was a peculiar atmosphere…" Brown wrote this entry about the event in his private journals: 'Notre-Dame du Bon Secours (June 1992). Played in a 16th century baroque church, *Bon Secours* on the *rue du marché au charbon*: Luc at the trumpet, Blaine on the violin, Steven on the church organ, Korg and sax-clarinet, all acoustic. On the balcony overlooking some 200 people sitting and lying around on the floor below, even on the steps of the altar, even Buster [*i.e. Martine Jawerbaum's dog*]. One of the anarchist kids is drinking a glass of beer with Nina [*Shaw*] on the altar. There's ten seconds of reverb. Everyone is sitting down below, looking up at us on the balcony in white robes and hoods. Maybe it was too much. Ulf Maria [*Kühne*] started the show walking out of a confessional singing Rachmaninov, also in a white robe. It was hard to hear the organ and each other (…)'

The only trace on record of that concert is the track "Fuga," alleged to be a homage to Brown's mother (Tina Fuga) and/or to famous born in Florence Roman architect Ferdinando Fuga (co-responsible for the Santa Maria Maggiore basilica and builder of the strange, skulls-ornated, S. Maria dell'Orazione chapel in Rome). The track would later be added to *Subway To Cathedral*, Brown's compilation album released in 1999.

The second event was, according to Reininger, a "battle of the bands." It took place at the huge Lycabettus theater in Athens (4,000 capacity, the theater half full for the occasion) on June 22nd, 1992. Steven Brown played with his band (including Luc van Lieshout and Ivan Georgiev) and Blaine Reininger was accompanied by The Virulent Violins. They first played separately to finally join in a short and unprepared jam session that left many fans longing for more. The whole affair was driven by financial need more than anything else and the fans were essentially duped by an event that was billed as ExTuxedomoon but that bore none of Tuxedomoon's spirit on stage. Reininger: 'We landed this gig through the good graces of a friend of ours, Kalindi Dighe, who called a contact of hers in the film industry. He arranged that gig. I have since encountered this guy in the advertising game here in Athens.' Ivan Georgiev does not entertain fond memories of the gig, admitting that the main motive was financial, Tuxedomoon being a huge name in Greece. Some fans present on that night remember a 'rather disjointed event' and describe the awaited

final jam as 'a short and messy affair, clearly not rehearsed, which felt that it finished earlier than it should have…'[67] Only Brown wrote a positive report in his journals: 'Athens, 1992. It was great in spite of incomplete soundcheck in giant stage, 4,000 seats arena in a scolding heat. Blaine and JJ hanging out on stage, bad vibing us. Nineteen hundred according to Niko (…) Then as I was going on stage, he and Stamos came up and asked if it's Ok to let in the mob at the gate, the cops want to know. As he speaks, the gates open and in stream hundreds of people for free. The rocks overlooking the stage are filled with concert goers also. So everyone loses some money but what a great crowd! (…) They really reacted to new stuff and it really seemed that the whole audience was checking us out listening. It's the biggest audience I've ever done alone and the best enthusiastic energy of the thousands. At the end, we jammed…'

Brown, according to many who attended, was the most cohesive. Furthermore the journal entry hints to the tension that seemed to be ongoing between Brown and Reininger. Both were obviously desperate to succeed in their respective solo careers but they seemed to be nonetheless sentenced to work together in order to make their artistic path financially sustainable.

1993: dissolution of the Tuxedomoon ASBL; Steven Brown leaves Brussels for Mexico City; release of Tuxedomoon's Solve Et Coagula compilation album

In 1993 Brown decided to dissolve the Tuxedomoon ASBL [*i.e. the non-profit organization that served as a legal structure for Tuxedomoon's* Operations] reluctantly as he had somehow always kept a door open for Tuxedomoon's revival. But years had passed since the Reunion Tour and Tuxedomoon didn't appear to be a creative unit anymore, only being brought back to life for some concerts that were put together solely for reasons of financial survival. By 1993 it appeared that the Tuxedomoon legal person was actually costing more money than the minimal income generated by the undertaking. Friends of Brown remember having seen him quite dismayed on the night following the dissolution of the Tuxedomoon ASBL: "Now it's *really* over with Tuxedomoon…"

Steven Brown leaves Brussels for Mexico City. Brown
had been contemplating leaving Brussels for a while already, wanting to head "somewhere South, somewhere socialist." Now that Tuxedomoon seemed to be dead, there were of course even fewer reasons for him to stay in Belgium, except for Blaine Reininger but then the tensions between them were palpable. Finding the destination was somewhat of a

03/92 BLR & SB play at Centre Culturel Le Triangle, Rennes at the closing Party of *Festival De Vidéo Création* (prom.: mc.live & Video Pop Combo), providing musical accompaniment to the projection of de Geetere's films *De Doute Et De Grâce & Premier Sang* (the latter strongly inspired from *L'Amant* by Marguerite Duras and featuring Winston Tong). A similar event took place in Nantes around that time.

06/92 SB + band (composed of BLR, LvL, Nikolas Klau, Didier Fontaine & Fabienne Vandeplas) play at Kaput, Brussels. The concert was filmed by Julien Bosseler.

06/19/92 BLR, SB and LvL gig together at the Notre-Dame du Bon Secours church, Brussels. The track "Fuga" that is featured on SB's *Subway To Cathedral* compilation album (Arteria, 1999) was recorded during this concert.

06/22/92 SB band + BLR with Virulent Violins + LvL + IG + video show by Nina Shaw play as ExTuxedomoon at Lycabettus Theater (open air theater)

Summer '92 SB (+ Nikolas Klau & Martine Jawerbaum) spends his vacation time in Mexico (after a visit to Belize) during which he performed two shows in Mexico City with the help of Carlos Becerra

07/17/92 SB plays at Escuela Nacional de Música, Mexico City

07/18/92 SB plays at LUCC, Mexico City

Busy week. 'Monday of this week, 2nd November [*1992*], finished mixing soundtrack for an Italian short film. Next day went to Blaine's to rehearse. Next day, rehearse again with Blaine and with Niko for poetry festival. Two rehearsals and a soundtrack overlapping this week. Bruce arrives Thursday to do poetry festival with us. It's a bit late and he doesn't seem too keen on what we're doing. Must contribute something of his own now since me and Niko have been working for two weeks already off an on. Thirty five minutes of *Half Out* songs. Some outright texts of Keats. Two films: *Alto sax* and *Praise Of money Resurrected*. Busy week. Blaine off to London for two weeks. JJ goes for the first time in eight years. At last she leaves the country for pleasure and *en plus* an English-speaking country…' (excerpt from Steven Brown's private journals)

11/19/92 PP plays with Pookah at Brownies, NYC

11/20/92 PP plays with Pookah at Room Temperature, NYC

11/24/92 BLR & SB play at Teatro Actores Alidos, Cagliari

11/25/92 BLR & SB play at Sonny Boy, Treviso

11/26/92 BLR & SB play at Alpheus, Rome

11/29/92 BLR & SB play at Auditorium Flog, Florence

12/01/92 PP plays with Pookah at Paradise Theater, NYC

12/02/92 BLR & SB play at Piccolo Teatro, Catania

'I know you better! (December 3rd, 1992). Coming back to Brussels after the Italian tour in Leonardo Da Vinci airport, Roma. Me and Blaine checking in. An airline person that checks in reads tickets, looks at me and says "Are you Steven Brown, complimenti!" We shake hands. He says he knows my music. Has *Desire*. I say: "Well, this is Blaine, also from Tuxedomoon.." "Yes but I know you better!" He had to work the night of our show at Alpheus. He asked for a tape and we give him a *Croatian CD*. All the while, we're scared about having too much carry-on baggage and we don't even ask him for help and anyway it isn't a problem...' (excerpt from STEVEN BROWN's private journals)

12/07/92 BLR & SB + Deine Lakaien Akustik play at Prinzregententheater, München

12/09/92 BLR & SB + Deine Lakaien Akustik play at Weltspielkino, Hannover

12/10/92 BLR & SB + Deine Lakaien Akustik play at Volksbühne, Berlin

12/10/92 PP plays with Pookah at Brownies, NYC

12/11/92 BLR & SB + Deine Lakaien Akustik play at Schauburg, Bremen

12/12/92 BLR & SB + Deine Lakaien Akustik play at LiveStation, Dortmund

12/13/92 BLR & SB + Deine Lakaien Akustik play at Schützenhaus, Stuttgart

'A quiet descending upon the house. The best thing that happened on the German tour with Blaine, December 7th to 14th, besides playing to a sold-out wonderful house in *Volksbühne* in East Berlin, was the sensation for the first time so graphically present of winning over in the course of performance a hostile or indifferent public. To date, we've been used to pin-drop respectful quiet audiences in Germany. We at times fought a battle with the din at the bar and our plaintive melodies were summoned to disarm the crowd and make them yield their attention. Dortmund in particular, this was a powerful experience. Halfway through the show, achieving this and hearing after a noisy opening twenty minutes a quiet descend upon

Steven Brown and Martine Jawerbaum, Belize, 1992. Photo courtesy of Steven Brown

problem. So Brown let destiny decide for him: "I wanted to get out of Europe, after twelve years of living in Brussels and after like five years looking for a house in Italy but then could find nothing I could afford. Finally I decided: "What the hell, I want to get out of Europe!" Me and Niko [*Klau*] were living together at the time in Brussels and we both wanted to leave and so we took up a globe, spinned the globe and pointed a finger on… Belize! Ok great let's go to Belize!

So in the Summer of 1992, Niko, my dearest friend Martine [*Jawerbaum*] and I decided to go to Belize for a vacation and check it out. We took a plane. To get to Belize, you have to go through Mexico City. In Mexico City, it was like: "Wow, what is this?!" Niko and I both loved it. Niko stayed in Mexico City: "The hell with Belize, I'm staying here!" Me and my friend Martine went on to Belize and (laughs) experienced "that." Then we went back to Mexico and I thought: "Well, maybe Mexico is a better place to live than Belize." Coming back to Mexico after Belize was like going to the first world after the third world. Belize is really frontier, really too wild wild West for me. There was just something about Mexico City that I liked and that Niko liked and so, we just basically said: "What do we do in Brussels, we could be living here!"

When the vacation was over, we went back to Brussels and one year later, almost to the day [*in September '93*], I went back to Mexico City. Niko followed three months later and stayed. It was just, again, completely naïve, completely feeling, instinct. We didn't know what we'd be going to do, why we liked it or what. It just seemed right and I think it was a good choice…"

Before leaving for Mexico City, Steven Brown participated in a memorable concert/party co-organized by Martine Jawerbaum and Antoine Pickels at the Plan K in Brussels. Brussels journalist and friend of the band Thierry Coljon attended and wrote a piece fraught with nostalgia about the event:

'It was twelve years ago. Then an avant-garde group from San Francisco came to establish themselves in Brussels. Tuxedomoon played their first European concert at the Plan K. This venue (…) will remain a symbol of an era, not only for having given birth to a troupe of the same name that is still celebrated worldwide but also for having hosted lots of memorable parties and concerts throughout the eighties. It was the pride of a cosmopolitan city and Tuxedomoon was the magical symbol of a dark and torn, exacerbated romanticism. It was before MTV, it was a time when music primarily influenced the creation of ballets and dance spectacles of all sorts and vice versa. It was a time when Tuxedomoon inspired Béjart or Wim Wenders, a time when video art, more than clips, served to express talent rather than promotion (…) Scattered on two floors, films, video and music, party and

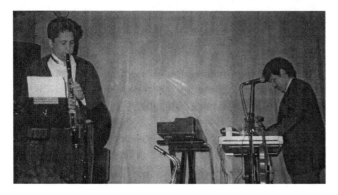

Reininger and Brown live at LiveStation, Dortmund, 12/12/92. Photo Oliver Schupp

good old time's performances strived on making us forget the passing of the years. For a party that, as it had to, looked more like a funeral complete with dressed in black zombies (...) and the elder's embraces, all glad to meet again those that our quite different modern times had separated. All until dawn... On that night when the moon left (...) Seeing again films and videos, listening again to this music quite unique, experimental while talking the language of a wounded heart, one can tell that times have changed. That Brussels will never be the same again, that the budgets allowing the final opening of the Plan K are still not available, that excessive regionalization sacrificing culture does not leave any room for creative people like Steven. Steven who leaves... Before the others would follow... Brussels, you were beautiful!' [68]

Release of Tuxedomoon's Solve Et Coagula compilation album. By the end of 1993, when obviously nothing new was expected from Tuxedomoon, Crammed released a Tuxedomoon compilation album including some remixes. The title, *Solve Et Coagula*, was a motto from alchemy which used to adorn Reininger's personal checks in San Francisco. [69] A press conference was held in Brussels for the occasion, with only Reininger and Geduldig attending as they were the only historical members of the band still living in Brussels. At the time Reininger considered *in petto* that it was a strange mission 'to do interviews to promote a record by a defunct band' [70] while he valiantly proclaimed during said interview session that "Tuxedomoon will never die (...) I can see us coming back together on stage one day..." [71] However such exclamation was then just an act of bravado addressed to the press as the relationship between Reininger and Brown had deteriorated to a point well documented in a letter that Reininger sent to James Nice early in 1994. In this letter Blaine narrated the shooting of a widely broadcast (four millions viewers) TV appearance of the pair Brown/Reininger in Mexico City in October 1993, when they performed a few gigs as "Blaine & Steven" in Mexico City and León. The letter describes, in the hilarious tone of a tragi-comedy, another

the house, all eyes on stage. I catch the eye of a boy upstairs at the table sitting, he smiles and waves, I wave back...' (excerpt from Steven Brown's private journals)

1993

Some time in '93 Release by Crammed Discs of Ramuntcho Matta's album entitled *2 L'Amour* with BLR guesting on "Les Choses De L'Amour"

In 1993, PP works with Anna Domino and her band (Michel Delory & Hearn Gadbois). They will also make a long tour together

02/18/93 SB (with Nikolas Klau) plays at The Opera House, Toronto, with Weird Library Of Art opening

Spring '93 SB plays (with Nikolas Klau & Frank Balafette) at club Luna Park, West Hollywood, a performance centered on *Half Out*

04/03/93 PP participates with Bradford Reed & Phil Kline + his orchestra of boom boxes in *An Evening Of Instrumental Music*, The Gargoyle Mechanique Laboratory, NYC

04/29/93 The dissolution of the Tuxedomoon ASBL gets published in the Belgian official journal

Some time in '93 BLR (for the track "Fame A La Mode," with Bertrand Burgalat & Bilou Doneux guesting, BLR & GM producing) and SB (for the track "Sous Quelle Etoile Suis-je Né?" With Chris Haskett guesting & Haskett + SB + Nikolas Klau producing) guest on the by Bertrand Burgalat (France) produced project of a (various artists including Nick Cave, The Residents, Pulp, Peter Hammill, Marc Almond & Pascal Comelade) *Tribute To Polnareff* released by XIII Bis Records in 1999

06/04/93 SB's farewell concert to Brussels, *Bye Bye Brussels*, at the Plan K, Brussels (with BLR, LvL, BG & PZ), a hugely successful party co-organized by Antoine Pickels and Martine Jawerbaum, with choreographer Thierry Smits dancing on one of SB's songs and performer/dancer Eric Stone with a performance preceding SB's "Voodoo" song conceived as a satire about Europe's politics favoring financial markets to the detriment of humble people.

09/93 SB (& Nikolas Klau) leaves Brussels for good for Mexico

Some time in '93 SB guests on Odio Fonky (a duo consisting of future Nine Rain member José Manuel Aguilera & Jaime López)'s CD entitled *Tomas De Buró*

10/17/93 BLR & SB play at Sala Nezahualcóyotl, Mexico City (with JJ La Rue doing the lights, Nikolas Klau as sound engineer and Jose Manuel Aguilera guesting on an encore). A recording of this concert will be released in 2006 with the Independent Recordings label as BLR & SB's *Flower Songs*

Around that time BLR & SB also performed an excerpt of *The Ghost Sonata* live on a TV show in Mexico City.

10/19/93 BLR & SB play at Teatro Manuel Doblado, León

10/26/93 BLR & SB play at Teatro-bar El Hábito in Coyacán, Mexico City

By the end of 1993 Release by Crammed Discs of Tuxedomoon's compilation album entitled *Solve Et Coagula (The Best Of Tuxedomoon)* featuring the following tracks (the pieces marked by an * were remixed for the occasion): 1. "What Use;" 2. "No Tears;" 3. "The Cage;" 4. "Some Guys;" 5. "Dark Companion;" * 6. "In A Manner Of Speaking;" 7. "Atlantis;" 8. "The Waltz;" 9. "L'Etranger;" 10. "Tritone (Musica Diablo);" 11. "East/Jinx;" 12. "Desire;" 13. "59 To 1;" * 14. "You (Christmas Mix)" *

Around that time, NYC film-maker and video artist Merrill Aldighieri made a video clip for "No Tears" consisting in a mix of the band's archive footage and animation images. The clip was turned down by MTV. Some fragments can be seen in *Tuxedomoon – No Tears,* Greek TV documentary directed by Nicholas Triandafyllidis, Astra Show Vision & Sound, 1998

1994

Some time in '94 BLR & LvL guest on Italian band Minox's 7" entitled *Plaza*

Some time in '94 LvL composes the music for Antoine Pickels's play entitled *Abel/Alexina* that opened at Le Botanique in Brussels

Some time in '94 PP works on *More media* for Macromedia (in Macromedia catalog 1994): loops and midi files sound devices

Some time in '94 Release by Les Disques Du Crépuscule of BLR's *Brussels USA (The Best Of Blaine L. Reininger Vol. 1)* compilation album featuring the following tracks: 1. "Night Air;" 2. "Gigolo Grasiento;" 3. "Mystery And Confusion;" 4. "Ash And Bone;" 5. "Teenage Theatre;" 6. "Tombée De La Nuit;" 7. "Zeb & Lulu;" 8. "Software Pancake House;" 9. "To The Green Door;" 10. "Café Au Lait;" 11. "Come The Spring;" 12. "Ralf & Florian Go Hawaiian;" 13. "Right Mind;" 14. "Letter From Home;" 15. "Broken Fingers;" 16. "One-Way Man;" 17. "El Mensajero Divino"

Some time in '94 BLR contributes a song, "Wilde Jahre," to the soundtrack of a film of the same name directed by Burkhard Steger (Germany)

Some time in '94 Release of BLR's *UVOII – Sound Of Heaven* CD by Fax (Germany) featuring the following tracks: 1. "Soundtrack Of My Dreams;" 2. "God's Picture In The Internet;" 3. "Enanariyo;" 4. "The Bodhi Tree"

Some time in '94 BLR guests on Phillip Boa's CD entitled *God* released by Motor (Germany)

Some time in '94 PP guests (track "Emotions") on Arthur Lee's CD entitled *A Tribute To Arthur Lee And Love* released by Alias

01/29/94 BLR plays at Passage Nord/Ouest, Paris

03/31/94 BLR attends the *première* of NICHOLAS TRIANDAFYLLIDIS'S short film (21 min.) entitled *Dogs Licking My Heart* at Cine Atsy. In this film BLR plays the lead role of a detective and some TM music is used for the soundtrack

04/01/94 BLR plays at West Club, Athens

04/02/94 BLR plays at Mylos, Thessaloniki

episode of Brown/Reininger's everlasting struggle. Brown showed up totally drunk for the show. He was after giving these TV "facists" (the show was allegedly financed by huge financial conglomerates) the treatment they deserved. His rebellion took the form of throwing cactus pots at the employees' heads backstage and, while on air, of "playing" the longest introduction to *The Ghost Sonata* in recorded history, plucking the piano's strings with a pen cap that soon was dropped into the piano where it rattled for the rest of the performance. During the interview, he paused for about 30 seconds after he was asked a question by some bimbo interviewer. Meanwhile Reininger was desperately trying to calm things down. Unfortunately he had been suffering from a sinus condition brought back by "the bad air of Mexico and joy of being re-united with Steven" with every of his sniffles captured by an ultra sensitive microphone as he was playing his viola. Reininger closed his story remarking that it was no surprise to anyone but Steven that he would find it difficult to achieve gainful employment in Mexico after such stunning *début* in front of everyone who could have possibly helped in furthering his career in Mexico. As far as he was concerned, he found himself to be much better off since Brown had left: "Since he left, I have been getting studio work, film work, concerts, all sorts of things, far more than when he was here."

From 1994 to 1997: Brown and Reininger's works in Europe and Mexico respectively.

In 1994, Les Disques Du Crépuscule released a compilation album – named *Brussels USA* – of Reininger's best work. His next major artistic undertaking was his collaboration with a Greek film-maker, Nicholas Triandafyllidis, the same who had written about Tuxedomoon's first concert in Greece in 1988. "I've always had a fascination for Blaine, says Triandafyllidis. I have deep respect for Steven but with Blaine there was something different, sentimentally. Steven is a bit too intellectual for my taste. Blaine was more in the tradition of a man from the 19th century, evocative of Lautreamont or Baudelaire. He was, I have to admit, more rock and roll than the others. So I remained in touch…"

Reininger got his first opportunity to appear as an actor in Triandafyllidis's short film entitled *Dogs Licking My Heart.* In the film Reininger plays the lead role of a somewhat disenchanted detective. Triandafyllidis: "I wrote that having Blaine in mind, without telling him. It's kind of an homage to Lemmy Caution [*Lemmy Caution being the name of a a detective inspired by Bogart's films, incarnated by Eddie Constantine in movies shot in the sixties by Bernard Borderie and Jean-Luc Godard*]. It was shot in London, black and white and actually Eddie Constantine died the same year (1993). The character played by Blaine is

Page 354

a little bit of a Lemmy Caution on the dark side of the moon. Blaine was in that period, spiritual, psychological phase, a very dark period of his life. Steven was gone and there was no one around. He was very lonely…" Blaine didn't find it too hard to find himself in actor's shoes: "(I found this to be) Entertaining. But being on stage as a musician is also a kind of acting."[72] The soundtrack to the film features some Tuxedomoon pieces as there was no money available for an original soundtrack. [73]

This collaboration was to be the first of a series as, one year later, Reininger played the lead role of a singer/violinist and provided the soundtrack music to Triandafyllidis's feature film *Radio Moscow*. Then, in 1997, Reininger starred in Triandafyllidis's *Overcoat*, for which he provided a soundtrack as well. Reininger: "This film was a TV film adaptation of Gogol's *The Overcoat* for the Greek national TV. Since it was to be played around Christmas time there was a certain amount of Christmas baggage in the film. Among these things was a certain melancholic American composer playing Santa Claus. I even had to work with a dog. I kept getting nicotine stains in the beard. At one point the damn dog tried to eat my Santa Claus suit." Triandafyllidis: "Blaine and I became like brothers, even more than brothers, it was too close. Critics used to write that Blaine was my alter ego, I didn't mind, we used to joke about that. It was very creative to work with him because I always believed that musicians, performers, are much better than actors and Blaine is one of the good examples for that." One remarkable feature of all the films that Triandafyllidis shot with Blaine is that Reininger always appears to be pretty much playing his own role. Triandafyllidis: "That's why you choose Blaine. He's a very charismatic person…"

Also worthy of note during this period are Reininger's many guest appearances on other artists' albums, some of whom would become quite famous in later years like Miossec in France and Philipp Boa in Germany.

It was also in Germany that Reininger worked on the *Falling Infinities/Kingdom Of Dreams* project. Reininger: 'This was a project which was organized by a German friend of mine named Stefan Grebe who was the director of photography on Nicholas Triandafyllidis's films, writes Blaine. He introduced me to three of his friends, Michel Pagenstedt, Ingo Schnorrenberg, and one Amir Abadi, known as Dr. Atmo. The idea was to introduce me to some guys from the techno-DJ-club culture of the time, the middle 90's. We all went into the studio in Bergisch Gladbach, near Cologne, owned by Mr Pagenstedt and I laid down some blaine-atude, vocals and violins over their pumpin thumpin grooves. The tracks were bought up by Dance Pool, a sub label of Sony and we even did some gigs to promote. There was a video as well. I thought this

06/12/94 SB publishes an article (in French) about the Zapatista uprising in Chiapas in the *Partis Pris* review, vol. 7, published by Plateau, Brussels

06/15/94 BLR plays a Fnac showcase in Brussels

'Alive and well. I now believe in miracles… I have arrived safe and sound in Mexico City. In Boulder Colorado where I was visiting my family I went to the Public Library and picked up Homer's Odyssey. Without really thinking about it I checked it out and soon couldn't put it down. It was a pure joy to read and reading it when I did really helped me get through this trip. My first attempt at Voyage to Planet Mexico took place on 17 April. Two hours South of Denver my faithful Ford died. Ironically (or not) it was ten miles outside of Pueblo, Blaine's birthplace, that my engine locked up and froze to death. Rick Chiarito, truck mechanic and nice guy, found me another motor and another friendly crazed mechanic put it in. Second attempt, 26 April. Halfway through the state of Zacatecas I was on the verge of flipping out. "Where am I?" "Why am I doing this?!" Really starting to question the moorings of my reason. I was dreading the six hours yet to go and the travails certainly in store, not the least being STAYING AWAKE AND IN TOTAL CONCENTRATION, I had already committed countless infractions in an arcane system of highways and byways.

Only once I got "bit" (la mordida) and to pay off a cop. "Fold the bills, fold the bills." In Mexico the autoroute will suddenly dissolve and you find yourself in the center of a town; a labyrinth to be navigated by sheer wit, the object being to find your way out and pick up the same highway on the other side. Yes there are signs and if you wanted to take the time you might find them. This highway reality is a grim joke among the natives here and one I can now share. But back to my near breakdown in Zacatecas.

I saw a vision. Just as despair began to cloud into my car, an eagle flew overhead. It had something in its mouth. It was a serpent. Way back in the mists of Pre-Columbian America the tribe that would one day be the Aztecas wandered and waited for a sign from their god to indicate where they could stop wandering and settle down. The divine sign was an eagle with a serpent in its mouth. The wanderers found it where Mexico City stands today. I was humbled and buckled down and drove.

Later, stoked on liters of Nescafe bought at Hiway Pemex stations and the liquid ginseng my brother Mark had given me I stand at the summit before the plunge into the Beast. A huge black cloud looms over el DF even at night. A black cloud…

I laugh, put Mozart into the cassette player and jam out into the chaotic roller coaster flowing rapidly into what I've called "home" for seven years…' (excerpt from Steven Brown, *Stories From Mexico*, Rowhouse Press, 2001. This book was published again, with a Russian translation, by Neo Acustica as appended to the ltd edition *Nine Rain Choice* compilation box set released by this label in 2003)

08/94 SB is in Chiapas during the Zapatista uprising where he meets the members of the anarchist collective named La Guillotina who will become close friends in Mexico City and later in Oaxaca

12/08/94 SB plays in Mexico City with Nikolas Klau, Jose Manuel Aguilera, Juan Carlos López & LvL

Page 355

1995

Some time in '95 BLR, SB and TM are credited for the soundtrack music of Rudolf Mestdagh's short film entitled *Beauville*

Some time in '95 BLR releases *Radio Moscow*, the soundtrack music to the film of the same name directed by NICHOLAS TRIANDAFYLLIDIS where BLR plays one of the lead roles as a singer/violinist. This soundtrack was recorded in Athens (Action Studio, from 12/94 till 06/95, prod.: BLR & Gilles Martin) and released by Polygram Greece as a LP/CD featuring the following tracks: 1. "Night Ride;" 2. "Radio Moscow Theme (Ghosts Of The Arbat);" 3. "Portemanteau;" 4. "Polar Orbit;" 5. "Moscow Calling;" 6. "Night Streets/Lone Pianist;" 7. "The Czar's Music Box;" 8. "Arbat Café Orchestra;" 9. "Bolshoi, Bolshoi;" 10. "Ambient Hell;" 11. "Radio On;" 12. "A Kick In The Head;" 13. "Ladies & Gentlemen…;" 14. "Totentanz;" 15. "Four Card Stud;" 16. "Let's Kick Again." Tracks 1 to 9 were re-released in 2007 on LTM's *Elektra/Radio Moscow: Soundtracks* CD

Some time in '95 BLR guests on Miossec's album (released by Pre, France) entitled *Boire* for the following tracks: "Crachons Veux-Tu Bien;" "Recouvrance;" "Gilles;" "Combien T'Es Beau, Combien T'Es Belle;" "Que Devient Ton Poing Quand Tu Tends Les Doigts"

Some time in '95 BLR guests on Dominic Sonic's CD (released by Pre, France) entitled *Les Leurres*

Some time in '95 PP guests on Benjamin Lew's CD, *Le Parfum Du Raki* released by Crammed (MTM vol. 35)

Some time in '95 Alejandro Herrera joins SB's band in Mexico and the group begins to work on what will become **Nine Rain**'s first CD. In December Nine Rain participates in the *Festival Internacional De Musicas De Vanguardia*, with Pink Dots, Mexico at the UNAM Cultural Center

Some time in '95 Release of (various artists) *The Materiali Sonori Guide To Intelligent Music*, vol. 2, including SB's "To Hope" (from the *Lame* album)

02/16/95 PP plays participates in a festival presented by Phil Kline at The Gallery, NYC, entitled *Hammering Away*

09/07/95 BLR on a one-man show at Ex-voto, Brussels

10/14/95 Phil Kline plays at La MaMa, NYC, with PP a.o.

1996

01/96 Martine Jawerbaum suddenly dies of an aneurysm

Between 1996 and 2000 PP performed several times in the NYC area with Ecco Bravo, an ensemble consisting of PP, bass player Dave Kennenstein, drummer Josh Mathews of Vardo and DJ Jeff Davis as sound generator. Some of PP's work with Ecco Bravo will be released in 2005 (on PP's *Idyllatry* CD, released by LTM in 2005, with the track "Tunguska" and on Stilll Records' (various artists) compilation album entitled *Stilllysm* with the track "Do You Feel Five?")

would be the big time. It wasn't. Will they never learn? It was good stuff, in any case.'

As for Brown, if his decision to move to Mexico did not prove to be such a sound one at first financially speaking, the political activist found himself almost immediately in the land of his dreams. Brown: "I thought that leaving for Mexico was a good choice: it's a beautiful country with beautiful people. Then I also had the feeling that *something* was in the air: "Something very important is going to happen and I want to be there when it happens!" And, like eight months after I got there, the Zapatistas took over five towns in Southern Mexico and a revolution started! And I was: "This is it, an Indian revolution, finally…" For me, it was a very personal involvement that I had. In 1970 I had joined an Indian occupation outside of Chicago. They occupied a national laboratory, saying it was their land that the government had stolen from them. I went there and made a super-eight documentary of this event and met their leader. I just felt this affinity with these people, being part of a minority myself as a queer person. The Indians had been *so* ripped off and humiliated. And so 20-30 years later when the same thing happened in Mexico, I was there! I made my way into a big meeting: the Zapatistas invited the civil society to a big rally. It was 1994, in Aguascalientes, Chiapas. [74] They had set up a big tent, an amphitheatre and all the *commandantes* got up and spoke and at one moment they had this march. Oh man! It was really something else, to see hundreds of men, women and children marching. These people had so much courage to just declare war on the Mexican government (Brown talks with tears in the eyes), saying: "You know what? It's better to die with dignity than to live like dogs!" Tears were flowing at one point. And these were "little" Indian people who were so fucked over for so many hundreds of years. I was happy to be there and experience it, just to feel this wave of…revolution, of power and of dignity! That word, "dignity," is one that you don't use much anymore. What does it mean? What kind of life do we want? They just raised all these questions that everybody thinks about but doesn't want to address. Especially for Mexico, when they appeared, they really resonated with the entire population because Mexicans don't really complain, they're always smiling and look happy but underneath: they're fed up. They know that they're getting shit on. They don't have anything but they're always smiling. Finally these guys came along and they said it like it is. It didn't happen in Mexico City, it didn't happen in Universities, it didn't happen with the rich or the *bourgeois* or the students. It happened with the poorest of the poor: it took *them* to teach the rest of us. "Wake up! I went down there twice with Nine Rain [*once was in 1996; Nine Rain being Brown's Mexican band*] to play on different occasions. One

Page 356

was an intergalactic meeting against neo-liberalism (laughs). Intergalactic meeting! These guys have a sense of humor, it's got Marcos, their *sub-commandante*. He's like a poet-warrior, a guy right out of mythology in his flesh and blood... I shook his hand and I gave him a Nine Rain record (laughs)."

A member of the left-wing anarchist group named "La Guillotina" [*a publication of the same name is distributed on University campuses and places of culture in Mexico's main cities*] remembers their first meeting with Brown: "Tuxedomoon was known in Mexico from the start of the eighties. At that time underground or alternative music was to be found on cassettes or bootleg recordings. Since the so-called "Mexican Woodstock" in 1971,[75] an event that had scandalized Mexico's conservative society by the presence of drugs, nudity and... the American flag, rock had been banned in Mexico for more than a decade. But Tuxedomoon and alternative music never ceased to be part of La Guillotina's ambient. We met Steven Brown through the Zapatistas' uprising in Chiapas, in August 1994. It was like this fight was his personal fight and he obviously got involved body and soul into it. Later he participated in lots of political actions for which he and La Guillotina shared a community of views. Brown and his band Nine Rain also contributed to popularize the Zapatistas abroad and in Italy particularly [*Nine Rain did a short European tour in 1996, with dates mainly in Italy but also in Brussels and Amsterdam, during which members of La Guillotina showed films and gave conferences*]. We do consider our relationship to Steven Brown as "magical" as we always got to meet in places and at times that were quite special, in some sort of strange synchronicity. His passion for Mexico does not pertain to the folkloristic kind, it goes to the essence. He's like a mesmerizer through his non-material or non-rational view of history..."

On the artistic level, Brown's main act in Mexico was the founding of a band, Nine Rain, mixing local musicians and sounds with his own inspirations, with help from his friend/ assistant Nikolas Klau.
Alejandro Herrera, a founding member and from many viewpoints co-leader of Nine Rain, tells us the story of this band's origins. 'In 1993, writes Herrera, Steven Brown, Nikolas Klau, José Manuel Aguilera and Juan Carlos López got together in the city of Mexico to work on new musical compositions. During that year, they went on tour and presented material from Brown, Klau, Aguilera and Tuxedomoon, where the fusion of sounds, rhythms and musical trends like blues, jazz, pop, rock and hip hop all got blended with Mexican musical elements.
In 1995, I joined the band that was then still called Steven Brown & band, incorporating my Veracruz influence along

Some time in '96 PP produces Bradford Reed's CD *LIVE! at home*, released by Ft. Lb. records

Some time in '96 BG, LvL and Bernadette Martou form Microdot. The CD, *Trouble In Paradise*, gathering their work over a period of five years will be later released in 2003 by Neo Acustica

Some time in '96 Release by Sony (Germany) of:
1) BLR's EP *Falling Infinities/Kingdom Of Dreams*, with following tracks: 1. "Kingdom Of Dreams – Chapter 1 (Radio Edit);" 2. "Kingdom Of Dreams – Chapter 2 (Album Version);" 3. "Kingdom Of Dreams (Paul Cooper Mix);" 4. "Kingdom Of Dreams (I.N.G.O. Mix)"
2) BLR's double LP/CD entitled *Falling/Kingdom Of Dreams* featuring the following tracks: 1. "Kingdom Of Dreams – Chapter 2 (Album Version);" 2. "The Cricket;" 3. "Cadillac Nights;" 4. "Big Computer;" 5. "Carpet Of Stars;" 6. "Kingdom Of Dreams – Chapter 1 (Radio Edit);" 7. "Kingdom Of Dreams – Chapter 5"
3) BLR's mini CD, Falling Infinities/Cadillac Nights, with following pieces: 1. "Cadillac Nights – Radio Version;" 2. "Cadillac Nights – Trip Loop Edit;" 3. "Cadillac Nights – Feel The Sky Mix;" 4. "Cadillac Nights – Album Edit;" 5. "Cadillac Nights – Hardloop Mix"

Some time in '96 Release of The Sleepers's compilation album *Less An Object* (Tim/Kerr) with SB guesting on "Mirror" and "Theory"

Some time in '96 Release by Opción Sónica (Mexico) of SB's Mexican group Nine Rain's first CD (Nine Rain then consisting of SB, Nikolas Klau, José Manuel Aguilera, Juan Carlos López & Alejandro; with LvL, Pierre Narcisse, Patricio Iglesias, Poncho Figueroa & Ivan Georgiev guesting. Note: "Nine Rain" is sometimes spelled in one word: "Ninerain" or referred to as "9rain"), *Nine Rain*, featuring the following tracks: 1. "Rainy Jaranero;" 2. "Raw Girls;" 3. "Medios Masivos;" 4. "A Drink With Jim;" 5. "Oración Caribe;" 6. "Razza;" 7. "Too Bad;" 8. "The Virgin Is A Molecule;" 9. "Sodomy Dancing;" 10. "God Of Duality;" 11. "Marcos/Carnaval;" 12. "The Way;" 13. "Into The Sea". The CD is dedicated to Martine Jawerbaum. Band's official website: www.ninerain.com

Some time in '96 SB plays the role of Aaron Copland in Jose Luis García Agraz's feature film entitled *Sálon México* (prod.: Televicine S.A. de C.V.), a remake of the forties' classic of the same name

Some time in '96 BLR contributes two songs ("Simple Advice" & "Trumpet Song") to the soundtrack CD entitled *Freispiel* released by EMI (Netherlands) (see http://www.filmevona-z.de/filmsuche.cfm?wert=67761&sucheNach=titel&CT=1)

Some time in '96 Release of Harold Budd's CD (All Saints, USA) entitled *Luxa* featuring a cover of SB's "Pleasure". SB and Harold Budd will later work together but nothing from that collaboration was ever released

01/96 SB was back in Europe with friends from La Guillotina, playing with Nine Rain (with LvL) on a tour promoting the Zapatistas. He played some dates in Brussels (including one at the Beursschouwburg and one at Magasin 4 on 01/05/96) , six dates in Italy (including one in Milan - CS Leoncavallo - on 01/14/06) and one date in Amsterdam.

Page 357

Luc van Lieshout: "I worked with Steven Brown and Nikolas Klau until they left for Mexico. Then, around 1994, I went to Mexico and I played a few gigs with them and Nine Rain. Then I played with them in 1996, which was when they came to promote the Zapatistas. We then played two gigs in Brussels and six concerts in Italy in socialist squats. In Milan, for instance, we played for 2,000 people on the site of an abandoned factory. Then we played for ten people in another city with the same kind of promoter. It was quite anarchistic. In Brussels we played the Beursschouwburg. So we'd play but there were also some activists from Mexico City doing their propaganda for the Zapatistas, including films and conferences. I played on the first Nine Rain record as they had sent me a tape in Brussels. I played here, in my basement in Brussels, and sent them back the tape in Mexico where they mixed my trumpet into the whole. It happened because I had already played parts with them when I visited in Mexico."

03/96 Presentation of Nine Rain's CD at the bar La Tirana, Mexico City

03/29/96 Nine Rain plays at Nuevo Lucc, Mexico City

07-08/96 SB plays with Nine Rain at the first EZLN (Ejército Zapatista de Liberación Nacional: *Zapatista Army of National Liberation*) intergalactic meeting in the Lacandone forest in Chiapas

10/96 Nine Rain participates in the celebration of Radio Educacion's 28th Anniversary, Mexico City

11/96 Nine Rain provides original music for choreography *Cranck, La cultura del Safo* directed by Gabriela Medina

1997

Some time in '97 Release of Anna Domino's compilation album, *Favourite Songs From The Twilight Years 1984-1990*, featuring "Rhythm" with SB guesting

Some time in '97 LvL composes the music (with Noise Maker 5) for Thierry Smits/ Antoine Pickels's ballet entitled *Corps(e)*. Later he worked with the same Smits/pickels for a ballet named *Nat* created in Antwerp

Some time in '97 BLR guests on Trance Groove's *Paramount* CD released by Intuition (Germany)

05/10/97 PP plays with Vardo at the Knitting Factory, NYC

05/24/97 Nine Rain plays at Museo Universitario Del Chopo, Mexico City

Some time in '97 Release by Ankh Prod (Greece) of BLR's soundtrack music CD to NICHOLAS TRIANDAFYLLIDIS's TV film *The Overcoat* (81 min., Astra Show Vision & Sound) entitled *Manic Man* featuring the following tracks: 1. "Manic Man;" 2. "Tragic Sky;" 3. "Build A House;" 4. "Silent Blight;" 5. "King For A Day;" 6. "Cancel Spring;" 7. "Love Bite;" 8. "Freeway;" 9. "Al Haqq;" 10. "Jingle Hell;" 11. "Sanctus;" 12. "Xmas Blooz." The film stars a.o. BLR as Santa Claus

06/12/97 PP plays at The Charleston, NYC, with Ecco Bravo

with the sounds from requinto jarocho [*i.e. a small Spanish guitar typical of the son jarocho music style from Veracruz*], jarana [*i.e. a guitar-shaped fretted stringed instrument, from the Southern region of the state of Veracruz*] and harmonica. Of course I had heard some Tuxedomoon songs before on some very underground kind of radio programmes in Mexico City and on Wenders's film *Wings Of Desire*. When Steven and Nikolas arrived in Mexico, I was introduced to them by a big fan of Steven, Teresa Mendicuti, who was aware that they were looking for a musician who played son jarocho. So for her birthday party she organized a big live music event and we jammed together for a wild time. Then Niko gave me their address and during rehearsals they played "good cop-bad cop" with me, with Steven being the bad cop kind of character. At the time, they were playing in a bar called "Bar Mata" in downtown Mexico City. I joined them for a couple of gigs. There I got to meet the rest of the band: José Manuel Aguilera and Juan Carlos López. I was finally invited to join the recording of their first album.

The band called itself Nine Rain in March 1996. A recording of the same name [*i.e. their first CD released by Opción Sónica*] was released the same year. It was mainly made in Mexico City but there were also people from Belgium [*Luc van Lieshout guested from a distance, recording his parts in his home studio in Brussels*] who collaborated in the making of the work.'

The release of Nine Rain's first album coincided with a huge drama in van Lieshout and Brown's personal lives. In January 1996, Martine Jawerbaum, Tuxedomoon's ex manager, van Lieshout's companion and Brown's closest friend, suddenly died of an aneurysm a few months after she had given birth to a baby girl, Zoé, she had with Luc van Lieshout. Brown eloquently expressed his mourning by dedicating Nine Rain's first album and 'everything I've ever done' to Martine Jawerbaum.

As for the reason why the band called itself Nine Rain, Brown gives the following explanation: 'Nine Rain the name comes from a cut-up of the Aztec calendar. There are 20 days in the Aztec month each with a name. Day # 19 is "rain," day # 9 is water. "19 rain" was too cumbersome so we changed it to 9. Hoping the gods won't be angry. Nikolas and I thought we had invented this name, Nine Rain. A few years later we were surprised to learn from an old gentleman well versed in Mexican history that 9rain was a deity, a "tlaloque" (Tlaloc is the god of rain for the Aztecs. A tlaloque is a deity related to Tlaloc). He said the pyramid in Cholula was related to 9rain. A year or so later I happened to be visiting Cholula and I took a tour of what was left of the pyramid... Not much... from what once was the apex now stands a little church and from there you can see down in the distance the perimeters of

Page 358

what was the largest pyramid in the world second only to Giza in Egypt. On the tour I summoned the courage to ask the guide if he knew anything about a deity by the name of 9rain. Expecting a negative reply I was overwhelmed when he explained that the original pyramid built on this site (…) was built for the god 9rain who represented the concept or essence of rain (…) 9rain was the deluge: 365 days of rain… the matrix as it were. I still think this is why it rains almost every time 9rain plays or has a meeting. I also think 9rain is alive and well and living in Belgium.'[76]

CHAPTER X
From the nineties till Tuxedomoon's 30th Anniversary in 2007: the never-ending story continues...

1997 (continuing) - 1999: release of Joeboy in Mexico; Tuxedomoon plays as a trio in Tel Aviv, Athens and Polverigi; release of Nicholas Triandafyllidis's Tuxedomoon - No Tears documentary; Blaine Reininger leaves Brussels for Athens with his wife JJ La Rue terminally ill; Reininger releases his The More I Learn The Less I know solo album

1997 was the year of Tuxedomoon's resurrection, albeit one reduced to the "core" trio of Brown/Principle/Reininger. It began with the recording of an album in Mexico, *Joeboy In Mexico*, that only hardcore fans could spot as a Tuxedomoon undertaking as the name of the band was not mentioned on the cover. Most probably for contractual reasons: the

1997

Some time in '97 Release by Opción Sónica of the *Joeboy In Mexico* CD (Esteban Café: SB; Pandro Hocheval: PP; Paco Rosebud: Nikolas Klau; Matt Pockoy: Alejandro Herrera; Berliner Angelini: BLR; Ruan Rotterdam: Juan Carlos López; Cox: Vicente Cox Gaitán; Polo Pavón: Polo Pavón) featuring the following tracks: 1.

Steven Brown and Peter Principle in Mexico City while recording *Joeboy In Mexico*. Behind them the sign commemorating Belgian presence in the 1966 Olympics. Photo Eugenia Montiel

"The Door/Viaje En La Sierra Madre;" 2. "Brad's Loop;" 3. "Les Six;" 4. "Shipwreck;" 5. "Zombie Paradise I;" 6. "Zombie Paradise II;" 7. "Bitter Bark;" 8. "El Popo;" 9. "Hindi Loop;" 10. "Ambient Popo;" 11. "Keredwin's Reel"

06/13/97 TM plays at *Next Festival*, Tel Aviv: *Hypothetical Elevator Music*

06/18/97 TM plays at Lycabettus Theater, Athens: *Urban Leisure*, followed by a concert in Thessanoliki. The concert in Athens was filmed by Nicholas Triandafyllidis (also promoting the Greek shows) and forms part of the material featured in his upcoming *Tuxedomoon – No Tears* documentary released in 1998

Excerpt from the programme distributed at this concert: 'Tuxedomoon, an artistic collective, a gang that disturbs the stagnant waters of the musical intelligentsia, the flower power with thorns and French perfumes, street intellectuals, the rainbow bridge between existentialism and electrocution, choose and function as spiritual ancestors of Dadaism, surrealism, like beat aesthetes with dirty hands creating happenings in the streets and leading a swarm of young Californian artists spreading their wings just as punk and the self-regulation of the music culture broke out, the independent record labels started out and hand-made fanzines were distributed...'

Peter Principle about Winston Tong's input in Tuxedomoon: "He was a first class performer, he brought a lot to the group's aesthetics and wrote interesting lyrics. One could say that Tuxedomoon was the music and he was the face..." (G. Episcopo, "Tuxedomoon, la musica multimediale", 11/97, interview visible on: http://www.nautilus.tv/9711it/musica/tuxe. htm)

07/12/97 TM plays in Polverigi (Italy), *In Teatro Festival* for the 15th Anniversary of *The Ghost Sonata*

Note: A live version of "Brad's Loop" recorded during one of the 1997 aforementioned concerts is featured on *Lost Cords*, part of the *Unearthed* double CD forming part of TM's *77o7* 30th Anniversary box set released by Crammed Discs in 2007

09/19/97 SB plays in Toronto, as a guest of The Weird Library Of Art + party to celebrate the release of *Joeboy in Mexico* + première screening of SB's *The Super-Eight Years With Tuxedomoon* short film

10/97 Nine Rain provides original music to a multimedia show for the presentation of the *Hojarasca* review, Claustro de Sor Juana, Mexico

From 10/30/97 until into the next century: PP regularly acts as a DJ at Bar d'O, NYC: radio In Hi-Fi Exotic Cocktail Music Thursday evenings, Jack Fetterman being the MC of most of these evenings. See: http://www.inhi-fi.com/schedule.htm

12/14/97 PP plays with Vardo, NYC

12/97 Presentation of the *Joeboy in Mexico* CD at Aula Magna Del CAN, Mexico City

1998

Some time in '98 BLR appears in Guido Henderickx's feature film entitled *S*

Page 362

CD was released by the Mexican label Opción Sónica and not by Tuxedomoon's record company, Crammed Discs. Consequently, *Joeboy In Mexico* was released in similar circumstances to *Joeboy In Rotterdam* some 16 years earlier. The mystery surrounding its release intensified as the musicians involved in the recording all took fake names for the album.

It had started from an idea of Peter Principle, who sent some sounds of his own making to Steven Brown around the time when Brown was busy working with Nine Rain. As a result the music featured on *Joeboy In Mexico* was written by Principle, Brown and Nine Rain's member Alejandro Herrera. Juan Carlos López, also from Nine Rain, played on this release as well. Alejandro Herrera: 'After having recorded with Nine Rain, Steven told me that he was planning to record *Joeboy In Mexico* with Peter Principle, and he invited me to participate along with them. He let me hear the ADATs that Peter sent from New York, and we started working on some pieces or loops. When Peter arrived in Mexico City, the three of us started recording at Steven´s home. Niko (Klau) was doing the engineering. When we went to the studio all the other guys joined in.' Blaine Reininger participated at a distance, recording his parts in Brussels to be later mixed into the final result.

Considering the way it was made, *Joeboy In Mexico* got very little attention from the specialized music press. The album is a brilliant mix of Principle's elaborate loops and distinctive bass lines, found sounds collages, bound together by Brown/Herrera's sense of melody ("Les Six" being an absolutely underrated masterpiece). There's a definite Mexican influence, strengthened by Herrera's use of local musical instruments. A great work of ambient music.

Tuxedomoon plays as a trio in Tel Aviv, Athens and Polverigi; release of Nicholas Triandafyllidis's Tuxedomoon - No Tears documentary. After the recording of *Joeboy In Mexico*, Brown received an invitation from Rami Fortis (of Israeli group Minimal Compact) and his wife Naomi to participate in the Next festival of new music in Tel Aviv, on June 13th, 1997. Brown in turn invited Principle to be part of the event. Peter Principle had a plan in the back of his mind: "Steven had invited me in Mexico and we had recorded *Joeboy In Mexico* together. Then Steven and I were offered this possibility to play at this festival in Tel Aviv. I suggested pulling Blaine into it and for me it was also an excuse to see if we could get anything going and restart the band. What had been on my mind was that we had been, in our early days, already influenced by lounge and easy listening music. Back then, one of the reasons why we did instrumental music was that we thought that we were easy listening music for the

dark depressed *nouveau* poor [1] (…) And Blaine grew up in a *milieu* where there was a lot of easy listening music and we tried to absorb it while many people aimed to reject that. In the mid nineties I got involved in this lounge revival wave in New York City. In the meantime sample technology had arrived and a lot of people started to look for other music than the most current music that everybody had been doing. Up until the sampling, trendy music had evolved in a kind of very straight line and directly related to what had been directly before that. But now you could sample together music coming from all these different environments: 50's jazz drum beats with Taiwanese singers for instance. Suddenly there was a worldwide movement to open easy listening bars and eventually all easy listening places…

So in 1997 I remembered how Steven and Blaine had done "Urban Leisure." So why not do "Urban Leisure" for the late nineties? We decided we would get together and do a set of instrumentals that we were going to write on the spot in Tel Aviv but of course our ambitions were larger than our capacity. We ended up doing some music and some we re-arranged from other periods and even managed to play some versions of some of the *Joeboy In Mexico* CD. So we had to throw that show together without being in a really coherent whole and hence it did not really work for any of us. But in the meantime Blaine, through his management friend Nick Triandafyllidis, found us two gigs in Greece [*including one in Athens on June 18th, 1997*], one of which they filmed [*to be featured on Triandafyllidis's Tuxedomoon – No Tears documentary released in 1998*]. We even played the 15th Anniversary of *The Ghost Sonata* at the Polverigi Theater festival on that tour [*on July 12th, 1997*]. We did these shows together and then we kind of agreed to meet again and we didn't.'

Blaine Reininger leaves Brussels for Athens with his wife JJ La Rue terminally ill; Reininger releases his *The More I Learn The Less I know* solo album. Between the Summer of 1997 and Tuxedomoon's next move, late in 2000, more than two years passed. What happened? First of all, Tuxedomoon's situation had changed: from having its members concentrated in the small microcosm that was Brussels, the band had to adjust to the fact that they were geographically dispersed. Getting together somewhere physically or simply getting anything discussed within the group had become difficult, even more so when considering their state of chronic poverty. Also Principle suspects Brown and Reininger attempted to carry on as a duo. Principle: 'I wasn't invited to the next events which had Steven and Blaine performing with a backup tape somewhere in France and Italy during 1998. So I guess that everyone was still trying

(Belgium, Europartners Film Cooperation)
Early 1998 BLR leaves Brussels for Athens with his wife JJ La Rue terminally ill

Some time in '98 BLR contributes the track "The Flying Game" to the soundtrack CD of Nikos Kypourgos's film entitled *Black Out*, released by Ankh Prod. (Greece)

Some time in '98 WT contributes the track "Negative Confessions" to the *Beaten to the bone – Erotic Spoken Word* compilation CD released by Lure/Black Madonna productions, San Francisco

Some time in '98 Release of BLR's *Orphans* 7" featuring the following tracks: "Cosy Little Planet" & "Burnsday," released by Syntatic, limited ed. of 100 copies

Some time in '98 Release of Nicholas Triandafyllidis's *Tuxedomoon - No Tears* documentary (prod.: Astra Show Vision & Sound). The film (aired on Greek TV) features long interviews with BLR, SB & PP and a wealth of archive footage

Excerpts from the interviews featured in Triandafyllidis's documentary: (Steven Brown) "We did the music that we liked (…) If it was interesting to us, that was Ok (…) If anybody came up with an idea that sounded a little bit too much like this or that, we said: "no, no, no." It had to be something we thought was original, something from us. We were honest, people like honesty. I think if you speak for yourself, then you speak for many people…" (Peter Principle) "We always tried to make acoustic instruments sound electronic and electronic instruments sound acoustic. So that was another aesthetic that we had. We didn't want to use the electronics just to sound cold, alienating and electronic by themselves. We had a firm belief that technology is an extension of the human condition and we wanted to make that apparent through our music" (Blaine Reininger) "I've always been a symmetrical person (…) a certain beauty of mathematical symmetry, a sort of classicism. Chaos doesn't have a great part in the music I make on my own. So I guess these guys, and Steven in particular, and Peter, would be working against my passion for symmetry, almost compulsive, obsessive. I also like extremely simple melodies, so simple that they become heartbreaking (…) That's what appeals to me: just to be on the edge of *naiveté*. So these guys were working against me. So we had tensions (…) I guess that made the music interesting to people."

Between 1998 and 2000 According to Mirco Magnani from the Italian band Minox, BLR & SB contributed to some as yet unreleased Minox tracks recorded at their studio in Pistoia (Italy)

Some time in '98 BLR & SB play at some locations in France and Italy according to PP

Late February /early March Presentation of the *Joeboy In Mexico* CD at Salón Mexico in Mexico City including:
02/28 Screening of SB's *The Super-Eight Years With Tuxedomoon* short film at Tower Records, in the presence of SB & PP
03/05 *Joeboy In Mexico* multimedia concert (with projections & 15 dancers: Miguel Angel Díaz & Gerardo Delgado choreographers) with SB, PP, Nikolas Klau, Alejandro Herrera Vicente Cox Gaitán, Pancho Saénz & Arno González.

Peter Principle: 'The show as presented never happened. I did go to Mexico and we did perform at a different club some days after that. it was a huge extravaganza with 20 or so of Steven's dancer friends on stage as well as Niko, Alejandro (from Nine Rain), a violinist and a drummer...'

05/31/98 PP plays at Context, NYC, with Phil Kline & Bradford Reed

06/14/98 PP plays with Ecco Bravo at Wah Center, NYC

07/15/98 JJ La Rue dies in Athens

An ex-BMG artistic director, Francis Weyns, reminiscing about Blaine Reininger and Tuxedomoon in the nineties. 'In 1996, I started working as publishing manager at BMG in Brussels. At the time a colleague of mine, V(...) D(...), who knew Tuxedomoon, because she once had had a relationship with Bruce Geduldig, called me up and told me that Blaine was looking for a publishing and recording deal. I was (and still am) a huge TM-fan, so I called Blaine and asked him to come over to talk. He was at first reluctant to come. After a while I knew why he was reluctant: he was in desperate need of money, and every trip to our office cost him money.

He came in, suave and elegant, smoking cigarettes with a small cigarette holder. I felt like I was meeting a movie-star from the thirties. Some colleagues (*i.e* I believe from the label Play It Again Sam had "warned" me: Blaine was over and out, was a drug-addict and just needed money).

We talked, and I was very interested, although I saw that the warnings I got were not very much besides the truth. The thing I firmly believed in was that Blaine was a very creative guy and that with the right settings he could make a fantastic album. On the next time we met, he brought some demos on DAT, and his Tuxedomoon albums and we started talking about looking for a record deal. I signed a publishing deal with him with a substantial advance. I gave the demos to the classical

to feel out the situation and it was not clear what course it all would take. Trying to remember about that led me to think about my real role in Tuxedomoon. The boys have pretty much always resented their needing me to facilitate their relationship (before me it was probably Tommy Tadlock; I didn't know them well enough then). In 1998 after I had tried to reform the group, they then tried to make an album amongst just the two of them. Of course they were not working on a Tuxedomoon project specifically but the timing was suspicious since we had agreed six months earlier to do this very thing together and spoke of it to the press. Evidently they got very little done despite dedicating a lot of time. Blaine's wife, JJ La Rue, often called me "the glue" but more often I do seem like the schoolmaster as we are so seldom together and time seems to be more of an issue for me – as I have to manage to survive in such an expensive place as New York City – than the rest of them...'

The year 1998 was a "black year" in many ways for Blaine Reininger, followed by one during which he had to build himself up again, including the necessity of rebuilding his friendship with Steven Brown which had greatly deteriorated in the early nineties. In 2001, when interviewed about this period of his life, Blaine delivered a poignant testimony: "To tell you the real truth about it, my career withstanding, life in Brussels was absolute hell from the first day I arrived until the day I left. I hated everything about it. I was subjected to indignities I was not prepared for, that I couldn't understand, that I couldn't foresee. I at least managed to survive then. Having my gas turned down in the middle of the winter, sitting there in the freezing cold with no means to cook food or heat

water. It seemed barbaric and the rules were so absurd. In the US you paid for what you used and you were billed for it. In Belgium they took an average of what you used over a year and at the end of the year you would have to pay more or be paid back something. It didn't make any sense anyway, it wasn't logical and I was constantly bumping my head against these massive cultural differences and I couldn't understand why people were doing things the way they did them.

And it was just a constant struggle for money in Belgium. I just ended up doing just anything. And I brought a lot of that on myself because of my drinking and my drug use. I was miserable in Belgium and there were very few islands, very few moments of joy, moments of grace… For me it was a hell, it was 17 years of hell. I played gigs but after a while I began to be so disillusioned about the whole thing and the music became a means to an end, which wasn't healthy. And as a foreigner without papers, I couldn't go working anywhere. I did what I could and kept everything afloat but the artistic satisfaction was really found wanting. "I'm the famous Blaine Reininger, so you can't turn my gas down, you can't take my phone because I need it" "We don't care who you are!" I felt like a petty criminal. And I suppose I was: I didn't register with the police when I moved, we don't have to do that in America, I didn't pay taxes etc. I'm amazed I managed to keep my sense of humor through all this, it was tough. And the things we did, the records we made, there was a body of work there but taken as a whole, the whole experience was a nightmare… And it ended as an ultimate nightmare. When things fell apart, they fell completely, absolutely, apart.

It was 1998 when I became aware of the fact that JJ was ill. I realized that when we went to play in Bologna as JJ complained about shortness of breath. We thought it was related to the fact that she smoked as much as I did. We had to run to catch the plane from Bologna and I was: "Come on JJ, you have to hurry up!" And I turned around and she was laying flat on the pavement. She just fell over. "Oh Jesus Almighty, what is this?!" And she was just fainted. There was obviously something major wrong there. I didn't know what the fuck it was. So they sent me, no checking, on the plane and there on the plane she fainted again, fell over. We went back to Brussels and JJ said on the plane: "Blaine, I'm scared." I didn't know what to think or to do except what was immediately required, to be there. After we landed in Brussels, she fell over again, just melted, while we were coming down the stairs of the plane. So they put her into an ambulance. We didn't know what was happening.

So, *par hasard*, wandering through the streets of Brussels, I happened to see a sign on a wall about a catholic social center in Ixelles and it said: "Health Care For People Without

department of BMG, and they were very interested: they wanted to sign a one record deal. At the time they wanted to make "other" records than mere classical ones, and I believed that these guys understood what it was about! Blaine was very, very happy, and started contacting people (I think *i.e.* Luc van Lieshout). Upsetting fact: after a month, the guys from the classical department decided not to pursue the recording. Blaine was enormously depressed, and I was very angry. Those two guys were assholes in the first place, as it's a thing you don't do: signing a deal and afterwards saying that you won't do the recording.
A couple of months later we tried another "constellation": performances with Peter Vermeersch [*i.e. now the leading force behind The Flat Earth Society, a big band that counts Luc van Lieshout among its members*], Blindman Kwartet and Blaine. It didn't work out. In the meantime I was talking to Crammed as I proposed to buy their publishing catalogue, with *entre autres* the TM-publishing. The idea was to "re-release" the classics from the catalogue and to try to re-form Tuxedomoon. I talked that over with Peter in New York City but the fact that every member of the group lived in another part of the world didn't make it easy. In '99 Marc Hollander gave way to sell his publishing catalogue to us. Big surprise: BMG headquarters said "no" (although they told me beforehand to start negotiate). Marc was pissed off (he was right) and sold his catalogue to Les Editions Confidentielles. He needed the money because his licensing deal with I think Warner in France was discontinued so he didn't have an advance anymore. Marc used the idea to re-release the classic Crammed-albums later on [*in 2003 as the Crammed Global Soundclash re-release of 12 classic albums*], and I got the whole Crammed catalogue at home. A 1000 times "Merci" Marc! In 2000 I left BMG Publishing, because I was fed up with the job (I felt like a bank manager) and started working for EMI. I heard nothing back from Blaine, until I heard his wife had died, and that he lived in Greece…'

Marc Hollander (in 2003): "We tried, around the *Ship Of Fools* and *You* time, to enter into licensing agreements with some so-called "major" record companies but they were not interested, now even less of course. Once there were discussions with a guy who was an artistic director of BMG Belgium who was proposing to re-release everything but it never led us anywhere. I believe it was more of a fan's frenzy rather than the strategy of such multinational company. These people never precede an event. If something happens, then yes: they will jump on the running train…"

Around 1998-99 LvL forms Microdot with BG (LvL composing the music, BG writing the lyrics). The band was joined by Bernadette Martou (BG's future wife) taking care of the visuals and various Belgian jazz musicians eventually played with them. The band's *répertoire* leans towards cabaret-lounge-jazz music best heard at dinner parties or special events rather than at rock clubs

Bruce Geduldig: "We were actually a quintet, with a bass player, a guitar player and a drummer and Luc and myself singing and that was difficult to organize. We did some concerts but it was difficult to get those guys together because they were all working and playing with all kinds of different bands. There was a also a communicational problem as we were asking jazz players to do something that normally they were resistant to or trained to be resistant to. We kind of quit that format and Luc and I started again, just working together the two of us. It just

Page 365

kind of came up out of nowhere. Luc had some material and he asked me whether I wanted to sing on it and then it grew out of that with breaks and stops…"

1999

Some time in '99 Release of SB's compilation CD, *Subway To Cathedral*, dedicated to his friend the late Martine Jawerbaum, by Arteria Records, featuring the following tracks: 1. "Jerry's Theme;" 2. "Waltz;" 3. "The Ball;" 4. "Besides All That;" 5. "This Land;" 6. "Last Rendez-Vous;" 7. "Mi Sono Innamorato Di Te;" 8. "Un Giorno Dopo L'Altro;" 9. "Jean Gina B ;" 10. "The Harbor;" 11. "Life Gone By;" 12. "Fill For me;" 13. "Amid The Wreck;" 14. "You Say You Love;" 15. "The Flight;" 16. "L'Arrivée Dans Le Jour;" 17. "Iberia;" 18. "Music # 2;" 19. "Out Of My Body;" 20. "Decade;" 21. "A Quoi Ca Sert L'Amour;" 22. "Fuga." Arteria Records was a label started by Carlos Becerra (Tuxedomoon's future tour manager) and SB

Some time in '99 BLR is "The Magician" in Nicholas Triandafyllidis feature film entitled *Mavro Gala (aka Black Milk)*, prod.: Astra Show Vision & Sound. Tryandafyllidis: "He was supposed to write the music for *Black Milk* as well but he couldn't since he was in a difficult psychological state since JJ passed away"

04/99 A friendly reunion of some TM members in Grand Junction, Colorado, BLR is back in the USA, many years after his last visit

Blaine Reininger: "When I went back home in Colorado for the first time in 17 years, I felt like a tourist. At the supermarket I didn't

Papers." I took down the numbers and it was just a conspiracy of doctors who had decided to help the needing ones. That's where I went with her. We had to go to the free clinic there in Ixelles, then we had to go to see another doctor and another doctor and another doctor, one series of tests after another… And then we found out that she had a heart condition that was absolutely critical and urgent, the artery going to the lung was obviously under stress and enormous pressure. And that was a heart condition that was extremely rare. There was almost no treatment for it and there was almost no understanding of it. So we were shuffled around from hospital to hospital. They had obviously decided to help as she was an extreme case. And the public health paid for these very expensive tests. And one day a doctor took us in and told us, he was a very blonde Flemish guy: "Well, I don't tell you no fairy tales, this woman is going to die in six months"…

We kind of accepted that. We were going every day to that hospital in Ixelles and she was getting all kinds of anti-coagulating drugs and she was getting her blood tested every day. And that became my mission in life: to care for her. In the meantime I had no energy to keep the house together and it just deteriorated in such a way and the landlord was just such a carnivore… We were living in a hell hole, paying a lot of money for it, 18,000 franks [*i.e. 450 euros*] a month, and it was just a dump, a shit pit and we couldn't go anywhere else. So this guy did everything that was in his power. He called the *huissier de justice* and they came in the door. I took my equipment and hid it in Luc van Lieshout's house. I was looking for some kind of legal aid, there was none. I exerted myself fully but most of my energy was dedicated to try to do what I could for her. And then they came in with the police. It was such a rape, such a violation. It had happened before: the police running into my apartment and writing down the serial numbers of the refrigerator, of the television. I wrote the landlord a letter. "There's a woman dying here, would you please leave me alone!?" No way!

We were planning an escape and Greece was the place. That was the only place. And there was a friend, a rich friend from Cologne who rented a van to get us out of there and we got out to Greece. And then JJ died in Athens [*on July 15th, 1998*]. I was there and watched her die. I was just so blank, I was so numbed by this enormous exertion of will. She didn't suffer that much but I had to deal with this culture in Greece right in the face, in a situation of extreme need. They were not doing anything. She was lying on a bed naked and covered in shit (…) And they kicked me out and then I came back in and I was: "My God, what are you doing here…" They didn't care at all. It was in a public hospital… By then she was already gone, somehow. I told her to go. I looked at the ceiling and I figured

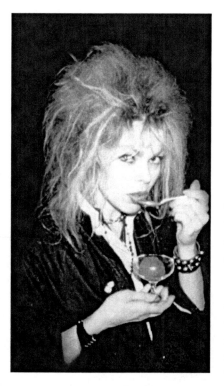

JJ La Rue. Photo courtesy of Blaine Reininger

Page 366

that she was hovering there and I said: "Go, don't worry about me, I'll take care of myself, you should go." And she did! Right after I said that, she began to die. She was 44. We had been together for 18 years. They buried her. She did not want to be buried but the Greek law didn't allow cremation. The Church wouldn't allow this. And they didn't know what a protestant was. She was buried somewhere in Athens.

I was a zombie for some time. Then I started to come out of it. I slowly started to be a human again. I had started to work with the other guys from Tuxedomoon again and it was a very slow process…"

In April-May 1999, Blaine Reininger returned to the USA for the first time in 17 years. It was a family reunion in all senses as he visited friends and family he had not seen in a long time but also met some Tuxedomoon members in Grand Junction, Colorado. Reininger: "It was psychologically a good thing for me. That was less than a year that JJ had died. I had called my mother and said: "Help!" My family was never in a position to help me with money. At Christmas 98, I got a card from my mother with a check for something like a thousand dollars and I was like: "Wow!" Almost fainted. I finally asked my mother if she would buy me a ticket to the States. That was the only manner for me to get back. I had tried and tried and tried but never managed. Money, money… I could not ever get enough money to pay for two airplane tickets to and from the United States…

So when I went back to the States in 1999, we had this little *rendez-vous* in Grand Junction, Colorado, a sort of reunion. Initially, I was just going to meet Nina [*Shaw, i.e. Tuxedomoon lighting designer*]. And more and more people came along. It happened that Steven was around at that time. And other people were around, old friends, Anna Domino, this friend Leslie [*Ward*], the guy who initially introduced me to Steven, who drove up from Oklahoma… So we had this really excellent week-end in Grand Junction, Colorado. It was just one of those golden times as they don't come that often in life. We all felt relaxed and happy to be with each other…

Then I told Steven he should come to Athens and maybe we could do something. As it turned out he did come but circumstances were such that it was pretty miserable. Once we got out of Greece, we had a show in Italy [*at Teatro Niccolini, San Casciano Val di Pesa on August 23rd, 1999*] and we got a little money. This was the first time since JJ died that I was just single and on my own and on holiday, with money. The show went pretty well but the interesting bit was that we met a guy, Davide, after the show who said: "You're my friends, you're my friends!" I had never seen this guy in my life before but he said: "Come to Venezia, I have a big festival there." So we went to Venice by train with this guy and he set

know that I had to put the vegetables into a plastic bag. I had to look hard to recognize the American coins as I had not seen any in many years. I must have looked like an extra-terrestrial being. Evidently a guy like me, with gray hair speaking without an accent and looking lost in the most trivial activities of life must have been an ex-convict who just got out of jail. That was how I was perceived in the United States…"
(BLR interviewed by Ch. Eudeline, "Post-punk – Tuxedomoon, le groupe phare de la new wave est plus en forme que jamais", *Nova*, 2004, translated from French)

09/23/99 BLR & SB play at Teatro Comunale Niccolini, San Casciano Val di Pesa (Italy)

10/21-24/99 SB performs in Julie Ann Anzilotti's play/ballet entitled *La Strana Festa*, Teatro Niccolini, San Casciano Val di Pesa, Italy. A limited number of CDs featuring the music composed by SB for the piece were released by Anzilotti's Compagnia XE in 2004. SB meets Sandro Pascucci, the director of two Italian theaters, namely in Longiano and Cagli, who offered a residency to SB and later (in 2000 and 2001) to Tuxedomoon

11/12/99 BLR plays in Athens

12/99 BLR plays the lead role in Aeschylus's *Agamemnon* theater play directed by Mikhail Marmarinos (in English, the rest of the cast acting in a new translation of ancient Greek) and plays Tuxedomoon's "The Ghost Sonata," "Egypt," "Jinx" and "Music # 2" for the occasion. The play was brought to Caracas, Venezuela, *International Theater Festival*, in 04/00 and in Tbilisi, Georgia, 10/00

us up with friends who had never heard about Tuxedomoon. These people kept us in their house in Venice for almost two weeks and took us around. The guy we had met took us around in his boat. Since they were from Venice, they took us the back way around so that we could avoid all the tourists and we had a really good time. After that Steven and I went to a Greek island, Sifnos. So at least Steven and I renewed our friendship in this way, and the possibility of working together again was that more tangible. So we began to court Peter, to get him involved..."

Musically speaking, Blaine completed his process of self-reconstruction by working on and releasing (in 2000) his next solo album with the evocative title *The More I learn The Less I Know* that he dedicated to his late wife JJ. Again the faithful friend Nicholas Triandafyllidis, who had promoted (and will continue to promote to this day) the recent Tuxedomoon gigs was present. "Myself and Coti K [2] (I introduced him to Blaine) pushed him a lot to do his solo record *The More I Learn The Less I Know* and helped out a lot for its financing, finding distribution etc."

However by then Reininger was also convinced that restarting Tuxedomoon was the only life-supporting option: "It was still a reasonably difficult time for me (…) It had become clear that doors would open for the three of us together or as Tuxedomoon. They were not necessarily open otherwise..." It was obvious indeed that all three of them could not really make it outside of Tuxedomoon. Principle could barely survive in the expensive New York City, doing about anything to make some money while Brown and Reininger, though living in cheaper places, experienced great difficulties to survive exclusively from their art.

2000

Some time in '00 Release of BLR's *The More I Learn The Less I know* CD (prod.: Coti K, executive prod.: Nicholas Triandafyllidis) by FM Rec. (Greece), prod.: Coti K, featuring the following tracks: 1. "Johnny Harpoon;" 2. "Flame On;" 3. "Nail Polish;" 4. "Silly Boy;" 5. "Metro;" 6. "Invisible;" 7. "Noche Lluviosa;" 8. "Monkey Boys;" 9. "Arc En Ciel;" 10. "Ghosts." The album is dedicated to his late wife JJ La Rue in such words: 'This work is dedicated to the memory of my beloved wife JJ. La Rue who left this world July 15, 1998. She was my muse, my soul mate, my boon companion on my travels, my universe entire. JJ., I am still here because I promised you I would stay. This is sorrow no words, no art can express. I love you. I miss you. I will see you later (JJ. La Rue September 19, 1954 – July 15, 1998)'

Some time in '00 PZ participates to a project named *FUBAR*, with Gered Stowe but none of the recorded tracks were ever released

Some time in '00 SB plays a few live dates with Italian band Minox

Some time in '00 BLR guests on Greek

2000-2003, the long road in the making of Tuxedomoon's next official album: Edo Bertoglio's feature film Downtown 81 is presented at the Cannes Film Festival; the Sandro Pascucci and DJ Hell connections; Nine Rain releases a second album, Rain Of Fire, and tours in Europe; Tuxedomoon tours and plays in cities where they had never been before (like St Petersburg and Belgrade) and in some prestigious venues like the Pompidou cultural center in Paris, and records their upcoming Cabin In The Sky album

2000 first brought some media exposure for Tuxedomoon as Edo Bertoglio's film centered on Jean-Michel Basquiat, *Downtown 81*, was finally completed, almost twenty years after its shooting, [3] and presented in May at the *Quinzaine Des Réalisateurs* of the Cannes Film Festival. In 1981 Tuxedomoon had hoped that the release of the film would help them to break through. Ironically *Downtown 81* eventually did help

them in their come back as a band and other artists featured (*e.g.* Kid Creole and the Coconuts, James White and the Blacks, DNA etc.) also got renewed press attention.

The Sandro Pascucci and DJ Hell connections. 2000 was the year that set Tuxedomoon in motion again as their attempts to start working together were clearly bumping into a major obstacle: the band still lacked the finances to organize a joint stay together somewhere long enough for them to compose new music. Back then, they sometimes said to the press that they would use the internet to work together at a distance but that couldn't work considering their *modus operandi*, based on long jams bringing them to a state close to some hypnotic trance. Principle: "We are an anarcho-syndicalist collective. We need to find ourselves all in the same room, improvise, *negotiate* with one another and exude our numbers in this way. Not an easy way to work but the best way for us. We have learned about the inescapability of the *thing* Tuxedomoon and accepted it, and this is where our way of working belongs." [4] One day Principle also attempted to give a description of Tuxedomoon's alchemy seen as a football game: "When we write music with Tuxedomoon, often I come with a bass line and that's like the foundation of what's going on in the end, as a stimulation for what people write on top of it. I found out that a lot of times when I do this with other people, they have a tendency just to play solos and it's very boring and I'm just not interested to play the bass for people like that. In Tuxedomoon in our better moments we're actually listening to each other and we're also actually listening to the muses or to where the music comes from so that as a group we can channel the music rather than have an individual bring something and so we can come to a consensus live. I think that writing music like that is very much like the European game of football or soccer: you have very few rules, you have to keep your eyes on the ball at all

Comuna^l.e
San Casciano Val di Pesa

23 SETTEMBRE 1999

STEVEN BROWN
BLAINE L. REININGER

band Gyro-Gyro's *Round Around* first CD released by Ankh Prod. (Greece)

Some time in '00 Nine Rain provides original music for the Mexican pavilion at the World Expo in Hannover

01/26/00 A "Natural" socialist regime. SB, then recording the upcoming Nine Rain – *Rain Of Fire* – album in La Havana, sends the following email to BLR:
'I've just returned from La Havana. I've never had any desire to go to Cuba and now... I cant wait to go back. It was truly a revolutionary experience!! It's a fairy tale city by a fairy tale sea. Havana is hands down one of the most beautiful I've ever seen. You're transported back in time and space to a city of NO traffic and NO stores (practically)... A void most Westerners try to fill with work and BUYing things is here left wide-open and inviting. Walking through old Havana is like walking through a more beautiful Mexico City (centro historico) 50 years ago... Or something out of *1001 Nights* or Pasolini's Roma or...
Sexy socialism hangs heavy in the air here. A man walking down the street making the briefest eye-contact with a woman will soon literally be assaulted by her. She will lock this drop dead stare onto him and just walk right into him on the street. It's practically the same (or can be) for two men!!! Cuba is a socialist country and it seems to me it always has been... Long before Fidel and Co. The people are very social in a way I've never seen anywhere. Fidel aprovecho de una situacion ya existente but he was a book-learned socialist and imposed a socialist government on what was already a socialist culture. This is basically a Carribean culture of calm, endemic to the region; at times I was reminded of New Orleans. Cubans get free food, free rent and free medical. And that's all there is. Everyone makes the same salary of about 10 USD a month. For the rest you have to use your head cause there's nothing you can buy to loose it... People who wanted that moved to Miami. People told us to bring gifts: soap, toothpaste, chocolate, clothing... This was too abstract for me. Toothpaste? I mean if someone is depending on the odd encounter with a stranger in order to brush or bathe?! There ARE alternatives to these items we take for granted and I couldn't believe in the course of their lifetime people hadn't found them. I did bring chocolate. I soon realized the truth of the situation: you want to give gifts to practically everyone you meet. Because they are such fine people they make you feel fine and you want to give in order to receive more from them. The book *Mount Analogue* is about a mountain that is invisible but according to calculations made by various savants simply must exist. Cuba is like that; only 2 and 1/2 hours from Mexico City but so much farther in time and space, so much farther. Once upon a time there was a revolution here and a new make-believe world was created. And when you're there you want desperately to believe in that world.
We are mixing what we recorded there in famous EGREM studios. Should be done in about two weeks...'

A year later, SB told me about that email: "I was there a year ago. It's a little bit tempered now. That was my first impression. I wouldn't want to live there but it's good to visit! I think that everybody should visit Cuba to see. The most important thing is to see an alternative way of living. You don't have to buy crap all day, every day. If there's nothing to buy and nowhere to spend money and no money, you start to think in a different way. And that's what I saw in

**Blaine in 1999.
Photo Susana Oliva**

Cuba. Even the kids, they're just different from American kids or European kids. They don't think about the new record to buy, the new video or the TV show. No, they have to use their imagination and create another world. And that is the beauty of Cuba. We are forgetting how to create alternative worlds. Is this what we want: coca-cola, Mc Donalds and shopping malls all over the planet? Pizza huts… Is that the reality that we really want? MTV? I don't think so…"

02/16/00 BLR plays at Teatreno, Mantova (Italy) (date not certain, could be in 2001)

03/00 Nine Rain plays at Cumbre Tajin, Vera Cruz

03/09/00 BLR gets married to a Greek artist named Athena Hadji Yanakis then pregnant of their son Ian, born a few months later. The couple separated later on

Some time in '00 SB provides original music for Julie Ann Anzilotti's *Appunti Furibondi* play/ballet

03/17-25/00 SB meets DJ Hell at the *Tecnogeist Festival*, Mexico City

Some time in '00 DJ Hell's International Deejay Gigolo Records (Germany) re-releases TM's *Half-Mute* album on vinyl and releases a CD, entitled *No Tears*, featuring the original versions and remixes of TM's "No Tears" and "What Use?" tracks: 1. "No Tears – H. Platzgumer Remix;" 2. "No Tears – Continuous Mode Remix;" 3. "No Tears – Adult Remix;" 4. "What Use – Heinrich Mueller Technik Mix;" 5. "What Use – Ectomorph Remix;" 6. "No Tears – Original;" 7. "What Use – Original"

04/00 Erik Stein founds a Yahoo discussion list devoted to Tuxedomoon that, years passing, will become quasi-official and gather not only fans but also most of the TM member themselves. Nowadays it's one of the best meeting points for up-to-date information

times and fast reactions matter, unlike the American football that is very much about strategy and getting ten yards etc. European football is all over the place and everybody is a star and the whole game can go one way or another on the flash of a second. In particular this thing without rules and with a very simple game plan, that is Tuxedomoon's working method. The difference between that and jazz is that we're trying not to get involved in all these solos. So we're trying to get some kind of classical film scory kind of music but in an improvisational environment. We try to respect each other by not taking a lot of solos. I always loved that about Tuxedomoon and yet again it's back to living in a commune kind of mentality where you have to share the responsibility for everything and work your deals on the fly and proceed on the basis of non-verbal communication."

Luckily for Tuxedomoon two benevolent "fairies," namely Italian theater director Sandro Pascucci and German DJ Hell, stepped out of the woods and enabled them to reunite and work together again for a significant period of time.

Steven Brown met Sandro Pascucci in Italy in October 1999, when he was performing *La Strana Festa* with Julie Ann Anzilotti's dance and theater company. Steven Brown: 'Sandro approached me after the show and called me the new Nino Rota!' "(He) invited me to take advantage of this artist-in-residence programme that he was in charge of, in these two small towns in central Italy [*namely Longiano and Cagli*]. Of course I jumped at it and after a few months ended up going there. And the deal is: they give you food and housing and a beautiful theater to work in with all the technical capabilities that a theater has, and at the end of your two weeks, a month, you present a show. That's it, that's the end of the deal. And so I did it and Sandro was real enthusiastic and so I said: "Can we do another one with Tuxedomoon?" And he said: "Sure!"" [5]

The other major encounter was Steven Brown's meeting with DJ Hell (real name: Helmut Josef Geier) at the *Tecnogeist Festival* in Mexico City in March 2000. Carlos Becerra, who had already worked with Steven Brown (in releasing his *Subway To Cathedral* compilation album for instance) was one of the promoters of this festival. "I was on my own doing the festival with my partner, remembers Becerra. I invited Steven to come. I started introducing some DJs to him. At first they didn't know who he was but when I told them: "This is Steven Brown from Tuxedomoon," they couldn't believe it! They explained how much Tuxedomoon's music had been an influence to them. It was very refreshing for everyone because although techno music is really happening in Latin America now [*i.e. in 2001, year of Becerra's interview*], I sensed that a lot of the scene was being influenced by the early eighties stuff. Some of my friends believe that techno is new but on the experimental

Isabelle Corbisier interviewing DJ Hell in 2002. Photo Patrick Bottu

side of the music, it remains pretty close to what Tuxedomoon was doing at the beginning (along with Coil, Cabaret Voltaire, Throbbing Gristle, Suicide…). All of this 80's underground electronic music scene, you can see that there is a connection today. After having talked with DJ Hell, he proposed to work on a Tuxedomoon remix project on his label, Gigolo Records, in Munich. And so Steven asked my opinion about it and I believed it could be a good thing to do. Then there was like a snowball effect and things started happening."

DJ Hell: "I was a fan when I was about 18-19, when *Half-Mute* was released and it was new music to me and music I had never heard before, very emotional, very powerful, a masterpiece. I saw them once near Munich but they were more punk at the time. [6] Anyway I liked their early work, *Half-Mute* and *Desire*, very much. This is why I was dreaming to be in touch with them. For me Tuxedomoon was always futuristic dance music. I'm a DJ and I play a colorful blend of music and to me Tuxedomoon, because they never had a drummer – they had a rhythm box – was always some kind of dance music. So I played it in my early DJ sets mixed with punk music and early dance music as well. *Half-Mute* is for me one of the greatest records ever and I think it's still modern, it's still fresh and new, it's still unique and there's no other band like Tuxedomoon who went that direction.

I was in Mexico in 2000 and I met Steven Brown at some

about the band and it does feature a calendar of TM's upcoming gigs. See: http://launch.groups.yahoo.com/group/tuxedomoon/

05/15/00 Edo Bertoglio's movie, *Downtown 81*, featuring a.o. Tuxedomoon, is presented at the *Cannes Film Festival*, quinzaine des réalisateurs

07/08/00 BLR performs in *Isaia L'irriducibile*, a play by Alfonso Santagata (see http://www.katzenmacher.it/isaia.html) at the 23rd *Polverigi International Theater Festival*
Note: Alfonso Santagata is Julie Ann Anzilotti's husband, so BLR found himself working for the husband while SB was working with the wife…

10/00 Nine Rain & Trova Lunar play at el Alcazar del Castillo de Chapultepec, Mexico City, for the presentation of the United Nations Peace Plan, with Rigoberta Menchú

press conference at a record shop. I was like: "I don't believe this, what are you doing in Mexico?" From this first meeting in Mexico, we had the idea of working together and I was always thinking of releasing remixes of "No Tears." Steven liked the idea and got in touch with Blaine and Peter and they all were into the idea."

This initial project ended up as an EP featuring various remixes of "No Tears" and "What Use?" Hell also re-released *Half-Mute* on vinyl on his Gigolo Records label. Hell: "My idea behind the remixes was to bring the band together again, go on tour and maybe do some new stuff together and release a new album on Gigolo Records that would be something like *Tuxedomoon featuring DJ Hell* or at least I would act as a producer for their new recording…"

Part of Hell's plans did materialize as a tour of some German cities, *Tuxedo Moon & DJ Hell – Remixed & United*, took place in December 2000 and Hell would indeed work with them in Cagli, Italy, later on during the Summer of 2001.

Tuxedomoon touring in 2000. In the meantime, Tuxedomoon had undertaken its first residency in Longiano in November 2000, and some gigs in Italy were booked thanks to Brown's connections from his zapatistas promotional tour with Nine Rain in 1996. This winter 2000 tour also saw Carlos Becerra come aboard to take charge of Tuxedomoon's bookings and tour managing, a position he still holds today.

A peculiarity of Tuxedomoon's tour of 2000 (and 2001) was that they exclusively played their older material, especially from the *Half-Mute* and *Desire* albums, with new arrangements that tended to be more acoustic than before. Steven Brown played the piano which was something he claimed he had never done with Tuxedomoon until then. Also their shows were visually very bare with no projections or lighting design involved. Just the three musicians on stage with white lights. The absence of visuals was not really intended. Brown (in 2001): "That was the situation. What did we have? We had the three of us. We didn't have lights. We didn't have film. So we said: "Ok, let's concentrate on the music, that's what the three of us do best. Let's just turn on the white lights and play it like a straight classical concert." So that was the idea from the beginning, not to discard future shows involving visuals. We've always been on the look-out for new things. The thing is that we did the movie thing for ten-fifteen years but it was new in 1978-80 but then everybody started doing it and we stopped. It was boring for us. It wasn't original anymore. But these things come and go…"

Peter Principle considered Tuxedomoon's late eighties shows, entirely organized around the visuals, as a very unsatisfactory way to perform. "I liked it better, says Principle, when we made

Page 372

the set list up backstage and then we went on because we knew how to play more songs than we needed. Working with projectors and all of this kind of things, that needed to be already pre-edited, was kind of cumbersome. And everything needed to be the same length every night and it needed to come in the same place in the set every night. I found that very tiring. I don't really enjoy working like that. I like to play the songs fast in a small venue and slow in a large venue. I like to work with the material space." A call to Bruce Geduldig was then still considered as premature.

Of Tuxedomoon's 2000 tour, two dates deserve to be singled out, namely St Petersburg (Russia) and Belgrade (Serbia) where they received a triumphant reception.

The St Petersburg gig, on November 27th, 2000, rested on the initiative of a long time fan, installation artist and designer Oleg Kuptsov, along with Gleb Palamodov and Sergey Vasiljev. All three had been dreaming for many years to see Tuxedomoon playing in their home town. Oleg Kuptsov: "This gig was my first experience of the kind as I'm not a concert promoter. When friends from the Materiali Sonori label told me that the band was going to make a tour of some European cities in November 2000, I sent an email to Steven Brown to propose a date in St Petersburg. He was quite enthusiast about the idea.

When the band finally showed up on November 26th at St Petersburg's airport, after months of preparation, I almost couldn't believe it. To my view their show at the State Music Theater was truly amazing, powerful and extremely well received by the audience. It sounded like fresh contemporary music although these were pieces that they composed more than 20 years ago."

This would not remain Kuptsov's unique attempt at concert promoting as he would be involved in subsequent Tuxedomoon and Nine Rain gigs in Russia. Furthermore the first St Petersburg gig was recorded and marked the beginning of a new project for Oleg Kuptsov as he set up a record label, Neo Acustica, to release a double CD recording of the whole concert. Later on, Neo Acustica put out other Tuxedomoon-related releases, including some Steven Brown and Blaine Reininger solo work along with a Nine Rain compilation and the first album by Microdot, a band formed between Luc van Lieshout and Bruce Geduldig around 1998-99.

The Belgrade gig, on December 13th, 2000, was the first of a series (as the band played there again in 2004, 2006 and 2007) that reminded the band of their "Tuxedomoonmania" early on in Italy. The venue was so packed that people could hardly see anything and the crowd roared with delight at having them on stage at last, after many years spent in the vaults of ex-Yugoslavia's underground.

10/17/00 Italian sound engineer Alessandro Cardellini (*aka* Ale Canaglia) starts working with TM (Roberto Nanni put him in contact with the band) and from then on will become TM's sound engineer on all of their tours (still to this date) except for the dates with DJ Hell (below from 12/02/00 till 12/12/00) and TM's US dates in 03/2005

11/03/00 TM plays at Teatro Petrella, Longiano (Italy). TM on residence in Longiano on the invitation of Sandro Pascucci. Carlos Becerra starts to work with TM as tour manager

11/04/00 TM plays at Teatro Communale, Riolo Terme

11/08/00 TV show with Red Ronnie

11/15/00 TM plays at Estragon, Bologna

11/16/00 TM plays at Palacavicchi, Rome

11/17/00 TM plays at Auditorium Flog, Florence

11/24/00 TM plays at Mamamia, Senigallia

11/27/00 TM plays at State Music Theater, St Petersburg (Russia). This performance was recorded and released as a double CD by Russian label Neo Acustica in 04/2002

Tuxedomoon seemingly "emerging" from the river Neva, St Petersburg, Nov. 2000. Photo Oleg Kuptsov

Tuxedo Moon & DJ Hell – Remixed & United Tour
12/02/00 TM plays at Flex, Vienna
12/04/00 TM plays at Karlstorbahnhof, Heidelberg
12/05/00 TM plays at Forum Bogefabrik, Bielefeld
12/06/00 TM plays at Ostbahnhof, Berlin. Set list: 1. "KM/Seeding the Clouds-Desire;" 2. "Fifth Column/Tritone;" 3. "James Whale;" 4. "Again;" 5. "Nite & Day;" 6. "Volo Vivace;" 7. "Break;" 8. "Loneliness;" 9. "Nazca/59 to 1/Nazca;" 10. "The Cage;" 11. "Litebulb Overkill;" 12. "Waterfront Seat;" 13. "What Use?"
12/08/00 TM plays at Scala, Ludwigsburg
12/09/00 TM plays at Conrad Sohm, Dornbirn (Austria)
12/10/00 TM plays at Muffathalle, Munich

(The following dates are not mentioned on the TM/DJ Hell joint tour poster)

12/11/00 TM plays at Prime Club, Cologne

12/12/00 TM plays at Paradiso, Amsterdam

12/13/00 TM plays at SKC, Belgrade

Indeed, even though the band was not so aware of it, Eastern Europe in general and Serbia in particular had been in love with Tuxedomoon for a long time. Nebojša Stanić, one of these long time fans, explains the origins of Tuxedomoon's popularity in Serbia: 'In the years that followed world war II we had a tough job to rise from poverty. Luckily we were left aside from the two big political blocks at the time. Since most states of former Yugoslavia were well situated, the ones who traveled (mostly for business) could bring back much of the Western influence.

That influence had a great impact on a small group of youngsters, mostly born in the 50s and the 60s, such as myself. Step by step we literally formed a rock musical culture and industry, behavior and whatever that came with it. In that "rock package" everything was much the same as in Western Europe: the Beatles and the Stones, Led Zeppelin, Bob Dylan, etc. And most of the influence came from Britain. Only domestic music was much neglected – even when it existed it was mostly a lousy copycat anyway. Of course, with this "rock package" the radio shows, magazines, concerts, gigs, TV shows came along as well…

Some of us didn't share the taste of the majority. We wanted new inspirations and experiences, somewhat different from the mainstream. We were lone souls with "different" records, such as Tuxedomoon, The Residents, Snakefinger, Kraftwerk, Holger Czukay… We'd be gathering in our rooms or parties listening to their music. We didn't quite understand most of it at the time, but we liked it and fed our dreams with it. Records

Tuxedomoon playing at State Music Theater, St Petersburg, Nov. 27th, 2000. Photo Anton Chernyavsky

were bought abroad by our parents who were traveling mostly for business and rarely for pleasure.

At that time we had enough money to buy vinyls however not so cheap for us. On the other hand, it was quite hard to find them as domestic record companies only published bestsellers. There were no imports. If you wanted to buy a Tuxedomoon LP, you HAD to go abroad and buy it and know about the places where you actually could find it. Nowadays everyone in Serbia can buy any record anywhere in the world, but the new problem is money. Now we are a much poorer nation. Let me add that the people who have money now are not interested in buying records of any kind.

Anyway, in Belgrade (Serbia), Zagreb (Croatia) and Ljubljana (Slovenia) small "underground" ghettos were formed. We mostly liked the same music and although we were very different from each other we created some sort of way of life just for ourselves. As we grew up, we became more independent and hence estranged from one another, busy with our jobs, families etc. We all drifted apart. Today, only a few remember, only a few are sentimental, but I can't deny that there actually are some youngsters (born in the 80s) who inherited that spirit from us, I wonder how.

Like any ghetto, we thought we were "on top of the world" and we totally neglected others – not only other cities and states but also other (Eastern European) countries. We thought that "life" was happening only in Berlin, London, New York City or Los Angeles; the rest was treated as in Orwell's *1984*. Occasionally, as we grew up and traveled

Blaine Reininger's online journal entry about the gig in Belgrade. 'Just got back from Belgrade. We only had one day there. We played to a sold out house, 1,500 people and they were fanatic fans of our work. We sat around signing autographs and generally holding court in a club after the gig, watching the young thangs gyrating most delightfully to the throbbing presentation of DJ Hell, our co-touring companion whose influence was pretty much responsible for this whole hootenanny. Belgrade itself was in remarkably good shape, we were in the company of a guy who runs the one radio station that people used to listen to to hear uncensored news (B-92) unadulterated by the Milosevic regime which pretty much everybody hated. He told us a hell of a lot of what life had been like in Yugoslavia over the last ten years but no one seemed to be down in the dumps. For once, we all just shut up and listened, not tempted to put our ill-informed two dinars in. We saw a couple of bombed out buildings, in particular the former party headquarters which was hardly touched. Them damn missiles is so accurate, they would fly in through the elevator shaft and blow up everything inside while leaving the building still standing. amazing. The city was buzzing, cars were once again polluting relentlessly since it was no longer necessary to buy gasoline on the street corner from Mafia types. I guess acquiring certain things under the sanctions was like scoring crack, you would give some sleaze bag some money and he would run around the corner to his secret stash and bring it back. Belgrade looked pretty much like any other European city, shops open people milling around, a hell of a lot better off than the poor miserable denizens of Georgia. Almost anywhere seemed better off than Tbilisi. The Yugoslavians were never as isolated as the Russians anyway, they had plenty of access to information and entertainment from abroad, including weirdos like us. Once again, the primary source of our records was from bootlegs, made in Bulgaria and sold on the cheap. We found all sorts of our own stuff for

Comic writer Sasa Rakezic *aka* Aleksandar Zograf's view of Tuxedomoon's first gig in Belgrade on Dec. 13th, 2000. The page reproduced here was later included in Aleksandar Zograf's book entitled *Regards From Serbia*, published by Top Shelf (USA) in 2007

more, we discovered that there were some similar ghettos in other Eastern European countries but much smaller: maybe because of what I said at the start – we enjoyed some degree of inaccessible freedom.

I'm pretty sure that the guys from Tuxedomoon were pleasantly surprised to hear and see our reaction on their Belgrade gig in 2000. That proved a lot of things for us. It's a pity that we had to wait that long. We had hoped they could have come 15 years earlier or so. Probably I could write a novel about these "underground" times as we called them then, or a great movie could be made about these long gone years…'

The year 2000 ended with promising prospects for Tuxedomoon. However the band was still in a process of re-founding itself, with just the three core members present, and wasn't proposing any new material yet on stage. Their 2000 *Half-Mute* tour made sense when placed in the context of Hell's re-releases project but touring exclusively on the strength of old material was risky in terms of the band's credibility with the press. [7] Tuxedomoon had yet to prove that it was a living unit and not some body artificially resurrected solely for financial reasons and surfing on an eighties revival wave.

Tuxedomoon's second residency, in 2001 in Cagli, Italy. 2001 was for Brown the year of the release of Nine Rain's second album, *Rain Of Fire*, partly recorded at La Havana in the legendary – of *Buena Vista Social Club* fame – Egrem Studios. For Tuxedomoon the year will prove a decisive one in their move towards a new studio album, as most of it was conceived during their second residency in Italy, this time in Cagli, in the theater generously put at their disposal by Sandro Pascucci.

On a more personal note this residency in Cagli also marked the start of my work on this book about Tuxedomoon's wandering story, in time and geography. For years I had had a "wandering story" theme on the back of my mind and had been considering using that angle to tell the story of some artists but couldn't decide on who to choose. Then one day, in May 2001, I had a conversation on the internet with a guy from Brussels, named Frank Altenloh. He had been a friend of Steven Brown during Tuxedomoon's early days in Europe. It was as if something suddenly cracked open in my mind.

I had been a Tuxedomoon fan in my youth for a short but very intense period, between late 1980 until December 2nd, 1983 or the day of Tuxedomoon's concert in Lille at Théâtre Sébastopol. Between then and May 2001, I had totally forgotten about Tuxedomoon and did not even remember the names of the musicians. But since my story with

sale including a couple of my own solo records that are no longer available in Europe.
I am not annoyed by this bootlegging. Without it we wouldn't have an audience in these places and I wouldn't get to go there.' (from: http://www.mundoblaineo.com/journalframes.html)

12/15/00 TM plays at Hiroshima Mon Amour, Torino

12/17/00 TM plays at Interzona, Verona

2001

Some time in '01 Release by Opción Sonica of Nine Rain's second album (Nine Rain was then omposed of SB, Nikolas Klau, Alejandro Herrera and José Manuel Aguilera but soon Aguilera left the band and became a "star" on his own playing with a band named La Barranca.), *Rain Of Fire*, partially recorded in Havana – Cuba – with some local musicians, featuring the following tracks: 1. "Guantanamo's Harpsichord;" 2. "Lawnmoaner;" 3. "Midelmis;" 4. "Why 2 K;" 5. "Radio 2 Nay I;" 6. "Isla;" 7. "Lamento;" 8. "Rain Of Fire;" 9. "Inproper Language;" 10. "Radio 2 Nay Ii;" 11. "Venus Rising;" 12. "Alex's Torture Song"

Alejandro Herrera: 'It was very exciting. For me it was the first visit to Cuba. The technical part great, the people great, except for the fact that we were without much money, because we trusted the record company's production, and so we felt poorer than the poorest Cuban on the island. And that is even worst as Cubans see you as a tourist with dollars in your pockets... Here are some notes about each of Rain Of Fire's songs:

1. "Guantanamo's Harpsichord" A melody that reminded us of a movie co produced between France and Mexico in the sixties (…) Never seen. Avant-garde? And other things that I prefer to forget not to bother Niko & George on the beach…

2. "Lawnmoaner" Of the great variety and richness of rhythms that exist on the island, namely the Guaguancó, Conga, Ritmo de palo, Eleggua, Ogún, Ochosi, Yemayá, Ochún , Obatalá, Oyá y Babalú Ayé, we finally ended up using none in that song but how good we sound! The lyrics were inspired by Philip K. Dick and the E.Z.L.N

3. "Midelmis" Something peculiar when we arrived in Cuba is that we had to ask every woman we met to tell us their name again as these were totally unknown to us. The reason for it is that ten years or more ago, the Cuban mothers started to create their own names for their daughters or combined two common names into a new and original one, so original that it was hard for us to remember and every time we got mistaken we were immediately corrected: "It's not Midermis but Midelmis!" Midelmis was the name of a Cuban waitress, who worked at the restaurant of the hotel where we were staying

4. "Why 2 K" The wind blowing through horns and clarinets, rising up into sonic columns lulling us into the air like a sheet of paper floating above El Malecón in La Havana, in this old town that smells like the sea and saltpetre, bringing us back to other times through the cornices of its old edifices and crumbling buildings, another place. The time of the drums humming in the African savanna. Another sound. The music of the sound. Y2K?

5. "Radio 2 Nay" In Cuba, we met a group of friends in the neighborhood of the studios and they asked us to participate in our recording. We lent a minidisc machine to Vladimir, who would like to be a DJ. After a week he gave us what he recorded, namely a slice of real life, to be found on "Radio 2 Nay"

6. "Isla" As José Manuel Aguilera and myself were flying over from Mexico to Cuba quite early in the morning, I woke up, looked through the window and saw some coastal line appearing in the vast Atlantic Ocean. Half asleep, I looked at my watch and thought: "How fast are we reaching Cuba!" So I woke Aguilera up and told him, pointing to the window: "Look. I believe this is Cuba!" Aguilera did wake up and started to look through the window, yawning. Then he took a paper napkin we'd been given with breakfast and started scribbling some words on it. When he was done he stucked the piece of paper into his wallet and went back to sleep. Half an hour later, I woke him up again and told him: "I believe that NOW we arriving in Cuba!" What had inspired José was in fact the peninsula of Yucatán. A month later, then at the Kaynah Studio in Mexico City, as Jorge Esteban was equalizing one of the tapes, José came in, retrieved some rumpled paper napkin from his wallet and read us a poem: those were the lyrics of "Isla"

7. "Lamento" The double bass sound of a Cuban musician we heard playing while we had lunch in a restaurant in the centre of La Havana and that we later invited to come play with us. A conversation between the guitar and the bass saxophone under a low-flying helicopter

8. "Rain Of Fire" Our recording had been preceded, a few months earlier, by an eruption of the vulcano Popocatépetl that happened to be the most important one in the last four centuries. It's gonna rain, rain, rain. Rain Of Fire!!! Maraca, maracame, haz que llueva. Bataca, batacame, haz que sane. Que sea parto natural el del volcán. Que no sea necesaria la cesárea

9. "Inproper Language" The band's "Woodstockhausen" concept in its utmost splendor. This piece unfolds its oriental veils through which we can catch a glimpse of palm trees, silhouettes twinkling through the blazing

Tuxedomoon had been so intense and emotional, how could I have possibly forgotten them for so many years? It seemed even more regrettable as I instantly realized that Tuxedomoon were the artists/wanderers that had been in my subconscious for so many years: undoubtedly it was their story that I was supposed to tell.

I was immediately seized with a feeling of emergency: I had to find them and ask for their cooperation. I was told that most of them had left Brussels and got dispersed all over the world. Luckily the internet came to my rescue and enabled me to find their names and even some email addresses. I wrote an email to Blaine Reininger and Steven Brown. Brown never replied but Reininger replied within the minutes that followed the sending of my mail. Again I was struck by how the internet had changed the world as I had known "another" world without it and with no cell phones either. The eighties suddenly seemed like centuries before. Without these communication means, individuals were way more focused on pacing their inner world, with sparks of moody creativity bursting of their *ennui*. Hours spent at home with nothing to do apart from rebuilding worlds from a few sentences taken from a book that one feels too lazy to read, no one to see when feeling too apathetic to go out and find like-minded people. In a way I understand why today's youngsters are yearning to rediscover this *Zeitgeist*. But I also realized then that these times were gone forever. Also feeling nostalgic about them would be a bit simplistic as it would have been absolutely impossible to embark on this very long quest/wandering story that my Tuxedomoon book would become without the help of the internet. Tuxedomoon had become such a disperse identity…

Reininger and I agreed that I would come to attend their July 16th, 2001, concert in Rome to talk to the other members of the band and see whether they were interested in cooperating. In the meantime I started to torture my mind to solve the mystery of my many years of amnesia of all things relating to Tuxedomoon. Little by little I remembered the night of December 2nd, 1983.

I was then a young law student at the Catholic University of Louvain in Belgium, totally estranged from my fellow students and professors (who – I learned it later on when I started to teach at this university myself – then had nicknamed me "The Atomic Punk") surviving solely out of my surprising ease to excel in an environment where none of my relatives or acquaintances had been before. I adored music and knew everything about pop, rock, jazz, avant-garde... My older brother had musically brought me up making me listen to Pink Floyd when I was a nine-year-old. So I was certainly ready when Tuxedomoon came along and like many alternative kids at the time I was in awe when they decided to emigrate from

Page 378

California to Brussels! The Winters were so cold back then in Brussels... I still have flashes of moments spent in the freezing cold waiting for the doors to open at the Plan K. Winston Tong singing "The Stranger" resonated so much with how I felt and still very much feel today although the "serenity" coming with age soothed down the pain a bit.

Back then I felt like my mission in this life could have been in managing bands as I could see that there were needs in that area and that many artists were getting screwed out of their clumsiness or sheer ignorance of how things ought to be conducted business-wise. I knew that Tuxedomoon had a female manager, Martine Jawerbaum, so I was quite confident that it might "work." I was looking for an opportunity to have a talk with Jawerbaum and possibly help her out on a benevolent basis and learning the "tricks" of the business in this way. However around then, late 1983, Tuxedomoon were very seldomly playing in Brussels so I seized the opportunity to attend the concert in Lille (reasonably close to my hometown) to arrange a meeting after the concert, going out for dinner with them. I remember singing on my way to Lille: I was going to meet my mates, the family I had chosen. But all went terribly wrong.

I went there, had a good time at first. Met some journalists from French radio station France Culture who interviewed me along with others in one of these attempts to define Tuxedomoon's music (my answer was that there was no way to define Tuxedomoon and that on the day I'll be able to define it, it probably won't interest me anymore). The concert was great although I did not recognize most of the material (as Tuxedomoon back then mostly toured on the strength of yet unreleased material). The problem was that Jawerbaum seemed extremely pissed off to see me. To cut a long story short she, during that dinner, managed to humiliate me in front of quite dumbfounded France Culture journalists who were sitting across from me at the same table.

I was devastated. I felt as if the earth was opening up under my feet. It was very cold in Lille on that night. I remember going to a park and lying down on a stone bench wishing I would fall into eternal sleep there. After all I had lost the only family I felt like having… After a while another "me" rose up from that bench and walked out. I looked over my shoulder and saw some sort of an aura resembling a corpse – the part of myself that I believed had died on that night – floating on the bench. I went into another life for 17 years…

Years later I realized that mostly my youthful innocence was responsible for the trauma I experienced on that night. Also I was told that Martine Jawerbaum could be at times extremely difficult with third parties as her job as Tuxedomoon's manager, caretaker and "mother" was far from

sand of the desert of Gobi. It's necessary to share the journey. Where the jarana gets simple (…) The mystery of the window opening, of the rum to savor (…) It's the condition to be able to speak. Inproper language

10. "Radio 2 Nay II" The voice of this young Cuban, an orphan adopted by the state, who dreams on broadcasting live from Cuba to all over the world. His name reminds of Russia but his Radio has an anglo-saxon name. The voices from those who were, from those who were prisoners of the island, and the seclusion that surrounds whoever goes to record a disc with a "grabador" Cubano y "toda la cosa chico"

11. "Venus Rising" This song has a lot to do with the Fobaproa (Fondo Bancario de Protección al Ahorro) (...) It's a musical cocktail prepared with a cup of Polka, two pinches of Corrido and another of ska, all in the most classical style of a caricature of a musical structure inspired from Rachmaninov. We are considering proposing it to the ministry of tourism for its invitation: "Come to Mexico and see the world upside down." And early on the sacred star rose up in the sky, mythical. Venus Rising...

12. "Alex's Torture Song" This instrumental piece should have been called "Sobre Las Olas" (Balsa en 3/4), where the requinto jarocho tells us the story of the hazards and desperations/hopes of whoever embarks on the perilous adventure of leaving the island to pursue the American dream, floating on an improvised raft. It's comparable to the anguish once described by García Márquez in his account of how these shipwreckeds finally reached Columbia after weeks of drifting on a sea infested with sharks and shaken by storms, without bread or water, without a hat or sunblock. But, as the one who suffered was the Requintista (me), due to the technical complexity of the performing technique, the other members of the band decided to call it "Alex´s torture song". And they enjoyed asking me again and again to play it all over from the beginning. (Da Capo)'

Some time in '01 Release of Minox's album entitled *Downworks* by Suite Inc. with BLR guesting, along with Lydia Lunch, Nobukazu Takemura, The Gentle People, etc.

Some time in '01 Release of Gianluca Lo Presti & BLR's CD entitled *Sun And Rain* by Materiali Sonori, featuring the following tracks: 1. "La Jam;" 2. "Freedom;" 3. "Zirab (Live);" 4. "Mistic Dream; 5. "Tuxedoloop (Live); 6. "Wayne Fontana Mix (Live);" 7. "Basta Cosi;" 8. "Zira (Reprise)"

Some time in '01 Release of Coti K's *Metamemoria* CD released by Vibrant Music (Germany) with BLR guesting on the track "M Key"

Some time in '01 Rowhouse Press (Seattle, directed by Greg Bachar) publishes SB's *Stories From Mexico*, a collection of SB's journal entries about his journeys in Mexico. The book was again published with a Russian translation by Neo Acustica as part of the ltd edition Nine Rain *Choice* compilation box set

02/23/01 BLR plays at Mirano, Venice

03/10/01 SB plays in Brisighella

05/01 Nine Rain plays in Mexico City, Monument To The Revolution, for a culture of peace and non-violence

05/04/01 A short documentary about Tuxedomoon working with DJ Hell is featured on German/French television channel ARTF as part of its *Tracks* broadcast. See: http://archives.arte-tv.com/tracks/20010504/ftext/Dream.htm

05-07/01 BLR is in Berlin playing as "Henry Fonda" in Albrecht Hirche's play entitled *Spiel Mir Das Lied Vom Tod*, Volksbuehne Theater, Berlin

06/16/01 Presentation of the new Nine Rain CD at Sala Blas Galindo del Cenart, Mexico City

06/09 till 08/17/01 Some of PP's records collection is displayed at *The LP Show* exhibition at Exit Art, New York City, an exhibition of innovating records covers from the '40s until today: 'a series that explore the intersection between visual art and graphic design'

07/13/01 Release of the movie *Downtown 81 (aka New York Beat Movie)* directed by Edo Bertoglio, writer Glenn O'Brien and Maripol, producer, featuring *a.o.* Tuxedomoon. See: http://www.downtown81.com

07/16/01 TM plays at Villa Ada, Rome, *Festival Roma Incontra Il Mondo*, where I met the members of the band who agreed to cooperate on my book project about them

07/18/01 TM plays in Palermo

07/19/01 TM plays in Catania

07/20/01 TM plays in Santa Teresa di Riva

07/21/01 TM plays in Cosenza

07/23/01 TM plays at Villa Arconati, Milan

08/05/01 TM plays at Rocca di San Leo

08/10-24/01 I am with the band, then spending a summer residency in Cagli, working at the teatro comunale, on the invitation of Sandro Pascucci when not playing gigs in Italy (see below). I then start my interview process with them. During their residency in Cagli, they are joined by LvL, Coti K (engineering) & DJ Hell. The musicians work on the material of their upcoming album *Cabin In The Sky*, released in 2004

easy. It was an environment where the (over-)use of various drugs made it all the more difficult. I also realized that I was much stronger than I had thought. The 17 years that passed afterwards probably accomplished their work in making it possible for me to face that trauma at last and resolve it. In 2002, I collected some tapes from James Nice's huge Tuxedomoon archive. I brought them back home and started listening to them, almost absent-mindedly as I had to go through a lot of material and select what was interesting from the merely trivial. Suddenly, my blood froze in my veins as I had heard a GHOST speaking! In fact it was me interviewed by these France Culture journalists before the gig on that fateful night of December 2nd, 1983. At the time picking up France Culture in central Belgium was very hard and so I never knew what became of the interview that these guys made with me. I was very surprised to find out, 18 years later, that the said journalists had given me the most to say from all these people they chose in the audience. So I had not been so stupid on that night after all…

On July 16th, 2001, I met Steven Brown and Peter Principle again for the first time in 17 years (as Blaine Reininger had already quit the band in December 1983). I was dizzy for a second as I felt like the part of myself I had left on that bench in Lille in 1983 was rushing back from time and space to merge with my soul again in some sort of volcanic explosion. I was a whole again. Also these middle-aged men were still ten years older than me but then I was a grown-up meeting other grown-ups and I immediately felt that I was dealing with my equals. I was not seeing them as a fan anymore – thanks God, otherwise I would have had to renounce to the book for a glaring lack of objectivity – but as a life companion/fellow traveler pacing similar side paths, sister planets' orbits crossing... Reininger was obviously pleased to introduce me to Principle and Brown, the latter greeting me with an unexpected: "Here's the famous Isabelle!" They invited me to join them in Cagli in August where they were going to spend their second time as artists-in-residence. My wandering story with Tuxedomoon had begun, at last.

From August 10th till 24th, 2001, I joined the band in Cagli where I conducted my first round of interviews with them. I also met Carlos Becerra and Nina Shaw (then on vacation and visiting her old friends) for the first time and interviewed them as well. Luc van Lieshout came to work with the band while I was there but I interviewed him later on in Brussels. For Luc, it was the first time he worked with the band again in many years and the first time he found himself in the situation to work on new material with Blaine Reininger. I also briefly met Francesca Pieraccini (from Materiali Sonori) and Julie Ann Anzilotti (the latter would later send me her interview recorded

on a cassette). Sandro Pascucci generously put me up in his own apartment for a few days when, due to some festivities going in the city, there was no room left at the hotel near the teatro comunale where the band was working every day. I did write a journal during this two-week stay. Here are some excerpts from its handwritten 106 pages, which, I believe, say a lot about the band's internal relationships, various personalities and way of working (sometimes on a symbolic level that didn't strike me then but became obvious when I read these pages again years later). It is also telling about the atmosphere that inspired and bathed their upcoming *Cabin In The Sky* album, namely a very hot and sunny summer in a small Italian town:

'Friday, August 10th, 2001
(…) A very hot afternoon, 5:04 p.m. (…) As I entered the theater for the first time, it seemed to be a slack moment. Steven was wandering about. Peter was vaguely strumming his bass while Blaine was endlessly tinkling away the same sequence of sounds on his computer keyboard, looking rather morose (…) (Later) Little by little things started liven up: Peter began to confer some sort of structure to the whole with his bass line. Blaine recorded a violin sequence that he undertook to mix while destructuring it with the sounds of his computer

**Nina Shaw, Peter Principle and Blaine Reininger, Cagli, August 2001.
Photo Isabelle Corbisier**

sequence. Steven came back on the stage, tapped out a few notes on the piano, then left it to grab his saxophone. Little by little some haunting climate was established, the electronic sequence of sounds operating like some sort of suffering pulse (…) Blaine set up a sardonic rhythm on his keyboard (…) Unbelievable: in about one half hour, something resembling a piece of music was created… (…)

5:43 p.m.

Blaine and Steven have disappeared. Peter cleans around the maze of cables and mikes.

Later: Blaine is back, "Well, if Steven can do it, then I can do it…" Steven is upstairs.

Later, dining with Peter and Blaine. Peter: "At the moment, we don't even know if we are going to be a band yet." (…) Peter tells me that it is Steven's way of working to be coming in and leaving constantly while the others keep on working steadily: "Steven needs to be impressed."

Saturday, August 11th, 2001

Around noon. Had a talk with Nina Shaw. She told me that Winston Tong should have been part of their present tour but then he cancelled at the last minute as he had to undergo some cataract surgery.

5:43 p.m.. Compared to yesterday, the day has been lethally boring: Blaine and Peter endlessly repeated the very same sequence of sounds for hours. Steven put on his sulky face, uttered a grunt in response to my "Hello!" then ignored me for the whole day, ostentatiously taking care of his own personal business like discussing Nine Rain with Carlos Becerra or having a look at his pile of his private journals that I had brought him from Brussels [8] (…)

In the evening we went to the concert of some brass band from Macedonia playing outdoors in front of the ruins of some abandoned castle. Blaine did not come with us (…) Steven, Nina and I spent most of the evening looking up at the sky, watching the shooting stars. We went back to Cagli in my rented car but we got lost on the way, as if Cagli was slipping away at our approach. We felt like we were entering the twilight zone when Peter finally succeeded in mastering the map and guided us back home.

Sunday, August 12th, 2001

I had a long talk with Nina Shaw. She told me about her most treasured artistic memory: Winston Tong opening for The Talking Heads, then at the very start of their career, reciting poetry by Rimbaud with two puppets of its own making that took a life of their own on stage. She believes that at one point Winston totally flipped out as he really wanted to become a superstar, which led him to mythomaniac behaviors as when he pretended that he would be cast in Bertolucci's movie, *The*

Last Emperor (1987). She also pointed out that Tong never took part in the Blaine/Steven's confrontation and always retreated in his own world when some of this would take place.

Nina told me that she always saw Tuxedomoon as a litter of kittens pretending to be dogs as sometimes they would pretend to adopt a "rock 'n roll" attitude when they actually never were rock 'n rollers.

About Blaine and Steven: "They're like two siblings. They love each other but beat each other up and fight all the time, like two brothers would."

Monday, August 13th, 2001
Nina Shaw's interview.

Tuesday, August 14th, 2001
Peter Principle's first interview [*another one will follow around the end of my stay*]. Back at the teatro comunale in the afternoon I heard a magnificent jam with Blaine's melody on the violin [9] reminding of some music I heard on the radio when I was a kid but that I never could identify.

Blaine's girlfriend had just left and Blaine cracked us all up at some break outside the theater as, returning from a pharmacy, he took his abandoned *gigolo grasiento* pose to say: "I went to the pharmacy to buy something to enable me to forget her..." and he pulled out a gigantic... plastic syringe out of a paper bag.

Wednesday, August 15th, 2001
We all went to the beach in Fano (without Blaine, who stayed alone at the theater, to work on some computer-based aspects of the music, he said). We had been invited there by two old friends of the band, Minny Forino and local artist Donatela Tonini. We spent the day on a strange beach, between sea and railway tracks with access to an (agitated) sea barred by a line of sharp-edged (and slippery) rocks. It was hot as hell and I was given the benefit of the sole parasol available after the locals saw the pallor of my skin. I made a few photographs including one of Steven suddenly adopting a "lizard Christ on the rocks" pose of some sort after minutes of me running after him on the slippery rocks begging for a photo. Some DJ on the beach played the Gigolo Records EP of "No Tears" remixes. We left at

**Steven Brown, the lizard Christ, Fano Beach, 2001.
Photo Isabelle Corbisier**

4 p.m., observed by quite a few pairs of eyes of people who had somehow been told that some "celebrities" were on the beach.

In the evening we all (except Blaine) went to see the *Nabucco* opera that was performed outdoors on Cagli's main *piazza*. Then Steven invited me and Nina (who's leaving tomorrow) for a *gelato*.

Thursday, August 16th, 2001
I took the band + Carlos to the Ancona airport in my rented car as they are to play at Reggio Di Calabria tonight. On the road, I risked the following: "Would I put it right if I'd say that Steven dreams of a world where there would be nothing to buy whereas Blaine dreams of a world where everything would be for free?"
Brown crisply half-smiled in my direction.
Peter: "No, no, Blaine likes to buy!"
Blaine: "Well, I like to bargain…"

Friday, August 17th, 2001
I'm alone in Cagli and spend the day wandering through this town with so many churches. I met an old lady on the street, mother of the owner of one of the *cafés* near the theater (we were quite an attraction in town, gently spied upon by the many elderly people lounging around the *cafés* and nearby *piazzas* warming up their bones under the boiling sun). She took me around to her favorite church and later to her house for delicious coffee.

In the late afternoon I left for Ancona to pick up the band on their return from Reggio Di Calabria and of course got lost on my way. Luckily their plane was late. I ended up with Blaine and Carlos in my own car, the others leaving with a guy named Alessio, who had a bigger car. On the way back, Blaine told me that he liked DJs, considered their work as at least partly creative and enjoyed DJing himself as the job is well paid for a tiny investment. He believes that the reason why DJs are so successful to be mainly of an economic nature: DJs cost less than a band and work longer. Also they carry a lot less gear around hence their life is much more simple than the life of a musician in a band.

Saturday, August 18th, 2001
I interviewed Blaine for the first time (four hours between 4 and 8 p.m.). Difficult as Blaine talked about the death of his wife JJ. It was hard for me not to cry and he actually cried during the interview. Blaine talked about his struggle with alcohol and his life now as an abstaining AA member. He said that a lot of his bitterness about Europe and Brussels in particular was related to his alcoholism and that he was evolving towards a more positive view/attitude since he stopped drinking.

Steven did not seem willing to be around while Blaine was getting interviewed so he sent Carlos [*from then on I will always picture Steven as Don Quixote and Carlos as Sancho Panza*] to borrow my car so that they could go to some rave party on a beach in Pesaro, get very drunk and return only a day after when they were sober enough to drive the car back.

Sunday, August 19th, 2001
Today I carried on with the second part of Blaine's interview: seven hours practically non-stop.

Monday, August 20th, 2001
Had lunch with Carlos and made his interview. Spent the evening at Donatella Tonini's house where she had invited along some Tuxedomoon friends from the "old days."

Tuesday, August 21st, 2001
Luc van Lieshout is here.
Getting Steven to sit down and be interviewed was quite a battle and the whole enterprise itself was quite an ordeal. After about an hour and a half of grunts, super short answers and of bearing an antsy Steven wriggling on his stool, I couldn't stand it any longer and thanked him for his time. He said: "That's it? So it's gonna be Blaine's book again as he gave you all these hours of interviews…" [10] I replied that I didn't want my book to be biased in any way but then I needed him to be more cooperative one way or another and I left him to think about the most appropriate way to achieve this.
Later in the theater, I'm listening to them, playing with Luc van Lieshout, what a pleasure…
Strange weather today: scorching heat in the morning and big thunderstorm with heavy hailstone rain in the afternoon followed by a very strange light with the sun filtering through an overcast sky. Took the evening apero with Carlos on the terrace of my hotel. Went shopping and then to the theater. Found them sitting at the *café* outside of the theater. Everyone is a bit tipsy. Luc van Lieshout doesn't talk much. Dinner around 9 p.m.. Very pleasant. Everyone was relaxed. Carlos took a photo of me with "The Tribe." Blaine is such a clown. Steven was laughing, even teasing me at times.

Wednesday, August 22nd, 2001
Steven had found the other way to cooperate. Since I had brought him his

**Isabelle with the band in Cagli, August 2001.
Photo Carlos Becerra**

Steven reading out his private journals, Cagli, August 2001. Photo Isabelle Corbisier

08/16/01 TM plays in Reggio di Calabria

08/30/01 DJ Hell joins the band in Cagli

09/03/91 TM plays in Cagli

09/06/01 TM plays in Naples

journals covering the period he spent in Brussels, he decided that this was a sign of destiny and hence he selected some excerpts from these journals that he thought were "wandering stories" and read them out to me this morning in a deserted theater (they were supposed to work in the afternoon only). I shot a photo of him while he was reading. It was such a great moment, time like suspended. He read with a great voice, very low, very serene, quite the opposite of the somewhat screeching voice, like fraught with interferences, he had when being interviewed… I hardly dared to move, fearing that it could break the magic of the moment. Meanwhile Blaine is on the street, singing droll versions of standards in what I would depict as a "Peruvian ethnic" style… He also went to the market and bought all kinds of crap including a mini laser thing that broke down after a few minutes of use and two Chinese mikes that seemed to be weighing about a ton each (…)

Late in the afternoon: no one in the theater except for Steven upstairs in his "office" discussing with Carlos. I find Peter, Blaine and Luc at the terrace of a *café* on the main *piazza*, cooling off. While returning to the theater, Blaine tells me: "Luke is a whole different musician than me, you know…

- How so? You mean he's more of a hard worker?

- Well, he likes to play. And he needs to. Whereas me, sometimes I'm like: AARGH!!"

Blaine and Steven both start to fool around each in his little corner: Blaine at the computer and Steven with a synthesizer he just bought. Peter plays alone on his bass, in some sort of "shadowy" fashion. Steven leaves the room. Luc can be heard in the distance, blowing his trumpet in the corridors…

Thursday, August 23rd, 2001

Today is Steven's birthday. We met again in the morning for another reading of his journals, as delightful as the day before. Blaine entered right in the middle of Steven's reading, acting like a clown again: "These are all lies!" He needed to grab some gear for an upcoming solo gig.

In the afternoon Steven lies down on the stage while Peter seems to be playing some ambient lullaby, his way to wish Steven a happy birthday I believe.

In the evening we all stayed up together at our favorite *café* until early in the morning. I will have to leave soon in the morning, to cover the distance between Cagli and Rome where I have to catch my plane. I didn't go to sleep on that night. When we parted, Steven told me: "Call me up when you will be back in Brussels."'

That was it for my first actual encounter with Tuxedomoon.

During their residency in Cagli, which extended until September, the band was also joined by Coti K, a half Italian

half Greek musician/engineer/producer and friend of Blaine. Coti assisted the band in recording/engineering until the very end of the process of producing their forthcoming *Cabin In The Sky* album. For Coti K, it was as if one of his dreams had come true as he had been a fan of Tuxedomoon for a very long time.

DJ Hell joined them in Cagli as well and worked on five songs with them. Hell: "We had such a great time in this theater in Cagli. It was such a magical place. These five songs we did in two days! Steven was somewhere and we were always looking for Steven… He disappeared all the time. Peter was always cool. I told him that the bass line was very important, *his* bass line is truly unique. I think I kind of forced them in Italy: "Let's do it now!" I don't know about their internal relationships and I'm not interested in knowing as I see them more from the professional side. I saw I had to push them and I pushed them really hard…."

At that point indeed it was still extremely hard to have Brown and Reininger working together in the same room for more than a few minutes, to such extent that van Lieshout's arrival in Cagli already came as a big relief, as Erik Stein's 2004 interview of the band clearly shows:

'What was it like for all three of you to be writing together after so many years?

SB: Well, four of us with Luc as well. You know, it had its ups and downs. It wasn't easy, I don't think. Everyday was different.

Luc van Lieshout: It was a good thing that I was there, as I understood. They were there for two months and I was there for two weeks, and they'd worked for maybe two weeks and a half!

SB: [Laughs] Yeah, we weren't there for two months, but it was good you were there. It was also good that Coti was there, our producer from Athens, because there were a lot of issues still. I mean, it was the first time we were recording together, working together and trying to be creative together in many, many, many years. So, in the end it worked out great, but it was rough going for a while, you know. Maybe because we were treated so well! [Laughs]

LvL: Too good.

Too good?

SB: Yeah.

When writing together, did you find that the roles within the band had changed at all or that the dynamics were different?

LvL: Well, when I arrived in Italy I hadn't been working – I had been working with Steven right up until he left for Mexico – but I've never really been playing with Blaine, because when I came into the band that was because of Blaine leaving the band. I had the impression that nothing had changed in fifteen years or something. All the roles, all the patterns,

Coti K's memories about working with TM: 'Their music had a deep impact on me as I believe I wasn't interested in electronics until I heard the way they were using them, in a very emotional context, as opposed to the more frigid way of other bands of their time. Working with BLR in the studio is usually me being the guy trying to organize the workflow, BLR is sometimes a bit chaotic with respect to the direction a track should have… And don't let him pick up that guitar, viola is what I prefer him on! I believe that during the TM recordings in Italy I went along very well with Peter – we were the "engineering" team – and let the others be more of the temperamental artists, not that Peter's artistic input was any less important, but he was also very organized, present all the time, and very friendly. Steven is definitely the temperamental type! Sometimes he makes me want to kiss him, and sometimes he makes me want to kick his ass! While recording he often seemed very lost in his thoughts and then he would disappear and come back and have an idea for a song, or an overdub…'

09/11/01 The two World Trade Center towers in Manhattan, NYC, are attacked and fall down, making it hard for PP to return in the USA where he finds his apartment (located nearby the fallen towers) in a quite sorry state, invaded by dust, with communication means down for a long time

10/23-28/01 BLR performs in *Isaia L'irriducibile*, the piece by Alfonso Santagata, at Teatro Arsenale, Milan

11/10/01 BLR performs in *Isaia L'irriducibile*, the piece by Alfonso Santagata, at Teatro Communale, Sardinia

11/17/01 BLR performs in *Isaia L'irriducibile*, the piece by Alfonso Santagata, at Teatro Communale, Arcidoso

11/21-22/01 BLR performs in *Isaia L'irriducibile*, the piece by Alfonso Santagata, at Teatro Communale, Buti (near Pisa)

11/24-25/01 SB participates in performances of Julie Ann Anzilotti's piece entitled *W Gep-eTTo*

11/25/01 BLR starts a *Sun And Rain* tour with Gianluca Lo Presti with a meeting in Faenza: *Etihette Indipendenti*

11/30/01 BLR & Gianluca Lo Presti were to play at Storyville, Arezzo, but the show had to be cancelled as no one showed up to attend. Consequently the tour with Lo Presti was shortened

Page 387

11/30/01 Nine Rain plays at Museo universitario del Chopo, Mexico City, Las ondas del Chopo (celebration of the local radio's 10th Anniversary)

12/31/01 A big event named *The Euro Bridge* was organized in Brussels's biggest park, esplanade du cinquantenaire, to mark the changeover to the European currency, under the artistic direction of SB's ex-musician Marc Lerchs, music: Dirk Brossé, Marc Lerchs & SB, performed by the European Festival Orchestra with jazzman Steve Houben playing the saxophone. An excerpt from that show can be seen on YouTube

Marc Lerchs: "We wanted to produce a show about the civilizations getting closer and not a show about money at all. I composed half of the music and Dirk Brossé the other half. I remembered of what I had gotten Steven to do for the first record I produced for Lara Fabian. I had asked him for a solo but then he gave me a whole track of sax. That gave a piece entitled "By Night" and another one called ""Il Y Avait." I retrieved that stuff from my archive and everyone told me that this was the music that had to be used for the event. Steven could not come for the occasion as he had other commitments in Mexico. So I asked a very well-known saxophonist from here, namely Steve Houben, to come and play his own interpretation starting from Steven's number. So we found ourselves on the night of 12/31, with a symphonic orchestra playing music by Steven Brown and me, performed by Steven Houben and sung before by Lara Fabian. But out of the, say, 200 journalists present at the press conference, there were maybe three who knew about Tuxedomoon…"

2002
Some time in '02 Release of Italian band Keen-o's *Nobody Knows How And Why* CD by Materiali Sonori, with BLR guesting

Some time in '02 SB provides soundtrack music to Bruno Varela's short film entitled *Frecuencia embotellada*

Some time in '02 Release of Bernadette La Hengst's *Der Beste Augenblick In Deinem Leben* CD by Trikont (Germany), with TM guesting

01/2002 Release of Italian band Autunna Et Sa Rose's *Sturm* CD by Materiali Sonori with SB guesting. See: http://www. erbadellastrega.it/musica/autunnaetsarose/

03/15/02 I'm in Lausanne, interviewing Maurice Béjart

03/17/02 BLR shaves the moustache he had been wearing since John Gill's 1981 review of the *Desire* album where he referred to his "greasy gigolo violins," BLR claiming to be mistaken for a Turk in Greece and for a Muslim anywhere else

03/29 till 04/16/02 I'm in San Francisco to interview Winston Tong, Patrick Roques, Michael Belfer, Esmeralda Kent, Theresa Herninko (PP' ex-roommate), Gregory Cruikshank, Corrie McCluskey (a friend of PZ), Annie Coulter (PP's ex-girlfriend), Bobby Burnside, Greg Langston, Eddy Falconer (film-maker, friend of WT), LX Rudis (musician, friend of WT)…

04/13/03 WT + Voodoo Cabaret (*i.e.* composed of Gisela Tangui & Zambu) perform at Labyrinth Salon, San Francisco, WT reading

everything was exactly the same as fifteen years ago. So it was kind of scary and kind of comfortable at the same time.'

2002: a transition period. For Tuxedomoon, 2002 was a year of transition in many ways.

First of all they had to decide on what to do with the pieces that they had composed in Cagli and included on a demo that circulated in the band's entourage. DJ Hell was pushing for a release on his Gigolo Records and some discussion took place between Hell and the band when they met at Barcelona's *Sónar Festival* in June, where the band played some of their newly composed material. But Hell's eagerness to push himself forward may have been at the band's expense (*i.e.* his willingness to name the record *Tuxedomoon featuring DJ Hell* or, at least, to produce it entirely). The nucleus formed by Brown, Principle and Reininger appeared more impenetrable than ever, probably as a consequence of re-forming themselves as a trio extending over about five years. Luc van Lieshout himself, who was called back in 2001, sometimes points out that most of the band's major decisions are often taken by the "old ones," with his own opinion only incidentally asked. So Tuxedomoon was not to be maneuvered, much less controlled, even by an individual who succeeded in shaking the band's tree like DJ Hell.

Until some time in 2002, Tuxedomoon's relations with their record company had been uneven. Crammed's boss, Marc Hollander, was skeptical about the outcome of the band's recent efforts to work together again. But things started to change in 2002 as Hollander heard some excerpts from their performance at the aforementioned *Sónar Festival* and of course the Cagli demo that was then circulating… At the time Crammed was considering a re-release programme of 12 of its major albums, including *Desire* to be launched as part of *Crammed Global Soundclash* for 2003. So a dialogue was slowly reinstated between Tuxedomoon and Crammed Discs. Meanwhile James Nice's LTM label was fostering interest in the band's earlier music by releasing the *Soundtracks – Urban Leisure* compilation album, a collection of soundtracks composed by the band along with their "Urban Leisure Suite" (*i.e.* their celebrated but almost impossible to find early lounge manifesto). This release earned the band a laudative review in the famous French rock magazine *Les Inrockuptibles*: 'It seems that no one remembers of Tuxedomoon nowadays. The best dictionaries (Assayas) are bluntly silent about this band that nevertheless was one of the most prominent ones during the first half of the eighties, combining new wave mannerism with what one was then not hesitant to call "new music" – meaning contemporaneous music being set free of dogmatisms to allow a more sensorial approach to space and instruments. If

the pop albums of these Californians once exiled in Belgium can still pass muster, their instrumental music written for other purposes (films, ballets, performances) is even more remarkable.

(…) Two scores, meant to be the soundtracks to films of Dutch director Bob De Visser, the oppressing *Plan Delta* (86) and the martial *Field Of Honor* (83), indicate Tuxedomoon's willingness to embrace the heritage of the American minimalists (Adams and Glass hover above these pieces) and the *Zeitgeist* of the time, cold wave mists and biting electronic particles.

Urban Leisure is the four part soundtrack of a multimedia project that was mainly conceived by Steven Brown, Blaine Reininger and one member of the excellent San Francisco Indoor Life's Bob Hoffner. It's a kind of perverse easy-listening track made out of aerial rhythmic and instrumental fragments, airplane take-offs and melodies played on the *saxo aphone* (…) Finally, the *Ghost Sonata*, termed an "opera without words" when it was presented for the first time to the audience in 82, unveils the elegant and refined chamber music of a band that undoubtedly have touched upon all fields of music.' [11]

2003: Tuxedomoon plays prestigious venues including the Beaubourg (Pompidou) cultural center and records their Cabin In The Sky album. 2003 will be decisive in the return of Tuxedomoon as a group not merely surfing on a wave of nostalgia. They gave a few landmark concerts in Belgium and in France, offering their new and yet unreleased material to demanding audiences and press. They also recorded their new material in Brussels, enabling some band members to come at terms with their past in that city.

Tuxedomoon playing Belgium again for the first time in 15 years originated in a request from Blaine Reininger who, some time in late 2002, asked me to find them a gig in Belgium as he felt he psychologically needed to make peace with Belgium. It was a prayer that I found difficult to resist but I knew nothing about concert promoting. But I soon could count on the help of two friends. First of all Brussels theater playwright and old friend of the band Rudi Bekaert gave me a contact for Peter Verstraelen, a renowned concert promoter in Belgium since more than twenty years. Peter immediately proposed some dates in early 2003 but somehow they did not fit with some of the band members' schedules. Then an old time Belgian Tuxedomoon fan providentially stepped out of nowhere in the form of Jean-Marie Mievis. Jean-Marie was longing for a Tuxedomoon gig in Belgium and as he worked as lighting designer at some local cultural center he obviously had some connections with venues. So when he was told that Tuxedomoon was looking for a venue in Belgium, he

his translations of some poems by Baudelaire. The show was filmed by Eddy Falconer and later released as a video entitled *Voodoo Cabaret Live*

04/2002 Release by Russian label Neo Acustica of a double live CD entitled *Live In St Petersburg*, a recording of TM's performance at St Petersburg's State Music Theater on 11/27/00 featuring the following tracks: 1. "KM/Seeding The Clouds;" 2. "Desire;" 3. "Fifth Column;" 4. "Tritone;" 5. "James Whale;" 6. "Again;" 7. "Nite & Day;" 8. "Volo Vivace;" 9. "Loneliness;" 10. "Nazca;" 11. "The Cage;" 12. "Litebulb Overkill;" 13. "Waterfront Seat;" 14. "What Use?"

05/05/02 SB holds one of his *Cinema Domingo* (SB playing live music while a film is being projected in his garden for people living in the vicinity) parties at home in Santa Maria Atzompa, Oaxaca, Mexico

06/02 The LTM label releases a number of TM-related CDs:
- TM's *Soundtracks – Urban Leisure* compilation CD featuring the following tracks: (Soundtrack to the *Plan Delta* movie) 1. "The Bridge;" 2. "Celebration Futur De La Divine;" 3. "Nimrod;" 4. "Lop Lop's People;" (*Urban Leisure Suite*) 5. "Urban Leisure" Pts 1-4; (soundtrack to *The Field Of Honour* movie) 6. "Fanfare;" 7. "No One Expects The Spanish Inquisition;" 8. "Driving To Verdun;" (from *The Ghost Sonata*) 9. "Basso Pomade;" 10. "Licorice Stick Ostinato;" 11. "Music # 2 (Reprise)" and (ending the recording) 12. "Celebration Futur De La Divine (live)"
- SB's *Decade* compilation CD (selected works 1982-1992) featuring the following tracks: 1. "Voxcon;" 2. "Decade;" 3. "Audiences;" 4. "Last Rendez-Vous;" 5. "The Thrill;" 6. "In The Still Of The Night;" 7. "The Lorelei/Overture;" 8. "Ombres Chinoise;" 9. "Music # 2;" 10. "R.W.F.;" 11. "L'Arrivée Dans Le Jour;" 12. "Tori;" 13. "Kwan-Yin;" 14. "Moments;" 15. "Lowlands Tone Poem;" 16. "Close Little Sixes;" 17. "Waltz;" 18. "This Land;" 19. "Out Of My Body;" 20. "You;" 21. "Halo Of My Memory"
- Re-release of BLR's *Instrumentals* album (originally released in 1987)
- Re-release of BLR's *Night Air* album (originally released in 1984)

06/13/02 TM plays at Sónar Festival, Barcelona. The set list is a mix of their old songs ("Dark Companion;" "Nur Al Hajj;" "Desire;" "Loneliness;" "Again") and of the material of their forthcoming *Cabin In The Sky* album ("Luther Blisset;" "Annuncialto;" "Baron Brown;" "Italian Song") released in 2004. The *Official Sónar 2002 Compilation* CD (released by sonarmusic in 2002) features a TM VS. DJ Hell version of "Luther Blisset" not otherwise released

Steven Brown: "When we got on stage after all these DJ-laptoppers, we looked like from another planet. Nevertheless something happened on stage and the audience responded enthusiastically. Above all we will always remain outsiders…" (SB interviewed by S. Lauwers, "Tuxedomoon blikt nooit terug", *De Standaard*, 06/02/04, translated from Dutch) "We discovered that we were perceived like the godfathers or grand fathers of this tribe of laptoppers, of a whole generation of young musicians…" (SB interviewed by JDN & JB, "Steven Brown et Tuxedomoon: les amis américains", *02*, 06/13/04, translated from French)

06/20/02 TM plays at State Chapel, St Petersburg, on the night of the summer solstice

06/23/02 TM plays in Moscow, B2 Club

Page 389

08/17/02 LvL & BG's band Microdot plays at part of the *Pleinopenair Festival* in Brussels

09/09/02 Congress of the Belgian socialist party (French-speaking) at the end of which Nine Rain's "Venus Rising" was aired as the concluding song by Marc Lerchs, in charge of the organization of events for this party. Hence major Belgian political figures found themselves cheering on stage at the sound of SB singing: "I feel like a junky; I am a junky; I feel like a whore; we are all prostitutes!"

09/28/02 Nine Rain plays at Haus Der Kulturen Der Welt, Berlin. This concert was recorded and some excerpts are featured on the *Nine Rain – Live In Europe 2003* album available for download on http://www.iguanamusic.com

10/20/02 SB participates in *Arte Y Moda En El Parián*, Cine Mudo y Saxofon. Film projected: *El Gabinete del Dr. Caligari*, with SB & Bruno Varela, Epson 19:00 hrs. See: http://artte.com/arteria.asp?cve_texto=90

11/02 I'm in Mexico with theater playwright Rudi Bekaert to spend some time and travel with SB. At the end of the month, Rudi and I are in New York City with PP and his girlfriend Gretchen Meyer

11/09/02 SB plays with Alex Hacke (from Einstürzende Neubauten) & Alejandro Herrera, a gig named *Post Mortem* as a reminder of the Days Of The Dead celebrated in Mexico in November, Bar Animal, Mexico City

2003

01/03 The Italian rock magazine *Blow Up* features two large articles about Tuxedomoon in a historical perspective (from E. Cilia for "Quel vecchio frac – Venticinque anni di Tuxedomoon" and Bizarre for "Una storia privata")

From 03/28 until into 05/03 BLR plays the role of a DJ and provides soundtrack music to Albrecht Hirche's play entitled *Die 10 Besten Rocksongs der Weltgeschichte*, Halle Kalk, Cologne

One of Reininger's lines in Hirche's aforementioned play: (Blaine talking to Kurt Cobain) "Kurt, come out of your fuckin' box you junky asshole!!! I've done everything in my life: traveling – a lot – all over the world. Everywhere! I've seen every airport on this fucking planet. I had women. Men. Dogs. I was married. I have kids. I've put everything in my mouth, in my veins, everything I could find. Now I am clean. I am a Fender man. I've sold more than 100,000 CDs in my life. Unlike you there is one thing I've never done: a number one. No number one. Not even a number ten. No hit single. That's why I'm sitting here tonight. Kurt! Was denkst du wann du hier bist?"

03/22/03 A concert of SB + Bill Nelson (ex- Be Bop Deluxe) at *Tecnogeist Festival*, Mexico City, had to be cancelled for financial reasons

05/12/03 WT + Factrix play at The Lab, San Francisco, a commemoration of RE/Search publications' 20th Anniversary

started to call around. His mission proved difficult at first as many considered Tuxedomoon as "has-beens" but, in the end, he got an enthusiast response from a small club in Hasselt bearing the appropriate name for Reininger's reconciliation with Belgium: België (*i.e.* "Belgium" in Flemish).

Meanwhile, still in late 2002, I was put in touch with Arnaud Réveillon, then in charge of live music selection for the world celebrated Beaubourg (Pompidou) cultural center in Paris. His attention on Tuxedomoon had been drawn by the band's recent doings with DJ Hell and he was proposing a date for early 2003. It turned out that Beaubourg's proposed date did not fit with Reininger's schedule. So in the end the Beaubourg date was moved to June, to take place just a few days after the Hasselt gig, programmed for June 21st, namely on the day of the *Fête De La Musique* with musical events happening all over Belgium.

Meanwhile again, a beloved friend of mine, late journalist Françoise De Paepe had put me in touch with a friend of hers, Lucas Balbo from Paris, to discuss some practical questions involved in the making of my Tuxedomoon book. It turned out that Lucas's wife, film-maker Merrill Aldighieri, originally from New York City, had known and filmed Tuxedomoon in the early eighties when they performed in some NYC clubs. In the nineties her path had crossed Peter Principle's and she made a video clip for "No Tears" based on some archive footage that Principle had provided her with. So by one of these extraordinary tricks of destiny, she learned, after her divorce from her American husband, remarriage with Lucas and moving to Paris, that Tuxedomoon was resurfacing in Europe after all these years! Not knowing what the outcome might be – but secretly convinced that she would make *something* out of it – I invited Merrill and Lucas to come at Tuxedomoon's Hasselt gig where she would start filming them, collecting her first images for what would later become her *Seismic Riffs* DVD.

That was how I became an *actor* of Tuxedomoon's story. It happened in a sort of natural course of things and not out of a conscious decision as I could see how badly the band needed all the help that could be offered and that such help could actually make a difference. I became involved, as so many were before me, a fact that Steven Brown emphasized in Alex Ivanov's 2005 short documentary about the band [12]: "We depend on the kindness of strangers."

I found myself for the first time on the road with Tuxedomoon – many other times would follow – when, in June 2003, they left their rehearsal studio located rue de Mérode in Brussels to step into the van that took them to Hasselt for their first gig in Belgium in 15 years. That gig also saw the return of Bruce

Page 390

Geduldig aboard to take care of the band's visuals.

Strangely enough, 2003 probably was the hottest summer recorded in Belgian history and in this way reminded everyone of the hot hot days spent in Cagli two years before. It seemed that their material composed back then necessarily had to drag that kind of atmosphere anywhere where it would be transported. And that was actually something that would come to characterize most of their 21st century compositions: a hot and sunny atmosphere. The eighties had been the years of dark *fin de siècle* angst for frozen exiled Californians touring North European cities in the middle of very cold Winters. Italy had been their refuge, their sunny island. Now Belgium, one *Greenhouse Effect* later, had become the somewhat spooky island of Tuxedomoon's return. As one of them noted then Brussels was akin to Centerville, after the name of the town in an episode of the famous *Twilight Zone* TV series [13]: no matter how hard they would try to flee, they will always be brought back to Brussels. Brussels, that they nicknamed Mortville in the eighties-nineties, had now become Centerville, where they finally enjoyed the stopover, as can be inferred from Brown and Reininger's writings at the time:

(Steven Brown) 'At one point I had to admit to myself that Brussels is one beautiful city. It had been ten years since I moved out and perhaps with that distance and more experience in the world I could see the city in a way one doesn't see anymore after living the day to day, year after year in any given place. That and the weather astounded us: we had expected and perhaps even looked forward to a gray misty humid ground to work in but from day one the temperature hovered around 35c with cloudless skies. This for the two months we were in Europe. You must realize that during the time I (we) lived in Brussels, two consecutive weeks of no rain was considered a marvelous summer. I exaggerate, but barely. As far as being "unique," yes you could say it is unique. I think Marc Hollander put it very well in a recent interview, one of many he is doing now on the occasion of the 20th Anniversary of Crammed Discs. He said that: "Belgium is really the Nowhere Land in the Beatles song, the place that shouldn't have been a country and that is sort of an accident of history where you are obliged to think Europe, the world. To be Belgian and chauvinist is an oxymoron (smiles) but in the end this incongruity is the source of our strength."' [14]

(Blaine Reininger) 'Belgium. Ah, Bruxelles! Ah Belgique! Ah, les frites! Ah le manneken pis! Let me tell you it was most strange to find myself back there. I spilt a great deal of vitriol and moaned many moans over that desolate ville. Stranger even was the fact that it didn't look all that bad this time. There's some mighty fine architecture thar. Faded old whore of a 19th century imperial capital.' [15] Later Reininger wrote me:

05/23-30/03 SB participates in the 5th regional cine/video festival named *Geografias Suaves* (plays live music on films projections) at Mérida, Yucatan, Mexico

06/14/03 Microdot plays at Crema e Gusto, Brussels

Some time in '03 BLR plays "The Foreigner" and provides soundtrack music to Albrecht Hirche's theater play entitled *Death Of Danton*, Theatro Amore, Athens

06/21/03 TM plays at Belge-Kunstencentrum, Hasselt (Belgium). Merrill Aldighieri starts filming them for her upcoming *Seismic Riffs* DVD

Page 391

Peter Principle at soundcheck, Hasselt, June 21st, 2003. Photo Isabelle Corbisier

'Well, I just have to say that the important thing about seeing Brussels this time was the fact that I saw it through "new eyes," that is, a point of view unclouded by bitterness and disappointment, and certainly by the many foul chemicals which used to inhabit my soul. In this way, everything seemed new. It was also important that I see that Brussels, like Athens and everywhere else I have lived is just a place. The misery was mostly mine.'

The concert in Hasselt on June 21st, 2003, was a success, with the band playing mostly their new material mixed with a few of their older standards. The coherence of the set was so well-achieved that a journalist did not notice that many of the pieces presented were new material. [16] The heat was so intense on that day that the sun-bathed compositions of their forthcoming *Cabin In The Sky* album sounded in tune with the damp atmosphere of this small club. The venue was very filled with a disparate audience mixing fans from the early hours with much younger people attracted by the cult aura that seemed to surround the group's work and exile in Europe. Many teenage fans were spotted in the front row, with eyes wide open: "We almost can't believe this! We thought we would never get the chance to see them play live one day…"

The concert in Paris at the Beaubourg (Pompidou) cultural center was probably one of the most important ones in Tuxedomoon's entire career and certainly gave them the opportunity to express themselves as much visually as acoustically. The conditions were ideal. The venue was simply put at their disposal for several days of rehearsals. The acoustics were near to perfect and Bruce Geduldig was given cinematic tools that barely exist in regular rock clubs. The tickets for the gig had sold-out several days before, which came much to the amazement of many. It was a confirmation of the strength of Tuxedomoon's "underground" following, the band still adored by many despite the scarcity of press attention. Tuxedomoon never was fashionable or at least considered as such by the so-called "authorized" voices of the Parisian press. "Near-religious listening experience" might the most apt description of Tuxedomoon's performance at Beaubourg. The audience quietly sat through a truly psychedelic set, [17] only to burst into wild applause between the pieces and to yell for some *encores*. Merrill Aldighieri and I were given dream-like conditions to film and shoot photos. Large excerpts of the concert and backstage mini sequences were later included in Aldighieri's *Seismic Riffs* DVD and my photos will be used for the cover art of *Cabin In The Sky*.

In the meantime the negotiations between Crammed Discs and Tuxedomoon made substantial progress and had reached a happy ending: the band now had a record deal. The timing of the band's gigs in Hasselt and in Paris allowed them to stay on in Brussels after the Hasselt and Paris concerts to record their *Cabin In The Sky* album at their rehearsal studio on rue de Mérode with the help of Coti K. Here are Steven Brown's impressions of this period otherwise largely illustrated by Aldighieri on her *Seismic Riffs* DVD:

'Tuxedomoon is back in Brussels recording a new CD for the first time in sixteen years (since *You* in 1987). Let me say that none of us six months prior would have imagined Tuxedomoon back together again recording in our old haunts... And haunt is the word. Still, once there, we all felt that it seemed right somehow or certainly not abrasive to what might be considered a destiny.

We're holed up in a funky rehearsal studio near the South Station recording into a laptop. One time ballroom high glass ceiling original glamour now old: paint peeling and fluorescent lights Peter fantasizes there was once a bordello here and indeed it is an addition stuck on to the back of a nondescript Brussels apartment building with an easily camouflaged entrance.

Ten hour days every day. Lunch break at 4 p.m. in nearby Greek restaurant to the amusement of our Greek engineer Coti. Here tensions are reversed: very visible Turk and Moroccan

06/26/03 TM plays a sold-out gig at Centre Pompidou (Beaubourg), Paris

populations that have shown hostility towards whites in recent months. Bruce, who is very blond and American has met with physical violence on two occasions from Muslim men lately. During the recent massacre in Iraq tension ran high and you can guess who the Moroccan city bus drivers gave preference to.

Brussels has become more cosmopolitan than ever. Black, brown, yellow and white stroll in parks soaking up unusual welcome sunshine. It's rare to hear either of the two national tongues (Flemish and French) spoken on the street. My friend Rudi [*Bekaert*] says it's like one of those images of the "new world" in the Jehovah's Witness magazine. He is so right. Marijuana decriminalized and same sex marriages now legal in this land I called home for twelve years. During that time two weeks without rain constituted a splendid summer. We've been here two months and every single day has been sunny and very hot! Greenhouse effect? There were no gray Belgian skies this time and I think we were all made more aware of being time travelers. We were in run down ex dance salon in Brussels but the weather was more like Southern Italy and in the streets you heard Portuguese and Moroccan, so where were we really? Perhaps this incongruity of Brussels had a bearing on the music... yes. It certainly had a bearing on our moods.

Transcription of a normal day in Tuxedomoon recording session : "Don't laugh! I'm not laughing. Don't even make a sound. But I like them all. Colorize that, would you? Help me find my car keys and we'll get out of here. His vocals should be up-front. Ba da da dah. Are you starting to repeat things? What's the little shiny one? What's the yellow bit there? Hope nobody is missing their bicycle pump. I borrowed it and never used it. KOM Hai EEEEE. Well that's it. Cut the big yellow one out. And insert a purple one. How many musicians does it take to hold up a music stand? Record Audio! Yes Mr. Brown we can call this "midday stroll." I would take the third. Tell me what to do. I'm losing it. So you want the third first. And then maybe the second. I would really wait. I don't know how far we are in time..."[18]

After the band finished recording, the timing continued to be perfect as they were able to take part in Crammed Discs's *Crammed Global Soundclash* promotional tour in the Fall of 2003. Posters, that did not originally mention Tuxedomoon, were hastily revised and an arrangement was reached with concert promoter Peter Verstraelen so that the booking of Tuxedomoon's concert at Brussels's beautiful Le Botanique venue on September 28th, 2003, would be part of a Crammed event, with Crammed artists featured in all the concert rooms available at Le Botanique. The gig received rave reviews from both French and Flemish-speaking journalists:

Tuxedomoon in Paris, Beaubourg, June 26th, 2003. Photos Isabelle Corbisier

Tuxedomoon in Paris, Beaubourg, June 26th, 2003. Photo Isabelle Corbisier

07/03 TM works on the recording of their forthcoming *Cabin In The Sky* album in Brussels (namely in a rehearsal studio in a crumbling house, rue de Mérode, seen in Aldighieri's forhcoming *Seismic Riffs* DVD) with the assistance of Coti K, engineering

07/06/03 Nine Rain plays at Villa Ada, Roma, *Festival Roma Incontra Il Mondo*. This concert was recorded and some excerpts are featured on the *Nine Rain – Live In Europe 2003* album available for download on http://www.iguanamusic.com

07/09/03 Nine Rain plays at Baratuna, Belgrade, *Belef Festival*. This concert was recorded and some excerpts are featured on the *Nine Rain – Live In Europe 2003* album available for download on http://www.iguanamusic.com

07/12/03 Nine Rain plays at Red Club, St Petersburg to present Neo Acustisca's release of *Nine Rain Choice*, a compilation CD featuring the following Nine Rain tracks composed between 1993 and 2002: 1. "Brother And Sister;" 2. "Rainy Jaranero;" 3. "Alex's Torture Song;" 4. "The Virgin Is A Molecule;" 5. "Guantanamo's Harpsichord;" 6. "Raw Girls;" 7. "Lawnmoaner;" 8. "Lamento;" 9. "Oración Caribe;" 10. "Venus Rising;" 11. "Cold;" 12. "Rain Of Fire;" 13. "Into The Sea;" 14. "Radio 2 Nay," with tracks 1 and 11 previously unreleased. A limited edition of 1,000 copies of a box set enclosing the aforementioned CD + SB's mini book entitled *Stories From Mexico* (previously published by Rowhouse Press) in its English original version + a translation into Russian. Additionally the St Petersburg concert was recorded and some excerpts are featured on the *Nine Rain – Live In Europe 2003* album available for download on

'We found intact all the magic of this music deprived of drums but not of inspiration, based on violin, trumpet, saxophone, clarinet…

(…) Tuxedomoon re-connected with its legendary past but never giving way to nostalgia in doing so.

(…) Love cries were bursting from the audience (…) Steven had a very hard time in preserving his gravity in the face of his old friend's pranks. A good mood that had the bearing of a reunion that will result in the release of a new album next year. What could be heard of the new pieces was, as matter of fact, quite promising…' [19]

'The concert luckily left little room to nostalgia but offered extraordinary performances of a whole series of brand new songs along with a few old ones (…) The new songs sounded so good in comparison with the older ones that we would have sworn that the band had rescued them from their best period (…) So the principle according to which old groups' reunions never end up in anything good does not apply to Tuxedomoon.' [20]

After Brussels, the *Crammed Global Soundclash* tour continued to Paris (at Le Bataclan on September 29th) where Tuxedomoon jammed with Romanian gypsy band Taraf De Haïdouks on a version of "Nur Al Hajj"/"Courante Marocaine" and then to

Amsterdam (at Melkweg on September 30th).

After such a busy 2003, the band members returned to their respective continents, with the prospect of an interesting year ahead. Meanwhile, I wrote the articles of incorporation for a new Tuxedomoon ASBL (Belgian non-profit organization), replacing the one that had been dissolved in the nineties.

> **From Cabin In The Sky until the release of their 30th Anniversary box set: Cabin In The Sky and related events in 2004; Tuxedomoon back in San Francisco in 2005 and participating in the New Atlantis Festival in Amsterdam (with George Kakanakis on board); 2006: release of their Bardo Hotel travelogue album; 2007: Tuxedomoon release their 30th Anniversary box set containing their latest Vapour Trails album and a wealth of archive material**

2004 saw the release of Tuxedomoon's first studio album proper (when one excludes 1997's *Joeboy In Mexico*, which was not released under their own name) in 17 years.

The gestation of the album was long: more than two years from the sketches that appeared on their Cagli demo. Crammed Discs used that time to enlist quite a few "names" to participate in the final mix: Marc Collin (from Nouvelle Vague, a long time Tuxedomoon fan), John Mc Entire (from Tortoise), Tarwater, Juryman, Aksak Maboul (*i.e.* Marc Hollander and Vincent Kenis) and some beats provided by DJ Hell. None of the artists named, with the exception of DJ Hell, Aksak Maboul and Marc Collin, actually met the band during the recording/mixing process of the album. Their contribution rested on Hollander's initiative, who sent them the tapes on which they worked.

The title given to the album was Brown's idea. Finding titles for albums always was a difficult task for the band. The idea of a "cabin in the sky" suddenly popped up in Brown's mind one day. He immediately found it appropriate: the members of the band being so dispersed geographically. The "cabin in the sky" defines this imaginary space, composed of all these locations scattered on the planet where they actually got together to work and create. Brown: "The idea of this cabin up in the sky is an adorable lunacy that we will bring on tour

http://www.iguanamusic.com

About Nine Rain's first European tour.
'I have just survived the first European tour of Nine Rain back to back with a mini Tuxedomoon (two shows) tour. Carlos and I flew from Brussels to Rome to meet the band arriving from Mexico. We played the annual music festival held in the Villa Ada, outdoors in front of a little lake in a forest. At first the audience was checking us out, polite applause. Little by little warming up to this new proposal. After forty minutes they were (…) ravenous. We were called back three times, re-playing songs from the set after we had played our *encores*. Luca Bracci, the man who had hired us and risked a substantial investment (plane tix) in this relatively unknown band was all smiles after the show.
After a 24-hour delay and confusion at the Serbian embassy we were off to Belgrade to play the Belef City Festival. The event took place in front of a massive fort built by the Turks on a hill overlooking the Danube and Sava rivers. Caves in the hillside bore witness to this strategic and beautiful spot having been used long before the Turks. Here the audience was primed from the beginning, applauding in recognition of first notes. As Alejandro pointed out to the glee of the crowd, Nine Rain's biggest fan base is here in Belgrade.
Met old friends from Radio B-92, a group that was instrumental in the overthrow of Milosevic and sponsors of Tuxedomoon's concert here in 2000. They have become quite commercial

**Blaine Reininger with Tuxedomoon, Brussels, September 28th, 2003.
Photo Isabelle Corbisier**

Brussels, Botanique, September 28th, 2003. Photo Isabelle Corbisier

and even have a TV channel now broadcasting Milosevic's trial every day. They are already at odds with the new government they had such hopes for only two years ago. Run down, worn-out, user-unfriendly and a language you will never speak; still you like the place-- Belgrade.
After Belgrade we flew back to Rome still unsure about the St Petersburg show which has been on again off again for weeks. Another night in hotel in Rome and finally at the last minute confirmation arrives by fax.
We were off and three hours later stand for two more in snail's pace Russian immigration line (…)
We arrive exhausted after midnight and are met by Oleg and Gleb for what is to be my 3rd visit to this city. I am not in good humor after the endless delays and hourly last minute changes in the weeks preceding our arrival. In what now seems a tradition here we mount four flights of stairs with our 300kgs+ of gear to our lodging. "No lift." Oleg says, smiling sheepishly. It was worth the trip. He has rented two brand new apartments for us: two kitchens, three bathrooms, six bedrooms, and located two blocks from the glorious Hermitage Museum. We are to play a small club with a good rep.
(…) The concert was to celebrate the release of *Choice*, our first Russian CD, a compilation of the first two Nine Rain CDs. (…)
In the evening we shovel ourselves into a train for the eight-hour trip to Moscow. No dining car. We must sustain ourselves on the offered fare of warm beer, vodka, white bread and sausage. By midnight Niko and Alex [*Herrera*] are hosting a wild party in the smoking den. We arrive at 4 a.m. at a rainy dark station. We had been told we would be met by people to take us to airport... No one is there, and

all over Europe."[21] Reininger also warmly approved a journalist who interpreted the title as a reference to Magritte's paintings.[22]

Winston Tong is co-credited for the song "Baron Brown" although he did not actually participate in the making of the album. In fact, Brown used some words once scribbled by Tong on one of his notebooks back in the eighties for the lyrics of the song. It was a way to render Tong present on the album, as the band had repeatedly attempted to bring him back on board since their reunion, but without success. Furthermore when scrutinized closer, the lyrics of "Baron Brown" stand as an ironic illustration of Reininger/Brown's legendary confrontation as Reininger's portrayal of a "lecherous old goat" sexually obsessed with young girls responded to Brown's incantations (inspired from the Nag Hammadi Codices' gnostic ideas) that were of a more spiritual nature:

Lyrics from the song "Baron Brown":
[Brown] Something something something something
something something bitter, or better
Something bittersweet
Make enemies and friends on barren ground
On barren ground make your enemies and friends

[Reininger] You women and girls

Tuxedomoon at the Bataclan (Paris) on September 29th, 2003:
Blaine with accordeon from Taraf De Haïdouks. Photo Isabelle Corbisier

You light up my world
This beautiful sight
Fills me with delight
See this lecherous old goat
In a leather overcoat
The only thing is that
I wanna wear you as a hat

[Brown] Given the magical privilege and power of the word
Move mountains, part seas
Make the lame walk
Make the blind see
Get them all to talk
Let them all hear about love
And that terrible beauty that runs in our blood
And that terrible beauty that runs in our blood

[Reininger] Young flesh revealed makes me squirm like an eel
A see of your leg makes me sit up and beg
That's me that you see
Hiding by a tree
In spite of all my schooling
I'm standing out here drooling

soon we are having a near violent showdown with baggage porters who are demanding $100 for having wheeled our belongings 100 meters. Soon the "police" arrive and things look grim. Gross pot-bellied thugs with badges and sticks. We try to negotiate with the porters but nobody speaks anything but Russian and I'm writing down numbers on a piece of paper and flashing them to our captors for approval. Finally we leave the station, attendants counting the wad of rubles and dollars we had thrust at them and jump in two taxi cabs after negotiating an $80 fee to the airport (down from $200). The ride is chilling to say the least: we have no idea where the airport is and these so-called taxistas could be taking us anywhere. I keep looking out the back window expecting to see us tailed by accomplices Mexican style. When the two cars pull off on a side road and stop I think: "this is it." They want to be paid now. Carlos: "We will pay you at the airport." Them: "Now!" (in Russian).
We have no choice and eventually arrive safely at the airport, later realizing the reason they wanted to be paid before arrival was to not be seen taking money from us as they aren't exactly official taxis. The horror continues in the Moscow airport with bitter mean Aeroflot attendants demanding $400 in overweight charges, a charge which curiously had not been charged us in Rome to arrive. "You no pay you stay in Russia." She snarls at one point. This is about half of our earnings we must fork over and by now everyone is a bit upset. Finally we are in the air and back to civilization and Rome (…)
I am here in Brussels now to begin recording the new Tuxedomoon CD. The blazing sun is gone today. Gray skies have come to greet

us, welcoming Tuxedomoon back to Brussels.'
(excerpt from STEVEN BROWN's private journals)

Summer '03 TM recorded their upcoming
Cabin In The Sky album in Brussels, with Coti K
engineering

09/28/03 TM plays at Botanique, Brussels, as
part of the *Crammed Global Soundclash Festival*.
To be noted: the *Crammed Global Soundclash*
consisted in the re-release of 12 of their major
albums originally released in the eighties. TM's
Desire album was part of that programme
along with Aksak Maboul, The Honeymoon
Killers, Benjamin Lew, Zazou Bikaye, Minimal
Compact, Karl Biscuit, Hector Zazou, Colin
Newman, Sonoko, Sussan Deyhim/Richard
Horowitz & Bel Canto. For the occasion a
double CD + leaflet + CD of remixes box set
named *Crammed Global Soundclash 1980-89
– The Connoisseur Edition* was also released
by Crammed Discs, featuring excerpts of the
re-released artists. The CD of remixes contains a
remix of TM's "The Waltz" by Chilluminati.

09/29/03 TM plays at Bataclan, Paris, as part
of the *Crammed Global Soundclash Festival*. TM
jammed with Taraf De Haïdouks at the end of
their concert (to be seen in Merrill Aldighieri's
Seismic Riffs DVD)

09/30/03 TM plays at Melkweg, Amsterdam, as
part of the *Crammed Global Soundclash Festival*

10/03 Neo Acustica releases Microdot
(mainly composed of LvL, BG and Bernadette
Martou)'s album entitled *Trouble In Paradise*
featuring the following tracks: 1. "Tape;" 2.
"Too Cool;" 3. "East;" 4. "Crash;" 5. "Talk About
It;" 6. "Megaspace;" 7. "Trouble In Paradise;" 8.
"One More;" 9. "Get A Life;" 10. "Carry On;" 11.
"Hooligans;" 12. "Nice Doggy"

10/03 SB starts a radio show named
Oaxtrax on Radio Universidad de Oaxaca (every
Friday from midnight till 1 a.m.). This show
presents a mix of Mexican folk music, world
music, avant-garde mostly European music and
movie soundtracks

10/23/03 Microdot plays at the
swimming pool, place du jeu de balle, Brussels.

11/09/03 Nine Rain plays at Festival
Xtacion De Musica (founded by SB), Oaxaca,
Mexico

12/05/03 WT plays with a super group
composed of people coming from Factrix
and The Units and himself from TM, as part
of *A Night Of Industrial Music* at The Lab, San
Francisco

2004

Some time in '04 SB composes, with
Bruno Varela, the soundtrack music of Varela's
short film entitled *Barrenador*

Some time in '04 LTM label releases
BLR's *Night Air 2*, 'a bittersweet meditation on
life in exile in a hostile city,' a compilation of
songs selected from several albums recorded
between 1989 and 1999, namely: 1. "Night
Ride" (from *Radio Moscow*, 1995); 2. "Invisible"
(from *The More I Learn The Less I know*, 1999); 3.
"Silly Boy" (from *The More I learn The less I know*,
1999); 4. "Flame On" (From *The More I Learn The
Less I know*, 1999); 5. "Al Haqq" (from *Manic Man*,
1997); 6. "Manic Man" (from *Manic Man*, 1997);

[Brown] Something something something something
something something bitter, or better
Something bittersweet
Make enemies and friends on barren ground
On barren ground make your enemies and friends

[Reininger] It's old Count Dracula
Take you in the bakula
Of your feast he will partake
A meal of you he'll make
That's me that you see
Over by the tree
In spite of all my schooling
I'm standing out here drooling

Reininger later described that song as an allegory for the duality
of human nature, as all men are torn between very down-to-
earth sexual matters and elevating their soul to more spiritual
ones. [23] The origin of the song's title is quite amusing: Principle
had rapidly written down the titles of the songs when putting
the Cagli demo together. Instead of "Barren Ground," he wrote
"Baron Brown." The keeping of the title reveals that the band
still had a sense for self-derision…

The album also features a song entitled "Luther Blisset," a
barely disguised reference to Tuxedomoon's situationist
heritage. [24] Brown: "Yes this song is about this Italian group of
anarchists who borrowed their name from this soccer player
named Luther Blissett. This group, inspired by the situationists,
even puts out books. I bought some in Italy and their authors
were like urging their readers to copy them and use their
ideas for their own purposes. So the piece has nothing to do
with Luther Blissett, the soccer player, but rather refers to the
concept, to the idea of freedom and negation of copyright."
[25]

The piece "Diario Di Un Egoista," sees Reininger singing in
Italian: (Reininger) "I wrote it thinking of Paolo Conte as I
believe that we have the same sort of *blasé* approach of life." [26]
"It's also telling the love story I had with an Italian woman for
some time. She couldn't speak English so well, so I owe her to
have become better with my Italian." [27]

The critics almost unanimously welcomed the new album.
Some samples:
'The three accomplices have thrown their science of contraries
into the pot and deliver an album that is faithful to their original
communal utopia (…) an album of a bluffing modernity (…)
Uncompromising and personal, but of a true generosity
towards the listener, Tuxedomoon's music breathes the found
again heedless attitude of those who have the experience,
the audacity of music lovers. *Cabin In The Sky* is a free record, a
rare item nowadays.' [28]

'More chameleon than they ever were (…) a great mix, intimate and polyglot: Tuxedomoon weaves its own agenda, commanding some orbital radio station with its studio moving up in the sky, overlooking a changeable and many-colored planet. The moon's tuxedo is more than ever an Harlequin costume… But, maybe, more than any of the other terms used towards them, *cyber-gipsy* is the most suitable for an album in turn hovering up and uncapping, ultra up-to-date and resolutely untimely.'[29]

'This new set might be their best since the passing of the era they helped to define (…) Happily the far-flung geography benefits the music (…) The angst quotient may have dipped since their heyday, and Winston Tong remains missing in action, but these enigmatic moodists still do night, fog and rhumba like nobody else.'[30]

'*Cabin In The Sky* finds them back together again, arguably more potent than ever (…) they've crystallized (…) a distinctly European sound (…) but tempered by a facetiously sinister wit (…) They evoke a diverse range of moods: the tropical fantasia of "Misty Blue," the Milesian "Cagly Five-0," the tribal "Luther Blisset," the tentative "La Piu Bella Reprise," in which lachrymose violin and stoic piano underscore an old Italian lament. But somehow, it all seems satisfyingly of a piece.'[31]

'This recording (…) is a perfect mix of Velvetian discord and Debussian lightness, combined with some electronic experimentation remanent of the post-punk break. With their cinematic writing *par excellence*, these avant-garde pioneers do not hesitate to draw from their imagination what others do from their record library. As the missing link between Joy Division and Radiohead, it was time to pay them a tribute.'[32]

The *Cabin In The Sky* promotional tour took the band to many, but not exclusively, European cities: Florence, Athens, Thessaloniki, Zagreb, Belgrade, Brussels, Ghent, Amsterdam, Rome, Paris, London, Tel Aviv, Madrid, Malaga, Cologne, Nancy, Vienna, Budapest, Linz, Stuttgart, Rimini, Moscow and Aveiro.

In Florence, their gig was part of a series of events that culminated in a concert/homage to the band which saw some locally famous musicians, gathered under the *Stazioni Lunari* monicker, perform some landmark Tuxedomoon pieces, with the band eventually joining them on stage

7. "Music Box" (from *Radio Moscow*, 1995); 8. "Europe After The Rains (pts 1-3)" (from *Songs From The Rain Palace*, 1990); 9. "Night Street" (from *Radio Moscow*, 1995); 10. "Noche Lluviosa" (from *The More I Learn The Less I know*, 1999); 11. "Ghosts Of The Arbat" (from *Radio Moscow*, 1995); 12. "Arc En Ciel" (from *The More I Learn The Less I Know*, 1999); 13. "Voice Of The Hive" (from *Songs From The Rain Palace*, 1990)

Spring '04 Release of TM's *Cabin In The Sky* album (TM then consisting of: BLR, SB, PP, LvL and BG, some words by WT forming part of the lyrics of "Baron Brown." Also guesting: Marc Collin, DJ Hell, Aksak Maboul, Juryman, John McEntire & Tarwater. Recorded by PP & Coti K and mixed by Coti K & PP with help from Marc Hollander & Vincent Kenis) by Crammed Discs, featuring the following tracks: 1. "A Home Away;" 2. "Baron Brown;" 3. "Annuncialto;" 4. "Diario Di Un Egoista;" 5. "La Più Bella;" 6. "Cagli Five-0;" 7. "Here 'Til X-Mas;" 8. "Chinese Mike;" 9. "La Più Bella Reprise;" 10. "The Island;" 11. "Misty Blue;" 12. "Luther Blisset;" 13. "Annuncialto Redux." To be noted: remixes of "Cagli Five-0" by Tarwater and of "Misty Blue" by John McEntire can be found on Merrill Aldighieri's **Seismic Riffs** DVD released later in 2004. This album will be released in the USA in the Fall of 2005 via Rykodisc and in Mexico, late 2005, by Independent Recordings (a label formed between SB & Carlos Becerra). The album is dedicated to Patrick Miller (from Minimal Man), who died in 2003

05/06/04 The new TM ASBL (Belgian non-profit organization)'s articles of incorporation and by-laws are published in the Belgian official journal

05/11-14/04 TM's **Florence Days** at Fabbrica

Steven Brown, Amsterdam, Paradiso, June 3rd, 2004. Photo Isabelle Corbisier

Europa, Florence:

05/11 press conference
05/12 a workshop involving people who worked with TM in Italy since the eighties
05/13 TM plays at Fabbrica Europa, Florence
05/14 Stazioni Lunari, an homage to TM by a super group of local artists, namely Francesco Magnelli, Paolo Benvegnù, Francesco Di Bella, Ginevra Di Marco, Max Gazzè, Andrea Salvadori, Arlo Bigazzi & Marzio Del Testa, performing some TM songs including a very energetic version of "No Tears." TM joined them on stage and played along during their performance

05/20/04 TM plays at Gagarin Club 205, Athens

05/21/04 TM plays at Club Mylos, Thessaloniki

05/23/04 TM plays at Club Mochvara, Zagreb

05/24/04 TM plays at Club Barutana, Belgrade

Steven Brown's impressions from Zagreb and Belgrade. Arriving Zagreb airport after friendly 60 min. prop plane ride from Vienna, we all head for the exit with our 250k on various carts and of course we are stopped by customs agent and must put everything through x-ray machine. The uniformed man asks if we are all musicians. "Yes," we meekly reply. Then to our astonishment he says: "All right go on ahead!"
Thus with joy in our hearts we enter the magical independent republic of Croatia. Everywhere people are happy, friendly. At one point desperate for answers Luc will ask a street vendor flat out: "Why is everyone so happy?"... "We have our problems. We don't have much money. But a smile is free..." A response worthy of Reader's Digest as Blaine will later remark. The first night in the restaurant B, well into his cups is happily served glasses of wine by the waiters who seem to actually enjoy his behavior. Everyone we meet speaks perfect American English and our young hosts are conversant in any topic that comes up. The club where we play is run collectively by some 20 or so young people. They are direct, assured, even tempered almost smug but with no malice
(...)
On to Beograd (white city)
Our driver speaks only Serbo-Croatian and happily chirps to us throughout the trip. He tries consistently to buy us beers and pays for our chocolate and tea. But this man, Yura by name, really won us over at the Serbian border. We had been alerted about this border as it is a real one, not so common anymore in these parts... Our host in Zagreb mentioning the fact that we had: "no drums or amps in our van was a good thing" did little to assuage our fertile imaginations. Yura not only sweet-talked six American passports and a van full of gear over the border, he even got a smile out of a border guard in the process!!! The scene was grim with big potential for more. We all had the same thought : East Germany in the 80's. But thanks to Yura we breeze through and make it to Hotel Parc in city center with on hour to spare before soundcheck.
We play in old Tito-era student center. Dragan our host and promoter from B92 says the place is falling apart because no one oversees its maintenance anymore. This place could be a gold mine for a capitalist entrepreneur. The complex houses three venues of varying sizes, three floors, a giant internet cafe with 2 full bars, shops etc. The show here is the last of this leg of the tour and is the best by far. This is number five and we are tight and relaxed at the same time. The Belgrade audience of

by the end of the concert. I also remember Bruce, at some Tuxedomoon workshop, telling me his definition in a nutshell of Tuxedomoon: "Living up to your dreams on a very low budget."

The London gig was Tuxedomoon's first appearance in that city in 22 years. This concert was the fruit of the perseverance of a dedicated London fan, Erik Stein (teaming with Gaya, from Hinoeuma [33]), who also had created and still moderates an internet discussion list devoted to Tuxedomoon. [34] The venue, called Electrowerkz, was small but filled with a colorful crowd – goths with rasta dreadlocks, some with the bearing of birds just rescued from a black tide. A review: 'The story is never over, as Blaine Reininger once said. Delivering 22 years in one night would be one mammoth of a task, but then it never felt like Tuxedomoon went away. It's the classic line-up here tonight. Flanked by Steven Brown on the piano – coming forward for the odd mad sax call – is the imposing Peter Principle, one Pete Townshend without the guitar-crashing antics, glacial yet so inwardly passionate, his heavy skeletal bass strums complementing the wackiness of Blaine Reininger's teasing violin breaks (...) They may be more the toast of French jazz festivals these days, but for a brief encounter they have the venue at *their feet*. Magic.' [35]

2005: Tuxedomoon is back in San Francisco, tours in Spain and participates in the New Atlantis Festival in Amsterdam (all with George Kakanakis in charge of the visuals). Blaine Reininger had been contemplating returning to San Francisco for some years already. Of course he had something on the back of his mind: working with Winston Tong again.

Tong had already been invited several times to join the band on tour in Europe. But then the same scenario as on the 1988 Reunion Tour repeated itself. In 2001, Tong promised he would come but then some sudden need for a surgery was brought up as an excuse for not coming. In 2003, he had been about convinced to fly in for the concerts including the one at Beaubourg in Paris. But then it was a last minute difficulty in renewing his passport that was given as a pretext for not showing up (not to mention that he didn't have the cash to buy a plane ticket). It wasn't surprising in the end. It had become clear that Tong never considered Tuxedomoon as an entity enjoying equal artistic ranking with himself. The "Stranger"/"Love/No Hope" single that Tong recorded with the band back in 1979 mentioned him as the featured artist, with Tuxedomoon presented as his backing band. In those days Tong *was* unarguably a star – who had won an Obie award for his puppetry and who could tour Europe on a lucrative theater circuit on the strength of his name – while

Page 402

Tuxedomoon was still an obscure combo. Later on, when he found himself in Europe with the band, he never hesitated prioritising his own work and was absent from some of the band's gigs when he had other things to do. Then Tong had tried to become a star on his own in Europe with his disco *Theoretically Chinese* album. It did not work out as he had hoped and he returned to the United States. He continued to be active as a performer, however with steadily declining success, his drug (ab)use being of course partly responsible for this. Today Tong's name can still be spotted in some European encyclopaedias of contemporary theater. It pops up again when artists (including Martin Gore and Nouvelle Vague) decide to cover the song "In A Manner Of Speaking" that he, incidentally, decided to register under his own name and not as a Tuxedomoon song. But most of Tong's past glory is gone, while Tuxedomoon is still a living and performing entity. Hence Tong is now being remembered mainly for his work with Tuxedomoon, undoubtedly something that he finds difficult to accept. Tong's intention had always been to instrumentalize Tuxedomoon in meeting his own ends and certainly not to be reduced to the status of a mere member of the band. Tong evidently harbored some resentment as he had somehow convinced himself that Tuxedomoon had fired him, which the band always denied and furthermore does not seem to be supported by the evidence. [36] As a result Tong trapped himself into a vicious circle, longing for some reunion with his European audience on one hand but, on the other hand, remaining in complete denial of the fact that Tuxedomoon would be his only realistic avenue for achieving that goal. Added to that that Tong had become quite reclusive over the years and actually seemed to fear what he imagined Europe had become, that sums up to several inertia factors explaining why Tong would not leave San Francisco to meet with the band.Reininger was probably aware of this, but, like all the other members of Tuxedomoon, was genuinely willing to work with Tong again as he believed that this would foster the band's inspiration. Going back to San Francisco was certainly the last chance of getting Tong involved.

Tong was of course not the only reason for the band's return to San Francisco. For all of them (with the exception of Luc van Lieshout, who would discover San Francisco for the first time), it was a return to the source of their creativity. Going back to San Francisco was also the search for "some" answer to a question that had haunted at least some of them for many years: what if they had stayed there? Could they still fall in love with San Francisco in the same way as they all did in the seventies? In other words, did they have reasons to regret their leaving San Francisco for Europe in the early eighties?

When they left for San Francisco, in March 2005, a new

course has everything to do with the successful show as well. We actually rouse ourselves from dressing room to descend two flights of stairs and do something we rarely do: re-play a song from the set, having already played our roster of five encores. Belgrade only in Belgrade.
(…)
Beograd airlines are as ruthless as their European counterparts and we are fleeced of 1/3 of our meager earnings in excess baggage charges. This coming on the heels of a 900 euro fine in Roma and then being denied passage through security to board our plane. Why? Too many carry-ons!!!! Our lamentations "We are musicians!" fall on deaf ears We literally sit down in front of x-ray machines in a daze as the long line of passengers files by..' (excerpt from Steven Brown's private journals)

05/25/04 TM interviewed by Radio Pure FM, Brussels

Since 06/04 BLR is in a relationship with Maria Panourgia, a Greek actress

06/02/04 TM plays at Handelsbeurs, Ghent

06/03/04 TM plays at Paradiso, Amsterdam

06/26/04 A meeting with SB & PP for the release of *Cabin In The Sky* at *La Feltrinelli Libri e Musica*, Roma, also with Roberto Nanni, Pierluigi Castellano, Arturo Stalteri & Giampiero Bigazzi

06/27/04 TM plays at Villa Ada, Roma, *Festival Roma Incontra Il Mondo*

08/15/04 WT + Voodoo Cabaret at Hush Hush, San Francisco

07/04 Neo Acustica releases BLR/Coti K's *Uneasy Listening* CD featuring the following tracks: 1. "Magician's Cirrhosis;" 2. "Odious Path;" 3. "Rebuild The Mosquito;" 4. "The Dogs;" 5. "Resurrection;" 6. "Honey Light;" 7. "Grandma;" 8. "Dictaphone;" 9. "Sleepy Bacteria;" 10. "Veri;" 11. "Hollywood;" 12. "Spain;" 13. "Razor Girl;" 14. "Ligeti Bolognese."

Coti K: "It's a sort of an absurd surrealistic cabaret/stand up comedy meets electronics…"

09/23/04 Presentation of Merrill Aldighieri's *Seismic Riffs* DVD at café Truskel, Paris. Aldighieri's DVD includes footage of TM recording *Cabin In The Sky* in Brussels and performing live in 2003. Video bonuses are: a live performance of "Nur Al Hajj" by TM and Taraf De Haïdouks on 09/29/03, vintage footage of "Incubus/Blue Suit" performed live at Hurrah's, NYC, 1981. Audio bonuses: remixes of "Cagli Five-0" by Tarwater and of "Misty Blue" by John McEntire

09/24/04 TM plays at La Villette, Paris, *Festival La Villette Numérique*

09/25/04 TM plays at Electrowerkz, London

09/30/04 TM plays at Zappa, Tel Aviv

10/01/04 TM plays at Barbie, Tel Aviv

10/07/04 TV show in Madrid

10/08/04 Promotion in Madrid

10/09/04 TM plays in Madrid, Festival ExperimentaClub

10/12/04 TM plays at Teatro Cervantes, Malaga

10/17/04 TM plays at Kantine, Cologne

10/19/04 TM plays at Salle Poirel, Nancy, *Festival Nancy Jazz Pulsations*

10/21/04 TM plays at Szene, Vienna

10/22/04 TM plays at A38 (venue on a boat), Budapest

10/25/04 TM plays at Posthof, Linz

10/26/04 TM plays at Röhre, Stuttgart

10/28/04 TM plays at Villagio Globale, Roma

10/29/04 TM plays at Velvet, Rimini

11/02/04 TM plays at Botanique, Brussels

11/03/04 TM plays at 16 tons, Moscow

11/05/04 TM plays at Gagarin 205, Athens. BLR temporarily fires BG after this gig, considering that BG should overcome his problem with alcohol before joining TM again

11/06/04 TM plays at Club Mylos, Thessaloniki

11/07/04 TM plays in Aveiro, *Festival Sons Em Transito*: TM's first date ever in Portugal

 12/04 SB guests on the CD of Mexican band Cine Mudo (counting Nine Rain band mate Daniel Aspuru within its members)'s first CD entitled *Cine Mudo Para Ciegos* available on following website: http://www.iguanamusic. com. Tracks: 1. "Muertos;" 2. "Resurrección;" 3. " Urbana;" 4. "Vigilantes;" 5. "Consecuencia"

2005

 Some time in '05 LTM label re-releases BLR & SB's *1890-1990 – One Hundred Years Of Music* album under the title *100 Years Of Music: Live In Lisbon 1989*. The CD features the following tracks: 1. "Iberia;" 2. "Egypt;" 3. "The Fall;" 4. "Les Odalisques;" 5. "Piano # 1;" 6. "L'Arrivée Dans Le Jour;" 7. "Music # 2;" 8. "Salad Variation;" 9. "Fanfare;" 10. "The Waltz;" 11. "Licorice Stick Ostinato;" 12. "Volo Vivace;" 13. "Litebulb Overkill;" 14. "Souffle Coupé"

 Some time in '05 LTM label releases PP's *Idyllatry* CD 'featuring a selection of instrumental works mostly made to specification for a variety of situations or medias recorded mostly during the second half of the nineties, with track 3 credited to Ecco Bravo, formed between PP, Josh Mathews, Dave Kennenstein & Jeff Davis. Full tracklist: 1. "Emotions;" 2. "Scissors Cut Paper;" 3. "Tunguska;" 4. "The Quarry;" 5. "The Cloisters;" 6. "The Unknown;" 7. "Desolate Idyll: Opening With Distractions – Grandfather Tree – Sculpting Til Dawn – Uncertain – Desolate Idyll Epilogue"

 Some time in '05 SB provides part of the music to Rolando Beattie's *Claroscuro* choreography, Mexico

 Some time in '05 Stilll Records (an independent Belgian label founded by Alain Lefebvre & Jerôme Deuson) releases the *Stilllysm* compilation CD featuring *a.o.* a track by Peter Principle & Ecco Bravo: "Do You feel Five?"

02/05 LTM label releases a DVD entitled *Umbrellas Under The Sun – A Crepuscule/Factory*

companion shared the journey in the form of the Greek visual artist George Kakanakis, who replaced Bruce Geduldig for a time. Kakanakis had spent most of his youth in New York City, which immediately brought him close to Reininger when they met in Athens, as Reininger had always been seeking the company of people who could speak a good American English. Kakanakis was an experienced visual artist who worked with theater groups and directors such as Albrecht Hirche (who had hired Reininger as an actor for a few of his projects). He successfully worked on a couple of Blaine's solo shows. So when Reininger temporarily fired Geduldig at the end of the 2004 tour (Bruce's drinking habits had gone a little too much out of control), Reininger proposed that Kakanakis would take over the job, which was accepted by all. Kakanakis, who had been an admirer of Geduldig's work, found himself on the road with Tuxedomoon on their 2005 and 2006 tours. His main concept on the Tuxedomoon shows was to use his digital camera as a rhythm instrument of some sort, collecting images on the night of the performance that were immediately projected on a screen or onto the musicians, using bizarre props such as plastic flowers or a Barbie doll.

San Francisco was not exactly the kind of place that the band members could afford for an extended stay (most of the yuppies were gone by then but had left the city's rocket-high prices behind). A few US gigs were scheduled, in the USA and Mexico City, but these were not really money making ventures. The band made about three times less money on their US gigs than for their performances in Europe. They found themselves in one of the only hotels that they could afford. The (in)famous St. Paul Hotel on Kearny street was a mainly residential hotel populated with a "bunch of weirdos" (dixit Reininger), namely people on welfare and, for many, after a life of drug abuse. For a band like Tuxedomoon, this hotel was quite inspiring in the end. Not that they actually enjoyed staying there, but it was surely evocative of other frequented places from the past and, according to Brown, its corridors looked a bit like the ones seen in *Barton Fink*, the movie by the brothers Joel & Ethan Coen. Many of the residents didn't seem to have much else to do than waiting for the end and the hotel manager particularly seemed to like "quiet" guests. This made for a peculiar atmosphere that undoubtedly permeated the long jams they performed in the studio, developing what they later called "spontaneous" compositions that would become their next album, entitled *Bardo Hotel*.

The return to San Francisco was not only a change of continent but also a journey back in time, as Reininger, Brown and Principle met many of their friends from the old days. Steven Brown gives his impressions:

Page 404

'SF notes direct out of moleskin journal.

Finally got up and out left the house and began walking.

Feel like Chancy Gardiner [37] overhearing American talk in the streets. My brain somewhere repeats and takes note of syntax... Tone. Walk down Fillmore 22 blocks turn right on Oak St and walk by the Old Angels Of Light house at Oak and Divisadero. Looking at the old Victorian house trying to eek some memories out of its physical presence there in front of me after so many years... Have a capucho at Oak and Broderick find self walking down Haight unconsciously stop in front of the other house I lived in; the first one with the girl from Chicago upon arriving in SF. Here where my Nizo super 8 camera got stolen and the thief left a pile of *merde* on the floor of still empty room. The double humiliation of getting robbed and cleaning up his shit.

Two blocks later still dazed a guy asks for a quarter as I stand at stop light looking down I see the Virgin of Guadalupe on an open page in a book sitting in a group of potted flowers…

Some fotocopies of news articles hang from a tree... The guy who asks for a quarter has a pot pipe in his hand. I ask him for some. He says that will be another 25 cents. I protest. He says he paid 20$ for the weed. Ok, I relent. Then I'm standing trying to light a pot pipe on a big city street in broad daylight. This is San Francisco I say to self. Across the street I see a man taking aim with a camera, he is shooting the street sign. I look up already knowing what I'll see. The sign says Ashbury. I'm standing at the corner of Haight and Ashbury with a pot pipe in my hand. I'm a tourist attraction!!

(…)

From an unheated penthouse with panoramic view of SF bay in Pacific heights to a hotel room 1x2meters in North Beach shower and toilet in the hall… The rooms here host a smell best defined by BLR as 50 years of sweat and farts and disinfectant.

(…)

We are riding the # 12 Folsum bus to the studio. Luc brings up (yet again) the first trip we made together on a bus to rehearsal in Rue de la Fourche in Bruxelles to begin working with Peter. The tram was the 93 and it ran down ave Churchill…(c 1983) as we proceed it dawns on me 9 + 3 = 12…

Sf 5 march o5

(…)

Each day the city reveals another facet or face. Today sad sad sad sad malicious Chinese woman in *café* a.m. starts the slow wheel of sorrow turning for the rest of day. We are all captives in the black iron prison. It's so much more obvious here then say, Mexico or even Europe… The voice of TV news anchor… Everything choreographed just so to keep illusion intact. All of us playing parts in one big tragedy or melodrama…

Benelux DVD 1979-1987 featuring *a.o.* TM live in Liège on 11/29/80 with "Jinx" (sung by SB) and "Litebulb Overkill"

02/05 TM hires George Kakanakis, a visual artist from Athens and friend of BLR, to replace BG temporarily

02/17&24/05 BLR plays in Athens, with George Kakanakis in charge of visuals. More gigs in Patra and Thessaloniki

03/05 TM is back in San Francisco where the band works on the material of their upcoming *Bardo Hotel* album when not playing gigs (see below)

03/17/05 TM plays at Teatro de la Ciudad, Mexico City, first concert ever in Mexico. The Mexican TV (XEIPN Canal TV ONCE) shot a documentary for the occasion.

03/19/05 TM plays at Café Du Nord, San Francisco, with WT guesting on "Nur Al Hajj." A song was dedicated to Tommy Tadlock

Report from a fan: 'Tuxedomoon live... It's been years in the making for me. And it was a treat, even if some events conspired to try to make it not... Mainly that the band didn't go on until midnight, which is a little late for my blood and a lot late for my wife's, who ended up asleep at a table in the back (…) But I had heard from a reliable source that Winston Tong was going to show up and play and felt like I had to stay for that. And he did, show up that is. As for singing, well, he seemed very nervous and out-of-sorts. Standing next to the mixing board has its rewards, as I could tell that the set list changed, from having a song ("The Cage") in which Winston actually sings to playing one in which he accompanies Blaine and Steven on vocals. It was still a real treat to see him with the rest of the group, and Steven seemed very happy to have him up there, putting his arm around him a few times. I saw Winston perform about eight years ago here in San Francisco, where he lives. It was an interesting performance, mostly spoken word, and I was fortunate enough to meet Winston and spend a few minutes with him. He was very lively and animated then, and not at all like he seemed on stage at du Nord, where he was very nervous (…) The crowd was pretty interesting. There was an older couple probably in their 80's hanging out in the back and some little kids running around as well.'

03/21/05 TM plays at Knitting Factory, Los Angeles (with Halloween Swim Team opening). According to Kakanakis, this was the US show where TM got the most enthusiastic audience

03/23/05 TM plays at Rickshaw Stop, San Francisco (The Cold War opening) with WT guesting on "Desire," "This Beast," "The Stranger," "Jinx" & "Nur Al Hajj." A song was dedicated to Tommy Tadlock

From Neil Martinson: 'It was an amazing show, much better in my opinion than Saturday at the du Nord. Winston sang backup on "Desire" and "This Beast," then for an *encore* sang "The Stranger," "Jinx" and "Nur Al Hajj." A second *encore* brought out "Litebulb Overkill" and an amazing impromptu "Pinheads On The Move" with Blaine on the piano. Over 150 people turned up for this show, and everyone seemed really happy (…)'

Page 405

What's the point? And still you know you would react the same as D who recounts at dinner that he began taking the aids cocktails because he didn't want to die.

(…)

Christ is in the ether

The evil ones on earth

All those with a voice who were subsequently silenced: Kennedy 1&2, King, Malcolm, Pasolini, Lennon, Palme, Dick, Clay, Milk, Moscone ….

(…)

Bl complaining about people at the club we go to after rehearsal being prude and rude. No drinks outside and no smoking inside. I take the snotty personnel in stride a watered down SF versions of NYC attitude. Bartender gives Bl free coke and free cranberry to me as if she felt our pain. When we arrive at hotel to check Nina in the desk clerk is a rude neurotic bitch and treats us like inmates in this jail of a hotel. It's easy to see life in USA like in any totalitarian country; Morocco, Cuba, Oaxaca where people are timid, cowering. Any one of any interest doesn't mix with politics and any time it comes up in conversation the talk softly blends into background, shuffle shuffle…

Nobody likes the situation though (and I believe banning of smoking in bars was an important first step) but people don't protest in a police state.

Here we even have the trappings of "alternative."

Its becoming all too easy to see; the bar is the black iron prison, anyone acting a little out of the norm is liable to be treated like a terrorist *i.e.*: with no respect and no rights whatsoever.

They've done it: they've cow-towed an entire nation… It's a sad sight.

When people are unhappy and miserable and repressed they are not pleased to see others in a good mood, happy and enjoying themselves. When given a little power these people will wield control over the other making them miserable and first of all wiping the smiles off their face. These are the types of people a tyrant employs.

Also it's known that when you are afraid or insecure (orange alert) you CONSUME more and eat more.

(…)

In your memory in your minds eye you see the city; Chinatown, North Beach, the Castro, The Mission, and they take on mythic qualities; shining gold dreams. Then you physically arrive at these places and your dreams are shattered, the reality is cold cement and unknown and unknowable, peopled by the smug and witless glee.

Everywhere beggars

Store entry halls become bedrooms for homeless men. You realize with horror how easy it would be to slide into this

vortex of broken minds and despair.

FREEING OURSELVES FROM THE SHAPELESS HORROR OF REALITY BY MEANS OF CREATION.

I read this quote from Octavio Paz one day before work to lift our spirits.

The whole issue of coming back to a place you can't ever come back to (now comfortable and undistinguished easy middle class life is lived).

The reality of being older and irrelevant in what was once home is somehow related to the situation to the country at large and the parallels to Nazi Germany… A government run by criminals, liars, torturers, and assassins, while the big blonde idiot populace blithely goes about business as usual.

(…)

Thoughts in SF

Faded fotos…

Reminder of mortality…

Think of threadbare faded drag and sequins stashed away in closets along with old Tuxedomoon records: curios from bygone era…

(…)

I used to think that being a musician meant sleeping in cheap hotels, living in them, like we are doing now.

(…)

Living on guarana

sandwiches coffee

Chinese noodles

Indian vegetable slop

Fresh ginseng root discovered next door to hotel is a wonderful revelation.

(…)

Ominous bulletin taped to doors announcing Pest Control tomorrow 1-2 p.m.

If you don't want them entering your room you sign the form.

Day can't be far off when we buy "clean" air like we now buy "clean" water. Stay in a vomit-urine stench hotel, or take a trip to Mexico City or any big urbe and you might hesitate to do your yogic breathing.

Synchronicity in el DF

We fly to Mexico City from SF and there after doing interview with the national public TV in street in front of hotel find this same channel is broadcasting a docu on the beats filmed largely in north beach and in city lights which is next door to our hotel there.

We are staying in the Colonia Roma a few blocks from house where WS Burroughs lived. Peter buys pot from a guy who owns land in Virginia where he and G are looking to buy.

(…)

Steven Brown and Winston Tong, live in San Francisco, March 2005. Photo Aaron Ross (*aka* Dr Yo)

Back in Paul's Hotel in North Beach on Kearny. Yesterday was in Mexico City. Last night on stage in San Francisco sold out show at Café du Nord. Today went to see the gang at Tina and Anthony's what I thought was a little get together turns out to be historic reunion: Tahara, Ralph, Madeline, Chuck, Beaver, Jet, Melody, Francine, Tony, Lenore, Ananda, Gregory, Janis…
We are all a little heavier but still crazy and funny and vulgar and witty and well let me digest it all…
Meeting people old friends you haven't seen for so many years, people who are part of your phenomenological self who you haven't forgotten in 20 or more years, when you first meet there is a charge or discharge of energy that quickly fades. You cannot expect the intensity of your memory or the years of your life spent with this person to be somehow matched now that the person is physically present. There is no continuum… The intensive time spent with this person cannot be resurrected, it remains in the realm of memory. The person in your memory is immortal or idealized, not of this physical plane whereas the friend before you is very much of the world… There is a conflict of dealing with two entities who are somehow one.
Jet who remains in the hallway the whole time everyone else is installed in living room lets fly one of his classic barbs saying that I "will be a footnote to the Angels history like Sylvester

was to The Cockettes… The one who succeeded… in getting away!'"

Winston Tong is absent from these memories, as he was from the band's work at Peter Mayer's Studio. Steven Brown does not recall having seen him there at all. Carlos Becerra remembers of a brief apparition à la Syd Barrett of a Winston humming around the others at work and then… disappearing for good. Tong did however show up when there was an audience to see him, namely at Tuxedomoon's two shows in San Francisco at Rickshaw Shop and Café Du Nord.

Tuxedomoon tours in Spain. Despite their humble existence in San Francisco, the band found themselves short of money by the end of their stay. Therefore the tour scheduled in Spain in April 2005 came somewhat as a relief. UK journalist John Gill spent time in Madrid with the band and wrote the following review for UK magazine *The Wire*: 'Reunited, lean, muscular, stroppy and cruising for a bruising. Tuxedomoon is a monstrous and beautiful thing to behold. Sneak into their soundcheck and you'll see what makes this group unique. Drumless, they are anchored by the seismic bass of the Buddha-like Peter Principle (…) Visual artist George Kakanakis manipulates live video of the musicians

03/30/05 TM plays at Knitting Factory, NYC

03/31/05 TM plays at Tribeca Grand, NYC

04/06/05 TM plays at Sala Apolo, Barcelona

04/07/05 TM plays at Centro Cultural del Matadero, Huesca

04/08/05 TM plays at Colegio Mayor San Juan Evangelista, Madrid

04/09/05 TM plays at Centro Cultural Ambigu, Valladolid

04/10/05 TM plays at Auditorio de Murcia., Murcia. PP: "There was nobody there but great acoustics!"

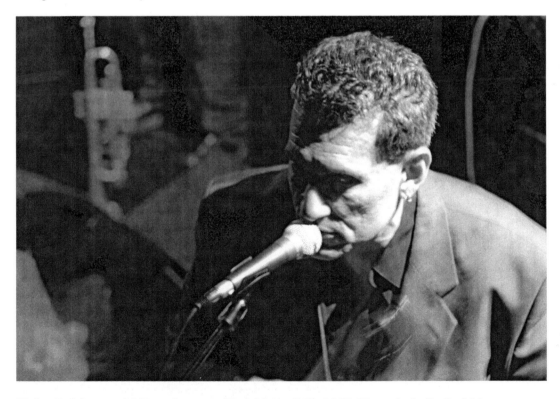

Blaine Reininger with Tuxedomoon, Madrid, April 8th, 2005. Photo Isabelle Corbisier

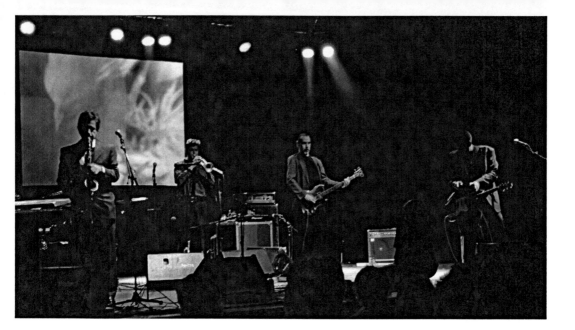

Tuxedomoon, Valladolid, April 9th, 2005. Photo Isabelle Corbisier

04/11/05 TM plays a showcase at Forum Fnac, Porto

04/12/05 TM plays at Casa Das Artes, Famalicão (Portugal)

04/13/05 TM plays at Forum Lisboa, Lisbon

04/16/05 TM plays at Zoo Animal Club, Ferrara (with Radio80)

06/05 An Australian tour (that should have comprised the following dates: 06/08/05 Corner Hotel, Melbourne; 06/09/05 Sidney; 06/11/05 The Rev, Brisbane) was cancelled for financial reasons

06/09/05 Nine Rain plays in Mexico City

and Pollock-like abstractions on a large screen.
Brown is exquisitely melancholy on grand piano, and insouciantly elegant on his reeds. When he and Reininger duet on vocals, Blaine has great fun playing the schmaltzy crooner, while Brown summons up an icy dread. Reininger is the Sinatra to Brown's Jim Morrison and, in a sense, the Twain to his Poe. Van Lieshout's horns are an elemental force with echoes of Miles's mute.
Pop all these into a particle accelerator with added electronics and treatments – Blaine singing through his miked-up violin, making space station alarm noises with his foot pedals, or letting rip with apocalyptic jackhammer sequencers ("Diario Di Un Egoista") – and you get the quantum physics that is a Tuxedomoon gig. This comeback tour is dominated by 2004's ravishing release *Cabin In The Sky*, although there is a brace of favourites: "The Waltz" off *Holy Wars*, and the title track from *Desire*.
There are moments of quiet beauty, not least Brown's languid piano and noir reeds, and at moments when van Lieshout's harmonica and Reininger's violin produce mutant bluegrass, but there are also sonic barrages that can pin you to the wall. I don't remember a Tuxedomoon concert this raw and visceral, not least the full-on Situationist funk of "Luther Blisset" – imagine Miles Davis and Wayne Shorter jamming with A Certain Ratio with some Charles Ives-like intertextuality at work.'[38]

Tuxedomoon participates in the New Atlantis Festival in Amsterdam. From end of June until mid-July, Tuxedomoon got the opportunity to get together and work on new material, some of which would be featured on their *Bardo Hotel* album

and some of which would later be included on their 2007 *Vapour Trails* album.

It was in Amsterdam that the *Bardo Hotel* concept, encompassing a soundtrack album and a film project with George Kakanakis, started to develop. Tuxedomoon and Kakanakis had been staying in this funky hotel in San Francisco earlier that year. There a series of factors led them to a *bardo* meditation of sorts. First there was the peculiar atmosphere of the St. Paul hotel, populated with these people for whom it probably was the last stop. Then they had to deal with that peculiar psychological state of finding themselves in this city that they recognized to be their old beloved "home" but that nevertheless had become alien to them in so many ways. Finally they were haunted with the *déjà vu* sensation of going through an almost initiatic experiment already gone through many times by themselves and other artists. According to the Tibetan Book of the Dead, or Bardo Thodol, the *bardo* refers to that intermediate state between life and rebirth (before reincarnation). The Tibetan Book of the Dead is a guide read aloud to the dead while he/she is in that state in order for them to recognize the nature of their mind and attain liberation from the cycle of rebirth. In a more Western view, *bardo* also refers to a period when life is suspended as, for instance, when a person is on retreat. The Bardo *Hotel* is also

06/24/05 till 07/15/05 TM participates in the *New Atlantis Festival* at Illuseum Art Gallery, Amsterdam (see: http://www.illuseum.com/atlantis/1-new-atlantis.htm):

06/24/05 press conference + mini concert at Illuseum Art Gallery, some excerpt of which can be seen on YouTube

06/25/05 TM plays at NDSM-island, Amsterdam, multimedia concert streamed on the internet (on http://www.live.nu/), a collaboration between the *New Atlantis* and *Test-Portal Festivals*. An excerpt from that show can be watched on YouTube

07/09/05 TM plays at Melkweg, Amsterdam, a concert involving some of the musicians who took part in workshops with TM at the Illuseum Art Gallery: Sahand Sahebdivani playing a base tar(r), Almuth playing the trombone and Olga playing alphorn. A band of young Moroccan musicians, DhakaDimaDima, is also supposed to play with TM but does not show up at the concert after some controversy about "Nur Al Hajj." Some excerpt from this concert can be watched on YouTube

07/10/05 TM plays an open air mini concert alongside a canal for a dinner party (on the bridge) of people living in the neighborhood of the Illuseum Art Gallery. Some excerpt can be seen on YouTube
Aside from these concerts, the members of TM work every day with locals of the De Baarsjes neighborhood (a multi-ethnic one) where the Illuseum Art Gallery is located, teaching music, writing music scores for marching bands & choirs. They also work with George Kakanakis on the making of a film for which

Peter Principle with Sahand Sahebdivani and Olga in Amsterdam, Melkweg, July 9th, 2005. Photo Isabelle Corbisier

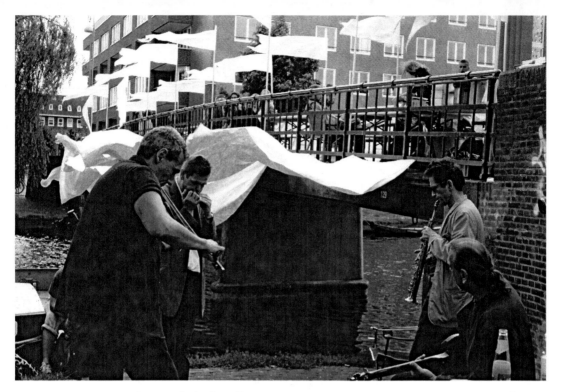

**Tuxedomoon playing for a dinner party of De Baarsjes inhabitants, Amsterdam, July 10th, 2005.
Photo Isabelle Corbisier**

their upcoming *Bardo Hotel* album is designed to be the soundtrack intended to be released before the film itself. A 12 min. documentary, entitled *Kind Strangers*, was shot by Alex Ivanov during TM's participation in the *New Atlantis* festival and can be viewed a: http://www.slonfilm.com/TrailersTUXMOONbelissima.html To Ivanov's question as to how they manage to get together, SB replies: "We depend on the kindness of strangers…"

06/26/05 TM plays at Ristofusion, Naples

06/30/05 TM plays at Parco San Giuliano, Mestre

07/02/05 TM plays in Athens, *Synch Festival*

08/05 BLR works on a film project entitled *Trees 'r Us* in Italy, starring a.o. Linton Kwesi Johnson & Tony Scott

08/31/05 SB + band playing live for cine regional histórico / curaduría: Iván Trujillo Bolió + Ximena Perujo Cano (Filmoteca UNAM), Oaxaca

09/05 WT joins the band Nouvelle Vague (i.e. Marc Collin's band) on stage in San Francisco for their cover of "In A Manner Of Speaking" featured on Nouvelle Vague's first CD entitled *Nouvelle Vague* and released by The Perfect Kiss label in 2004. To be noted: this wasn't the first cover of "In A Manner Of Speaking" as this song had already been covered by Martin Gore (from Depeche Mode) on his *Counterfeit* CD (Warner Bros) and 12" (Sire) released in 1989. Recently "In A Manner Of Speaking" was also covered by French artist Laurent Esmez (Frédéric Truong singing) on Frédéric Truong/Laurent Esmez double CD entitled *Renaissance/In Memoriam* released in 2005 by FTR_Label and by David Fenech on the *Next To Nothing – A Collection Of Tuxedomoon Covers* compilation CD released by Optical Sound in 2006

a direct reference to the famous Parisian hotel managed by Mme Rachou, located at # 9, rue Gît-le-Cœur and nicknamed the Beat Hotel, where William Burroughs and Brion Gysin developed the cut-up/fold-in technique. Gysin referred to it in his last novel *The Last Museum* [39] where the Beat Hotel becomes the Bardo Hotel, each room representing another stage in the after-death state. Gysin's friends, Ginsberg and Burroughs included, are depicted chanting in the street, their "heads shaven like Tibetan monks" and wearing orange robes.

The Bardo Hotel is a typical Tuxedomoon theme. All of the group's ingredients are in there: their long-lasting taste for Burroughs and Gysin's cut-up/fold in techniques, their fascination for "intermediate" states, the state in which they find themselves in while composing… Even some elements from their past, like their 1980 gig in Paris with the Master Musicians Of Jajouka and their meeting with William Burroughs at The Bunker in 1981 [40] and, of course, *The Ghost Sonata*, all seem in the end to bring us back to the *Bardo Hotel*.

The invitation to participate in the *New Atlantis* festival in Amsterdam came from Grace De La Luna and Alexander van der Woel from the Illuseum Art Gallery located in the multi-ethnic De Baarsjes neighborhood in Amsterdam. [41] This Gallery is a small but warm place located on two levels (ground floor and basement/club) with garden. Dozens of skinny Siamese cats wander about from their favorite sleeping/exhibit place

behind the Illuseum's front window on into the garden. Exhibits of painters, photographers and cartoonists regularly take place there.

The *New Atlantis* festival was an attempt of mixing local artists with guests coming from outside the De Baarsjes neighborhood. Tuxedomoon members found themselves conducting workshops with some local and not so local artists. Luc van Lieshout, for instance, worked with two female musiciens, namely a young trombone player from the neigborhood and a German alphorn player. They worked with a Choir, named the Curious Passerby Choir, for a rendition of "Jinx," later to be found on the *Bardo Hotel* album. The quartet of Brown/Principle/Reininger/van Lieshout also gave an almost all-acoustic peformance for a dinner party of De Baarsjes inhabitants, set up on a bridge crossing one of Amsterdam's many canals.

While there, the band started to work on their *Bardo Hotel* film project with George Kakanakis. Some scenes were shot on location, each member of the band being asked to create his own room or "Chapter" in the Bardo Hotel. To date (late 2007), the *Bardo Hotel* film project is still a "work in progress," with Brown having produced two rooms so far.

During their stay in Amsterdam, Tuxedomoon also played two "regular" gigs: one at the *Test-Portal Festival* on June 25th (the concert was streamed on the internet) and one at the Melkweg on July 9th. The second concert was particularly interesting as the band had invited the musicians who had worked with them at the Illuseum Gallery to participate. Unfortunately not everything went well with the proposed rendition of Tuxedomoon's "Nur Al Hajj" (*aka* "Courante Marocaine") in collaboration with DahkaDimaDima, a group of young musicians from the neighborhood. Steven Brown: 'Minutes before we began to play Blaine expressed misgivings. He said he was nervous about singing this particular song. We were about to rehearse a piece from the Tuxedomoon *répertoire* with a group of five teenage Moroccan musicians. We chose this piece as a possible second song to do because originally we had recorded it in the studio with two Moroccan musicians. And with its Arabic feel it seemed a likely choice as a piece to rehearse together with the Moroccans for the next day's performance. At a certain point in the song B breaks into a solo chant. On the record one of the Moroccans had sung this part. The chant is sung like a call to prayer, a kind of incantation. Sometimes B will sing: "Allah Hu Akbar" in the course of his solo. He had been greatly inspired by Sufi singers and in fact had himself lived in a Sufi commune in San Francisco. For him as a Sufi it was not extraordinary or of questionable taste to sing the Muslim call to prayer. As soon as it came to that part in the song there in our rehearsal space

10/05 SB participates as "special guest" in a concert of Daniel Aspuru, demonstrating his "Eolic Transducer," at the 3rd encounter of Young Creators at the National Foundation for Arts in Morelia, Mexico. A short video of the event can be viewed on google videos

11/17/05 SB plays the saxophone as "special guest" at Ana Diaz's concert, Jardin El Pañuelito, Oaxaca, Mexico

11/26/05 SB & his Cinema Domingo Orchestra participate in the inauguration party of the *Álbum Erótico* exhibition (collection José F. Gómez of the Centro Fotográfico Manuel Álvarez Bravo) and provide a musical backdrop to the projection of some of the UNAM collection of erotic cinema

12/15/05 BLR plays (with George Kakanakis) at *Potenza Film Festival*, Potenza (Italy)

Late 2005 I visit SB in Oaxaca, Mexico, and meet Sergio Castillo Merida (who works at Oaxaca TV). Sergio has been in a relationship with SB ever since

Page 413

in the basement of a place called Illuseum in Amsterdam the first syllable of A l l a h came out and it dawned on me what B had been nervous about. I hadn't even thought about him singing this above all at this place and time. Within seconds the leader of the group stood up and began shouting. The other boys didn't seem the least bit upset but this one had to be followed and they all stormed up the stairs. B sitting on his amp, me behind the organ, P in the other room with his bass, and Luc standing with his trumpet. The music stops (…)

We remained frozen there for a minute. Later the boys were grouped across the street. Alex Ivanov the noble cameraman documenting our participation in the festival decides to go speak to them. It's clear something must be done and the rest of us are immobile. B offers to go with him and would later recount what transpired. He had explained to the leader that he was a Sufi and when he sings "Allah Hu Akbar" it is in earnest and with respect. The youth replies that you cannot sing this in secular music (B would later refute this to us citing the example of Nasfrat Ali Khan). He recommends that B sing "Habibi Habibi" instead if he wants to sing something in Arab. Two different points of view in this mini religious congress on Witte de Withstraat in West Amsterdam. After their discussion the boys come back downstairs and we play music together (…) It was indeed a noble move on their part when they returned to rehearsal after the outbreak. Everyone was relieved. They behaved in a mature way. But the day of the concert they didn't show up. We heard later that they had called asking about money of which there had been no mention, and were referred to speak directly to us. They never did. Was this just a ruse to not show up? The real reason being religious based? Perhaps. Or simply a beginning band's bravado in action? Chalk it up as another arabesque in all our lives. What is true is that the explosive rehearsal took place on 8 July. Later we would learn that on 7 July a subway train and a bus were bombed by Al Quaida in London leaving some fifty dead.'[42] As a postscript, DahkaDimaDima's contribution to a version of "Baron Brown," recorded in the Illuseum basement, ended up on the *Bardo Hotel* album. [43]

2006: Tuxedomoon releases the Bardo Hotel travelogue album and tours in Europe while working on the Vapour Trails album, released in 2007. Early 2006 saw Tuxedomoon on the road for another European tour. Serbian online media Platselin [44] and, in particular, their music contributor Mileta Okiljević, a long time Tuxedomoon fan, asked me to write a review of some of the concerts I attended [45].

'*Tuxedomoon – Two gigs from their latest European tour : Opwijk (Belgium), Nijdrop, Jan. 26th, 2006 and Paris, Nouveau Casino,*

2006

Some time in '06 SB + Nikolas Klau compose the music of Elio Gelmini's 72 min. documentary about the life of experimental film-maker Kenneth Anger (A Few Steps Production, Segnale Digitale prod.) entitled *Anger Me*

Some time in '06 SB provides part of the music to Rolando Beattie's choreography entitled *Al Desnudo*, Mexico

Some time in '06 Optical Sound releases the *Next To Nothing – A Collection of Tuxedomoon Covers* compilation CD with the following TM

Page 414

Jan., 28th

Here we are in Paris at Nouveau Casino, one of these latest trendy places in town, for a Tuxedomoon concert. The organization of the event was facilitated by the release, by French label Optical sound under the coordination of Palo Alto's Philippe Perreaudin, of a rather brilliant CD of covers of Tuxedomoon songs by various artists including Scanner, Simon Fisher Turner, Ramuntcho Matta and many others.

The venue is located behind a no less trendy café named "Charbon" where you practically can't get any food – quite unusual for a French joint – but about all the exotic cocktails you want. Outside it's freezing and it's with a comforting Margarita drink that I'll be waiting for friends, including the aforementioned Philippe Perreaudin and DJ Gilles – a French DJ living and thriving between New York City and Europe – who contributed to put up two Tuxedomoon shows in New York city last year. Later I join the band at the end of their soundcheck. I had seen them two days before, playing a small venue in the middle of nowhere in Belgium (Opwijk, near my hometown Brussels but I had never heard of this place before). The atmosphere surrounding that gig was very Tuxedomoon and quite evocative of their long-lasting relationship with Belgium (…) Opwijk was standing in deep frost, with an improbable fair – complete with merry-go-rounds, luna park and all that jazz – planted in the centre of the village, silent, all lights turned off and with not a soul around. I shuddered

tracks covered: 1. "The Cage" (by Wild Shores); 2. "Desire" (by Les Hauts De Plafond); 3. "Atlantis" (by Jefferson Lembeye); 4. "In The Name Of Talent" (by Norscq); 5. "(Special Treatment For The) Family Man" (by Scanner); 6. "In A Manner Of Speaking" (by David Fenech); 7. "Fifth Column" (by Palo Alto/Laurent Pernice); 8. "Queen Christina" (by Simon Fisher Turner); 9. "59 To1" (by El Tiger Comics Group); 10. "Seeding The Clouds" (by Lefdup, Lefdup, Lefdup); 11. "The Stranger" (by Aka_Bondage); 12. "Loneliness" (by Jacques El); 13. "Time To Lose" (by Versari); 14. "Atlantis" (by Ramuntcho Matta); 15. "No Tears" (by Deux Pingouins); 16. "Basso Pomade (Dogs Licking My Heart)" (by Stensil); 17. "7 Years" (by Black Sifichi); 18. "27 Years In 1 Track (Medley)" (by Non Finito Orchestra)

01/18/06 TM plays at Fabrik, Hamburg

01/19/06 TM plays at Forum, Bielefeld

01/20/06 TM's gig at Kalkscheune, Berlin is cancelled

01/22/06 TM plays at Rockefeller, Oslo

01/23/06 TM plays at Sticky Fingers, Göteborg

01/26/06 TM plays at Nijdrop, Opwijk (Belgium)

01/27/06 TM plays at Tivoli, Utrecht

01/28/06 TM plays at Nouveau Casino, Paris

01/29/06 TM plays at 4AD, Diksmuide

01/30/06 TM plays at FZW, Dortmund

02/01/06 TM plays a sold-out gig at Akropolis, Prague

02/03/06 TM plays at Szene, Vienna

02/04/06 TM plays a triumphant gig at SKC, Belgrade

02/09/06 TM plays at Club Rec, Patra (Greece)

02/22/06 BLR, SB & PP jam together at Bios, Athens

Steven Brown in Opwijk, Belgium, January 26th, 2006.
Photo Isabelle Corbisier

and thought I had landed in a scene of André Delvaux's *Un Soir, Un Train* movie and asked myself how the hell there was going to be an audience showing up at that gig, considering the adventure it was to get to this place, the freezing cold and the fact that it was taking place on an uncomfortable Thursday night. I had gotten together with the band in the late afternoon and we were locked into this small *café*-venue, enjoying its cozy atmosphere, quite queer after the travails endured by all to get there.

At 8 p.m., a queue of people that seemed to have tumbled down from God knows what planet started to queue in the cold, only to be let in half an hour later. Local Flemish people, French-speaking Belgians but also a lot of people from France, mainly from Lille and surroundings. Europe at work: these Frenchies had no problem in preferring to go to Opwijk, finding themselves in a crowd of which – like in Delvaux's movie – they did not understand the local idiom rather than making it for Paris two days later. For these people from Northern France, Belgium was nearer, more familiar... and cheaper than *la capitale*.

This story of Tuxedomoon playing eccentric places but nonetheless filling them up with people who seemed to materialize like an instant before the event is a recurrent one in Tuxedomoon's lifetime and one that impressed them from their very first gigs in Europe (...) This must be what "cult" is about and undoubtedly Tuxedomoon is cult.

The gig in Opwijk was a success, the band taking its time to set up its typical atmospheres, somewhere near Dada Cabaret, nostalgia of what has now become a lost "old" Europe and their quite unique sense of the bizarre. "How to sing a sad song," was the sentence that George Kakanakis – the visual artist now working with them in replacement of Bruce Geduldig – wrote on a piece of paper pasted on an amplifier and played around with using his video camera and various home-made effects. Yes this sentence could be a statement of the essence of Tuxedomoon but with them sad songs strangely bear some exhilarating aspect, some cathartic virtue if you will...

Now in Paris, sitting at *café* Charbon and then relaxing with the band and their tour manager, Carlos Becerra – I have been on the road with them many times now, even finding myself once driving their van en route for London, but that's another story –, I wondered how the audience was going to be in Paris and whether people would care about coming, as Tuxedomoon had played Paris a couple of times already since their memorable sold-out gig at the Pompidou (Beaubourg) cultural center on June 26th, 2003. The venue at Nouveau Casino is a small one, of about a 350 people capacity, with the most minuscule "backstage" area I've ever seen. Soon the room was packed to such an extent that I asked myself

what would become of us would a fire start: consumed in the cult most probably... The audience was composed of this mix that seems now customary at Tuxedomoon concerts: "hardcore" fans who were there since the beginning and now in their forties and younger people who probably were told of Tuxedomoon's cult status or might have been attracted by the prestige nowadays attached to anything originating in the eighties. However, unlike many bands from these times now touring with their old *répertoire*, celebrating the cult of the God Dollar or Euro, whichever they prefer, Tuxedomoon has new material to offer, stemming from their still fresh *Cabin In The Sky* album (released in 2004) and brand new pieces still to be properly released on their forthcoming *Made To Measure* album (Crammed discs). Tuxedomoon in the old days was always one album ahead on stage, with the consequence that people going to their gigs attended an entire concert composed of pieces that they had never heard before. The band then considered it as non-sense to be going to a performance to hear numbers that you already knew by heart and could listen to in better conditions in your living-room. Today they reached a compromise and their set list is usually a mix of new, never heard before and "classic" tunes. Interesting to note however that, for a band that sort of disbanded by the end of the eighties to be re-united only around the start of the 21st century, there's a striking continuity between the older (some of which being 27 years old!) and newer pieces, all bearing this undeniable instantly recognizable timeless quality that denotes a Tuxedomoon "song" and this in spite of their being eventually very different from one another, ranging from long instrumental pieces setting up aural landscapes to short and energetic sung numbers.

Tuxedomoon's hallmark resides in some unique combination of instruments and personalities at work. First of all the group spent most of its existence without a drummer, Peter Principle's bass guitar setting a pulse that no other band possesses. Also it is not that common to see a sax-clarinet player (Steven Brown) and a violinist (Blaine Reininger) playing in a band pacing the so-called "rock circuit," eventually along with a trumpet/harmonica player (Luc van Lieshout) for good measure. But above all there is this never-ending wrestling story – a love/hate relationship – between Steven Brown and Blaine Reininger. Reininger puts forward flamboyant sonorities sometimes evocative of the Far East – probable reminiscence of his life, back in the seventies, in a Sufi community – or flirts with the self derision of postmodern dada cabaret. Brown strives for some sort of elegant sobriety – he once said that the future of music rests in... silence – while constantly introducing sardonic yet virtuosic dissonances into what

TM works on their upcoming *Vapour Trails* album

03/20/06 TM plays at Teatro Ciak, Milan, *Suoni E Visioni Festival*

03/25/06 TM plays at Palazzetto Sport, Taranto (a concert promoted by long time friend Natale Nitti + friends)

Spring '06 Independent Recordings (an independent label founded by SB & TM tour manager Carlos Becerra, see http://www. independentrecordings.com/ re-releases SB's *Subway To Cathedral* compilation CD and releases BLR & SB's *Flower Songs* CD, a recording (by Enrique Rojo, engineered and mastered by Nikolas Klau) of BLR & SB's 10/17/93 gig at Sala Nezahualcóyotl, Mexico City, featuring the following tracks: 1. "Elephants;" 2. "Violorganni;" 3. "Ghost Sonata;" 4. "Affaire At The Soirée;" 5. "39 Summers;" 6. "7 Nights;" 7. "Paris;" 8. "Ombres Chinoises;" 9. "Vieux Boulevardier;" 10. "Two Pizzicatti;" 11. "Golems & Grisâtre;" 12. "Pleasure;" 13. "Voguet;" 14. "Tarantella"
This CD is intended to be the complement to BLR & SB's *1890-1990 – One Hundred Years Of Music* or *100 Years Of Music: Live In Lisbon 1989* CD

Carlos Becerra about his founding of a label in Mexico with SB: "Until now the most interesting records were produced in Europe but by the time they're imported to Mexico, the price of a CD is about 30 dollars average. So the idea to set up a company with Steven is to release interesting music in Latin America at a reasonable price, so that people can be exposed to it. At the same time, part of our job is to bring bands to play live in Mexico and in Latin America. So we've been doing this for like ten years now…"

05/27/05 SB participates in the presentation of the *Esquivel Remixed!* CD released by Independent Recordings and Sony BMG Mexico at Centro Fotográfico

Reininger patiently builds up as the Maestro violonist/guitar player. During concerts, they rarely communicate except through this constant musical battle between them. In Paris, when a longer than usual transition was needed between songs, Brown summoned Reininger: "Keep talking… You never shut up" and Reininger of course went on babbling in a language known only of himself… Evidently this peculiar *modus operandi* would never work without THE balancing element into the group: Peter Principle, who, as we say in French, keeps the church in the middle of the village and brings the kids back working together after playtime. On their recorded works Principle also builds the sonic landscapes so typical of Tuxedomoon. Principle is the one that makes Tuxedomoon be an (art) "rock" band, while Reininger and Brown, when they work as a duo, do something that could be characterized as contemporary chamber music.

In Paris the newer pieces (set as first and seventh on the set list) were two impressive instrumental ones, for the time being named "DYD" and "Triptych," where jazz meets classical music in some kind of semi-improvised style, with Principle's bass providing, as usual, the spinal chord to these threnodies. In between came a bundle of songs from their latest *Cabin In The Sky* album (the situationist "Luther Blisset," the beautiful instrumental "Anuncialto," the self-mocking "Baron Brown," the now already classic "Cagli 5.0" and the crooning *à la* DJ Hell "Here till Xmas"). Of course "Desire," maybe their most emblematic hymn, came in the middle of the set, so powerful that even people who had never heard it before seemed to kind of "recognize" it. "Diario Di Un Egoista" came as Reininger's private schmalzy moment, followed by a "This Beast" vocally so strong that it brought the audience to their knees. "A Home Away" sounded like a reminder for Tuxedomoon's state of perpetual exile and, finally, the classics "Dark Companion" and "Loneliness" (with a brilliant ending riff at the violin that transports you right into the shower scene of Hitchcock's *Psycho* movie) closed the set. At this point the traditionally "cold" Parisian audience had lost any sense of snobbishness and loudly clamored for *encores* which it got first with a "Some Guys" bringing tears to the eyes of some of the "hardcore" fans and a "Nur Al Hajj (Fake Arab From New Jersey)" that made the whole room shake, rattle and roll. Of course the band was brought back on stage for a quiet version of "Again," Reininger singing at the piano and Brown accompanying at the saxophone. Before Blaine started he warned: "Ce sera le dernier, c'est une affaire de principe: nous sommes trop vieux" (This will be the last one, it's a matter of principle: we're too old), last love declaration to the audience in the form of a self-derisional statement. The audience didn't appreciate letting them go, even orally assaulting the technician who came on

stage to start dismantling the equipment but that's a fact: you don't get aristocrats like Tuxedomoon for multiple encores! But the people of Paris were happy, many of them rushing to the merchandise table to buy records before defying the deep frost reigning over Paris that night. I went out with a friend for a 2 a.m. dinner near the venue. Two days later, I would see the band playing in Diksmuide, near the Belgian coast: the never-ending story continues.'

During that tour, the band spent some time in Reininger's home town, Athens, and worked on new material that would later appear on their *Vapour Trails* album.

In June Crammed Discs released the band's *Bardo Hotel* soundtrack as the 38th *Made To Measure* volume, Crammed's instrumental/soundtrack series that was resurrected just for the occasion. The liner notes present the album as a musical chronicle of their perpetual wandering story around the world and of the peculiar atmosphere – "Hurry up and wait!" – on tour. Crammed's move to release the album as a *Made To Measure* volume was to indicate that *Bardo Hotel*'s collection of highly cinematic and ambient pieces was not to be considered as Tuxedomoon's new album proper after *Cabin In The Sky*, something that was not clearly understood by all critics. [46] Nonetheless most of the reviews were very welcoming:

'That Tuxedomoon tackles such a subject during their return home is particularly appropriate given the nature of Gysin's book, which itself is a fictionalized recollection of his days at the infamous Beat Hotel as it is being relocated from Paris to Malibu to be installed in the Museum of Museums. The music is a mix of jazz-inflected instrumentals and field recordings of conversations and announcements. Many of the songs are anchored by guitar or bass while strings bring an uneasy atmosphere and horns carve subtle melodies from the air. Although they're frequently relaxed, the songs never fully soothe and a sense of mystery is always close at hand. The field recordings range from things like a sojourn in Mexico to public transit announcements for Embarcadero Street without any sort of narrative transition to bridge the geographical displacement, giving a sense of both familiarity and dislocation that feels much like the style of Gysin's book. Similarly, perhaps as a nod to the way Gysin's novel flits between Europe and America and juxtaposes the present and the past, the group also includes a triptych of songs subtitled "The Show Goes On" that were recorded in Europe. Contrasted with the San Francisco material, these are much more brash and buoyant and even include some vocals, most prominently in "Loneliness." *Bardo Hotel* features its own Madame Rachou in the guise of "Mr. Comfort," a hotelkeeper with a hilarious list of requirements for his guests, including

Peter Principle in Diksmuide, Belgium, January 29th, 2006. Photo Isabelle Corbisier

Manuel Álvarez Bravo, Oaxaca. The CD includes contributions by TM members i.e. Principle Fetterman (Peter Principle & Jack Fetterman); Canaglia van Lieshout (Alessandro Cardelini & Luc van Lieshout); Brown Estevan (Steven Brown & Jorge Esteban)

06/20/06 Release of TM's *Bardo Hotel* CD (recorded mainly at Peter Mayer's Balanced Output Studio, SF; edited by PP & Coti K in Athens & Brussels, with assistance from BLR, Vincent Kenis & Marc Hollander) by Crammed Discs as vol. 38 of the *Made To Measure* series featuring the following tracks: 1. "Hurry Up And Wait (Flying Sequence);" 2. "Effervescing In The Nether Sphere;" 3. "Soup Du Jour;" 4. "Flying Again;" 5. "Triptych;" 6. "I'm Real Stupid;" 7. "Airport Blues;" 8. "Needles Prelude;" 9. "Prometheus Bound. The Show Goes On: 10. Baron Brown; 11. Jinx; 12. Loneliness;" 13. "Remote (Pralaya);" 14. "Dream Flight;" 15. "More Flying;" 16. "Vulcanic, Combustible;" 17. "Mr. Comfort;" 18. "Another Flight;" 19. "Invocation Of;" 20. "Carry On Circles" The leaflet accompanying the CD clearly sets the recording as the musical translation of TM's **wandering story**

Summer '06 Transparency releases SB's *The Super-Eight Years With Tuxedomoon* short film (Transparency 0227)

07/06 BLR composes a soundtrack for *Elektra*, theater play by Sophocles played at Athens Festival, 19-21 July 2006, by Theatro Domatiou, director Angela Brusko. This music will be released by the LTM label in 2007 as *Elektra/Radio Moscow Soundtracks*

09/06 Release of Nine Rain's double CD entitled *Mexico Woke Up* (disc 1 presenting new music and disc 2 containing a mix of previously released tracks) by Independent Recordings (recorded at Mula Producciones & LME Studios, Mexico Ciy, prod.: Nine Rain, the band then consisting of: SB, Nikolas Klau, José Luis Dominguez, Daniel Aspuru & Oxama) featuring the following tracks: Disc One: 1. "Mr Mekati;" 2. "Blowfish;" 3. "Sonona;" 4. "Jar The Cross;" 5. "Invisible Man;" 6. "Emancipation;" 7. "Las Voces;" 8. "Mexico Woke Up;" 9. "Tezcatlipoca;" 10. "Terrorist Attack;" 11. "Las Estrellas." Tracklist Disc Two: 1. "Guantanamo's Harpsichord;" 2. "Rainy Jaranero;" 3. "A Drink With Jim;" 4. "Raw Girl;" 5. "Oracion Caribe;" 6. "Lawnmoaner;" 7. "Lamento;" 8. "The Way;" 9. "Isla;" 10. "Midelmis;" 11. "Alex's Torture Song"

09/22/06 TM plays at Pedion Areos Park, Athens, *The Youth Festival Of Synapsismos* After this concert, the band will hang out for some days in Athens, working on their upcoming *Vapour Trails* CD

10/06 Neo Acustica re-releases SB's *Steven Brown Reads John Keats* CD, originally released by Sub Rosa in 1989. The reissue features some remixes by Alike and Parks

11/04/06 Presentation of the new Nine Rain CD at Escuela de Música Dim, Mexico City

11/23/06 SB plays with Nine Rain at *Festival Xtacion De Musica*, Oaxaca, Mexico

12/14/06 BLR plays a short gig at Madame JoJo's, London

12/21/06 Projection of Eddy Falconer's film entitled *Iberia* at Artists' Television Access, SF, with WT in the role of Ethiopian Emperor Haile Selassie, 'an hour-long, hybrid-genre film whose main ingredients are esoterica, poetry, ethnic pastiche, and camp humor. An atmosphere of paranoid desire builds on the cusp of some demise; a fictional totalitarian empire goes under. Occasionally ominous and at other moments slapstick, IbÈria forms an exotic landscape out of familiar Bay Area locations and peppers it with deluded aristocrats, unusual ritual celebrants, and improvisationally joyous dancers as if introducing the viewer to an alternative world of exotic customs...'

2007

Some time in '07 Release of BLR's *Glossolalia* CD by Stilll Records (OFF sublabel) featuring the following tracks: 1. "Throatsinging;" 2. "Glossolalia;" 3. "No Need To Move The Camera;" 4. "Lemonaki;" 5. "Ici Salvador Dali;" 6. "Hank And Audrey"

Peter Principle can be heard each month on Luxuriamusic.com as one of Jack Fetterman's Penthouse Party DJ's (www.luxuriamusic.com)

02/09/07 TM plays at Fabrik, Hamburg. Note: neither George Kakanakis nor BG are working with TM on the following shows

02/10/07 TM plays at 103 Club, Berlin

02/11/07 TM plays at Akropolis, Prague

02/14/07 TM plays at Nouveau Casino, Paris

02/15/07 TM plays at Concertgebouw, Brugge

02/16/07 TM plays in Portalegre (Portugal). A recording of that concert is to be found in TM's 30th Anniversary *77o7* box set released by Crammed Discs in 2007

02/20/07 TM plays at Szene, Vienna

02/21/07 TM plays at SKC, Belgrade

02/22/07 TM plays at Aquarius, Zagreb

02/23/07 TM plays at Transsilvania, Milan

02/24/07 TM plays at Teatro Nazionale, Pistoia

02/25/07 Homage to TM in Modena: a small event dedicated to TM, with a conference, interviews and video projections

the requisite no smoking, no drinking, and no drugs, but also forbidding bicycles in the room and insisting that guests are very quiet, smell nice, and smile when they see him. Although it's hard for me to imagine a film related to Gysin without an appearance by the Master Musicians of Jajouka, the form of this recording mirrors his novel with such dedication that it's easy to wave any misgivings aside. Regardless of how the film turns out, the album is a splendid journey in itself, a soundtrack for a state of mind.' [47]

'What does the new record sound like? A little like meditation and a little like travel. The musical attitude and the instrumentation are largely contemporary classical, though Luc van Lieshout's satisfying trumpet and flugelhorn passages are played in a jazz manner. The cyclic, trance-like nature of most of the pieces resembles a ragged version of Steve Reich or Philip Glass – or, alternatively, a sped-up version of Bill Laswell's *Hear No Evil* (Venture, 1988); the long and hypnotic "Vulcanic, Combustible" is the best example. (In contrast, "Baron Brown (Live)" is the most bizarre acoustic funk set to wax in a long long time.)

Cut-up and folded-in speech samples (a loudspeaker announcement at the Embarcadero BART station, instructions to airplane passengers, "welcome to Mexico City," quirky admonitions from a hotel manager) evoke travel. This echoes the Beats' apparent conviction that rambling physical travel could simulate, and maybe even trigger, more profound travel between states of consciousness (such as the bardo, so assiduously pursued by Allen Ginsberg).

The propulsive, repetitive nature of the music itself also suggests forward movement (this record sounds great on headphones while traveling by train); the very cyclicality, though, gives the impression of never reaching one's destination. But maybe that's the point.' [48]

The last reviewer quoted touched something that belongs to the essence of Tuxedomoon's endless wandering story: there's no destination. What matters is the traveling itself, not a goal other than discovering oneself on the way. Tuxedomoon is an existential combo, after all.

In the Fall, Steven Brown's Mexican band Nine Rain released their third album, *Mexico Woke Up*, and the band performed some gigs in Mexico to present their new material.

2007: Tuxedomoon is 30 years old and the neverending story continues... Tuxedomoon started the year 2007 as a "business like usual" one by embarking on a new European tour.

In the mean time work had progressed on the material

Page 420

that composed their next album, entitled *Vapour Trails* after a dream/vision of sorts experienced by Blaine Reininger.

Meanwhile Bruce Geduldig had been restoring some of Tuxedomoon's film footage (including *The Ghost Sonata* and the early University of Colorado footage) with a view to releasing it as a DVD. Peter Principle also worked hard in unearthing some of Tuxedomoon's never released ancient gems. So the idea naturally came to release a giant box set to celebrate Tuxedomoon's 30th Anniversary. The box set, released in 2007, includes Tuxedomoon's new album, *Vapour Trails* (also released separately), along with a double CD/DVD featuring Principle and Geduldig's *Lost Cords* and *Found Films* and, finally, a recording of their February 16th, 2007, gig in Portugal. As British famous designer Jonathan Barnbrook had always wanted to work with Tuxedomoon, he was hired to design the box set, which came out as a truly lavish package. A labor of love in many ways.

Another old fan, British journalist John Gill, published a long article and interview with Blaine Reininger and Steven Brown in the May issue of the online magazine *Paris Transatlantic* where he neatly summed up the peculiar friendship/struggle between an a-symmetrical Brown and the symmetrical Reininger. [49] Gill very rightly noted that, beyond their image of "the most European of American artists," Tuxedomoon were undeniably a group of Americans whose work simply met with a better understanding in Europe. Their exile outside of the United States for so many years probably led them to an increased awareness of their "Americanness":

'The, if you will, gluon that holds these two astronomical objects in balance is, perhaps, and paradoxically, the very thing they have spent much of their adult lives running away from: America. I will immediately problematise that observation by saying that "we" Europeans have a habit of misreading (North) Americans, but despite their exile, there is a very "American" voice in their work as composers and writers. I asked both of them if they weren't, really, still singing the "body electric" that Walt Whitman sang?

Blaine Reininger: I used to think that I was singing that glorious Whitman song, that Herman Melville, Allen Ginsberg, "land of the big shoulders," Jack Kerouac, pure American cry of rugged individuality and the romance of the lonely highway through the desert of night. I realized only recently that what moves me is the paradoxical, the state of love/hate, bitter/sweet, Irish coffee/baked Alaska, take on reality. Thus, though I have the sight of the full moon on virgin fields of snow under astral mountains in Colorado forever lased onto my heart, I have been away so long and I am so heartily disgusted by what my countrymen have made of the place in the last twenty or so

02/27/07 TM plays at Gagarin, Athens

Some time in 03/07 SB + Marc Lerchs play at Illuseum Art Gallery, Amsterdam for an exhibition dedicated to Oaxaca

04/19/07 Nine Rain plays at Foro Felipe Villanueva, Parque Estado de México Naucalli, Mexico, *Festival De Las Artes Naucalpan 2007*

04/28/07 Nine Rain plays at Deportivo Carmen Serdán, Delegación Gustavo A. Madero, Mexico City, *Circuito De Festivales De La Ciudad de México*
On the same day BG celebrates his wedding with Bernadette Martou in Brussels

05/04/07 Nine Rain plays at Deportivo Cacalote, Delegación Cuajimalpa, Mexico City, *Circuito De Festivales De La Ciudad de México*

05/14-20/07 SB conducts a workshop entitled *Música Y Sonido Para Cine*, Escuela de Música Dim, Coyacán, Mexico

05/21/07 Nine Rain plays at Auditorio Bicu Nisa, Juchitán de Zaragoza, Oaxaca, Mexico, *18th Festival Del Rio*

05/24&25/07 Nine Rain plays with the group Contradanza, Escuela de Música Dim, Coyacán, Mexico

Summer '07 BLR works as a DJ in Greece
06/09/07 Nine Rain plays at Casa Vecina, Centro Historico, Mexico City

06/15/07 Nine Rain plays at Teatro Juárez, Oaxaca, Mexico

08/07 SB works with 16 young musicians in Oaxaca and writes an original piece of music scored for them

09/07 Some Nine Rain members in residence in Oaxaca to work on new material with SB

09/07 LvL becomes "artiste-conseil" for music at La Maison Du Spectacle La Bellone, Brussels (see www.bellone.be) under the direction of Antoine Pickels

06/14/07 TM's 30th Anniversary

09/07 Release of TM's 30th Anniversary box set named 77o7 containing:

Page 421

- TM's new album entitled *Vapour Trails* (recorded at Kostis Bageorgios' Sweetohm Studio in Athens (2006); mixed by Cotik & PP at the Lemon Tree, Keramikos, Athens) featuring the following tracks: 1. "Muchos Colores;" 2. "Still Small Voices;" 3. "Kubrick;" 4. "Big Olive;" 5. "Dark Temple;" 6. "Dizzy;" 7. "Epso Meth Lama;" 8. "Wading Into Love." Note: the lyrics for "Muchos Colores" were borrowed from Sub-Commandante Marcos (see A. Tale, "Tuxedomoon – Surréalisme", *Rock & Folk*, 11/07 (in French))

- a CD entitled *Lost Cords* compiled by PP, featuring the following previously unreleased tracks: 1. "Day To Day (Demo 78);" 2. "Remember (Live 78);" 3. "Ill (April In Afghanistan) Prototype Of Crash 79;" 4. "Somnanbulist (Demo 83);" 5. "Heaven And Hell (Demo 82);" 6. "Atlantis Compilation (B-Side 85);" 7. "Up All Night (Live 85);" 8. "Lop Lop's People (Live 86);" 9. "Devastated (Demo 77;" 10. "Brad's Loop (Live 97);" 11. "Allemande Bleue (Demo 81);" 12. "No Business Like Show Business (Live 81);" 13. "Cell Life (Live 80);" 14. "Oceanus (Live 80);" 15. "Work Coda (Live 79)." Note: the date (1985) mentioned for the Atlantis B-Side is wrong as it was actually recorded and released in 1987

- a DVD entitled *Found Films* compiled by Bruce Geduldig featuring: 1. *The Ghost Sonata* video (shot by BG, 1982); 2. *1000 Lives By Picture* (nine clips shot by BG, 1982-85); 3. Nancy Guilmain's *Mythical Puzzle* documentary shot in 1988; *Colorado Suite* (1977); 4. *Jet Wave (1980) A Multimedia Loft Jam*; 6. *No Tears (A Montage Of Accelerated Memory)* (2007). Note the date mentioned for *Colorado Suite* is wrong as TM actually were artists-in-residence at the University of Colorado in 02/78

Lost Cords & Found Films form the *Unearthed* double CD/DVD

- a CD entitled *16207 (39°N 7°W)* constituting a live recording of TM's 02/16/07 concert featuring: 1. "Soup Du Jour/Effervescing;" 2. "Luther Blisset;" 3. "The Dip;" 4. "Still Small Voice;" 5. "Baron Brown;" 6. "Triptych;" 7. "Muchos Colores;" 8. "A Home Away;" 9. "The Big Olive;" 10. "Annuncialto;" 11. "Dizzy;" 12. "This Beast"

US release scheduled in 02/08

10/09/07 TM meets the press in Paris and attends a projection of *Downtown 81* at Ciné 13

10/10/07 TM plays at La Cigale, Paris, *Festival Factory*, with The Cinematic Orchestra (with The Cinematic Orchestra opening). BG is back aboard, working on the band's visuals. Set list: 1. "The Waltz;" 2. "Effervescing In The Nether Sphere"/"Soup Du Jour;" 3. "Luther Blisset;" 4. "In The Name Of Talent/Italian Western Two;" 5. "Still Small Voice;" 6. "Baron Brown;" 7. "Time To Lose;" 8. "Muchos Colores;" 9. "Triptych;" 10. "Big Olive;" 11. "Atlantis;" 12. "What Use?;" 13. "Home Away;" 14. "Dizzy;" 15. "This Beast". Encores: "59 To 1;" "The Cage;" "Desire;" "Egypt." Unfortunately the band is forced to leave the stage after "Big Olive" by rude festival organizers who had not told them that they were just supposed to play a short set. Brown dedicates "Atlantis," that they cannot perform, to the late Jean-François Bizot. The crowd is furious and comes very close to provoke a riot

10/11&12/07 A double concert/event at the Beursschouwburg, Brussels with TM playing their old material on the first night and their new (*Vapour Trails*) material on the 2ⁿᵈ night.

10/13/07 TM plays at Casa Da Musica, Porto

10/14/07 TM plays at FZW, Dortmund

years that I don't know where I'm from anymore. I retain two indisputably American qualities, my accent and my passport. The rest is uncertain.

Steven Brown: There's a phrase by American expat writer James Baldwin that has always haunted me. It essentially refers to that intangible feeling of recognition, or of having something in common when looking at another American. Living abroad for over 25 years, I have always avoided Americans. Maybe part of that is self-denial, but in the end what does one leave one's country of birth for, if not to start a new life freed from the past? Still, there is ultimately no way to eliminate your roots. I think it's true for anyone from anywhere, no matter how well you learn the local lingo or blend in to the local colour, you are always the stranger. As for Whitman, there was a time in my life when I felt the ecstasy of the promise for humanity he speaks of. Those days are few and far between nowadays, I'm afraid to say.'

Peter Principle also recently referred to Tuxedomoon's American identity:

"Our music has always had a very romantic edge. That's what made us sound so European to Americans. It gave a false perception to everybody, because everybody thought Americans cannot be romantic. They are supposed to be open, naïve, full of hope, not dark, brooding, tender, and dreamy. Initially, we were seduced by the idea, and decided to search out this Europe we had idealized. What we discovered over the years is that we are very American. And, conversely, that American romanticism does exist." [50]

But, in the end, it took years spent in Europe for Tuxedomoon's members to see clearly their American identity. And, conversely, it takes the mirror held by Tuxedomoon for many Europeans to be made aware of their European identity.

Released in the Fall 2007, Tuxedomoon's last album to date, *Vapour Trails*, captures their now fully acknowledged status of expatriate wandering musicians.

Interviewed by French journalist J.-F. Micard about the conducting thread between *Bardo Hotel* and *Vapour Trails*, Blaine Reininger insisted on their method of composition, gathering musicians dispersed around the globe: "The thread resides in our composition process that is globally the same but that [*in Vapour Trails*] was brought to a more advanced stage (…) It is a process that we first developed for *Cabin In The Sky* and that allows us to maintain some coherent and original artistic whole notwithstanding the fact that we live on the four corners of the planet and rarely get to actually meet each other."

Peter Principle: "Tuxedomoon is a state of mind that consequently does not need some physical localization to

maintain its continuity even though, as we write the music together, we have to find each other somewhere at a certain moment. But since a long time now we see ourselves as post-nationals."

Steven Brown: "We constantly have to rebuild our own territory under our feet. That's what makes it so personal to us…"

Vapour Trails brings this peculiar state of mind in action in a playful way, this time centered on the use of language.

Steven Brown: "The only conscious decision we took for this album was to have several languages featured. I suggested to try and present some choral work, using language and non-language and Blaine immediately agreed, considering that the audience would at any rate understand what we would be singing (…) We have only just touched on the possibilities inherent in this kind of work and I hope that we will continue to explore them. After all, so much can be done using the voice as an instrument, why should we limit ourselves to some worn-out formula?"

Blaine Reininger: "(…) we also use some synthetic languages in order to parody speech, to amuse ourselves but also to enhance the role of language in art." [51]

For the first time in their career, *Vapour Trails* earned Tuxedomoon largely unanimous welcoming reviews in the UK:

'(…) Tuxedomoon continue to explore the uncharted territory between pop, classical, chamber-jazz, techno and the *avant-garde*. Recorded in Athens, *Vapour Trails* offers a series of intriguing musical sketches whose eclecticism recalls Can: opener "Muchos Colores," for instance, adds clarinet and flügelhorn to a bed of piano and moaning violin. Elsewhere "Dizzy" blends blip-beat rhythms with abstract sonic bricolage and "Big Olive," their tribute to Athens, threads flügelhorn over a wiry Beefheartian guitar stomp. An absorbing blend of opposites: the raw and the cooked, industry and reflection, ancient and modern. [52] [*This*] artful blend of ancient and modern would be recognized by Henry James, were he alive, as belonging to an older, more respectful heritage of expatriate American exploration.' [53]

'(…) Of course, the best art rock band in the world are Tuxedomoon (…) Since they reformed (…) Tuxedomoon have slowly recaptured the magic (…) Tracks such as "Kubrick" are quite breathtaking, with a soundscape that embraces a *2001: A Space Odyssey* male choir and low-key electronic textures. "Big Olive" shows that Peter Principle [*sic*] has lost none of his ability to underpin songs with electric guitar shards and the Miles Davis trumpet work of Luc van Lieshout, and Steven Brown's emotive clarinet is just exceptional on

11/02/07 TM plays at Ydrogeios Club, Thessaloniki

11/03/07 TM plays in Athens, Gagarin 205

11/07/07 TM plays at P60, Amstelveen (The Netherlands)

11/10/07 TM plays at 103 Club, Berlin

11/11/07 TM plays in Wroclaw (Poland), *Industrial Festival*

11/13/07 TM plays in Zagreb, Kino SC

11/15/07 TM plays at Villagio Globale, Roma

11/16/07 TM plays at Forli, Rimini

11/17/07 TM plays at Spazio 211, Torino

11/19/07 TM plays at Purcell Room, Southbank Centre, London, *London Jazz Festival*. A very successful gig in the presence of Southbank Centre director. '(…) Tuxedomoon helped to pioneer composing soundtracks for imaginary films, and there was a strong cinematic element to much of the show. Both "In The Name Of Talent (Italian Western II)" and the new album track "Muchos Colores" evoked the overheated melodrama of a Sergio Leone western. At their best, these tunes drew on sources, from the lolloping polyrhythms of vintage Krautrock to the brassy staccato of bebop jazz. At their worst, they sounded arid and over cerebral (…) The band's in-house visual artist (…) filled a giant video screen with spooky mannequins and other striking imagery. When he donned carnival masks and began lurching wildly around the stage, there was an edge of laboured *cabaret*. But this was a rare clumsy

Steven Brown at Tuxedomoon's 30th Anniversary gig in Brussels, Beursschouwburg, October 11th, 2007. Photo Mayjana Beckmann

aside to a mostly enjoyable evening full of subtle, quirky and engrossing music.' (S. DALTON, 'London Jazz Festival – Tuxedomoon', *The Times*, 11/21/07)

11/20/07 Flat Earth Society (with LvL) plays at Purcell Room, Southbank Centre, London, *London Jazz Festival*

12/07 Release by some TM fans under the coordination of Oliver Schupp (from Germany) of a CD, entitled *Adaptations From The Moon – Tuxedomooning The World*, featuring adaptations of various TM tracks: 1. "Everything You Want" by John Costello (from England); 2. "Ninotchka" by Phlitman & Kangaroo (from Belgium); 3. "In The Name Of Talent" by Festspielhaus (from Germany); 4. "Where Interest Lies" by Gosane (France); 5. "Blind" by Cabaret Of Complexity (Portugal); 6. "Egypt" by John Costello; 7. "What Use?" by Another (from Mexico); 8. "In The Name Of Terror (Iraqi Western 2)" by !!* (from Australia); 9. "Some Guise" by Cult With No Name (from England); 10. "Everything You Want/The Stranger" by Gosane; 11. "East" by Duke Sexton (from USA); 12. "Time To Lose" by Dry Monopole (from France); 13. "(Special Treatment For The) Family Man" by Mistake Mistake (from Serbia); 14. "The Unknown Fan" by Anonymous (Europe). Website: http://www.tuxedomooning.com

Some time in '07 SB participates, for the track "Foxilandia," in by *a.o.* Daniel Aspuru (from Nine Rain) driven El Gabinete musical project, said track being included on their CD of the same name. SB appears in drag on the "Foxilandia" video clip (viewable at: www.elgabinete.org & www.iguanamusic.com)

12/07 through 01/08 BLR is cast and appears in drag as "Miss Colorado" in *The Night Of Secrets*, a play by Akis Dimou and directed by Elli Papakonstantinou, staged in Athens at Ethniko Theatro, Nea Skini, Synkrono Theatro Athinas

the atmospheric "Dark Temple." "Dizzy" blends reggae, dub and Latin rhythms into a delicious gumbo and, on "Epso Meth Lama" singer Blaine Reininger orchestrates the chants as well as playing his trademark viola. All told, an astounding album and art rock in its purest. Buy and be amazed.' [54]

'If there's any justice (…) *Vapour Trails* will finally make the breakthrough. It is, quite simply, the best album they have ever produced (…) It comprises everything that makes the group a special proposition – the familiar vocal and lyrical archness, surprising textural colourings from Steven Brown's keyboards and Blaine Reininger's violin, the stealthy Peter Principle basslines that tick away impassively. There's daring experimentation ("Kubrick" is like a meeting of Ligeti and Miles Davis circa *In A Silent Way*), lush balladry ("Muchos Colores" – part Angelo Badalamenti, part Victor Jara), propulsive but suave pop songs ("Still Small Voice") and more. It's impossibly debonair and stares pretentiousness full in the face – but stares it down. So what if they choose to flaunt their facility for foreign languages by singing in Spanish, Greek and something unidentifiable on "Epso Meth Lama"? (…) a crucial set from a group who operate entirely on their own terms. Cherish them.' [55]

Tuxedomoon's wandering story is certainly not over but this particular wandering story closes in November 2007, after Tuxedomoon's wonderful gig at the Purcell room (Southbank Centre) for the *London Jazz Festival*. It will continue, off record, at least as far as the author of this book is concerned… Remarkably Brown and Reininger both finished the year 2007 by appearing in drag in Athens and Oaxaca (Mexico). The Angels Of Light are not dead.

ENDNOTES

INTRODUCTION
On the road to San Francisco

1. All to be dealt in Chapter I.
2. P. EUDELINE, "Il ne rangeait jamais ses disques", *Rock & Folk*, 11/2007.
3. Even though some French fan considered that they were playing "punk jazz" in 1983 already, as can be heard on a Radio France Culture show recorded on the night of their 12/02/83 gig in Lille, France.
4. For instance, the influence of Italy is very clear on their *Cabin In The Sky* album (2004) that was composed in Cagli, Italy. A similar observation can be made for their latest *Vapour Trails* album (2007) that was composed in Athens.
5. Tuxedomoon's personnel changed many times in the course of their existence and the instruments played by the successive members also varied.
6. For instance, when Tuxedomoon was into minimalism, it was rather the consequence of scarcity of means than the outcome of a deliberate choice.
7. An obvious example is their *Ghost Sonata* album (1991) that was the offshoot of their theatrical project of the same name (1982). Recently their *Bardo Hotel* album (2006) featured some of the work that they accomplished while participating in the *New Atlantis Festival* in Amsterdam (2005).
8. The Youth International Party, whose adherents were known as the "Yippies," was a highly theatrical political party founded in the USA in 1966 and, more precisely, an offshoot of the free speech anti-war movements in the sixties.
9. "Die Wahreit über Tuxedomoon" (Interview Blaine L. Reininger), *59 to 1*, # 5, 1984.
10. *Ibid.*
11. *Ibid.*
12. *Ibid.*
13. Cfr X. QUIRARTE, "Steven Brown, un músico sin etiquetas", *El Nacional*, 10/09/93.
14. Steven Brown attended Western Illinois University from September 1970 through June 1972. His major was General Orientation.
15. From Steven Brown's short autobiography written circa 1982 in order to obtain legalization of his residence in Europe.
16. *Ibid.*
17. http://www.stbrown.blogspot.com/.
18. *The Cockettes*, a 2002 documentary directed by Bill Weber & David Weissman.
19. The Chicago Seven (or Eight) were people charged with conspiracy, inciting to riot and other charges related to violent protests that took place in Chicago, Illinois on the occasion of the 1968 Democratic National Convention. At the time Chicago was the scene of roaring demonstratons against the Vietnam war.

CHAPTER I
The Angels Of Light

1. SIMON REYNOLDS, *Rip It Up And Start Again: Postpunk 1978-1984*, London, Faber and Faber, 2005, p. 245.
2. As to Tadlock's visual works, see the following links:
 - http://www.eai.org/kinetic/ch1/gallery/film_video.html:
 Thomas Tadlock, *Quadrilateral Light Case With Changing Geometric Designs*, 1967
 An experiment in light, Tadlock's sculpture of random geometric patterns was exhibited at the Howard Wise Gallery as part of the *Lights In Orbit* exhibit in 1967. Tadlock was later also a participant of the gallery's *TV as a Creative Medium* exhibition in 1969. The following excerpt is from the Howard Wise Gallery Archives, Super 8mm, color, silent. Overall dimensions: 24 x 25 x 22 in. With video excerpt.
 - http://www.vasulka.org/Kitchen/essays_sturken/K_SturkenWise.html :
 Tadlock's Archetron presented a large console consisting of three monitors and an elaborate system of mirrors and filters to create kaleidoscopic imagery from broadcast TV. "it is not possible for this artist, (or any other using the Archetron)," wrote Wise in the exhibition brochure, "in effect to create simultaneously works of art on TV screens in countless homes."
 - http://www.newmedia-art.org/francais/reperes-h/60.htm (historical overview of video art with

Page 425

mention of the exhibit *TV as a creative medium* in which Tadlock took part).
- http://www.videoartsjolander.homestead.com/files/list_-__experimental_television_center_-_usa.htm ("The Medium is the Medium," WGBH-TV, Boston, with presentation of works of *a.o.* Tom Tadlock).

[3] Interview of Tommy Tadlock by Patrick Roques for *Vacation Magazine*, Oct. 1st, 1979

[4] About the Cockettes, see the 2002 documentary *The Cockettes* by directors Bill Weber and David Weissman (website : http://www.grandeillusion.com/; entry on the Internet Movie Database : http://www.imdb.com/title/tt0303321/combined21/combined) and read P. TENT, *Midnight at the Palace: My Life As a Fabulous Cockette*, Los Angeles, Alyson Books, 2004.

[5] See J. HAMMOND, "Drag queen as angel: transformation and transcendence in 'To Wong Foo, Thanks for Everything, Julie Newmar.' – motion picture", *Journal of Popular Film and Television, Fall '96* : 'An early equation of drag queens with angels can be found in Mark Thompson's history of drag theatrics. In the 1970s a drag queen named Hibiscus (*aka* George Harris) took a spiritual journey into the mountains outside of San Francisco and "… met a stranger who had told him that he was an angel - or at least one in training - and so he called his new [performance] group the Angels of Light" (…). In 1979 Thompson was told by group members, "The Angels of Light are an expression that represents an inward dream and vision. It means a positiveness, an idea of sharing the things that are important in uplifting people"'. This article can be viewed at : http://www. findarticles.com/p/articles/mi_m0412/is_n3_v24/ai_19506785

[6] John Waters in documentary cited above.

[7] http://www.pickupstricks.com/anth_95.htm

[8] Steven Brown, Interview with James Nice, July 5th, 1987 (unpublished)

[9] See his website at http://www.scrumblymusic.com/

[10] Esmeralda, former member of the Angels Of Light and of punk group Noh Mercy! estimates the number of women in the Angels Of Light to have been about one third of them. Pam Tent estimates women to have composed at least half of the troupe (P. TENT, *Midnight at the Palace : My Life As a Fabulous Cockette, op. cit.*, p. 149).

[11] Now a renowned costume designer in San Francisco's Bay Area.

[12] BAMBI LAKE & ALVIN ORLOFF, *The Unsinkable Bambi Lake – A Fairy Tale Containing The Dish on Cockettes, Punks and Angels*, San Francisco, Manic D Press, 1996, pp. 27-28.

[13] See the website of La MaMa experimental theater organization (NYC) at http://www.lamama.org/ Tuxedomon's member Winston Tong performed there in 1979 and 1982 (along with Bruce Geduldig in 1982).

[14] For a selection of recorded texts/interviews of some famous surrealists/dadaists, listen to *Surrealism reviewed. Original recordings by Breton, Duchamp, Aragon, Dali, Desnos, Ernst, Penrose, Soupault, Tzara, Man Ray, Miller and Artaud*, a CD published by LTM (LTMCD 2343, http://www.ltmpub.freeserve.co.uk/surrrev.html): interestingly, André Breton recalls that his assistantship at a psychiatric hospital during the first world war was a major influence on the development of his thinking as there he could test techniques such as the recording of dreams for interpretation and free association of thoughts.

[15] On situationism in its multiple and international ramifications, see the very complete and extremely well illustrated book published in France on this subject: L. CHOLLET, *L'insurrection situationniste*, Paris, Dagorno, 2000. In English, a classic is *Leaving The 20th Century. The Incomplete Work Of The Situationist International*, translated and edited by Christopher Gray, first published by Free Fall Publications, 1974, new edition by Rebel Press (London), 1998.

[16] See J.-M. MENSION, *La Tribu*, Paris, Allia, 2001; in English : *The Tribe*, City Lights, 2001.

[17] See also L. CHOLLET, *op. cit.*, p. 47.

[18] G. DEBORD, *La société du spectacle*, Paris, Buchet-Chastel, 1967; Paris, Gallimard, Folio collection, # 2788, 992. Available on line on http://library.nothingness.org/articles/SI/fr/pub_contents/7. In English : *The society of the Spectacle*, New York, Zone Books, 1994, available on line (translation by Ken Knabb) on http://www.cddc.vt.edu/sionline/si/tsots00.html

[19] On Cabaret Voltaire: an experiment where the artists used their soul and personality as their main "instrument", see Greil Marcus (*Lipstick Traces: A Secret History of the Twentieth Century*, Cambridge, Harvard University Press, 1989; French translation: *Lipstick traces, une histoire secrète du vingtième siècle*, Paris, Allia, 1998), p. 238 et seq. of the French Folio/actuel (# 80) collection.

[20] Quoted by L. CHOLLET, *op. cit.*, p. 31.

[21] See L. CHOLLET, *op. cit.*, pp. 59-62.

[22] R. VANEIGEM, *Traité de savoir-vivre à l'usage des jeunes générations*, Paris, Gallimard, 1967; Paris, Gallimard, Folio/ actuel, # 28, 1992. Available on line at http://arikel.free.fr/aides/vaneigem/. In English : *The Revolution of Everyday Life*, London, Rebel Press, 2003, available (in another translation) on line at http://library.nothingness.org/articles/SI/en/pub_contents/5

[23] M. P. SCHMITT, *V° Vaneigem, Raoul in Encyclopaedia Universalis*, Paris.

[24] L. CHOLLET, *op. cit.*, p. 34.

[25] From G. DELEUZE, see in particular his works with psychoanalyst F. GUATTARI: *Capitalisme et Schizophrénie*,

l'Anti-Oedipe, Paris, Editions de Minuit, 1972/1973 (in English : *Anti-Oedipus : Capitalism and Schizophrenia*, Minneapolis, University of Minnesota Press, 1983); *Capitalisme et schizophrénie 2, Mille plateaux*, Paris, Editions de Minuit, 1980 (in English : *A Thousand Plateaus : Capitalism and Schizophrenia*, Minneapolis, University of Minnesota Press, 1987).

[26] L. CHOLLET, *op. cit.*, p. 17.

[27] The links between situationism and the punk movement are explored at great length by G. MARCUS, *op. cit.*; see also L. CHOLLET, *op. cit.*, p. 300 et seq.

[28] About that house, see Chapter II.

[29] http://www.astro.wisc.edu/~mukluk/0snaps/1970s-book/1977-p3.html

[30] quoted by J. STARK, *Punk '77: an inside look at the san francisco rock n' roll scene, 1977*, San Francisco, RE/Search Publications, 1999, p. 15.

[31] BAMBI LAKE & ALVIN ORLOFF, *op. cit.*, p. 106.

[32] ELISABETH D, "Ils n'en font qu'à leur tête", *Actuel*, n° 15, January 1981 (translated from French).

CHAPTER II
Tuxedomoon New Music Ensemble in the Houses of San Francisco

[1] Ex Cockettes & Angels Of Light as well..

[2] About Agape and its connections with Thelema and Ordo Templi Orientis, see http://www.thelemapedia. org/index.php/Agape

[3] See http://www.diggers.org/overview.htm : 'The Diggers were one of the legendary groups in San Francisco's Haight-Ashbury, one of the world-wide epicenters of the Sixties Counterculture which fundamentally changed American and world culture. Shrouded in a mystique of anonymity, the Diggers took their name from the original English Diggers (1649-50) who had promulgated a vision of society free from private property, and all forms of buying and selling. The San Francisco Diggers evolved out of two Radical traditions that thrived in the SF Bay Area in the mid-1960s: the bohemian/underground art/theater scene, and the New Left/civil rights/peace movement.
The Diggers combined street theater, anarcho-direct action, and art happenings in their social agenda of creating a Free City. Their most famous activities revolved around distributing Free Food every day in the Park, and distributing "surplus energy" at a series of Free Stores (where everything was free for the taking.) The Diggers coined various slogans that worked their way into the counterculture and even into the larger society — "Do your own thing" and "Today is the first day of the rest of your life" being the most recognizable. The Diggers, at the nexus of the emerging underground, were the progenitors of many new (or newly discovered) ideas such as baking whole wheat bread (made famous through the popular Free Digger Bread that was baked in one- and two-pound coffee cans at the Free Bakery); the first Free Medical Clinic, which inspired the founding of the Haight-Ashbury Free Medical Clinic; tye-dyed clothing; and, communal celebrations of natural planetary events, such as the Solstices and Equinoxes. First and foremost, the Diggers were actors (in Trip Without A Ticket, the term "life actors" was used.) Their stage was the streets and parks of the Haight-Ashbury, and later the whole city of San Francisco. The Diggers had evolved out of the radicalizing maelstrom that was the San Francisco Mime Troupe which R.G. Davis, the actor, writer, director and founder of the Troupe had created over the previous decade. The Diggers represented a natural evolution in the course of the Troupe's history, as they had first moved from an indoor milieu into the parks of the City, giving Free performances on stages thrown up the day of the show. The Digger energy took the action off the constructed platform and jumped right into the most happening stage yet — the streets of the Haight where a new youth culture was recreating itself, at least temporarily, out of the glaring eye of news reporters. The Diggers, as actors, created a series of street events that marked the evolution of the hippie phenomenon from a homegrown face-to-face community to the mass-media circus that splashed its face across the world's front pages and TV screens: the Death of Money Parade, Intersection Game, Invisible Circus, Death of Hippie/Birth of Free.'

CHAPTER III
From "Just Desserts" to Milk and Moscone's assassinations

[1] In the early days, *Tuxedomoon* was often spelled with two words (namely *Tuxedo Moon*) until it stabilized in its one-word version (sometimes also spelled *TuxedoMoon*).

[2] P. BELSITO & B. DAVIS, *Hardcore California – A History Of Punk And New Wave*, Berkeley, The Last Gasp Of San Francisco, 1983, 6th printing of July 1996, p. 78: 'The Mutants are a five-guy, two-girl ensemble fronted by the irrepressible Freddie (Fritz) Fox, a video-burnout and the world's longest running art project; Sally Webster, a pint-sized, polka-dot Mona Lisa; and Sue White, whose frizzed blonde locks

Page 427

conjure images of a suburban housewife that likes to stick her fingers in wall sockets. Their early notoriety centered around this threesome's sometimes unpredictable stage antics which could include anything from ritualized TV destructions to squabbling over the one remaining operable microphone. Because most of the band members emanated from various art schools, the Mutants were originally labeled an "art" band. This misnomer was put to rest by one journalist who wrote "When you see the band on stage, the only concern they seem to have with art is with its complete and gleeful ruination'' (quoting ANNEX, "The Mutants", *Damage*, n° 6, p. 26).

[3] Steven Brown interviewed by James Nice, July 5th, 1987 (unpublished).

[4] JAMES NICE, *Tuxedomoon*, unpublished manuscript, 03/21/92, p. 3.

[5] P. BELSITO & B. DAVIS, *op. cit.*, p. 68

[6] For more details, read J. STARK, *Punk '77 : an inside look at the san francisco rock n' roll scene, 1977*, San Francisco, RE/Search Publications, 1999, pp. 11-17.

[7] excerpt from BRAD L., "Tuxedomoon", *Damage*, n° 9, 09-10/1980.

[8] http://www.ltmpub.freeserve.co.uk/ ; http://www.myspace.com/ltmrecordings

[9] JAMES NICE, *Tuxedomoon*, unpublished manuscript, 03/21/92, p. 4.

[10] BRAD L., *op. cit.*: 'After playing the Mab a couple of times, they were asked by producer Dirk Dirksen to open for Devo in early 1978 (…) Performing before a large, enthusiastic crowd (…) Tuxedomoon was instantaneously planted firmly in the middle of SF's punk rock scene'.

[11] Peter Principle interviewed by JAMES NICE, July 3rd, 1987 (unpublished).

[12] Steven Brown interviewed by BRAD L., *op. cit.*

[13] Steven Brown interviewed by BRAD L., *op. cit.*

[14] P. BELSITO & B. DAVIS, *op. cit.*, pp. 79-80.

[15] *Ibid.*

[16] Steven Brown interviewed by BILL EDMONDSON ("Interview Tuxedo Moon, week of July 15, 1980", *Praxis*, vol. I, # 6, 11/80).

[17] Blaine Reininger interviewed by ANDY GILL & BRYN JONES ("Gimme the moonlight", *N.M.E.*, 09/19/81).

[18] Blaine Reininger interviewed by RICHARD ROBERT ("Nouvelles lunes", *Les Inrockuptibles*, 07/13/04) (translated from French).

[19] excerpts from J. BARRON, "Bad moon rising", *Sounds*, 05/04/1985.

[20] Peter Principle interviewed by TASSOS SAKAS, NIKOS TRIANDAFYLLIDIS, GIORGOS MOUCHTARIDIS, ("Memories from the moonlight zone. Small, nostalgic confidences from Peter Principle, Blaine Reininger, Steven Brown", *Sound & Hi-Fi*, 01/88, translated from Greek by George Loukakis).

[21] C. EUDELINE, "Post-punk – Tuxedomoon, le groupe phare de la new wave est plus en forme que jamais", *Nova*, 2004 (reviewing the *Cabin In The Sky album*, translated from French).

[22] S. MEYER, "Tuxedomoon – Die dionysischen Jahre", *Zitty*, 05/88 (translation from German).

[23] S. MEYER, *ibid.*

[24] J. LANDUYDT, "Tuxedo Moon", *trespassers w*, # 3/4, 85/86 (in Dutch).

[25] Steven Brown interviewed by TASSOS SAKAS, NIKOS TRIANDAFYLLIDIS, GIORGOS MOUCHTARIDIS, *op. cit.* (translated from Greek by George Loukakis).

[26] Blaine Reininger interviewed by Dirk Steenhaut ("Wij waren op het gevoel", *De Morgen*, 06/12/04) (translated from Dutch).

[27] JAMES NICE (*Tuxedomoon*, unpublished manuscript, 03/21/92, p. 4) adds an anecdote about Tuxedomoon's relationship to punks: 'Around this time [i.e. after the gigs opening for Devo at the Mab] Brown, Tong and Lowe proposed a concession towards the anarchistic spirit of punk by changing the group's name from Tuxedomoon to Disband. All three made and sported badges bearing the bizarre new sobriquet, with Brown even dreaming up a shiny new punk pseudonym in Steve End. Thankfully, Reininger steadfastly resisted the wind of change and reason won out'.

[28] P. BELSITO & B. DAVIS, *op. cit.*, p. 80.

[29] M. GOLDBERG, "I left my heart in San Francisco. The residents, MX-80 and Tuxedomoon", *N.M.E.*, 11/17/79.

[30] Scott Ryser interview (Fall 2000) available at http://www. synthpunk.org/units/ryser1.html

[31] This opinion is partly shared by Ronald Chase (in whose commune Tong lived early on): 'This, from everything I can gather, was taken up more as an identity—especially with the tragic heroines of the Black Blues singers--both Holiday and Smith. Winston smoked grass, but never indulged in anything except LSD when he was with us. It was his move to Rotterdam [*where the band moved in 1981*] that sent him down the spiral, though I believe he took heroin while still in SF (and New York)'.

[32] P. BELSITO & B. DAVIS, *op. cit.*, p. 80.

[33] Interview with Blaine Reininger, Radio 21 (Belgium), April 1987.

[34] JAMES NICE, *Tuxedomoon*, Materiali Sonori, 1988, p. 8.
About Donald L. Philippi/Slava Ranko, see: http://www.scaruffi.com/vol4/ranko.html (in Italian) and a 1984 interview with him with focus on the SF musical scene at the end of the seventies is available on http://www.jai2.com/dlpivu3.htm: "I began to notice, in 1977, that something was happening at a place called the Mabuhay Gardens on Broadway. A man called Dirk Dirksen, whom I came to know and

admire, was propagating something known then as punk rock. I began to go down there and, of course, immediately understand what was happening. It was a sort of revolution, and you know how well I relate to revolutions. it happened to lots of other people I knew, too -- Steven Brown, Esmeralda, Patrick Miller, and many, many others. Before I knew it I was in the midst of a burgeoning new music scene. My friends were forming bands, and I was driving them around to nightclubs. There were other places besides the Mabuhay-- Steven Brown had a band called Tuxedo Moon, Winston Tong and Bruce Geduldig were doing performance art, and Esmeralda and another woman had a band called Noh Mercy in which I also briefly performed. It was a very exciting and exalting scene. When the Sex Pistols played at Winterland in November 1978 I was there and experienced what must have been the most ecstatic experience in my life. I also experienced something similar when I heard Tuxedo Moon play once (…)"

35 JAMES NICE, *Tuxedomoon*, Materiali Sonori, 1988, p. 8.
36 JAMES NICE, *Tuxedomoon*, unpublished manuscript, 03/21/92, p. 4.
37 JAMES NICE, *Tuxedomoon*, Materiali Sonori, 1988, p. 8.
38 Peter Principle backstage after Tuxedomoon's concert in Paris (Centre Pompidou) on 06/26/03 and filmed by Merrill Aldighieri for her *Tuxedomoon – Seismic Riffs* dvd (Crammed, Cramboy, 2004).
39 A. GILL, "American Tux exiles", *The Independent*, 07/28/04.
40 P. BELSITO & B. DAVIS, *op. cit.* , p. 78.
41 Steven Brown interviewed by James Nice, July 5th, 1987 (unpublished).
42 according to Paul Zahl.
43 B. EDMONDSON, "Interview Tuxedo Moon, week of July 15, 1980", *op. cit.*
44 Michael Belfer's words for the story of his audition and Diego Cortez' *Grützi Elvis* are a combination of an interview with author and an e-mail interview given to James Nice.
45 E-mail sent by Michael Belfer to James Nice, 04/09/02.
46 this track, the first that Reininger and Brown composed together, wouldn't have denoted as part of Riz Ortolani's soundtrack for *Cannibal Holocaust*, released in 1980.
47 According to the *San Francisco Chronicle* of 01/14/79, this EP came out on January, 15th, 1979.
48 In fact the amp didn't belong to Peter Principle who, in order to secure his position in the band, couldn't return it to whom he had lifted it from for about six months. Hence Principle spent then a lot of time running away from an irate amp owner: Peter Principle interviewed for *Tuxedomoon – No Tears*, Greek TV documentary directed by Nicholas Triandafyllidis, Astra Sound and Vision, 1998.
49 For more details, see *The Times Of Harvey Milk*, a documentary by R. EPSTEIN & R. SCHMIECHEN, Black Sand Productions (1984).
50 SIMON REYNOLDS, *Rip It Up And Start Again : Postpunk 1978-1984*, *op. cit.*, p. 262.
51 Peter Principle interviewed by A. GILL & B. JONES, "Gimme the moonlight", *N.M.E.*, 09/19/81.
52 See the introduction to chapter I.
53 SIMON REYNOLDS, *op. cit.*; P. BELSITO & B. DAVIS, *op. cit.*, p. 115.
54 Radio Capitale Interview (Belgium), October 2nd, 1980.

CHAPTER IV
Outgrowing San Francisco

1 P. BELSITO & B. DAVIS, *op. cit.*, p. 94.
2 P. BELSITO & B. DAVIS, *ibid.*
3 P. BELSITO & B. DAVIS, *ibid.*
4 Scott Ryser interview (Fall 2000) available at http://www.synthpunk.org/units/ryser1.html
5 Peter Principle interviewed by James Nice, July 3rd, 1987 (unpublished).
6 They went: "I don't want to be politically correct; I don't need no Caucasian guilt; I never cooked no Jews; I never took no Indian land; I never made no Black my slave; I never dug no Latino grave; Never made no Chinese build me a Rail road; I never put no Jap in a camp; I don't care if faggots call me a cunt; I don't care if they take me out to lunch; I don't mind high heels on a dyke; Just don't knock me off my bike; Hey!". This song can be listened to at: http://wfmu.org/onthedownload.php/0411
7 Peter Principle interviewed by JAMES NICE, July 3rd, 1987 (unpublished).
8 Quoting from BRAD L., "Tuxedomoon", *Damage*, n° 9, 09-10/80.
9 BRAD L., *ibid.*
10 'Steven's cruel phase was special and specific as he was consistently cruel to everyone all the time for a while. An attempt to cut out all bullshit from life or something similarly ascetic. But bullshit, in one form or another, be the spice of life so he grew up and relaxed.'
11 JAMES NICE, *Tuxedomoon*, unpublished manuscript, 03/21/92, p. 8.
12 JAMES NICE, *ibid.*
13 M. GOLDBERG, "I left my heart in San Francisco. The residents, MX-80 and Tuxedomoon", *N.M.E.*, 11/17/79

Page 429

[14] A. Gill, "1-9-8-0 Left My Art in Ol' Frisco", *NME*, date uncertain.
[15] *in* M. Goldberg, *op. cit.*
[16] Peter Principle interviewed by James Nice, July 3rd, 1987 (unpublished).
[17] Radio Capitale Interview (Belgium), October 2nd, 1980.
[18] James Nice, *ibid.*
[19] James Nice, *op. cit.*, pp. 9-10.
[20] Quoted by James Nice, *op. cit.*, p. 10.
[21] Brad L., "Tuxedomoon", *Damage*, n° 9, 09-10/1980.
[22] Read in the Minneapolis City Pages (http://citypages.com/databank/24/1190/article11520.asp):
'The M-80 Project Oak Street Cinema, 7:30 p.m. Wednesday, October 1 (2003)
Sort of *The T.A.M.I. Show* of new wave, this previously "lost" 1979 concert video captures the first international festival of the alternative scene--and at that naive moment before music videos and hardcore entered the picture. Shot at the University of Minnesota field house, the film features 16 of the 23 bands that played, including DEVO (under their Christian-rock pseudonym, Dove), the Suicide Commandos (doing a breathtaking "Complicated Fun"), the Suburbs ("Cows"), the Monochrome Set (from the U.K.), Tuxedomoon (San Francisco), the Fleshtones (New York), and Minneapolis legend Curtiss A. Anyone who thinks the Rapture have a new idea should note the Contortions' cover of Chic's "Good Times." --Peter S. Scholtes'
[23] Email sent by Michael Belfer to James Nice on April 10th, 2002.
[24] Emails sent by Michael Belfer to James Nice on April 10th and 24th, 2002.
[25] W. Cresser, "Tuxedomoon and the limits of endurance", *East Side/West Side*, 06/80.
[26] Glenn O'Brien's Beat. "Fun in Lullsville. Recording history", *Andy Warhol's interview magazine*, 3/1980.
[27] Brad L., *Damage* (no date mentioned).
[28] J.-E. Perrin, *Rock & Folk*, 02/81 (translated from French).
[29] J. Gill, *Time out*, 03/21-27/85.
[30] A. Gill, "Single of the week (no contest) TUXEDOMOON: What Use?", *NME, 1980*.
[31] B. Edmondson, "Interview Tuxedo Moon, week of July 15, 1980", *Praxis*, vol. I, n°6, November 1980.
[32] Some excerpts of which can be seen on You Tube..
[33] G. O'Brien, "Tuxedomoon gone global", *Andy Warhol's interview magazine*, 1982.
[34] J. Landuydt, "Tuxedo Moon", *trespassers w*, nrs. 3/4, 85/86 (translated from Dutch).
[35] Peter Principle interviewed for *Tuxedomoon – No Tears*; Greek TV documentary directed by Nicholas Triandafyllidis, Astra Sound and Vision, 1998.
[36] P. Ramont, "Rolfing with Ralph", *The Daily Californian*, 12/07/79.
[37] P. Belsito & B. Davis, *op. cit.*, p. 96.
[38] P. Belsito & B. Davis, *ibid.*
[39] Peter Principle interviewed by James Nice, July 3rd, 1987 (unpublished).
[40] B. Edmondson, "Interview Tuxedo Moon, week of July 15, 1980", *op. cit.*
[41] James Nice, *Tuxedomoon*, unpublished manuscript, 03/21/92, p. 13.
[42] Simon Reynolds, *Rip It Up And Start Again: Postpunk 1978-1984*, *op. cit.*, p. 253.
[43] Brad L., "Tuxedomoon", *Damage*, n° 9, 09-10/80.
[44] Radio Capitale Interview (Belgium), October 2nd, 1980.
[45] Steven Brown interviewed by James Nice, July 5th, 1987 (unpublished).
[46] B. Edmondson, "Interview Tuxedo Moon, week of July 15, 1980", *op. cit.*
[47] B. Edmondson, *ibid.*
[48] The said rumors were probably fueled by the band's sometimes fuzzy and contradictory assertions, which is quite understandable considering the passing of time.
Peter Principle: "We were contacted by an English agent, Michael Nulty and he wanted us to tour with Joy Division who were coming to America and so it was going to be Joy Division and Tuxedomoon American tour but the guy killed himself and the tour never happened" (Peter Principle interviewed by James Nice, July 3rd, 1987 (unpublished)).
"Then we got involved with Michael Nulty, you know that we had to play with Joy Division and then Ian Curtis died and we ended up going to Europe instead" (our own interview with Peter Principle)
Steven Brown: 'We were scheduled to tour in Europe in 1980 with Joy Division when Ian killed himself... We eventually did the tour without them as we had the same tour agent in London at the time... Mike Nulty' (email sent by Steven Brown to Nick Blakey on October 9th, 2004).
Steven Brown seems to be the one who's right for that matter as the existing published info about that Joy Division cancelled US tour never cite Tuxedomoon as support (or main) act:
http://members.aol.com/lwtua/concerts.htm
Furthermore the notes from Rob Gretton (Joy Division's manager) about this cancelled tour were recently published on the Manchester District Music Archive's website (see http://www.mdmarchive. co.uk/index.php?option=displaypage&Itemid=106&op=page&SubMenu=) and bear no mention of Tuxedomoon. We also contacted the administrator of this archive, who had a closer look at all

49 James Nice, *Tuxedomoon*, Materiali Sonori, 1988, p. 12.

50 Peter Principle interviewed by James Nice, July 3rd, 1987 (unpublished).

51 Peter Principle interviewed by Erik Stein, London, September 26th, 2004, available on the Yahoo discussion list devoted to Tuxedomoon (http://launch.groups.yahoo.com/group/tuxedomoon/files/).

52 James Nice, *Tuxedomoon*, Materiali Sonori, 1988, p. 12.

53 Peter Principle interviewed by Erik Stein, London, September 26th, 2004, *op. cit.*

54 see http://www.garethjones.com/

55 Peter Principle interviewed by Erik Stein, London, September 26th, 2004, *op. cit.*

56 For a biography (in French) of Frédéric Flamand, see http://www.ballet-de-marseille.com/bio-flamand.htm

57 see Frank Brinkhuis' wonderful *Crepuscule and Factory pages* on http://home.wxs.nl/~frankbri/index.html, for an extensive archive.

58 Interview Radio Capitale, Brussels, October 2nd, 1980 (interview at which their future manager, Belgian Martine Jawerbaum, was present).

59 Elisabeth d, "Ils n'en font qu'à leur tête", *Actuel*, n° 15, 01/1981 (translated from French). The same article was translated in Italian and published in *Frigidaire* of 03/1981.

60 See the history of the Master Musicians of Jajouka on: http//www.jajouka.com

61 James Nice, *Tuxedomoon*, unpublished manuscript, 03/21/92, p. 15.

62 Peter Principle and Steven Brown interviewed by Erik Stein,*op. cit.*

63 Elisabeth d, *op. cit.*

64 L. Majer, "La luna in frac?", *Musica 80*, n° 8, 10/80 (translated from Italian).

65 A. Gill, "A sense of unease", *NME*, 03/21/81.

66 I. Pye, *Melody Maker*, 1981.

67 *Actuel*, 03/81 (translated from French).

68 D. Koopman, *Vinyl*, 05/81 (translated from Dutch).

69 F. Vincent, *Rock & Folk*, 05/81 (translated from French).

70 J. Gill, "Ultimate somewhere elseness", *Sounds*, 03/21/81.

71 'Radio Città, a private radio, had been organizing concerts since 1977 (John Martyn, Joe Jackson and Peter Tosh among others)', reminds Roberto Caramelli, Central Unit's drummer.

72 See http://www.antoniano.it

73 Peter Principle interviewed by Erik Stein, London, September 26th, 2004, *op. cit*. The reference to Homer is not in the online version of this interview. It is included here as it was repeated in an email interview done by Peter Principle with Michael J. West and forwarded to author.

74 email conversation with Fabrizio Cavallaro.

75 Radio interview Steven Brown WREK Georgia Tech (USA) 06/14/86.

76 R. Ronnie, "Tuxedomoon, l'ultima voce del rock", *Il Resto Del Carlino (Bologna)*, 12/09/80.

77 L. Giuliani, "Taxedomoon [sic], rock di alta tecnologia", *Il Resto Del Carlino (Bologna)*,12/11/80.

78 F. Guglielmi, "Foreword" to James Nice, *Tuxedomoon*, Materiali Sonori, 1988, p. 4.

79 James Nice, *Tuxedomoon*, unpublished manuscript, 03/21/92, p. 15.

80 P. Zanger, "The Neo-Dada performers", *The Bulletin*, 03/12/82.

81 PV, "Tuxedomoon", *Vu*, 05-06/86 (translated from French).

82 Bruce Geduldig interviewed by C. Evers ("Tuxedomoon in: Rambo III", *Oor*, 09/21/85, translated from Dutch).

83 P. Zanger, *op. cit.*; C. Evers, *op. cit.*

84 J. Landuydt, "Tuxedo Moon", *trespassers w*, nrs. 3/4, 85/86.

85 J. Landuydt, *op. cit.*

86 James Nice, *Tuxedomoon*, unpublished manuscript, 03/21/92, p. 16.

87 Blaine and JJ had returned to America to deliver the master of *Desire*: 'As it went', writes Blaine, '[JJ] went on ahead to San Francisco from New York and delivered the master herself'.

88 Saskia Lupini: "Backstreet was a record shop and Backlash was the record company".

89 Peter Principle interviewed by James Nice, July 3rd, 1987 (unpublished).

90 Radio interview Steven Brown WREK Georgia Tech (USA) 06/14/86.

91 See the movie's website : http://www.downtown81.com/

92 This was Glenn O'Brien's punk rock New York City cable TV show (broadcast between 1978 and 1982).

93 See http://www.indiewire.com/people/int_OBrien_Bertog_010713.html (interview of Glenn O'Brien, Edo Bertoglio and Maripol) and http://www.chronicart.com/downtown81/ev1.htm (interview with Maripol, in French).

94 I. Shirley, *Meet With The Residents,* Wembley, SAF, 1993, p. 91.

95 James Nice, *Tuxedomoon*, Materiali Sonori, 1988, p. 14; also conversations of Roberto Nanni and Peter Principle with author.

96 Radio interview Steven Brown WREK Georgia Tech (USA) 06/14/86.

97 P. Petroskey, 'Tuxedomoon – Jinx", *H&N Music News:* accessible online at http://www.angelfire.com/wv/musiceyeball/videos/tuxedomoon.html. Other reviews available on www.canyoncinema.com/ (enter "tuxedomoon" as search term) and www.cinedoc.org/htm/collection/fiche_oeuvre.asp?id=326# (in French).

98 *i.e.* on You Tube, for instance

99 M. Goldberg, "The terror of Tuxedomoon", *SF Chronicle,* 01/14/79.

100 R. Kozak, "French Celluloid has 'exciting' N.Y. debut", *Billboard,* 04/04/81.

101 James Nice, *Tuxedomoon,* Materiali Sonori, 1988, p. 14.

Chapter V
From the Ghosts of Nancy to The Ghost Sonata

1 Peter Principle in correspondence with James Nice, 03/92.

2 See the anecdote told by Peter Principle in Chapter III dealing with Tuxedomoon's drug use.

3 FW, "Indoor Life/Tuxedomoon/Snakefinger. Rock in Loft (27/3)", *Rock & Folk,* 05/81 (translated from French).

4 A. Gill & B. Jones, "Gimme the moonlight", *N.M.E.,* 09/19/81.

5 Peter Principle interviewed by James Nice, July 3rd, 1987 (unpublished).

6 Tuxedomoon's 30th Anniversary box set entitled 77o7 released by Crammed Discs in 09/07 features (on the *Lost Cords* CD that forms a part of the *Unearthed double* CD/DVD) a version of "Cell Life" recorded some time in 1980 at the Eureka Theater, San Francisco.

7 Peter Principle in an email conversation with author.

8 James Nice, *Tuxedomoon,* Materiali Sonori, 1988, p. 14.

9 Peter Principle interviewed by James Nice, July 3rd, 1987 (unpublished) and in an email conversation with author.

10 Additionally Celluloid's manoeuvres starved the band out of the royalties on thousands of copies of *Half-Mute* and *Desire* sold by Celluloid: A. Prosaïc, "Tuxedomoon", *Gloria magazine,* 03/83 (interview with Blaine Reininger); Steven Brown interviewed on France Culture (French radio show) in 12/83.

11 James Nice, *Tuxedomoon,* Materiali Sonori, 1988, p. 14.

12 James Nice, *Tuxedomoon,* unpublished manuscript, 03/21/92, p. 18.

13 Peter Principle interviewed by James Nice, July 3rd, 1987 (unpublished).

14 James Nice, *Tuxedomoon,* unpublished manuscript, 03/21/92, p. 18.

15 James Nice, *Tuxedomoon,* unpublished manuscript, 03/21/92, p. 19.

16 An impressive view of Blaine's hand is documented in Steven Brown's film *The Super-Eight Years With Tuxedomoon.*

17 Blaine Reininger interviewed by Michael Snyder ("The brighter side of Tuxedomoon", *San Francisco Sunday Examiner & Chronicle,* 12/81).

18 James Nice, *Tuxedomoon,* unpublished manuscript, 03/21/92, p. 19.

19 F. Heirman, "Misverstanden Tuxedomoon opgehelderd", *Gazet van Antwerpen,* 02/21/88.

20 See Pam Tent, *Midnight at the Palace : My Life As a Fabulous Cockette,* Los Angeles, Alyson Books, 2004, p. 242: 'At the Theatre for the New City on Manhattan's West Side in 1973, Hibiscus performed for Belgian ballet choreographer Maurice Béjart in his production of *Gossamer Wings.* Maurice was captivated by the performance and flew the East Coast Angels to Europe along with John Rothermel. They performed in Paris and at the Mickery Theatre in Amsterdam.' See also Bambi Lake & Alvin Orloff, *The Unsinkable Bambi Lake – A Fairy Tale Containing The Dish on Cockettes, Punks and Angels,* San Francisco, Manic D Press, 1996, p. 61.

21 see http://www.bejart.ch/fr/argus/light.htm

22 Maurice Béjart interviewed by author in Lausanne, March 15th, 2002 (translated from French).

23 Steven Brown interviewed by James Nice, July 5th, 1987 (unpublished).

24 Béjart's website (http://www.bejart.ch/fr/bejart/oeuvres_ballets2.htm#1970) indicates that it was *premiered* in December 1981. However it is certain that TM attended one of the 1983 performances indicated above as referenced on a flyer that was issued for the occasion.

25 Radio interview Steven Brown WREK Georgia Tech (USA) 06/14/86.

26 Peter Principle interviewed by James Nice, July 3rd, 1987 (unpublished).

27 Maurice Béjart interviewed by author in Lausanne, *op. cit.*

28 James Nice, *Tuxedomoon,* unpublished manuscript, 03/21/92, p. 20.

29 For Gilles Martin's CV, see : http://www.flammusic.com/pages/profil_fr.php?pro_id=14&find_type=0#cv and his MySpace page: http://www.myspace.com/gillesmartin

30 As by then Gerald Hesse had ceased to be part of the band's entourage.

31 Still active today: see http://perso.wanadoo.fr/sordide.sentimental/

32 James Nice, *Tuxedomoon*, unpublished manuscript, 03/21/92, p. 22.

33 Blaine Reininger interviewed by Michael Snyder, *op. cit.*

34 A. Gill, "American Tux exiles", *The Independent*, 07/28/04.

35 James Nice, *Tuxedomoon*, unpublished manuscript, 03/21/92, p. 21.

36 James Nice, *Tuxedomoon*, unpublished manuscript, 03/21/92, p. 22.

37 James Nice, *op. cit.*

38 Peter Principle interviewed by James Nice, July 3rd, 1987 (unpublished).

39 Entretien avec Martine Jawerbaum, Spring '82, unpublished (translated from French).

40 L. Barber, "Blaine L. Reininger. Broken Fingers", *Sounds*, 06/82.

41 A. Prosaïc, "Blaine Reininger : Broken fingers", *Rock & Folk*, 11/82 (translated from French).

42 H. Schellinckx, "Blaine Reininger : Broken fingers", *Vinyl*, nr 17, 1982 (translated from Dutch).

43 MaG, "Blaine Reininger : Broken fingers", *het laatste nieuws*, 10/82.

44 James Nice, *Tuxedomoon*, unpublished manuscript, 03/21/92, p. 23.

45 R. Denselow, "Venue. Tuxedo Moon", *The Guardian,* 03/82.

46 A. Prosaïc, "Time to lose", *Rock and Folk*, 11/82.

47 R. Ronnie, "Rock dei Tuxedomoon in versione italiana", *Il Resto Del Carlino (Bologna)*, 03/24/82.

48 M. Ebertowski, "Suite En Sous-Sol", *Vinyl*, 11/82.

49 L. G. Campling, "Tuxedomoon : the brighter side", Interview Peter Principle in San Francisco, 01/01/82 (unpublished).

50 R Cook, "A Greta love…", *NME*, 03/82.

51 http://www.inteatro.it

52 More precisely : "Music # 2" (already recorded in March for Les Disques Du Crépuscule), "The Cascade" (*aka* "The Fall"), "Basso Pomade" and "Licorice Stick Ostinato" arose during the *Divine* rehearsals. The title track, "Ghost Sonata," originates as far back as the *Desire* recording sessions. Only the three electronic pieces, namely "An Affair At The Soirée," "Les Odalisques" and "Unsigned Postcard" were especially composed, as were the sound effects and *musique concrète* collated by Peter Principle (James Nice, *Tuxedomoon*, unpublished manuscript, 03/21/92, p. 26).

53 James Nice, *Tuxedomoon*, unpublished manuscript, 03/21/92, p. 26.

54 See her website: http://www.vortexlighting.com

55 In fact Blaine Reininger had made the mistake of telling Inteatro that his orchestration was "easy," with the result that his first orchestra consisted of schoolchildren aged between 8 and 12. Replacements had to be found quickly to form his *Polverigi Strings* (James Nice, *Tuxedomoon*, unpublished manuscript, 03/21/92, p. 26).

56 G. Martin, *Ghost Sonata* sleeve notes.

57 *The Ghost Sonata* was properly released only in 2007, as part of the *Found Films* DVD forming part of the band's *7707* 30th Anniversary box set released by Crammed Discs. However the credits stated are practically the same as on the until 2007 circulating bootleg.

58 Peter Principle interviewed by James Nice, July 3rd, 1987 (unpublished).

59 F. Gorin, "Tuxedomoon : art-rock en smok", *Le matin*, 11/30/83.

60 According to *Sounds*, 09/85.

61 *Rock Yearbook*, Vol. VII from Virgin Books edited by Tom Hibbert (1986).

62 This review was originally available at http://media-arts.rmit.edu.au/Phil_Brophy/InternationalVideos.html but the link does not work anymore. More details about Brophy on http://www.philipbrophy.com/

63 Late in 1982, Brown recorded "The Cascade" (as "The Fall") for *Music For Solo Piano*, his first solo album, with Blaine Reininger guesting. Then, in January 1983, recordings of "Music # 2 (Reprise)," "Licorice stick ostinato," "Basso pomade (Dogs licking my heart)" were commissioned by the BRT [*Belgian Flemish radio station*], performed by the Flemish Chamber Orchestra and produced by Wim Mertens. Theses pieces appear on Blaine Reininger's solo album entitled *Instrumentals*, released in 1987 and re-released (with bonus tracks) by LTM records in 2002. Then in late 1986, Reininger re-worked "Les Odalisques" into a track named "Japanese Dream" that will appear on his *Byzantium* solo album released in April 1987 and re-released (with bonus tracks) by LTM records in 2004.

64 http://www.ltmpub.freeserve.co.uk/ltmhome.html

65 In the eighties Nice's name was sometimes spelled "Neiss" as, dixit James Nice himself, the name "Nice" (his real name) did not sound so right in the (post)punk world.

66 D. Hoffmann, "Tuxedomoon", *Zillo*, 05/91 (translated from German).

67 *Gonzo Circus*, 11-12/97.

68 F. Sanchez, *Collector*, 05/91 (translated from French).

69 About this group see G. Basile & M. Nitti, *Vestivamo "New Wave" – Vita, Musica ed Eventi Nella Taranto Degli Anni '80*, S.I.A.E., 2005, pp. 153-155. See also this band's website: http://www.centralunit.com/

70 *Central Unit*, published in 1983 by CGD.

Chapter VI
From "This Beast" to THE Beast in Dreux - Blaine Reininger leaves Tuxedomoon

[1] JAMES NICE, *Tuxedomoon*, unpublished manuscript, 03/21/92, p. 27.
[2] Roques himself has no recollection at all of that episode.
[3] Little Big One was a recording studio located in Brussels where the band often used to work at that time.
[4] Namely the *Night Air* album, released in 04/84.
[5] JAMES NICE, *op. cit.*
[6] JAMES NICE, *ibid*. See *infra* what is said about Brown's take on Blaine Reininger's departure from Tuxedomoon.
[7] Oscar COSULICH, reviewing Steven Brown's *Music For Solo Piano Music* in Italy, saw an analogy between this LP cover and the legendary "falsi del male," the latter being the diversion of pictures of well-known Italian figures to make them illustrate obviously fake/impossible/hilarious news, an approach endorsed by a contemporaneous sub-branch of Italian situationism named Luther Blissett (that in 2004 will become the title of a Tuxedomoon track featured on the *Cabin In The Sy* album).
[8] Contrary to what most people seem to think, "Lew" isn't a name of Anglo-American origin as Lew is Belgian but of Polish ascent, "Lew" furthermore meaning "heart" in Yiddish according to Lew.
[9] JAMES NICE, *Tuxedomoon*, unpublished manuscript, 03/21/92, p. 29.
[10] Winston Tong interviewed by A. PROSAIC ("Tuxedomoon", *Gloria Magazine*, 03/83, translated from French).
[11] JAMES NICE, *Tuxedomoon*, unpublished manuscript, 03/21/92, p. 29.
[12] JAMES NICE, *ibid*.
[13] Steven Brown interviewed by James Nice, July 5th, 1987 (unpublished).
[14] Steven Brown interviewed by James Nice, *op. cit*. See also JAMES NICE (*Tuxedomoon*, unpublished manuscript, 03/21/92, pp. 30-31) discussing Brown's opinion about Duval's role in having Reininger leaving Tuxedomoon: 'Brown's interpretation of the ensuing Cold War was that, spurned, Duval had deliberately sought to destroy Tuxedomoon by encouraging Reininger – and later Tong – to leave the group in exchange for apparently lucrative solo contracts. It's an overtly paranoid reaction, but circumstantial evidence supports it to a degree. Both *Night Air* and later *Theoretically Chinese* were expensive albums for an independent label to produce, and Tong's disasterously so. After Reininger's departure, Tuxedomoon were swiftly ejected from their rehearsal space in the Himalaya building at 4 rue de la Fourche – offices also occupied by Crépuscule. Kataline Kolosy's resignation from Crépuscule *and* Tuxedomoon coincided, as did the protracted delay in releasing *Music For Solo Piano*. Indeed there would be no serious dialogue between Brown and Duval again until 1987 when negotiations were opened on *Composé et Dirigé Pour Le Cinéma Et Le Théâtre*.'
[15] Tuxedomoon's articles of incorporation were published in January '84 in the Belgian Official Journal.
[16] JAMES NICE, *Tuxedomoon*, unpublished manuscript, 03/21/92, p. 32.
[17] Email sent by Michael Belfer to James Nice, April 24th, 2002
[18] JAMES NICE, *Tuxedomoon*, unpublished manuscript, 03/21/92, p. 31.
[19] JAMES NICE, *ibid*.

Chapter VII
Tuxedomoon's Holy Wars - Winstong Tong leaves Tuxedomoon

[1] JAMES NICE, *Tuxedomoon*, unpublished manuscript, 03/21/92, p. 32.
[2] G. KEUNEN, "Tuxedomoon revisited", *Gonzo Circus*, 06/05/94 (translated from Dutch).
[3] J.-L. RENARD, "Open system project. Entretien avec Steven Brown", *Musiques diverses*, 03/85 (translated from French).
[4] J. LANDUYDT, "Tuxedo Moon", *trespassers w*, nrs. 3/4, 85/86 (translated from Dutch).
[5] J.-L. RENARD, *op. cit.*
[6] P. CORNET & PRALINE, "Tuxedomoon" (Interview), *Oxygène*, 06/84 (translated from French).
[7] "Tuxedo Moon, l'après Reininger", *Liberation*, 10/83 (translated from French).
[8] See our preceding Chapter, sub-title *Tuxedomoon turns down an offer made by Les Disques Du Crépuscule to record an album with them.*
[9] Alan Rankine will become house producer for Crépuscule between 1984 and 1987 (JAMES NICE, *Tuxedomoon*, unpublished manuscript, 03/21/92, p. 33).
[10] JAMES NICE, *Tuxedomoon*, unpublished manuscript, 03/21/92, p. 33.
[11] JAMES NICE, *op. cit.*, p. 35.
[12] This is James Nice's opinion (*ibid.*) that furthermore corresponds to Alain Lefebvre's memories of

recording the *Theoretically Chinese* album.

[13] James Nice, *Tuxedomoon*, unpublished manuscript, 03/21/92, p. 36.

[14] On *Contradictions Are A Luxury*, an album, released by Antler Records in 1989 and on which guest both Blaine Reininger and Peter Principle.

[15] James Nice, *Tuxedomoon*, unpublished manuscript, 03/21/92, p. 36.

[16] James Nice, *ibid*.

[17] James Nice, *Tuxedomoon*, unpublished manuscript, 03/21/92, p. 32.

[18] M. Palazzi, "Tuxedomoon", *Dry*, 07 & 11/83 (in two parts) (translated from Italian).

[19] P. Grosclaude, "Tuxedomoon : l'angoisse californienne", *La Voix du Nord*, 12/03/83 (translated from French).

[20] P. Cornet, "Des américains à Bruxelles", *Le vif*, 06/21/84 (translated from French).

[21] This sentence is taken from the lyrics of the track "Lawnmoaner" that appears on Steven Brown's Mexican band Nine Rain's 2nd album entitled *Rain Of Fire*, released by Opcion Sonica in 2001.

[22] James Nice, *Tuxedomoon*, unpublished manuscript, 03/21/92, p. 32.

[23] which appeared uncertain to many, even way into1984. See for instance A. Balthazart, "Tuxedomoon : chacun pour soi?", *La nouvelle gazette*, 07/27/84 (translated from French) : 'Does Tuxedomoon still exist or did they split up? This is a mystery as the opinions of the band's members diverge…'.

[24] James Nice, *Tuxedomoon*, unpublished manuscript, 03/21/92, p. 33.

[25] James Nice, *ibid*.

[26] Steven Brown interviewed by Gust De Coster for BRT2 (Belgian Dutch speaking radio), May 8th, 1985.

[27] The recording of *Holy Wars* will cost about 23,000 €

[28] James Nice, *ibid*.: 'Can engineer Renee Tanner would also later work on "Bonjour Tristesse," though the pair didn't pan out.'

[29] J. Landuydt, "Tuxedo Moon", *trespassers w*, nrs. 3/4, 85/86.

[30] James Nice, *ibid*.

[31] A. Sommer, "I left my heart in San Francisco – a collision with Tuxedomoon", *MM*, 01/85 (translated from Danish by Eiliv Konglevoll).

[32] Steven Brown interviewed by A. Sommer, *op. cit*.

[33] In fact the lyric, excerpted from Steven Brown's track entitled "Decade," goes: "Has the destination disappeared or is it the will to travel?"

[34] Steven Brown interviewed by K. Muylaert & C. Windels ("Brussels – California", 12/84).

[35] Lolita Danse's agent was then Maria Rankov.

[36] Peter Principle interviewed by James Nice, July 3rd, 1987 (unpublished).

[37] James Nice, *Tuxedomoon*, unpublished manuscript, 03/21/92, p. 34.

[38] Peter Principle interviewed by A. Prosaïc (""Tuxedomoon", *Gloria magazine*, 03/83, translated from French).

[39] J. Landuydt, "Tuxedo Moon", *trespassers w*, nrs. 3/4, 85/86.

[40] P. Claesz, "Peter Principle/Sedimental journey", *Vinyl*, 06/85 (translated from Dutch).

[41] Both still live and work together nowadays, directing their own dance company named *Système Castafiore* based in Grasse, France. See their website: http://castafiore-systems.com/

[42] Ms. Barcellos is of Brazilian origin but she lives and works in France since age 18.

[43] *i.e.* for the piece "Regrets Eternels" (1983).

[44] J. Barron, "Men in the moon", *Sounds*, 03/23/85.

[45] J. Barron, "Bad moon rising", *Sounds*, 05/04/1985. This article has also been published in Greece under the name of N. Kontogouris ("Tuxedomoon", *Pop & Rock*, 01/86).

[46] Th. Coljon, "Minimal Moon et Tuxedo Compact : le retour des exilés", *Le Soir*, 04/05/85 (translated from French).

[47] Ch. Perrot, "Tuxedo Mou", *Libération*, 05/21/85 (translated from French).

[48] G.J. Walhof, "De heilige paradox", *Vinyl*, 05/85; C. Evers, "Tuxedomoon in : Rambo III", *Oor*, 09/21/1985 (translated from Dutch). See also U. Blermans, "Tuxedomoon", *Musik Szene*, 06/85 (translated from German): [*Luc van Lieshout*:] "The recording is a collection of songs, each bearing the individual imprint of one of the musicians, each having led one's own private holy war."

[49] P. Stevens & E. Tordoir, *Télémoustique*, 1985 (translated from French).

[50] H. Inhülsen, *Musikexpress*, 05/85 (translated from German).

[51] tb, *Nebelhorn*, 06/85 (translated from German).

[52] J. Romney, "Noir fun", *NME*, 07/06/85.

[53] D. Watson, "Travels with my tux", *N.M.E.*, 07/06/85.

[54] M. Aston, *Melody Maker*, 07/13/85.

[55] D. Maryon, *Sound Choice*, Fall 85 (USA).

[56] J. Landuydt, "Tuxedo Moon", *trespassers w*, #. 3/4, 85/86 (translated from Dutch).

[57] W. Bauduin, *Audio*, 12/86 (translated from French).

[58] Steven Brown interviewed circa 06-07/87.

[59] Their first show being on 05/24/83 (see above in this Chapter)

60 TH. VAMVAKARIS, "Just a boy from Colorado – Blaine Reininger", *Cine7*, 05/22/88 (translated from Greek by George Loukakis).

61 See their website at http://www.theweathermen.net/

62 JAMES NICE, *Tuxedomoon*, unpublished manuscript, 03/21/92, p. 35.

63 And now (2007) the director of La Bellone (maison de la danse) in Brussels.

64 This was James Nices opinion: *op. cit.*, p. 36.

65 P. MATHUR , "Winston Tong. ICA, London", *Melody maker*, 08/10/85.

66 With Minimal Compact for the by Peter Principle produced soundtrack for *Pieces For Nothing* in 1982 (as referred to in our preceding Chapter).

CHAPTER *VIII*
The end of Tuxedomoon's second era

1 D. MCRAE, *NME*, 06/14/86.

2 G. DAUBLON, *Best*, 10/86 (translated from French).

3 P. REMY, *Rock FM*, 06/86 (translated from French).

4 P.C., *Rock This Town*, 06/06/86 (translated from French).

5 According to A. VIKOER, "Concert – The Norwegian Opera – Tuxedomoon", *Klassekampen*, 12/06/85; Y. EKERN, "Rock in the Opera", VG, 12/02/85 (translated from Norwegian by Eiliv Konglevoll).

6 Casper Evensen interviewed by A. W. CAPPELEN ("Tuxedomoon draws many to the Opera", *Aftenposten*, 11/30/85, translated from Norwegian by Eiliv Konglevoll).

7 T. EGGEN, "From basement to Opera", *Dagbladet*, 11/27/85 (translated from Norwegian by Eiliv Konglevoll).

8 J. RUSTAD, "From San Francisco to the Opera", *Nye Takter*, # 144 (translated from Norwegian by Eiliv Konglevoll).

9 *op. cit.*

10 T. NESET, "Shadow pictures in the opera", *Dagbladet*, 12/02/85 (translated from Norwegian by Eiliv Konglevoll).

11 See, for instance, PH. FRANCK, "Steven Brown ou le malaise urbain", *Le Drapeau Rouge*, 04/08/87 (in French); GROSSEY, "Steven Brown (Tuxedomoon): de luisteraar is nooit verkeerd", *Kuifje*, 01/28/86 (in Dutch).

12 E. J. HARMENS & W. DE BRUIJN, "A poet stuck in Brussels", *Poezie nieuws*, 03/92 (translated from Dutch).

13 Blaine Reininger interviewed by N. TRIANDAFYLLIDIS & A. PAPADOPOULOS, "Wanted : the muses", *Sound & HiFi*, 02/88 (translated from Greek by George Loukakis).

14 TH. COLJON, "Tuxedomoon: vogue le navire!", *Le Soir*, 04/07/86 (translated from French).

15 O. STOCKMAN, "Tuxedomoon' en concert: un bateau de fous", *Le Drapeau Rouge*, 04/10/86 (translated from French).

16 K. VAN BOCKSTAEL, "Koncert Tuxedomoon: de geveinsde waanzin", *De Morgen*, 04/05/86 (translated from Dutch).

17 WS, "Tuxedo Moon: totaalspektakel loopt voortijdig uit de hand", *Nieuwsblad*, 04/05/86 (translated from Dutch).

18 J. LANDUYDT, "Tuxedo Moon", *trespassers w*, # 3/4, 85/86 (translated from Dutch).

19 JAMES NICE, *Tuxedomoon*, unpublished manuscript, 03/21/92, pp. 37-38.

20 See I. ZARATA, "La inquietante Belleza de Tuxedomoon", *Diario Vasco*, 09/05/86.

21 OL for *Télémoustique* (translated from French).

22 *Le Drapeau Rouge*, 04/27/87 (translated from French).

23 J.-M. MOSTAERT, *Le Soir*, 05/14/87 (translated from French).

24 *Normal*, 04/87 (translated from German).

25 *Stern*, 05/87 (translated from German).

26 It can be seen in the video clip that Bruce Geduldig shot for the song "The Waltz" in the eighties. This clip can be viewed on the *Found Films* DVD (*1000 Lives By Picture* clips) that forms part of the *Unearthed* double CD/DVD included in Tuxedomoon's *77o7* 30th Anniversary box set released by Crammed Discs in 2007.

27 G. ZUILHOF, "Grabbelen in de trukendos van de clip", *De Groene Amsterdammer*, 09/24/86 (translated from Dutch).

28 T. VAN DER LEE, "De Tijdbom van Bob Tuxedo", *Oor*, 11/15/86 (in Dutch).

29 P. SLAVENBURG, "Plan Delta van Bob Visser: Uniek in alle opzichten", *Het Vrije Volk*, 11/24/86 (in Dutch).

30 JAMES NICE, *Tuxedomoon*, unpublished manuscript, 03/21/92, pp. 38-39.

31 *Melody Maker*, 08/22/87.

32 T. C., *Rock & Folk*, 1987 (translated from French).

33 *Les Inrockuptibles*, 05/87 (translated from French).

34 M. ASTON, *Underground*, 07/87.

35 CH. MELLOR, *The Catalogue*, 07/87.

36 James Nice, *op. cit.*
37 James Nice, *Tuxedomoon*, unpublished manuscript, 03/21/92, p. 39.
38 Interview with Steven Brown and Blaine Reininger, Brussels, Radio 21, 04/87 (translated from French).
39 See James Nice, *Tuxedomoon*, unpublished manuscript, 03/21/92, p. 40.
40 *Radio 21* interview, *op. cit.*
41 Miller had relocated to Brussels from Berlin in 1986 after signing with based in Brussels label Play It Again Sam. James Nice : '(…) all five remaining members of Tuxedomoon would contribute heavily to his albums *Slave Lullabyes* and *Hunger Is All She Has Ever Known*. Indeed the mad, bad and dangerous to know Miller even hijacked several San Francisco vintage Tuxedomoon tapes as backing tracks on his swansong instrumental set, *Pure*' (James Nice, *Tuxedomoon*, unpublished manuscript, 03/21/92, p. 39).
42 Steven Brown interviewed by G. Zota ("The loneliness of activism", *Pop Rock*, 1992, translated from Greek by George Loukakis).
43 See http://www.suiteinc.com/pages/about.html
44 Facts confirmed by film-maker Roberto Nanni.
45 Based on Jean Genet's novel (already mentioned). The film was actually entitled *Querelle*.
46 James Nice, *Tuxedomoon*, unpublished manuscript, 03/21/92, p. 39.
47 according to James Nice, *ibid.*
48 See his MySpace page: http://www.myspace.com/PaulZahl
49 James Nice, *Tuxedomoon*, unpublished manuscript, 03/21/92, p. 40.
50 See T. Sakas, N. Triandafyllidis & G. Mouchtaridis, "Memories from the moonlight zone. Small, nostalgic confidences from Peter Principle, Blaine Reininger, Steven Brown", *Sound & Hi-Fi*, 01/88; N. Triandafyllidis & A. Papadopoulos, "Wanted : the muses", *Sound & HiFi*, 02/88.
51 J.-J. Annaud, *L'Amant*, 1992, with original music by Gabriel Yared.
52 It would seem however that the film was eventually projected a few times including the closing Party of *Festival De Vidéo* held in 03/92 at Centre Culturel Le Triangle in Rennes.
53 J.-M. Mostaert, "*Une victoire au goût amer*", Le Soir, 02/18/1988.
54 A French singer/songwriter and electric violin player.
55 Viseux, "Tuxedomoon, la nouvelle lune", *Libération*, 03/08/88.
56 Lefebvre is the Belgian musician previously mentioned for his collaborations with Tuxedomoon, solo members as well as with other bands.
57 This documentary is included on the *Found Films* DVD that forms part of Tuxedomoon's *77o7* 30th Anniversary box set released by Crammed Discs in 2007.

Chapter IX
From the eighties into the nineties (1988-1997) or Tuxedomoon's Dark Age

1 Peter Principle interviewed by A. Azzouz, *Spirit Of*, 06/89 (translated from French).
2 Peter Principle interviewed by A. Azzouz, *op. cit.*
3 D. H., "Getting the measure", *Which Compact Disk*, 10/89.
4 B.D., "PETER PRINCIPLE : Tone Poems", *Télémoustique* (translated from French).
5 A. Azzouz, "PETER PRINCIPLE *Tone Poems*", *Spirit of*, 06/89 (translated from French).
6 N. Raggett for AMG All Music Guide (http://www.allmusic.com/cg/amg.dll?p=amg&sql=10: ubduak5khm3l).
7 J. Gill, "Steven Brown Half Out – Blaine Reininger Book Of Hours LTM CDs", *The Wire*, 08/05.
8 J.-F. Ducrocq, *Les Inrockuptibles*, 06/06/89 (translated from French).
9 Galateia Zota, "The loneliness of activism", *Pop Rock*, 1992 (translated from Greek by George Loukakis).
10 E. J. Harmens & W. De Bruijn, "A poet stuck in Brussels", *Poezie Nieuws*, 03/92 (translated from Dutch).
11 Galateia Zota, *op. cit.*
12 M.M., "La musica del Duemila sarà fatto di silenzio", *La Gazzetta*, 07/10/89 (translated from Italian).
13 E. J. Harmens & W. De Bruijn, *op. cit.*
14 James Nice, *Tuxedomoon*, unpublished manuscript, 03/21/92, p. 41.
15 James Nice, *Tuxedomoon*, unpublished manuscript, *op. cit.*, p. 41.
16 See the presentation of Sam Shephard's play on http://www.bookrags.com/studyguide-buriedchild/ : '(…) The play is a macabre look at an American Midwestern family with a dark, terrible secret. Years ago, Tilden, the eldest of three sons belonging to Dodge and Halie, committed an act of incest with his mother. She bore his child, a baby boy, which Dodge drowned and buried in the field behind their farmhouse.

Page 437

The act destroyed the family (…) there is a swing to it all, a vagrant freedom, a tattered song. Something is coming to an end, yet on the other side of disaster there is hope. From the bottom there is nowhere to go but up (…) the play was hailed as a comical and insightful presentation of the disintegrating American dream.'

[17] To be found on his *Composés Pour Le Théâtre Et Le Cinéma* LP/CD released in 1989 by Les Disques Du Crépuscule.

[18] Also to be noticed in the cast was Catherine Jauniaux, an artist then recording with Crammed Discs.

[19] See G. Marcus (*Lipstick traces. Une histoire secrète du vingtième siècle*, 1989, Allia 1998 for French ed., Folio Actuel, p. 253) who reminds us of Janco's 1953 aborted attempt to recreate the Cabaret Voltaire in Israel: "'Poems were read simultaneously in different languages," announced the *Jerusalem Post*; it was of course pathetic.'

[20] Th. Coljon, "De doute et de grâce dans le silence de la nuit", *Le Soir*, 10/09/91 (translated from French).

[21] Ph. Franck, "Steven Brown: l'élégance nonchalante", *D'entre les pavés*, 1991 (translated from French).

[22] It was in April 1985, during the Les Disques Du Crépuscule showcases in Japan (see Chapter VIII).

[23] M. Zumkir, "Steven Brown – Une décade de musique", *Jazz in time*, 09/91 (translated from French).

[24] P. Espinosa, "No queremos identificaciones ni etiquetas; tan sólo música: Brown y Reininger", *LaJornada*, 10/10/93 (translated from Spanish).

[25] D. Simonet, "L'ombre lumière de Blaine L. Reininger", *La Libre Belgique*, 11/25/90 (translated from French).

[26] C. Evers, "Steven Brown & Delphine Seyrig – De doute et de grâce", *Oor*, 06/30/90 (translated from Dutch).

[27] J.-L. Cambier, "Blaine Reininger and Steven Brown : One hundred years of music", *Télémoustique*, 04/30/90 (translated from French).

[28] (Anonymous), "Blaine Reininger and Steven Brown - One hundred Years of Music (Les disques du Crépuscule)", *Le Peuple*, 05/02/90 (translated from French).

[29] (Anonymous), "These boots were made for dancin", *The Sunday Times*, 11/04/90.

[30] K. Watson, "The rock of Agis", *Hapstead & Highgate*, 11/02/90.

[31] K. Watson, "The rock of Agis", *op. cit.*

[32] K. Watson, *ibid.*

[33] (Anonymous), "These boots were made for dancin'", *op. cit.*

[34] See http://www.compagniaxe.it/stranafesta_it.htm

[35] See http://www.compagniaxe.it/appufuri.htm

[36] See http://www.compagniaxe.it/wgepeto_it.htm

[37] D. Simonet, "L'ombre lumière de Blaine L. Reininger", *La Libre Belgique*, 25/11/90 (in French).

[38] (Anonymous), "Blaine L. Reininger: "Als balling heb ik wellicht betere kijk op mijn land"", *Het Nieuwsblad*, 11/20/90 (translated from Dutch).

[39] C. Evers, *Oor*, 06/30/90.

[40] J.-L. C., *Télémoustique*, 10/07/90 (translated from French).

[41] J.M.M., *Belgique n° 1*, 11/22/90 (translated from French).

[42] (Anonymous), *Le courrier de l'Escaut*, 10/26/90 (translated from French).

[43] D. Steenhaut, "Paganini speelt rock 'n roll", *De Morgen*, 11/24/90 (in Dutch). See also VFG ("Blaine L. Reininger wint zijn thuismatch", *Het Nieuwsblad*, 11/24/90, in Dutch) who deplores the fact that too many old pieces were played on that night.

[44] Th. C., *Le Soir*, 09/26/90 (review for *Songs From The Rain Palace*, in French).

[45] Th. Coljon, "Peine de Blaine", *Le Soir*, 11/21/90 (translated from French).

[46] J. Gill, *The Wire*, 07/05.

[47] See Chapter IV.

[48] L. Gulinck, "De melancholie van het dagelijkse leven", *De Morgen*, 08/14/91 (translated from Dutch).

[49] Ph. Jugé, "La quatrième dimension", *Magic Mushroom*, Spring 1991 (translated from French).

[50] J.H.M., "Steven Brown", *Keep on fighting*, 11/91 (translated from French).

[51] This line refers to the argument of the play by Aleksandra Turya (known as Sasha) for which Steven Brown and Blaine Reininger produced the soundtrack music, which was released in 1992 as their *Croatian Variations* (later dealt with in this Chapter).

[52] Galateia Zota, "The loneliness of activism", *Pop Rock*, 1992 (translated from Greek by George Loukakis).

[53] L. Gulinck, "De melancholie van het dagelijkse leven", *op. cit.*

[54] Galateia Zota, "The loneliness of activism", *op. cit.*

[55] Ph. Franck, "Steven Brown: l'élégance nonchalante", *D'entre les pavés*, 1991 (translated from French).

[56] Steven Brown interviewed by Ph. Jugé, "La quatrième dimension", *op. cit.* (translated from French).

[57] H. H. Henry, "Les humeurs de Steven Brown", *Rock this town*, 11/91 (translated from French).

[58] Steven Brown interviewed by J.H.M., "Steven Brown", *op. cit.*

[59] S. Degenne, "Steven Brown – Half Out", *Another view*, Summer 1991 (translated from French).

[60] Th. Heck, "Steven Brown – Half Out", *Vox*, 09/91.

[61] J. Gill, "Steven Brown Half Out – Blaine Reininger Book Of Hours LTM CDs", *The Wire*, 08/05.

[62] (Anonymous), "Half Out", *Libération*, 04/23/91 (translated from French).

63	H. H. Henry, "Les humeurs de Steven Brown", *Rock this town*, 11/91.
64	E. Therer, "Steven Brown – Une décennie en exil", *Ritual*, 03-04/92.
65	Although Anouk Adrien & Bob Eisenstein actually did shoot a video clip for the song "A Quoi Ca Sert L'Amour."
66	M. Draine, "Steven Brown & Blaine Reininger – Croatian Variations", *i/e* Summer 1993.
67	E-mail from Spilios Argyropoulos, June 2005.
68	Th. Coljon, "Steven Brown, du Crépuscule à l'aube", *Le Soir*, 04/93 (translated from French).
69	According to Blaine Reininger's 03/13/94 letter to James Nice.
70	Blaine Reininger's 03/13/94 letter to James Nice.
71	G. Keunen, "Tuxedomoon revisited", *Gonzo Circus*, 06/05/94.
72	D. Rigopoulos, "Blaine Reininger in Greece", *Kathimerini (Daily)*, 03/94.
73	(Anonymous), "Concerts for a... detective Blaine Reininger in Athens", *Ethnos (Nation)*, 03/31/94.
74	More precisely it was in August, 1994, when a National Democratic Convention gathered 20,000 indigenous people in Aguascalientes, Chiapas, a Zapatista controlled territory.
75	This festival actually took place in the valley of Avándaro near the city of Toluca, a town neighboring Mexico City.
76	S. Brown in his Foreword to the *Nine Rain Choice* compilation album released by the Neo Acustica label in 2003.

Chapter X
From the nineties till Tuxedomoon's 30ᵗʰ Anniversary in 2007: the never-ending story continues...

1	See Chapter IV.
2	*i.e.* Tuxedomoon's future recording sound engineer.
3	See Chapter IV for the story.
4	Peter Principle interviewed by J. Haagsma, *Oor*, 05/04 (translated from Dutch).
5	Steven Brown interviewed by Erik Stein, owner of the Tuxedomoon discussion list on Yahoo, 09/26/04, available at: http://launch.groups.yahoo.com/group/tuxedomoon/files/
6	It was the gig that they performed near Dachau – see Chapter VI – when, according to Patrick Roques, the club owners forced them into doing it really "bar bones."
7	As a matter of fact some journalist in Russia did not hesitate to depict them as "has-beens" duping an allegedly more tolerant Russian audience: S. Chernov, "Tuxedomoon: has-beens dupe 'tolerant' Russian audience", *The St Petersburg Times*, 12/01/00.
8	Denis Rommelaere, a friend of Steven from Brussels, had trusted me with a suitcase full of the journals that Brown had written during his years in Brussels. Brown ended up reading me some excerpts of these journals (these are Brown's journal entries that can be found throughout this book) as the interview process with him proved difficult.
9	This would become the violin line on "Baron Brown," featured on the *Cabin In The Sky* album.
10	Brown probably hinted at James Nice's small book about Tuxedomoon, published by Materiali Sonori in 1987. As Nice is a friend of Reininger, the book is sometimes depicted by TM's entourage as "Blaine-biased."
11	Ch. Conte, *Les Inrockuptibles*, 09/11/02 (translated from French).
12	Entitled *Kind Strangers*, viewable online at: http://www.slonfilm.com/TrailersTUXMOONbelissima.html
13	The episode, entitled *Stopover In a Quiet Town* (1964, part of the series's fifth season), features a young couple, Bob & Millie Fraziers, leaving a party after slightly too many drinks. They wake up to find themselves in Centerville, a small town with no one around: the houses are empty, the trees are props, the food is plastic and not even a bird can be heard singing outside. The only way out is a train station. However the train relentlessly brings them back to Centerville, merely accomplishing a loop. They then leave the train station and start walking down the street to get away when suddenly a giant hand picks them up. The hand belongs to a little girl, whose mother can be heard in the distance: "Be careful with your new pets, dear. Your father brought them all the way from Earth." They are put back on the "ground," and run off.
14	Steven Brown interviewed by Greg Bachar for *Jack Mackerel Magazine*, 09/03.
15	Excerpt from Blaine Reininger's 08/16/03 entry to his online journal, available at: www.mundoblaineo.com
16	G. Genicot, "Tuxedomoon – Casiotone for the Painfully Alone – Geographique", concert review available at: http://www.etherreal.com/magazine/concerts/?file=tuxedomoon01 (the author stating that: "the band, dissolved fifteen years earlier (...) does not work on new material anymore").
17	F. Allart ("Tuxedomoon", concert review available at:

Page 439

http://www.etherreal.com/magazine/concerts/?file=tuxedomoon02) emphasized that Geduldig's work impressed the audience probably all the more as the major part of the (younger) audience had never seen such sort of visuals.

[18] Steven Brown interviewed by Greg Bachar for *Jack Mackerel Magazine*, 09/03.

[19] TH. COLJON, "La lune était si belle", *Le Soir*, 09/30/03 (translated from French).

[20] K. DE MEESTER, "Geen nostalgie voor Tuxedomoon", *De Morgen*, 09/30/03 (translated from Dutch).

[21] Steven Brown interviewed by A. D'AGNESE, "Tuxedomoon, folli visioni alternative", Interview KataWeb (translated from Italian) available at: http://www.kwmusica.kataweb.it/kwmusica/pp_scheda.jsp?idContent=120140|idCategory=2028

[22] D. STEENHAUT, "Wij waren op het gevoel", *De Morgen*, 06/12/04 (in Dutch).

[23] Y. BLAY, "Tuxedomoon", *D-Side 22*, 05-06/04 (in French).

[24] Luther Blissett was originally a British soccer player of Afro-Carribean origins who was transferred to the Italian AC Milan team in 1983 where he played just one season with miserable results. His name lived on in Italy as in the nineties it became the name of a group of anarchists that adopted the collective identity of "Luther Blissett." This society waged guerrilla warfare on the cultural industry, ran solidarity campaigns for the victims of censorship and played elaborate media pranks as a form of art. In 1999 the Luther Blisset society committed a ritual suicide but its name kept re-emerging ever since with a constant reference to the situationist heritage.

[25] Steven Brown interviewed by D. STEENHAUT, "Wij waren op het gevoel", *De Morgen*, 06/12/04 (translated from Dutch).

[26] Blaine Reininger interviewed by F. PALOSCIA, "Con i Tuxedomoon ritorno alla new wave", *la Reppublica – Firenze*, 05/12/04 (translated from Italian).

[27] Blaine Reininger interviewed by F. SOLIANI, Interview "Jazzer", 05/13/04 (translated from Italian) available at: http://www.jazzer.it/tuxedomoon/Tux_Intervista.htm

[28] O. DE PLAS, *Trax*, 2004 (translated from French).

[29] B. HEUZÉ, *Keyboards*, 05/04 (translated from French).

[30] J. HAYWARD (*aka* James Nice), *Uncut*, 06/04.

[31] A. GILL, *The Independent*, 06/25/04.

[32] CH. EUDELINE, "Post-punk – Tuxedomoon, le groupe phare de la new wave est plus en forme que jamais", *Nova*, 2004 (translated from French).

[33] http://www.hinoeuma.org/

[34] http://launch.groups.yahoo.com/group/tuxedomoon/

[35] R. RUCHPAUL, "Tuxedomoon/Attrition, London/Electrowerkz", *Terrorizer*, 11/04.

[36] See Chapter VII.

[37] Chancy Gardiner is the name of a character played by Peter Sellers in Hal Ashby's *Being There* feature film (1979): Chance is a simple-minded gardener who has spent all his life in the Washington D.C. house of an eccentric old man. When the man dies, Chance is put out on the street with no knowledge of the world except what he has learned from television. Chance walks out of the house for the first time in his life and encounters a street gang, which he tries to make go away with a remote control TV changer…

[38] J. GILL, "Tuxedomoon – Madrid Colegio Mayor San Juan Evangelista", *The Wire*, 04/05.

[39] New York, Grove Press, 1986.

[40] See Chapter IV.

[41] See their website at: http://www.illuseum.com/

[42] Excerpt from Steven Brown's online blog at: http://stbrown.blogpost.com/2005_08_01_archive.html

[43] Steven Brown also kept a food diary of those days, published in Greg Bachar's *Jack Mackerel Magazine* and available at: http://jackmackerel2005.blogspot.com/

[44] http://www.plastelin.com

[45] Viewable at: http://www.plastelin.com/index.php?option=com_content&task=view&id=251&Itemid=100

[46] See E. GRANDY, "*Bardo Hotel* review", *Stranger*, 07/06/06: 'As a film score, *Bardo Hotel* is satisfying, even without the visual element, but as a Tuxedomoon record, it's a bit of a disappointment.'

[47] Matthew Amundsen, 09/21/06, viewable at: http://brainwashed.com/index.php?option=com_content&task=view&id=5567&Itemid=64

[48] J. DAYTON-JOHNSON, *All About Jazz*, 06/29/06.

[49] Available at: http://www.paristransatlantic.com/magazine/interviews/tuxedomoon.html

[50] Peter Principle interviewed by D. OANCIA, "Tuxedomoon", *Score* (Spain), 11/04.

[51] J.-F. MICARD, "Tuxedomoon", *D-Side*, 10/07.

[52] A. GILL, *The Independent*, 11/02/07.

[53] A. GILL, *The Independent*, 11/23/07.

[54] I. SHIRLEY, *Record Collector*, 01/08.

[55] K. MOLINE, The Wire, 01/08.

SELECTED BIBLIOGRAPHY [1]

Books

BELSITO, P. & DAVIS, B., *Hardcore California – A History Of Punk And New Wave*, Berkeley, The Last Gasp Of San Francisco, 1983, 6th printing of July 1996

BROOKS, A., *Flights Of Angels – My Life With The Angels Of Light*, Vancouver, Arsenal Pulp Press, 2008

BROWN, S., *Stories From Mexico*, Rowhouse Press, 2001

GILL, J., *Queer noises*, Cassels (UK) & University of Minnesota Press (USA), 1995

LAKE, B. & ORLOFF, A., *The Unsinkable Bambi Lake – A Fairy Tale Containing The Dish on Cockettes, Punks and Angels*, San Francisco, Manic D Press, 1996

NICE, J., *Tuxedomoon*, Materiali Sonori, 1988

REYNOLDS, S., *Rip It Up And Start Again: Postpunk 1978-1984*, London, Faber and Faber, 2005

SHIRLEY, I., *Meet With The Residents*, Wembley, SAF, 1993

STARK, J., *Punk '77: an inside look at the san francisco rock n' roll scene, 1977*, San Francisco, RE/Search Publications, 1999

TENT, P., *Midnight at the Palace: My Life as a Fabulous Cockette*, Los Angeles, Alyson Books, 2004

A wealth of details about Tuxedomoon and solo members' discographies until the nineties was found in three (very) limited ed. booklets published (in French) by a mysterious collective named Groupe Paris – Bruxelles – Venise (including Franz Regnot): *Tuxedomoon – Description d'une dérive*, 1988, 24 p.; *Tuxedomoon – Portraits de quelques visionnaires*, 1990, 42 p. & *Tuxedomoon – Opérations Trois*, 1990, 29 p.

Articles

A.P., "BLAINE REININGER Poitiers (28/1) MINIMAL COMPACT – TUXEDOMOON Bataclan (1/2)", *Rock & Folk*, 05/83 (in French)

AZZOUZ, A., "Interview avec Peter Principle", *Spirit Of*, 06/89 (in French)

BARRON, J., "Bad moon rising", *Sounds*, 05/04/85

BERND SUCHER, C., "Viel hübsches nebeneinander", *F.R.*, 06/25/1981

BERNIÈRE, V., "Tuxedomoon", *Technikart*, 08/27/03 (in French)

BIZARRE, "Una storia privata", *Blow Up*, 01/03

BLAY, Y., "Tuxedomoon", *D-Side 22*, 05-06/04 (in French)

BOURSEILLER, CH., "Continent inclassable", *7àParis*, 10/18/89

BRUNELLI, R., "Uno Steven Brown lunare sbarca a Prato. L'alchimia musicale et l'arte politica", *Paese sera*, 07/28/89

BRUYN, P., "Een melancholieke Amerikaan in Europa", *Haarlems dagblad*, 12/23/91

CAPPELEN, A. W., "Tuxedomoon draws many to the Opera", *Aftenposten*, 11/30/85 (in Norwegian)

CARUSO, G., "Effetto serra in musica", *L'Unita*, 07/28/89

CASTALDO, G., "Con i Tuxedomoon il rock è di nuovo musica 'colta'", *la Repubblica*, 03/31/88

CASTALDO, G., "Basta un filo di voce…", *la Repubblica*, 05/03/89

[1] This selection does not include record reviews. Language is indicated when unclear from the title. Articles with unknown authors are listed at the end of the "Articles" section.

CHERNOV, S., "Tuxedomoon: has-beens dupe 'tolerant' Russian audience", *The St Petersburg Times*, 12/01/00

CILIA, E., "Quel vecchio frac – Venticinque anni di Tuxedomoon", *Blow Up*, 01/03

COLJON, TH., "Steven Brown story", *Le Soir*, 12/06/84

COLJON, TH., "Blaine L. Reininger direct from Brussels", *Le Soir*, 08/21/84

COLJON, TH., "Minimal Moon et Tuxedo Compact: le retour des exilés", *Le Soir*, 04/05/85

COLJON, TH., *"Tuxedomoon: vogue le navire!", Le Soir,* 04/07/86

COLJON, TH., "De doute et de grâce dans le silence de la nuit", *Le Soir*, 10/09/91

COLJON, TH., "Peine de Blaine", *Le Soir*, 11/21/90

COLJON, TH., "Steven Brown, du Crépuscule à l'aube", *Le Soir*, 04/93

COLJON, TH., "La lune était si belle", *Le Soir*, 09/30/03

COLMENERO, J., "Tuxedomoon – Aranando el futuro desde dentro", *Diario de Jaen*, 03/15/87

CORNET, PH., "Amitié belgo-américaine", *Rock this Town*, 05/83

CORNET, PH., "Des américains à Bruxelles", *Le vif,* 06/21/84

CORNET, PH. & PRALINE, "Tuxedomoon (Interview)", *Oxygène*, 06/84 (in French)

CORNET, PH., "L'incomparable Tuxedomoon", *Le Vif/L'Express*, 06/11/04

D, ELISABETH, "Ils n'en font qu'à leur tête", *Actuel*, # 15, 01/1981

DE BRUYCKER, D., "Plan K: métamorphoses de Winston Tong", *Le Soir*, 11/82

DE LUCA, F., "Una luna lunga dieci anni", *Il Manifesto*, 03/31/88

DE MARINIS, G. & TOMASETTA, F., "Ghost sonata. Intervista ai Tuxedomoon", *Quindi*, 07/82

DE MEESTER, K., "Geen nostalgie voor Tuxedomoon", *De Morgen*, 09/30/03

DENSELOW, R., "Venue. Tuxedo Moon", *The Guardian*, 03/82

DIENER, T., "Tuxedomoon", *59 to 1*, 06/85 (in German)

DOERSCHUK, B., "The new synthesizer rock", *Keyboard*, 06/82

e.a., "Suono e immagine con l'anima nel sintetizzatore", *La Repubblica*, 11/11/81

EDMONDSON, B., "Interview Tuxedo Moon, week of July 15, 1980", *Praxis*, vol. I, # 6, 11/80

EGGEN, T., "From basement to Opera", *Dagbladet*, 11/27/85 (in Norwegian)

EKERN, Y., "Rock in the Opera", *VG*, 12/02/85 (in Norwegian)

ESPINOSA, P., "No queremos identificaciones ni etiquetas; tan sólo música: Brown y Reininger", *La Jornada*, 10/10/93

EUDELINE, CH., "Post-punk – Tuxedomoon, le groupe phare de la new wave est plus en forme que jamais", *Nova*, 2004

EVERS, E., "Blaine Reininger", *Oor*, 09/07/85 (in Dutch)

EVERS, C., "Tuxedomoon in: Rambo III", *Oor*, 09/21/85 (in Dutch)

FISCHER, H., "Winston Tong", *Artforum*, 12/78 (in English)

FORIER, J.-P., "Blaine L. Reininger - De grootste idioten hebben nu ook een synthesizer", *Het belang van Limburg*, 08/19/87

FRANCK, PH., "Steven Brown ou le malaise urbain", *Le Drapeau Rouge*, 04/08/87

FRANCK, PH., "Steven Brown: l'élégance nonchalante", *D'entre les pavés*, 1991

FW, "Indoor Life/Tuxedomoon/Snakefinger. Rock in Loft (27/3)", *Rock & Folk*, 05/81 (in French)

GARCIA, S., "Tuxedomoon recargado – Europa revisited", *Independiente*, 07/08/03

G.D., "Lunatique Tuxedo", *Best*, 02/87

GILL, A. & JONES, B., "Gimme the moonlight", *N.M.E.*, 09/19/81

GILL, A., "American Tux exiles", *The Independent*, 07/28/04

GOLDBERG, M., "The terror of Tuxedomoon", *SF Chronicle*, 01/14/79

GOLDBERG, M., "I left my heart in San Francisco. The residents, MX-80 and Tuxedomoon", *N.M.E.*, 11/17/79

GORIN, F., "Tuxedomoon: art-rock en smok", *Le Matin*, 11/30/83

GORIN, F., "Smoking de luxe et guerres saintes", *Le Matin*, 05/21/85

Page 442

GROSCLAUDE, P., "Tuxedomoon: l'angoisse californienne", *La Voix du Nord*, 12/03/83

GROSSEY, "Steven Brown (Tuxedomoon): de luisteraar is nooit verkeerd", *Kuifje*, 01/28/86

GULINCK, L., "De melancholie van het dagelijkse leven", *De Morgen*, 08/14/91

HARMENS, E. J. & DE BRUIJN, W., "A poet stuck in Brussels", *Poezie nieuws*, 03/92

HEIRMAN, F., "Misverstanden Tuxedomoon opgehelderd", *Gazet van Antwerpen*, 02/21/88

HENRY, H. H., "Les humeurs de Steven Brown", *Rock this town*, 11/91

HUNTER, M., "Moving from the margins into a genre of their own", *Passion*, 11/85

HUYS, J., "Blaine live: meevaller", *De Morgen*, 02/15/86

HUYS, J., "Blaine L. Reininger: rock in het bloed", *De Morgen*, 04/30/87

JDN & JB, "Steven Brown et Tuxedomoon: les amis américains", *02*, 06/13/04

J.H.M., "Steven Brown", *Keep on fighting*, 11/91 (in French)

J.M.D.B., "Franchimont: le dernier bastion des petits festivals d'été", *Le Soir*, 06/18/82

JUGÉ, PH., "La quatrième dimension", *Magic Mushroom*, Spring 1991

KEUNEN, G., "Tuxedomoon revisited", *Gonzo Circus*, 06/05/94 (in Dutch)

KIMBLE/A. CUYPERS, "Blaine Reininger", *Bierfront*, 01/85 (in German)

KOOPS, P., "Extreme muzieksoorten krijgen alle kans op Tegentonen-Twee", *de Volkskrant*, 05/21/85

L., BRAD, "Tuxedomoon", *Damage*, n° 9, 09-10/1980 (in English)

LANDUYDT, J., "Dolend langs de gewelven der kunst Tuxedomoon", *Vinyl*, 02/82

LANDUYDT, J., "De vrouw, de man. De derde dimensie", *Vinyl*, 02/83

LANDUYDT, J., "Een nieuwe vaagheid", *Vinyl*, 03/83

LANDUYDT, J., "Tuxedo Moon", *trespassers w*, # 3/4, 85/86 (in Dutch)

LANE, J. F., "What's burning' on Adriatic coast", *International daily news*, 07/06/81

LAUWERS, S., "Tuxedomoon blikt nooit terug", *De Standaard*, 06/02/04

LECLANCHE, J.-F., "Brown et Reininger à la chapelle de l'Oratoire", *Ouest-France*, 03/25/91

L.G., "Tuxedomoon opnieuw samen", *Het volk*, 02/10/88

L.G., "Reünie Tuxedomoon: verdacht geurtje", *Het volk*, 03/88

LOUKAS, V., "Tuxedomoon – 'We are a collective of artists'", 12/87 (in Greek)

LUCAS, G., "Tuxedomoon", *Les Inrockuptibles*, 03/87 (in French)

MCDONALD, R., "Winston Tong's cultural synthesis", *artweek*, 09/23/78

MAHIEU, G., "Blaine Reininger: ik will sterven als mijn tijd daar is en niet als Reagan zin heeft om op een knop te drukken", *Humo*, 1984

MAJER, L., "La luna in frac?", *Musica 80*, n° 8, 10/80

MANZELLA, G., "Su Roma luccia la luna di Tuxedo", *Il Manifesto*, 03/16/82

MARLIER, F., "Tuxedomoon, ils ont marché sur la terre", *Elegy*, 09/03

MARTINSON, N., "Peter Principle", *Proof*, # 1, 1999 (in English)

MATHUR , P., "Winston Tong. ICA, London", *Melody maker*, 08/10/85

MAZZONE, G., "Tuxedomoon: multisuoni da luna elettrica", *L.C.*, 11/11/81

M.M., "La musica del Duemila sarà fatto di silenzio", *La Gazzetta*, 07/10/89

MOSTAERT, J.-M., "Une victoire au goût amer", *Le Soir*, 02/18/1988

M.S., "Het brusselse dagboek van Blaine L. Reininger", *Backstage*, 09/89

MW, "Blaine L. Reininger, een nieuwe halve belg", *Het Nieuwsblad*, 01/05/85

M.Z., "Steven Brown au théâtre 140, 07/11", *Jazz in time*, 12/91

NANNI, R., "Brown", *Dolce Vita*, 19/04/89 (in Italian)

NESET, T., "Shadow pictures in the opera", *Dagbladet*, 12/02/85 (in Norwegian)

O'BRIEN, G., "Fun in Lullsville. Recording history", *Andy Warhol's interview magazine*, 3/80

O'BRIEN, G., "Tuxedomoon gone global", *Andy Warhol's interview magazine*, 1982

OANCIA, D., "Tuxedomoon", *Score*, 11/04 (in Spanish)

OOMKES, J., "Blaine Reininger voert mooi muzikaal dagboek", *Amsterdam Algemene Dagblad*,

09/83

PALAZZI, M., "Tuxedomoon", *Dry*, 07 & 11/83 (in Italian)

PALOSCIA, F., "Con i Tuxedomoon ritorno alla new wave", *La Repubblica – Firenze*, 05/12/04

PENA BLANCO, L., "Los sonidos del silencio en la sala Nezahuacóyotl", *Macropolis*, 10/04/93

PERROT, CH., "Tuxedo Mou", *Libération*, 05/21/85

PETRINI, A., "Blaine Reininger – Steven Brown, freaky frac", *Libération*, 06/29/91

PROSAÏC, A., "Tuxedomoon", *Gloria magazine*, 03/83 (in French)

QUINT, E., "Muziek voor donkere dagen", Goudsche Courant, 12/20/91

QUIRARTE, X., "Steven Brown, un músico sin etiquetas", *El Nacional*, 10/09/93

RALLIDI, I., "I'm a citizen in the demonic empire. Interview with Blaine Reininger", *Sholiastis*, 1988 (in Greek)

RAMONT, P., "Rolfing with Ralph", *The Daily Californian*, 12/07/79

REINA, M., "Tuxedomoon", Rockerilla, 05/82

RENARD, J.-L., "Open system project. Entretien avec Steven Brown", *Musiques diverses*, 03/85

RIGOPOULOS, D., "Blaine Reininger in Greece", *Kathimerini (Daily)*, 03/94 (in Greek)

RIJVEN, S., "Brown is veelzijdig componist", Trouw, 12/19/91

ROBERT, R., "Nouvelles lunes", *Les Inrockuptibles*, 07/13/04

RODRIGUEZ, J., "El futuro viene detras", *Rock De Lux*, 07/85

RONNIE, R., "Tuxedomoon, l'ultima voce del rock", *Il Resto Del Carlino (Bologna)*, 12/09/80

RONNIE, R., "Rock dei Tuxedomoon in versione italiana", *Il Resto Del Carlino (Bologna)*, 03/24/82

ROQUES, P., "Interview with Tommy Tadlock", *Vacation Magazine*, 10/01/79

ROZEN, M., "Steven Brown: nous sommes des réfugiés politiques de l'Amérique de Reagan", *Le Soir*, 1982

RUSSO, P., "Le alchimie di Steven Brown. Un musicista allo specchio", *La Repubblica*, 07/28/89

RUSTAD, J., "From San Francisco to the Opera", *Nye Takter*, # 144 (in Norwegian)

SAKAS, T., TRIANDAFYLLIDIS, N., MOUCHTARIDIS, G., "Memories from the moonlight zone. Small, nostalgic confidences from Peter Principle, Blaine Reininger, Steven Brown", *Sound & Hi-Fi*, 01/88 (in Greek)

SCHWERDT, A., "Ein Amerikaner in Brüssel", *Tip*, 06/87

SIMONET, D., "L'ombre lumière de Blaine L. Reininger", *La Libre Belgique*, 11/25/90

S.J., "Blaine L. Reininger: l'amour et Ceausescu", *La Nouvelle Gazette*, 11/16/90

SLAVENBURG, P., "Plan Delta van Bob Visser: Uniek in alle opzichten", *Het Vrije Volk*, 11/24/86

SNYDER, M., "The brighter side of Tuxedomoon", *San Francisco Sunday Examiner & Chronicle*, 12/81

SOMMER, A., "I left my heart in San Francisco – a collision with Tuxedomoon", *MM*, 01/85 (in Danish)

SONST, W., "Exile aan de vijvers van Elsene", *Fabiola*, 04/86

STEENHAUT, D., "Paganini speelt rock 'n roll", *De Morgen*, 11/24/90

STEENHAUT, D., "Wij waren op het gevoel", *De Morgen*, 06/12/04

STOCKMAN, O., "Tuxedomoon' en concert: un bateau de fous", *Le Drapeau Rouge*, 04/10/86

STRAUSBAUGH, J., "Winston Tong's cool gestures", *City Paper (Baltimore)*, 02/29/80

TALE, A, "Tuxedomoon – Surréalisme", *Rock & Folk*, 11/07

THERER, E., "Steven Brown – Une décennie en exil", *Ritual*, 03-04/92

TRIANDAFYLLIDIS, N. & PAPADOPOULOS, A., "Wanted: the muses", *Sound & HiFi*, 02/88 (in Greek)

VAMVAKARIS, TH., "Just a boy from Colorado – Blaine Reininger", *Cine7*, 05/22/88 (in Greek)

VAN BOCKSTAEL, K., "Koncert Tuxedomoon: de geveinsde waanzin", *De Morgen*, 04/05/86

VAN DEN TROOST, G., "België/U.S.A. Blaine L. Reininger", *Fabiola*, 08/07/89

VAN DER LEE, T., "De Tijdbom van Bob Tuxedo", *Oor*, 11/15/86

VANDER TAELEN, L., "Blaine Reininger: uit Tuxedo Moon stappen was als een echtscheiding", *Topics*

magazine, 01/84

VFG, "Blaine L. Reininger wint zijn thuismatch", *Het Nieuwsblad*, 11/24/90

Vikoer, A., "Concert – The Norwegian Opera – Tuxedomoon", *Klassekampen*, 12/06/85 in Norwegian)

Viseux, "Tuxedomoon, la nouvelle lune", *Libération*, 03/08/88

Walhof, G. J., "De heilige paradox", *Vinyl*, 05/85

Watson, D., "Travels with my tux", *N.M.E.*, 07/06/85

Watson, K., "The rock of Agis", *Hapstead and Highgate*, 11/02/90

Webb, Ch., "Dazzling, vivid, fascinating – and infuriating", *Western mail*, 06/05/81

Weiner, B., "Puppeteer's stunning power", *San Fransico Chronicle*, 02/19/79

WS, "Blaine Reininger oververmoeid tijdens opnamen van live-elpee", *Het Nieuwsblad*, 04/86

WS, "Tuxedo Moon: totaalspektakel loopt voortijdig uit de hand", *Het Nieuwsblad*, 04/05/86

Zaccagnini, P., "I Tuxedomoon al Trianon. Tutto è musica", *Il Messaggero*, 11/09/81

Zanger, P., "The Neo-Dada performers", *The Bulletin*, 03/12/82

Zarata, I., "La inquietante Belleza de Tuxedomoon", *Diario Vasco*, 09/05/86

Zie, K., "Interview", *Search & Destroy*, # 7-11, p. 76

Zota, G., "The loneliness of activism", *Pop Rock,* 1992 (in Greek)

Zuilhof, G., "Grabbelen in de trukendos van de clip", *De Groene Amsterdammer*, 09/24/86

Zumkir, M., "Steven Brown – Une décade de musique", *Jazz in time*, 09/91

"Blaine L. Reininger: "Als balling heb ik wellicht betere kijk op mijn land"", *Het Nieuwsblad*, 11/20/90

"Blaine Reininger: meestermuzikant", *Zoetermeersche Courant*, 04/14/86

"Concerts for a… detective Blaine Reininger in Athens", *Ethnos (Nation)*, 03/31/94 (in Greek)

"Die Wahreit über Tuxedomoon" (Interview Blaine L. Reininger), *59 to 1*, # 5, 1984

"How I left the moonies", *Underground*, 02/88

"These boots were made for dancin'", *The Sunday Times*, 11/04/90

"Tuxedo Moon, l'après Reininger", *Liberation*, 10/83

Internet

Tuxedomoon's official website and MySpace page: www.tuxedomoon.com ; www.myspace.com/tuxedomoon

Guido Marcolongo's website: www.tuxedomoon.org (a wealth of information and photos + an impressive list of bootlegs)

Patrick Laschet's Tuxedomoon and solo members' discographies: http://www.berlinwerk.de/tuxedomoon/

Yahoo discussion group about Tuxedomoon: http://launch.groups.yahoo.com/group/tuxedomoon/

Crammed Discs' website and MySpace page: www.crammed.be ; www.myspace.com/crammeddiscs

Materiali Sonori's website and MySpace page: http://www.matson.it/html/default.asp ; www.myspace;com/materialisonori

LTM Recordings' website and MySpace page: www.ltmpub.freeserve.co.uk/ ; www.myspace.com/ltmrecordings

Independent Recordings' website and MySpace page: www.independentrecordings.com ; www.myspace.com/independentrecordings

Neo Acustica's website and MySpace page: www.neoacustica.spb.ru/ ; www.myspace.com/neoacustica

Steven Brown's blog: www.stbrown.blogspot.com/

Blaine Reininger's website and MySpace pages: www.mundoblaineo;com ; www.myspace.

com/blainereininger ; www.myspace.com/blainereininger
Winston Tong's website and MySpace page: www.winstontong.com ; www.myspace.com/winstontong
Bruce Geduldig also has MySpace page (enter "Bruce Geduldig" as search term)
Paul Zahl's MySpace page: www.myspace.com/PaulZahl
Michael Belfer's MySpace page: www.myspace.com/michaelbelfer
Nine Rain's website and MySpace page: www.ninerain.com ; www.myspace.com/ninerain
The Weathermen's website and MySpace page: www.theweathermen.net ; www.myspace.com/theweathermen
Flat Earth Society's website: www.fes.be
Frank Brinkhuis' Crépuscule and Factory pages: http://home.wxs.nl/~frankbri/index.html
Several Tuxedomoon or solo members-related videos can be viewed on www.youtube.com

ACKNOWLEDGEMENTS

Very Special thanks to: Alain "La Dentellière" Bottu, Erik Stein, Oleg Kuptsov, Frank Altenloh, Steven Brown, Rudi Bekaert, Blaine Reininger, Carlos Becerra, Paul Zahl, Patrick Roques & Peter Principle

Many thanks to: Anouk Adrien & Bob Eisenstein, Naïma Al Boukhari, Merrill Aldighieri, Victoria Allen (*née* Lowe), Hector Alvelos, Julie Ann Anzilotti, Spilios Argyropoulos, Daniel Aspuru, Greg Bachar, Lucas Balbo, Marcia Barcellos, Jonathan Barnbrook, Annick Baudri, Jennifer Bayer-Brown, David Beaugier, the late Maurice Béjart, Inge Bekkers, Michael Belfer, Peter Belsito, Gianpiero Bigazzi, Léon Bille, Karl Biscuit, Uli Bösking, Julien Bosseler, Patrick Bottu, Philip Brophy, Mark Brown, Tina Brown-Fuga, Bob Burnside, Mireille Buydens, Roberto Caramelli, Greta Carbonez, Alessandro Cardellini, Fabrizio Cavallaro, Ronald Chase, Joe Cheek, Alex Chong, Bob Cooter & Blair Dean, Emile Corbisier, John Costello, Annie Coulter, Gregory Cruikshank, Daniel Curzon, Elisabeth D, Joëlle Dagri, Véronique Danneels, Patrick de Geetere, Grace De La Luna & Alexander van der Woel, the late Françoise De Paepe, DJ Hell, Anna Domino, Martine Doyen, Pierre Droulers, Corné Evers, Eddie Falconer, Pascale Feuillée-Kendall, Minny Forino, Hardy Fox, Bruce Geduldig, Elio Gelmini, Richard Lee Georget, Ivan Georgiev, John Gill, Dave Goerk, Jeff Good, Hanna Gorjaczkowska, Micheline & Georges Gosset, Nancy Guilmain, la Guillotina group from Mexico, Hans-Peter Habicht, Terry Hammer, Theresa Herninko, Alejandro Herrera, Marc Hollander, Marie-Dominique Hollen, Annik Honoré, André Jawerbaum, Alain Jennotte, Gareth Jones, Coti K, George Kakanakis, Walter Kelley, Vincent Kenis, Esmeralda Kent, Adam Klein, Scrumbly Koldewyn, Katalin Kolosy, Eiliv Konglevoll, Stéphane Lambert, Greg Langston, Nadine Lannaux, Brad Lapin, Patrick Laschet, Jean-Marc Lederman, Alain Lefebvre, Gilles Le Guen, Marc Lerchs, Benjamin Lew, Lig (*aka* Lynn Brown), George Loukakis, Alessandro Luci, Saskia Lupini, Corrie McCluskey, Mirco Magnani, Guido Marcolongo, Maripol, Gilles Martin, Bernadette Martou, Jean-Marie Mievis, Anne Militello, the late Patrick Miller, Renaud Monfourny, Niki Mono, Wendy Mukluk, Mark Nacker, Roberto Nanni, James Nice, Dan Nicoletta, Natale Nitti, Glenn O'Brien, Mileta Okiljević, Sandro Pascucci, Mark Pauline, Antoine Pickels, Francesca Pieraccini, Sasa Rakezic (*aka* Aleksandar Zograf), Maria Rankov, Alain Renard, Lucius Romeo-Fromm, Denis Rommelaere, Aaron Ross (*aka* Dr Yo), Lx Rudis, Laurent Sabido, Satonya, Willem Schipper, Oliver Schupp, William Lee Self, Nina Shaw, Yuval Shkedi, Kiran Singh, Claudia Skoda & Skipper, Thierry Smits, Michel Sordinia, Joe Stalpaert & Elodie, Nebojša Stanić, Thierry Steuve, Eric Stone, Erik Stormer, Jeffrey Surak, Olivier Taylor, Nicolet Theunissen, Nicholas Triandafyllidis, Jean-Pierre Turmel, Moucci Tong, Winston Tong, Frédéric Truong, Deborah Valentine, Cathérine Vanhoucke, Luc van Lieshout, Vic Vinson, Bob Visser, Daniel Wang, Michael J. West, Francis Weyns, Graeme Whifler, Jean-Claude Wouters, Andy Wilson…

You all know why…

This list was hard to compile. Please forgive me if I forgot to mention your name on here…

Cover design and photographs by Oleg Kuptsov (neoacustica@gmail.com)

INDEX

When page number is followed by "s," the reference is to text featured in the side bar column. When page number is followed by "&s", the reference is both to main and side bar columns.

1344 McAllister Street, SF 33, 45s-53s
1890-1990: One Hundred Years Of Music 330s, 331-332, 334s, 404s, 418s
2001: A Space Odyssey 423
23 Skidoo 194, 196s
3645 Market Street, SF 33
"59 To 1" 89, 96, 97s, 98, 104s, 148, 197s
77o7 30th Anniversary box set 421-422

A

AC/DC 155
A Certain Ratio 231, 410
Act Up 344&s, 345&s, 346
Actuel 105, 106s, 107-108, 113s, 128s, 162
Adaptations From The Moon: Tuxedomooning The World 424
Adelin, Jean-Claude 226&s
Adrien, Anouk 278-280, 327, 341&s, 349s
"A Fez Goes To Brooklyn" 218s
Agamemnon 367s
Agape Lodge 45s-47s
Agis, Gaby 332, 334s
Aksak Maboul 246, 247, 397, 400s, 401s
Alan Parsons Project, The 284s
Albee, Edward 226&s
Alcantara, Peter 45s-47s
Alcohol 20, 31, 68-69, 143, 170, 174&s-175&s, 203, 221, 239, 307, 341s, 345s, 347s, 384, 404s
Aldighieri, Merrill 127s, 354s, 390, 391s, 393, 396s, 400s, 401s, 403s
Allen, Victoria *see* Lowe, Victoria
Almond, Marc 138, 353s
Altamont 25s
Altenloh, Frank 124s, 377
Altman, Robert 49s
Alvarez, Luis 260, 262, 320&s, 323s
A Modest Proposal 322s, 325-327, 347s, 348s
Amon Duul 303
Amnesia 35-36
Ancienne Belgique (venue) 139s, 239, 244s, 246s, 247s, 269s, 270, 274, 281-283, 301s-302s, 303, 310s
Anderson, Laurie 179s, 219s
Angels Of Light, The 5, 14, 15, 19-32, 33, 36s, 37-38, 39&s, 41, 46, 57-58, 62, 65, 74&s, 75, 82, 147, 149, 174s, 237, 282, 332, 348, 405, 408, 424
Angst 6s, 57, 63, 65, 92, 98, 106&s, 109s
Annaud, Jean-Jacques 303
Ant Farm 12
Anzilotti, Julie Ann 332&s, 333-335, 342s, 367s, 370&s, 371s, 380, 387s
A Propos D'Un Paysage 248&s
Appunti Furibondi 334, 370s

Aquino, Ness 59-60
Archiduc (venue) 274s, 300
Arno (Hintjes) 154
Art Zoyd 220s
Aschenbach 201
"Ash & Bone" 145, 219s, 220s, 221s
Aspinall, Vicki 110, 112, 114s, 135
Aspuru, Daniel 404s, 413s, 419s, 424s
Astley, Virginia 231s
Atget, Eugène 179
"Atlantis" 275, 278s, 293s, 321, 354s, 415s, 422s
Athens 300s, 302-303, 305s, 350-351, 354s, 356s, 362s, 363&s, 364s, 366, 367&s, 387, 391s, 392, 401, 404&s, 405s, 412s, 415s, 419&s, 420s, 421s, 422s, 423&s, 424&s
A Thousand Lives By Pictures 141-142
Auschwitz 77s-78s
Avengers, The 51s, 74&s
A Walk On Dinosaur Hill 324s, 335s, 336, 337

B

Bach, Johann Sebastian 10, 12, 168s, 288
Badalamenti, Angelo 424
Baker, Josephine 22s
Baldwin, James 422
Ball, David 189s
Ball, Hugo 28
Ballard, J.G. 31s, 45, 96, 137s, 152
Barbieri, Gato 170s
Barbieri, Richard 189s
Barcellos, Marcia 249, 250, 260&s, 262, 278s, 295s-296s
Bardo Hotel 108, 404, 405s, 410-412, 413, 414, 419s-420
Barnbrook, Jonathan 421
"Baron Brown" 398-400, 401s, 414, 418, 419s, 420, 422s
Barrault, Jean-Louis 42s
Barrett, Syd 100, 278-279, 300s, 409
Barry, John 166
Bartok, Bela 67, 164, 288
Barton Fink 404
Basquiat, Jean-Michel 122, 368
"Basso Pomade" 174s, 191, 198s, 206s
Bators, Stiv 256
Baudelaire, Charles 172, 344, 354s, 389s
Bauer, Beaver 25, 29s, 37s, 408
Bauhaus 114s, 270, 288
Beatles, The 12, 241, 259, 374
Beat generation 5, 19-20
Becerra, Carlos 286&s, 351s, 366s, 370, 372, 373s, 380, 382, 384, 385, 386, 397s, 399s, 401s, 409, 416, 418s
Beckett, Samuel 67
Beethoven, Ludwig von 241, 288
Béjart, Maurice 148-151, 155, 158s, 243s-244s, 259, 263, 325, 333, 352

Page 449

Bekaert, Rudi 322, 347s, 389, 390s, 394
Belafonte, Harry 12
Belfer, Michael 43, 48-50, 53, 55, 60, 63, 67, 76-81, 83, 92-96, 201-205, 208s, 210-211, 212, 218-222, 281s, 294, 299s, 326, 388s
Belgrade 148, 373-377, 396s-398s, 401, 402s-403s, 415s, 420s
Belsito, Peter (& Davis, B.) 63, 67&s, 70, 75s, 96s
Belushi, John 128
Benigni, Roberto 296s
Bennett, Tom *see* Virulent Violins, The
Bergland, Bond 338
Berkeley (Bay Area) 42
Berkeley, Busby 23s
Berlin 198-201
Berlin cabaret 25s, 275
Berry, Chuck 241
Bertoglio, Edo 122&s, 368, 371s, 380s
Bertrand, Plastic 194
Besides All That (compilation) 332s, 335
"Besides All That" (the track) 281&s, 295s, 366s
Beursschouwburg 156, 166s, 192, 196s, 263&s, 270s, 280&s, 293s, 294s, 322s, 323, 357s, 358s, 422s, 423
Bhagwan 216
Bigazzi, Gianpiero 117-118, 296s
"Birthday Song" 145, 167s, 189&s, 201s, 219, 221&s, 222
Biscuit, Karl 232s-233s, 249, 296s, 400s
Bizarros, The 153
Bizot, Jean-François 6
Black Panthers, The 14
Blondie 44
Boa, Philip 355
Bodart, Jef 258s
Bogart, Humphrey 105s, 354
Bogarde, Dirk 119s
Book Of Hours 316&s-318
Bösking, Uli *see* Virulent Violins, The
Bosseler, Julien 345-347, 350, 351s
Bound Feet 42s, 43s, 63, 74s, 84s, 88s-89s, 91s
Bowie, David 12, 21, 87s, 91s, 101, 159, 210, 220s, 232, 258s, 259, 281s, 287, 316, 335, 341s
Bowley, Al 207
"Boxman" 285, 289s, 290, 291, 295
Boy George 256
"Break The Rules" 274, 275, 278s
Brel, Jacques 197, 230&s
Breton, André 29
"Broken Fingers" 145, 219s
Broken Fingers 157-159, 167s, 218s, 336
Brophy, Philip 179, 182
Brown, James 90
Brown Plays Tenco (album & tour) 295-299, 304s-305s, 310s, 316s
Bruinsma, Drem 226s, 319, 320, 323s, 324s, 333s, 334s, 341s, 345s, 348&s, 350s
Brussels 6, 78s, 97s, 106-107&s, 108, 109s, 119, 124s, 128, chapters 5 to 9, 362, 363&s-365, 377-380, 384, 386, 388s, 389, 390-394, 396&s, 397, 400, 401, 403, 404, 415, 419s, 421s, 422s, 423
Brussels USA 354&s
Bunnydrums, The 163s
Burgalat, Bertrand 353s

Buried Child 322-325
Burke, Clem 44
Burnel, Jean-Jacques 114
Burnside, Bob 20-21
Burroughs, William 29, 44, 74s-75s, 87s, 108, 127s, 128, 137, 153s, 164s, 310s, 318, 407, 412
Butchens, Richard 105
Byron, George Gordon (Lord) 167
Byzantium 279s, 287-288, 316, 317

C

Cabaret Voltaire (dadaist) 28
Cabaret Voltaire (the band) 105, 194, 196s, 258
Cabin In The Sky 380s, 381, 387, 389s, 392, 393, 396s, 397-402, 403s, 410, 417, 418, 419, 422
"Café Au Lait" 219s, 220s, 221s
Cage, John 63, 65, 87s, 97, 241, 331, 336, 337
"The Cage" 189, 190s, 196, 197s, 212, 223, 225, 240, 259s
Cagli 367s, 370, 372, 377, 380-388, 391, 397, 400
Cale, John 90s-91s, 239, 284s, 327, 328, 349s
California Dream tour 70-71, 127s, 128, 133-136, 138
Campbell Soup 295, 342s
Camus, Albert 87s
Can (the band) 323s, 336, 341s
Cannes Film Festival 368, 371s
Can You Hear Me? Music From The Deaf Club 89, 96s
Captain Beefheart 12, 97, 281s, 423
Caramelli, Roberto 186s-188s
Carbonez, Greta 226&s, 227
Carcinogenic, Peter (*aka* Principle) 82&s
Carlson, Carolyn 149
Casady, Jack 300
Castro Street Fair (SF) 37-38, 57&s
Caution, Lemmy 354
Cave, Nick 353s
CBGB (NYC) 59s
"Celebration Futur De La Divine" (*aka* "Burning Trumpet") 274, 288&s, 389s
Cell Life 137
Celluloid 102s, 105-106, 127s, 128&s, 133, 138-142, 156, 205
Centerville 391
Central Unit 115, 185s, 186s, 188, 189
Centre Pompidou (Beaubourg) 390, 393, 395, 396
Cézanne, Paul 42s
Chance, James 90&s, 95, 121&s, 327, 349s
Chamorro, Paloma 225&s, 255&s
Chandler, Raymond 317
Chaplin, Charlie 172, 280s
Charisma Records 105-106, 123, 137-140
Charlier, Daniel 226&s
Chase, Ronald (and commune) 39s, 42s, 43s, 61s
Chelsea Hotel (NYC) 90
Chéreau, Patrice 278s, 325
Chiapas 355s, 356-357, 358s
Chicago Seven Conspiracy, The 14
Chien Andalou 98
China Crisis 256
Chopel, Farid 143s
Chopin, Frederic 39
Chrome, 19&s, 67, 92, 153

Page 450

Circle Jerks 64
City Of The Red Dawn 128
Clarendon College (Nottingham) 136-138
Clarke, Michael 275
Clem, Jay 19s, 93, 94s, 127, 140-141, 153s
Cockettes, The 5, 14, 21-31
Cocteau, Jean 22s, 215s, 288, 342
Cocteau Twins 275
Coel Studios (Florence) 177
Collin, Marc 397, 401s, 412s
Colorado Suite (TM performance) 72&s, 74&s, 422s
Colorado Suite (BLR solo work) 241s-243s, 246
Communism 32s
Community College (electronic music class), SF 34-36
Compagnia XE 333, 367s
Complot Bronswick 321s
Composés Pour Le Théâtre Et Le Cinéma 233s, 236s, 320, 321s, 325
Conjunction 324s, 335s, 336-337
Constantine, Eddie 354
Conte, Paolo 400
Copland, Aaron 357s
Coppola, Carmine 282s
Cortez, Diego 79
Cosel, Howard 227
Costello, Elvis 90s
Coti K 368&s, 379s, 380s, 396-387&s, 393, 396s, 400s, 401s, 403s, 419s
Cow, Henry 115, 246
Coward, Noel 207
"Crash" 96, 97s, 141, 219s, 294, 422s
Craig, Adrian 80&s, 81-82, 87, 88s, 92s, 93-94, 128
Craig, Gordon 40s
CramBoy 72, 141, 153s, 158s, 169s-170s, 174s, 197s, 237s, 243s, 247
Crammed Discs 141, 152, 182, 185, 190s, 191, 201, 215, 246&s-247, 255, 262, 290, 291, 310s, 315s, 321&s, 340, 345s, 353-354&s, 362, 365s, 388, 393, 394, 397, 401s, 417, 419&s
Crammed Global Soundclash 365s, 388, 394, 396, 400s
Creach, Papa John 10
Creatures Of The Night, The 291-292
"Crickets" 225s
Crime 60, 74s
Croatian Variations 237, 348-349
Cruikshank, Gregory 19-21, 22-27, 30-32, 36s, 38&s, 57-59, 83s, 300s, 303, 388s, 408
Crutchfield, Robin 95, 102s, 103
Cryptic Corporation 92, 94s, 124, 127
Cuba 286s, 369s-370s, 377s-379s, 406
Cudù 324s, 342s, 350s
Cure, The 160s, 208s, 209s
Curtis, Ian 102s, 104
Cutler, Chris 115, 246
Cut-up technique 108, 191, 238, 248, 358, 420
Czukay, Holger 159, 323&s, 336, 374

D

D, Elisabeth 105s-106s
Dachau 196-198
Dadaism 28, 31s, 32&s, 40, 44, 67, 82s, 90, 282, 288, 318,

324, 332, 362s, 416, 417
D.A.F. 276
Dalida 296
Dandyism 23, 43, 207s, 265
Dante 215s, 288
"Dark Companion" 71, 87s, 104&s, 105s
Darkday/Del-Byzanteens 103
Darkness 124s
Davis, Miles 7, 410, 423, 424
Davis, Rene 14
Dead Kennedys, The 51s, 82, 87, 105
Deaf Club 60s, 85, 87, 88&s, 89s, 93s, 96s, 101-102, 107
Debord, Guy 28s
Debussy, Claude 10, 67, 168s, 297s, 335, 401
Decade 198s, 389s
"Decade" 327, 341&s, 342-343, 349s, 366s, 389s
De Coster, Gust 254-255
De Doute Et De Grâce 321s, 330s, 331, 351s
de Geetere, Patrick 135, 230&s, 245&s, 278-279, 299s, 303, 306s, 321s, 327-328, 330s, 331, 349s, 351s
Deine Lakaien 352s
De La Luna, Grace 412
Deleuze, Gilles 29, 29s-30s
Delvaux, André 416
Deneuve, Catherine 232
Depeche Mode 145&s-146, 189s
De Palma, Brian 198
"Desire" 103, 122, 123, 127s, 142, 405s, 415s, 418
Desire 103, 106, 108-115, 121, 138s, 139-140, 151, 160, 168s, 169s, 171-172, 205, 247, 253, 292-293, 352s, 371, 372, 400s
Deutsche Grammophon 164, 191
Deville, Willy 284s, 287, 304
Devine & Statton 316&s, 333s
Devo 61&s-62, 72, 95, 172, 232
Deyhim, Sussan 237s, 244s, 264-266
DhakaDimaDima 411s, 413-414
DJ Hell (*aka* Helmut Josef Geier) 199s, 370&s-372, 373s, 374s, 377, 380s, 386s, 387, 388, 389s, 390, 397, 401s, 418
Dick, Philip K. 152, 377s
Dietrich, Marlene 22s
Diggers, The 45s-46s
Dighe, Kalindi 350
Digital Dance 234, 260
Dirksen, Dirk 60&s, 61
Dish, Thomas 152
Disques Du Crépuscule, Les 107&s, 151, 155s, 156-157, 158s, 159-160, 166s, 167s, 169s, 189, 192, 193&s-194, 196s, 198s, 205, 212&s, 213&s, 218, 223, 231&s, 234, 240s, 258, 259&s, 266, 293s, 300, 316, 331, 354, 404s
Divine (the actor who worked with John Waters) 23
Divine (Béjart ballet & TM album) 70, 149-150, 154, 157, 158s, 160, 164, 170s, 171, 172, 191, 205, 223s
DIY (Do It Yourself) 29, 31s-32s
DNA 32s, 68s, 79, 95, 101s, 102, 106&s, 107s, 122, 163s
Doctors, The 48s, 82
Dogons 191s
Dogs Licking My Heart 354&s
Dolto, Françoise 265
Dolby, Thomas 332
Domino, Anna 90-91, 139s, 195s-196s, 212s-213s, 217s, 231s-232s, 234, 239, 244s, 246s-247s, 258&s, 259&s-260,

Page 451

269s, 270, 292s, 306, 316, 334s, 339, 353s, 367
Donn, Jorge 150
Don Quixote 6, 307, 385
Doublevision 178
Douzième Journée: Le Verbe, La Parure, L'Amour 190s, 191-192, 246, 248
Doyen, Martine 226-227
"Dream Assassins" 233, 244s-245s
Dream Makers 231s
Dreux 206-212
Droulers, Pierre 237s, 263-266
Drugs 11, 20, 21s, 23, 25s, 29s, 30, 31, 40s, 42, 48&s, 49, 51s, 53&s, 54, 63, 67-71, 78, 88, 94, 97-98, 102-103, 108, 121&s, 128, 133, 142, 144, 145s, 146, 163&s, 165s, 170-172, 174-175, 177s, 178, 187, 192-193, 195s, 197s, 198, 200, 203, 209, 212s, 216, 217&s, 221, 231s-232s, 239-240, 251, 262, 264s, 266, 279, 295s, 297, 302, 307, 320, 328-329, 357, 364s, 365, 380, 403, 404, 405, 420
Duchamp, Marcel 64s, 107, 318
Duncan, Isadora 22s
Duras, Marguerite 167s, 191s, 193s, 246s, 263s, 303, 306s, 351s
Durutti Column, The 152, 156, 231, 232, 234, 240s, 241s, 248, 263s, 270s, 275, 336
Duval, Michel 107, 151, 189, 205, 212&s, 213, 232s, 332

E

Eagles, The 30
Eastman, Donald 43s
Ecco Bravo 339, 356s, 358s, 364s, 404s
Echo & The Bunnymen 230-231, 259
Ectoplam 153&s, 154s
Edge, Damon 19s
"Egypt" 152, 153s, 225, 243s, 293s, 305s, 330s, 367s, 404s, 424s
Einstürzende Neubauten 290s
Elektrowerkz 402, 403s
El Paso 287s, 301s, 316s, 317
Emerson, Ralph Waldo 71
Enigma Records 286
Eno, Brian 35, 36s, 44, 64s, 65, 79, 87s, 97, 101, 104, 113-114, 123, 219s, 230s, 316, 341s
Eno, Roger 296s-297s
Eraserhead 153, 280s
Esmez, Laurent 255
"Eurasianstab" 79
Evensen, Casper 276-277
"Everything You Want" 91s, 92, 149, 293s, 424s
Expatriate Journals 321s

F

Fabian, Lara 296, 388s
Factory Records 192
Factory (Warhol's) 327, 349s
Factrix 19, 338
Fad Gadget 260
Faithfull, Marianne 114
Falconer, Eddy 389s, 420s
Falling Infinities/Kingdom Of Dreams 355-356, 357s
Fassbinder, Rainer Werner 25s, 198s
Faust 171s

Feinstein, Diane 85
Fellini 23&s, 26, 117, 288, 297, 333s
Feminist movement 24-25
Ferbus, Jean-Pol *see Jean-Gina B*
Ferry, Brian 252
Field Of Honor 201
Fields, Dougie 100
Finley, Karen 290s, 291
Fitzgerald, Francis Scott 307
Flamand, Frédéric 107, 148
Flamin' Groovies 299s, 300-301&s
Fleetwood Mac 30
Flesh & Fell 302
Fleshtones, The 95
Flipper 19, 64
Flock, The 10
Flog, The 10
Flower Songs 418s
Formula, Dave 231, 234, 240s
Fortis, Rami 248s, 362
Fourratt, Jim 90, 128&s
Fox, Fritz (Freddie) 338
Fox, Hardy 92, 141
Foxx, John 105-106, 109-110
Frankenstein 12
Frankie & Johnnie: A True Story 108, 113s, 114, 138s-139s, 142s-143s, 165s, 175, 196s, 207, 231, 264
Friday, Gavin 349s
Fripp, Robert 70
Froberger, Johann Jacob 163
Front 242 276
Front National 206, 212
Fuck Your Dreams This Is Heaven 278-280, 300s
"Fuga" 350, 351s, 366s
Fugitives In Black And White 230s
Funkadelic 114

G

Gallery, The 302
Gallo, Vincent 122
Garbarek, Jan 344
Garbo, Greta 150, 164
Gardiner, Chancy 405
Gaye, Marvin 12, 302
Gelmini, Elio 145s
Genet, Jean 67, 239s
Georgiev, Ivan 269-274, 282, 285, 286s, 292, 302, 307, 316, 320, 321, 334s, 344, 348s, 349, 350, 357s
Gershwin, George 219s
Gesamtkunstwerk 5, 153, 154s-155s
Ghost Sonata, The 136&s, 138, 145, 151, 160, 164s, 166s, 168-185, 188&s, 189-191, 198s, 199s, 206&s, 211, 235, 236s, 242, 262s, 293s, 319, 324, 331, 334s, 345s, 349&s, 353s, 354, 362s, 363, 367s, 389&s, 412, 418s, 421, 422s
"Gigolo Grasiento" 167s, 168s
Gigolo Records 370s, 371, 372, 383, 388
Ginsberg, Allen 11, 412, 420, 421
Glass, Philip 219s, 420
Glitter rock 21
Godard, Jean-Luc 323, 354
Gogol, Nicolas 355

Page 452

Gong 171s
Goodman, Benny 201
Goodman, Jerry 10
Gore, Martin 189s, 255
Gothism 5, 114, 170, 172, 179
Goutier, Alain 218s, 219s, 220, 244s, 249s, 258&s, 259
Greece 363, 365s, 366, 367, 368s, 388s, 421
Greenhouse Effect (SB show) 318, 319-320&s, 322s, 324s, 333s, 334s, 341, 348
Gropius, Walter 198
Grützi Elvis 79
Guilmain, Nancy 295, 301s, 305, 306, 322-235, 334s, 337, 422s
Guillotina, La 355s, 357&s
Guattari, Félix *see* Deleuze, Gilles
Guthrie, Woody 32s
Gysin, Brion 108, 412, 419, 420

H

Hacienda, The 192
Haig, Paul 156, 166s, 205, 258&s, 259, 263s
Haight-Ashbury 19, 45s, 53s, 405
Hair (the musical) 41, 42s
Half-Mute 87s, 95-100, 110, 113-115, 124, 141, 142, 149, 169s, 188s, 217, 246, 247, 292-293, 341, 370s, 371, 372, 377
Half Out 320, 341-344, 346, 348s-349s, 351s, 353s
Hammill, Peter 254, 276, 284s, 353s
Hampton, Fred 14
Hanrahan, Robert 87
Harris, George *see* Hibiscus
Haskett, Chris 341s, 344, 347s, 348s, 353s
Haydée, Marcia 150
Heather (Zahl's girlfriend) 53-54, 203
"Heaven And Hell" 201s
Hell, Richard 29, 91s
Hemingway, Ernest 155, 288, 317
Hendrix, Jimi 38, 77-78
Heretics, The (radio show, SF) 82
Hernandez, Carlos 325s, 327, 328
Herrera, Alejandro 356s, 357-358, 361s, 362, 363s, 377s-379s, 398s
Herrmann, Bernard 13
Hesse, Gerald 106
Hesse, Hermann 98
Hibiscus 21, 22, 24, 29s
Hippies, 5-6, 8s, 11, 19, 20s, 21, 24, 25s, 29-32, 33, 41-43, 45&s, 46s, 49s, 52s, 57, 62-67
Hirche, Albrecht 380s, 390s, 391s, 404
Holiday, Billie 102s, 113s, 197, 207-208, 231s
"Holiday For Plywood" 112, 114s, 172
Hollander, Marc 190s, 191-192, 221, 246-247, 248s, 262, 270, 289s, 291, 365s, 388, 391, 397, 401s, 419s
Holy Wars 201s, 214, 215, 218, 225, 237s, 238, 239, 243&s, 246s, 247, 248s-255, 260&s, 262&s, 263, 292-293, 300, 410
Honeymoon Killers, 270
Honoré, Annik 107
Horizon Of Dogs 332s, 333-334
Horne, Lena 143s
Horowitz, Richard 264

Howard Wise 20
Huelsenbeck, Richard 28
"Hugging The Earth" 218&s, 237s, 238, 239s
Human League, The 189s
Huxley, Aldous 102, 238

I

"I Heard It Through The Grapevine" 37-38, 57s
"I Left My Heart In San Francisco" 47, 91s, 92, 293s, 303s
Illuseum Art Gallery 411s, 412-414, 421s
Image Video 170, 177
Improvisation Trouvée 124s
"In A Manner Of Speaking" 223s, 243s, 249, 251, 252, 253, 255, 261s, 285&s, 354s, 403, 412s, 315
Indoor Life 103s, 104, 128&s
Industrie Discografiche Lacerba 296, 304s
Instrumentals 191, 206s, 230s, 258s, 389s
Interférence, L' 192
Intimacy 278
IRA 139-140
Island Records 231, 234
Isolation Ward 156, 166s, 230s
Isou, Isidore 28
Italian Records 162, 170s
Ivanov, Alex 390, 412s, 414
Ives, Charles 410
"I Was An Apple In The House Of Orange" 321, 322s

J

Jackson, Jesse 14
Jacobs, James 87s
James, Elmore 171s
James, Henry 423
Jamoul, Jean-François 153-154
Jara, Victor 424
Jarman, Derek 123, 138
Jarmusch, Jim 227
Jarvis, Scott 338
Jason And The Argonauts 13
Jawerbaum, Martine 69s-70s, 158-159, 168s, 194, 213, 214-215, 216, 217&s, 234, 237&s-239, 243, 257, 277&s, 325, 351s, 352, 353s, 356s, 357s, 358, 366s, 379
Jean-Gina B 236-237
Jefferson Airplane 10, 278&s, 300
Jet, The 256
"Jinx" 103, 114, 123-127, 139-140, 165s
Jobson, Richard 156, 166s, 167s, 182, 233s, 238s, 246s, 256, 284s,
"Joeboy The Electronic Ghost" 72
Joeboy In Mexico 72, 122, 361&s-362&s, 363&s
Joeboy In Rotterdam 72, 121&s-122
John, Elton 21
Johnson, Holly 304s
Johnson, Jack 155
Jones, Gareth 106, 109-110, 114s, 116, 145s, 160, 169s, 200, 219s, 220
Jones, Jim 102
Journey 31s
Jovi, Bon 304
Joyce, James 288
Joy Division 67, 102s, 104, 152, 153, 160s, 270, 333, 401

Page 453

Juran, Nathan 13
Juryman 297, 401s
Just Desserts (pastry shop, SF) 36-37, 57&s

K

Kadokura, Satoshi 232, 241s
Kafka, Franz 288
Kakanakis, George 404, 405s, 409, 411, 413&s, 416, 420s
Kaliflower commune 21
Kamins, Mark 289s-290s, 291-292, 310s, 322s
Karakos, Jean 128s, 149
Kaufman, Bob 293
Kenis, Vincent 270, 315s, 397, 401s, 419s
Kent, Esmeralda 30, 68, 89
Kerouac, Jack 8s, 88, 421
Kesey, Ken 69
Kid Creole & The Coconuts 122
Kid Montana 234, 260
King Crimson 284s
Kipling, Rudyard 261
Klang, Klaus 258&s
Klau, Nikolas 278-280, 281s, 291, 295s, 296, 298, 299s, 301s, 304s, 310s, 321s, 322s, 324s, 333s, 341&s, 344, 345s, 347s, 348s, 350s, 351s, 352, 353s, 355s, 357&s, 358s, 361s, 362, 363s, 377s, 414s, 418s, 419s
Kline, Phil 103, 339, 350s, 353s, 356s, 364s
Koldewyn, Scrumbly 24&s, 29s, 37s
Kolosy, Katy 151, 153s, 164, 175, 177, 185, 188&s, 194, 198s, 213
Kovacs, Janos 101
Kraftwerk 113, 189s, 287s, 374
Kühne, Ulf Maria 341s, 342s, 350

L

L'Age D'Or 72s, 74
Labriola, Ann 79
Lacey, Steve 263
La Edad De Oro 225, 255&s
La Grâce Du Tombeur 329, 333&s, 345
Lake, Bambi 21s-22s, 25, 32
Lambert, Stéphane 24s-25s
Lame 334, 342s
La Movida Madrileña 225
Landschap, Mensen, Stad, Cultuur 230s
Landuydt, Jan 283-285
Langston, Greg 51, 83s, 87&s, 90s-91s
La Rochelle 223s
La Rue, JJ 95s, 96, 106, 116, 121, 139s, 140, 142, 143, 144, 163, 167s, 169, 170, 172&s, 173, 174&s, 175, 176s, 180, 184, 208-211, 218-219, 223s, 227, 231s-232s, 239s, 259, 281, 300, 301s, 307, 322&s, 335&s, 347, 351&s, 353s, 363s, 364-367, 368&s
Last Emperor, The (Bertolucci's movie) 266
La Strana Festa 334, 367s, 370
Last Tango In Paris (Bertolucci's movie) 278
Laswell, Bill 420
Lausanne 165-168
Leary, Thimoty 69
Led Zeppelin 31s, 374
Lee, Arthur 239, 354s
Lefebvre, Alain 190s, 192, 219s, 234, 243s, 244s, 248&s,

259, 304, 306s, 404s
Le Guen, Gilles 239s, 415
Len, Guy D. 226
Lennon, John 116, 406
Léon, Daniel 192
Leone, Sergio 323s, 423s
Le Pen, Jean-Marie 210
Lerchs, Marc 279s, 296-299, 310s, 318s, 319, 322s, 341s, 344, 347s, 348s, 388s, 390s, 421s
Les Contaminations 327-328, 349s
"Les Nuages" 159, 167s, 168s
Lew, Benjamin 190s, 191-193, 220s, 246, 247, 248&s, 293s, 294s, 295, 301s, 303, 306s, 316s, 345s, 356s, 400s
"Licorice Stick Ostinato" 151, 174s, 191, 198s, 206s
Lievaart, Frankie 143, 177s, 188, 227s, 230s, 239&s
Ligeti, György 424
Light 149-150
Like The Others 193&s-194s, 195s, 196s
Lilly, John 69
"Lily Marlene" 59, 75
Lindsay, Arto 90
"Litebulb Overkill" 37, 49, 74s, 80&s, 82
Live In Brussels 280-281
Live In St Petersburg 389s
Logan, Andrew 297s
Lolita Danse 243, 245&s, 249-250, 255&s, 262
Lord Chapeau 349s
Lounge Lizards, The 90, 221, 296s
Love Yes 324s, 325, 341s
Lowe, Victoria 30, 38-40, 44, 57, 72, 74-76
Lowe, Jacques 40s
"Lowlands Tone Poem" 274s, 275, 305s, 316s, 324s, 334s, 389s
Lugosi, Bela 179
Lunch, Lydia 79, 122
Lupini, Saskia 107, 109s, 112&s, 120, 121s, 141, 145-147, 177s, 178, 180, 186, 189, 213, 227&s, 230s, 248, 292s, 293s, 306s, 315&s, 321s, 322&s, 323s, 324s, 330s, 336, 337, 338
Lurie, John 122, 227
"Luther Blisset" 389s, 400, 401&s, 410, 418, 422s
Lynch, David 153

M

Mabuhay Gardens, The 30s, 32, 57-65, 74&s, 75s, 77, 81s, 82, 83s, 85s, 88&s, 89s, 92s, 95s
Made To Measure 201, 242s, 246, 247, 305s, 315, 340, 419&s
Madonna 122
Magazine see Formula, Dave
Magnani, Mirco 118, 296&s, 304s, 363s
Magritte, René 154, 288, 398
MaMa, La 26, 74s, 83, 89s, 91s, 163s, 244s
Manley, Beatrice 39s
Man Who Fell To Earth, The 221s
Marine 166s, 234
Maripol 122&s
Marker, Chris 153
Marnell, Brian 301
Martin, Gilles 151-152, 153s, 155s, 176, 186-188, 191s, 192, 204, 207s, 231s, 239, 247&s, 249, 262s
Master Musicians Of Jajouka, The 108, 113s, 162, 412

Page 454

Materiali Sonori 117, 185s, 226s, 270s, 281s, 287s, 293, 300, 302s, 310s, 318s, 321, 322, 324s, 334, 342s, 348, 350s, 373, 380
Mavro Gala (aka Black Milk) 366s
May-Wong, Anna 143s
McCartney, Paul 80, 158
McEntire, John 397, 401s, 403s
McGeogh, John 256
McKinnis, Burt 9
McLaren, Malcolm 29, 32&s, 43
Mekas, Jonas 327
Melville, Herman 317, 421
Mertens, Wim 161s, 191, 213s, 231s, 258&s, 259
MetalBeat 106
Mexico 326, 330, 334, 344, 346s, 351&s-353&s, 354, 355s, 356&s, 357&s, 358&s, 361&s, 362&s, 363s, 364s, 369s, 370&s, 371&s-372, 377s-379s, 380s, 388s, 389s, 390s, 391s, 400s, 401s, 404&s, 405s, 407, 408, 410s, 413s, 414s, 418s, 419&s, 420&s, 421s,
Me, You And The Licorice Stick 280-281, 335
Microdot 365s-366s, 373, 390s, 391s, 400s
Midland Group 136-138
Mievis, Jean-Marie 389
Mikado 231, 240s, 241s
Mike, Micky 230, 246s
Militello, Anne 173, 176s-177s
Militia 333s, 350s
Milk, Harvey 84-85, 119, 406
Miller, Patrick (*aka* Minimal Man) 20s, 83s, 89s, 93s, 96s, 100s, 103, 106, 155s, 272s, 294s, 295, 299s, 325s, 328, 401&s
Miller, Steve 207
Miners' Benefit 74&s
Minimal Compact 201s, 207s, 209s, 236, 237s, 246s, 247, 263, 278&s, 280, 362, 400s
Minimal Man *see* Miller, Patrick
Minox 118, 263&s, 279s, 296, 301s, 354s, 363s, 368s, 379s
Miossec 355, 356s
Mirk, Shonach 149
Miserere 263-266
Mitterrand, François 206
"Moaning Low" 341&s, 344
Mohamed, Miri 162, 170s
Mohamed, Khessassi 162, 170s
Montana Blue 296, 301s, 310s, 322s
Mono, Niki 230-234, 239s-241s, 244s-245s, 246s, 262&s, 278&s, 299s, 316&s, 322s
Monochrome Set, The 95
Monroe, Marylin 251
Moroder, Giorgio 87s
Morricone, Ennio 67, 323s, 341s
Morris, Eric 39s
Morris, Steven 231, 234, 240s
Morrissey, Paul 327
Morrison, Jim 97, 410
Morrison, Sterling 327
Mortville 334s, 391
Moscone, George 84-85, 119, 406
Motown 12, 123
Mozart, Wolfgang Amadeus 166, 212, 288, 337, 355s
MTV 125, 338, 352, 354s, 370s
Mukluk commune 33

Mukluk, Wendy 20s, 24s, 30
Music For Solo Piano 190&s, 197s, 198s, 217s
Music In Four Suites Based On The Times Of Day 225-226
"Music # 2" 151, 160, 169s, 174s, 191, 198s, 199s, 206s
Mutants, The 57-58, 62-63, 67, 74s, 89s, 97s, 102, 338
Muzak 63, 98, 113, 236s, 316, 321s, 340
MX-80 Sound, The 89s, 91, 100&s, 153, 285
Mythical Puzzle 301, 305-308, 334s, 422s

N

Naggar, Carole 321s, 331
Nag Hammadi 398
Name, Billy 327
Names, The 156-157, 166s
Nanni, Roberto 118, 156s, 160, 161-162, 165s, 175, 176-179, 239, 240, 319-320&s, 323s, 324s, 373s, 403s
Nelson, Bill 182
Neo-Mayan Easter 35
Neon Judgment, The 230
"Nervous Guy" 92s, 93, 100, 223s, 290s
New Facts About Cement 230s
"New Machine" 49, 74s, 80&s
Newman, Colin 337, 339, 400s
New Atlantis Festival 410-414
New No Wave Festival (Minneapolis, 1979) 53s, 94, 95&s
New Order, The 231
New wave 32, 64-66, 75s, 83s, 91s, 92s, 107, 128s, 137s, 141, 152, 155, 169s, 189s, 270, 290&s, 317, 341, 388
New York Dolls, The 21, 29
Next Festival, Tel Aviv 362, 363s
Next To Nothing (the collection of TM covers) 412s, 414s
"Next To Nothing" (the track) 59s, 293s
Nice, James 182, 185, 205, 270s, 281s, 300, 310s, 321-322&s, 388
Nice, The 256
Nietzche, Friedrich 229
Night Air 97s, 201s, 212, 213, 218-221, 222s, 258s, 336, 354s, 389s, 400s
Nijinski, Vaslav 22s, 74s, 89s
Nine Rain 277, 353s, 355s, 356&s-358&s, 362&s, 364s, 369s, 370s, 371s, 372-373, 377s-379s, 380s, 382, 388s, 390s, 396s-400s, 404s, 410s, 419s, 420&s, 421s, 424s
"Ninotchka" 172
Nitti, Natale 115-116, 188
"No Business Like Show Business" 137s, 138
Noh Mercy! 20s, 30, 68, 88s, 89&s, 92s
Nomi, Klaus 89s, 91s
"No Tears" 49-51, 80-82, 89, 90s, 91, 94, 115-116, 157, 164s, 270s, 289s-290s, 291-292, 310s, 354s, 370s, 371-372, 383, 390, 415s
Notre-Dame du Bon Secours 350&s, 351s
Nouveau Casino 414-419, 420s
Nouvelle Vague 397, 403, 412s
No Wave 55, 79, 90, 121, 123, 340
Nuits Magnétiques 236&s
Nulty, Michael 104, 106, 116, 136, 151, 152s, 153s
Numan, Gary 92, 280s
Nuns, The 60, 74, 96
"Nur Al Hajj" (*aka* "Courante Marocaine") 137, 159, 162, 167s, 396

Page 455

O

O'Brien, Glenn 99, 102, 122&s
"Octave" 225s
O'List, Davy 256
OPERAtions 170, 174s, 242-246
Opium 165s
Optigon 20
Opwijk 415-418
Orchestral Manoeuvres In The Dark 189s
Orwell, George 219, 238
Osmond, Donny & Mary 287s
Overcoat, The 355, 358s

P

Paganini, Niccolò 10
Paik, Nam June 327
Pale Fountains, The 194, 196s, 231s
Palmer, Robert 114
Pandemonium 227&s, 247-248
Papa, Velia 145, 165s, 168-169, 170s, 188s, 215, 295
Paris En Automne 258&s, 287s
Pascucci, Sandro 367s, 370, 373s, 377, 380s, 381
Pasolini, Pier Paolo 83s, 334, 406
Pauline, Mark 54, 92s-93s
Paz, Octavio 407
Peccadillos, The 92s, 95s
Peeters, Benoît 248
Perreaudin, Philippe 415
Peter Principle, The (the book and theory) 82s
"Petite Pièce Chinoise" 159, 167s, 168s
Philips 158s, 164
Piaf, Edith 22s, 341
Pieraccini, Francesca 380
Picasso's Balcony 293s
Pickels, Antoine 246s, 260-262&s, 263, 281&s-282, 295, 301s, 305, 307-308, 324, 325, 333&s, 344&s, 352, 353s, 354s, 358s, 421s
Pinheads On The Move (compilation) 293&s-294
"Pinheads On The Move" 63, 72, 90s, 94
Pink Floyd 12, 31s, 66, 79, 113-114, 138, 155s, 207, 240s, 254, 262s, 378
Piston, Walter 171
Plan Delta 288-289, 389&s
Plan K 106, 107s, 108, 147, 150, 151, 153s, 155s, 163, 172s, 191, 192, 199, 230&s, 236, 260, 263, 264, 290s, 333, 352, 353&s
Plant, Robert 171s
Plastics, The 122
Playin' Your Game 218&s
Poe, Amos 227
Poe, Edgar Allan 172, 410
Police, The 91s
Pollock, Jackson 410
Polverigi Theater Festival 143s, 145&s, 165s, 168-170, 174s, 176, 178s, 179&s, 239s, 249, 324, 362s, 363, 371s
Polygram 141
Polyphonic Size 234
Pommerand, Gabriel 28
Ponty, Jean-Luc 10
Pookah 338, 339, 351s, 352s
Pop Group, The 252

Page 456

Pow Wow label 291
Pre Records 54, 102s, 105-106, 138-142, 153s
Presley, Elvis 251, 304
Prévert, Jacques 135
Price, Rodney 37s
Punk (rock or movement) 5-6, 19&s, 29-32, 33, 41-43, 44&s, 45, 48s, 52s, 53s, 54, 57, 59-60, 62-68, 72, 74, 75s, 77, 81-82, 83s, 84-85

Q

"Queen Christina" (*aka* "Pretty Moderne") 145s, 158s, 167s

R

Rachou, Madame 412
Radiohead 67, 401
Radio Moscow 355, 356s, 400s-401s, 419s
Ralph Records 54, 87, 88s, 91s, 92&s-94s, 95, 97&s, 99-100, 102s-104s, 105-106, 114s, 115, 123&s, 124-126, 127&s, 128&s, 138-142, 153&s, 156, 165s, 205
Ramones, The 29, 91s
Rankine, Alan 231, 233-234, 240s, 244s, 263s
Ranko, Slava (*aka* Donald L. Philippi) 32s, 72, 75s, 84s
Rankov, Maria 75s, 84s, 139s, 142s-144s, 145, 147-148, 155, 159s, 169, 206, 215
Reagan, Ronald 26, 32s, 117, 169s, 192s, 228, 229, 252, 344
Recommended Records 115, 246
Red Hot Chili Peppers, The 123s
Reed, Bradford 339, 353s, 357s, 364s
Reed, Lou 116, 349s
"Reeding, Righting, Rhythmatic" 248s, 255s, 270s, 274, 275, 278s, 321
Reich, Steve 91s, 242s, 420
Reid, Jamie 29
Reilly, Vini 231-232, 248&s
Renard, Alain 260, 262
Residents, The 19&s, 82, 91&s, 92&s, 93-94, 96, 98, 100, 102s-103s, 105, 116, 123&s, 124, 125, 139, 141-142, 149, 153, 163s, 169s, 172, 246, 285, 330s, 353s, 374
Reunion Tour 299-310, 321, 324s, 334s, 351, 402
Revisionaries 242-246, 248-252
Reynolds, Simon 19
"Rhumba" 61s, 293s, 294
"Rhythm Loop" 57s, 293s, 294
Rico, Layne 189s
Ridgway, Stan 189s
Riley, Terry 92, 297s
Rilke, Rainer Maria 264
Rimbaud, Arthur (also Tong's piece) 42s, 74s, 84s, 348&s, 382
Robinson, Ali 110, 114s
Rockabilly 207-209
Roeg, Nicolas (*Performance*) 24s, 49s
"Rolf & Florian Go Hawaiian" 287s, 298s, 299s, 321s
Rolling Stones, The 150, 259, 374
"Roman P" 274, 289s, 290, 321, 322s, 326
Romeo-Fromm, Lucius 325s, 327-330, 334s, 345s, 349s
Ronnie, Red 70, 118, 160
Roques, Patrick 8s-9s, 20s, 30-31, 33, 43-44, 46, 48, 53-55, 72, 74s, 88s, 90s, 93-94, 99, 100, 105, 116, 119s, 164-168,

172s, 175-176, 177s, 185-188, 189, 194-201, 203, 206-210, 213-215, 326, 327
Ross, Diana 12
Rota, Nino 117, 169s, 281s, 341s, 370
Rouse, Mikel 236&s, 241s, 242s, 243s
Rousseau, Henri (*dit* le douanier) 191s
Roxy Music, The 98, 256, 341
Rundgren, Todd 124s
Ryko Discs 141
Ryser, Scott 59s-60s, 67-68, 88, 189s

S

Sack, Stephen 295
Sakamoto, Ryuchi 182
Santagata, Alfonso 371s, 387s
Saqqara Dogs 338
Sartre, Jean-Paul 288
Satie, Erik 191s, 220s, 288, 297s, 331, 335, 344
Savage, Tommy 52s
Savoy Tivoli 85, 107s
Savoy Sound Wave Goodbye 127s, 128
Scanner 415
Schifrin, Lalo 244
Scream With A View 50, 85, 92s, 93-95, 97s, 105, 111
Scriabin, Alexander 315s
Schaumburg, Michael 178
Schiele, Egon 197
Schönberg, Arnold 10, 288, 337
Schuiten, François 248
Scorcese, Martin 113
Screamers, The 54, 92s
Search & Destroy (fanzine) 30s, 32, 40s, 74s, 82
Searching For Contact 281, 295&s, 341
Sedimental Journey 227, 246, 247&s-248
Seismic Riffs DVD 390, 391s, 393, 396s, 400s, 401s, 403s
Seventh Voyage of Sinbad, The (the movie) 13
Sex Pistols, The (and their "God Save The Queen") 30, 32&s, 44
Seyrig, Delphine 321s, 330s, 331
SF Mime Troupe 23s
Sfyzer, Thierry 274s
Shaw, Nina 113s, 139s, 140, 143s, 162, 165s, 170, 173-174, 177-180, 184, 227, 231s, 239, 241-245, 257-258, 270, 272, 285, 286s, 300, 302, 310s, 320, 323s, 334, 345s, 350, 351s, 367, 380-384, 406
"Shelved Dreams" 170s, 294
Shepard, Sam 42s
Ship Of Fools 215s, 245s, 246, 274-276, 278s, 281-283, 365s
Shorter, Wayne 410
Short Stories 189, 197s, 223
Sinatra, Frank 219s, 410
Singh, Kiran 216s-217s
Situationism 28&s-32&s, 154, 191, 282, 400, 410, 418
Sleepers, The 55, 60, 67, 74&s, 75s, 77, 78, 81s, 87s, 96, 102s, 203-204
Smith, Bessie 43s,
Smith, Patti 29, 39, 40s, 75-76, 83s, 116, 278
Smits, Thierry 329, 332, 333&s, 344&s, 345, 353s, 358s
Snakefinger 92s, 93, 100&s, 103s, 125, 128, 162, 170s, 374
Soft Cell 189s

Soft Machine, The 114
Soft Video 170, 177
Solo Piano Music see Music For Solo Piano
Solve Et Coagula 290, 353-354&s
Soma 101&s, 102, 237s, 238
"Some Guys" 218&s, 243s, 254, 255, 272, 321, 354s, 418, 424s
Somerville, Jimmy 262
"Somnambulist" 205s
Sónar Festival 388, 389s
Songs From The Rain Palace 335&s-336
Sonic, Dominic 356s
Sordide Sentimental 152-154, 159s, 160s, 208&s
Soundtracks – Urban Leisure 388-389&s
(Special Treatment For The) Family Man 85, 92s, 93
Sparks, The 287
Spigel, Malka 293s
Sprung Aus Den Wolken 330s, 332s
Stanislavsky, Konstantin 39s
Stazioni Lunari 401, 402s
Stein, Erik 370s, 387, 402
Stein, Gertrude 155
Steven Brown – L'Autre Chez Moi 345-347&s
Steven Brown Reads John Keats 318&s-320, 324s, 335, 351s, 420s
Stiff Records 93
"St-John" 218&s, 243s, 249, 253
St. Paul Hotel (SF) 404, 408, 411
Stockhausen, Karlheinz 10, 65
Stories From Mexico 355s, 379s, 396s
St Petersburg 373-374, 375, 389s, 396s, 398s
Stratton-Smith, Tony 138
Stravinsky, Igor 288
Streisand, Barbra 12
Strindberg, August 169, 179, 185
Structuralism 83
Sturm und Drang 197
Sub Rosa 166s, 226s, 318&s, 324s, 332s, 335
Subterranean Modern 91&s, 92, 106, 111, 115, 149, 246
Subway To Cathedral 198s, 277, 286, 350, 351s, 366s, 370, 418s
Sufis 35, 43
Suicide (the band) 122, 128s, 159, 189s
Suite En Sous-Sol 136&s, 137, 162-163, 166s, 169s, 170s-171s, 172s
Sumac, Yma 22s
Super-Eight Years With Tuxedomoon 124s, 138s, 170s, 300s, 303, 362s, 363s, 419s
Supremes, The 12
Surman, John 344
Surrealism 28-29, 92, 105s, 113, 179, 250, 288, 291, 315&s, 317, 362s, 403s, 422s
Suzuki, Atsuo 232, 241s
SVT 51, 300
Snowy Red 230, 234, 246s
Sylvester 22&s, 408
Sylvian, David 182, 316, 332

T

Tadlock, Tommy 20&s-22, 24s, 25-26, 30-31, 33-36, 38, 41, 44-50, 57, 72, 79-82, 87, 88s, 89, 93, 364, 405s

Page 457

Tadzio 201
Talking Heads, The 90s, 91s, 100, 104
Taraf De Haïdouks 396, 399, 400s, 403s
Target Video 96s, 113s, 194, 197s
Tarwater 397, 401s, 403s
TC Matic 154
Teatro Antoniano 115-116
Teatro San Luis 330&s, 331
Telex 287
Temple Beautiful 92s, 95s, 97s, 100s, 101&s, 102
Tenco, Luigi *see Brown Plays Tenco*
Tent, Pam 22s, 29s
Ten Years In One Night 321-322, 324
Théâtre Sébastopol 236&s, 243, 248s, 249
"The Cascade" (*aka* "The Fall") *see* "The Cascade"
"The Fall" (*aka* "The Cascade") 190, 198s
"The Hunger" 232-233, 241s, 244s
The Last Museum 108, 412
The More I Learn The Less I know 368&s, 400s-401s
Theoretical China 231-233, 239s, 240s, 241s, 244s
Theoretically Chinese 231, 233-234, 240s, 241s, 243, 244s, 266
"The Stranger/Love/No Hope" 87&s, 94, 115, 162-163, 171s
"The Train" 215s, 274s, 289s, 290
Theunissen, Nicolet 326
"The Waltz" 217, 243s, 251, 253, 270s, 321, 400s, 410
"This Beast" 189, 190s, 196, 197s, 212, 223
This Heat 36s, 138s, 140
"This Land" 225&s
Thomas, David 284s
Thoreau, Henry David 71
Triandafyllidis, Nicholas 300s, 302-303, 354&s-355, 363, 366s
Throbbing Gristle 105, 112, 152, 153, 160s, 189s
Tidal Wave Records, 72&s
Time Release Records 72s, 80&s, 87&s, 92s, 93-94, 115
Time To Lose 159-160, 169s, 170s, 259s, 262s
Tirez Tirez 236&s, 241s
Tohu 292s
Tone Poems 315-316
Topping, Simon 231, 240s
Tortoise *see* McEntire, John
Tovaritz foundation 321&s
Traces Au Carré 124s
Tribute To Polnareff 353s
"Tritone" 87s
Truong, Frédéric 255
Tubes, The 11, 154s
Turmel, Jean-Pierre 152-154, 159s-161s, 208&s
Turner, Simon Fisher 415
Turya, Aleksandra (*aka* Sasha) 348
Tuxedo Moon – Le Train 114-115
Tuxedomoon – No Tears 72s, 90s, 107s, 164s, 354s, 362s, 363&s
Twain, Mark 410
Tycoons, The 10
Tzara, Tristan 28

U
Ultravox 72, 105

Page 458

Uneasy Listening 403s
Une Nuit Au Fond De La Frayère 152-154
Univers Zero 220s
Un Soir, Un Train 416
Urban Leisure Suite 74, 101s-102s, 103&s-104, 214, 362s, 363, 389&s
Urban Verbs, The 114
Utopia commune (Rotterdam) 121&s-122, 136&s, 142, 145&s-146&s, 147, 162

V
Vacation Magazine 20s-21s, 54, 88s
Vale 30s-31s, 32
Valenciennes, University of 243-245
Valentine, Deborah 207, 208, 209s-210s, 211, 212
Van Acker, Luc 231s, 247s, 258s
Van Der Graaf Generator 254
van Der Woel, Alexander 412
Vaneigem, Raoul 29&s
Vanhoucke, Cathérine 302
van Lieshout, Luc 215-218, 223s, 224, 238, 241, 260, 264s, 273, 274, 277, 292-293, 295, 296, 298, 300, 316, 320, 321, 344, 348s, 349-350, 358&s, 365s, 366, 373, 380, 385, 387, 388, 403, 410, 413, 417, 419s, 420, 423
Vapour Trails 411, 418s, 419, 420s, 421, 422-424
Vardo 339, 356s, 358s, 362s
Varèse, Edgard 10
Veld Van Eer see Field Of Honor
Velvet Underground 67, 110, 154s, 241, 278&s, 279
Vietnam war 13, 14&s, 21s, 26, 32s, 252
Vincent, Véronique 270
"Violorganni" (*aka* "Song For L") 329, 341&s, 345s, 418s
Virgin Prunes, The 208s
Virulent Violins, The 345s, 347&s-348&s, 350&s, 351s
Visconti, Luchino 305
Visser, Bob 201&s, 247, 288-289, 389
Vivaldi, Antonio 127s, 149, 168s, 288
von Sternberg, Josef 22s
Voltaire 288
"Voodoo" 341&s, 342s, 353s
VPRO 201, 216, 217, 236s, 244s, 261s, 284s, 288s, 345s, 348s, 349s
Vromman, Yvon 270

W
Wagner, Cathy 321s, 328, 349s
Wagner, Richard 178, 288
Waits, Tom 219s, 251, 284
Walkau, Stefan *see* Virulent Violins, The
Walker, Scott 281s
Wang, Daniel 249s, 280s, 284s, 345s
Ward, Leslie 34, 367
Warhol, Andy 99, 122, 294-295, 327-328, 342s, 349s
"Watching The Blood Flow" 201s, 243s, 251, 254
Waters, John 21
Weathermen, The 260, 263s, 299s, 300, 301, 310s, 316s, 321
Weather Underground 14, 26, 46s
Webber, Rachel 189s
Weill, Kurt 277
Wenders, Wim 255, 288, 305, 325, 352, 358

West, Michael J. 141
Westwood, Vivienne 29, 32
Weyns, Francis 364s-365s
W Gep-eTTo 334, 335, 387s
"What Use?" 80s, 96, 97&s, 98, 124s, 141-142, 165s, 216-217
Whifler, Graeme 123-127, 139-140
White, Barry 218s
White, Dan 84-85
White Night Riots 85
Whitman, Walt 244, 421, 422
Wild Boys, The 42s, 74s, 84s, 121s, 128, 197
Wilde, Oscar 63, 305, 307
Williams, Tennessee 22s
Wilson, Robert 138, 263
Winston Tong Sings Duke Ellington 262s, 263&s, 270s
Wire, The *see* Newman, Colin
Wobble, Jah 231, 234, 240s
Workdogs 338
Wouters, Jean-Claude 148, 152

Y

Yardbirds 278&s
Yello 275, 276
You (the album) 281s, 289-292, 295, 365s, 393
"You" (the track) 290, 293s, 389s
Young Marble Giants, The 316
Youth International Party (Yippies) 8

Z

Zahl, Paul 33, 43, 45-53, 55, 74, 76, 80, 83, 87&s, 299s, 300-302, 305, 311, 316&s, 320s, 321
Zapatistas 355s, 356-357&s, 358s, 372
Zappa, Frank 10, 169s, 303s, 317
"Zeb & Lulu" 301s, 310s, 322s, 335&s, 354s
Zeitgeist 229, 378, 389
Zelasny, Roger 48s, 62
Zeman, Karel 153
Zoo Story 226&s, 227, 259s

Page 460

Printed in the United States
114835LV00007B/1/P